AMERICAN
FOLK SCULPTURE

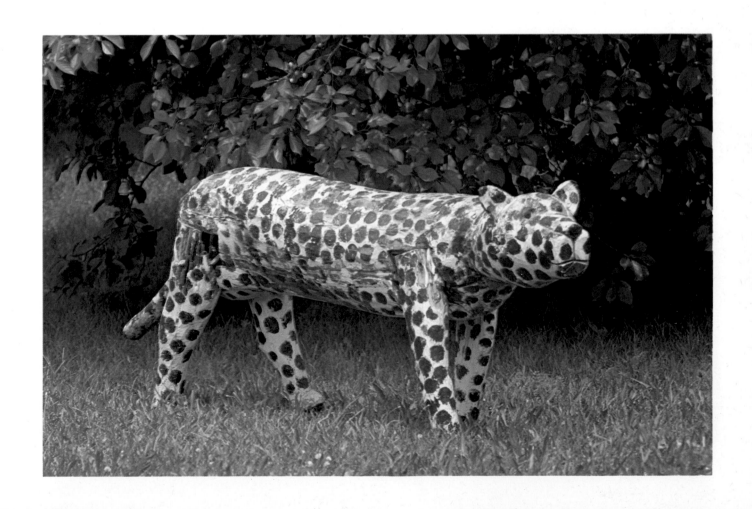

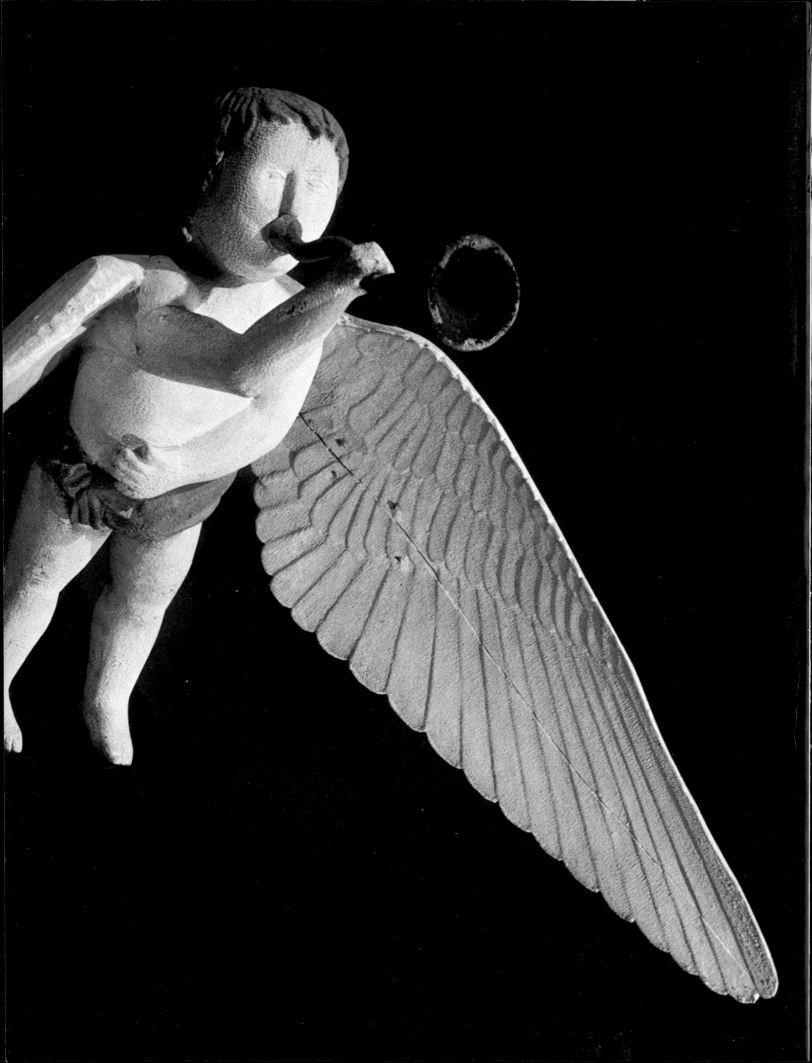

AMERICAN FOLK SCULPTURE

by
Robert Bishop

Museum Editor, Greenfield Village and Henry Ford Museum

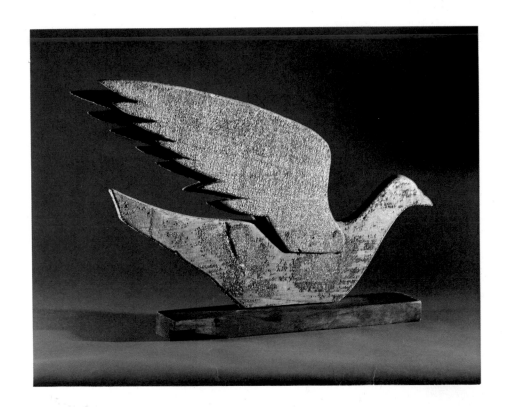

NEW YORK

E. P. DUTTON & CO., INC.

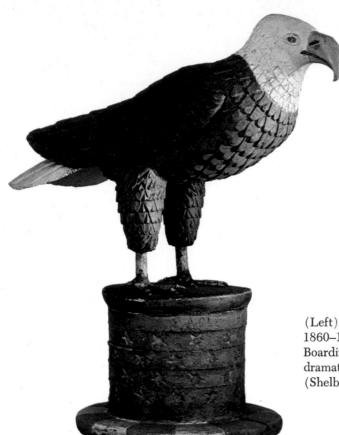

(Left). Eagle on hat. Pittsburgh, Pennsylvania.
1860–1870. Wood. H. 24″. The Veterans'
Boarding House in Pittsburgh sported this
dramatic carving inscribed "Eagle House U.S."
(Shelburne Museum, Inc.)

Color plate, page 1: Leopard. Maine. Early twentieth century. Tree trunk and limbs.
L. 77″. This figure was made by a lumberman, who used it as an outside decoration
at a lumber camp. (Private collection)

Color plate, page 2: Detail of tavern sign. Guilford, New York. C. 1827. Wood, painted.
W. 46½″. This splendid angel Gabriel, one of the masterpieces of American folk sculp-
ture, was used under the portico of the Angel Tavern at Guilford. The tavern was built
by Captain Elihu Murray for his son, Dauphin. See page 392 for an illustration of the
complete sculpture. (Mrs. Jacob M. Kaplan; photograph courtesy Gerald Kornblau
Gallery)

Color plate, page 3: Dove. Kansas. Late nineteenth century. Wood. L. 24½″. Some of
the original paint remains on this carving, which once served as a ridgepole decoration
on a granary. (Private collection; photograph courtesy Ralph M. Meyer)

Color plate, page 8: Detail of the Watts Towers. Simon Rodia (1879–1965). Watts,
California. Begun in 1921; completed in 1954. Steel rods, mesh, and mortar decorated
with broken bottles, dishes, tiles, and seashells. Height of tallest tower is approximately
150 feet. This incredible structure was built without a predrawn design and includes
towers, arches, fountains, pavilions, and labyrinths. (Photograph courtesy James Eakle)

First published, 1974, in the United States by E. P. Dutton & Co., Inc., New York. / All
rights reserved under International and Pan-American Copyright Conventions. / No
part of this book may be reproduced or transmitted in any form or by any means, elec-
tronic or mechanical, including photocopy, recording, or any storage and retrieval sys-
tem now known or to be invented, without permission in writing from the publishers,
except by a reviewer who wishes to quote brief passages in connection with a review
written for inclusion in a magazine, newspaper, or broadcast. / Published simultane-
ously in Canada by Clarke, Irwin & Company Limited, Toronto and Vancouver. /
Printed and bound by Dai Nippon Printing Co., Ltd., Tokyo, Japan. / Library of Con-
gress Catalog Card Number: 74-10477 / ISBN 0-525-05350-6. *First Edition*

FOREWORD

The tradition of the self-taught carver that began in the Colonies is one of the longest lived in American folk art, with the nineteenth century marking the years of its greatest prospering. Despite the development and general use of machine methods, handcrafting of decoys, store figures, and toys continued well into this century.

In the country that grew from the original towns along the seaboard and up the rivers to new farms and settlements, the folk sculptor followed soon after the frontiersman. His creations were often useful, but broad vigorous handling of three-dimensional designs before long made utility secondary to aesthetic worth.

Although many carvers are known by name, they are outnumbered by the anonymous legions whose circumstances were as varied as their creations. Soldiers, sailors, blacksmiths, tinsmiths, coppersmiths, ship and ornamental carvers, lumberjacks, hunters, farmers, and itinerant craftsmen all contributed to the torrent of sculptured objects. For some, handcrafting was their source of livelihood; for others, whittling was a pleasurable way to spend newfound leisure.

A general definition of folk art identifies it as the creation of self-taught artists working for their peers in the country and in small towns. For this reason, the greatest number of sculptures was made in the Northeast, in areas in which the middle class was dominant. From these states, outcroppings later appeared in Ohio and in the Southern Highlands.

Unlike American folk painting, which for the most part observes unities of time, place, form, and style as strictly as any Greek drama, American folk sculpture begins earlier and lasts longer, was created by a wider range of artisan craftsmen, and shows no common approach within its many diverse forms. Although certain subjects were favorites, the self-taught carver employed various and wondrous ways of modeling and shaping these reiterated forms. Most were originally created for a myriad of purposes: to lure the game bird from the sky; to mark a grave; to indicate wind direction; to identify a shop; to guide a ship; to hold a corset straight and tight. And yet, even in these uses the impulse everywhere was to enhance, to decorate, and to enlarge upon practicality.

The materials at hand often dictated the form. Some decoys and certain animal carvings still show their natural origins as stumps or roots or wood burls. Direct European inspiration came from imported toys, pots, and tinware. Sometimes American artisans translated from Staffordshire to wood or pottery. Sometimes small imported animal or figure carvings—carved, gessoed, and painted in distinguishable Middle European pattern —were surprising and felicitous ornaments on homemade, American-fashioned whirligigs and mechanical toys. Sometimes a manufactured weathervane was transformed by the folk sculptor's urge to improve and embellish the objects at hand.

The rediscovery of folk painting and sculpture began in Maine in the late 1920s where artists, dealers, and collectors gathered like mayflies in summer, and there they began to see the simple paintings and carvings in a new way. Portraits and landscapes, weathervanes, gravestones, ship and architectural carvings—these and many other objects were reappraised as aesthetic objects and as grass-roots inspiration for the painters and sculptors who came there. In the 1920s and 1930s landmark exhibitions of American folk art at the Whitney Studio Club, The Newark Museum, and The Museum of Modern Art lent further cachet to these rediscovered objects. Always interesting, frequently visually appealing, and often fashioned with great skill and sensitivity, examples of folk sculpture began to appear in at least one modern art collection—Abby Aldrich Rockefeller's—as rootstock and first flowering.

The single most common human inspiration for the folk sculptor—in his life and for long after—was George Washington. His death in 1799 brought a dramatic change from the personable angels and icon symbols of gravestones to stylized willows, urns, and mourning figures. Washington was cast as a stove, fashioned as a cookie-cutter hero in tin, carved as a toy, designed as a figurehead, and sculpted into the twelve-foot, topmost figure on a temporary wooden monument honoring his memory.

Similar honor was bestowed on the flag as it was executed in tin, wood, pottery, and chalk. It became a pasture gate and a Liberty weathervane's banner. The eagle, national bird of the new republic, flew atop ships' pilothouses and courthouse flagpoles, perched above house and cupboard doors, and settled restlessly upon the parlor table.

Some names and identities are known. The Skillins, Samuel McIntire, and William Rush evoke images of ship and architectural ornaments, as do the later practitioners, John Bellamy, Edbury Hatch, and Laban Beecher. Uzal Ward and John Stevens were gravestone carvers, respectively in New Jersey and Newport. Bernier carved eagles, as did Wilhelm Schimmel and Aaron Mountz, who are also well known for their roosters and parrots (and in the case of Mountz, a single, majestic, elongated crane). Julius Caesar Melchers, grandfather of the twentieth-century painter, Gary, carved the most elegant of cigar store Indians in Detroit. A. Elmer

Crowell carried into the twentieth century the Indian tradition of the decoy maker. McKillop's carvings seem like Bosch nightmares, and George Lopez, the *santero,* works today in New Mexico fashioning the last of a great ghostly parade of Southwestern saints.

Amid this heterogeneous array the viewer seeks the ribbon that binds it together. In recent and distant times, in all the several American cultures in which folk sculpture appears, in the diverse intentions, aspirations, and skills that gave it form, is there a unifying force—any common bond? It seems to me that there is and that Robert Bishop's dazzling, wide-ranging selection is unified in these respects: the intent and first purpose that the sculptor served was a practical and useful one; and he (or she) was performing for an audience of peers— patrons who often were closer than members of a common society, bound by bonds of blood, marriage, or friendship to the creators. While these creators followed highly individual directions in enriching the surface, form, or basic style of their three-dimensional objects, there is usually an innocent and innovative mind and talent at work reducing the sometimes complex natures of their models to the simplest, most basic, and direct ones.

The societies from which most folk artists spring are small and individual. Beat and measure are strongly felt within this kind of cultural island, where small eccentricities and creativity—often self-taught and frequently exercised—are closely observed and many times encouraged. Its members are bound together and share common purposes and problems. These are the folk sculptors' unities, and in this book we see them followed in rich and excellent array.

MARY BLACK

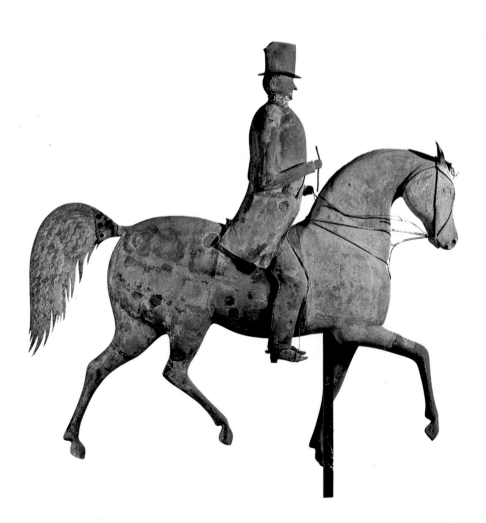

(Above). Horse-and-rider weathervane. Howard. New York. 1870–1880. Copper with lead head. H. 41″. Weathervanes occasionally are fitted with cast-lead heads so that the front of the vane will balance with the heavier rear quarters. This piece is beautifully weathered with traces of gold leaf forming an interesting pattern. (Collection of Edith Barenholtz)

ACKNOWLEDGMENTS

I wish to express my sincere gratitude to the many individuals and institutions that have generously provided pictorial and textual material for this volume. It gives me great pleasure to make a special acknowledgment to my editor, Cyril I. Nelson; to Patricia Coblentz, who not only served as Associate Editor, but whose countless hours of patient reading and typing have made this book a reality; and to Mary Black, Curator of Painting and Sculpture at The New-York Historical Society, who read the manuscript, wrote the Foreword, and offered so many valuable suggestions. Special mention should also be made of the fine photographs that have been provided by Charles T. Miller, Carl Malotka, and Rudy Ruzicska of Greenfield Village and Henry Ford Museum, and Arthur Vitols of Helga Photo Studio, New York.

Collectors and Dealers:
Mary Allis; Effie Thixton Arthur; Mr. and Mrs. Leonard Balish, Englewood, New Jersey; Mr. and Mrs. Bernard Barenholtz; Richard Benizio; George O. Bird; Mr. and Mrs. Jerome Blum, Lisbon, Connecticut; Mr. and Mrs. Edwin C. Braman; Mr. and Mrs. Gordon Bunshaft; Mr. and Mrs. W. B. Carnochan; Russell Carrell, Salisbury, Connecticut; Patricia Coblentz; Barry Cohen; Gary C. Cole, New York; Mr. and Mrs. Eugene Cooper; Allan L. Daniel, New York; Terry Dintenfass, Inc., New York; James Eakle; Raymond O. Davies, The 1807 House, Farmingdale, New Jersey; Mr. and Mrs. Robert Evermon; Howard A. Feldman; Burton and Helaine Fendelman, The Fendel Shop, Scarsdale, New York; George Finckel, Bennington, Vermont; Dr. Milton E. Flower; Mr. and Mrs. Walter Buhl Ford II; Frederick Fried; Dr. Alvin E. Friedman-Kien; Edmund L. Fuller; Benjamin Ginsburg, Ginsburg & Levy, Inc., New York; Leah and John Gordon, New York; Dr. and Mrs. William Greenspon; Stewart E. Gregory; Mr. and Mrs. Charles V. Hagler; Collin Hall; Mr. and Mrs. Michael D. Hall; Roland B. Hammond, Inc., North Andover, Massachusetts; Nelle and Richard Hankinson; Herbert W. Hemphill, Jr.; Barbara Johnson; Mr. and Mrs. Harvey Kahn; Mrs. Jacob M. Kaplan; Mr. and Mrs. James O. Keene; Jolie Kelter and Michael Malcé, Kelter–Malcé Antiques, New York; F. Frederick Bernaski and Howard Rose, Kennedy Galleries, Inc., New York; Mr. and Mrs. Joshua Kind; Gerald Kornblau Gallery, New York; James Kronen Gallery, New York; Halvor Landsverk; Robert Lang; William LeMassena; Mrs. Schuyler Lininger; Howard and Jean Lipman; Bertram K. and Nina Fletcher Little; Dr. John B. Little; George T. Lopez; Dr. Allan I. Ludwig; Arthur R. Luedders; Ralph M. Meyer, Delaware Water Gap, Pennsylvania; Mr. and Mrs. J. Roderick Moore; Mr. and Mrs. Wayne Naegele; Kenneth M. Newman, The Old Print Shop, New York; Elliott Orr; Mr. and Mrs. Robert Peak; Henry J. Prebys; Ernest S. Quick; Mr. and Mrs. Leo Rabkin; William R. Ray; Mr. and Mrs. John Remensnyder; Mr. and Mrs. Jeremy Samson; Raymond Saroff; George E. Schoellkopf Gallery, New York; Mr. and Mrs. Jack Sharp; Mr. and Mrs. Walter E. Simmons; Mr. and Mrs. Walter E. Simmons, II; R. Scudder Smith; Peter Socolof; Mr. and Mrs. Gary J. Stass; Betty Sterling, Brainstorm Farm, Randolph, Vermont; Adele Earnest and Cordelia Hamilton, Stony Point Folk Art Gallery, Stony Point, New York; Bernard Plomp, Village Green Antiques, Richland, Michigan; Clark Voorhees; William L. Warren; Carl M. Williams; Several Anonymous Private Collectors.

Institutions:
Barbara Luck, Abby Aldrich Rockefeller Folk Art Collection, Williamsburg, Virginia; Georgia B. Bumgardner, American Antiquarian Society, Worcester, Massachusetts; Harold E. Brown, Bath Marine Museum, Bath, Maine; Thomas W. Parker, The Bostonian Society, Boston, Massachusetts; Bridgeport Public Library, Bridgeport, Connecticut; Burton Historical Collection, Detroit Public Library, Detroit, Michigan; Travis Coxe, Chester County Historical Society, West Chester, Pennsylvania; Alison M. Swift and Joseph B. Zywicki, Chicago Historical Society, Chicago, Illinois; Carol Macht and Carla M. Martin, Cincinnati Art Museum, Cincinnati, Ohio; C. P. Fox and Robert L. Parkinson, Circus World Museum, Baraboo, Wisconsin; Thompson R. Harlow, The Connecticut Historical Society, Hartford, Connecticut; Roger H. Steck, Cumberland County Historical Society, Carlisle, Pennsylvania; Larry Curry and Margaret DeGrace, The Detroit Institute of Arts, Detroit, Michigan; Margaret L. Nelson, Essex Institute, Salem, Massachusetts; Carl E. Ellis, Everhart Museum, Scranton, Pennsylvania; Fairmount Park Commission, Philadelphia, Pennsylvania; Dorothy C. Gates, Firefighting Museum, Home Insurance Company, New York; Shirley O. Rieger, First Church in Cambridge Congregational, Cambridge, Massachusetts; First National Bank of Portland, Portland, Maine; Hugh R. Kirkendall, Genealogical Society of the Church of Jesus Christ of Latter-Day Saints, Salt Lake City, Utah; Dr. Donald A. Shelley, Robert G. Wheeler, Frank Caddy, George O. Bird, and Walter E. Simmons, II, Greenfield Village and Henry Ford Museum, Dearborn, Michigan; H. Bradley Smith, Heritage Plantation of Sandwich, Sandwich, Massachusetts; Stuart P. Feld, Hirschl & Adler Galleries, Inc., New York; Historical Society of Pennsylvania, Philadelphia, Pennsylvania; Richard C. Schultz, Historical Society of York County, York, Pennsylvania; Betty Madden, Illinois State Museum, Champaign, Illinois; Lina Steele, Index of American Design, Washington, D.C.; Insurance Company of North America, Philadelphia, Pennsylvania; Ada Whisenhunt, Ladies' Hermitage Association, Hermitage, Tennessee; Long Island Historical Society, Brooklyn, New York; Elizabeth G. West, Maine State Museum Commission, Augusta, Maine; Marblehead Historical Society, Marblehead, Massachusetts; Robert H. Burgess, The Mariners Museum, Newport News, Virginia; Romaine S. Somerville, Lois B. McCauley, and Eugenia Calvert Holland, Maryland Historical Society, Baltimore, Maryland; Virginia H. Dustan, Memorial Art Gallery of the University of Rochester, Rochester, New York; Christine Meadows, The Mount Vernon Ladies' Association of the Union, Mount Vernon, Virginia; Janet Jakubowski and Bruce Johnson, Museum of American Folk Art, New York; Charlotte LaRue and Margaret D. Stearns, Museum of the City of New York; Museum of Early Southern Decorative Arts, Winston-Salem, North Carolina; Jonathan Fairbanks, Museum of Fine Arts, Boston, Massachusetts; David B. Warren and Dean F. Failey, Museum of Fine Arts, Bayou Bend Collection, Houston, Texas; E. Boyd, Museum of New Mexico, Santa Fe, New Mexico; Museum of Woodcarving, Spooner, Wisconsin; Philip L. Budlong and J. Revell Carr, Mystic Seaport, Mystic, Connecticut; Fearn C. Thurlow and Wilmot T. Bartle, The Newark Museum, Newark, New Jersey; Frank Anaya, New Mexico Department of Development, Santa Fe, New Mexico; James J. Heslin and Mary Black, The New-York Historical Society, New York; The New York Public Library, New York; Maria Zamelis, New York State Historical Association, Cooperstown, New York; Marion Nelson, Norwegian-American Museum, Decorah, Iowa; Catherine B. Remley, Ohio Historical Society, Columbus, Ohio; Old North Church, Boston, Massachusetts; Old State House, Boston, Massachusetts; Henry J. Harlow, Old Sturbridge Village, Sturbridge, Massachusetts; Philip C. F. Smith, Peabody Museum of Salem, Salem, Massachusetts; Carolyn J. Diskant, Pennsylvania Academy of the Fine Arts, Philadelphia, Pennsylvania; Beatrice B. Garvan and Alfred J. Wyatt, Philadelphia Museum of Art, Philadelphia, Pennsylvania; Princeton University Library, Princeton, New Jersey; Susan G. Ferguson; Rhode Island Historical Society, Providence, Rhode Island; Karen Tsujimoto, San Francisco Museum of Art, San Francisco, California; Eleanor L. Nowlin, Shelburne Museum, Inc., Shelburne, Vermont; Anne M. Serio, Ann Auman, Anne C. Golovin, and Richard E. Ahlborn, Smithsonian Institution, Washington, D.C.; Daniel M. Lohnes, Society for the Preservation of New England Antiquities, Boston, Massachusetts; William B. Osgood, State Street Bank and Trust Company, Boston, Massachusetts; Kendra E. Bowers, Taylor Museum, Colorado Springs Fine Arts Center, Colorado Springs, Colorado; Robert A. Carlisle and Captain J. H. B. Smith, United States Department of the Navy, Washington, D.C.; Captain A. G. Ellis (Ret.), United States Naval Academy Museum, Annapolis, Maryland; Linda Gruber and Elizabeth H. Culler, Virginia Museum of Fine Arts, Richmond, Virginia; Harold Cullop, Lynn Golub, and Jane Hartland, Western Reserve Historical Society, Cleveland, Ohio; Philip F. Purrington, The Whaling Museum, New Bedford, Massachusetts; Karol A. Schmiegel, The Henry Francis du Pont Winterthur Museum, Winterthur, Delaware.

ROBERT BISHOP

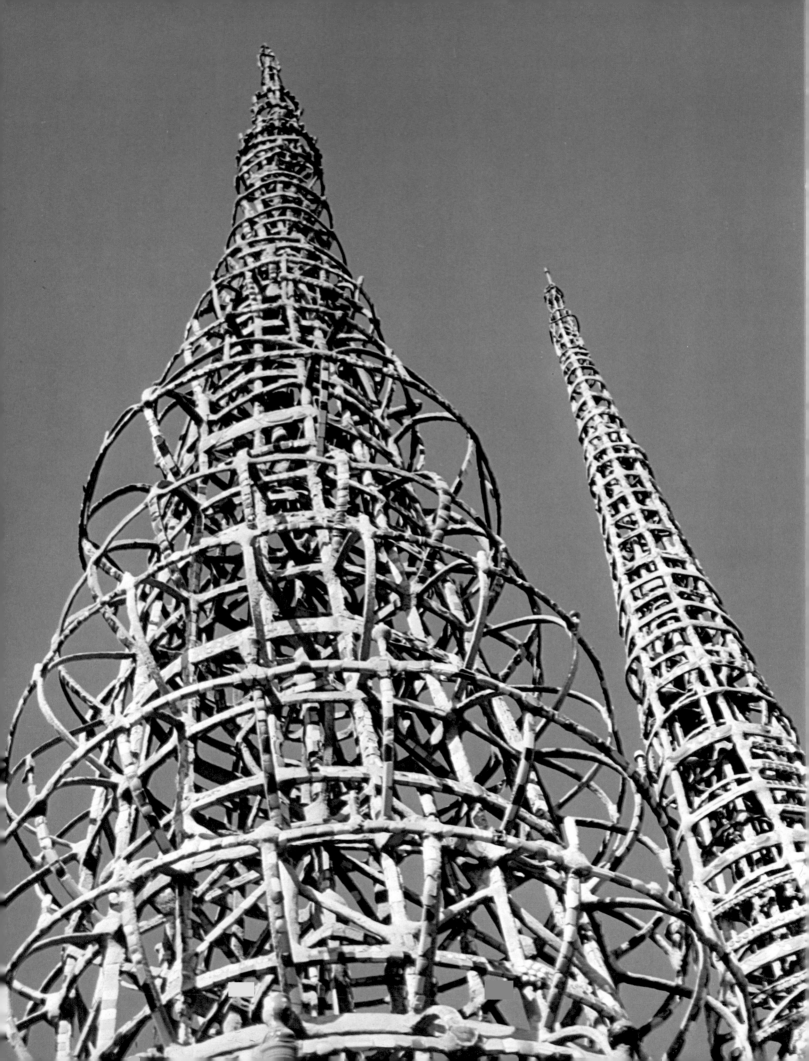

CONTENTS

INTRODUCTION

The first recorded exhibition of American folk art was presented at the Whitney Studio Club in New York City from February 9th through 24th in 1924. H. E. Schnakenberg, curator for the exhibition, had borrowed most of the pieces from major contemporary artists like Charles Sheeler, Charles Demuth, and Yasuo Kuniyoshi. These professionals were among the first to appreciate the aesthetics of American folk art and to collect it.

The first museum in the United States to mount a major exhibition of American folk art and more specifically, American folk sculpture, was The Newark Museum of Newark, New Jersey. In its special exhibition, held from October 1931 through January 1932, "American Folk Sculpture—The Work of Eighteenth and Nineteenth Century Craftsmen," the museum showed pieces selected by Holger Cahill chiefly from the pioneer collection formed by Abby Aldrich Rockefeller. Mr. Cahill had previously assisted with an exhibition of folk paintings, "American Primitive Painting," at the same museum in 1930, which later circulated to the University of Chicago and the University of Rochester. He noted in the show catalogue that most of the artists represented had no doubt seen originals or reproductions of paintings from foreign schools.

In his foreword to the catalogue of the sculpture exhibition at Newark, Arthur F. Egner, then president of the museum, stated enthusiastically: "What is so stimulating about the present exhibit is that we have in it a truer and more indigenous expression of the American artistic sense because of its very absence of pretense and importance.

"When the men here represented laid their hands to their tasks, whether in the production of a weathervane, a decoy, an emblem, or a tradesman's sign, they doubtless did not aspire to the rank of painters of portraits and landscapes. They were fashioning articles for practical use. Not being consciously engaged upon art, they consulted no guide but nature. The high result which they frequently achieved is eloquent of the truth of their observation and the reverence and affection with which they handled their material . . ." This statement effectively sums up several of the reasons why collectors feel so strongly about American folk sculpture: it is uniquely American; it represents the American people; its appeal is universal; and it can be incredibly beautiful.

Mr. Egner went on to say: "We may go through the collection almost at random. We find a bird or a horse observed so understandingly and rendered with such extraordinary synthesis as to invite comparison with examples of Chinese art. May we not even find in these humble articles an American tradition?

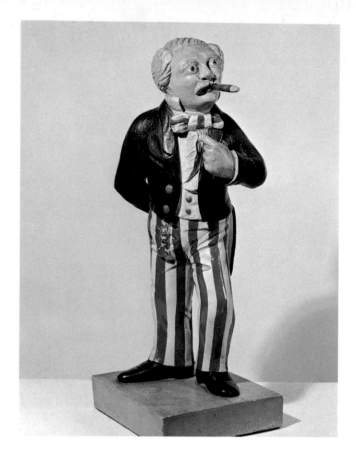

1 (above). Counter display figure. Late nineteenth century. Wood, painted. H. 28″. (Collection of Edith Barenholtz)

2 (opposite). Root monster. Miles B. Carpenter (b. 1889). Waverly, Virginia. 1972. Wood, painted. H. 13″. (Herbert W. Hemphill, Jr.)

"Some would have us believe that all our Art has come to us in ships. This exhibit is a refreshing demonstration that native in America there have existed fine observation and handiwork even as in the case of like expressions in other countries and times."

Another early and perhaps even more influential exhibition than that held in Newark was installed at The Museum of Modern Art in New York in 1932. The distinguished dealer, Edith Gregor Halpert, assisted Holger Cahill, director of the exhibition, in bringing together the 175 objects in the show. Again, most of the pieces were from Mrs. Rockefeller's collection. Oil paintings, watercolors, paintings on velvet, paintings on glass, a special design group of cookie molds, twenty-five pieces of wood sculpture, fifteen pieces of metal sculpture, and thirteen plaster ornaments were shown. Ships' figureheads, toys, small carvings, cigar store Indians, ornamental eagles and roosters, weathervanes and decoys, metal stove plates and figures, and plaster figures (now commonly referred to as chalk) accounted for the total variety of sculptural forms.

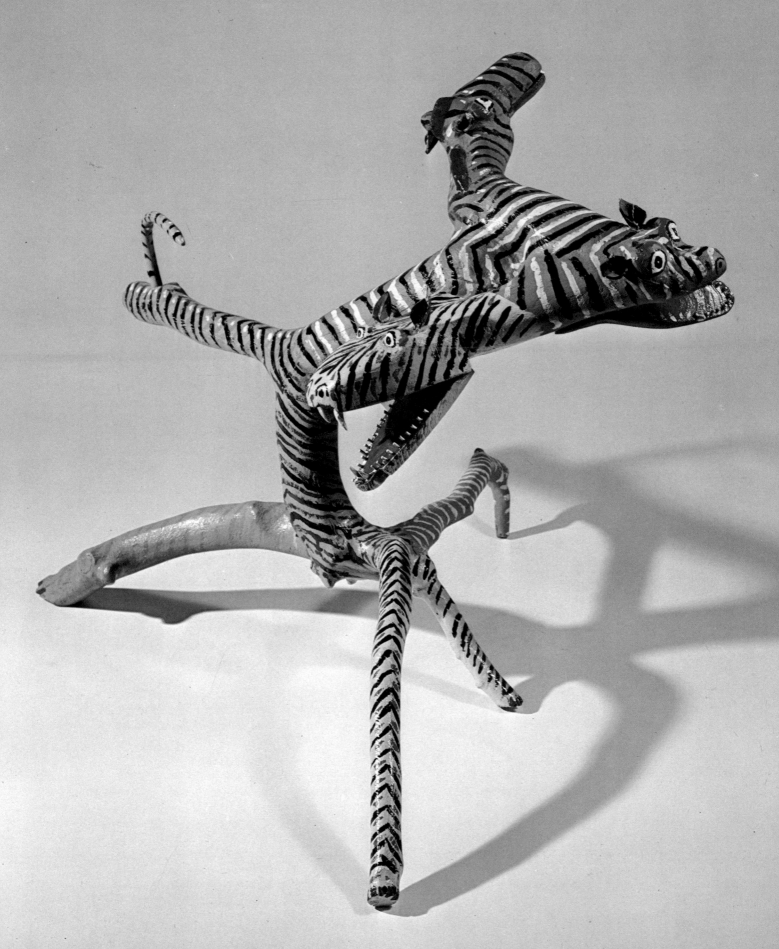

Pottery, decorative ironwork, religious carvings, signs, and several other categories were ignored. Perhaps these were simply omitted through oversight, but more probably they were not considered "artistic" enough to be included in the exhibition despite its title: "American Folk Art—The Art of the Common Man in America 1750–1900."

Speaking of the artists represented, Mr. Cahill made the following remarks to a public that disbelieved everyday objects could be elevated to the status of important art: "Many of these people had little training, but all of them knew how to coordinate the activity of the hand and the eye, and had the art of making things with their hands, an art which has declined rapidly with the progress of the machine age. . . . It is a varied art, influenced from diverse sources, often frankly derivative, often fresh and original, and at its best an honest and straightforward expression of the spirit of a people. This work gives a living quality to the story of American beginnings in the arts, and is a chapter intimate and quaint, in the social history of this country."

The Whitney Studio Club, The Newark Museum, and The Museum of Modern Art led the way, and the rest of the American museum community followed. Every institution worth its salt eagerly jumped on the bandwagon, and folk art became as popular in the early 1930s as concern for ecology did in the early 1970s.

Several museums have developed major collections of American folk sculpture. Through the years the efforts of the Abby Aldrich Rockefeller Folk Art Collection at Colonial Williamsburg in Virginia have been trailblazing. The Collection has mounted numerous in-depth exhibitions and has produced many significant publications covering the subject.

At Shelburne Museum in Vermont, the New York State Historical Association at Cooperstown, and Old Sturbridge Village in Massachusetts, Americans on the eastern seaboard have been able to see comprehensive collections of American folk art for many years. Greenfield Village and Henry Ford Museum at Dearborn, Michigan, also have impressive holdings. Farther west, the Denver Art Museum and the International Folk Art Museum of Santa Fe are well known for their collections of Colonial Spanish religious woodcarvings. Back in the east, a newly founded museum, Heritage Plantation of Sandwich, Massachusetts, is assembling a splendid collection of folk sculpture. One can also find beautiful folk art exhibited at Washington's Smithsonian Institution as well as The Brooklyn Museum, The New-York Historical Society, and The Metropolitan Museum of Art.

In the past few years the efforts of a young museum in New York have been notable in making America aware of its folk art. The Museum of American Folk Art opened its initial loan exhibition at the Time and Life Exhibit Center on October 5, 1962, and many fascinating exhibits have been held at the museum's headquarters on West 53rd Street in the years since. Its purpose has been to establish in New York a place where visitors can see historical America in terms of what its people have accomplished and what they stand for, as shown in the work of their hands, arts, tools, products, signs, and symbols.

Probably one of the most influential scholars in this field in recent years is Mary Black, former director of the Abby Aldrich Rockefeller Folk Art Collection and later the second director of the Museum of American Folk Art. Her summary of folk art is exemplary: "The genesis, rise, and disappearance of folk art is closely connected with the events of the nineteenth century when the dissolution of the old ways left rural folk everywhere with an unused surplus of time and energy. People were free to invent and make simple things for their own pleasure in each household and in each village, until the rise of industrial production toward the end of the nineteenth century. Folk art occupies the brief interval between court taste and commercial taste."

Mrs. Black's words account admirably for the great explosion in all fields of folk art in nineteenth-century America, but it must not be thought that folk art is just a thing of the past. Far from it. Handcrafted weathervanes are rarities now, of course, and whittled playthings for children have been replaced by mass-produced toys, but the basic urge to create remains today as strong and vital in the self-taught artist as it ever was. Perhaps it is only that the artist now reacts to his contemporary environment in ways that are somewhat different from those of his forebears. Several outstanding examples of twentieth-century folk sculpture are illustrated in this book.

Another point of view was recently expressed to me that supports a regional analysis of American folk art. This theory states that folk art is the product of a society in which the artist serves only as a conductor through which traditional folk customs are transmitted. This view, in my opinion, negates the real aesthetic accomplishments of our untrained artists, which are often finer art objects than those created by professionals. Great folk sculpture is timeless, and it speaks to all.

Conservative taste may well dismiss some of the more avant-garde pieces we illustrate. For me, S. P. Dinsmoor's monumental Adam and Eve in the Garden of Eden at Lucas, Kansas, page 184, is far more inspiring than Wilhelm Schimmel's carvings of the same theme seen on pages 204 and 205. Dinsmoor's great work is of lasting importance in the history of American art, for it is the creation of a divinely inspired visionary.

One of the most impressive folk-art exhibits in recent years was "American Folk Sculpture—The Personal and Eccentric" held at the Cranbrook Academy of Art Galleries in Bloomfield Hills, Michigan. Michael Hall assembled the works of art and supervised their installa-

tion. In the catalogue Mr. Hall formulated the purpose of the show: "The selection is not comprehensive nor does it attempt to trace historical developments or stylistic derivations. Instead, this exhibition seeks to illustrate the personal and often eccentric turn of expression that the naive 'private vision' can produce. Each piece must be measured by itself and yet be seen against a backdrop of the whole history of sculpture. Against this backdrop, many of the works in the exhibition stand out as extremely vigorous in concept, daring in form, and free in execution." Through such careful study and analysis our understanding of folk sculpture has deepened.

America's fine arts would be far less meaningful without the legacy of her folk artists, and their creations have deservedly achieved a permanent place in the history of American art. Indeed, the best of our folk sculpture should be valued as highly as the work of our most sophisticated sculptors, for it is an authentic expression of the untutored American artist, and it mirrors the values and sentiments of the American people.

ROBERT BISHOP

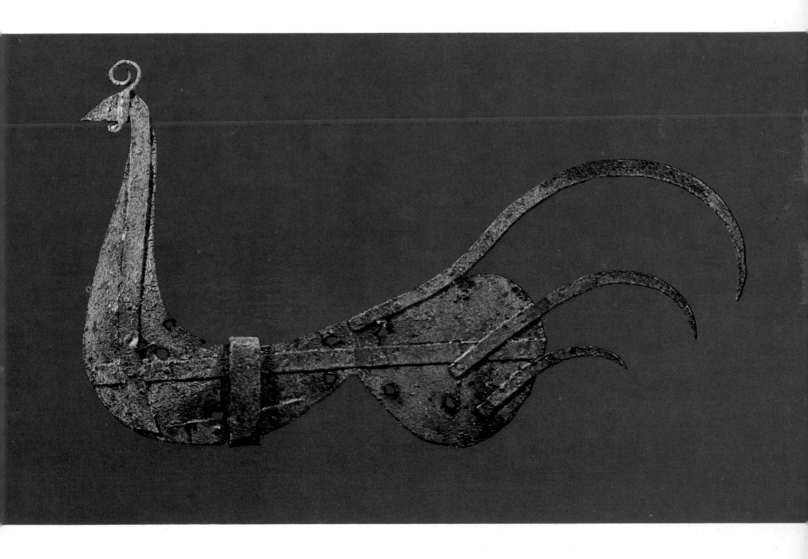

3 (above). Peacock weathervane. Pennsylvania. C. 1800. Sheet and wrought iron, painted. L. 34½".
The unknown craftsman who designed and forged this vane deserved to be "proud as a peacock" of his work. Few artists create such a beautiful piece in an entire lifetime. (Herbert W. Hemphill, Jr.)

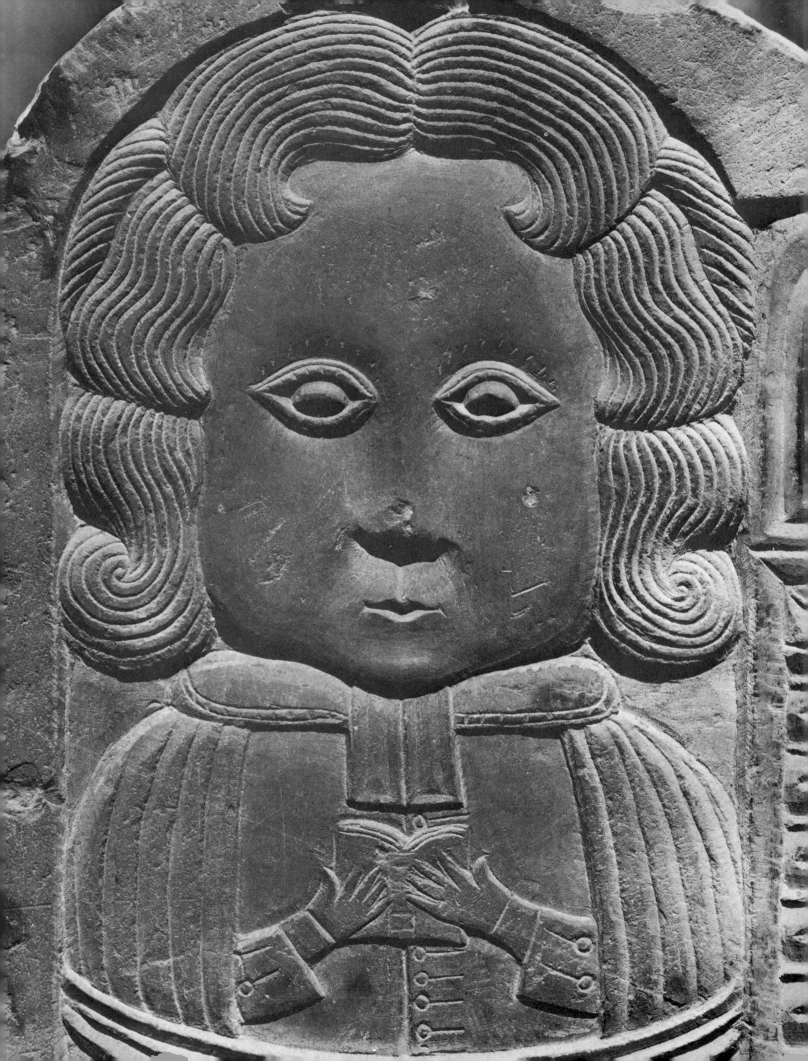

Despite their intense fear of idolatry the New England Puritans took great delight in infusing their grave markers with a dark strain of passion and mystical symbolism. Though the results of the stonecutter's efforts might be naïve in comparison to similar work in Europe, an iconic vocabulary developed that, once perfected, continued to be used throughout the seventeenth and much of the eighteenth centuries.

Grave markers, monuments, and other funerary art are the earliest dated American sculpture. Groups of grave markers with stylistic similarities indicate that stonecutters, working in close proximity and borrowing design concepts, developed a common type of embellishment. It is possible to trace a symbolic motif on a gravestone originating in some coastal workshop to general usage some years later much farther in the interior.

Almost simultaneous with the settling of a community was the establishment of a burying ground. The grim effigies—the hollow skulls and fire- and scythe-bearing skeletons—convey to our eyes a meaning quite different from that understood by the early colonists. For them, the symbols represented not death, but entrance into the hoped-for world of eternal peace.

Preoccupation with the grave and life in the hereafter was by no means a New England prerogative. In 1710, six years after the death of his father, William Byrd II of Virginia wrote in his diary, "I had my father's grave opened to see him but he was so wasted there was not anything to be distinguished." He concluded, "I ate fish for dinner." [1]

Though the incidence of death was high during the seventeenth century, many rural communities were too small to support a stonecutter or gravestone carver. This service was frequently provided by those in related businesses. Henry Christian Geyer, whose shop was "near the Tree of Liberty, second end," informed his customers in the *Boston News-Letter* on August 13, 1767: "That he has by him a considerable assortment of Connecticut Free Stones fit for architect Work Tomb-Stones, Hearth and Fire Stones, some Frontice-Pieces, work'd in with some of the compleatest Moldings of any in this Town." The same newspaper, on July 30, 1772, noted that Mr. Geyer had executed a gravestone in the "Composite Order with twisted Pillars, and other proper ornament, having a Cherub's Head on Wings with a label flowing from the mouth inscribed 'Robert Sandeman who died at Danbury, Conn. Apr. 2, 1771.'"

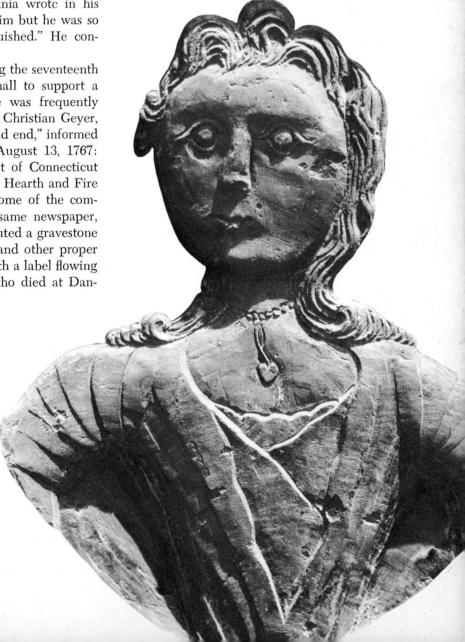

4 (opposite). Detail of the Reverend Jonathan Pierpont gravestone. Initialed "N L," possibly standing for Nathaniel Lamson. Wakefield, Massachusetts. 1709. Slate. H. 27½". This is the oldest known portrait effigy from New England. (Photograph courtesy Dr. Allan I. Ludwig)

5 (right). Detail of the Patience Watson gravestone. Plymouth, Massachusetts. 1767. Slate. H. 35". This portrait is probably an accurate representation of Patience Watson, for she appears to be wearing personal jewelry. (Photograph courtesy Dr. Allan I. Ludwig)

6 (left). Detail of Reverend Samuel Ruggles gravestone. Billerica, Massachusetts. 1837. Slate. Dimensions unavailable. The hourglass containing the sands of time was frequently used on gravestones, for it symbolized the drama of death. This stone bears the inscription "From death's arrest no age is free." (American Antiquarian Society)

7 (below). Gravestone of Mrs. Mary Price. Made by David Jeffries (an immigrant from New England). Elizabethtown, Essex County, New Jersey. 1766. Sandstone. H. approximately 48″. The material for this marker is from a Newark quarry probably owned by Samuel Medlis, who supplied stones for Trinity Churchyard, New York. (Carl M. Williams)

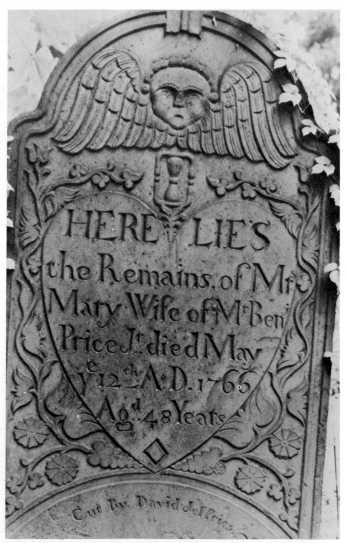

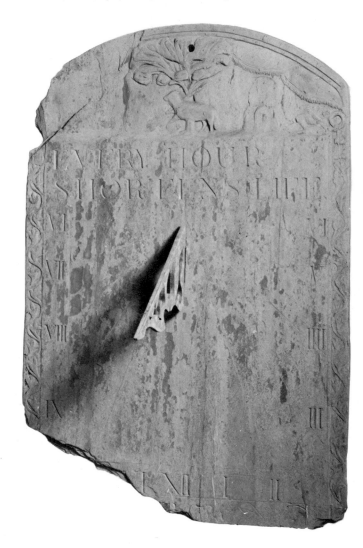

8 (above). Sundial. Massachusetts. Dated 1784. Slate. H. 28″. This sundial was probably used in conjunction with a cemetery. The crest is decorated with a crudely carved tree and stylized animal, and the stone is inscribed, "EVERY HOUR SHORTENS LIFE." (Mr. and Mrs. Jerome Blum)

9 (opposite). Detail of the Samuel Green gravestone. Lexington, Massachusetts. 1759. Slate. H. 33¾″. Abstract designs decorated many grave markers. Geometric designs occasionally occurred in the seventeenth century, consisting mostly of pinwheels and rosettes. This stone was probably carved by a craftsman with little experience in rendering human or floral designs, for he relied upon a straight edge, compass, and cutting tools. Such abstract imagery was frequently used during the eighteenth century in rural areas, where it became a native tradition. (Photograph courtesy Dr. Allan I. Ludwig)

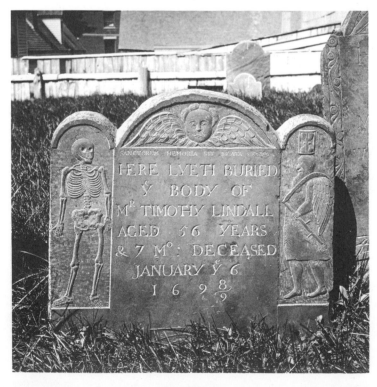

SANCTORUM MEMORIA SIT BEATA

HERE LYETH BURIED
ẙ BODY OF
Mʀ TIMOTHY LINDALL
AGED 56 YEARS
& 7 Mᵒ: DECEASED
JANUARY ẙ 6
169 8/9

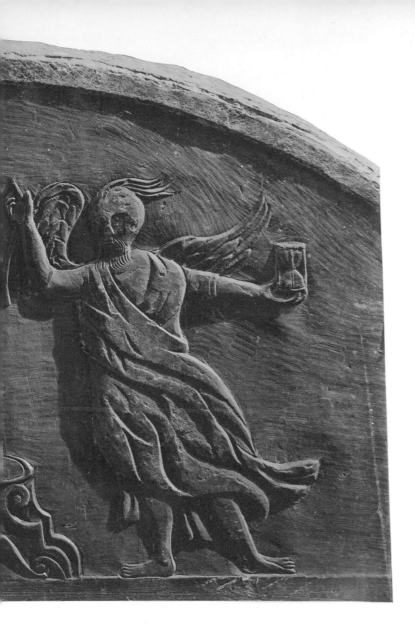

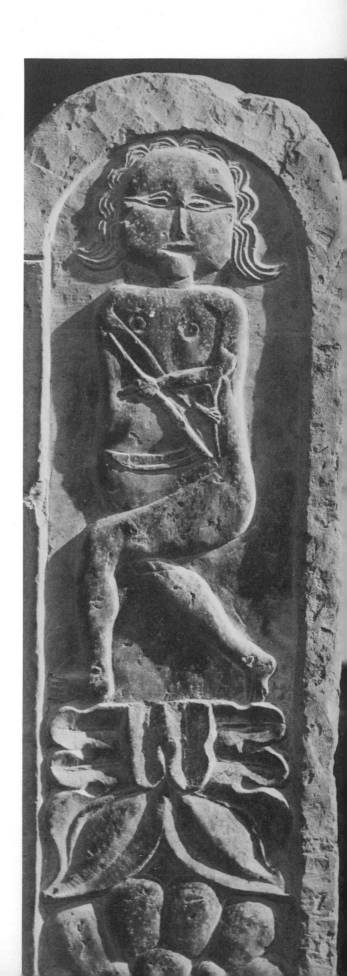

10 (opposite, left), 13 (right). Details of the left and right panels of the John Stone gravestone. Watertown, Massachusetts. 1691. Slate. Dimensions unavailable. Demons of the underworld carrying darts of death, the hourglass, and a scythe cavort amid stylized floral decorations on this grave marker. Such representations of Hades were popular motifs and were included on the Marcy Brown gravestone from Providence, Rhode Island, dated 1736. "Old age being come, her race here ends/Where God ye fatal dart He sends." (Photograph courtesy Dr. Allan I. Ludwig)

11 (above). Detail of the Rebekah Gerrish gravestone. King's Chapel, Boston. 1743. Slate. Dimensions unavailable. (Photograph courtesy Dr. Allan I. Ludwig)

12 (opposite, right). Gravestone of Timothy Lindall. Probably Salem, Massachusetts. 1698/99. Slate. H. 20". Lindall was born in Duxbury, Massachusetts, in May, 1642. It can be said that American sculpture in stone was both born in the graveyard and nourished there by death. (Essex Institute)

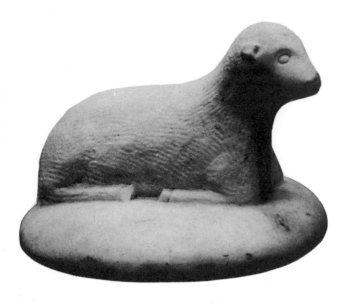

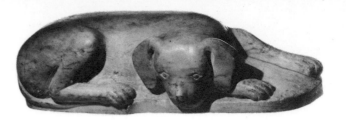

15 (above). Grave marker in the shape of a dog. New England. 1860–1880. Marble. L. 11½". Isolated grave markers for pets predate the popular pet burial grounds of today. (Private collection)

14 (above). Grave marker in the shape of a lamb. Lee, Massachusetts. First half of the nineteenth century. Marble. H. 5¼". Through the influence of the European Romantic movement, weeping willows and mourning figures came to represent bereavement. The lamb was a popular symbol for a child, and its use as a grave marker usually indicated a child's grave. (William L. Warren)

16 (below), 17 (opposite). Grave marker of Colonel Henry G. Wooldridge and representations of his relatives, friends, and animals. The equestrian sculpture of Colonel Wooldridge and most of the other figures were carved from Bedford stone by William Lydon, a young stonecutter from Paducah, Kentucky, during the 1880s and 1890s. This unique group of life-size figures was installed in the Maplewood Cemetery, Mayfield, Kentucky, where the colonel was buried in 1899 at the age of seventy-seven. Wooldridge, a wealthy horse trader, sportsman, and eccentric bachelor, decided to be shown awaiting Gabriel's call on horseback, accompanied by his favorite hound, Bob. (Photographs courtesy Michael D. Hall)

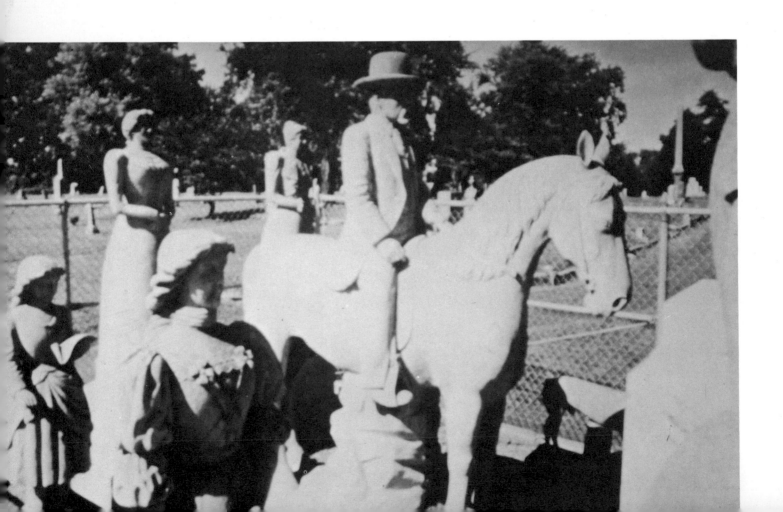

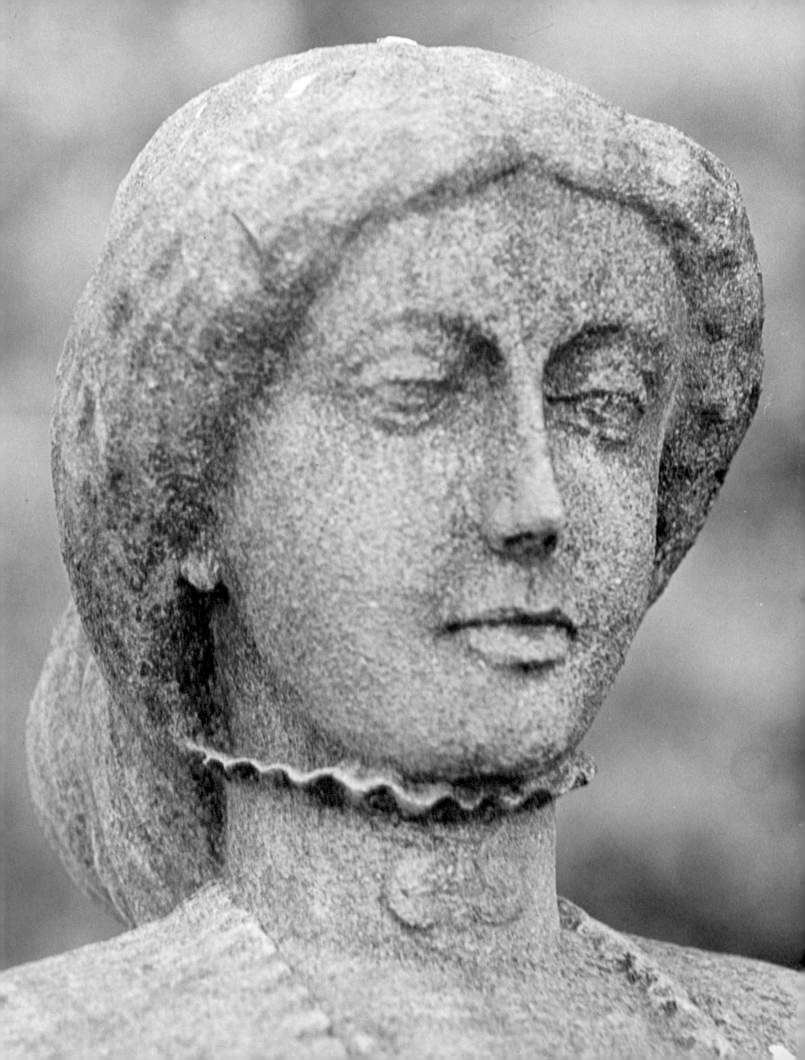

SIGNS OF THE PAST

Almost as soon as Colonial settlements in New England grew from outposts in the wilderness, churches were built to save man from hell; however, taverns sprang up where he could be eased down the primrose path. It is a well-documented fact that churchgoers were also tavern-goers. Occasionally, even the parson himself dropped in for a libation.

The General Court of Massachusetts, quick to discover a source of revenue, passed its first law governing tavern activities in 1633. "Strong waters" were available only from those who had secured a vendors' permit from the Governor or Deputy Governor. In spite of such laws, however, taverns flourished and tavern signs became a familiar part of both town and country landscapes.

When education was a privilege and literacy uncommon, the ideal trade sign was one that immediately caught the attention and was totally self-explanatory. Benjamin Franklin related to Thomas Jefferson an anecdote that illustrated how essential these requirements were. A young hatmaker was considering a signboard for his new shop. The sign he envisioned would show a hat in outline and read "John Thompson, Hatter, makes and sells hats for ready money." He asked many friends for their opinions. One felt the word "hatter" dispensable, since the sign would already say that Thompson made hats. Another suggested the elimination of the word "makes." A third thought "for ready money" unnecessary because his business was to be a cash-and-carry operation. A fourth felt the word "sells" could be omitted for a hatmaker always sold his wares. And another suggested the word "hats" be deleted. So in the end, only Thompson's name was lettered on his hat sign.

Sign carving and sign painting were important factors in the economic structure of many early craftsmen's lives. Carvers, cabinetmakers, and even blacksmiths contributed to the finished piece. Little is known about the earliest sign-makers, for they rarely signed their work, and even when they did, their signatures have been obliterated by the addition of several coats of paint.

Through the years signs have continued to be one of the most popular means of publicizing business endeavors. At the close of the nineteenth century, one weary traveler, while visiting Chicago, was awed by "whole fronts of flamboyant architecture . . . almost concealed behind huge bombastic signs, while other advertising devices hung suspended overhead, watches three feet in diameter, and boots and hats of a giant race." [2]

Today's signs are rarely sculptural in form since neon bulbs and Dayglo paint usually flaunt a modern business-man's wares.

18 (opposite). Felon. East Greenwich, Rhode Island. Second half of the eighteenth century. Wood. H. 30″. This handcuffed figure originally was used at the Kent County Jail in East Greenwich. (Rhode Island Historical Society)

19 (below). Mercury Alighting on the Earth. Simeon Skillin, Sr. Boston. Second half of the eighteenth century. Wood. H. 42″. This figure is from the store of a Mr. Hutchinson at 126 Commercial Street, Boston. It is reputed to be the oldest figural sign in Boston, and in 1750 it stood over the door of the post office on State Street. (The Bostonian Society)

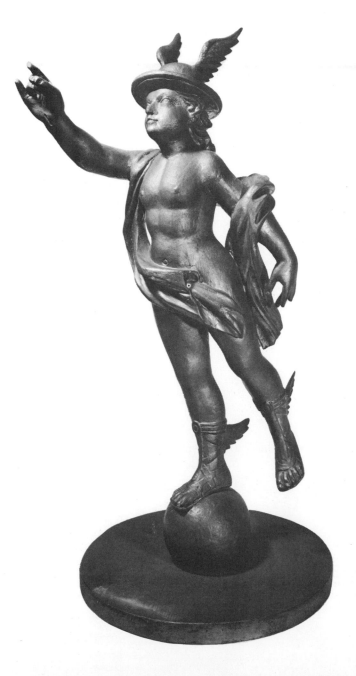

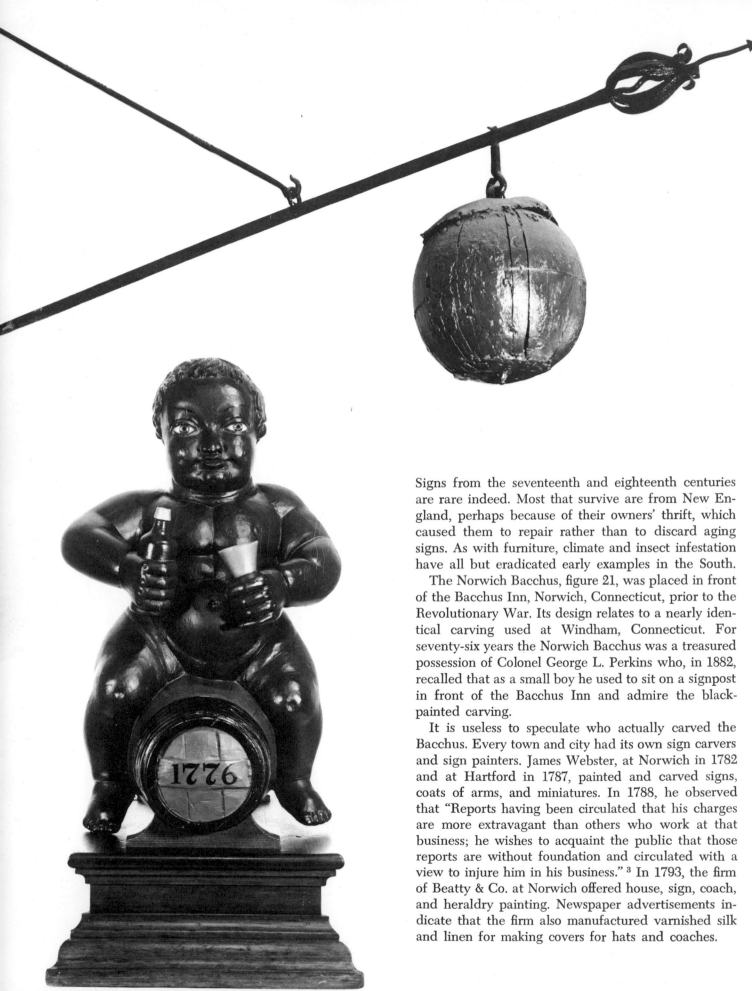

Signs from the seventeenth and eighteenth centuries are rare indeed. Most that survive are from New England, perhaps because of their owners' thrift, which caused them to repair rather than to discard aging signs. As with furniture, climate and insect infestation have all but eradicated early examples in the South.

The Norwich Bacchus, figure 21, was placed in front of the Bacchus Inn, Norwich, Connecticut, prior to the Revolutionary War. Its design relates to a nearly identical carving used at Windham, Connecticut. For seventy-six years the Norwich Bacchus was a treasured possession of Colonel George L. Perkins who, in 1882, recalled that as a small boy he used to sit on a signpost in front of the Bacchus Inn and admire the black-painted carving.

It is useless to speculate who actually carved the Bacchus. Every town and city had its own sign carvers and sign painters. James Webster, at Norwich in 1782 and at Hartford in 1787, painted and carved signs, coats of arms, and miniatures. In 1788, he observed that "Reports having been circulated that his charges are more extravagant than others who work at that business; he wishes to acquaint the public that those reports are without foundation and circulated with a view to injure him in his business." [3] In 1793, the firm of Beatty & Co. at Norwich offered house, sign, coach, and heraldry painting. Newspaper advertisements indicate that the firm also manufactured varnished silk and linen for making covers for hats and coaches.

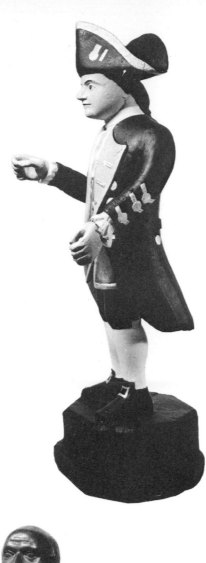

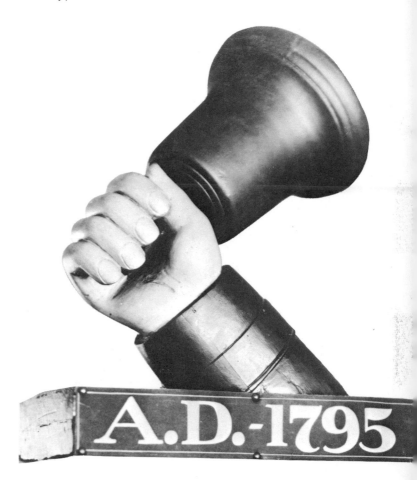

20 (opposite, above). Blue Ball Sign. Probably Boston. C. 1712. Wood with iron bracket. Diameter 12″. This sign is said to have belonged to Josiah Franklin, father of Benjamin Franklin, and was used on the Milk Street home where Benjamin was born in 1706. (The Bostonian Society)

21 (opposite, below). Bacchus. Connecticut. Eighteenth century. Pine. H. 26½″. This figure was used in front of the Bacchus Inn at Norwich, Connecticut, prior to the American Revolution. (The Connecticut Historical Society)

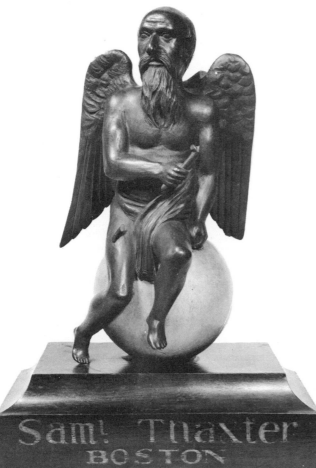

22 (top). The Little Admiral. Simeon Skillin, Sr. Boston. Eighteenth century. Wood. H. 42″. Tradition maintains that this figure was used as a sign for the Admiral Vernon Tavern, and the figure is thought to have once held a glass and a bottle. The piece later stood at No. 1 Long Wharf where William Williams maintained an instrument-making establishment. (The Bostonian Society)

23 (left). Father Time. Shop of John and Simeon Skillin. Boston. C. 1790. Wood. H. 19¾″. "Father Time" functioned as a store sign for Samuel Thaxter at his State Street establishment. (The Bostonian Society)

24 (above). Bell in Hand. Eighteenth century. Wood. H. 24″. This sign was first used at Samuel Adams's tavern on Eliot Street, Boston. James Wilson, successor to the Adams establishment, served as town crier and retailer of spirits. (The Bostonian Society)

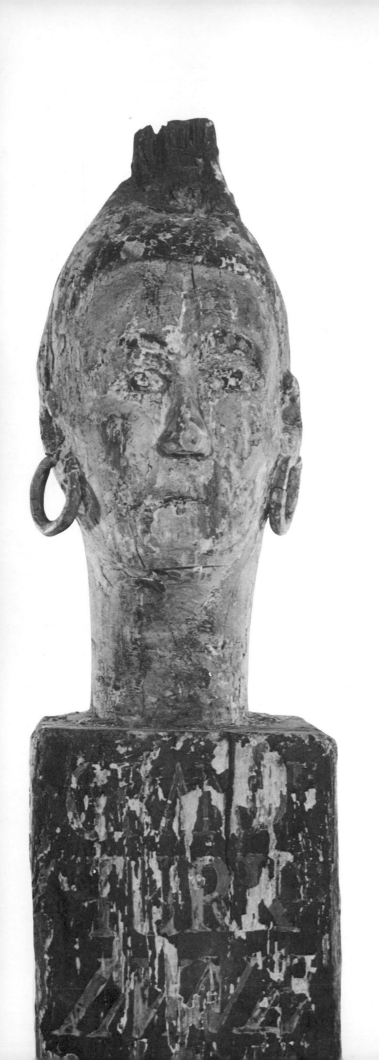

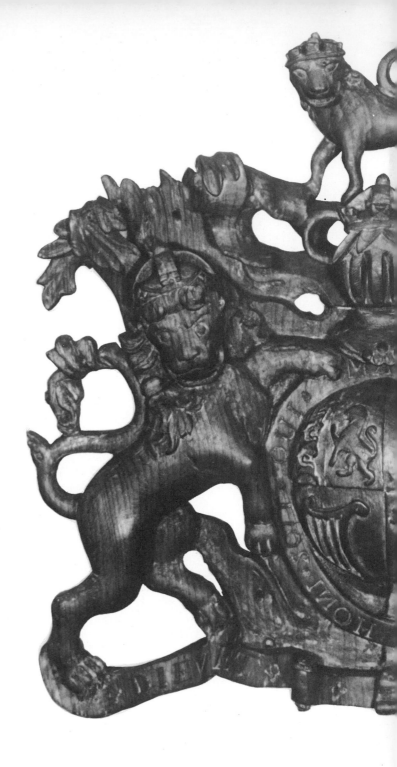

25 (left). Grand Turk. Inscribed "1789." Wood. H. 31".
Israel Hatch, innkeeper, was at the sign of the Grand Turk
Inn in Boston from 1789 to 1796. (The Connecticut
Historical Society)

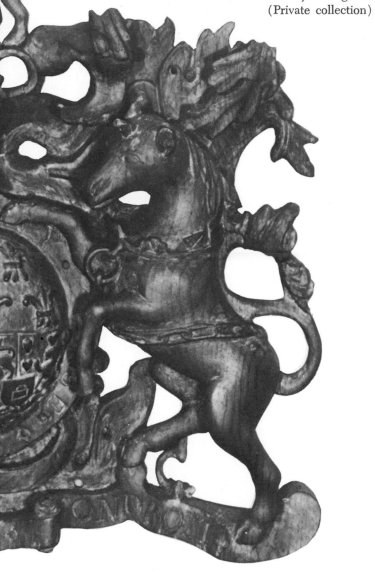

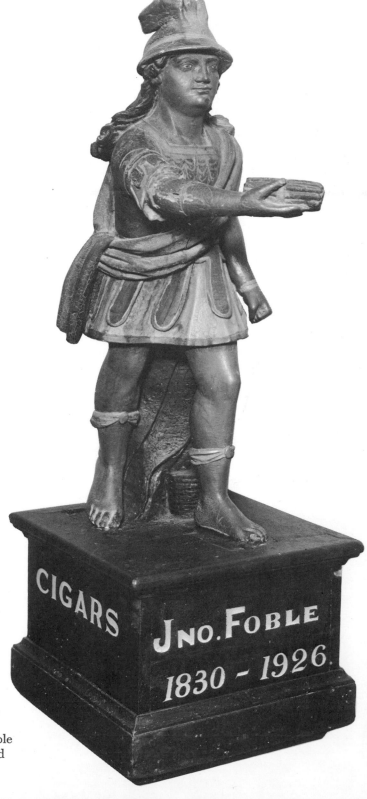

26 (center). Arms from Gardner Chandler House. Winthrop Chandler. Worcester, Massachusetts. C. 1773. Pine, originally painted, now unpainted. H. 16″. These arms were placed over a fireplace in the Worcester, Massachusetts, home of Gardner Chandler, first cousin of the carver. At the outbreak of the Revolution, Chandler was allowed to keep this carving of the British arms. It descended directly through the Chandler family for over 180 years. (Private collection)

27 (right). Mercury. William Rush. Philadelphia. C. 1830. Wood. H. 38″. This representation of the messenger of the gods stood in front of the tobacco shop owned by John Foble at Cambridge, Maryland, and is inscribed with his name and the dates 1830–1926. (Maryland Historical Society)

27

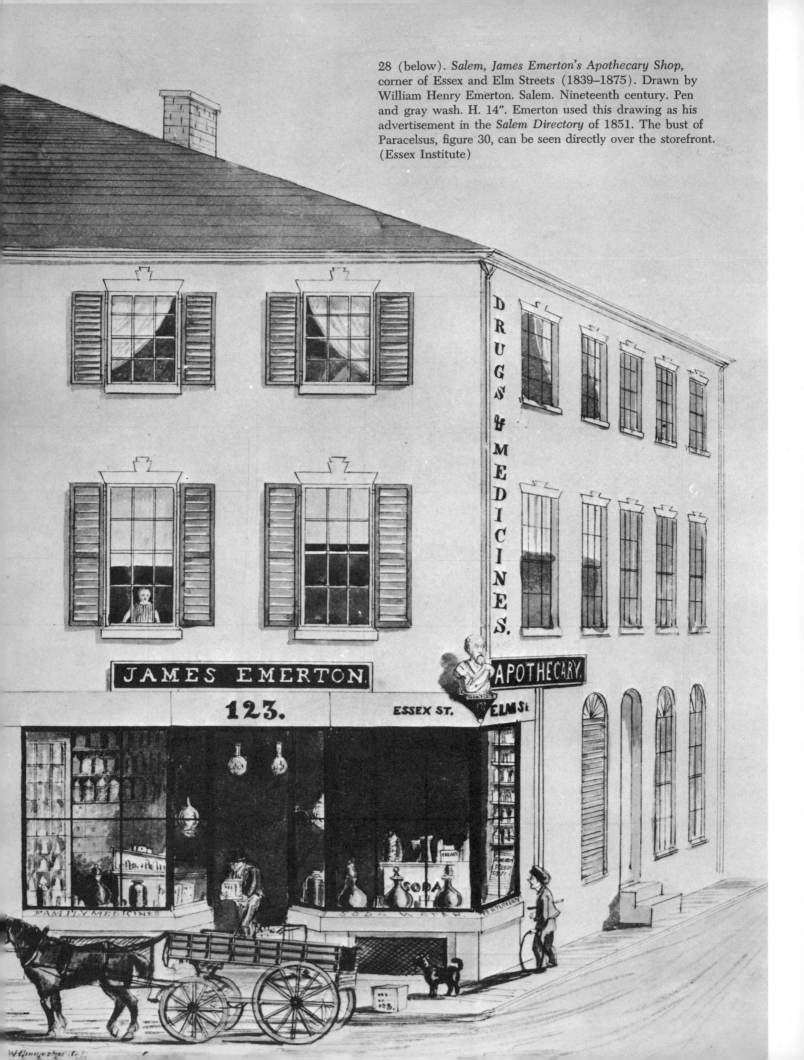

28 (below). *Salem, James Emerton's Apothecary Shop,* corner of Essex and Elm Streets (1839–1875). Drawn by William Henry Emerton. Salem. Nineteenth century. Pen and gray wash. H. 14″. Emerton used this drawing as his advertisement in the *Salem Directory* of 1851. The bust of Paracelsus, figure 30, can be seen directly over the storefront. (Essex Institute)

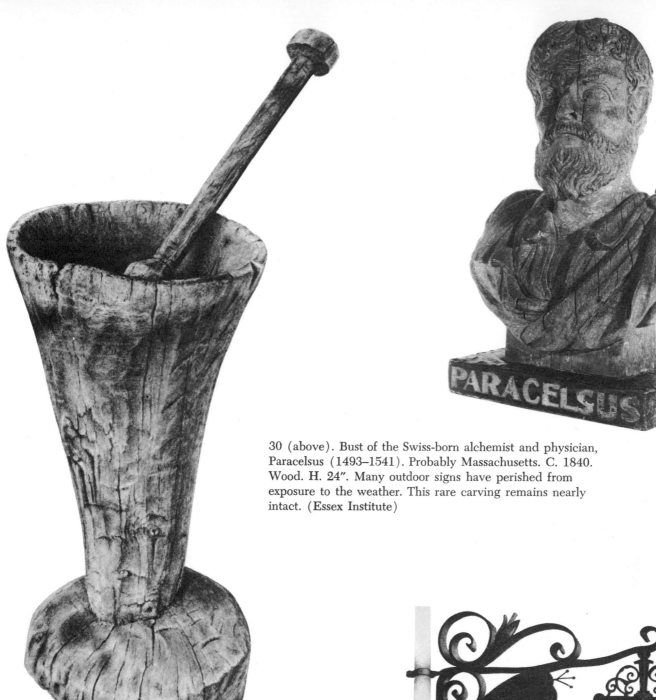

30 (above). Bust of the Swiss-born alchemist and physician, Paracelsus (1493–1541). Probably Massachusetts. C. 1840. Wood. H. 24″. Many outdoor signs have perished from exposure to the weather. This rare carving remains nearly intact. (Essex Institute)

29 (above). Mortar and pestle. Made by slaves. Bordeaux Plantation, St. Genevieve, Missouri. 1745. Hickory and oak. H. 27″. This rough, hand-hewn carving probably served two functions—as a practical utensil it could be used to grind produce and, when standing outside a cabin, would indicate that the occupant was responsible for grinding. (Index of American Design)

31 (right). Locksmith's sign. John A. Mangin. New Orleans. 1895. Wrought and sheet iron. H. 54″. French influence is evident in this graceful piece which was made by one of the most distinguished nineteenth-century locksmiths in New Orleans. (Index of American Design)

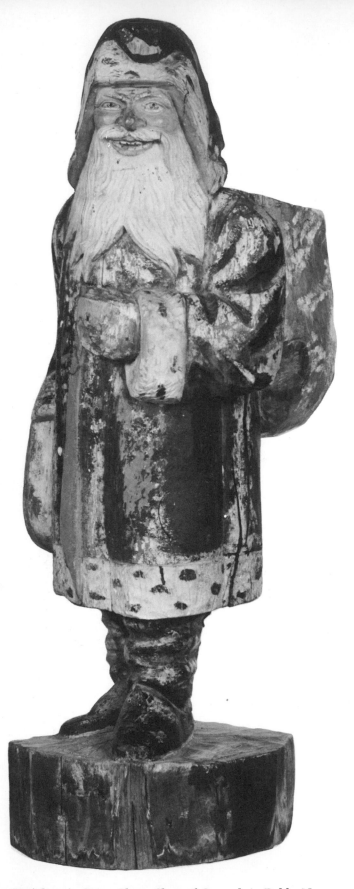

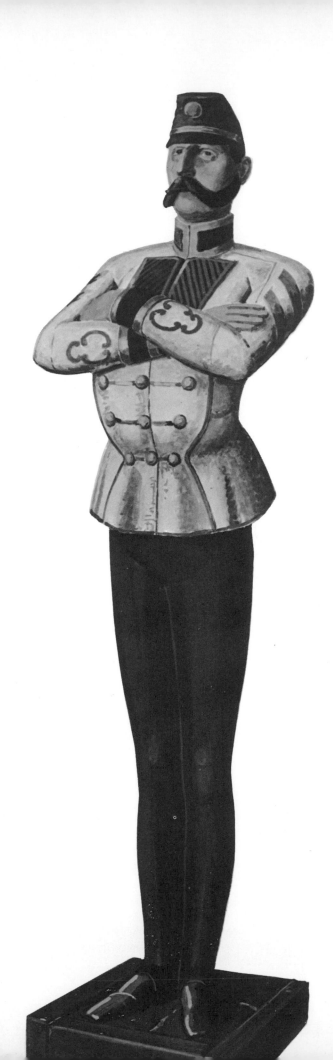

32 (above). Santa Claus. Shop of Samuel A. Robb. New York. C. 1880. Wood. H. 35¼″. Robb manufactured "ship and steamboat carvings, eagles, scrolls, block letters, figure carving, tobacconist signs, dentist, and druggist signs," [4] and by 1890 he had been in business nearly twenty-six years. (Smithsonian Institution, Van Alstyne Collection)

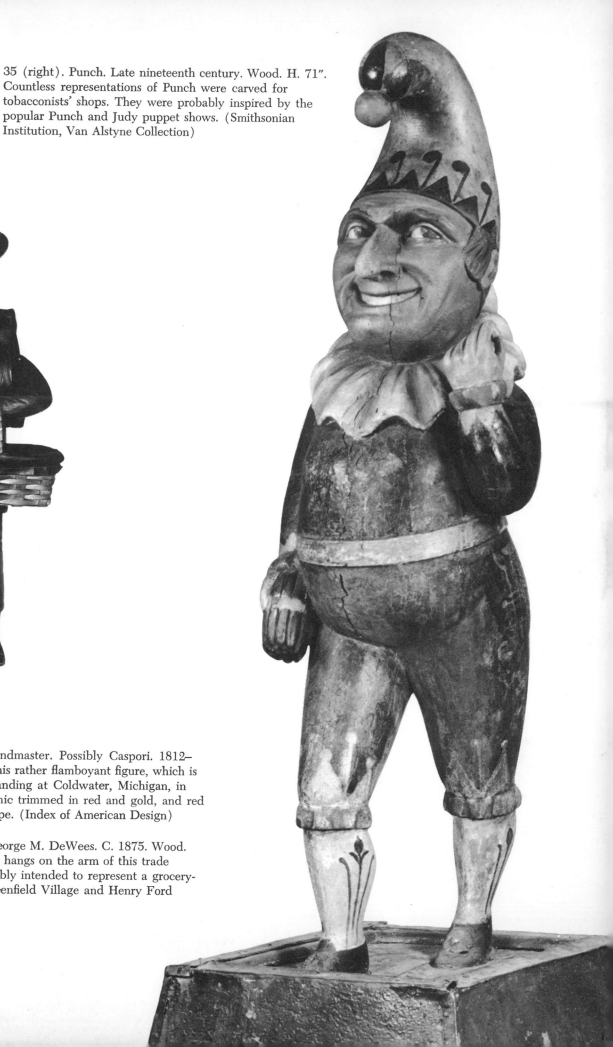

35 (right). Punch. Late nineteenth century. Wood. H. 71″. Countless representations of Punch were carved for tobacconists' shops. They were probably inspired by the popular Punch and Judy puppet shows. (Smithsonian Institution, Van Alstyne Collection)

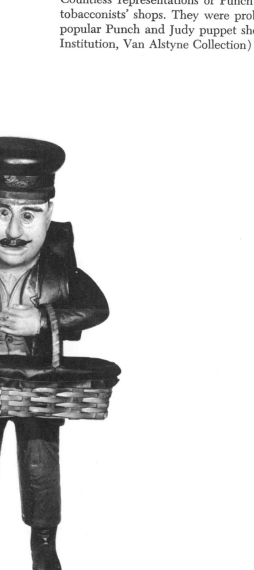

33 (opposite, right). Bandmaster. Possibly Caspori. 1812–1860. Wood. H. 69″. This rather flamboyant figure, which is known to have been standing at Coldwater, Michigan, in 1855, sports a green tunic trimmed in red and gold, and red trousers with a gold stripe. (Index of American Design)

34 (above). Peddler. George M. DeWees. C. 1875. Wood. H. 27¾″. A splint basket hangs on the arm of this trade figure, which was probably intended to represent a grocery-store delivery boy. (Greenfield Village and Henry Ford Museum)

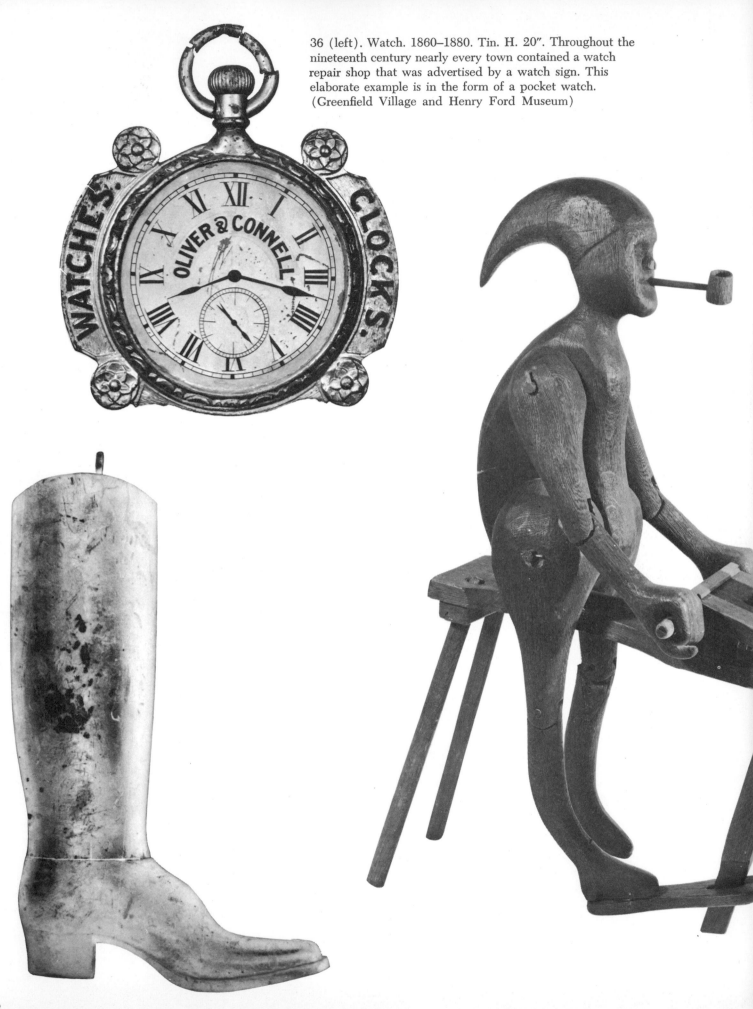

36 (left). Watch. 1860–1880. Tin. H. 20″. Throughout the nineteenth century nearly every town contained a watch repair shop that was advertised by a watch sign. This elaborate example is in the form of a pocket watch. (Greenfield Village and Henry Ford Museum)

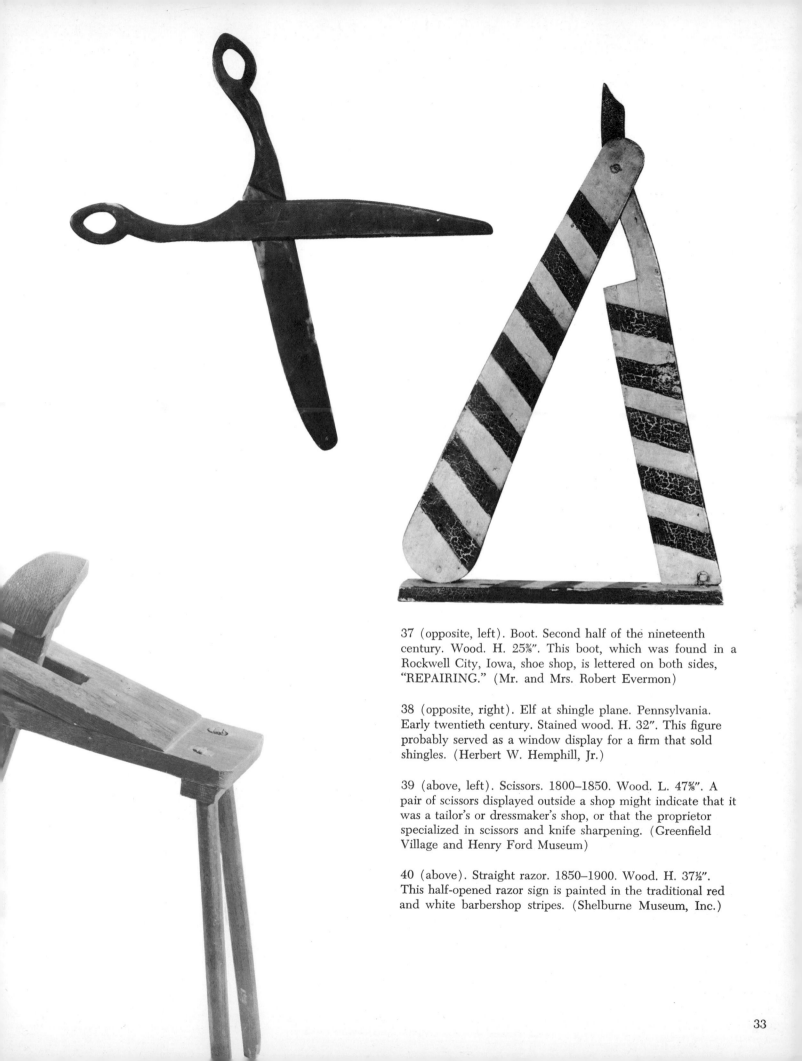

37 (opposite, left). Boot. Second half of the nineteenth century. Wood. H. 25⅜". This boot, which was found in a Rockwell City, Iowa, shoe shop, is lettered on both sides, "REPAIRING." (Mr. and Mrs. Robert Evermon)

38 (opposite, right). Elf at shingle plane. Pennsylvania. Early twentieth century. Stained wood. H. 32". This figure probably served as a window display for a firm that sold shingles. (Herbert W. Hemphill, Jr.)

39 (above, left). Scissors. 1800–1850. Wood. L. 47⅝". A pair of scissors displayed outside a shop might indicate that it was a tailor's or dressmaker's shop, or that the proprietor specialized in scissors and knife sharpening. (Greenfield Village and Henry Ford Museum)

40 (above). Straight razor. 1850–1900. Wood. H. 37½". This half-opened razor sign is painted in the traditional red and white barbershop stripes. (Shelburne Museum, Inc.)

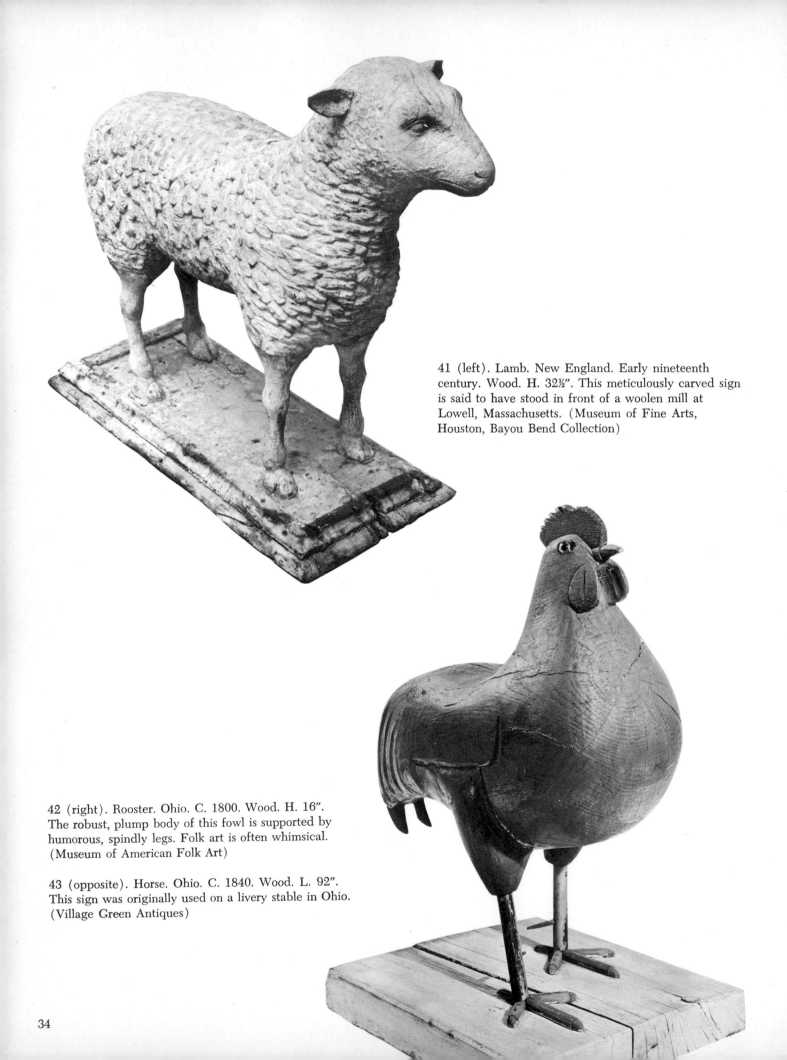

41 (left). Lamb. New England. Early nineteenth century. Wood. H. 32½". This meticulously carved sign is said to have stood in front of a woolen mill at Lowell, Massachusetts. (Museum of Fine Arts, Houston, Bayou Bend Collection)

42 (right). Rooster. Ohio. C. 1800. Wood. H. 16". The robust, plump body of this fowl is supported by humorous, spindly legs. Folk art is often whimsical. (Museum of American Folk Art)

43 (opposite). Horse. Ohio. C. 1840. Wood. L. 92". This sign was originally used on a livery stable in Ohio. (Village Green Antiques)

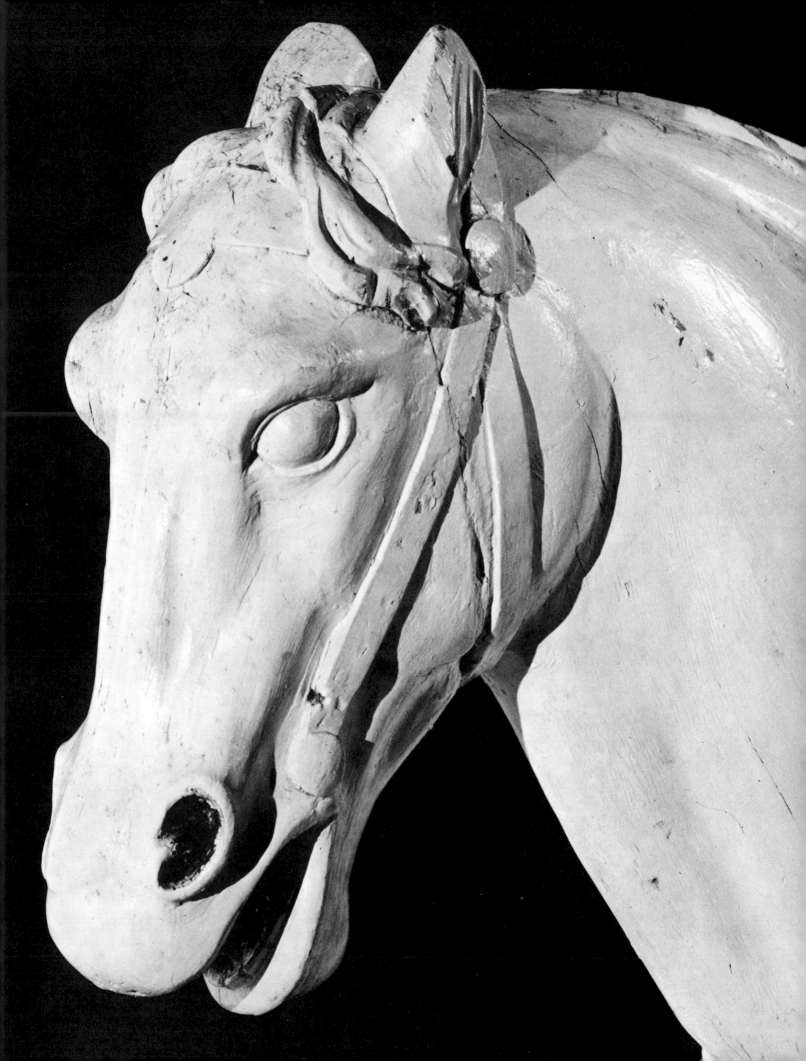

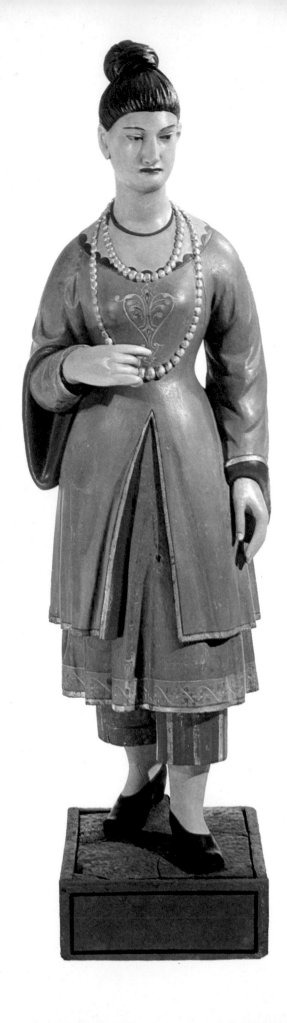

44 (left), 45 (below). Chinese woman and man. Mid-nineteenth century. Wood. Woman—H. 63¼". Man—H. 66½". East Coast merchants who specialized in the import and sale of tea used Chinese figures as trade signs. (Greenfield Village and Henry Ford Museum)

46 (opposite, above). Teapot. C. 1875. Tin, painted gold. H. 42". Teapot shop signs were occasionally attached to pipes and in cold weather emitted steam from their spouts. Even today such signs continue to be used in Boston. (Greenfield Village and Henry Ford Museum)

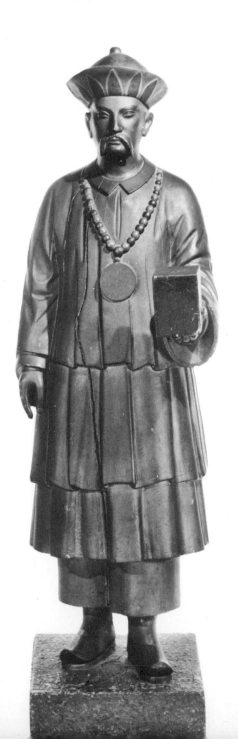

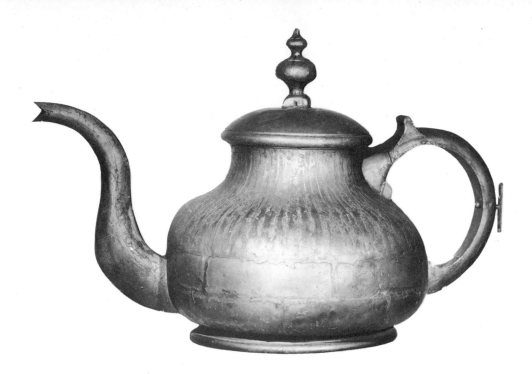

47 (below). Detail of a painting by Jurgan Frederick Huge (1809–1878). Connecticut. 1876. Watercolor. 29¼″ × 39½″. Huge was born in Hamburg, Germany, and came to Bridgeport, Connecticut, where in 1830 he married Mary Shelton. In the 1862 Bridgeport directory he is listed as a grocer; however, he had been active as a professional artist well before 1838. In the directory of 1869–1870, he describes himself as "Grocer and artist, North Avenue near Woolen Mills." The New England Tea Store was housed in the old Burroughs Building at the corner of John and Main Streets at Bridgeport. Chinese tea figures can be seen in the store windows at the left and right of the entrance. (Bridgeport Public Library)

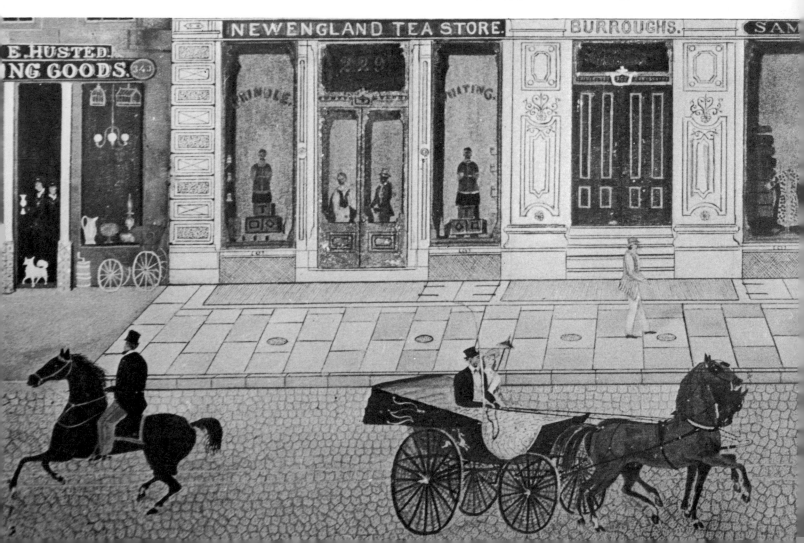

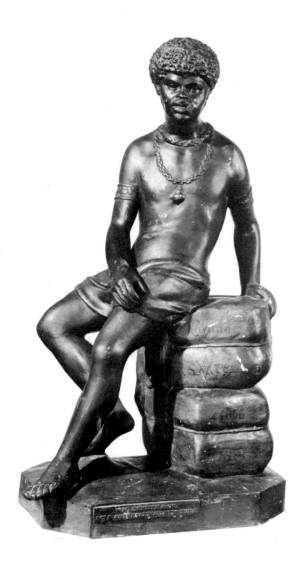

48 (above). Kaffir smoker. William Demuth (1835–1911) & Co. New York City. Late nineteenth or early twentieth century. Metal. H. 30″. This figure represents a member of a South African Bantu tribe popularly known as Kaffirs and is fitted with a tube through which the shopkeeper could force smoke, giving the figure the appearance of smoking. (Greenfield Village and Henry Ford Museum)

49 (center), 50 (opposite). Tin man. J. Krans(?). New York. C. 1900. Sheet metal, painted silver. H. 68″. The artist who created this debonair tin sign dressed his gentleman in the evening finery of top hat, bow tie, and tails. (Mr. and Mrs. Eugene Cooper; photographs courtesy Jean Lipman)

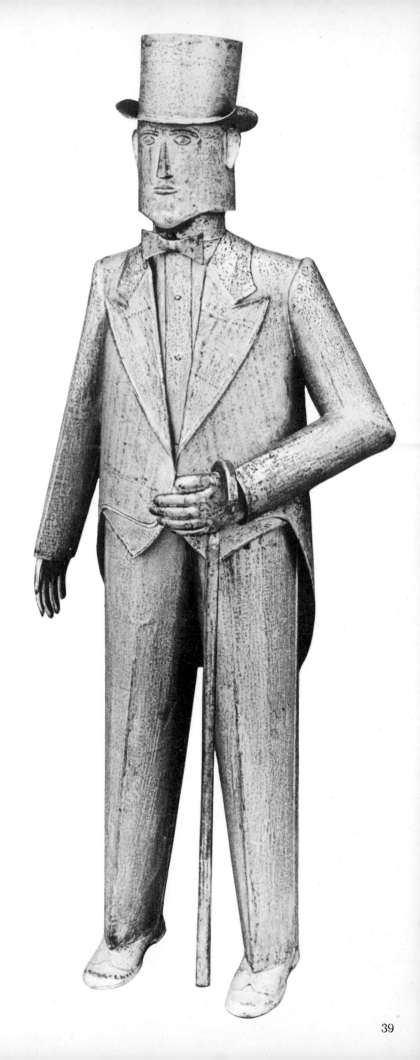

39

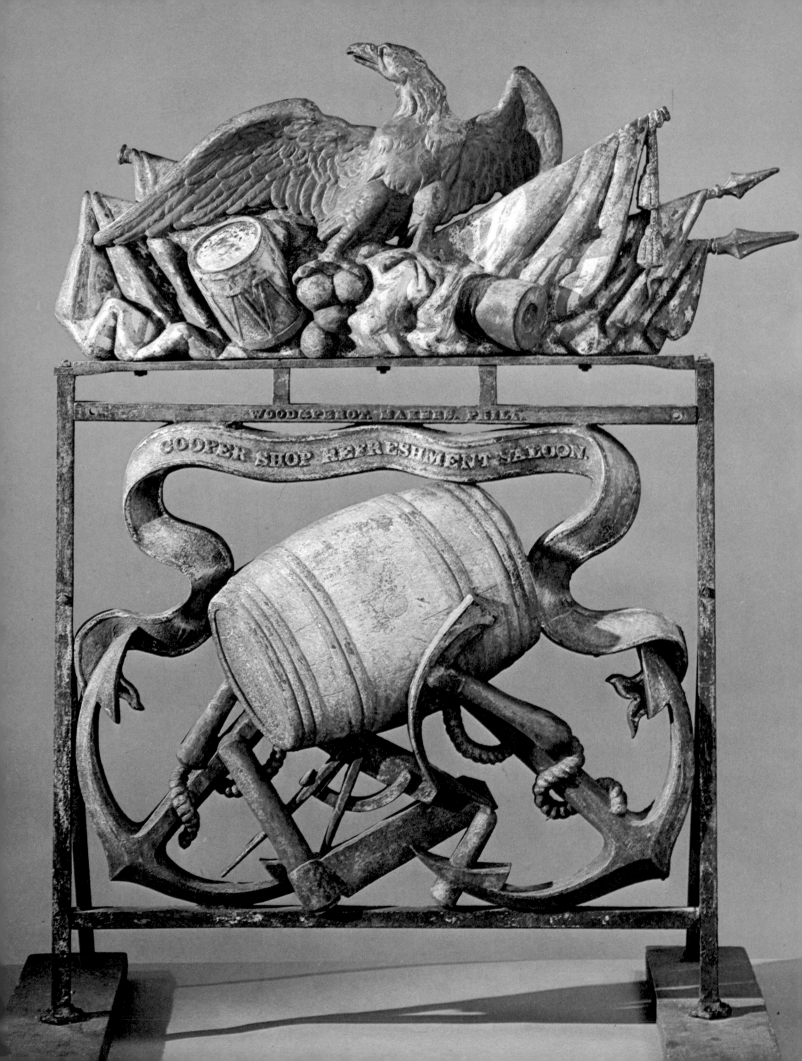

51 (opposite). Cooper Shop sign. Wood & Perot. Philadelphia. C. 1861. Cast iron, painted. H. 50″. This sign marked the location of the Cooper Shop Refreshment Saloon in Philadelphia, where Union volunteers were fed and housed during the Civil War. (Abby Aldrich Rockefeller Folk Art Collection)

52 (below). Personification of Time. 1825–1840. Wood, painted white. H. 20⅝″. Carved figures holding hourglasses were used to decorate hearses. (Hirschl & Adler Galleries, Inc.)

53 (right). Father Time. C. 1910. Wood and metal. H. approximately 48″. The craftsman who fashioned this unusual figure paid little attention to anatomical accuracy. The form is merely a stylized representation of the human body. (Museum of American Folk Art)

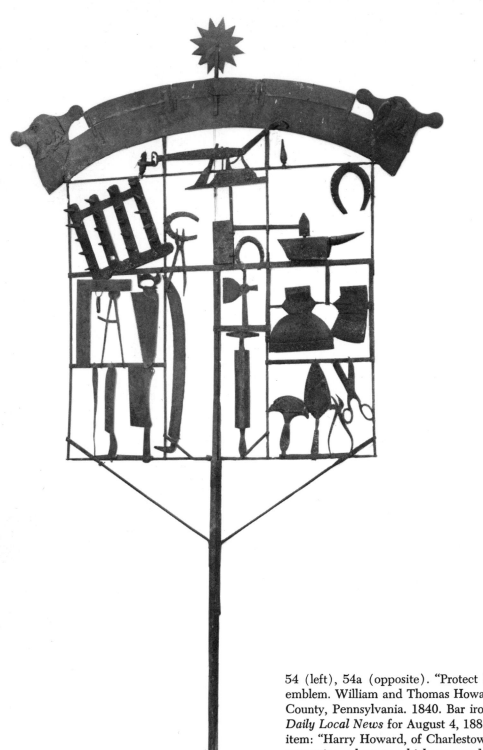

54 (left), 54a (opposite). "Protect Home Industries" political emblem. William and Thomas Howard. Charlestown, Chester County, Pennsylvania. 1840. Bar iron. H. 84″. The *West Chester Daily Local News* for August 4, 1888, carried the following news item: "Harry Howard, of Charlestown township, has in his possession a banner which was made for the Harrison campaign of 1840 . . . Each square represents by appropriate tools, some particular industry, the broad axe, saw and hammer, the carpenter, the shoemaker's awl and last are here, the tanner's tools are represented, and a blacksmith's anvil and a hammer that automatically strikes a bell as it is carried in a procession, make it the most striking banner that remains to tell the mute story of its use in the campaign to promote home industries, waged in 1840 . . . It is a marvel of inventive genius and would be hailed with acclamation if used at the Blaine reception in New York." (Chester County Historical Society)

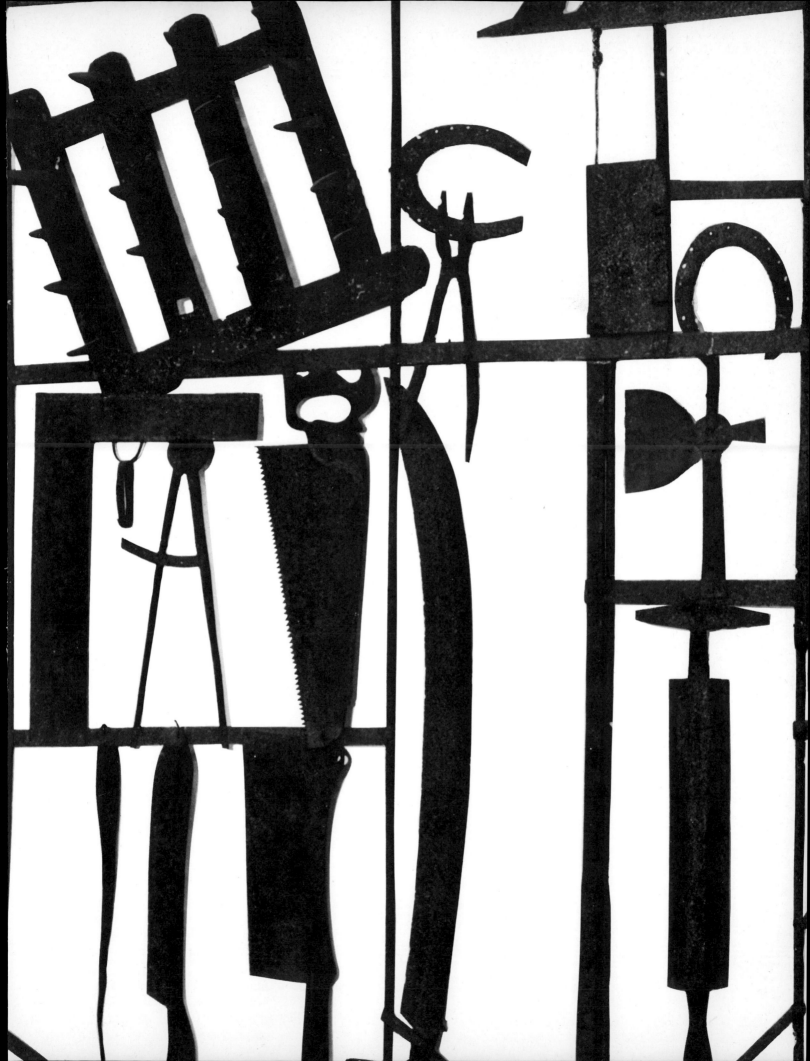

METAL WEATHERVANES

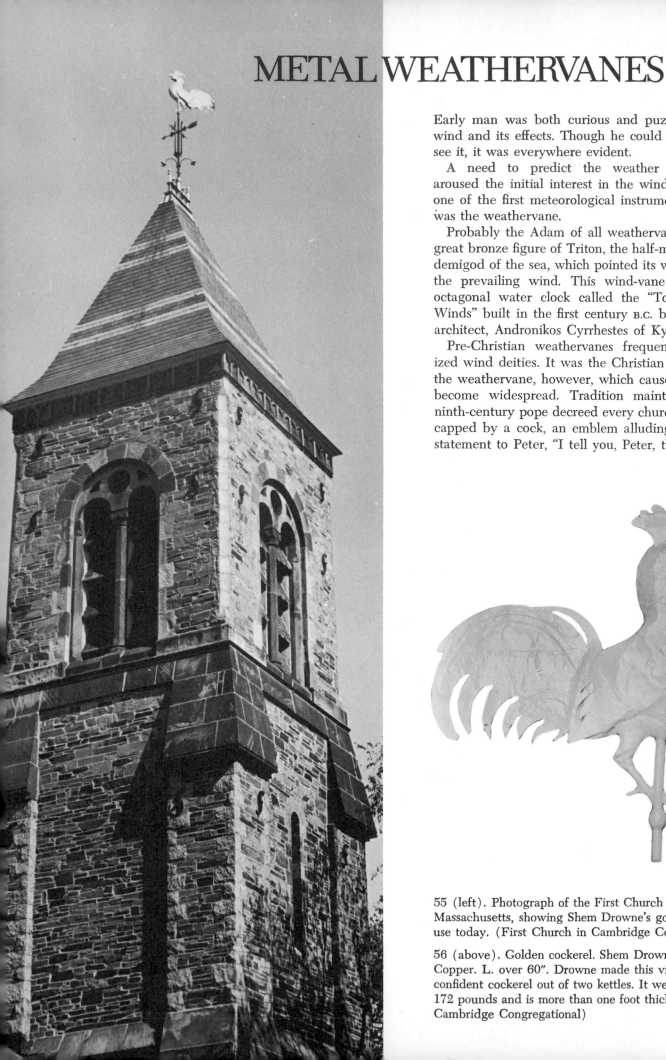

Early man was both curious and puzzled by the wind and its effects. Though he could not actually see it, it was everywhere evident.

A need to predict the weather presumably aroused the initial interest in the wind's direction; one of the first meteorological instruments devised was the weathervane.

Probably the Adam of all weathervanes was the great bronze figure of Triton, the half-man, half-fish demigod of the sea, which pointed its wand toward the prevailing wind. This wind-vane topped an octagonal water clock called the "Tower of the Winds" built in the first century B.C. by the Greek architect, Andronikos Cyrrhestes of Kyrrhos.

Pre-Christian weathervanes frequently symbolized wind deities. It was the Christian adoption of the weathervane, however, which caused its use to become widespread. Tradition maintains that a ninth-century pope decreed every church should be capped by a cock, an emblem alluding to Christ's statement to Peter, "I tell you, Peter, the cock will

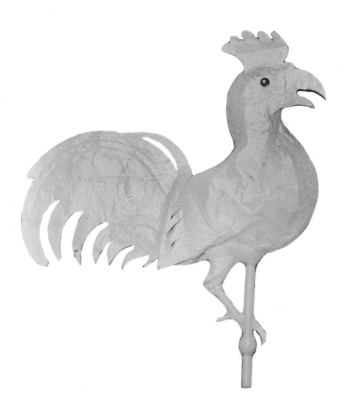

55 (left). Photograph of the First Church in Cambridge, Massachusetts, showing Shem Drowne's golden cockerel in use today. (First Church in Cambridge Congregational)

56 (above). Golden cockerel. Shem Drowne. Boston. 1721. Copper. L. over 60". Drowne made this vigorous, self-confident cockerel out of two kettles. It weighs approximately 172 pounds and is more than one foot thick. (First Church in Cambridge Congregational)

not crow this day, until you three times deny that you know me." [5]

During the Middle Ages and the Renaissance, weathervanes were created in primarily two shapes —the cock and the banner-shaped vanes popular for the castles of the nobility. As cosmopolitan cities grew, weathervanes were used on churches and other public buildings. An eleventh-century artist even wove into the Bayeux Tapestry a scene of medieval craftsmen fastening a rooster to the spire of the recently built Westminster Abbey.

After the Great Fire of London in 1666, Sir Christopher Wren and other architects used banneret vanes on their elegant spires. Wren, the architectural genius of his time, redesigned fifty-five of the eighty-seven churches destroyed in the holocaust. His fascination with wind and weather inspired the creation of his "weather clock," an invention that recorded wind or rainfall, or both.

The exact date of the first American-made weathervane is probably unrecorded. However, several are known to have existed in the mid-seventeenth century, for marginal decorations on early maps in the form of cityscapes show them in use. At first, American weathervanes were probably direct copies of European imports; however, craftsmen were soon producing their own designs, which displayed a vigor that has caused many people to consider the American weathervane the first significant form of American sculpture.

Some weathervane makers were famous in their own time. Deacon Shem Drowne, who was born at Kittery, Maine, in 1683 and died in 1774 at the age of ninety-one, has received more attention than any other American vanemaker. His family moved to Boston in 1692, where he later became one of the leading metalsmiths in that growing seaport. In 1716 Drowne fashioned a glass-eyed Indian with bow and arrow for the Peter Sargeant mansion,

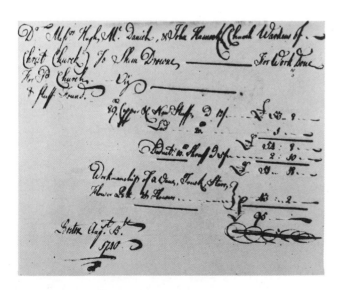

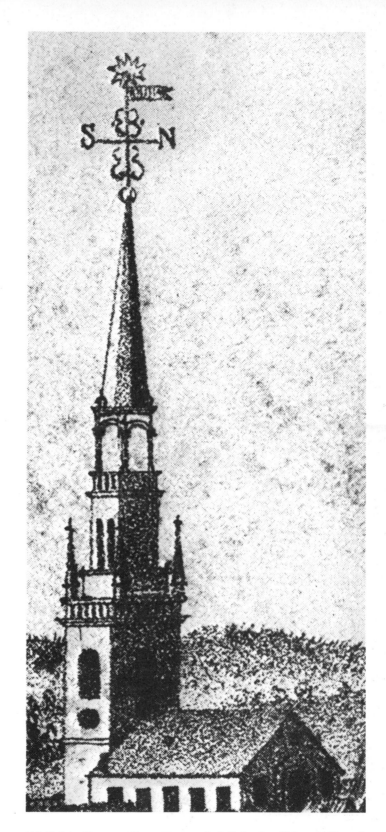

57 (left). Deacon Shem Drowne's bill for his "blew ball and banner" is dated August 15, 1740. (Old North Church, Boston)

58 (above). Detail of *A South East View of ye Great Town of Boston in New England in America,* drawn by William Burgis and engraved by I. Harris, c. 1743, shows the Christ Church built in 1725. The steeple, which is topped by the blue ball vane, was added in 1740. (The New York Public Library)

45

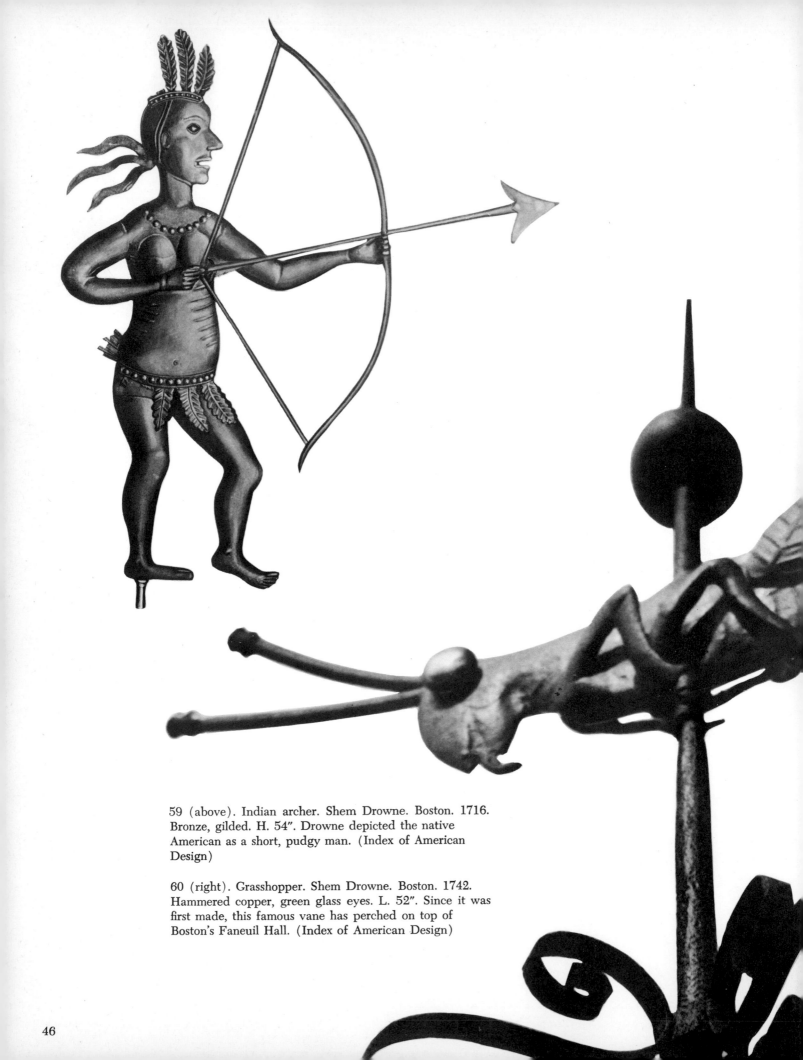

59 (above). Indian archer. Shem Drowne. Boston. 1716. Bronze, gilded. H. 54″. Drowne depicted the native American as a short, pudgy man. (Index of American Design)

60 (right). Grasshopper. Shem Drowne. Boston. 1742. Hammered copper, green glass eyes. L. 52″. Since it was first made, this famous vane has perched on top of Boston's Faneuil Hall. (Index of American Design)

which had been built in 1679 and became the home of the royal governor of the Province of Massachusetts in 1716.

Other vanes by Drowne survive. A rooster was ordered from him for the new Brick Church built on Hanover Street by a congregation that seceded from the older North Church on North Square. The golden cockerel was taken down several times for repairs and new gold leaf. In 1779 it was placed on a different church when the New Brick Society united with the Second Church. During a violent storm in 1869, the steeple was blown to the ground and the cockerel flew through the air, landing in a nearby house where supper was being served. It was repaired and in 1873 the Shepard Congregational

Society at Cambridge, Massachusetts, bought the cockerel for their new Garden Street church, where it has perched ever since.

Drowne's work seems to have been protected by Divine Providence, for his "blew ball" and banner mounted on Christ Church, Salem Street, Boston, on August 15, 1740, still surmounts the steeple.

The most famous American weathervane is the green-eyed grasshopper that Shem Drowne made for Peter Faneuil's famous Faneuil Hall. This piece, made of hammered copper, was created by Drowne in his Ann Street shop and placed in position by the craftsman himself in 1749. The grasshopper is an exact copy of a vane used on top of the London Royal Exchange. If its glass eyes could relate everything they have witnessed, some of the most dramatic scenes of American history would be among them, including the Boston Massacre and the Boston Tea Party. When Boston suffered a severe earthquake in the fall of 1755, the giant insect was thrown to the ground. Drowne's son, Thomas, replaced a broken leg, and once again the famous landmark returned to Faneuil Hall. In 1761 it survived a severe fire without injury; however, in 1889, it fell to the earth during a festive celebration commemorating the evacuation of Boston. Again it was repaired and replaced. Today, visitors to Boston, like their eighteenth- and nineteenth-century counterparts, always look for Shem Drowne's remarkable grasshopper.

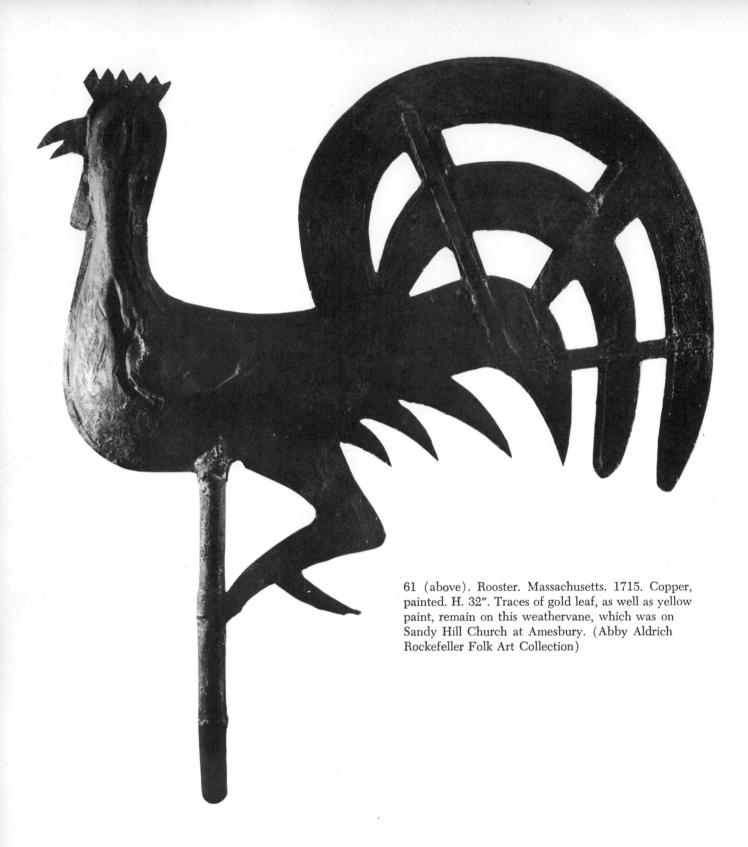

61 (above). Rooster. Massachusetts. 1715. Copper, painted. H. 32". Traces of gold leaf, as well as yellow paint, remain on this weathervane, which was on Sandy Hill Church at Amesbury. (Abby Aldrich Rockefeller Folk Art Collection)

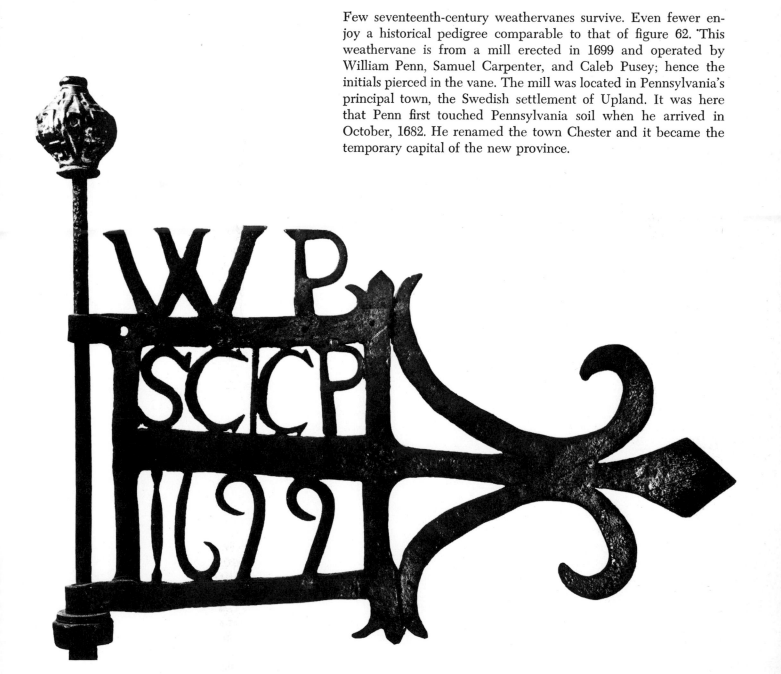

Few seventeenth-century weathervanes survive. Even fewer enjoy a historical pedigree comparable to that of figure 62. This weathervane is from a mill erected in 1699 and operated by William Penn, Samuel Carpenter, and Caleb Pusey; hence the initials pierced in the vane. The mill was located in Pennsylvania's principal town, the Swedish settlement of Upland. It was here that Penn first touched Pennsylvania soil when he arrived in October, 1682. He renamed the town Chester and it became the temporary capital of the new province.

62 (above). Banner. Pennsylvania 1699. Iron. H. 12″. (Historical Society of Pennsylvania)

During the summer of 1787 George Washington ordered for Mount Vernon a new weathervane to be executed in Philadelphia by Joseph Rakestraw. In a letter to Mr. Rakestraw, Washington carefully described the form he desired: "I should like to have a bird (in place of the Vain) with an olive branch in its Mouth. The bird need not be large (for I do not expect that it will traverse with the wind and therefore may receive the real shape of a bird, with spread wings), the point of the spire not to appear above the bird. If this, that is the bird thus described, is in the execution, likely to meet any difficulty, or to be attended with much expence, I should wish to be informed thereof previous to the undertaking of it." [6]

In a later letter to George A. Washington, his nephew, he carefully explained how to mount the frame base, copper ball, and Dove of Peace. "Great pains (and Mr. Lear understands the Compass) must be taken to fix the points truly; otherwise they will deceive rather than direct— (if they vary from the North, South, East, and West)—One way of doing this may be by Compass being placed in a *direct* north line on the ground at some distance from the House by means of which and a plumb line the point may be exactly placed—that is by having the points in a true line between the plumb line and the Spire —so with respect to the other three points.— What the paper means by cutting off the top of the present Cupulo, is no more than the small octagon at the very top, so as that the work of the *old* & *new* may fit each together; . . . Let particular care be used to putty, or put copper on, all the joints & to prevent the leaking, & rotting of the wood as it will be difficult, & expensive to repair it hereafter . . ." [7]

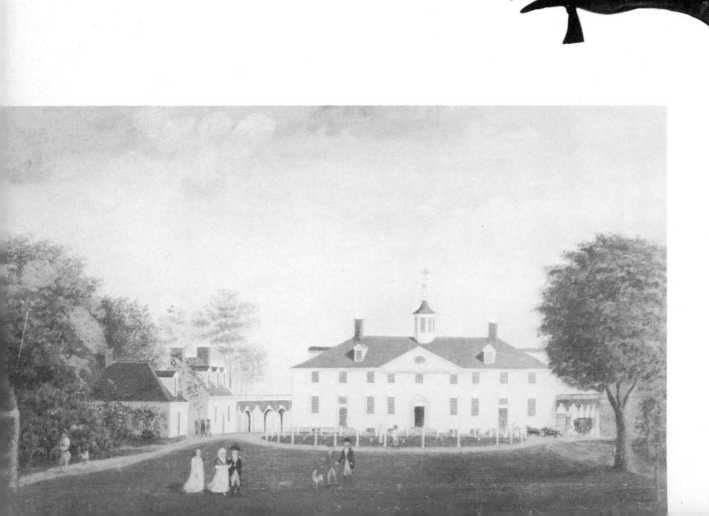

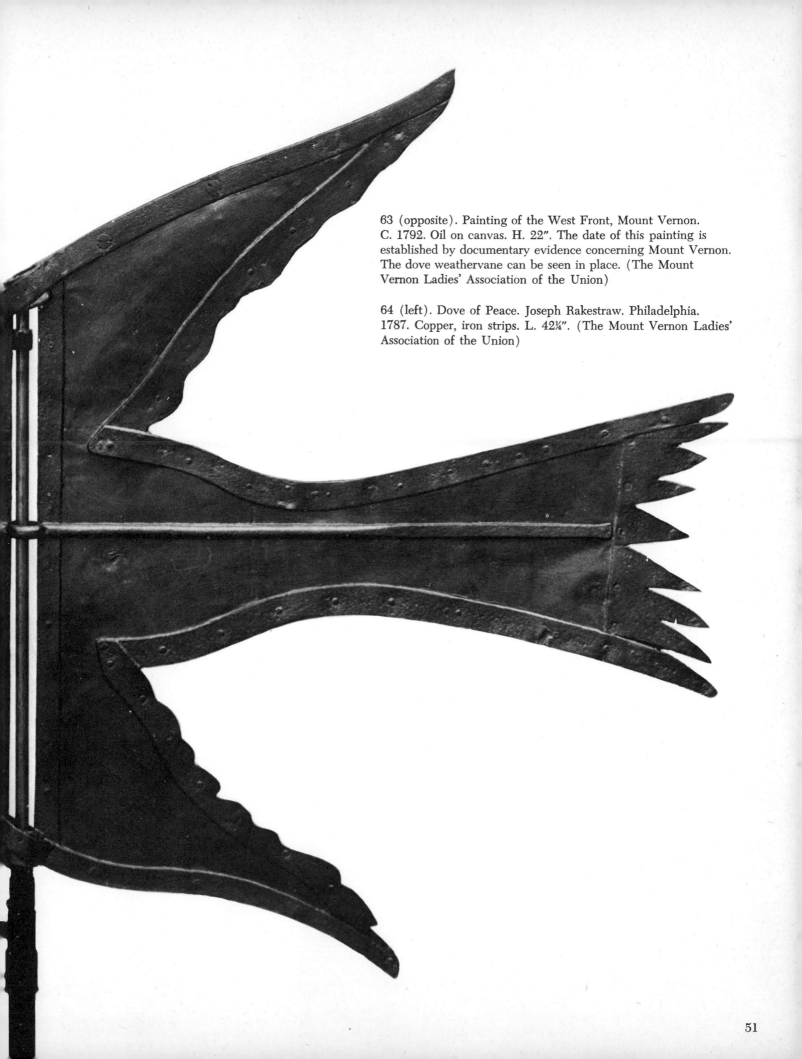

63 (opposite). Painting of the West Front, Mount Vernon. C. 1792. Oil on canvas. H. 22″. The date of this painting is established by documentary evidence concerning Mount Vernon. The dove weathervane can be seen in place. (The Mount Vernon Ladies' Association of the Union)

64 (left). Dove of Peace. Joseph Rakestraw. Philadelphia. 1787. Copper, iron strips. L. 42¼″. (The Mount Vernon Ladies' Association of the Union)

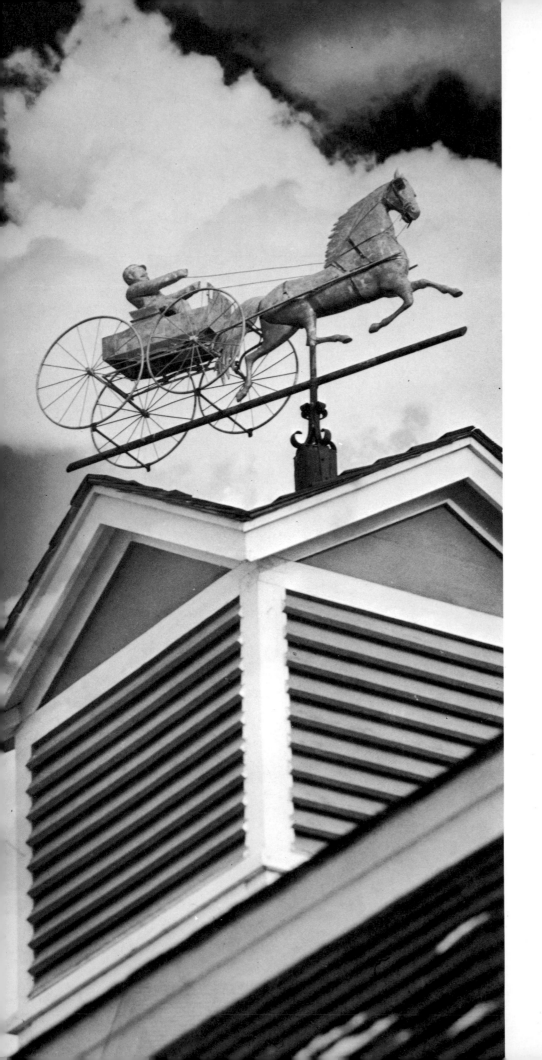

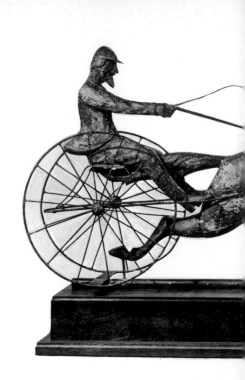

65 (left). Horse and sulky. C. 1875. Copper, gold leafed. L. 36″. (Greenfield Village and Henry Ford Museum)

66 (above). Horse and sulky. Nineteenth century. Lead and copper. H. 22½″. (Mr. and Mrs. W. B. Carnochan; photograph courtesy Hirschl & Adler Galleries, Inc.)

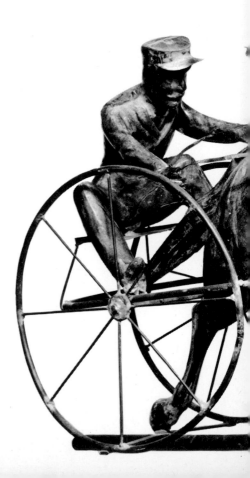

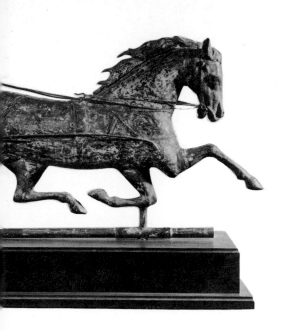

68 (right). Horse and rider. George Loebig. New Albany, Indiana. 1880–1890. Sheet iron. H. 54″. This vane was made by a local blacksmith and was used on top of the Lone Star General Store. (Dr. Alvin Friedman-Kien; photograph courtesy Stony Point Folk Art Gallery)

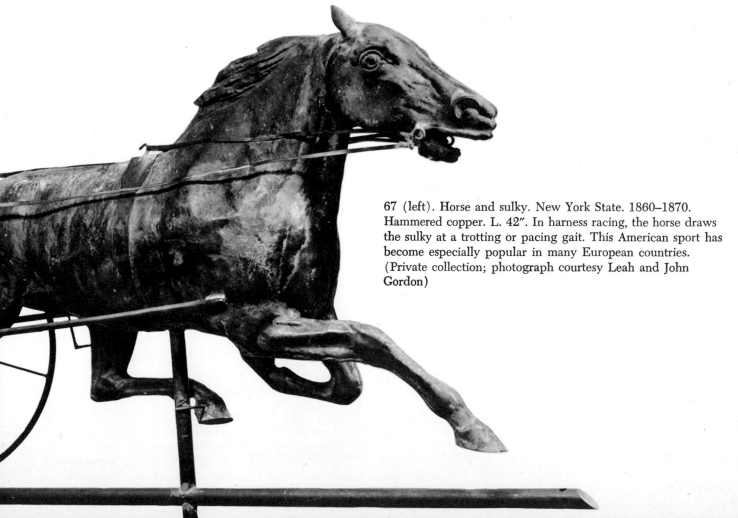

67 (left). Horse and sulky. New York State. 1860–1870. Hammered copper. L. 42″. In harness racing, the horse draws the sulky at a trotting or pacing gait. This American sport has become especially popular in many European countries. (Private collection; photograph courtesy Leah and John Gordon)

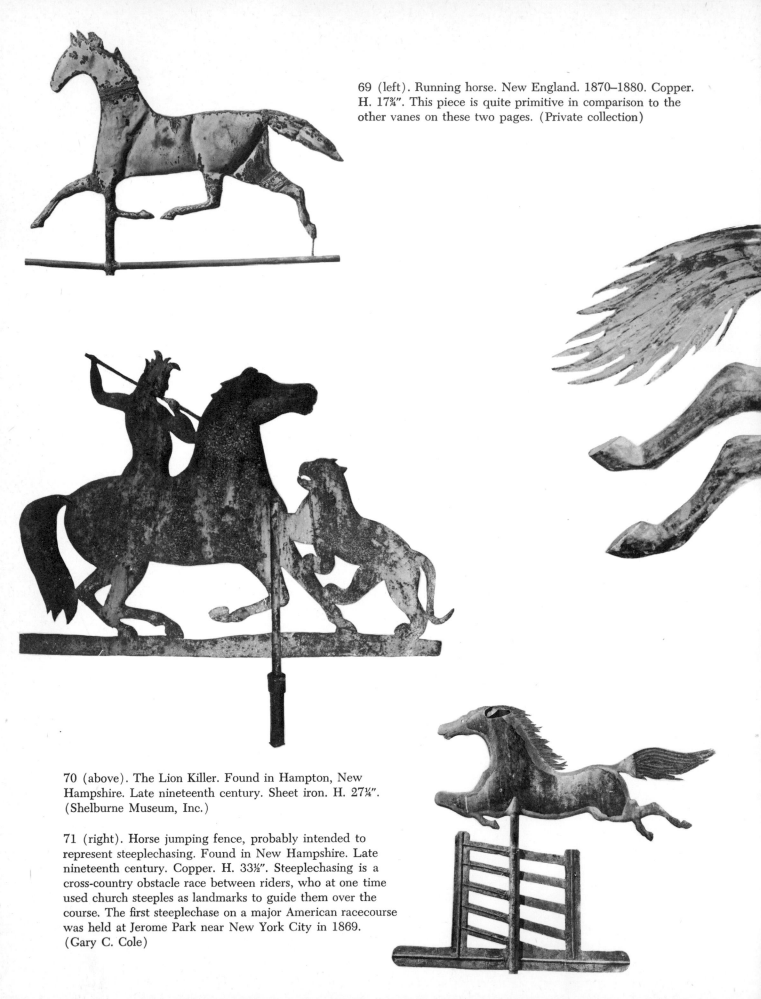

69 (left). Running horse. New England. 1870–1880. Copper. H. 17¾″. This piece is quite primitive in comparison to the other vanes on these two pages. (Private collection)

70 (above). The Lion Killer. Found in Hampton, New Hampshire. Late nineteenth century. Sheet iron. H. 27¼″. (Shelburne Museum, Inc.)

71 (right). Horse jumping fence, probably intended to represent steeplechasing. Found in New Hampshire. Late nineteenth century. Copper. H. 33½″. Steeplechasing is a cross-country obstacle race between riders, who at one time used church steeples as landmarks to guide them over the course. The first steeplechase on a major American racecourse was held at Jerome Park near New York City in 1869. (Gary C. Cole)

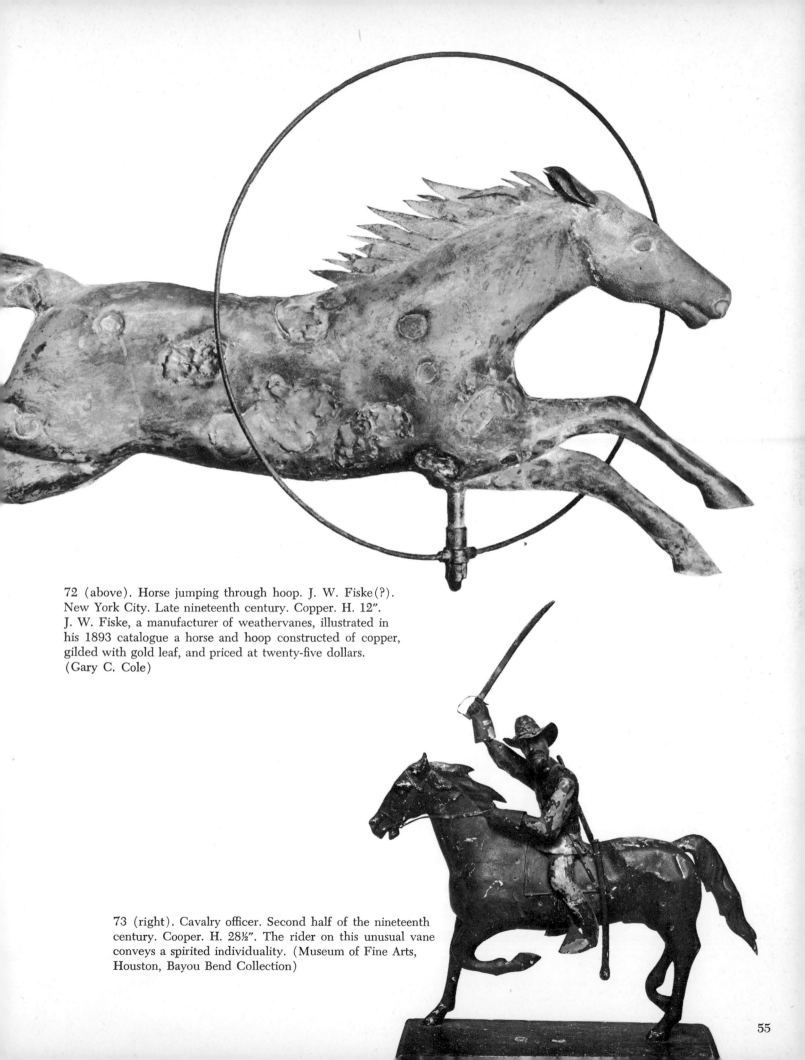

72 (above). Horse jumping through hoop. J. W. Fiske(?).
New York City. Late nineteenth century. Copper. H. 12".
J. W. Fiske, a manufacturer of weathervanes, illustrated in
his 1893 catalogue a horse and hoop constructed of copper,
gilded with gold leaf, and priced at twenty-five dollars.
(Gary C. Cole)

73 (right). Cavalry officer. Second half of the nineteenth
century. Cooper. H. 28½". The rider on this unusual vane
conveys a spirited individuality. (Museum of Fine Arts,
Houston, Bayou Bend Collection)

74 (below). Indian. Mid- or late nineteenth century. Sheet iron, polychromed. H. 51″. The base of this flat, silhouette vane carries the inscription "TO,TE," which probably stands for a fraternal order. Several other pieces of folk art carrying identical inscriptions are known to exist. (Index of American Design)

75 (center). "Saint Tammany." Found in East Branch, New York. Mid- to late nineteenth century. Copper, molded and painted. H. 108″. Saint Tammany is unique; no other American vane of such size and workmanship is known. It stood on a lodge building (figure 76), where it functioned as a symbol for the fraternal organization known as "The Improved Order of Redmen." Numerous fraternal societies adopted Indian customs and dress and pledged their moral and aesthetic allegiance to Tammany, chief of the Delaware Indians, a semimythical personage revered in Colonial America for his eloquence and courage. Such allegiance to patron-symbols was not uncommon in the early days of the republic. (Museum of American Folk Art)

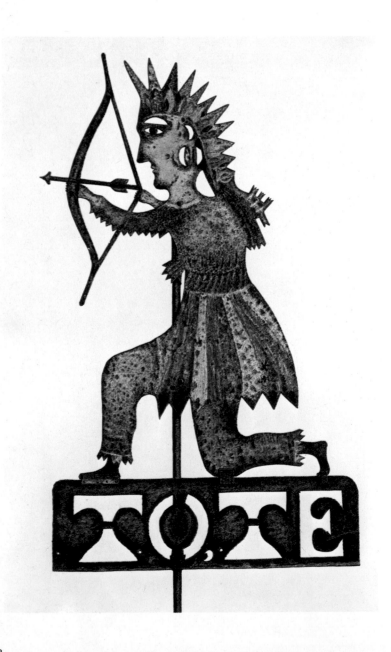

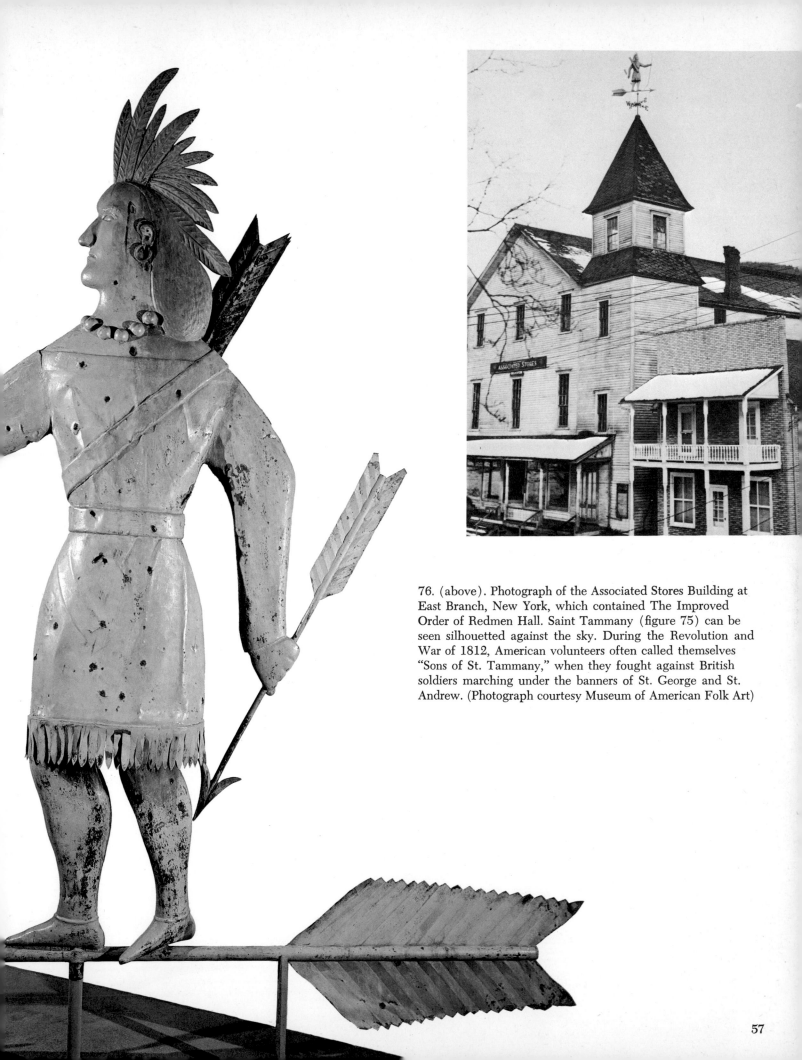

76. (above). Photograph of the Associated Stores Building at East Branch, New York, which contained The Improved Order of Redmen Hall. Saint Tammany (figure 75) can be seen silhouetted against the sky. During the Revolution and War of 1812, American volunteers often called themselves "Sons of St. Tammany," when they fought against British soldiers marching under the banners of St. George and St. Andrew. (Photograph courtesy Museum of American Folk Art)

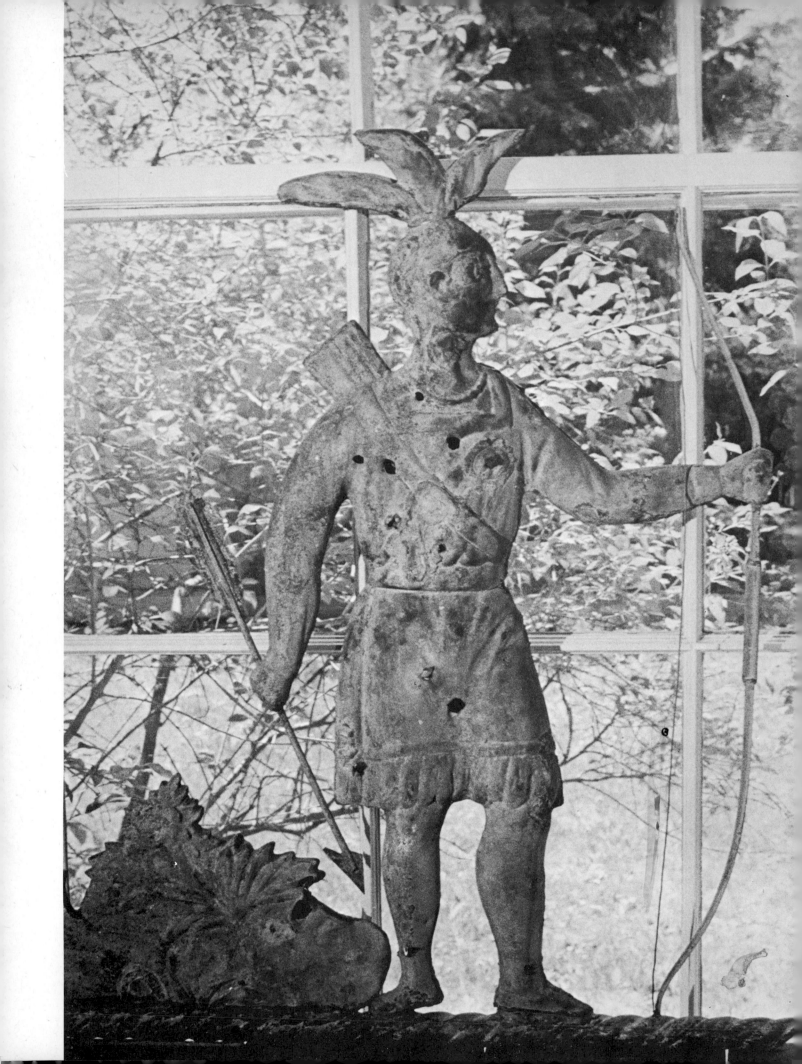

77 (opposite). Indian. Harris and Company. Boston. Late nineteenth century. Copper. H. 30″. This weathervane represents Massasoit, chief of the Wampanoag Indians, a tribe that lived in what is now southern Massachusetts and Rhode Island. (Mr. and Mrs. Edwin Braman)

78 (left). Indian. Found in New Jersey. Nineteenth century. Gold leaf feathers, remainder nickel plated. H. 60″. Especially large weathervanes were generally the products of an individual craftsman. (Village Green Antiques)

79 (below). Indian and deer. Found in Rhode Island. Early nineteenth century. Copper and zinc. L. 33″. (Current whereabouts unknown; photograph courtesy Jean Lipman)

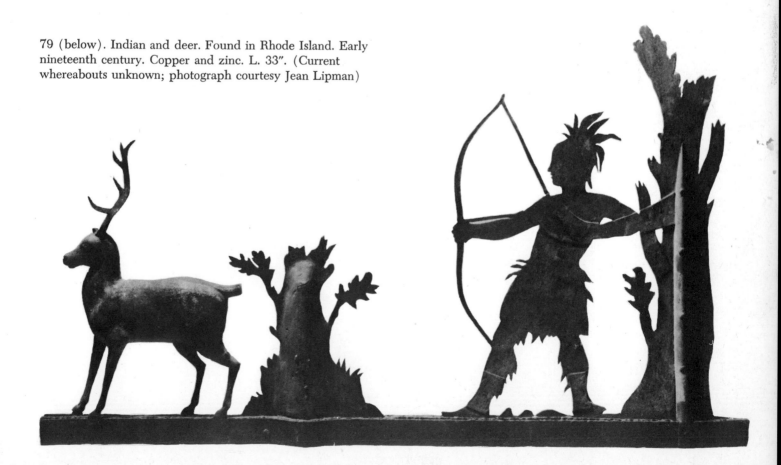

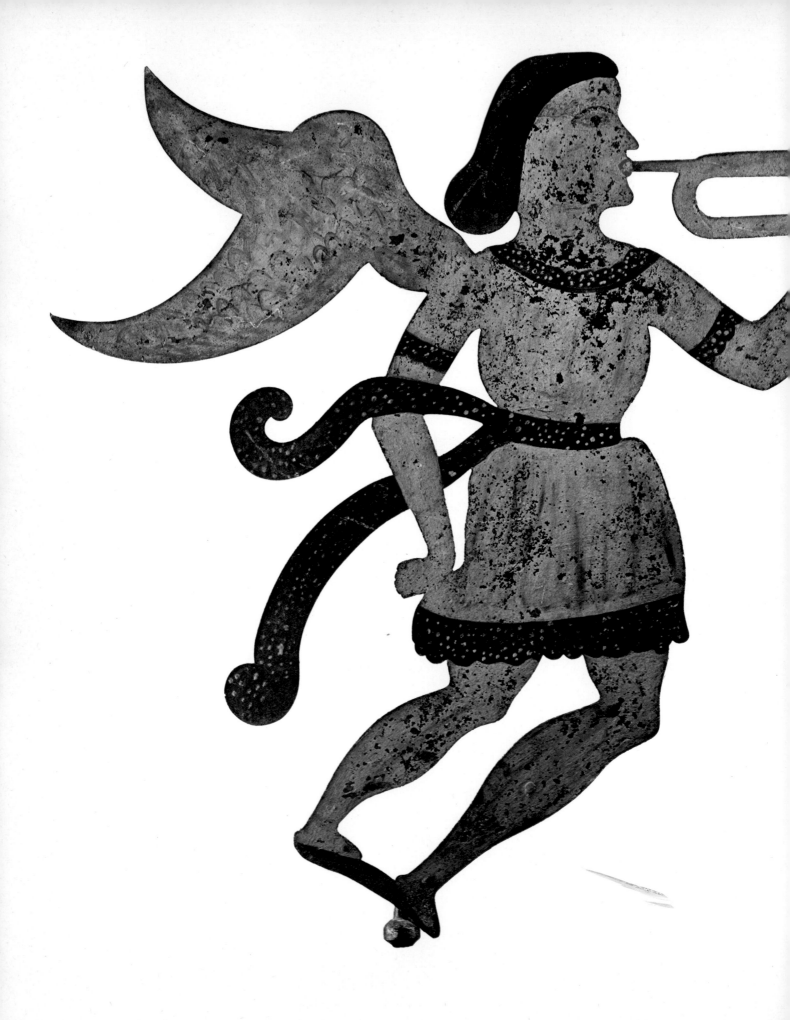

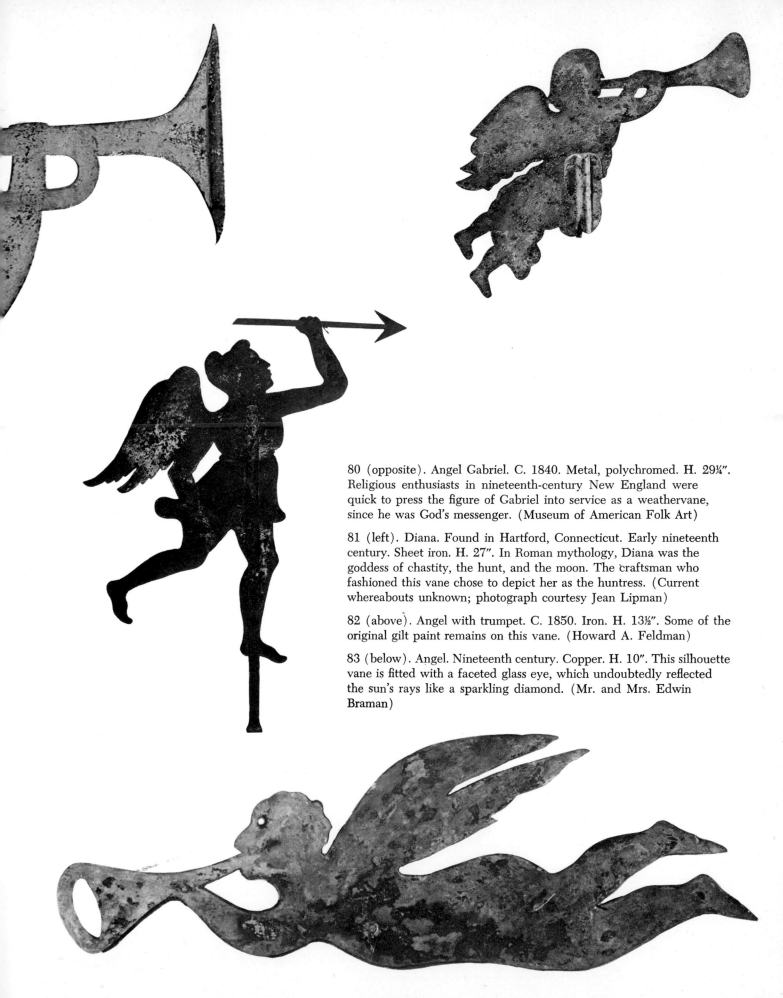

80 (opposite). Angel Gabriel. C. 1840. Metal, polychromed. H. 29¼".
Religious enthusiasts in nineteenth-century New England were
quick to press the figure of Gabriel into service as a weathervane,
since he was God's messenger. (Museum of American Folk Art)

81 (left). Diana. Found in Hartford, Connecticut. Early nineteenth
century. Sheet iron. H. 27". In Roman mythology, Diana was the
goddess of chastity, the hunt, and the moon. The craftsman who
fashioned this vane chose to depict her as the huntress. (Current
whereabouts unknown; photograph courtesy Jean Lipman)

82 (above). Angel with trumpet. C. 1850. Iron. H. 13½". Some of the
original gilt paint remains on this vane. (Howard A. Feldman)

83 (below). Angel. Nineteenth century. Copper. H. 10". This silhouette
vane is fitted with a faceted glass eye, which undoubtedly reflected
the sun's rays like a sparkling diamond. (Mr. and Mrs. Edwin
Braman)

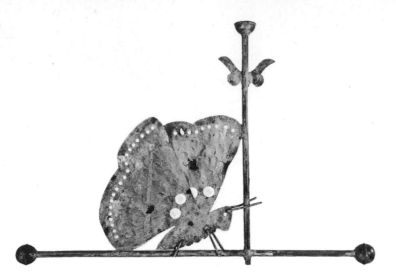

84 (above). Butterfly. Found in Connecticut, but originally from New Hampshire. Late nineteenth century. Sheet copper. H. 19″. J. W. Fiske, in his 1893 catalogue, offered a thirty-inch-long butterfly weathervane for eighteen dollars. The Fiske version was more elaborately pierced than this example. (Shelburne Museum, Inc.)

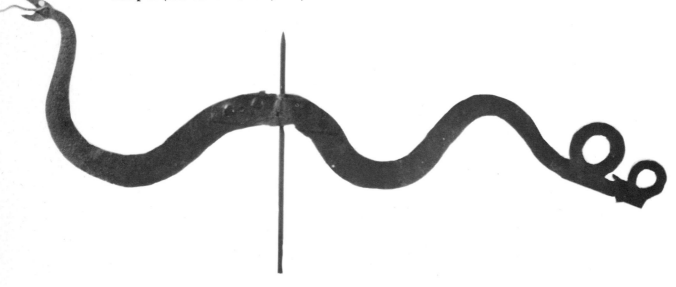

85 (above). Snake. Found in Danbury, Connecticut. Nineteenth century. Sheet iron. L. 29¾″. This homemade vane contrasts sharply with factory-produced pieces. Accurate dating of such examples is extremely difficult since handcraftsmanship in the old tradition persisted well into the twentieth century. (Abby Aldrich Rockefeller Folk Art Collection)

86 (right). Squirrel. C. 1880. Copper. H. 18″. A similar vane is illustrated in the 1883 catalogue of Cushing & White, Waltham, Massachusetts. This example retains traces of gilt on an ocher ground. (Private collection; photograph courtesy Gerald Kornblau Gallery)

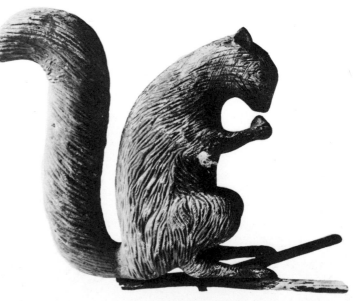

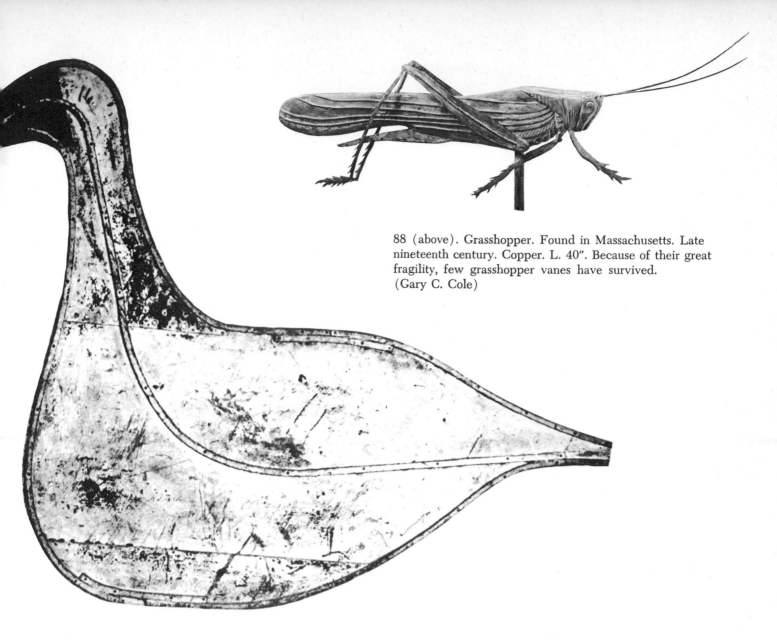

88 (above). Grasshopper. Found in Massachusetts. Late nineteenth century. Copper. L. 40″. Because of their great fragility, few grasshopper vanes have survived. (Gary C. Cole)

87 (above). Curlew. Cape May, New Jersey. C. 1870. Sheet iron with original gold leaf. H. 51″. This mammoth weathervane was made for the Cape May County Shooting and Gun Club, Cape May, New Jersey. It is an extraordinary example of weathervane sculpture. (Mrs. Jacob M. Kaplan)

89 (right). Stag. New England. C. 1845. Hammered copper, gilded. L. 32″. Several similar weathervanes have the additional embellishment of foliage under the leaping animal. This majestic piece is exceptionally handsome. (Private collection; photograph courtesy Leah and John Gordon)

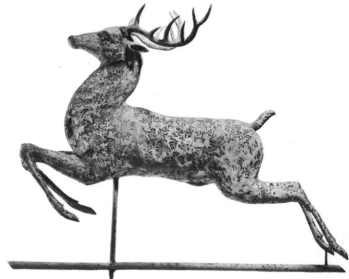

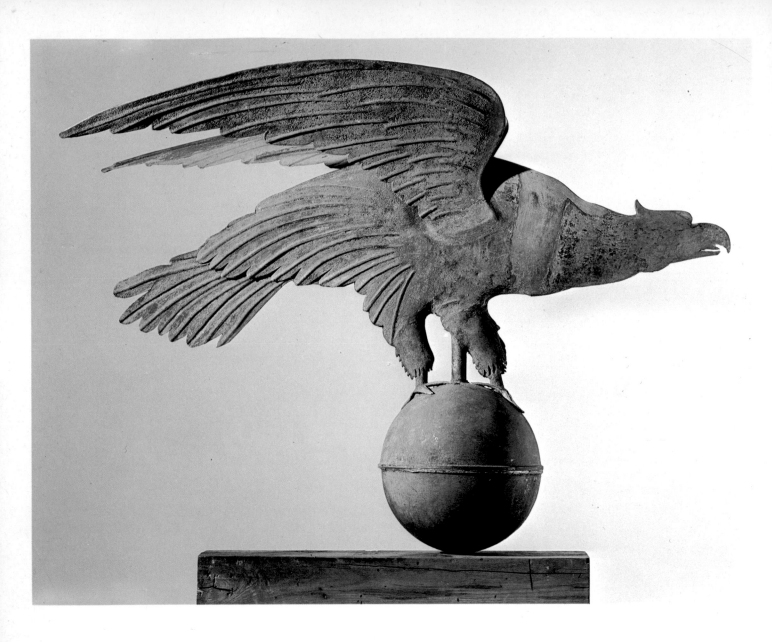

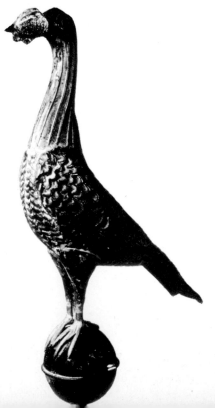

90 (above). Eagle. Massachusetts. Second quarter of the nineteenth century. Copper and lead. H. 27½". This weathervane came from a shoe factory in Rockland, Massachusetts. Like many nineteenth-century examples, the body is of copper and the head is of cast lead, a combination often appearing on horse vanes as well. (Dr. and Mrs. William Greenspon)

91 (right). Carrier pigeon. C. 1860. Copper. H. 17¼". Carrier pigeons, or homing pigeons, were frequently used during battles to send messages from the front lines to intelligence centers based at the rear. This vane is especially well modeled. (Abby Aldrich Rockefeller Folk Art Collection)

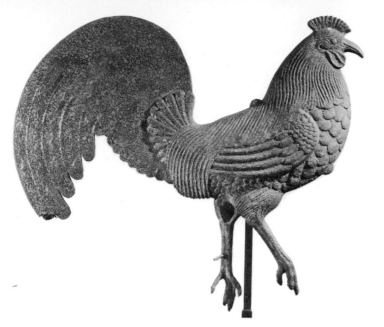

92 (left). Cock. Second half of the nineteenth century. Cast iron and tin. H. 31½″. This weathervane is from the carriage house of Château-sur-Mer, the home of William S. Wetmore at Newport, Rhode Island, which was built in 1851–1852. The vane remained in place until October, 1969. The house is now the property of The Preservation Society of Newport County. (Dr. and Mrs. William Greenspon)

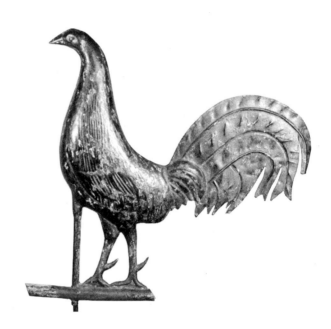

93 (right). Fighting cock. C. 1830. Copper. H. 18½″. Fighting cocks were specially bred to develop physical power, speed of movement, courage, and a killer instinct. In a cockfight the combatants battle each other until one is dead. Captain Jonathan Caldwell, of Haslet's Delaware Regiment in the Continental Army, enjoyed cockfights and always carried fighting cocks with him. The fame of his contests spread among the soldiers, and the Delaware troops became known as the Blue Hen's Chickens. In time, Delaware was named the Blue Hen State. Cockfighting is now illegal in most of the states. (Mr. and Mrs. Edwin Braman)

94 (below). Rooster. Ohio. 1850–1860. Sheet and wrought iron. H. 28″. (Herbert W. Hemphill, Jr.)

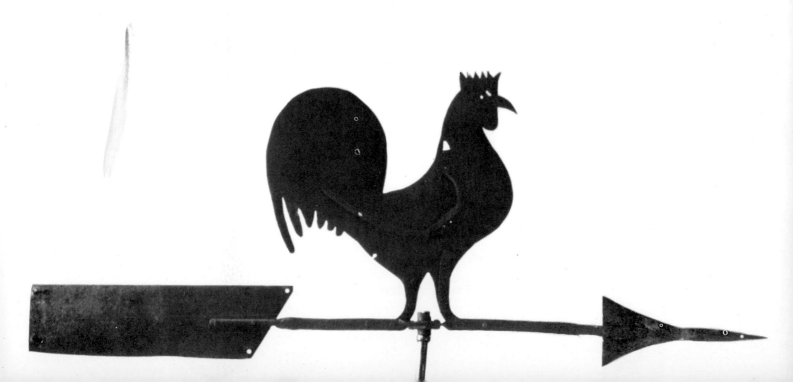

95 (below). Peacock. C. 1860. Copper and zinc, traces of
original gilt. H. 16¼". Weathervanes with broad, flat tails
were especially effective since they provided a surface that
easily caught the wind. (Peter Socolof; photograph courtesy
Gerald Kornblau Gallery)

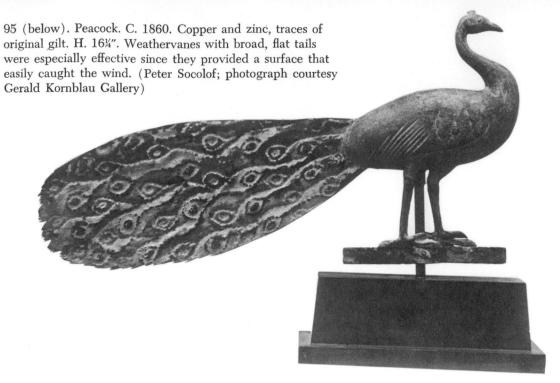

96 (below). Rooster. Found in New York State. Early
nineteenth century. Iron. H. 21". Slight traces of red paint
remain on this one-of-a-kind weathervane. Stylized
pineapple finials over the initials denote hospitality.
(Mr. and Mrs. Gary J. Stass)

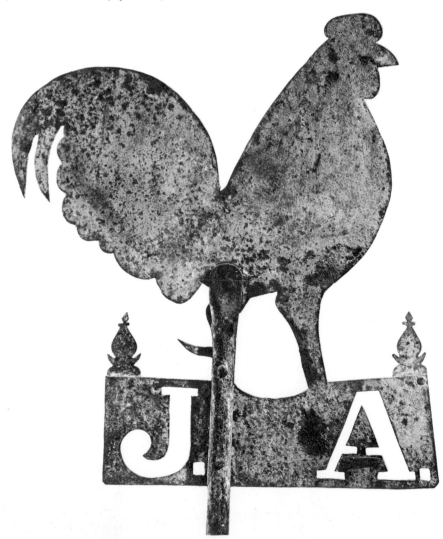

97 (right). Rooster. 1880–1890. Copper. H. 27″. A seemingly endless variety of roosters and hens indicate their great popularity as wind indicators. (Mr. and Mrs. Jerome Blum)

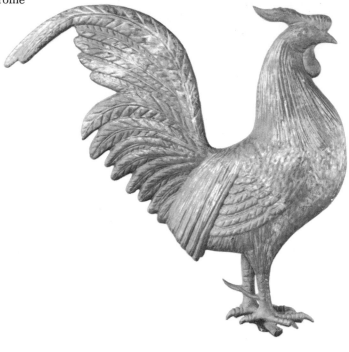

98 (left). Rooster. From a church at Saddle River, Bergen County, New Jersey. Early eighteenth century. Sheet iron. H. 43½″. This weathervane, which was originally acquired from the Ackerman family of Bergen County, New Jersey, once stood in the family yard. By the addition of a seat, it was converted into a playground object, much like a large hobbyhorse or carousel figure. (The Newark Museum)

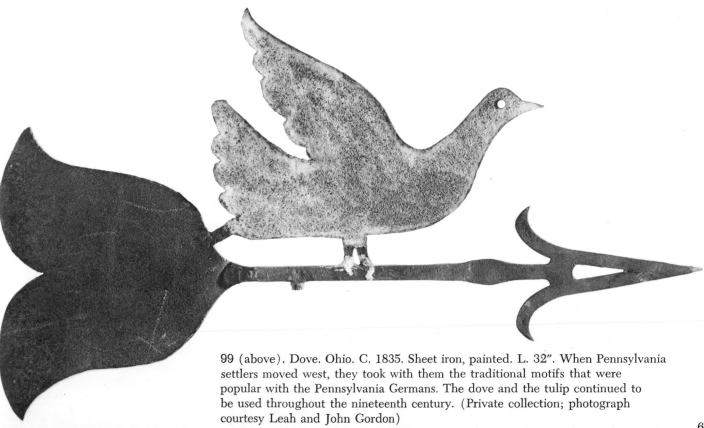

99 (above). Dove. Ohio. C. 1835. Sheet iron, painted. L. 32″. When Pennsylvania settlers moved west, they took with them the traditional motifs that were popular with the Pennsylvania Germans. The dove and the tulip continued to be used throughout the nineteenth century. (Private collection; photograph courtesy Leah and John Gordon)

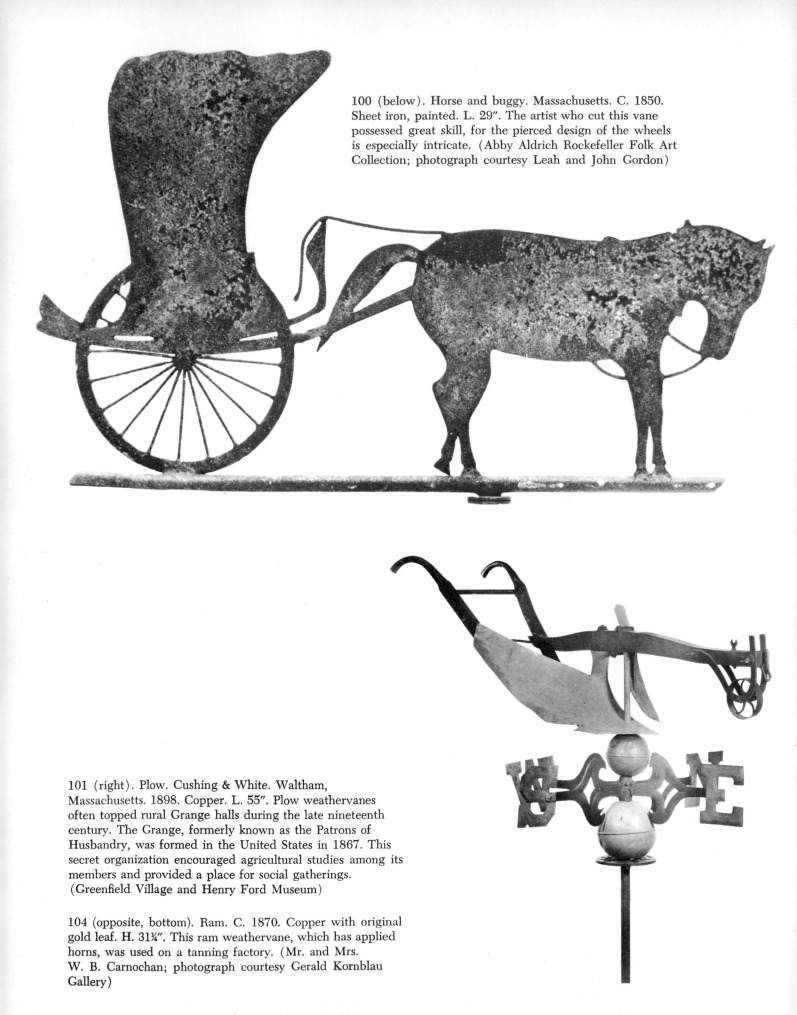

100 (below). Horse and buggy. Massachusetts. C. 1850. Sheet iron, painted. L. 29″. The artist who cut this vane possessed great skill, for the pierced design of the wheels is especially intricate. (Abby Aldrich Rockefeller Folk Art Collection; photograph courtesy Leah and John Gordon)

101 (right). Plow. Cushing & White. Waltham, Massachusetts. 1898. Copper. L. 55″. Plow weathervanes often topped rural Grange halls during the late nineteenth century. The Grange, formerly known as the Patrons of Husbandry, was formed in the United States in 1867. This secret organization encouraged agricultural studies among its members and provided a place for social gatherings. (Greenfield Village and Henry Ford Museum)

104 (opposite, bottom). Ram. C. 1870. Copper with original gold leaf. H. 31¼″. This ram weathervane, which has applied horns, was used on a tanning factory. (Mr. and Mrs. W. B. Carnochan; photograph courtesy Gerald Kornblau Gallery)

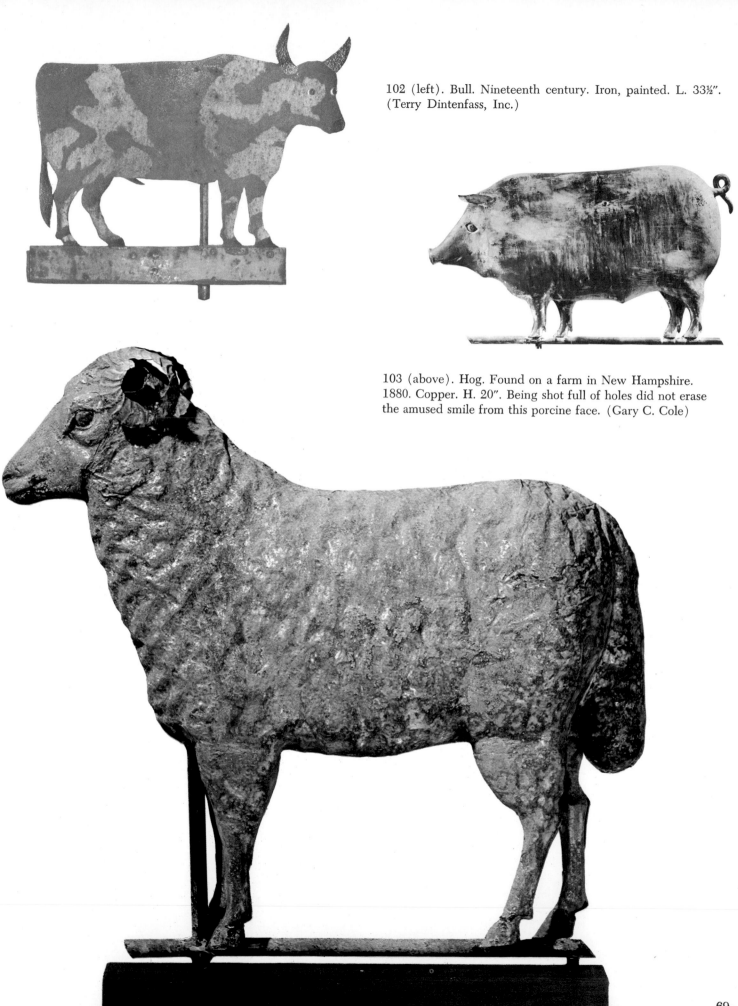

102 (left). Bull. Nineteenth century. Iron, painted. L. 33½".
(Terry Dintenfass, Inc.)

103 (above). Hog. Found on a farm in New Hampshire.
1880. Copper. H. 20". Being shot full of holes did not erase
the amused smile from this porcine face. (Gary C. Cole)

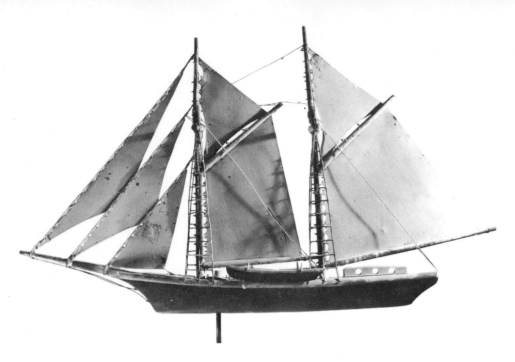

105 (above). Ship. New England. C. 1850. Sheet copper and wire. L. 48″. New Englanders were noted for their practicality. Even a vessel to sail in the wind was fitted with a lifeboat. (Private collection; photograph courtesy Leah and John Gordon)

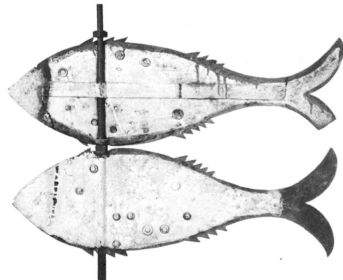

106 (right). Fish. New York State. Late eighteenth century. Sheet iron. L. of each fish, 33″. Though found in Connecticut, this vane is believed to have been made in New York and is probably the work of an amateur. (Shelburne Museum, Inc.)

107 (below). Swordfish. Pennsylvania. Early nineteenth century. Sheet iron. L. 32″. Like many artifacts of Pennsylvania origin, this fish is decorated with a cutout heart. It was found in Lubaska, Pennsylvania. (Photograph courtesy Jean Lipman)

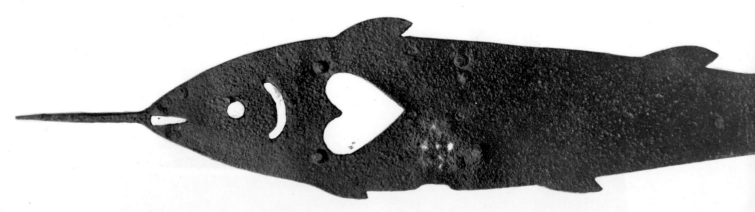

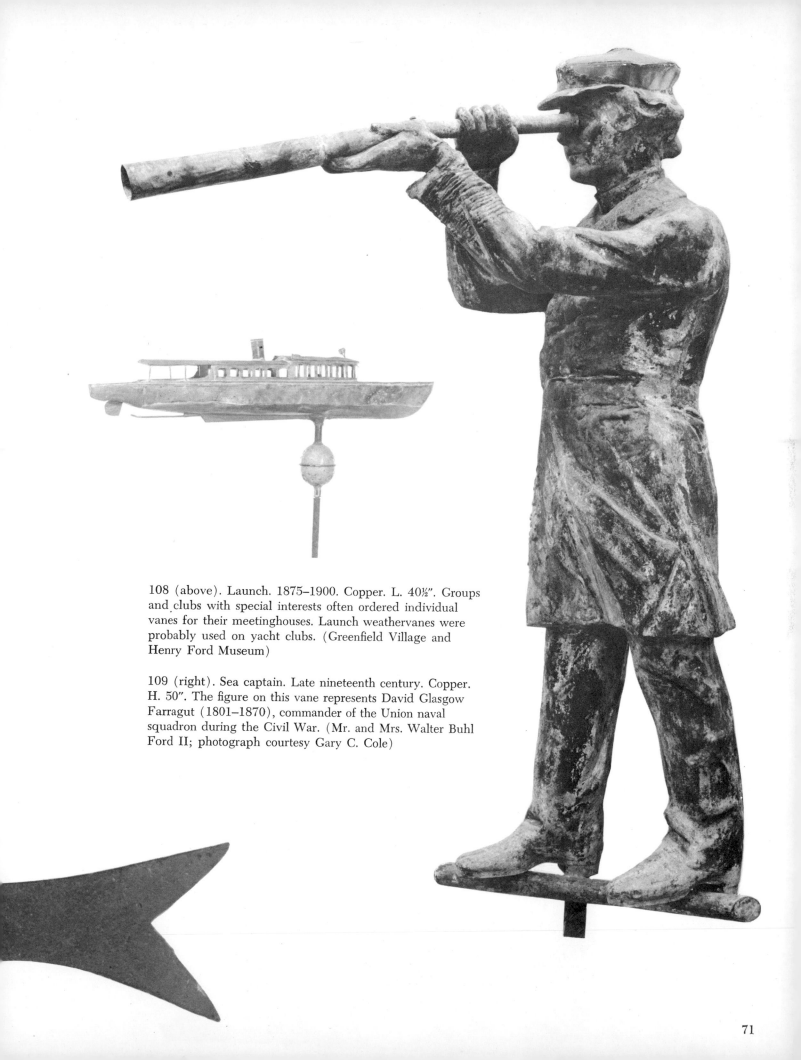

108 (above). Launch. 1875–1900. Copper. L. 40½″. Groups and clubs with special interests often ordered individual vanes for their meetinghouses. Launch weathervanes were probably used on yacht clubs. (Greenfield Village and Henry Ford Museum)

109 (right). Sea captain. Late nineteenth century. Copper. H. 50″. The figure on this vane represents David Glasgow Farragut (1801–1870), commander of the Union naval squadron during the Civil War. (Mr. and Mrs. Walter Buhl Ford II; photograph courtesy Gary C. Cole)

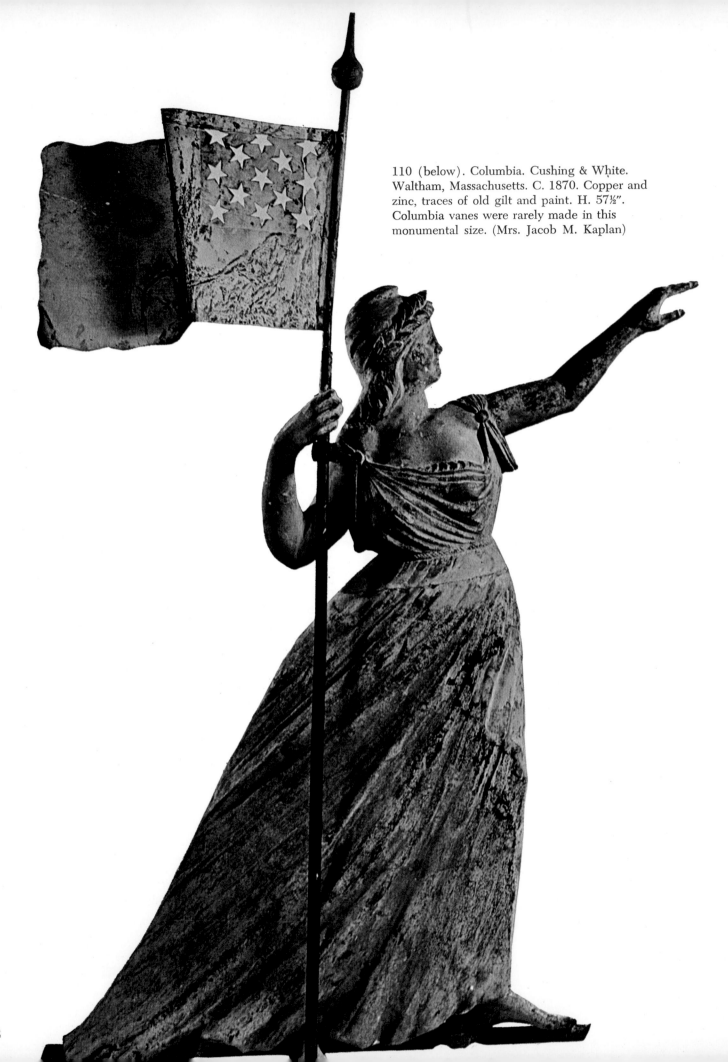

110 (below). Columbia. Cushing & White. Waltham, Massachusetts. C. 1870. Copper and zinc, traces of old gilt and paint. H. 57½". Columbia vanes were rarely made in this monumental size. (Mrs. Jacob M. Kaplan)

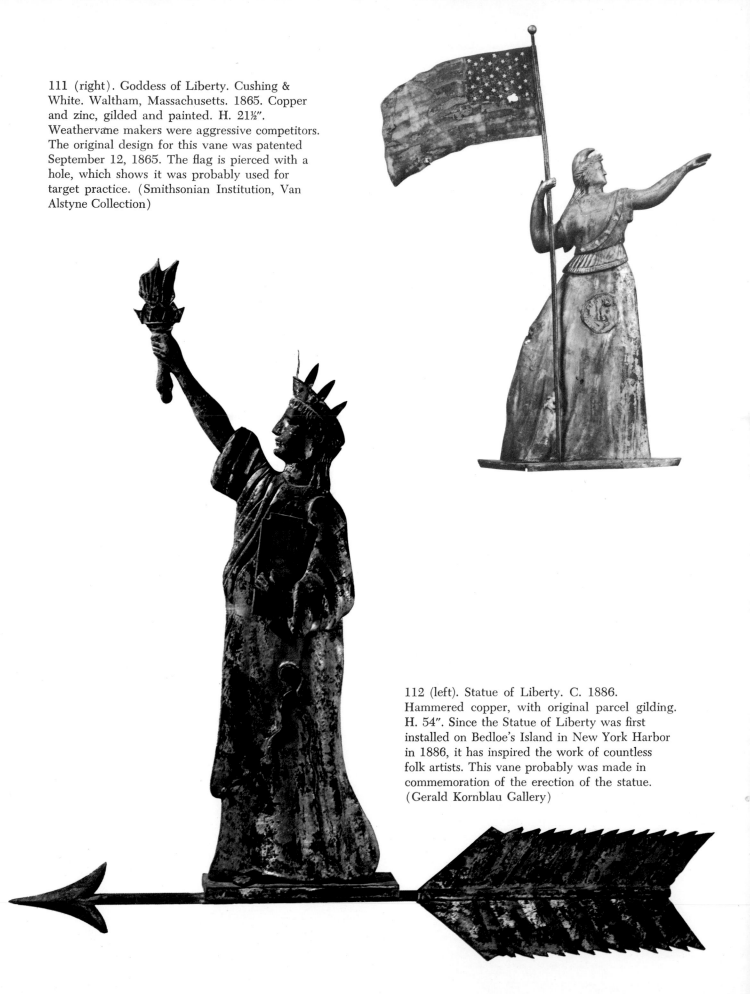

111 (right). Goddess of Liberty. Cushing &
White. Waltham, Massachusetts. 1865. Copper
and zinc, gilded and painted. H. 21½".
Weathervane makers were aggressive competitors.
The original design for this vane was patented
September 12, 1865. The flag is pierced with a
hole, which shows it was probably used for
target practice. (Smithsonian Institution, Van
Alstyne Collection)

112 (left). Statue of Liberty. C. 1886.
Hammered copper, with original parcel gilding.
H. 54". Since the Statue of Liberty was first
installed on Bedloe's Island in New York Harbor
in 1886, it has inspired the work of countless
folk artists. This vane probably was made in
commemoration of the erection of the statue.
(Gerald Kornblau Gallery)

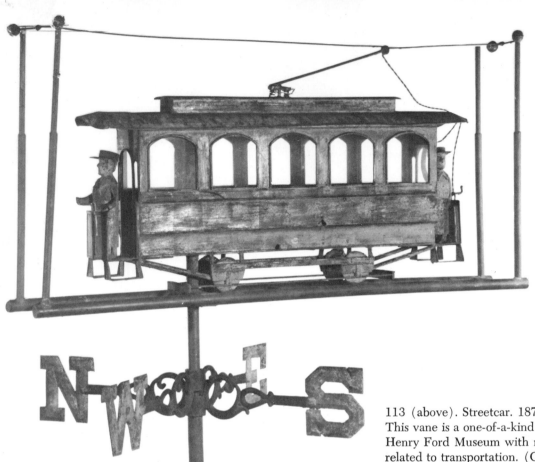

113 (above). Streetcar. 1876–1900. Sheet copper. L. 49″. This vane is a one-of-a-kind piece, and it is displayed at the Henry Ford Museum with numerous other weathervanes related to transportation. (Greenfield Village and Henry Ford Museum)

114 (below). Locomotive and tender. C. 1875. Copper. L. 107″. Many weathervanes are executed with meticulous detail, as can be seen in this example. (Greenfield Village and Henry Ford Museum)

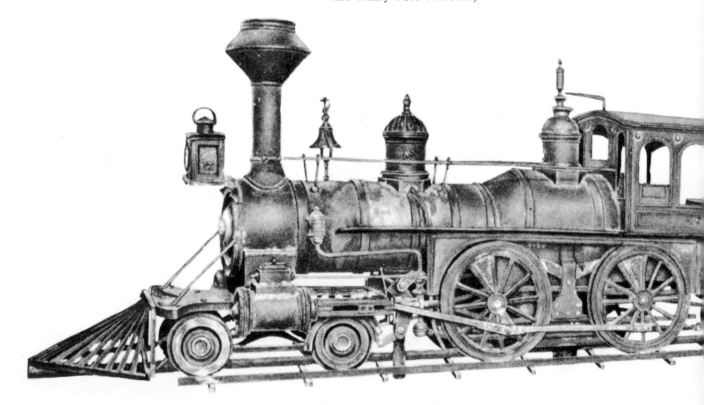

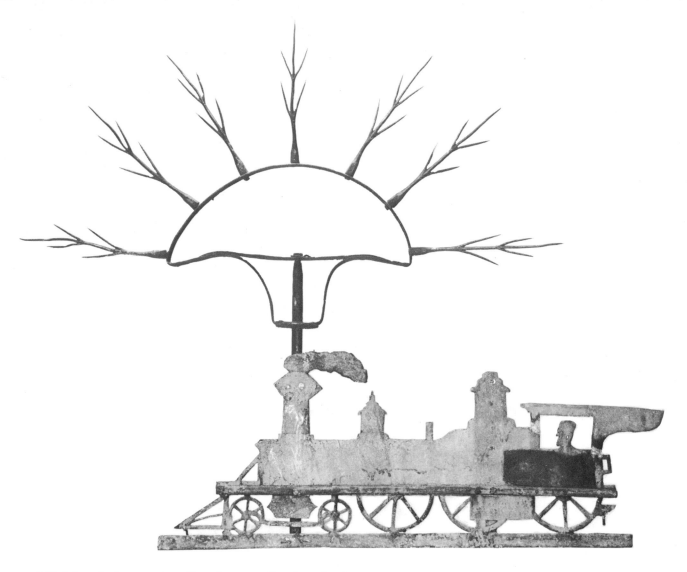

115 (above). Locomotive. Found on a railroad station in Providence, Rhode Island. C. 1840. Sheet zinc, wrought brass. H. 36″. Because of the different treatment of the two sections of this weathervane, it is possible that it is not the work of one man. The stylish brass superstructure appears to be of a later date. (Shelburne Museum, Inc.)

116 (above). Car. C. 1900. Copper. L. 42″. As the motorized vehicle became popular, automobile weathervanes were made for both commercial and personal garages. (Greenfield Village and Henry Ford Museum)

117 (opposite). Early photograph of the Aberdeen and Rockford Engine No. 35. This powerful "iron horse" is decorated with a silhouette Indian and a full-bodied eagle that were made in North Carolina. (Photograph courtesy Jean Lipman)

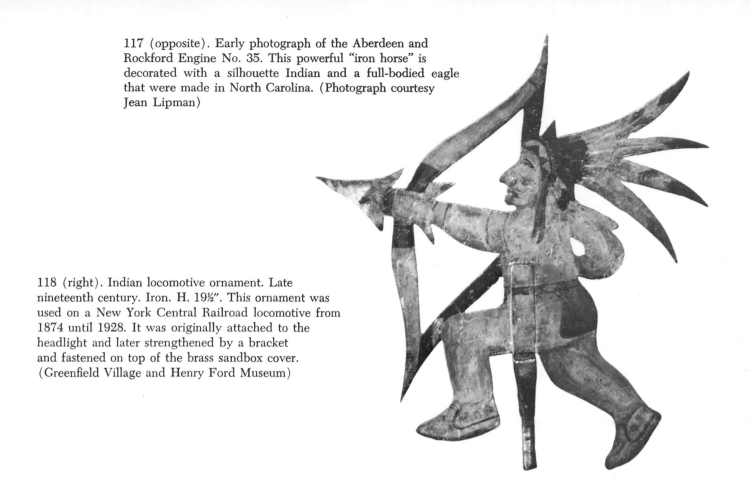

118 (right). Indian locomotive ornament. Late nineteenth century. Iron. H. 19½". This ornament was used on a New York Central Railroad locomotive from 1874 until 1928. It was originally attached to the headlight and later strengthened by a bracket and fastened on top of the brass sandbox cover. (Greenfield Village and Henry Ford Museum)

119 (below). Locomotive. Probably New England. 1850–1860. Iron, with original blue and red paint. H. 20". The windows in the cab of the "Peerless" reflect the Victorian Gothic taste, for they are in the form of pointed arches. (Dr. John B. Little)

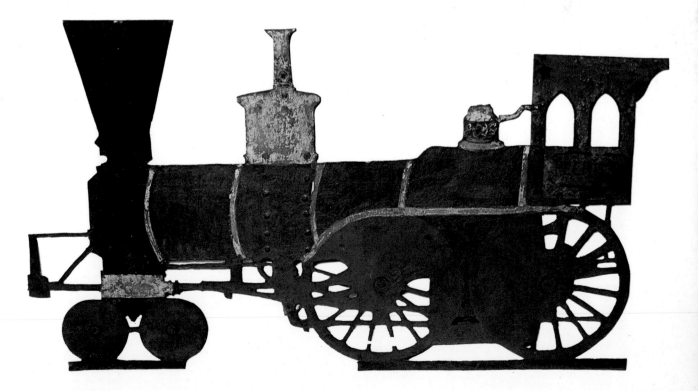

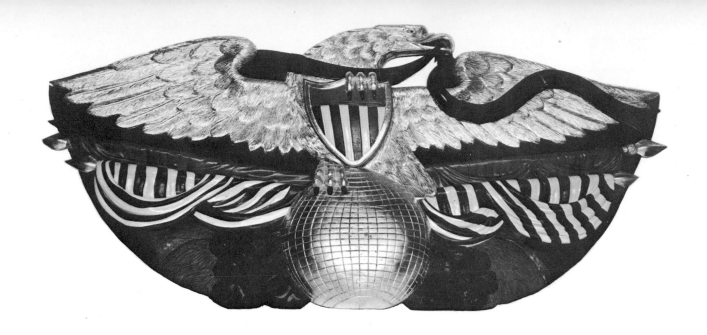

SHIPS AND FIGUREHEADS

Shipcarvings are nearly as old as the shipping industry itself. Through the seventeenth century and the first half of the eighteenth century, Colonial figureheads generally followed English animal prototypes and were in the form of "lyons" and other "beasts." By the 1760s, human figures symbolizing the vessel's name became popular.

Simeon Skillin, Sr. (1716–1778), and his sons, John (b. 1746) and Simeon, Jr. (b. 1757), were America's leading carvers during the last half of the eighteenth century. These versatile craftsmen could provide a large figurehead for a ship or a tiny jewel-like portrait bust for the pediment of a piece of furniture. Samuel Skillin, working first at Boston and later at Philadelphia, in 1765 billed James Wharton "for Carved Work Don for the Brigg *Morning Star,* To a Venus head 7 feet long at 12 Shillings for a foot £4.18.0." [8]

Throughout most of the nineteenth century wooden sailing vessels were constructed in burgeoning seaboard cities from Maine to South Carolina and were decorated with elaborate figureheads, sternboards, archboards, and other carved wooden embellishments. Figureheads were used at the front of the ship under the bowsprit where the sides converge, and they often possessed a symbolic meaning that frequently inspired a fanatic loyalty in the crew. These robust carvings relied upon contour and silhouette for their impact. Visually they were an extension of the bow, and their beauty can only be truly appreciated when seen soaring above vigorously lapping waters parted by a swiftly moving prow.

American figurehead carvers gained fame not only at home, but in the far-distant ports of Europe and Asia as well. They probably lived near the wharf section of the city where frequent mingling with shipowners and captains would bring them profitable commissions. Unemployment occasionally caused shipcarvers to turn elsewhere for a living. Many created ornate garden ornaments; some even fashioned three-dimensional signs, cigar store Indians, and circus wagons.

Shipcarvers, like all true folk artists, learned their craft through practical experience. Though essentially self-trained, many, including William Rush of Philadelphia, developed reputations that far exceeded those of most contemporary academic artists. Immediately after the Revolutionary War, Philadelphia rapidly emerged as the shipbuilding center of the infant nation. Rush's figurehead for the *Washington*—"a figure of General Washington as large as life . . . exhibiting a capital likeness . . . in full uniform as commander in chief, pointing with his finger at some distant object and holding a perspective glass grasped in his left hand" [9] caused a sensation in London where admirers saw in it "perfection manifest in all its parts and proportions." [10]

By the close of the nineteenth century, the use of iron and steel as shipbuilding materials made the installation of figureheads difficult. However, eagles still perched atop the pilothouses of many riverboats. In 1907 figureheads were ordered removed from all U.S. Navy ships, thus dealing a deathblow to this art form.

120 (above), 120a (opposite). Sternboard figure of an eagle from the whaling schooner *Walter Irving.* Massachusetts. 1849–1850. Wood, gilded, and polychromed. W. 68¼". (Mystic Seaport)

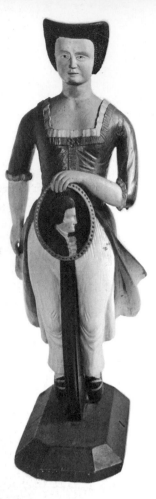

The Reverend William Bentley, a self-assured diarist and art critic, wrote, in 1802, of the Salem woodcarver Samuel McIntire, "As a Carver we place Mr. McIntire with [Simeon] Skillings of Boston. In some works he succeded well. He cuts smoother than Skillings but he has not his genius. In Architecture he excells any person in our country and in his executions as a Carpenter, or Cabinet Maker."[11]

Though McIntire executed carvings for the ship *Mount Vernon*, for the frigate *Essex*, for the brigantine *Pompey* in 1802, the ship *Asia* in 1803, and the ship *Derby* in 1806, his nautical woodcarvings were not totally successful. Even one of his most important and influential architectural patrons, the fabulously rich merchant prince, Elias Hasket Derby of Salem, sent to Boston to the Skillin shop for most of his shipcarvings as well as for his now famous "Tea House" or garden figures that were incorporated into a structure designed by McIntire.

McIntire owned "1 book drawings of ships" which was offered for sale upon his death in 1811. Several of his sketches for ship decorations survive.

121 (left). Figurehead. Attributed to Samuel McIntire. Salem. 1800–1805. Wood. H. 26″. This figurehead was acquired at an auction of McIntire's estate. (Peabody Museum of Salem)

122 (below). Sketch on reverse of "Model Diagrams, Designs for Eagle Figureheads and Archboards." Samuel McIntire. Salem. Ink, pencil, and crayon. 13″ × 8″. (Essex Institute)

123 (opposite). Figurehead. Isaac Fowle. Boston. C. 1820. Wood. H. 74″. "The Lady with the Scarf" was used as a shop sign by the carver. (The Bostonian Society)

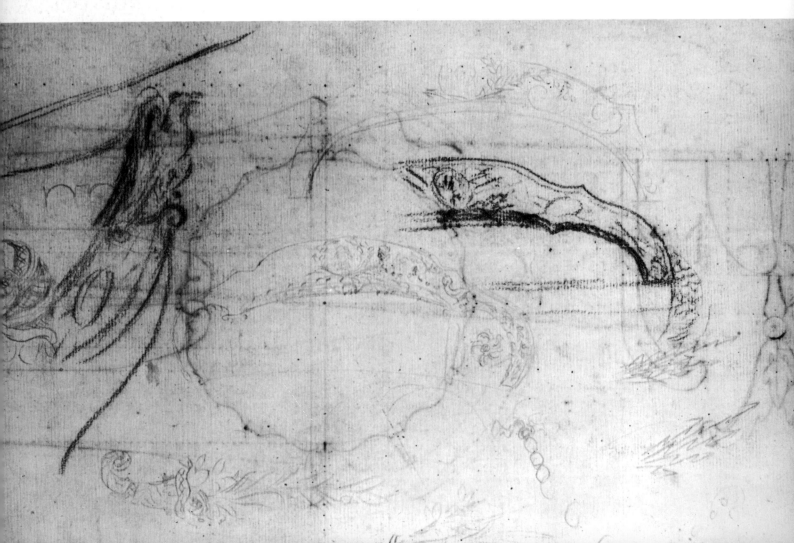

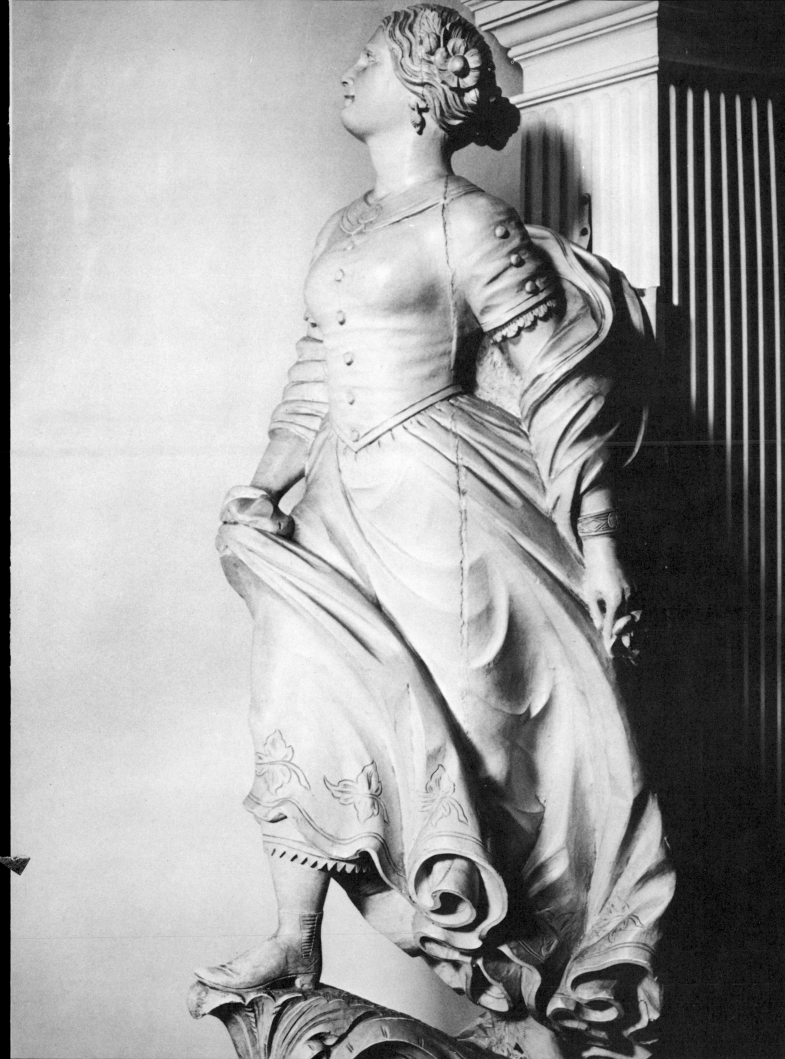

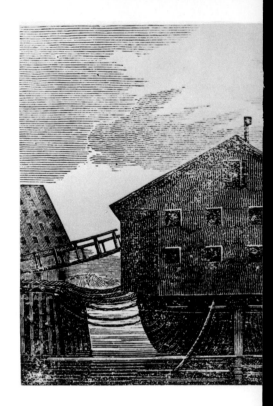

124 (above). Portrait bust. Nantucket, Massachusetts. 1838. Wood, polychromed. H. 14″. The scrimshaw plaque on the base is inscribed, "M. Starbuck Nantucket 1838." (Stewart E. Gregory)

125 (right). Benjamin Franklin figurehead bust. William Rush (1756–1833). Philadelphia. 1815. Wood. H. 55″. This figurehead was originally carved for the U.S.S. *Franklin*, a seventy-four-gun ship of the line, built in Philadelphia. The *Franklin* was flagship of the Mediterranean Squadron between 1817 and 1820 and of the Pacific Station between 1821 and 1825. (U.S. Naval Academy Museum)

126 (center). View of the U.S.S. *Constitution*, built in 1797, showing her moored between the U.S.S. *Columbus* and the U.S.S. *Independence* at the Boston Navy Yard in June, 1834. The *Constitution* is wearing her famous Andrew Jackson figurehead. (United States Navy Department)

127 (opposite, right). Andrew Jackson figurehead. Laban S. Beecher. Boston Navy Yard. C. 1834. Wood. H. 118″. Beecher charged Commodore Jesse D. Elliott three hundred dollars to carve this figure of Jackson. (Index of American Design)

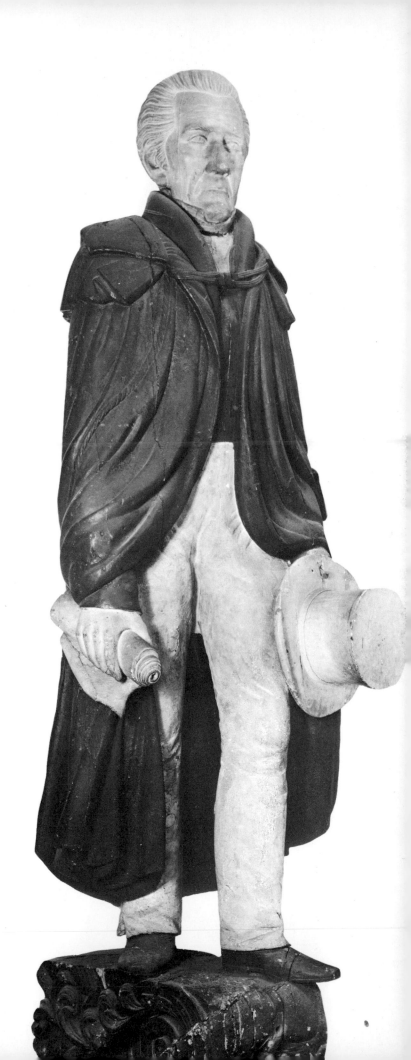

William Rush enjoyed a noteworthy reputation as a shipcarver even away from his native city, for the *New-York Gazette and General Advertiser* on May 23, 1799, carried the following item: "Mr. Daniel N. Train, a young gentleman of genius and abilities, late a pupil of Rush, the famous Carver of Philadelphia . . . has lately completed the ornaments of the Ship Adams, soon to be launched at the Walabought, Long Island." Apparently Train had learned well his master's predilection for patriotic symbols, for the article continued: "The following is a sketch of these ornaments. On the head of the ship is a figure of the President, represented in the attitude of addressing both Houses of Congress. In his left hand is a scroll, supposed to be his address—his right is raised in spirited position, as if in the act of bidding defiance to the enemies of America. At his side, is a branch of oak, springing from a rock, emblematic of his firmness and patriotic virtues, in support of the rights of his country." Also depicted were the "Arms of the United States, supported by Sybele and Neptune," the "Infant Navy," a "Key of the Earth," and a "Youth with Emblems of Agriculture."

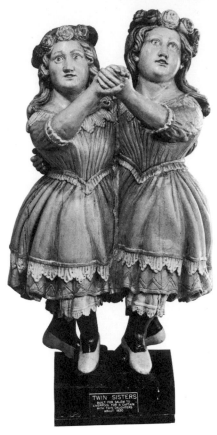

128 (below). Deck figure. C. 1858. Wood, polychromed. H. 68". This figure of Liberty was made to stand before the pilothouse of a Great Lakes steamer. Her right hand rests on a shield and a sheaf of wheat stands at her left side. (New York State Historical Association)

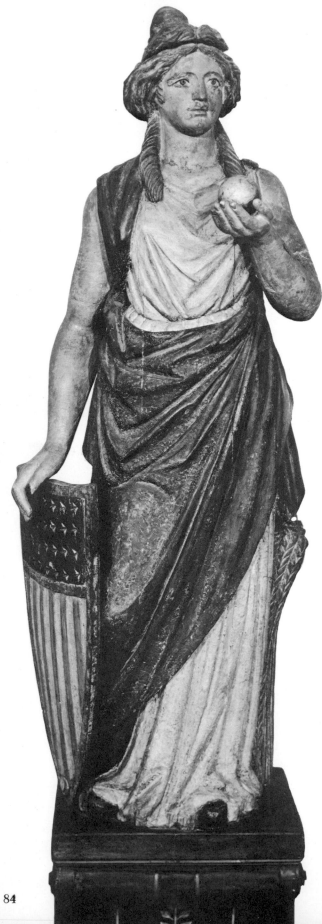

129 (above). Twin sisters figurehead. C. 1830. Wood. H. 36". This figurehead was built for a ship that sailed between Salem, Massachusetts, and Liverpool, England. The captain had been blessed with twin daughters. (Mystic Seaport)

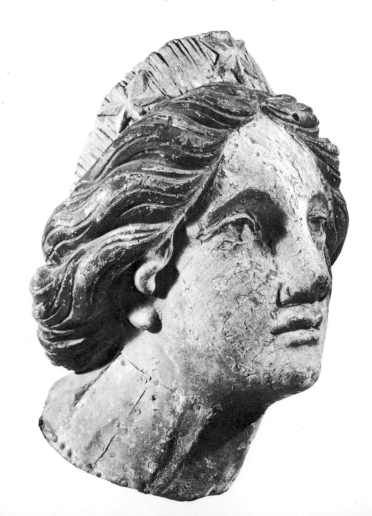

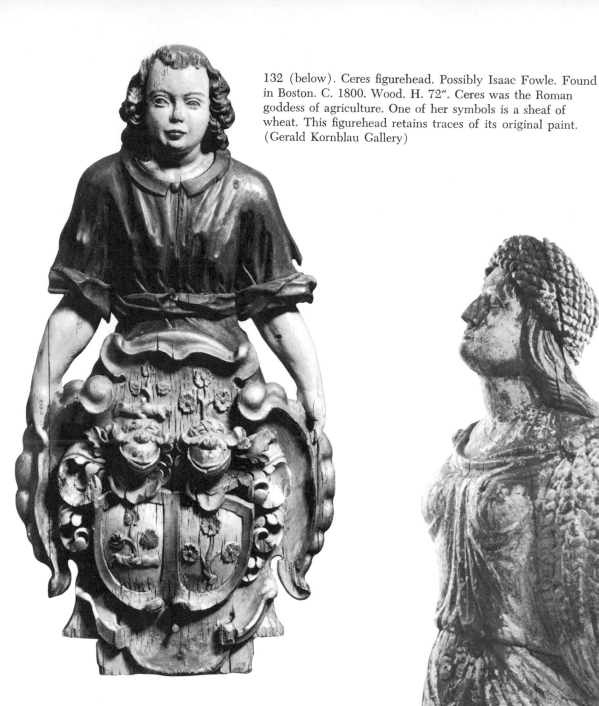

132 (below). Ceres figurehead. Possibly Isaac Fowle. Found in Boston. C. 1800. Wood. H. 72". Ceres was the Roman goddess of agriculture. One of her symbols is a sheaf of wheat. This figurehead retains traces of its original paint. (Gerald Kornblau Gallery)

130 (opposite, bottom). Liberty head. Attributed to the Skillin workshop. Boston. C. 1790. Wood, painted. H. 18". Though a star is usually represented with five points, the cap on this figure is decorated with a six-pointed variant. (Private collection; photograph courtesy Leah and John Gordon)

131 (above). Sternboard figure of a girl with shield. Salem. Eighteenth century. Wood, polychromed. H. 41". The sterns of two different ships have carried this carving. Originally it was on a frigate owned by the Derby family of Salem whose coat of arms is on the shield. Later, it graced the frigate *Angela* which burned at Mystic, Connecticut, in 1871. (Memorial Art Gallery of the University of Rochester)

134 (below). Deck figure. Charles J. Dodge. Mid-nineteenth century. Wood. H. 69″. This figure originally stood on the ship *Thomas Powell*, which was built in 1846. (Museum of the City of New York)

133 (above). Harvester figurehead. C. 1849. Wood. H. 78″. This unusual representation was used on the ship *Albany.* The scythe blade is made of metal. The figure was later mounted on an elaborately carved base. (Museum of the City of New York)

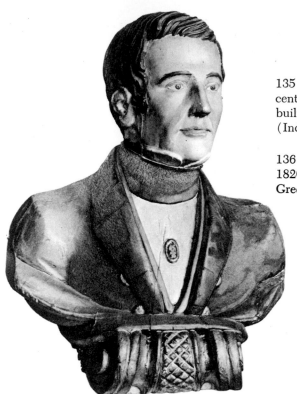

135 (left). Figurehead bust. Boston. Mid-nineteenth century. Wood. H. 30″. The ship, *Solomon Piper*, built in 1854, originally carried this figurehead. (Index of American Design)

136 (below, left). Portrait bust figurehead. 1815–1820. Wood. H. 35½″. (Dr. and Mrs. William Greenspon)

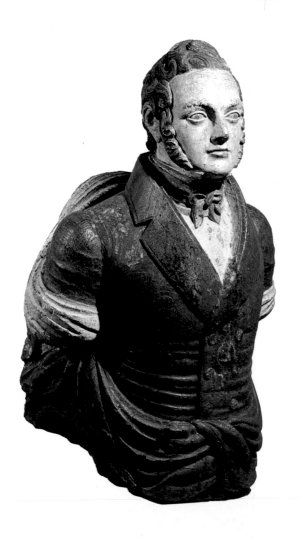

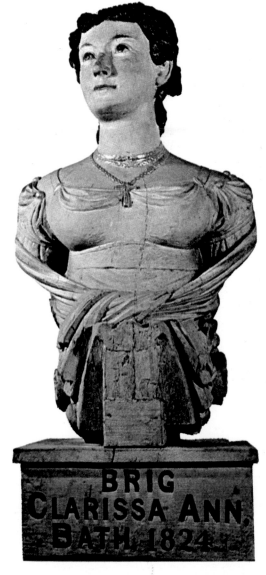

BRIG
CLARISSA ANN,
BATH 1824

137 (above). *Clarissa Ann* figurehead. Probably Maine. 1824. Wood. H. 30″. Levi Houghton, a merchant and shipbuilder, built and owned a brig that he named for his daughter, Clarissa Ann. His commercial activities were concentrated in the seaport town of Bath, Maine. (Bath Marine Museum)

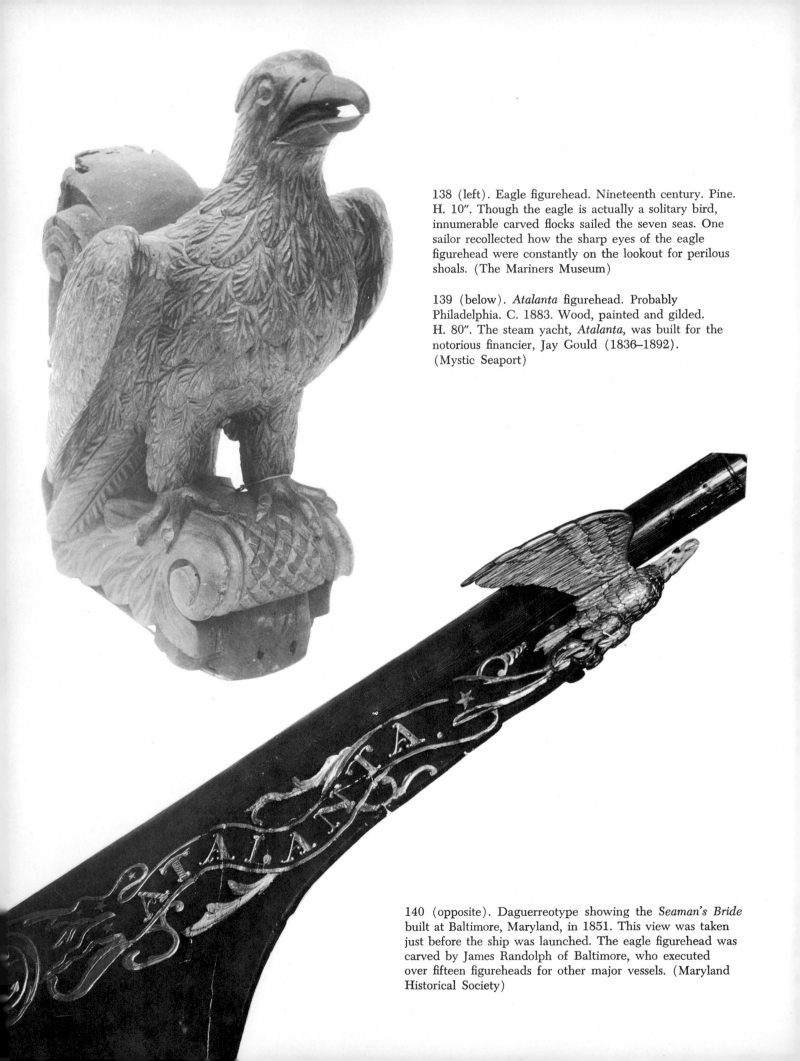

138 (left). Eagle figurehead. Nineteenth century. Pine. H. 10″. Though the eagle is actually a solitary bird, innumerable carved flocks sailed the seven seas. One sailor recollected how the sharp eyes of the eagle figurehead were constantly on the lookout for perilous shoals. (The Mariners Museum)

139 (below). *Atalanta* figurehead. Probably Philadelphia. C. 1883. Wood, painted and gilded. H. 80″. The steam yacht, *Atalanta,* was built for the notorious financier, Jay Gould (1836–1892). (Mystic Seaport)

140 (opposite). Daguerreotype showing the *Seaman's Bride* built at Baltimore, Maryland, in 1851. This view was taken just before the ship was launched. The eagle figurehead was carved by James Randolph of Baltimore, who executed over fifteen figureheads for other major vessels. (Maryland Historical Society)

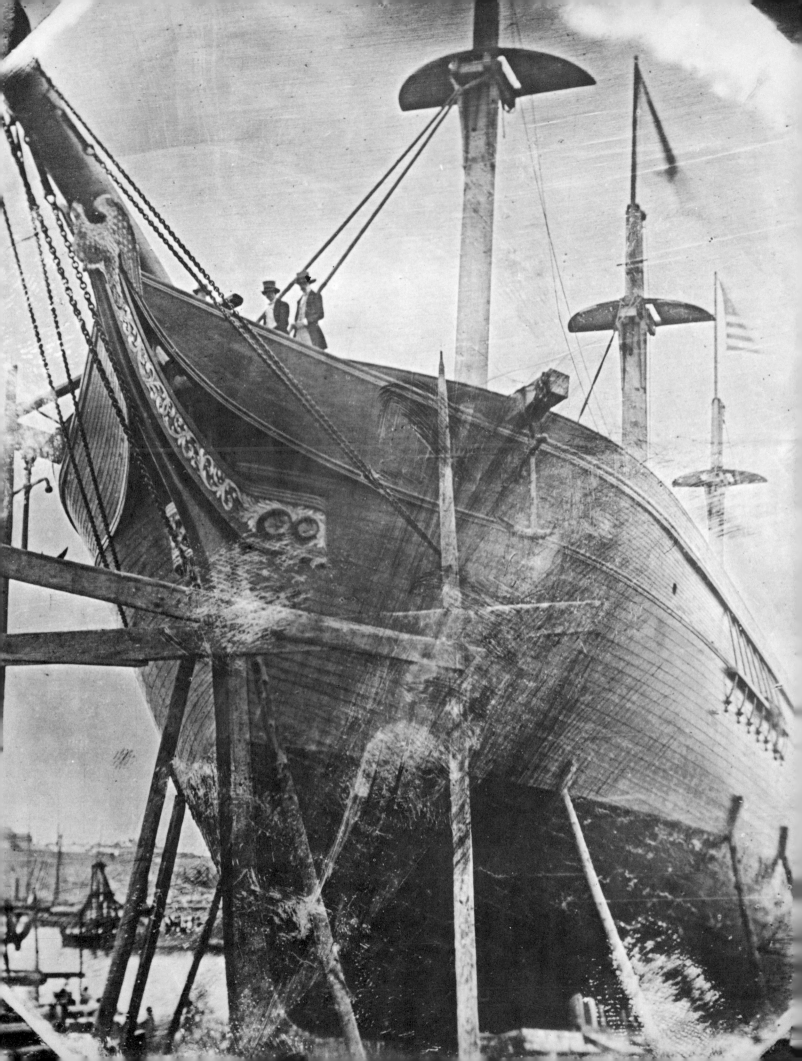

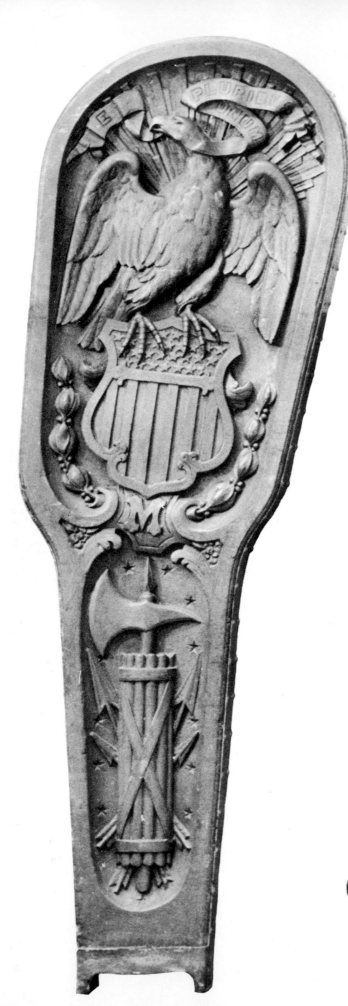

141 (left). Gangway board from U.S. Navy ship *Michigan*. Nineteenth century. Mahogany. H. 64″. Gangway boards are heavy pieces of hardwood with a carved design generally symbolizing the name of the vessel. When gangways through the high bulwarks of naval vessels and packet ships came into use, the end faces of the bulwarks were finished off with "gang way boards." The *Michigan,* a sidewheel steamer, was the first iron ship used in the United States Navy and was commissioned in 1844. She was constructed of plates made by hand at Pittsburgh in 1842. They were hauled to Erie where the vessel was completed. (The Mariners Museum)

142 (below). Turk figurehead. Salem(?). Nineteenth century. Wood. H. 26″. During the early nineteenth century, three Grand Turk vessels sailed out of Salem, the home port of many famous seafarers. (State Street Bank and Trust Company)

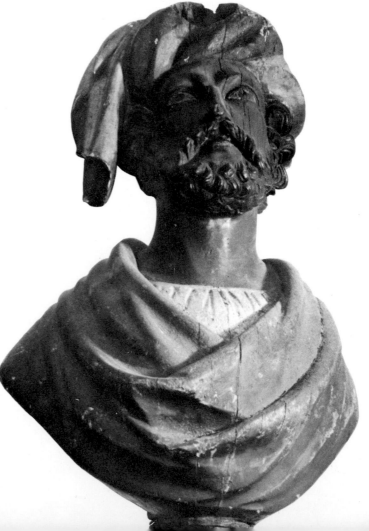

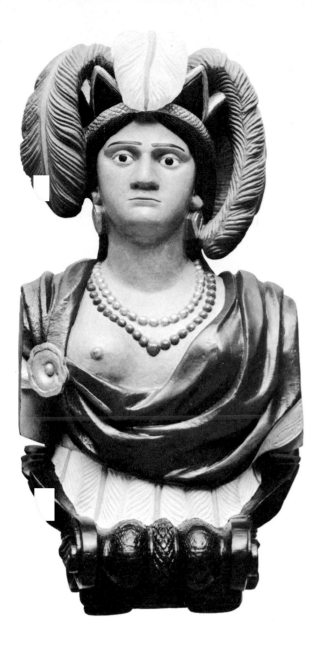

143 (left). Awashonks figurehead. Massachusetts. 1830. Wood, gold leafed and polychromed. H. 38″. Awashonks, chieftess of the Saconett Indians, was persuaded by Captain Benjamin Church to refrain from participating in King Philip's War in 1675, one of the worst Indian wars in New England's history. The figurehead was removed in 1865 and replaced by a billethead. (New Bedford Whaling Museum)

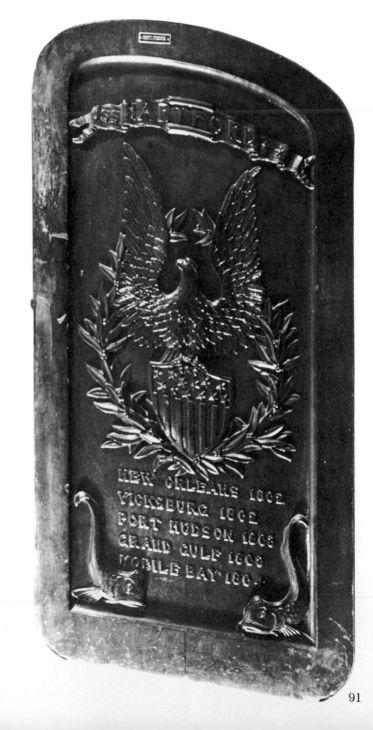

144 (right). Gangway board from U.S.S. *Hartford*. Probably Mare Island, California. 1894–1899. Wood. H. 53″. The *Hartford* was rebuilt in the Navy Yard at Mare Island, California, from 1894 to 1899 and sent to the U.S. Naval Academy for use as a training ship from 1900 to 1912. She was station ship at the Charleston, South Carolina, Navy Yard from 1912 to 1926. Her gangway boards were removed in 1926 for exhibit at the Sesquicentennial Exhibit at Philadelphia, and then transferred to the U.S. Naval Academy. (U.S. Naval Academy Museum)

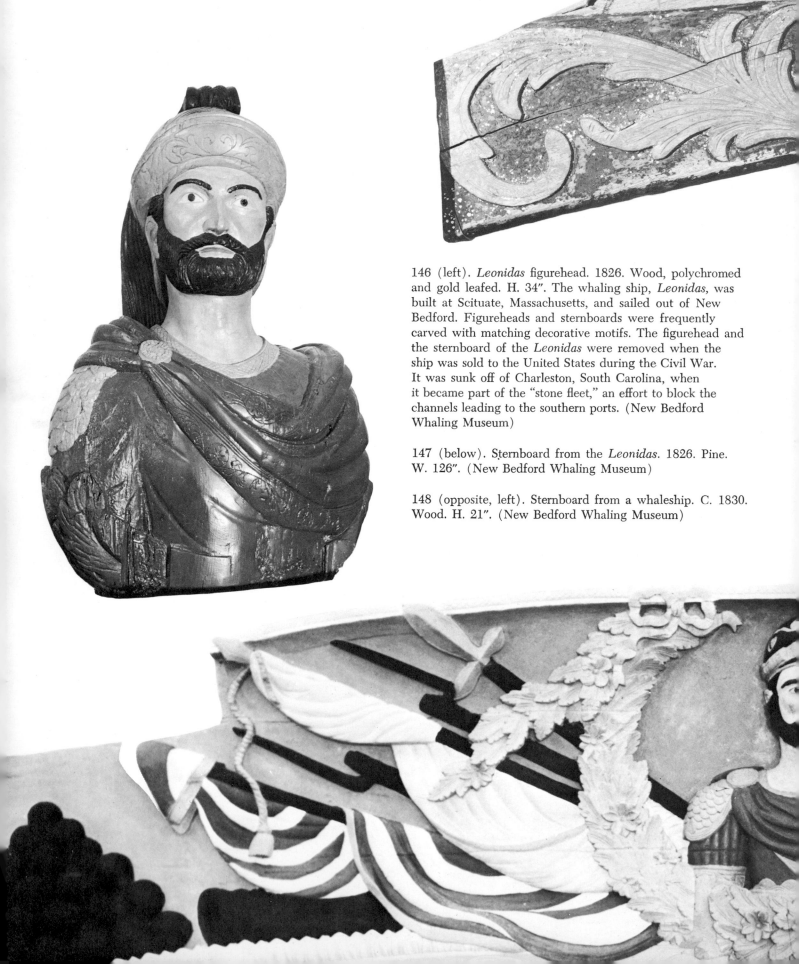

145 (right). Billethead. John Bellamy. Late nineteenth century. Oak, painted blue and yellow. H. 50″. (Barbara Johnson; photograph courtesy Gary C. Cole)

146 (left). *Leonidas* figurehead. 1826. Wood, polychromed and gold leafed. H. 34″. The whaling ship, *Leonidas*, was built at Scituate, Massachusetts, and sailed out of New Bedford. Figureheads and sternboards were frequently carved with matching decorative motifs. The figurehead and the sternboard of the *Leonidas* were removed when the ship was sold to the United States during the Civil War. It was sunk off of Charleston, South Carolina, when it became part of the "stone fleet," an effort to block the channels leading to the southern ports. (New Bedford Whaling Museum)

147 (below). Sternboard from the *Leonidas*. 1826. Pine. W. 126″. (New Bedford Whaling Museum)

148 (opposite, left). Sternboard from a whaleship. C. 1830. Wood. H. 21″. (New Bedford Whaling Museum)

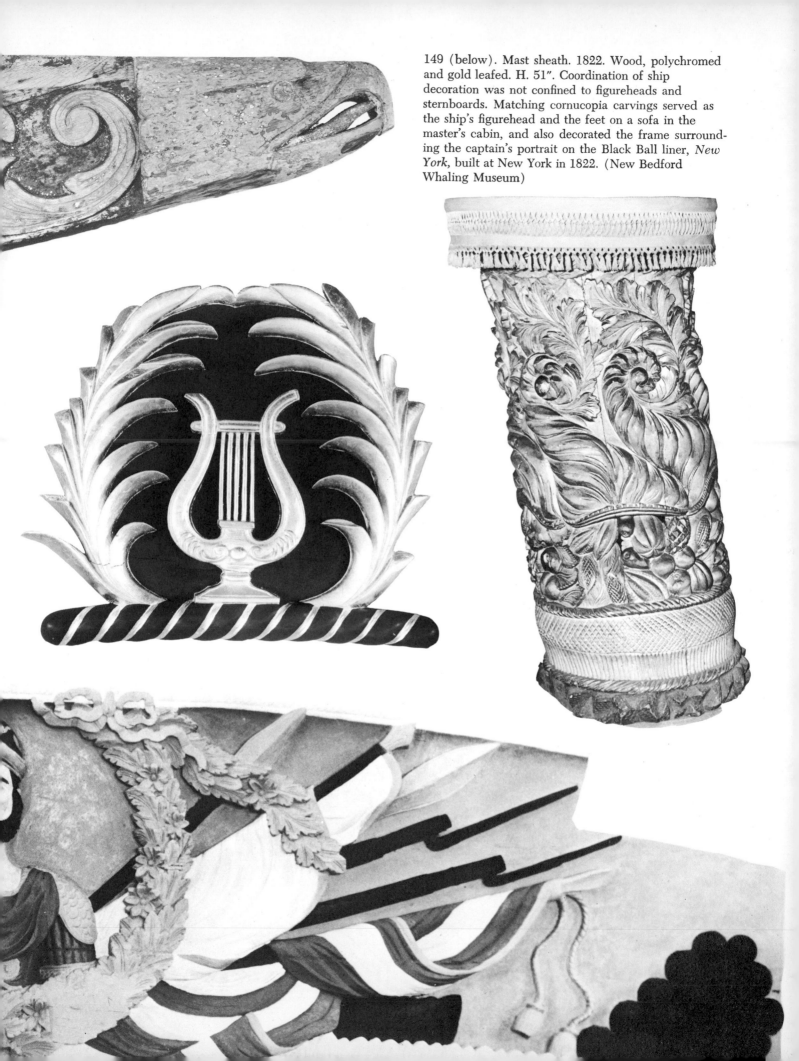

149 (below). Mast sheath. 1822. Wood, polychromed and gold leafed. H. 51″. Coordination of ship decoration was not confined to figureheads and sternboards. Matching cornucopia carvings served as the ship's figurehead and the feet on a sofa in the master's cabin, and also decorated the frame surrounding the captain's portrait on the Black Ball liner, *New York*, built at New York in 1822. (New Bedford Whaling Museum)

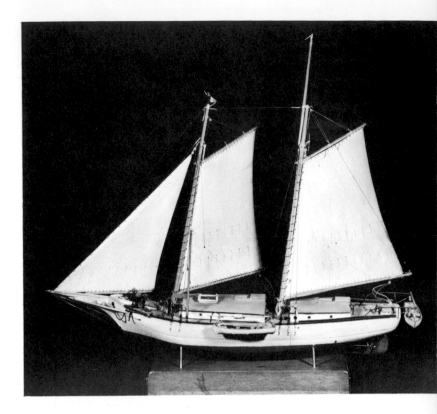

150 (above), 150a (left). Model of sailing vessel, *Lottie L. Thomas*. The model of this two-masted bugeye schooner of the Chesapeake Bay type appears to have been built after the *Thomas* was converted to a yacht, since it has a deckhouse and davits amidships and a propeller for an engine, which would not have been part of the original equipment. L. 29″. (Private collection)

151 (opposite, left). Photograph of the sailing vessel, *Lottie L. Thomas,* which was built in 1883 by J. W. Brooks at Madison, Maryland. This 65½-foot vessel was unusual in that it had a square stern and yet was schooner-rigged. Captain Edwin Gibson owned and sailed the *Thomas* from just after the turn of the century until the time of World War I, when he sold her to Captain Matt Bailey. By 1932 she had passed into the hands of Edward G. Jay of Mansfield, Massachusetts, who was then Commodore of the Boston Yacht Club. The mast of the *Lottie L. Thomas* was topped by an unusual figure (figure 152) believed to have been carved by a West Indian black named Cook who worked at Wareham's on the Delahay in St. Britton's Bay, St. Mary's County, Maryland. (Private collection)

152 (opposite, right). Mast figure from the vessel *Lottie L. Thomas*. Wood, painted. H. 18½″. A miniature version of this figure can be seen on top of the mast of the model ship, figure 150a. (Private collection)

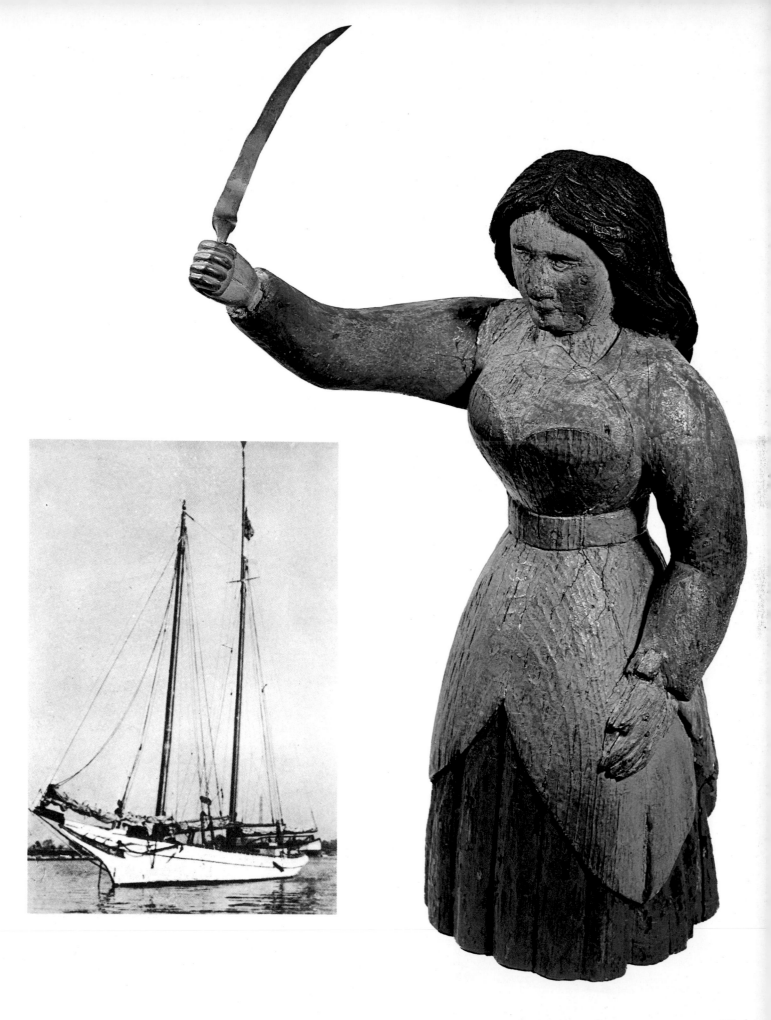

153 (below). Sternboard. Rhode Island. 1845. Wood, polychromed. W. 78". The *Eunice H. Adams* was a whaling brig built at Bristol, Rhode Island, that sailed out of New Bedford, Massachusetts. The realistic carving on her sternboard contrasts with the stylized work found on other ships. (New Bedford Whaling Museum)

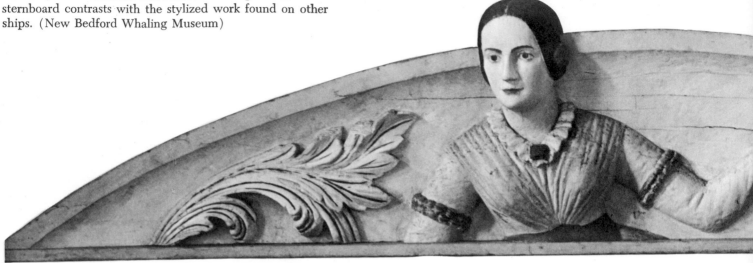

154 (left). Lunette-shaped housing from the steamboat *Neptune*. Last half of the nineteenth century. Wood. H. 40". Nearly every class of ship during the last half of the nineteenth century was decorated with some form of carving. (Smithsonian Institution, Van Alstyne Collection)

155 (below). Sternboard carving from the ship *American Indian*. North River, Plymouth County, Massachusetts. C. 1785. Wood, polychromed. W. 117½". (Photograph courtesy Jean Lipman)

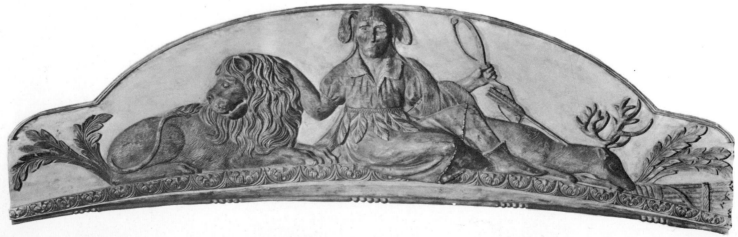

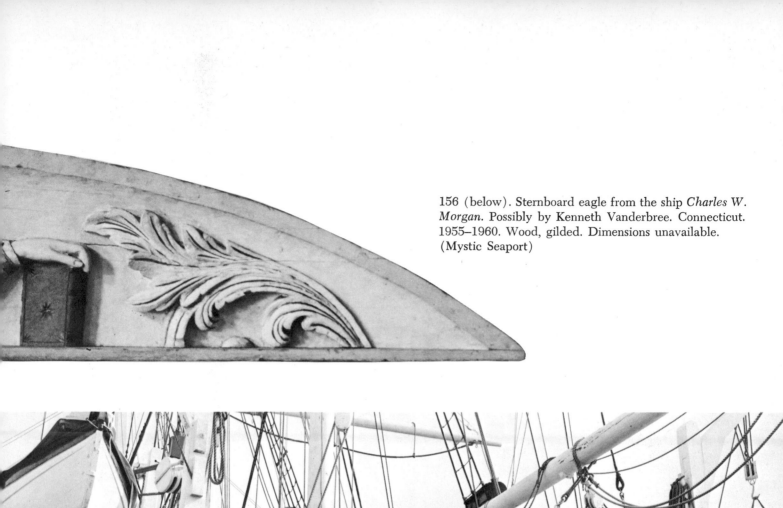

156 (below). Sternboard eagle from the ship *Charles W. Morgan*. Possibly by Kenneth Vanderbree. Connecticut. 1955–1960. Wood, gilded. Dimensions unavailable. (Mystic Seaport)

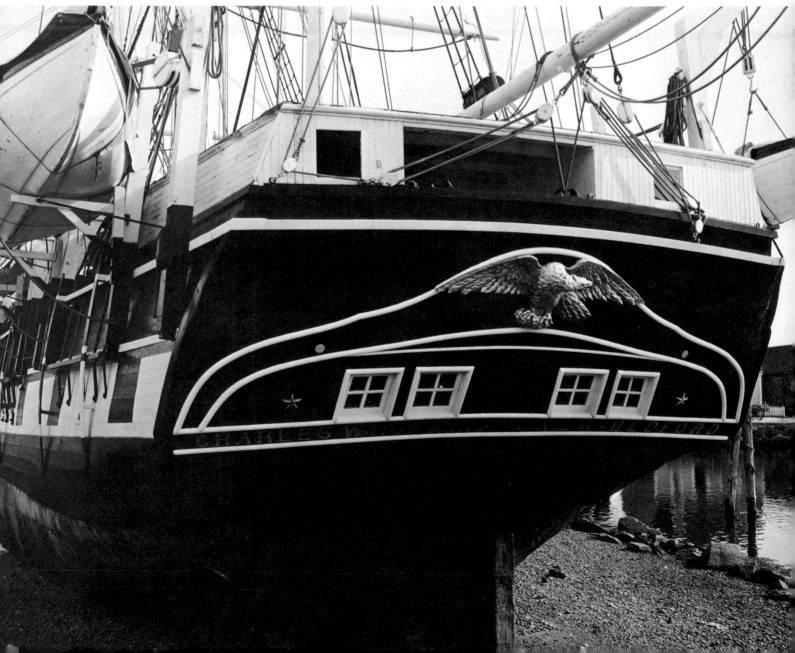

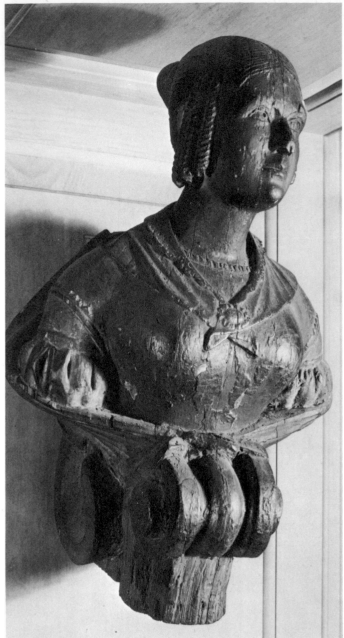

157 (left). Figurehead. Nineteenth century. Wood.
H. 67". A late coat of white paint has been removed,
revealing the original pale green, red, and black
colors. (The Detroit Institute of Arts)

158 (above). Figurehead from the whaler *Sally*. Late
eighteenth century. Wood. H. 25". The *Sally*, which
made its first whaling trip in 1788, hailed from
Nantucket. This is one of the oldest surviving carvings
from an American whaling ship. (State Street Bank
and Trust Company)

159 (opposite). William W. Geggie carving one of a
pair of sea horses for the foyer of The Mariners Museum
at Newport News, Virginia. 1957. (The Mariners
Museum)

William W. Geggie was born in Scotland in 1880, where he studied ornamental design at the Glasgow Technical College and Glasgow School of Art. This five-year course included formal college and apprenticeship work in woodcarving under the guidance of a noted figurehead carver.

In 1903 he immigrated to America, where he worked for a time at Boston and Chicago, finally settling at Newport News, Virginia, in 1907. Geggie was employed by the Newport News Shipbuilding and Dry Dock Company as a woodcarver to embellish ships and provide interior decorations for steamers.

While at the Virginia shipyard, Geggie carved two figureheads—one of them for the Italian bark *Doris,* which put in for repairs during World War I. The captain, a superstitious man, would not set sail until a figure-head was carved to replace the one lost in a collision just off the coast. Within seven days Geggie had completed the figure of a woman, which was then painted and secured to the ship's stem. He also carved a figure-head for the large steam yacht *Viking* built at the Newport News shipyard in 1929. This three-quarter-length figure was completed in about five weeks.

When the officers of The Mariners Museum decided that they needed foyer ornaments, they went to Geggie, who worked forty hours a week for four months to complete his pair of rampant sea horses, figure 159, which he symbolically associated with the motive power of Neptune's chariot. Geggie refused to use sandpaper on his carvings. Chisel and gouge marks attest to the hand-craftsmanship that has almost completely disappeared from American seaports.

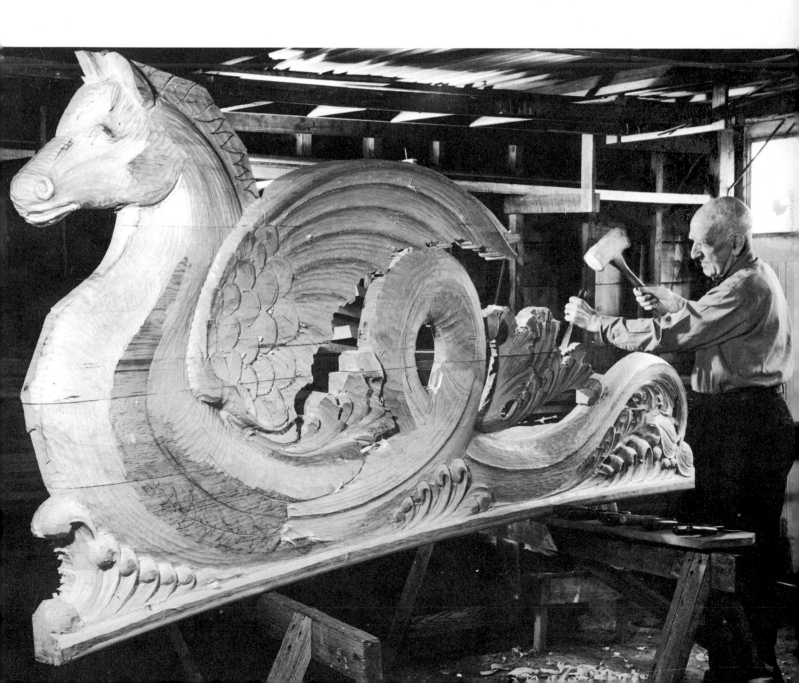

160 (below), 160a (right). Sea chest and detail. Maine. 1840–1850. Pine. W. 41½″. The name "Rufus Russell" appears in pencil on the underside of the lid on this chest, which is carved in bas-relief. Construction details include butt hinges and large dovetails. There is a small till on the interior right-hand end of the piece. Like many chests intended for sea use, it is slightly splayed out at the bottom and fitted with rope beckets, or handles. (Mr. and Mrs. Gary J. Stass)

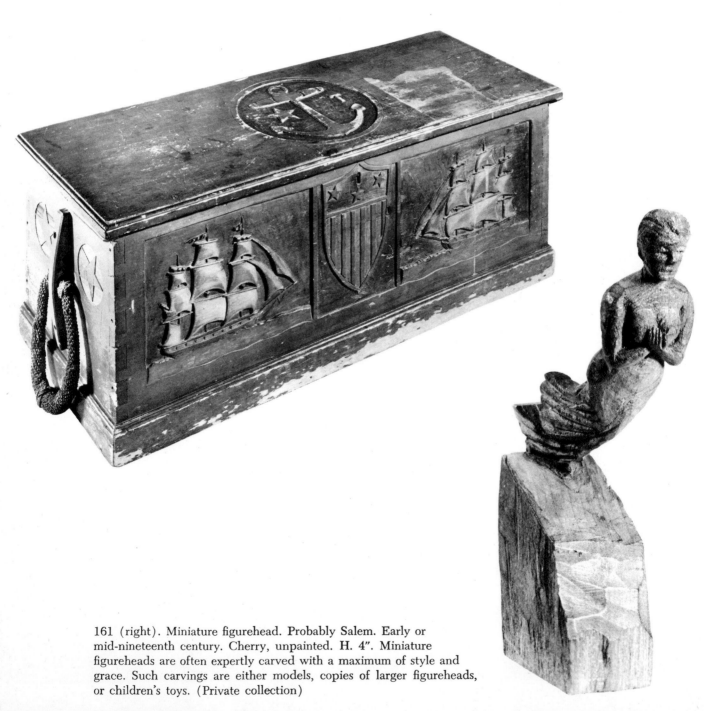

161 (right). Miniature figurehead. Probably Salem. Early or mid-nineteenth century. Cherry, unpainted. H. 4″. Miniature figureheads are often expertly carved with a maximum of style and grace. Such carvings are either models, copies of larger figureheads, or children's toys. (Private collection)

100

162 (right). Model for a figurehead. New England. C. 1835. Wood. H. 9½″. (Mr. and Mrs. Harvey Kahn)

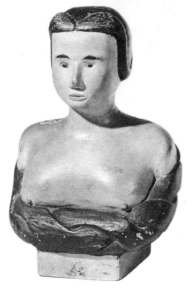

163 (right). Miniature figurehead. Probably Salem. Early or mid-nineteenth century. Cherry, unpainted. H. 5″ to tip of trumpet. This miniature was found in an old Salem house. (Private collection)

164 (below). S.S. *May-Flower*. Cape Cod, Massachusetts. C. 1920. Wood, painted. H. 14½″. Quite possibly this represents one of the ferries that traveled between Cape Cod and the outlying islands. (Herbert W. Hemphill, Jr.)

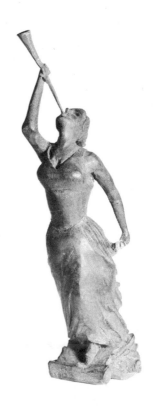

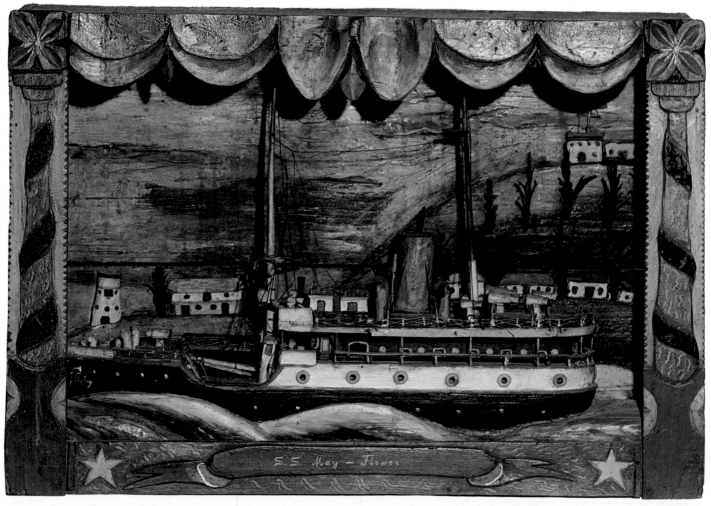

S.S. May-Flower

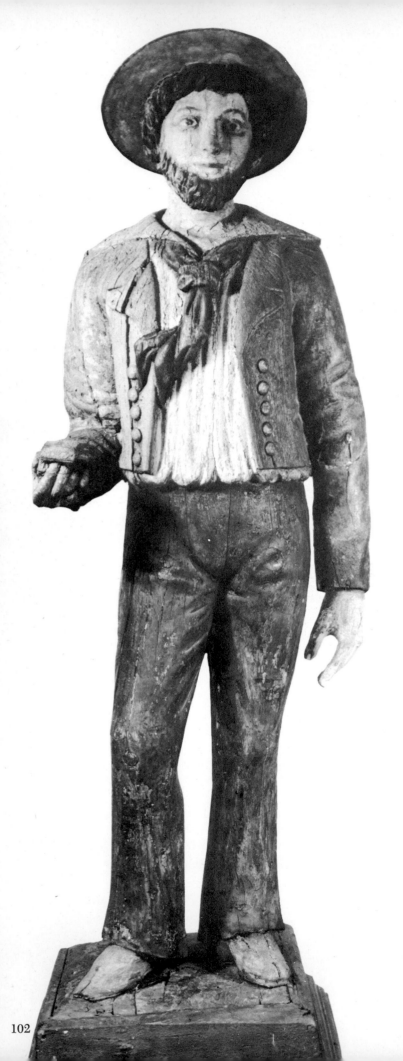

165 (left). Cigar store sailor. T. V. Brooks or Anderson. New York. C. 1860. Wood. H. 75″. This distinctive sailor figure greeted customers of the R. Chichester & Co., "Segar Dealer," 51 Bowery, New York City. Such pieces were probably intended to be multipurpose in that they could be used outside of both cigar stores or ship chandlers' shops. (The New-York Historical Society)

166 (above). Telescope shop sign. New England. C. 1875. Wood. L. 56¹⁵⁄₁₆″. This sign would be equally appropriate in front of a ship chandler's shop or that of a maker of scientific instruments. (Greenfield Village and Henry Ford Museum)

167 (opposite, left). Sailor boy with binnacle. Jacob Anderson. New York. 1875. Wood, polychromed. H. 56″. The binnacle, or nonmagnetic stand on which the ship's compass case is supported, holds an instrument made by T. S. Negus & Co., 140 Water Street, New York. This figure was originally made for the clipper ship, *N. B. Palmer.* (Museum of the City of New York)

168 (opposite, right). Ship chandler's shop sign. C. 1850. Pine, polychromed. H. 66″. Few carved shop signs have the fine sense of movement expressed by this figure. (Index of American Design)

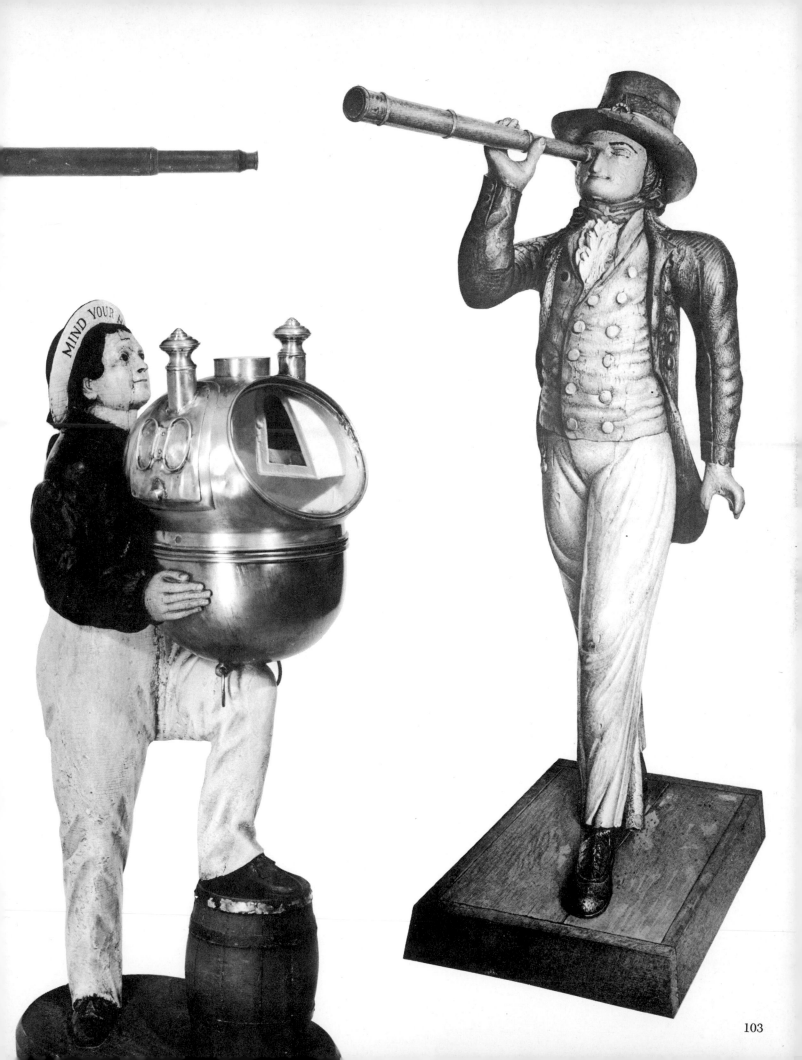

169 (opposite). Photograph of James Fales, Jr., in the doorway of his watch- and clockmaking shop at New Bedford, Massachusetts, c. 1870. "The Little Navigator," figure 170, is visible directly over Mr. Fales's head. (New Bedford Whaling Museum)

170 (right). The Little Navigator. Newport, Rhode Island. 1810–1820. Wood, polychromed. H. 25½". This famous shop sign was first installed over the door of James Fales, a maker of nautical instruments in Newport. Later it was taken to New Bedford, Massachusetts, where it advertised the wares of his son, James Fales, Jr., as seen in figure 169. (New Bedford Whaling Museum)

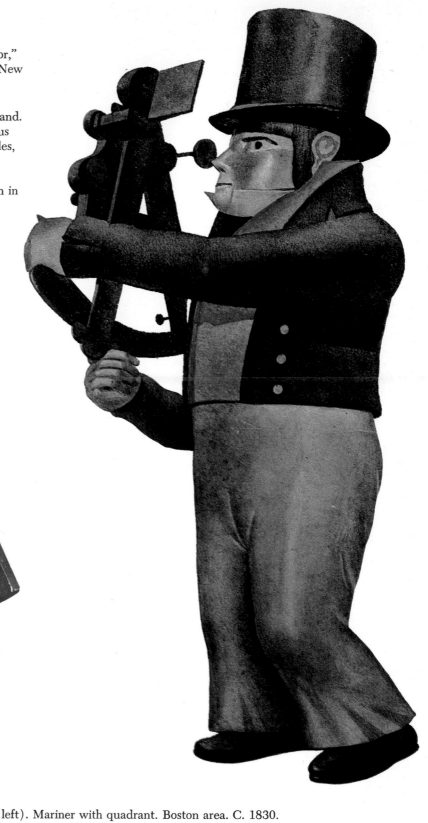

171 (left). Mariner with quadrant. Boston area. C. 1830. Wood, polychromed. H. 24". This carving was probably a trade sign for a maker of precision instruments. (New York State Historical Association)

172 (left). Half-nude woman. C. 1860. Whale ivory. H. 4¼". Three-dimensional scrimshaw sculptures of the human body are seldom found. This example, in its undulating curvaceousness, is quite baroque in style. (New Bedford Whaling Museum)

173 (below). Sperm whale tooth. Thought to be by William Perry. New Bedford, Massachusetts. C. 1930. L. 7½". The dramatic scene on this tooth was probably inspired by a nineteenth-century print. (Mystic Seaport)

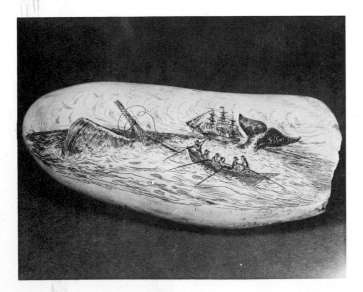

SCRIMSHAW

The American whaling industry began with the shore whaling activities of the earliest settlers and by 1846 had reached a peak when the American sailing fleet numbered some 740 ships.

Whaling expeditions frequently lasted up to four years and often proved fatal to the men. The tensions of physical danger, rigorous environment, and many idle hours were relieved by the sailors' pastime of creating scrimshaw objects.

The men aboard whaleships used the materials at hand that had little commercial value in their raw state. The lower jaw of a medium-sized sperm whale yielded approximately fifty teeth from four to ten inches long. White bone and panbone were also taken from the jawbone. White and bowhead whales were the source of black bone. Tradition maintains that an unwritten law gave the lower jaw of the sperm whale, with its teeth, to the crew. When the teeth were first removed from the jawbone, they were rough and ridged. The first step was to smooth the surface while the teeth were still soft, for they hardened with age. An entry in an early journal indicates that shark skins were probably used as sandpaper for smoothing rough teeth. While being worked on, teeth were occasionally soaked in brine to soften them. Polishing was achieved by the use of pumice or ashes. The final polish, however, came from the endless rubbing by seaworn hands.

The tools used for carving scrimshaw were of the simplest kind—jackknives, sail needles, files, and saws made from barrel hoops and many other improvised devices. Once a tooth was etched with a design, lampblack with a varnish fixative was rubbed over it and then wiped away, thus filling the design with pigment.

Though whale teeth, tusks, and related forms are not strictly three-dimensional sculpture, they are typically decorated with incised carving and have been included for that reason.

174 (left). The Proposal. C. 1830. Whale ivory and bone. W. 3½". This romantic scene probably originally included a tiny spinning wheel that fitted into the four holes in the base of the carving at the right. (New Bedford Whaling Museum)

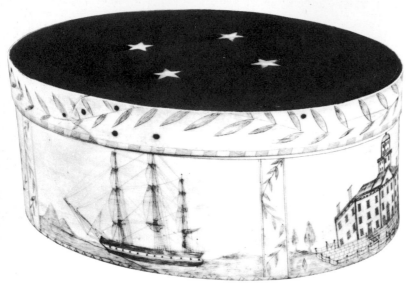

175 (left). Oval ditty box. Nineteenth century. Panbone and wood. 7¾" x 5⅞" x 3¼". Incised decorations on the side of this box include the United States flag, a harp, a ship, and a building. The top is inlaid with four bone stars. (Peabody Museum of Salem)

176 (below). Brooch. Nineteenth century. Ivory. W. 1¾". Note the elaborate way in which the maker of this brooch has pierced out the name "Rose." (Peabody Museum of Salem)

177 (below). Pie crimper in the form of a sea horse with the head of a unicorn. C. 1840. Whale ivory. L. 6". Pie crimpers in elaborate and often whimsical forms were made as homecoming gifts for sweethearts and wives. The crimpers were used to seal the edges of the pie crust to prevent bubbling juices from seeping out. (New Bedford Whaling Museum)

178 (above). Horse. C. 1850. Whale ivory. W. 4½". (New Bedford Whaling Museum)

179 (below, left). Whale tooth. J. Hayden. New York. 1861. H. 6⁷⁄₁₆". Nationalistic emblems are the subject of the expert decoration, including a portrait of George Washington, crossed American flags, and an eagle. (Museum of the City of New York)

180 (below, right). Whale tooth. Nineteenth century. H. 5⅝". The incised carving depicts an Indian with bow and arrow looking toward a harbor-bound ship. (Museum of the City of New York)

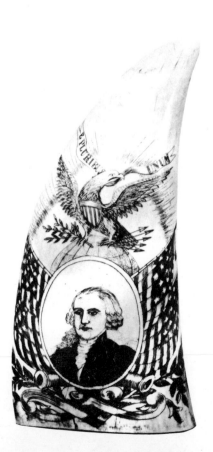

181 (above, right). Busk. Massachusetts. C. 1830. Whalebone. L. 10". At the rear of a sperm whale's jaw there is an area of bone nearly as smooth as ivory. This highly prized panbone was used for larger items of scrimshaw that could not be made from teeth. (New Bedford Whaling Museum)

Scrimshaw, the whalemen's art, provided a link for the sailor with his home. Nearly every piece was intended as a homecoming gift. The scrimshander (the scrimshaw-maker) produced articles that were both decorative and utilitarian. There is little doubt that the creation of these fancifully decorated pieces served a therapeutic purpose by providing a useful type of busyness during idle hours on board ship. As one salt indicated, "Nothing in sight and no signs of ever seeing any spirm whales around here the old man and the mate devote their time a Scrimshorning that is all they think about." [12] Another observed, "Nothing to do but make canes to support our dignity when we are home." [13]

182 (right). Noah's Ark. C. 1850. Whalebone. H. 9″. In this extraordinary creation the crank is used to move the animals up the gangplank and into the noble ark. (Robert Lang; photograph courtesy The Old Print Shop)

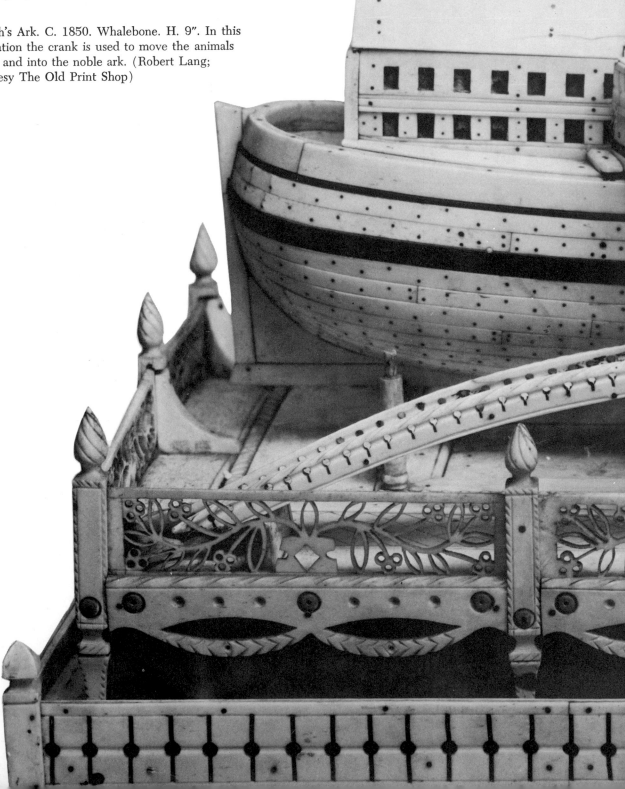

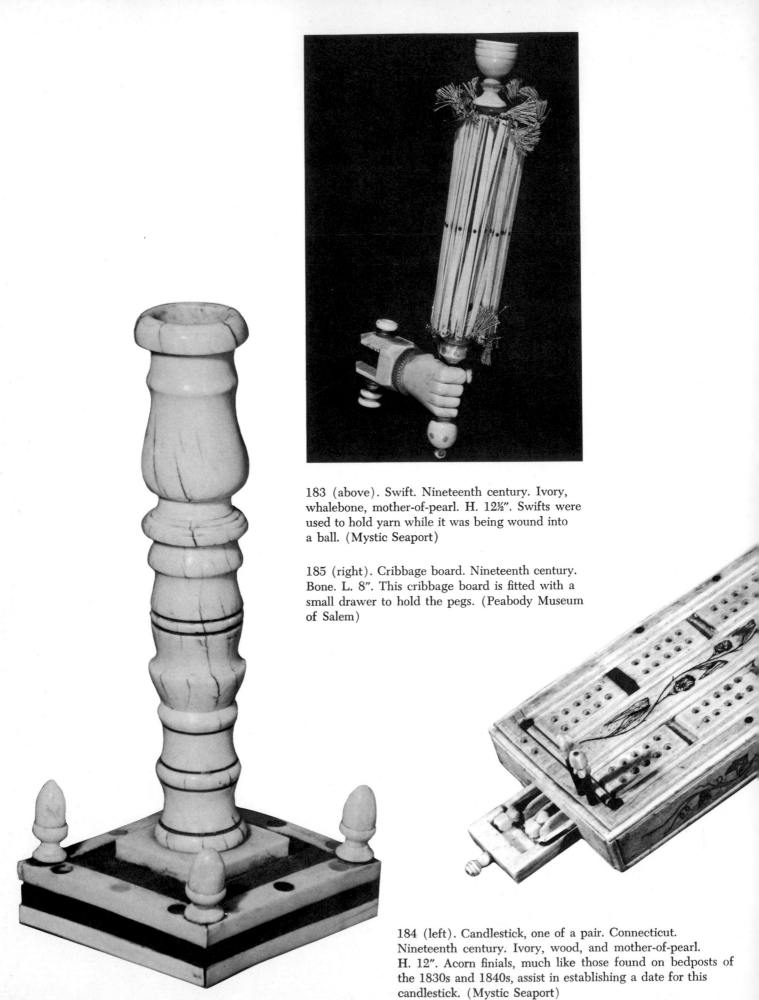

183 (above). Swift. Nineteenth century. Ivory, whalebone, mother-of-pearl. H. 12½". Swifts were used to hold yarn while it was being wound into a ball. (Mystic Seaport)

185 (right). Cribbage board. Nineteenth century. Bone. L. 8". This cribbage board is fitted with a small drawer to hold the pegs. (Peabody Museum of Salem)

184 (left). Candlestick, one of a pair. Connecticut. Nineteenth century. Ivory, wood, and mother-of-pearl. H. 12". Acorn finials, much like those found on bedposts of the 1830s and 1840s, assist in establishing a date for this candlestick. (Mystic Seaport)

186 (above). Assorted scrimshaw pieces. Nineteenth
century. Ivory, bone, various tropical hardwoods. Knitting
needles, clothespins, needle holders, and tatting shuttles
are included among this assortment of utilitarian
objects made by sailors for their women at home.
(Mystic Seaport)

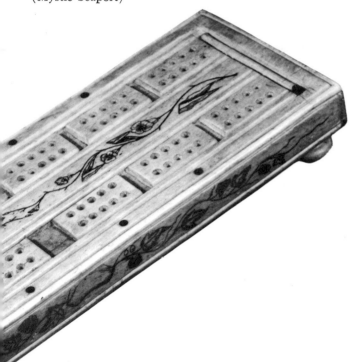

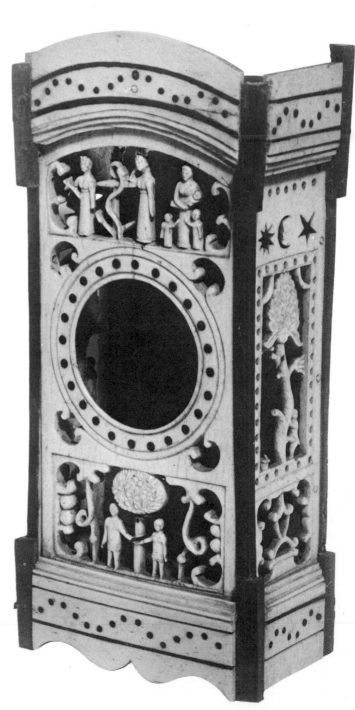

187 (right). Watchstand. Marked "Charles B. Toby, Cape
Horn, 1819." White and black whalebone. H. 8½". This
watchstand with filigree carving on the front and sides is one
of the earliest pieces of dated scrimshaw. The women and
children in the top vignette gather about the anchor,
the nineteenth-century symbol for hope. The lower vignette
shows Adam and Eve, the apple tree, and the black snake
of temptation. (The Mariners Museum)

188 (above). Sewing basket. Massachusetts. 1860. Whale ivory and bone. H. 9½″. The flat-cut, scrolled feet of this basket relate it to the pillar-and-scroll style of the 1850s. (Barbara Johnson)

189 (below). Parrot cage. Massachusetts. 1850. Whalebone. H. 29″. This is the only known example of a parrot cage made in scrimshaw; however, several birdcages exist. (Barbara Johnson)

190 (bottom). Pie crimper. William Williams. New Bedford, Massachusetts. 1920. Whale ivory. L. 8″. This masterful carving joins a goat-headed, finned, upper torso to a fish's body with spikelike feet. (Barbara Johnson)

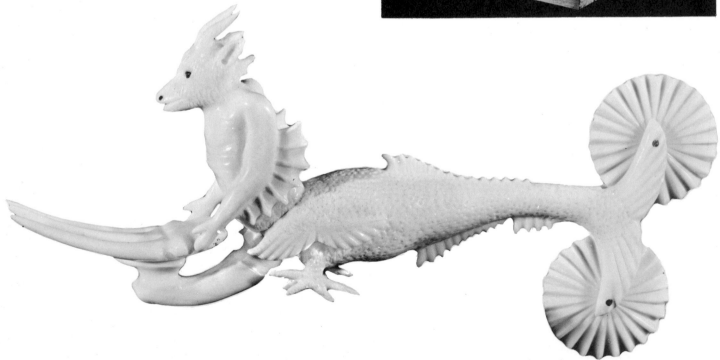

191 (below). Wall pocket. Nantucket, Massachusetts. 1870. Whale ivory and bone. H. 20½″. Wall pockets were popular during the late nineteenth century and were used for holding newspapers and magazines. It is a delightfully elaborate creation. (Barbara Johnson)

192 (left). George Washington. Attributed to Samuel McIntire. Salem. C. 1800. Pine panel, painted. 15¾" x 11". This plaque descended in the Hathaway family of Danielson, Connecticut. Many artists produced idealized likenesses of our national heroes. (Old Sturbridge Village)

194 (opposite, left). George Washington. Probably Pennsylvania. 1850–1870. Pine, gessoed and painted. H. 37½". Folk artists enjoyed re-creating the pageantry of the American Revolution. This piece shows Washington in full uniform. (Richard Benizio and Ernest Quick)

193 (right). George Washington. Major Barton. Illinois. Nineteenth century. Wood, leather, and metal, polychromed. H. 9½". George Washington, the squire of Mount Vernon, was truly a Renaissance man. An accomplished surveyor and a military leader, he was first and foremost a farmer. His diary for January 1, 1760, recorded: "Visited my Plantations and received an Instance of Mr. French's great Love of Money in disappointing me of some Pork because the price had risen to 22/6 [22 shillings, 6 pence] after he had engagd to let me have it at 20/.

"Calld at Mr. Posseys in my way home and desird him to engage me 100 Barl. of Corn upon the best terms he coud in Maryland.

"And found Mrs. Washington upon my arrival broke out with the Meazles." [14] (Leah and John Gordon)

FAMOUS AMERICANS

Political heroes and the symbolic figures of Liberty and Uncle Sam were popular subjects with folk artists during the nineteenth century.

When Paul Svinin, a Russian diplomat, visited the United States between 1811 and 1813, he observed: "It is noteworthy that every American considers it his sacred duty to have a likeness of Washington in his home, just as we have images of God's saints." [15] The "Washington fever" was not new, for as early as 1779 in the *Nord-Americanische Calendar*, published by Francis Bailey at Lancaster, Pennsylvania, George Washington had been called "Father of his country."

After the Statue of Liberty arrived in the United States in 1886 as a gift from France, her torch lighted New York Harbor and welcomed many European immigrants, many of whom settled on the Western frontier. Through their folk carvings they contributed substantially to America's heritage.

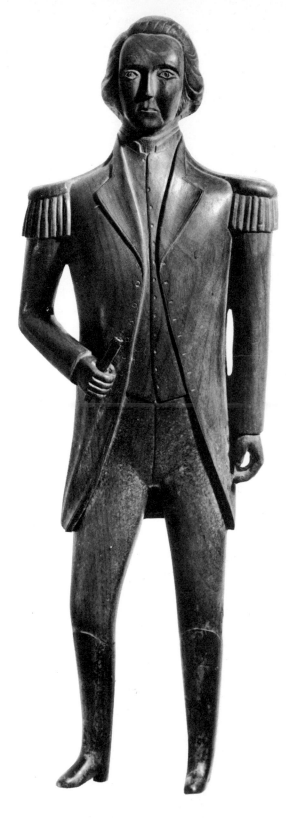

195 (above). George Washington. Pennsylvania. Early nineteenth century. Walnut. H. 24". This carving is said to have been found in the Washington Masonic Lodge at Adams, Pennsylvania. The carving is in the half-round, flattened on the back so that it can hang on a wall. The costume is highly stylized, thus creating a pleasing semiabstract pattern. (Benjamin Ginsburg)

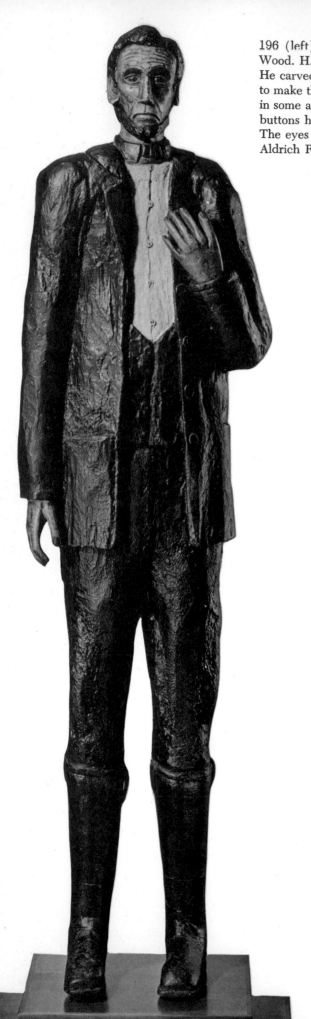

196 (left). Abraham Lincoln. William Norris. Illinois. 1938–1939. Wood. H. 71¼". The sculptor was born in Virginia, Illinois, in 1861. He carved this brooding figure from a single log, using a pocketknife to make the details. The almost life-size sculpture is painted, and in some areas the artist has used plaster to build up the form. Real buttons have been nailed onto the shirt and the coat and painted. The eyes are emphasized by the addition of shellac. (Abby Aldrich Rockefeller Folk Art Collection)

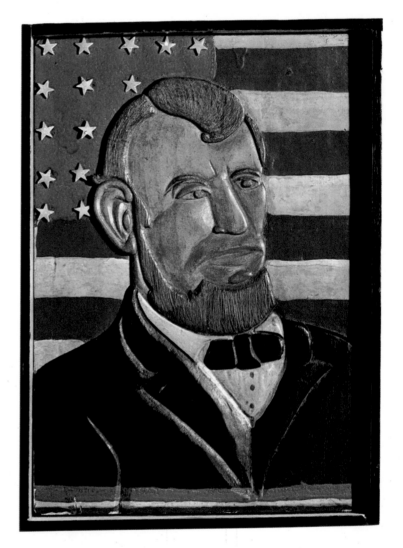

197 (above). Abraham Lincoln. Signed "Robert Kriner"(?). Pennsylvania. C. 1887. Wood. H. 10½". (Allan L. Daniel)

198 (opposite). William F. "Buffalo Bill" Cody. 1880–1890. Wood, painted. H. 23½". Buffalo Bill (1846–1917) was a famous American frontiersman and scout. He is also remembered for his fabulous Wild West shows in which he appeared with the incomparable Annie Oakley. (Heritage Plantation of Sandwich)

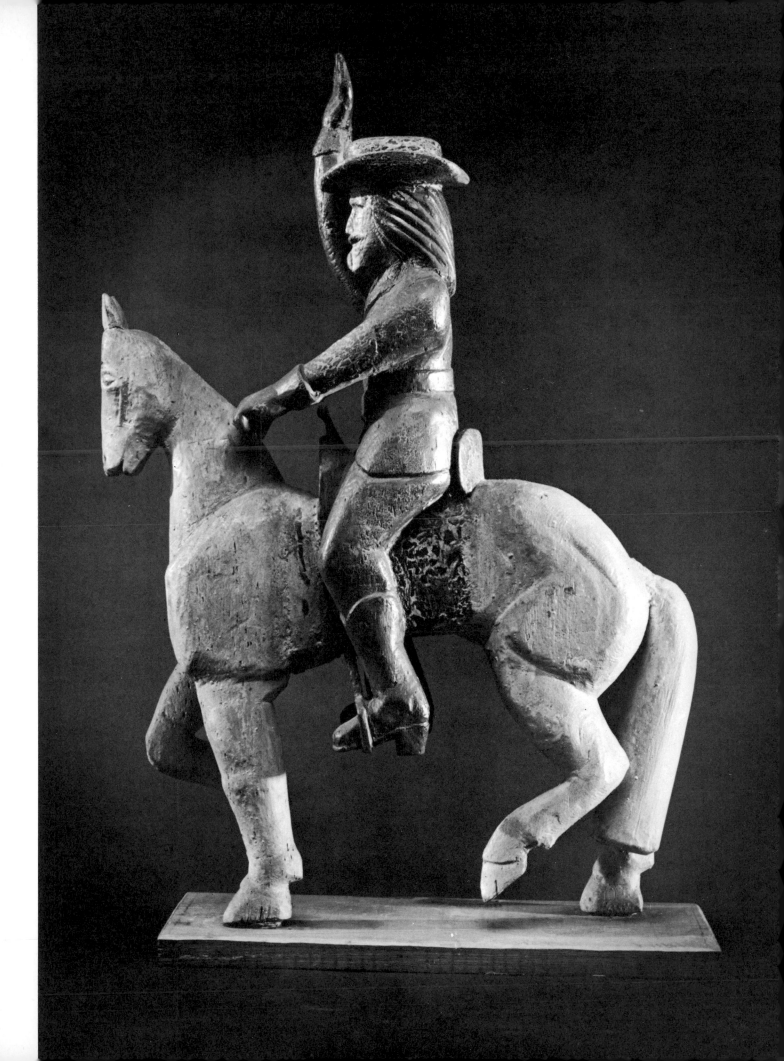

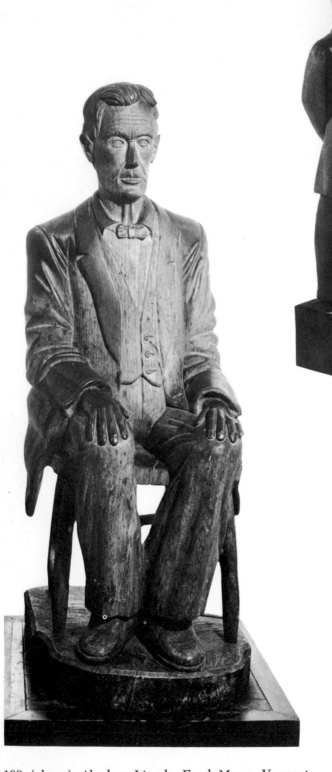

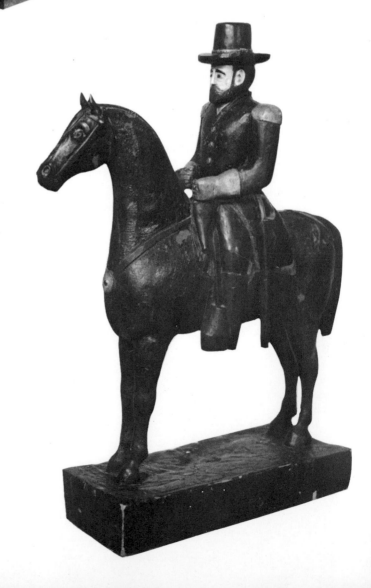

200 (left). Abraham Lincoln. Signed "Theodore Jeffries." Newark, Ohio. Early twentieth century. Pine. H. 13¾". Because of his martyrdom, Abraham Lincoln was perhaps even more popular than George Washington as a folk art subject. (Mr. and Mrs. James O. Keene)

201 (below). General Grant on horseback. Frank Pierson Richards (1852–1929). Illinois. 1880–1888. Wood, polychromed. H. 31". The artist was a farmer who carved patriotic and religious objects in his spare time. When he moved to Springfield, Illinois, Richards displayed his patriotic pieces on the front lawn of his house on the Fourth of July. Because they were borrowed for local parades, he drilled holes through their hands so that they might carry American flags. (Illinois State Museum)

199 (above). Abraham Lincoln. Frank Moran. Vermont. 1924. Pine. H. 54". The artist has managed to convey the sense of dignity and compassion associated with Lincoln, the first president of the United States to be assassinated. (New York State Historical Association)

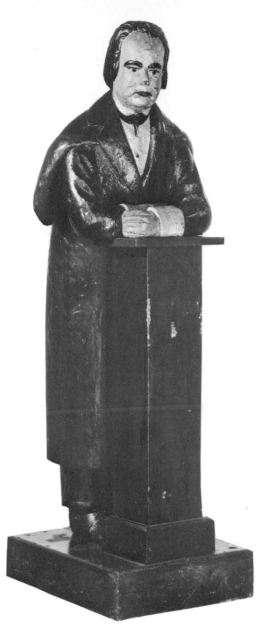

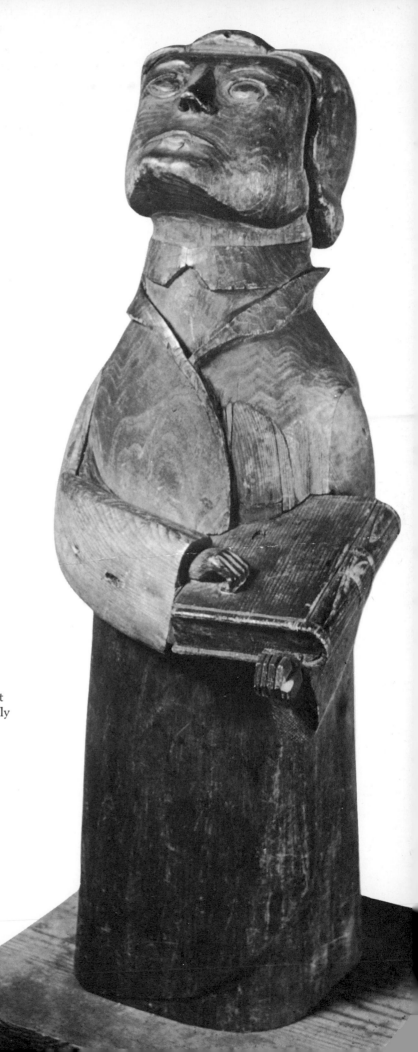

202 (above). Henry Ward Beecher. 1870–1890. Wood. H. 70″. Beecher, a noted clergyman, editor, and abolitionist leader, would undoubtedly have been more than moderately displeased at serving as a cigar store figure. Just visible under a later coat of paint on the base of this piece is the legend, "BEECHER CIGARS." (Greenfield Village and Henry Ford Museum)

203 (right). Henry Ward Beecher. Corbin. Centreville, Indiana. 1850–1860. Wood. H. 21″. This piece is believed to have been carved after Beecher visited Corbin's farm sometime between 1850 and 1860. It is one of the most widely known examples of American folk sculpture. (Abby Aldrich Rockefeller Folk Art Collection)

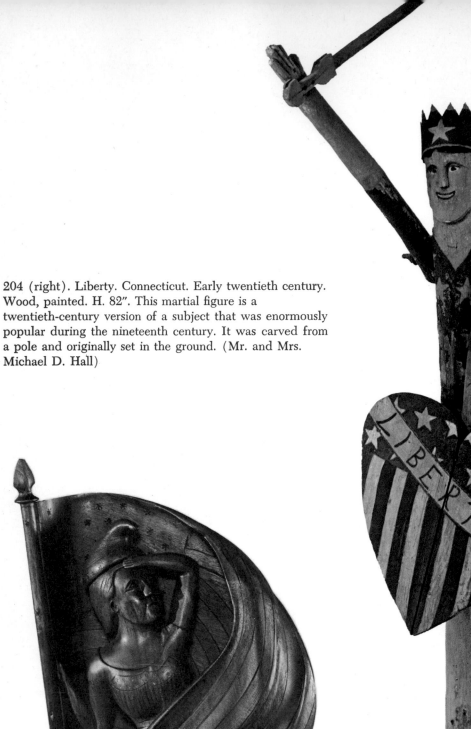

204 (right). Liberty. Connecticut. Early twentieth century. Wood, painted. H. 82″. This martial figure is a twentieth-century version of a subject that was enormously popular during the nineteenth century. It was carved from a pole and originally set in the ground. (Mr. and Mrs. Michael D. Hall)

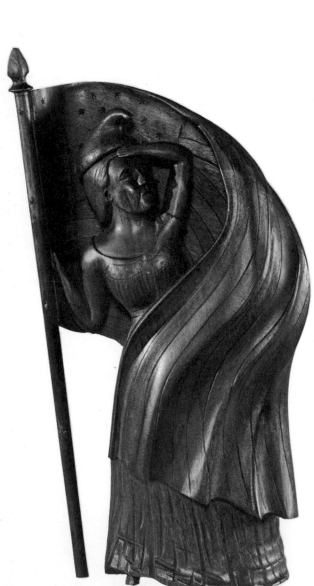

205 (left). Liberty. Late nineteenth century. Wood. H. 15″. This carving of Liberty and the flag was executed from one piece of wood. The bodice of the dress is in the form of an American shield, and a Liberty Cap is on her head. (Barbara Johnson)

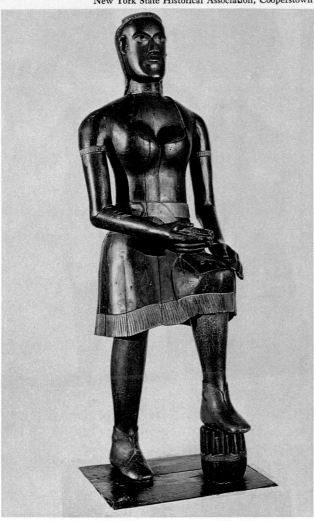

A slave named Job is said to have carved this cigar-store figure about 1825 for a New Jersey shop.

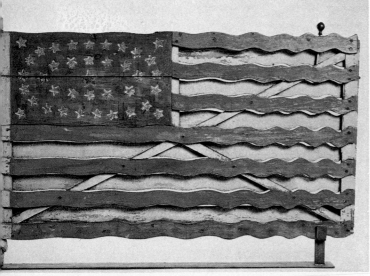

A patriotic pasture gate, probably from the 1870s, once decorated the Darling Farm in upstate New York.

and unschooled artists produced a rich body of art that possessed a visceral, ingenuous quality which modern sensibilities often find more appealing than the sometimes belabored, academic efforts of the period.

"Looking at these paintings is like eating olives," says Nina Fletcher Little, a Brookline, Massachusetts, collector. "At first you don't like their sharp taste. But after a while you catch their spell and special appeal."

What is folk art? A semantic battle has been simmering over a definition for the past 40 years and has peaked with this show. Essentially, the debate revolves around whether to lump the naive paintings and sculptures together with the useful objects and call them all folk art. The controversy has become so heated that one important collecting couple, Edgar William and Bernice Chrysler Garbisch, refused to lend to the show from their personal holdings (although many works that they have given to museums will be included).

"These watercolors, pastels and oil paintings are naive," says Edgar Garbisch, whose collection includes only pictorial works. "That's the only proper word for them. Look it up in Webster's. Everything else is folk art—the cigar-store Indians, the weathervanes, the needlework pictures. They belong to the crafts."

Basically, folk art is the art of the lower classes where the craft traditions have been passed on unchanged from generation to generation. But in America, a classless society, folk art refers to useful items made by and for all the people, including George Washington who had a dove weathervane made for Mount Vernon.

Nevertheless, it is a mistake to assume that any pot or shovel conceived by a country craftsman for a rural home is folk art. Only when the maker is so skilled that he can enhance his work with excellent design and endow it with artistic merit is the piece folk art. At that point, the everyday object transcends its purely practical function and becomes a work of art to be admired, cherished and preserved.

Unfortunately, the term folk art has come to be used to describe two distinct categories, and therein lies the confusion and conflict. The first area accurately relates to those objects which stem from the crafts and were made to serve some practical purpose. The other erroneously includes paintings and sculptures by largely untrained artists who are not part of the mainstream of the academic tradition. They remained, as one New York dealer describes them, nonacademic, following throughout their lives a personal style that is today prized for its spontaneity, incisiveness and innocence. "Folk art and American naive painting may share an area of overlap, but it is negligible in comparison with the extremity of the difference between

Leah Gordon, of Time, *has also written on art for the* New York Times *and* New York *magazine.*

By Leah Gordon

Unschooled artists, deft craftsmen in a dazzling show

The diversity and originality of American folk art is celebrated in serious and gay exhibition at New York's Whitney Museum

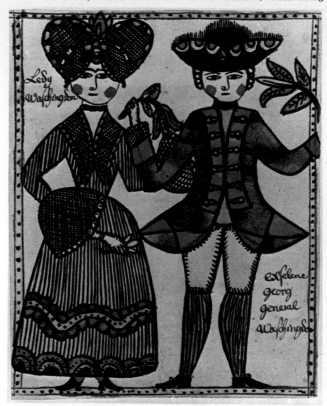

Only the oddly spelled names identify this picture of George and Martha by a contemporary Pennsylvanian.

"Aristocracies produce a few great paintings; democracies a multitude of little ones," remarked Alexis de Tocqueville, that 19th-century French historian who had something to say about nearly everything in American life. And if, today, Tocqueville were to visit the Whitney Museum of American Art in New York, he would see the works that he considered minor hailed as probably the most characteristic art expression of our nation. For there are more than 200 examples in the exhibition billed as "The Flowering of American Folk Art 1776-1876"—paintings, sculptures and useful objects produced by native craftsmen and nonacademic artists in the years between the Revolution and the nation's centennial.

In a sense, the Whitney's show can be considered both a culmination and a beginning. It is a tour de force of folk art, bringing to light many works which have never been seen before. And it is among the first of dozens of exhibitions around the country that will explore our national artistic heritage as we approach the Bicentennial year.

From the Whitney, where the show is on view from February 1 through March 24, the works will travel to the Virginia Museum of Fine Arts in Richmond (April 22-June 2) and the M.H. De Young Memorial Museum in San Francisco (June 24-September 15).

Selected from more than 10,000 pieces, the 200 items are intended to represent the cream of America's folk-art production, including pottery, weathervanes, ships' figureheads, toys, scrimshaw, quilts and gravestones—

nearly everything that touched the lives of 19th-century Americans from the cradle to the grave. Although the works were chosen with the aid of specialists, the show, which is sponsored through a grant from Philip Morris, Inc., is basically the work of two extraordinary women, Jean Lipman, for many years the editor of *Art in America,* and Alice Winchester, the former editor of *Antiques* magazine.

"The best folk art compares with the best academic art of its time and in some instances is better," says Jean Lipman. "A number of gifted folk artists arrived at a power and originality and beauty that were not surpassed by the greatest of the academic painters."

But much that is touted and sold today as great folk art is, in fact, nothing more than grotesque, inept painting. Even in this quality show, a few such pieces have crept in. For example, there is one watercolor showing a coarsely drawn couple in a cardboard embrace, their mouths askew, their eyes crossed. The drawing was probably copied from a print, and the end result is bad art by any standard.

But for the most part, the works on display bear out the contention that in the 100 years from 1776 to 1876 folk art flourished with a diversity and an originality in this country as in no other. Our native craftsmen

53

206 (below, left). Statue of Liberty. 1890–1900. Wood. H. 96″. New York's Statue of Liberty, which inspired this carving, weighs 225 tons and is 151 feet tall. The people of France presented the Statue of Liberty to the United States after raising some $450,000 to pay for it. The artist, Frédéric Auguste Bartholdi, began work in 1881; the statue arrived at New York in 1885 and was installed on Bedloe's Island in the autumn of 1886. (Greenfield Village and Henry Ford Museum)

207 (below, right). Liberty. Eliodoro Parete. Anawalt, West Virginia. C. 1863. Wood, polychromed. H. 3″. This unusual representation of Liberty is crowned by a tiara, and the base is inscribed "UNITED STATES OF AMERICA." (Index of American Design)

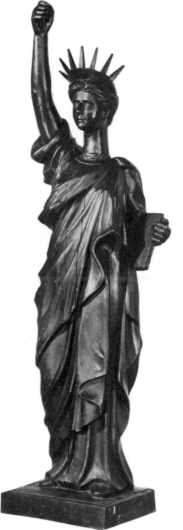

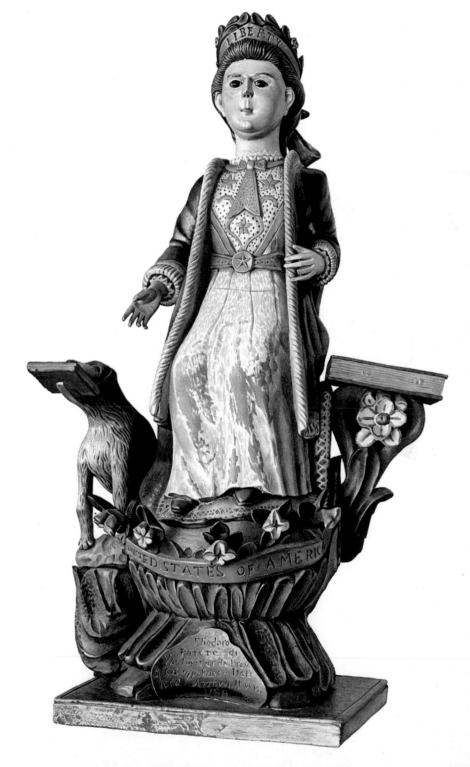

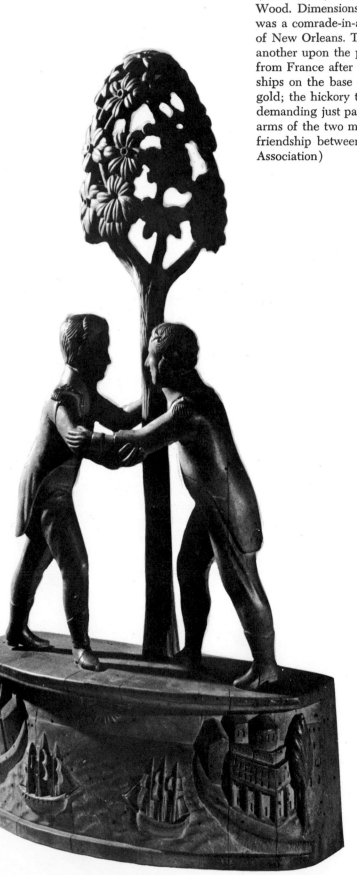

208 (below, left). General Andrew Jackson and King Louis Philippe of France. Pierre Joseph Landry (1770–1843). First half of the nineteenth century. Wood. Dimensions unavailable. Pierre Joseph Landry was a comrade-in-arms of General Jackson at the Battle of New Orleans. The figures are shown saluting one another upon the payment of the indemnity due from France after the Battle of New Orleans. The ships on the base represent the vessels bringing the gold; the hickory tree symbolizes Jackson's firmness in demanding just payment; the circle formed by the arms of the two men probably represents the lasting friendship between them. (Ladies' Hermitage Association)

209 (above). Miss Liberty. C. 1850. Wood. H. 30″. (Greenfield Village and Henry Ford Museum)

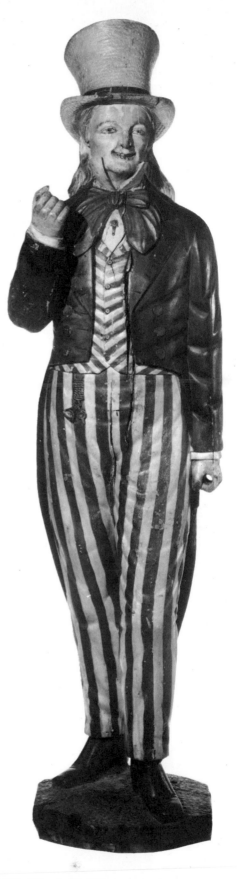

211 (right). Uncle Sam or Brother Jonathan. C. 1890. Wood. H. 72". Brother Jonathan was a name originally applied by British soldiers to American patriots during the Revolutionary War. The name Uncle Sam was an extension of the initials U.S. stamped on the U.S. Army supply packages during the War of 1812. During the nineteenth century the appellations of Brother Jonathan and Uncle Sam became synonymous. Today, the name Brother Jonathan has all but disappeared from popular usage. (Greenfield Village and Henry Ford Museum)

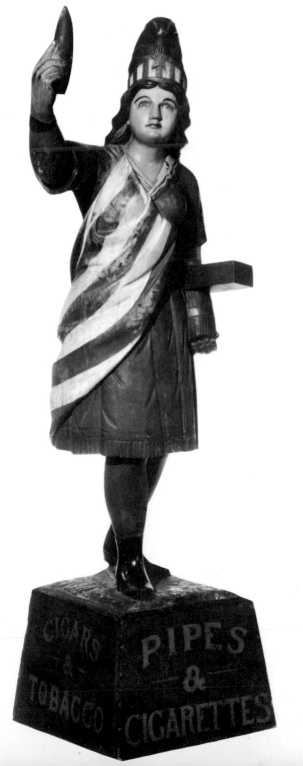

210 (left). Columbia. C. 1890. Wood. H. 56". Though whole tribes of Indians were used to hawk tobacco and other smoke shop supplies, patriotic figures were seldom used in this way. (Greenfield Village and Henry Ford Museum)

125

213 (right). Dapper Dan. C. 1875. Wood, original paint. H. 72″. This nattily dressed, trim figure was used as a tonsorial or barbershop advertising figure. His cane is in the shape of a barber pole. It is painted red and white, recalling the days when many tonsorial shops also offered minor medical treatment. (Gerald Kornblau Gallery)

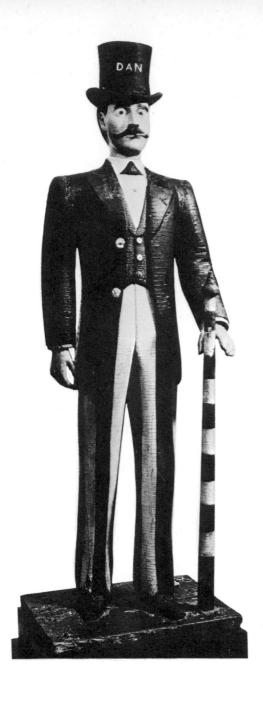

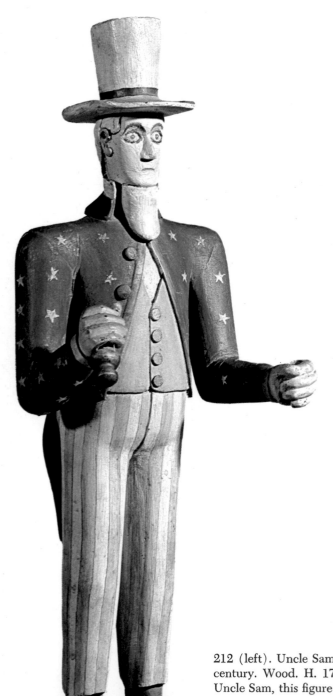

212 (left). Uncle Sam. New Hampshire. Late nineteenth century. Wood. H. 17¼″. Like many representations of Uncle Sam, this figure probably held a flag at one time. (Collection of Edith Barenholtz)

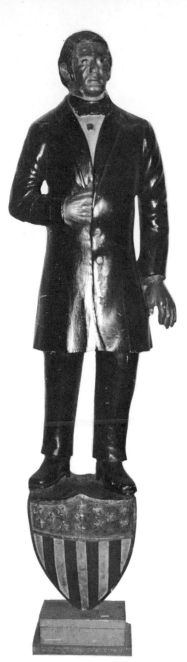

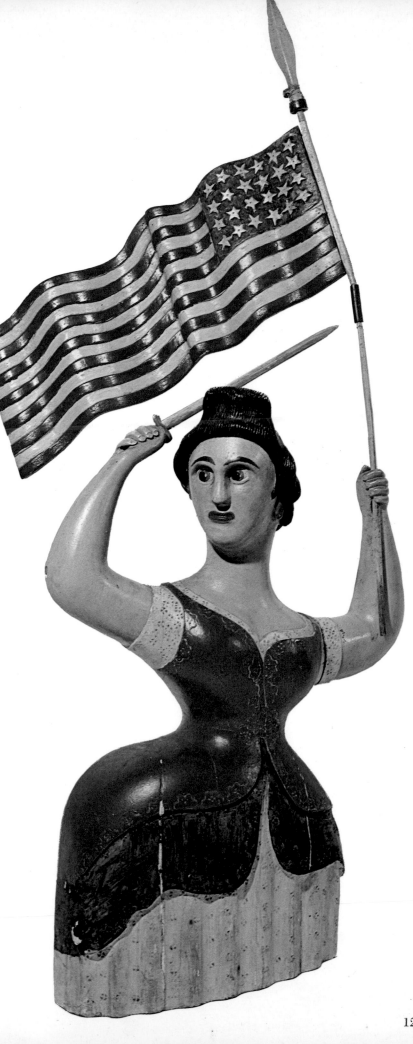

214 (above). *Henry Clay* figurehead. Attributed to Thomas Collyer. C. 1850. Wood, polychromed. H. 56″. This piece was found in Poughkeepsie, New York. It originally was used on the pilothouse of the Hudson River sloop, *Henry Clay,* which ran between New York and Albany. The boat was built in the shipyard of Thomas Collyer at the foot of 20th Street, New York, in 1850, and was launched on August 7, 1851. In the summer of 1852, it caught fire during a race and was run ashore at Riverdale, New York. (Terry Dintenfass, Inc.)

215 (right). Miss Liberty. Probably New Hampshire. 1850–1860. Wood. H. 25¾″. Although many representations of Liberty depict her as the defender of America, few convey the sense of fierceness found in this piece. The carving originally came from a boathouse at Tuftonborough, New Hampshire. (Collection of Edith Barenholtz)

216 (above). Sacred Cod. John Welch. Boston. C. 1760. Pine. L. 58". This famous
symbol was made from a solid pine log and is a replica of an even earlier codfish that
was set up in the Old State House, Boston, as a "Memorial to the importance of the cod
fishery to the welfare of the Commonwealth." Thomas Crafts, Jr. painted the new
Sacred Cod in 1773 and charged fifteen shillings for his work. (Old State House, Boston)

217 (below). Shadow box. Massachusetts. 1725–1775. White pine, glass. H. 11".
(The Henry Francis du Pont Winterthur Museum)

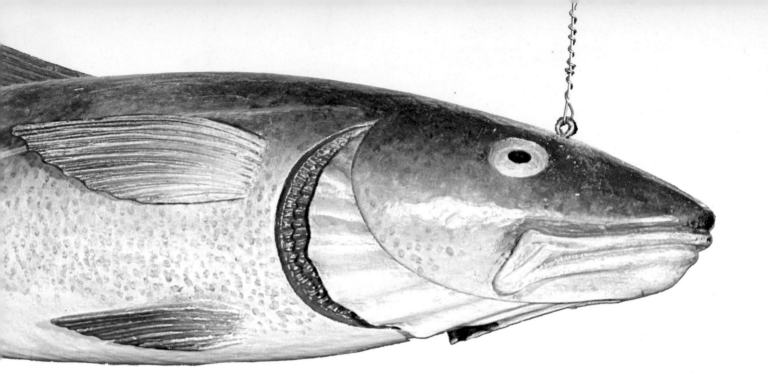

Much folk art, like all art through the ages, has been inspired by religion. During the seventeenth and eighteenth centuries, weathervanes on American churches were frequently made in the form of a fish, a major symbol of Christianity.

The Sacred Cod, figure 216, now hanging in the House of Representatives in the Boston State House, symbolizes the Bay State's early dependence upon its shipbuilding and fishing industries. This piece, created by John Welch (1711–1789), is one of the earliest and certainly most important documented carvings that has survived. Welch opened his Town Dock Shop in Boston in 1733. Though the Sacred Cod served as a symbolic image, other carved fish were painted and hung as advertising signs above the doors of fish markets.

FROM THE WATERS

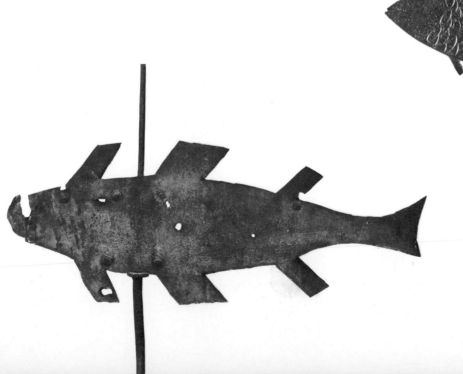

218 (left). Fish weathervane. Probably New England. 1825–1850. Sheet iron with traces of paint. L. 24″. (Mr. and Mrs. Michael D. Hall; photograph courtesy Herbert W. Hemphill, Jr.)

219 (above). Axhead socket from a Conestoga wagon. York County, Pennsylvania. C. 1800. Iron. L. 8¼″. (Cincinnati Art Museum; photograph courtesy Leah and John Gordon)

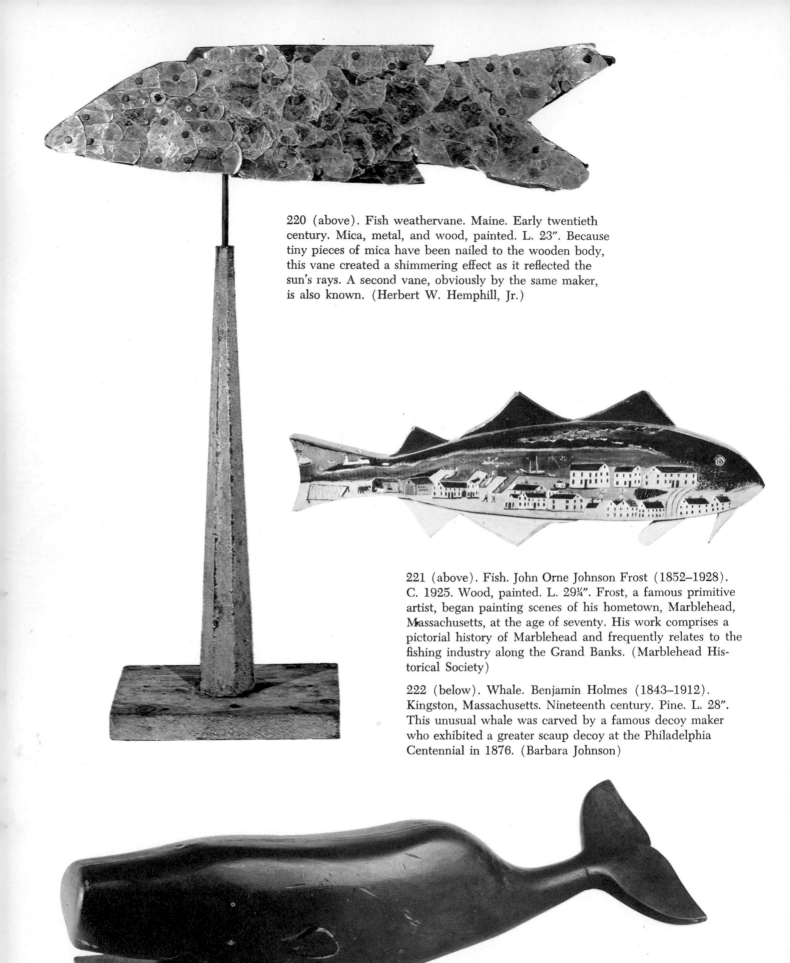

220 (above). Fish weathervane. Maine. Early twentieth century. Mica, metal, and wood, painted. L. 23″. Because tiny pieces of mica have been nailed to the wooden body, this vane created a shimmering effect as it reflected the sun's rays. A second vane, obviously by the same maker, is also known. (Herbert W. Hemphill, Jr.)

221 (above). Fish. John Orne Johnson Frost (1852–1928). C. 1925. Wood, painted. L. 29¼″. Frost, a famous primitive artist, began painting scenes of his hometown, Marblehead, Massachusetts, at the age of seventy. His work comprises a pictorial history of Marblehead and frequently relates to the fishing industry along the Grand Banks. (Marblehead Historical Society)

222 (below). Whale. Benjamin Holmes (1843–1912). Kingston, Massachusetts. Nineteenth century. Pine. L. 28″. This unusual whale was carved by a famous decoy maker who exhibited a greater scaup decoy at the Philadelphia Centennial in 1876. (Barbara Johnson)

223 (right). Fish shop sign. New England. 1850. Wood, polychromed. L. 15″. (R. Scudder Smith)

224 (below). Whale doorstop. Signed "D. Baker." New Bedford, Massachusetts. 1860. Iron. L. 21½″. Tradition maintains that Baker was sitting one day with seven whaling captains when they were asked by a child what a whale looked like. None of them could adequately describe a whale, so Baker cast seven doorstops, one for each of the captains, in order that they need never again be at a loss for words! (Barbara Johnson)

225 (bottom). Three fish decoys. Midwest. First half of the twentieth century. Wood with metal fins. L. of top fish, 7″. Fish decoys were merely lures and not fitted with hooks. (Private collection)

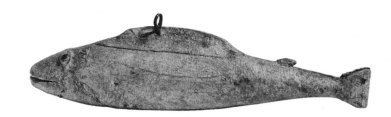

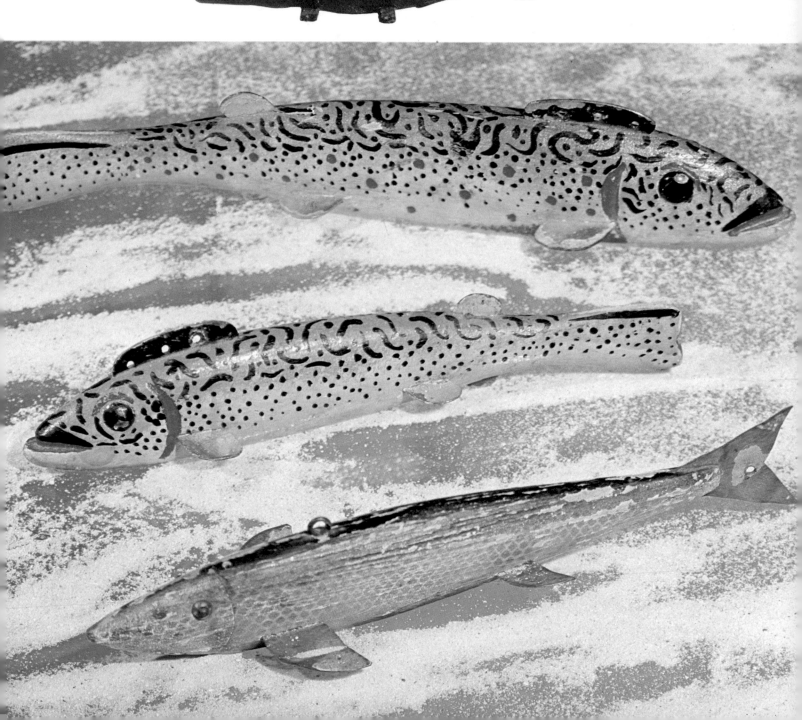

Fish decoys were used during the nineteenth and the first half of the twentieth centuries almost exclusively in the Great Lakes area. The body was usually made of pine hollowed out underneath and filled with molten lead for ballast. Tin, and occasionally leather, were shaped to form the fins and tail on these unusual pieces that had no hooks. The tail and body were sometimes carved in one piece, with the tail splayed outward so that the decoy could be maneuvered in a circle.

Fish decoys were commonly used by winter fishermen who built small shanties over large holes in the ice. The interior of the windowless shanty was usually painted black so that a curious fish, investigating the decoy that had been dropped through the hole, could be easily seen.

Decoys vary in size from just a few inches in length to the granddaddy of them all, figure 231, which is over four feet long.

226 (top). Fish decoy. Michigan. Twentieth century. Wood and tin, painted. L. 11½″. Glass eyes are occasionally used on fish decoys; more frequently, however, a nailhead serves the same purpose. (Private collection)

227 (middle). Fish decoy. Wisconsin. Twentieth century. Wood and tin, painted. L. 29″. A massive lead strip runs under the belly of the decoy. (Private collection)

228 (bottom). Fish decoy. Michigan. C. 1900. Wood and tin. L. 8¼″. Fish decoys were often used with jigging poles like that seen in this illustration. (George O. Bird)

229 (opposite, above left). Fish decoy. Great Lakes area. Twentieth century. Wood. L. 6¾″. A leather tail and fins were used on this decoy. (Private collection)

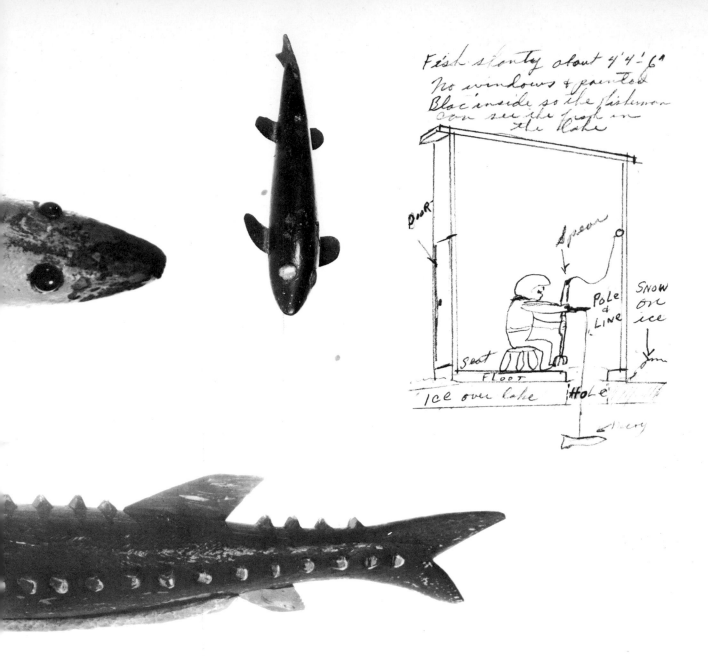

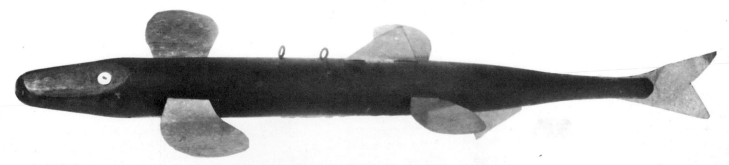

230 (above, right). Memory sketch of a man ice fishing. Arthur B. Johnson. Manton, Michigan. 1973. Pencil. H. 4¾". This sketch from memory illustrates how fishermen utilized fish decoys, spears, and shanties. (Photograph courtesy the artist)

231 (below). Fish decoy. Wisconsin. Twentieth century. Wood and tin, painted. L. 48". A hopeful fisherman wrote on the body of this mammoth decoy, "Have faith keep sailing." This is one of the largest working fish decoys known. (Private collection)

133

WOODEN WEATHERVANES

233 (above). Rooster. Massachusetts. Late eighteenth century. Wood and iron, painted. L. 45″. This distinctive piece is composed of several sections that are joined to form a complete unit. The legs are of wrought iron. It was taken from the barn at the Old Fitch Tavern, which was built before 1731 in Bedford, Massachusetts. On the morning of April 19, 1775, the Minutemen rallied at this tavern. (Shelburne Museum, Inc.)

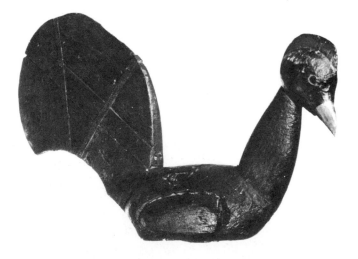

234 (above). Cockerel. Late nineteenth century. Wood. L. 45½″. The tail is made of several pieces of wood held together by iron straps. (Abby Aldrich Rockefeller Folk Art Collection; photograph courtesy Stony Point Folk Art Gallery)

Because wooden weathervanes are much more perishable than those made of metal, few eighteenth-century examples remain. In fact, even those examples dating before the mid-nineteenth century are rare.

Early wooden vanes were fashioned by hand and a seemingly endless variety of forms attests to the folk artists' individual sense of design. Full-bodied, three-dimensional examples, like figure 234, were the most difficult to carve. Flat-bodied vanes, like figure 236, were occasionally embellished with carved details. Nearly all were originally painted, and those that retain early paint are the most sought after.

Folk art collectors today usually mount their vanes on bases; however, to appreciate a weathervane fully, it should be seen in its natural habitat, silhouetted against a colorful sky.

232 (opposite). Rooster. Maine. 1786. Pine, pieced and glued and then carved and gilded. L. approximately 48″. This is reputed to be the oldest American wooden weathervane still in use. It originally topped the Cumberland County Courthouse in Portland, Maine. (First National Bank of Portland)

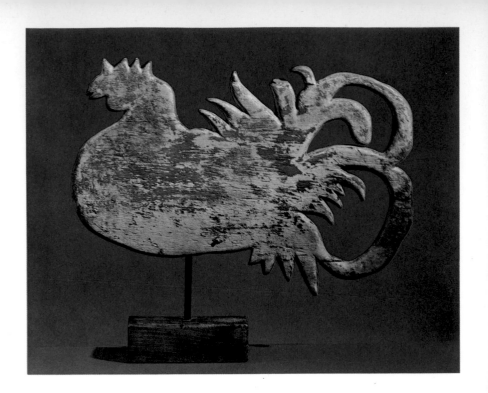

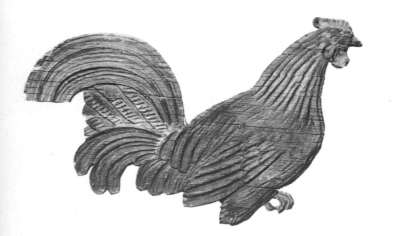

235 (above). Rooster. James Lombard (1865–?). Bridgton, Maine. Late nineteenth century. Wood. H. 14″. James Lombard was born in Baldwin, Maine. He was a farmer by profession and an amateur furniture and weathervane maker. This vane retains much of its original ocher paint, which was used in imitation of gold leaf. (Nelle and Richard Hankinson)

236 (left). Rooster. C. 1800. Wood. L. 23½″. This flat, silhouette vane has been deeply carved, probably to give it a three-dimensional quality. (Abby Aldrich Rockefeller Folk Art Collection; photograph courtesy Stony Point Folk Art Gallery)

237 (below). Rooster. New England. Late nineteenth century. Wood. H. 18½″. Folk artists frequently utilized materials at hand. This jaunty vane is fitted with a leather cockscomb. (George E. Schoellkopf Gallery)

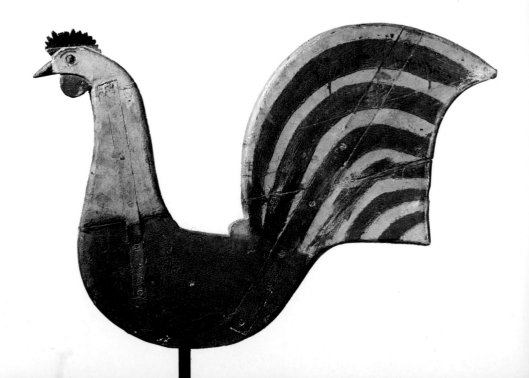

238 (right). Spotted hen. New England. 1850–1860. Wood. H. 16½". The quality of the hand-craftsmanship found in figure 232 is also seen in this piece made some fifty or seventy-five years later. The hen's body is constructed of five pieces of wood nailed together. It stands on a metal arrow base. This vane is a mid-nineteenth-century masterpiece of folk art. (Private collection)

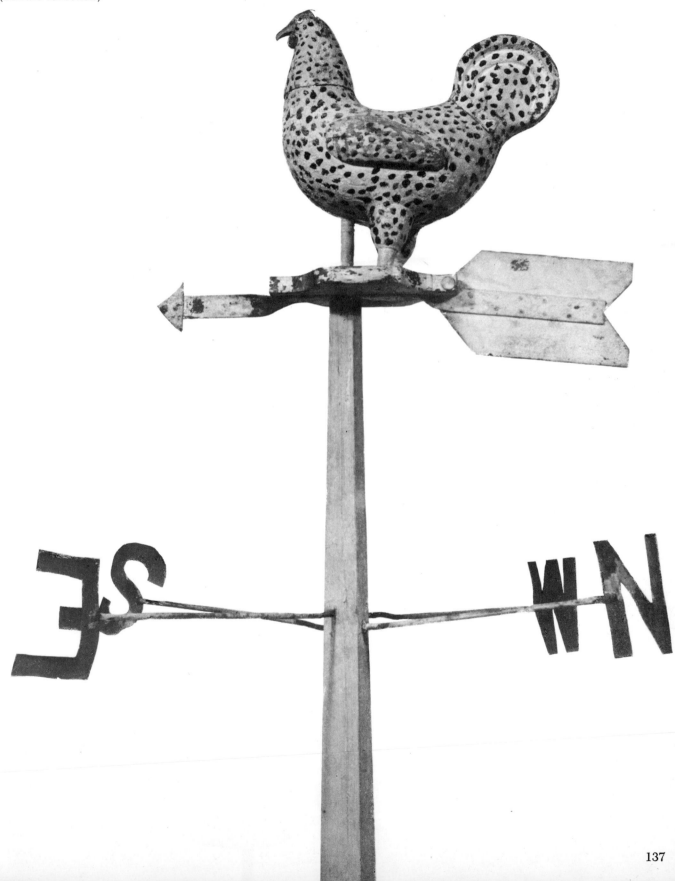

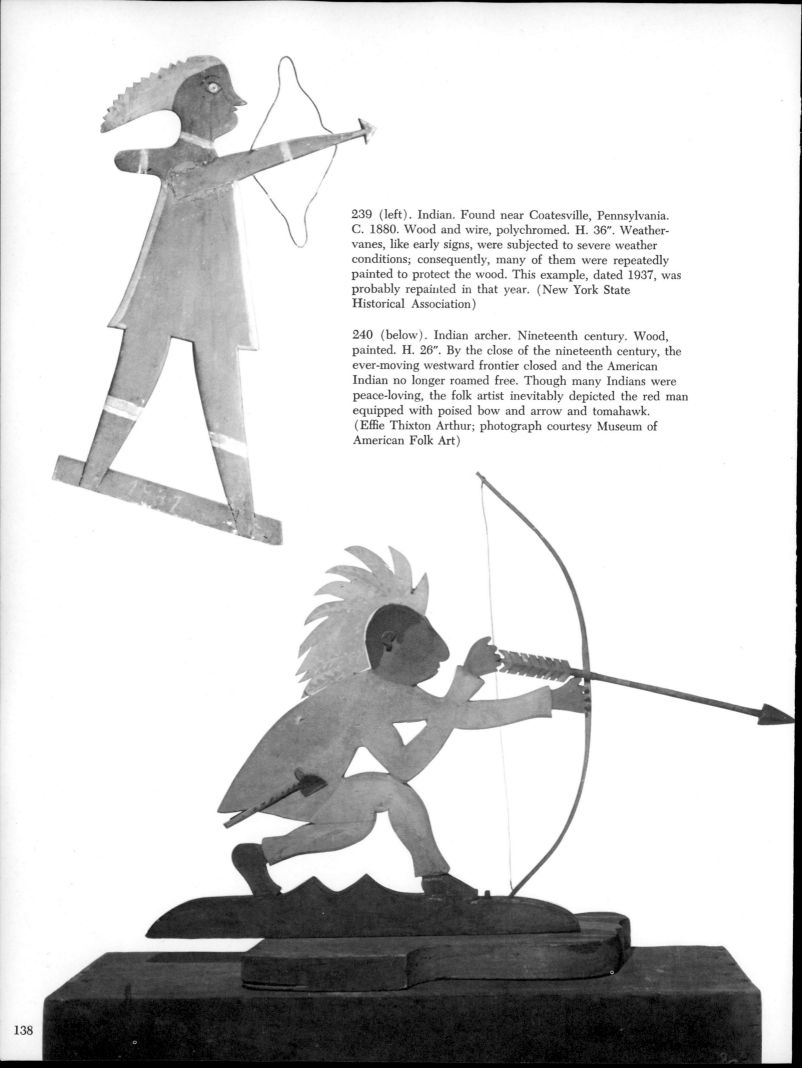

239 (left). Indian. Found near Coatesville, Pennsylvania. C. 1880. Wood and wire, polychromed. H. 36″. Weathervanes, like early signs, were subjected to severe weather conditions; consequently, many of them were repeatedly painted to protect the wood. This example, dated 1937, was probably repainted in that year. (New York State Historical Association)

240 (below). Indian archer. Nineteenth century. Wood, painted. H. 26″. By the close of the nineteenth century, the ever-moving westward frontier closed and the American Indian no longer roamed free. Though many Indians were peace-loving, the folk artist inevitably depicted the red man equipped with poised bow and arrow and tomahawk. (Effie Thixton Arthur; photograph courtesy Museum of American Folk Art)

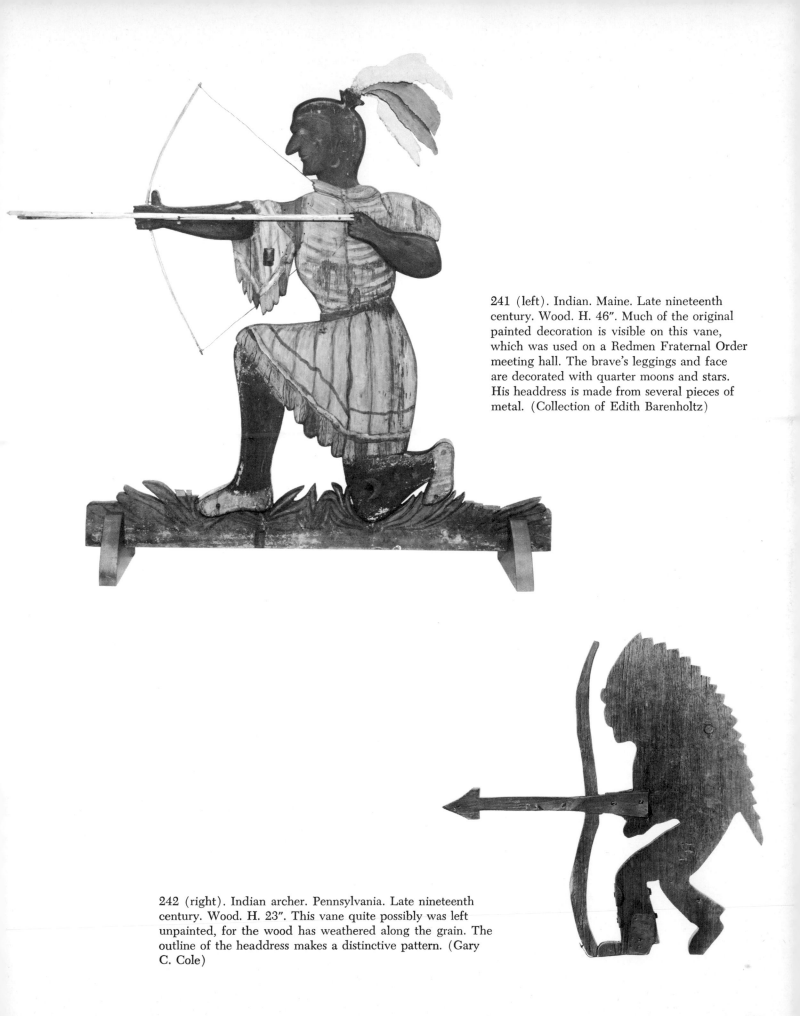

241 (left). Indian. Maine. Late nineteenth century. Wood. H. 46″. Much of the original painted decoration is visible on this vane, which was used on a Redmen Fraternal Order meeting hall. The brave's leggings and face are decorated with quarter moons and stars. His headdress is made from several pieces of metal. (Collection of Edith Barenholtz)

242 (right). Indian archer. Pennsylvania. Late nineteenth century. Wood. H. 23″. This vane quite possibly was left unpainted, for the wood has weathered along the grain. The outline of the headdress makes a distinctive pattern. (Gary C. Cole)

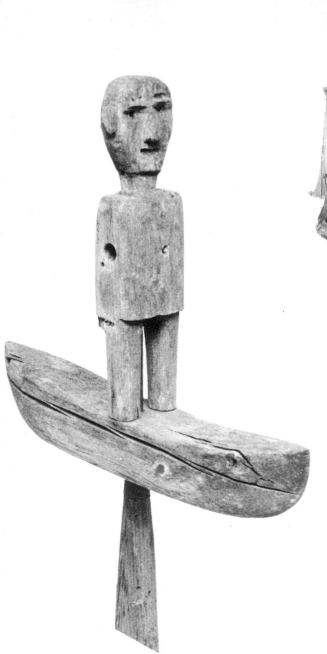

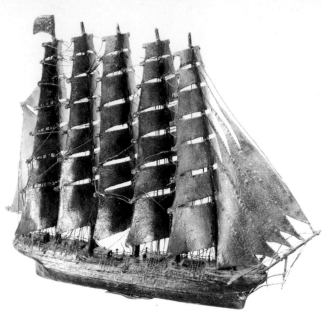

243 (above). Ship. New England. Late nineteenth century. Wood with metal sails. H. 20". New England fishing villages nestled along the coast were the seas upon which countless ship weathervanes sailed. (Mr. and Mrs. Jerome Blum)

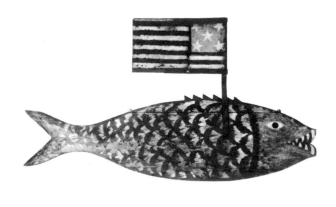

244 (above). Man in boat. Found at Readfield Depot, Maine. C. 1870. Wood. Dimensions unavailable. This weatherworn figure was undoubtedly originally fitted with paddle arms that turned in the wind. (Current whereabouts unknown)

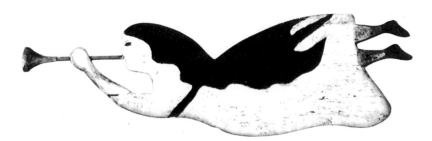

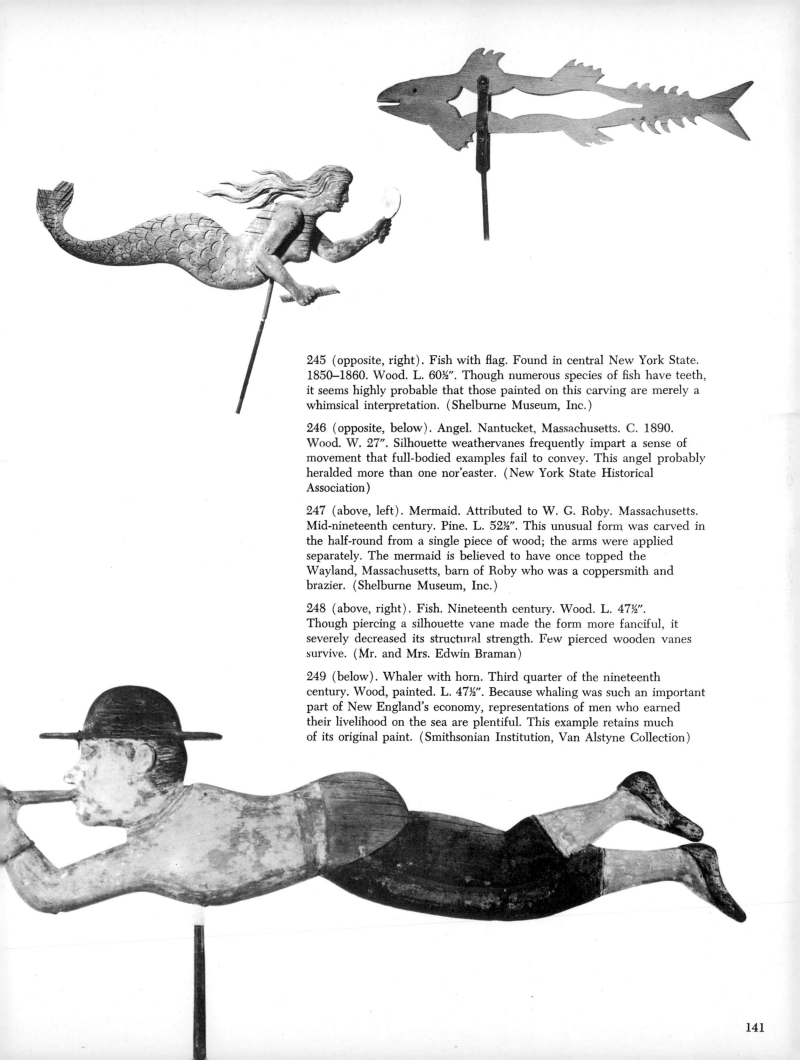

245 (opposite, right). Fish with flag. Found in central New York State. 1850–1860. Wood. L. 60½″. Though numerous species of fish have teeth, it seems highly probable that those painted on this carving are merely a whimsical interpretation. (Shelburne Museum, Inc.)

246 (opposite, below). Angel. Nantucket, Massachusetts. C. 1890. Wood. W. 27″. Silhouette weathervanes frequently impart a sense of movement that full-bodied examples fail to convey. This angel probably heralded more than one nor'easter. (New York State Historical Association)

247 (above, left). Mermaid. Attributed to W. G. Roby. Massachusetts. Mid-nineteenth century. Pine. L. 52½″. This unusual form was carved in the half-round from a single piece of wood; the arms were applied separately. The mermaid is believed to have once topped the Wayland, Massachusetts, barn of Roby who was a coppersmith and brazier. (Shelburne Museum, Inc.)

248 (above, right). Fish. Nineteenth century. Wood. L. 47½″. Though piercing a silhouette vane made the form more fanciful, it severely decreased its structural strength. Few pierced wooden vanes survive. (Mr. and Mrs. Edwin Braman)

249 (below). Whaler with horn. Third quarter of the nineteenth century. Wood, painted. L. 47½″. Because whaling was such an important part of New England's economy, representations of men who earned their livelihood on the sea are plentiful. This example retains much of its original paint. (Smithsonian Institution, Van Alstyne Collection)

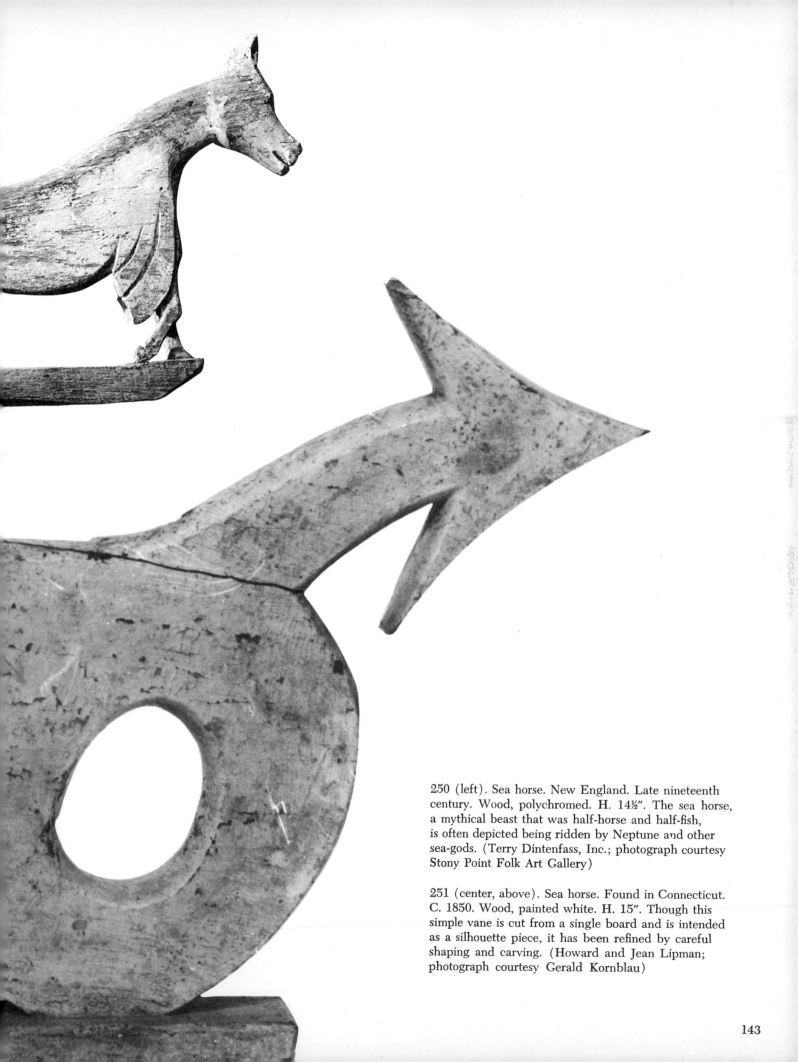

250 (left). Sea horse. New England. Late nineteenth century. Wood, polychromed. H. 14½". The sea horse, a mythical beast that was half-horse and half-fish, is often depicted being ridden by Neptune and other sea-gods. (Terry Dintenfass, Inc.; photograph courtesy Stony Point Folk Art Gallery)

251 (center, above). Sea horse. Found in Connecticut. C. 1850. Wood, painted white. H. 15". Though this simple vane is cut from a single board and is intended as a silhouette piece, it has been refined by careful shaping and carving. (Howard and Jean Lipman; photograph courtesy Gerald Kornblau)

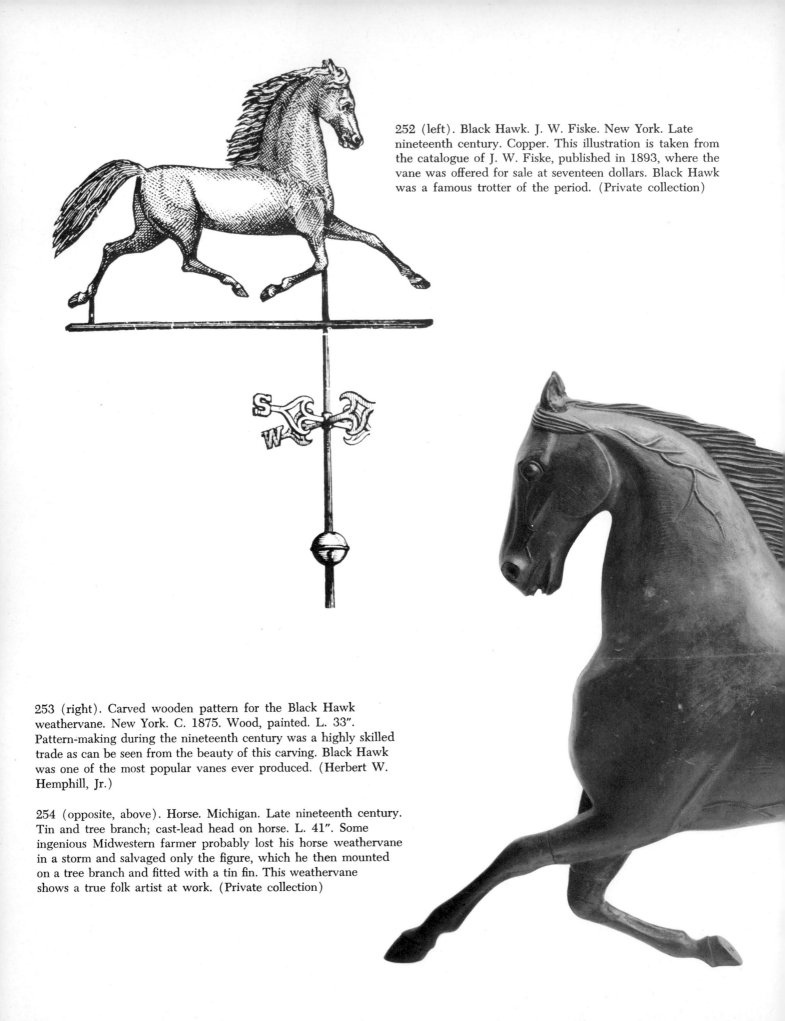

252 (left). Black Hawk. J. W. Fiske. New York. Late nineteenth century. Copper. This illustration is taken from the catalogue of J. W. Fiske, published in 1893, where the vane was offered for sale at seventeen dollars. Black Hawk was a famous trotter of the period. (Private collection)

253 (right). Carved wooden pattern for the Black Hawk weathervane. New York. C. 1875. Wood, painted. L. 33″. Pattern-making during the nineteenth century was a highly skilled trade as can be seen from the beauty of this carving. Black Hawk was one of the most popular vanes ever produced. (Herbert W. Hemphill, Jr.)

254 (opposite, above). Horse. Michigan. Late nineteenth century. Tin and tree branch; cast-lead head on horse. L. 41″. Some ingenious Midwestern farmer probably lost his horse weathervane in a storm and salvaged only the figure, which he then mounted on a tree branch and fitted with a tin fin. This weathervane shows a true folk artist at work. (Private collection)

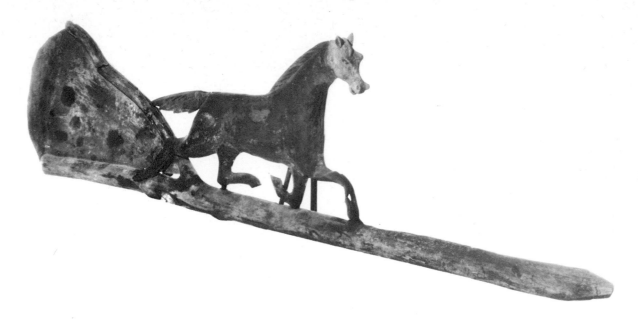

By the mid-nineteenth century, the Industrial Revolution was firmly established in the United States, and the handcrafted weathervane, like so many other consumer goods, was made obsolete by mass production. Inexpensive commercial vanes became readily available, and the products of individual craftsmen grew scarce.

The most common method of producing a commercial vane was as follows: A carver fashioned a wooden model from which an iron mold was cast. The mold was then cut into component parts. Next, each part was filled with molten lead. When the lead cooled, sheet copper was sandwiched between it and the iron mold. The lead was then hammered, forcing the copper to conform to the shape of the mold. Finally, the shaped copper was removed and the separate parts soldered together, thus achieving a sculptural three-dimensional vane. Eventually, handcrafting was given up, and the individual parts were manufactured by automatic pressing machines.

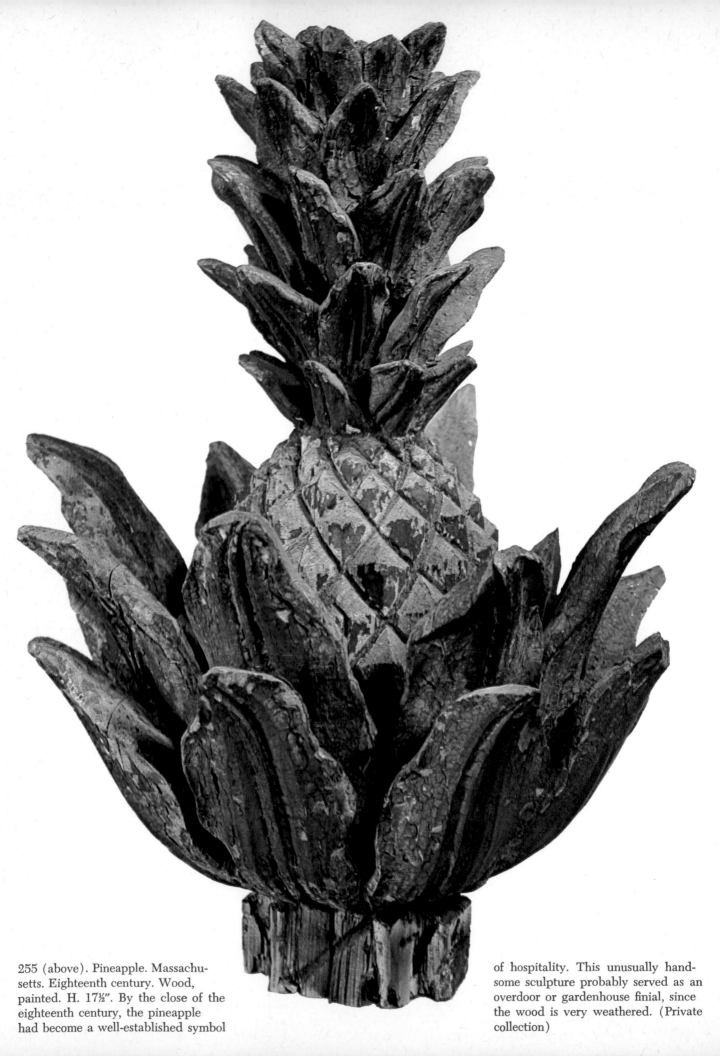

255 (above). Pineapple. Massachusetts. Eighteenth century. Wood, painted. H. 17½". By the close of the eighteenth century, the pineapple had become a well-established symbol of hospitality. This unusually handsome sculpture probably served as an overdoor or gardenhouse finial, since the wood is very weathered. (Private collection)

146

HOW THE HOUSE WORKS

Soon after American settlers had built their first homes in the wilderness, they began to seek physical comforts and to beautify their dwellings. Throughout much of the early eighteenth century, wealthy men continued to favor imported products over those made by local craftsmen. Many who could not afford imports made their own wares, often leading to the creation of objects that today are considered great folk art.

The same patriotic zeal responsible for carved likenesses of George Washington and Thomas Jefferson caused householders to use representations of the American flag for decoration. An outstanding example of this is the flag gate, figure 257. The Continental Congress, on June 14, 1777, resolved: "The flag of the United States shall be thirteen stripes, alternate red and white, with a union of thirteen stars of white on a blue field, representing a new constellation." [16] Betsy Griscom Ross (1752–1836), the American patriot, is the legendary seamstress who fashioned the first American flag. The only real evidence that she actually stitched flags in her upholstery shop is a voucher dated May 29, 1777, for making flags for the Pennsylvania navy.

256 (above). Flag weathervane. Probably New England. Late nineteenth century. Sheet-metal flag with wooden hammer. H. 34″. This vane is believed to have been used on a Mason or Mechanics Guild Hall. (Collection of Edith Barenholtz)

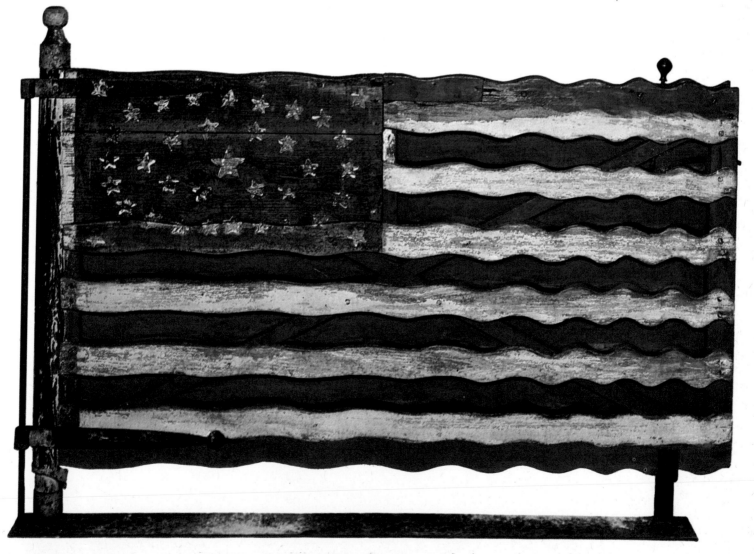

257 (above). Flag gate. New York State. C. 1872. Wood and metal, painted. H. 40″. The wrought-iron strap hinges are similar to those used on large barn doors. This gate was found at the Darling Farm, Jefferson County, New York. It is one of the handsomest and most unusual examples of utilitarian folk art known. (Museum of American Folk Art)

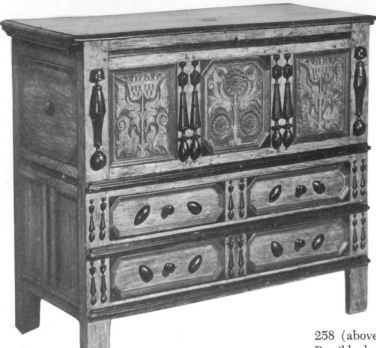

258 (above), 258a (opposite). Tulip and sunflower chest. Possibly by Peter Blin (1639/40–1725). Probably Wethersfield, Connecticut. C. 1680. Oak, pine, and maple. H. 41¼". The flat relief carving on this handsome chest from the Connecticut River Valley features highly stylized tulip, sunflower, and leaf motifs. (Greenfield Village and Henry Ford Museum)

259 (right). Spanish-American armchair. New Mexico. Late eighteenth century. Pine. H. 38". Spanish settlers in the Southwestern United States brought with them the Catholic religion and a baroque style that was ultimately diluted by the flat, geometric design concepts of the Indians. The carving on this chair is typical of late eighteenth- and early nineteenth-century works made by the Indians, and the piece as a whole possesses a strong sculptural and architectural quality. (Museum of New Mexico)

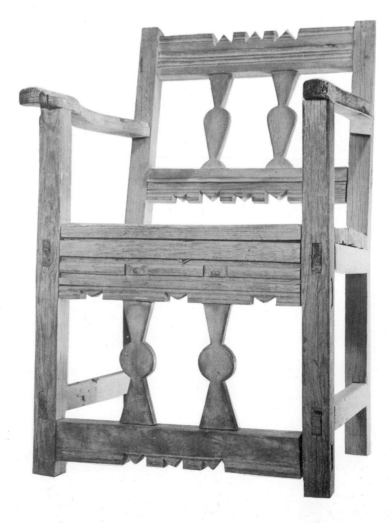

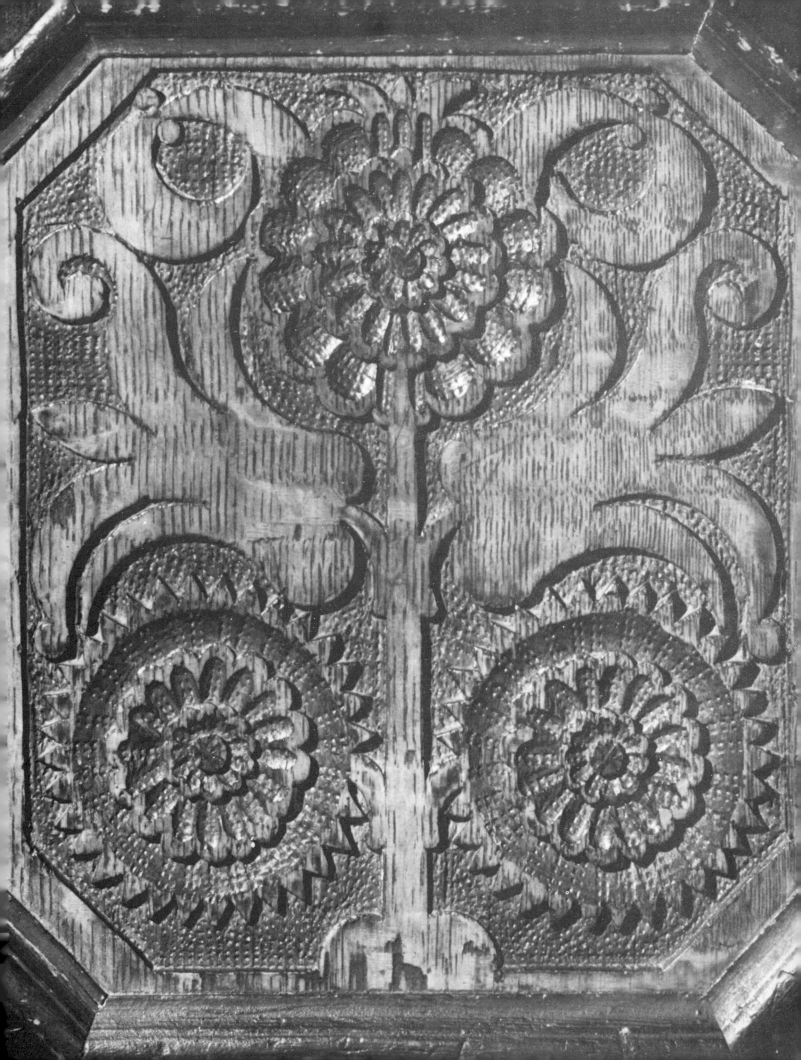

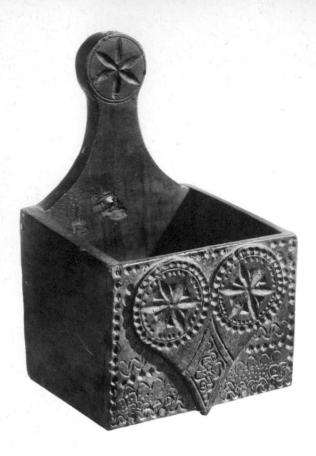

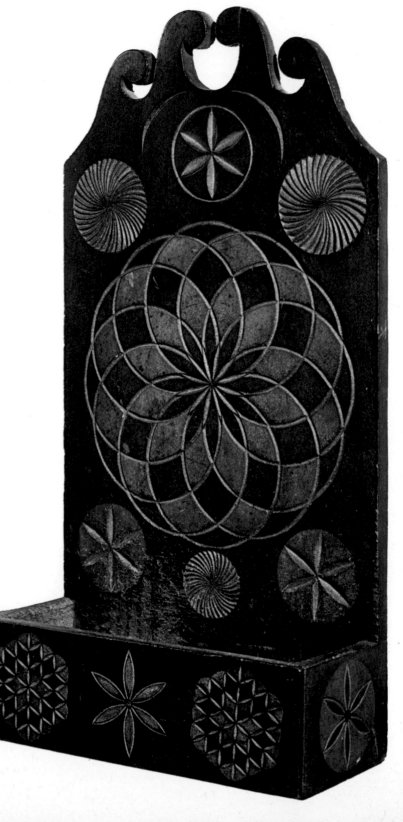

260 (above). Spill box. Connecticut. Eighteenth century. Cherry H. 7½". Because the cherry tree was plentiful in the Connecticut River Valley, vast quantities of cherrywood were used for the construction of furniture. This whimsical spill box is decorated with carved pinwheels and punched decoration frequently found on Connecticut pieces. (Mr. and Mrs. James O. Keene)

261 (right). Candle holder. Pennsylvania. C. 1800. Wood, polychromed. H. 25". This utilitarian piece satisfies the demands made by even the most particular collector in his quest for splendid folk art. The elaborate carving is enhanced by the original painted decoration. Countless hands reaching into the box have worn away portions of the paint surface. (Howard and Jean Lipman)

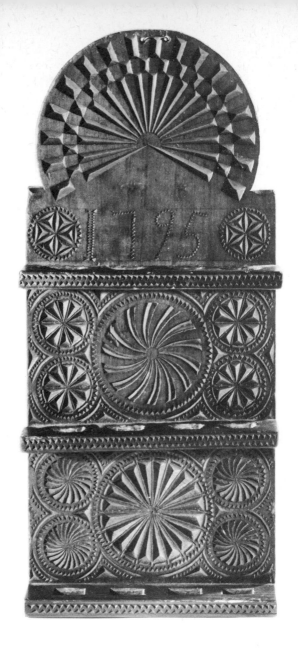

262 (left). Spoon holder. New England. Dated 1795. Pine, chip-carved. H. 20″. This is an outstanding example of chip-carved decoration. (Private collection; photograph courtesy Leah and John Gordon)

263 (below). Knife box. Found in New York State. Last quarter of the nineteenth century. Wood, polychromed. H. 15″. Folk artists were enchanted with the possibility of fashioning utilitarian objects that would allow them creative expression. The carved decoration on this piece includes draft horses, stars, and flat, almost ghostlike figures; the handle is in the form of a man wearing a cap. (New York State Historical Association)

264 (bottom). Knife box. Portland, Maine, area. 1850–1875. Walnut. L. 14″. Even the seasoned folk-art collector is surprised to learn that German settlements existed in Maine during the eighteenth century. As in Pennsylvania, immigrant craftsmen transmitted European art traditions to rural communities. Hooked rugs, sheet-iron weathervanes, and German-style furniture indicate the survival of this influence well into the nineteenth century. This knife box, without its documented Maine history, might well be attributed to Pennsylvania. (Roland B. Hammond, Inc.)

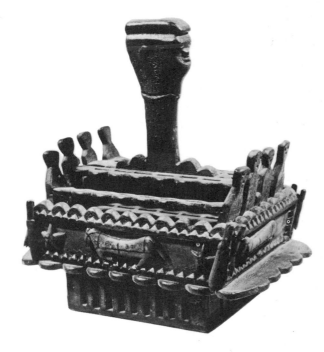

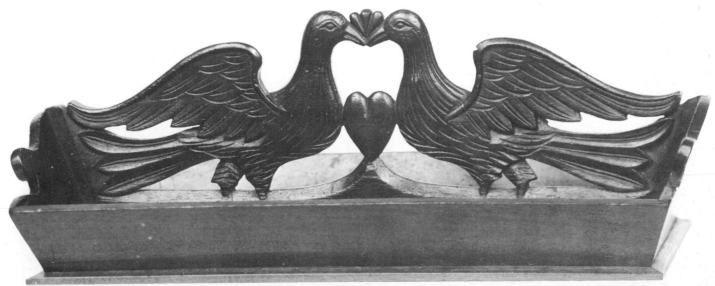

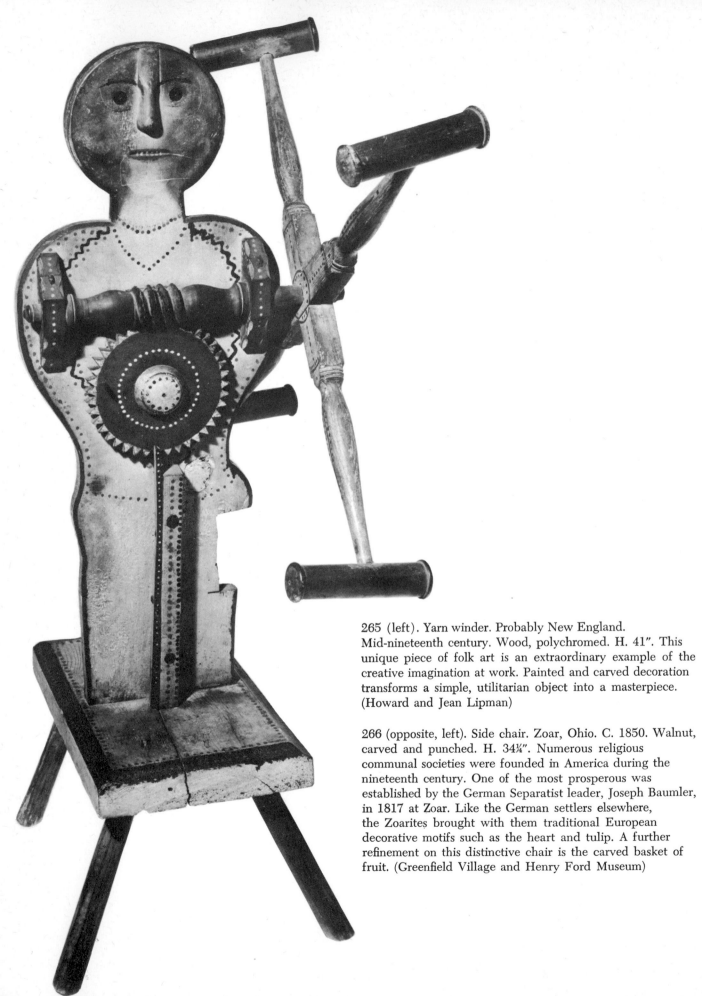

265 (left). Yarn winder. Probably New England. Mid-nineteenth century. Wood, polychromed. H. 41″. This unique piece of folk art is an extraordinary example of the creative imagination at work. Painted and carved decoration transforms a simple, utilitarian object into a masterpiece. (Howard and Jean Lipman)

266 (opposite, left). Side chair. Zoar, Ohio. C. 1850. Walnut, carved and punched. H. 34¼″. Numerous religious communal societies were founded in America during the nineteenth century. One of the most prosperous was established by the German Separatist leader, Joseph Baumler, in 1817 at Zoar. Like the German settlers elsewhere, the Zoarites brought with them traditional European decorative motifs such as the heart and tulip. A further refinement on this distinctive chair is the carved basket of fruit. (Greenfield Village and Henry Ford Museum)

267 (below). Bed headboard. Jewett. Maine. Nineteenth century. Wood. H. 39⅜″. This headboard reputedly was carved as a wedding present for Almira Jewett Bailey of Palermo, Maine, by her father, a sailor who took the wood to sea and fashioned the piece while on a voyage. A traditional European double-headed eagle tops the headboard. (Maine State Museum Commission)

268 (bottom). Chest. Union County, Pennsylvania. Mid-nineteenth century. Pine. L. 22¾″. Stylized leaves and branches set in flowerpots, along with a semicircular panel decorated with pinwheels, enliven the front of this diminutive chest. (Mr. and Mrs. James O. Keene)

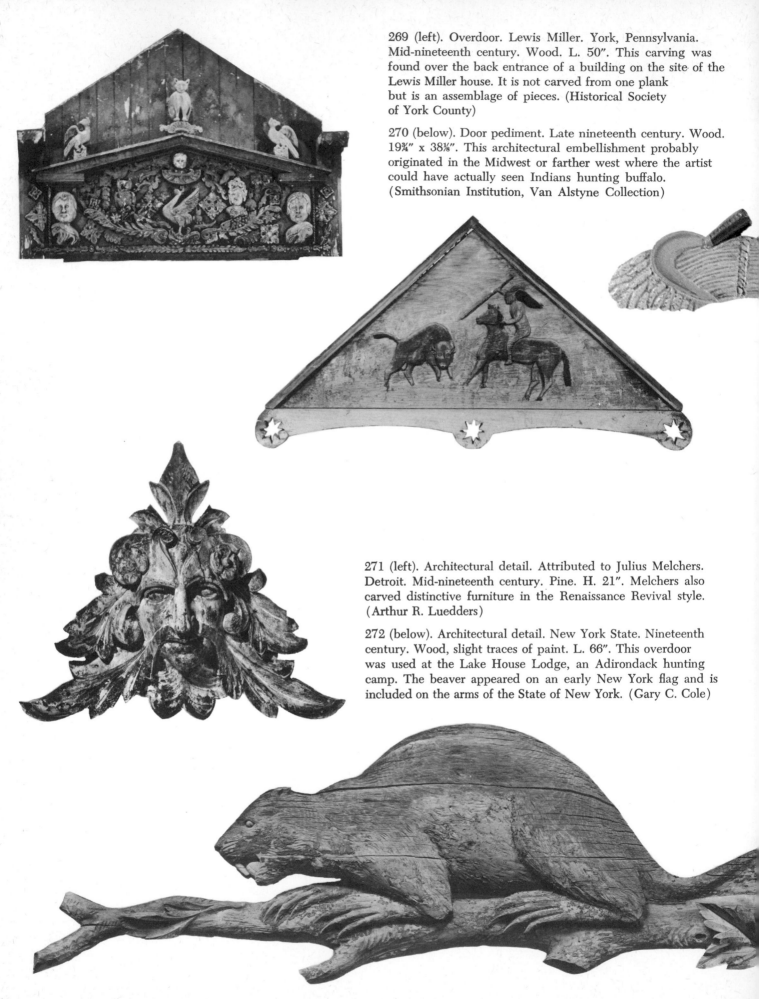

269 (left). Overdoor. Lewis Miller. York, Pennsylvania. Mid-nineteenth century. Wood. L. 50″. This carving was found over the back entrance of a building on the site of the Lewis Miller house. It is not carved from one plank but is an assemblage of pieces. (Historical Society of York County)

270 (below). Door pediment. Late nineteenth century. Wood. 19¾″ x 38⅛″. This architectural embellishment probably originated in the Midwest or farther west where the artist could have actually seen Indians hunting buffalo. (Smithsonian Institution, Van Alstyne Collection)

271 (left). Architectural detail. Attributed to Julius Melchers. Detroit. Mid-nineteenth century. Pine. H. 21″. Melchers also carved distinctive furniture in the Renaissance Revival style. (Arthur R. Luedders)

272 (below). Architectural detail. New York State. Nineteenth century. Wood, slight traces of paint. L. 66″. This overdoor was used at the Lake House Lodge, an Adirondack hunting camp. The beaver appeared on an early New York flag and is included on the arms of the State of New York. (Gary C. Cole)

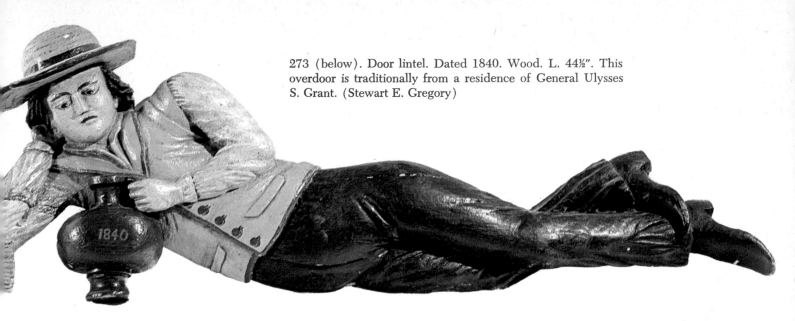

273 (below). Door lintel. Dated 1840. Wood. L. 44½″. This overdoor is traditionally from a residence of General Ulysses S. Grant. (Stewart E. Gregory)

274 (below). Overmantel. New England. Dated 1804. Pine and gesso, gilded. L. 23¹⁵⁄₁₆″. This architectural ornament is marked on the reverse "Front of mantel from the Old Pond Homestead . . ." (Greenfield Village and Henry Ford Museum)

Almost as soon as America's first settlers were no longer faced with the basic struggle for existence, they began to embellish their homes and shops with carved architectural ornaments and details. Several seventeenth-century dwellings in New England and Virginia and eighteenth-century plasterwork ceilings in Pennsylvania establish this fact.

As the frontier moved westward and adventurous citizens settled new territory, the pattern of upward mobility from crude log cabins to handsome frame houses was repeated. Folk artists were also very active on this Western frontier in the nineteenth century.

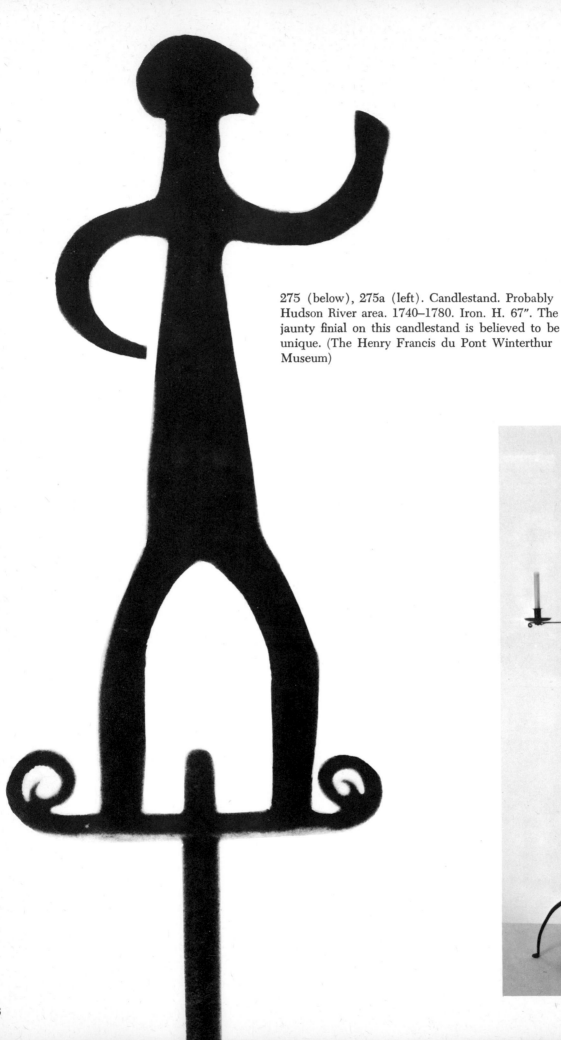

275 (below), 275a (left). Candlestand. Probably Hudson River area. 1740–1780. Iron. H. 67". The jaunty finial on this candlestand is believed to be unique. (The Henry Francis du Pont Winterthur Museum)

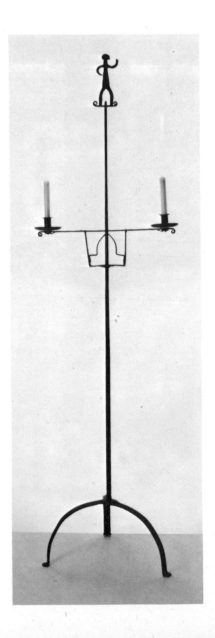

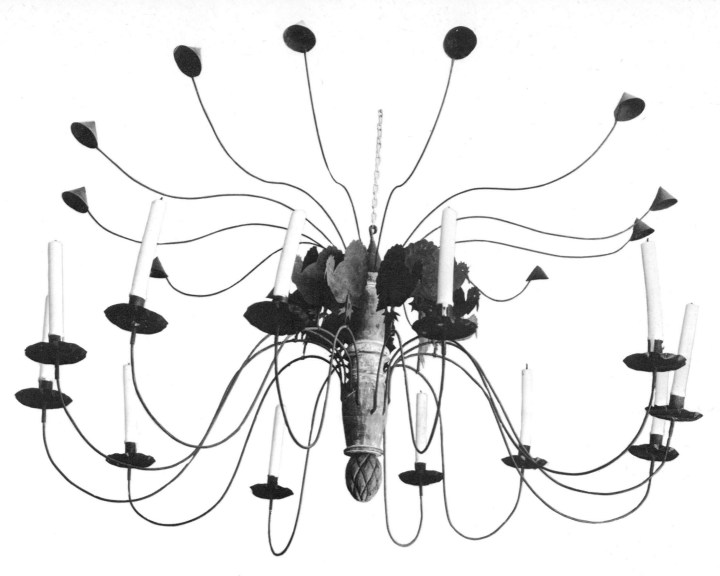

276 (above), 276a (below). Chandelier. Massachusetts. C. 1800. Wood and tin. W. 48″. Though many utilitarian objects possess sculptural qualities, few display the incredible beauty of this piece. A turkey cut from tin is mounted on each of the twelve arms; when the chandelier was new and the tin bright, the turkeys were undoubtedly meant to reflect the candlelight. (Leah and John Gordon)

277 (left). Door latch. Pennsylvania. C. 1850. Metal. H. 14″. The Pennsylvania German blacksmith frequently forged door latches and ornamental hinges in the shape of a tulip surrounded by vinelike tendrils. The use of the human figure for such ornamentation is rare. (Mr. and Mrs. Harvey Kahn)

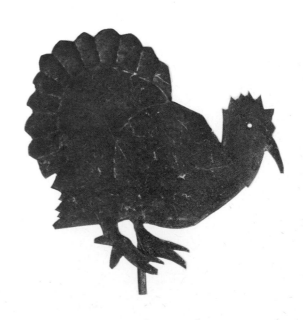

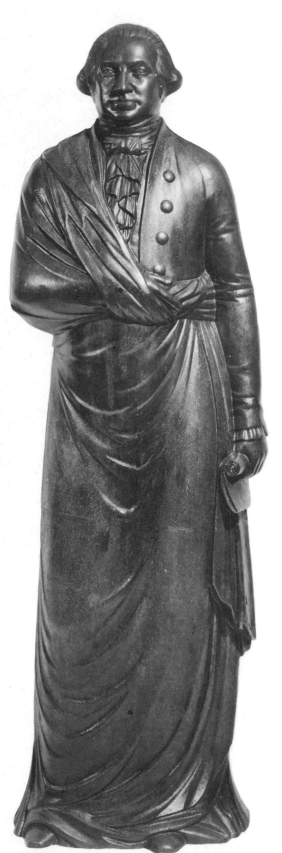

278 (left). Stove figure. Albany, New York. 1848. Iron. H. 50″. This ornament is marked "Albany 1848." Similar pieces are known to have originated in Brooklyn, New York. The George and Martha Washington stove ornaments were utilitarian in that they were attached to a boxlike stove and served as heat radiators. (Barbara Johnson)

279 (below, center). Hitching post. Late nineteenth century. Cast iron. H. of figure 13″. By the 1860s, nearly every major city contained an iron foundry that manufactured hitching posts in a multitude of forms. (Allan L. Daniel)

280 (below, right). Doorstop. Probably Pennsylvania. Late nineteenth century. Cast iron. H. 7½″. Doorstops were generally mass-produced. This Amish gentleman is dressed in an orange coat, blue pants, and the traditional black hat. (Private collection)

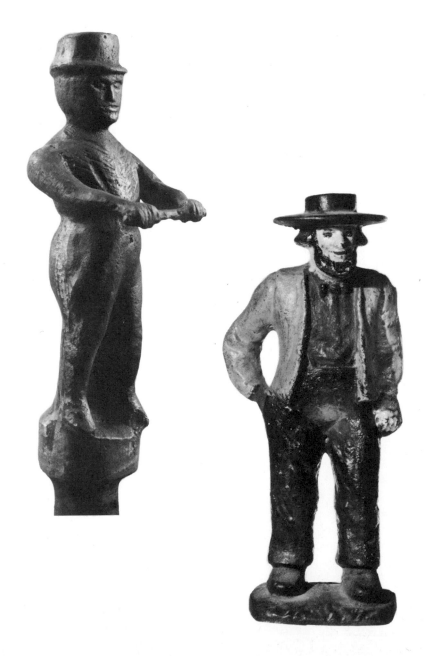

281 (right). Snowbird. Probably Pennsylvania. Nineteenth century. Cast iron. H. 5¼". Snowbirds were used on the edges of a roof to retain snow until it melted. These ingenious devices were actually an early form of accident insurance. (George O. Bird)

282 (below). Swan. Late nineteenth century. Iron, painted white. H. 20½". This garden ornament is mounted on an iron bracket that can be thrust into the ground. (Private collection)

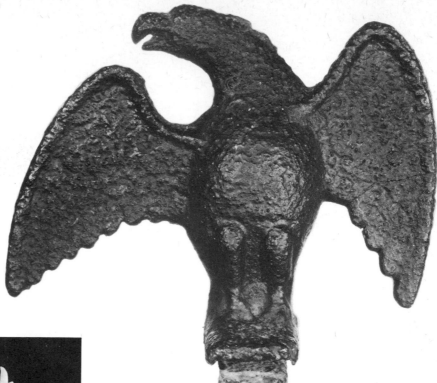

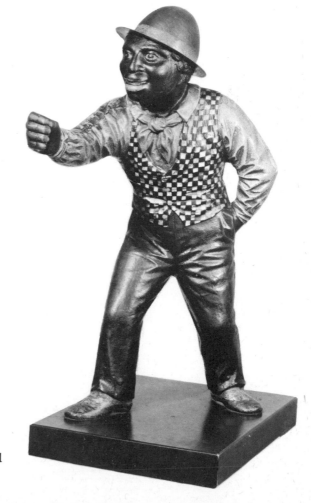

By 1857 the American iron industry was surpassed in output only by England, and the use of iron—to at least one American author—was the gauge by which the "relative height of Civilization among nations" [17] was measured. Iron could be cast into almost any conceivable design, and objects ranging from doorstops and garden seats to whole building fronts indicate the diversity of articles that grew out of this ferromania. By the mid-nineteenth century, firms such as J. B. & J. M. Cornell at 141 Center Street, New York, specialized in building facades, bridges, roofs, girders, beams, stairs, columns, and so forth.

283 (right). Hitching post. C. 1875. Iron. H. 29". (Greenfield Village and Henry Ford Museum)

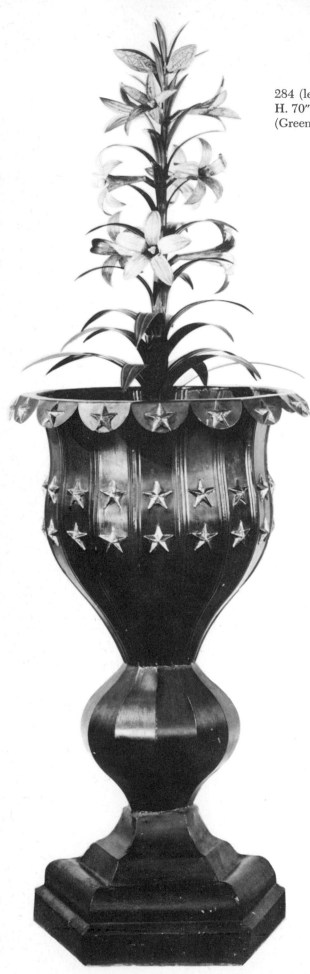

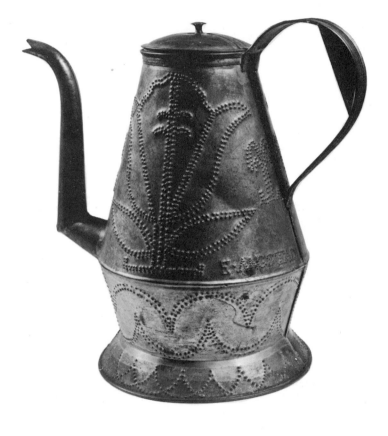

284 (left). Pot of lilies. Probably American. 1850–1875. Tin. H. 70". Stars decorate this metal vase that holds metal flowers. (Greenfield Village and Henry Ford Museum)

285 (above). Coffeepot. Marked "E. Angstad." Pennsylvania. C. 1800. Tin, punched, with brass finial. H. 10". Punched tin decoration also appears on lanterns and on the panels of pie safes. (Private collection; photograph courtesy Leah and John Gordon)

286 (opposite, top left). Cake board. J. Conger. Massachusetts(?). C. 1800. Wood. W. 27¼". Many national symbols are incorporated into the design of this cake board. The American flag, an American Indian, the eagle, an American shield, and the motto, "Free and Independent," are some of the devices included. (Greenfield Village and Henry Ford Museum)

287 (opposite, left). Butter print. C. 1840. Wood. Diameter 4¼". Floral devices, including the morning glory, the clover, and the tulip, appear more often on butter prints than the eagle on this example. (Greenfield Village and Henry Ford Museum)

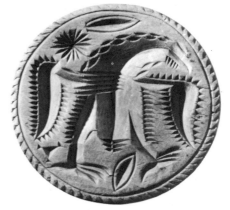

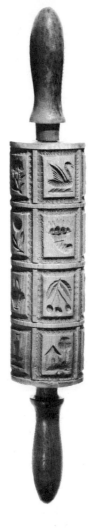

288 (far right). Rolling pin. Pennsylvania(?). C. 1850. Pine cylinder pivoted on a maple shaft. L. 18¼". Twenty incised designs of flowers, fruits, animals, birds, buildings, and household objects could be transferred from this rolling pin to the cookie batter. (Greenfield Village and Henry Ford Museum)

289 (below). Cake board. Pennsylvania. C. 1800. Mahogany. W. 14⅜". An early hand-drawn fire engine, a fireman's ladder, and a fireman sounding the alarm are part of the design on this "Superior" cake board. (Index of American Design)

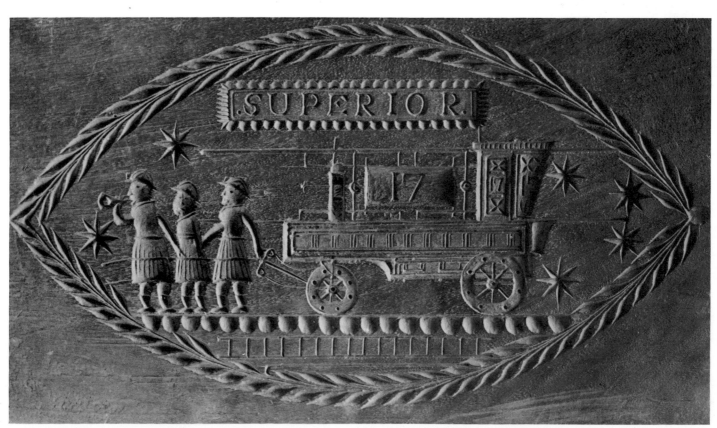

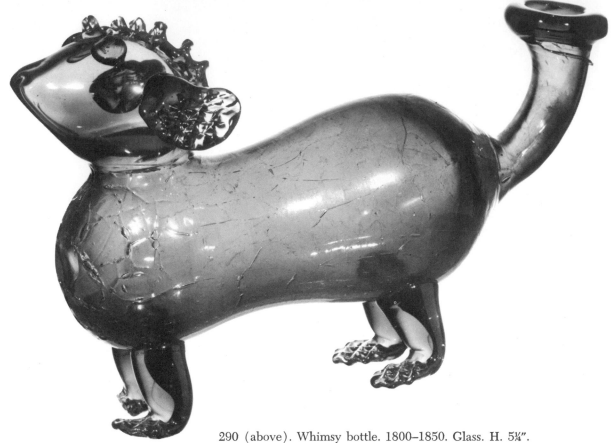

290 (above). Whimsy bottle. 1800–1850. Glass. H. 5¼".
This bottle was blown from amber-colored glass. (Greenfield
Village and Henry Ford Museum)

291 (left). Whimsy. Pittsburgh, Pennsylvania. 1800–1850. Glass.
H. 4⅜". The rooster finial was a popular motif with glassblowers, for it
also appears on numerous blown sugar bowl covers. (Greenfield Village
and Henry Ford Museum)

292 (above). Whimsy. Pennsylvania(?). 1800–1825. Glass. L. 5¼".
This figure of clear aquamarine glass is perhaps intended to represent a
peacock. (Greenfield Village and Henry Ford Museum)

Glassmakers, like potters, became casualties of the Industrial Revolution. Up until the time that mechanical devices were invented to mass-produce glass products, each piece was a one-of-a-kind creation and, therefore, a costly and prized object. Those who could not afford the luxury of glass were forced to content themselves with tin or pottery substitutes.

A glass manufacturing plant like the Tibbey Factory, figure 294, was able to price its products inexpensively enough so that they were within the reach of all.

End-of-day pieces, or whimsies, figures 290, 291, and 292, were fashioned by glassworkers as take-home presents for family and friends. They were shaped in a variety of forms that expressed the creativity of the individual artist.

293 (above). Glassmaking tools. This group of glassmaking tools and paperweights belonged to Ralph Barber, an employee of Whitall, Tatum & Company at Millville, New Jersey, during the early 1900s. (Greenfield Village and Henry Ford Museum)

294 (below). Painting of the Tibbey Bros. Glassworks, Sharpsburg, Pennsylvania. W. Heerlein. Pennsylvania. 1880. Watercolor on paper. 14¾″ × 22⁷⁄₁₆″. Tibbey Bros. manufactured many of the bottles used by the H. J. Heinz Company, originator of the famous "57 Varieties." (Greenfield Village and Henry Ford Museum)

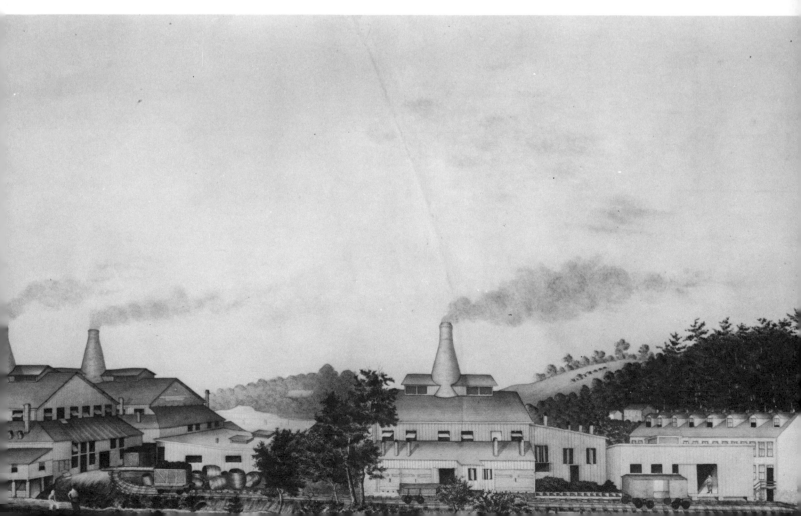

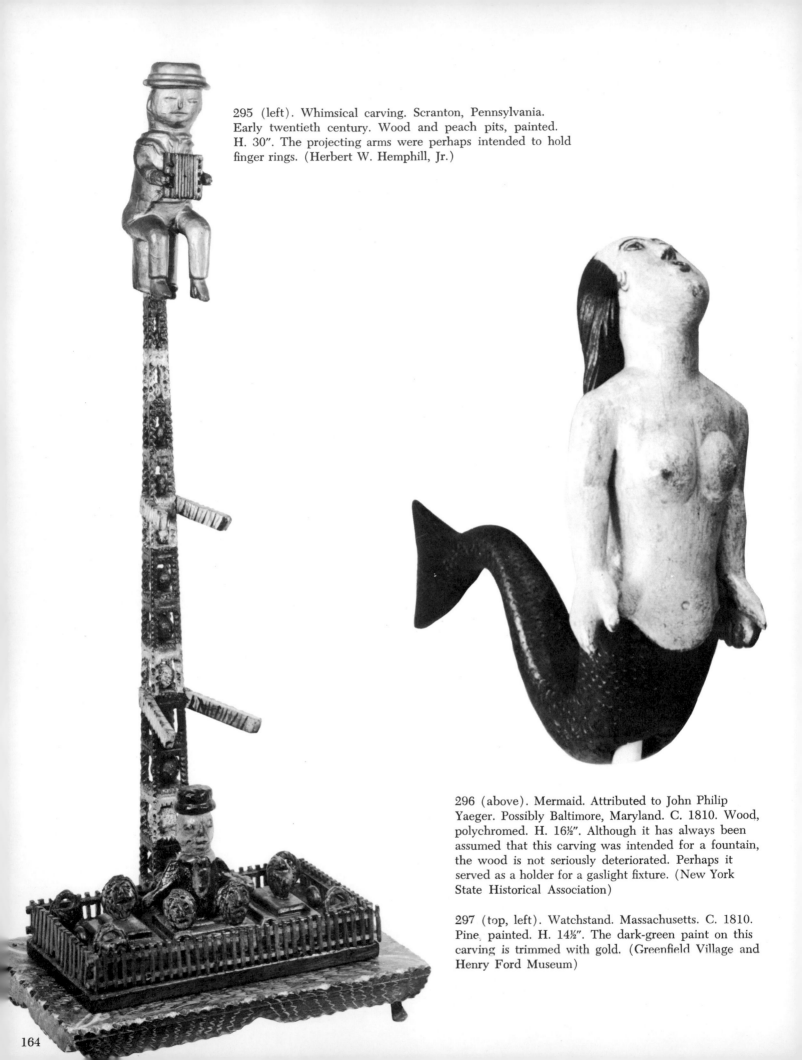

295 (left). Whimsical carving. Scranton, Pennsylvania. Early twentieth century. Wood and peach pits, painted. H. 30″. The projecting arms were perhaps intended to hold finger rings. (Herbert W. Hemphill, Jr.)

296 (above). Mermaid. Attributed to John Philip Yaeger. Possibly Baltimore, Maryland. C. 1810. Wood, polychromed. H. 16½″. Although it has always been assumed that this carving was intended for a fountain, the wood is not seriously deteriorated. Perhaps it served as a holder for a gaslight fixture. (New York State Historical Association)

297 (top, left). Watchstand. Massachusetts. C. 1810. Pine, painted. H. 14½″. The dark-green paint on this carving is trimmed with gold. (Greenfield Village and Henry Ford Museum)

298 (right). Bandbox. Connecticut(?). C. 1890. Wood, painted. H. 17″. When raised, the roof of this carving reveals a small storage compartment. Many European prototypes are known for this piece. It is possible that it was made by an immigrant. (Herbert W. Hemphill, Jr.)

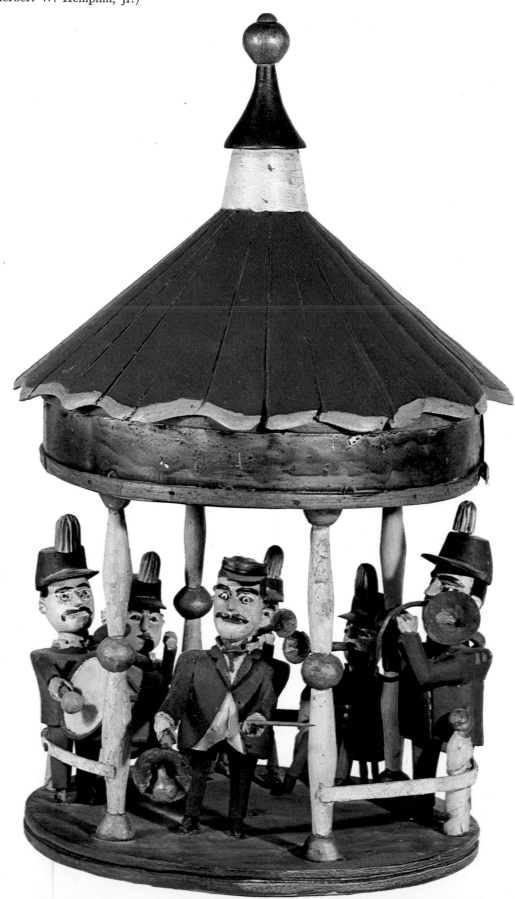

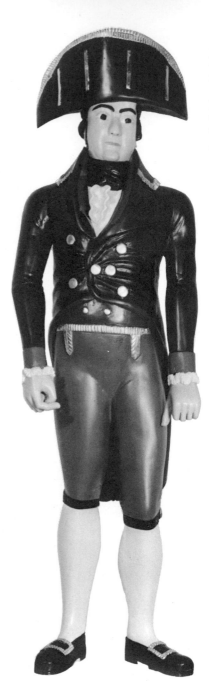

299 (left). Sir William Pitt. Joseph Wilson. Newburyport, Massachusetts. 1801. Wood. H. 78". "Lord" Dexter commissioned this figure to be carved for his outdoor museum, figure 300. (Smithsonian Institution)

300 (below). View of the mansion of "Lord" Timothy Dexter at Newburyport, Massachusetts. Boston. 1810. Mezzotint. L. 26⅞". The images of Sir William Pitt and other world-famous people stand atop the pedestals and arches in Timothy Dexter's garden. (Greenfield Village and Henry Ford Museum)

301 (opposite, right). Bird. Oneonta, New York. Third quarter of the nineteenth century. Wood. H. 28". This figure, which originally topped a barn, was later taken down and used as a lawn or garden piece. (Mr. and Mrs. J. Roderick Moore)

"I was born when grat powers Rouled—I was borne in 1747, January 22; on this day, in the morning A grat snow storme—the sines in the seventh house wives; mars came fored—Joupeter stud by holding the Candel—I was to be one grate man." [18]

So wrote "Lord" Timothy Dexter (1747–1806), the renowned Newburyport, Massachusetts, eccentric who commissioned a local shipcarver, Joseph Wilson, to ornament his house and property with a group of august statues, which included himself and George Washington, Thomas Jefferson, John Adams, Napoleon Bonaparte, and others. His unusual character was complemented by his close circle of friends—mystical seers and astrologers. Though Dexter on several occasions took to drink, one of his favorite pastimes was to escape from his wife to a summerhouse, where he smoked his pipe and read songs such as those composed by his poet laureate, Jonathan Plummer:

> His house is filled with sweet perfumes,
> Rich furniture doth fill his rooms,
> Inside and out it is adorn'd
> And on the top an eagle's form'd.[19]

Dexter built a tomb for himself on the grounds of his estate. "In one of the banks of the garden is an elegant new Tomb, on the top of which is erected the Temple of Reason, twelve feet square, eleven feet high with one hundred and fifty-eight squares of glass in it." [20] He had a coffin made of choice mahogany painted green and white, and legend maintains that he often rested in it while visiting the tomb, for it was a cool and comfortable place on warm New England summer days. Occasionally he even enjoyed funeral rehearsals.

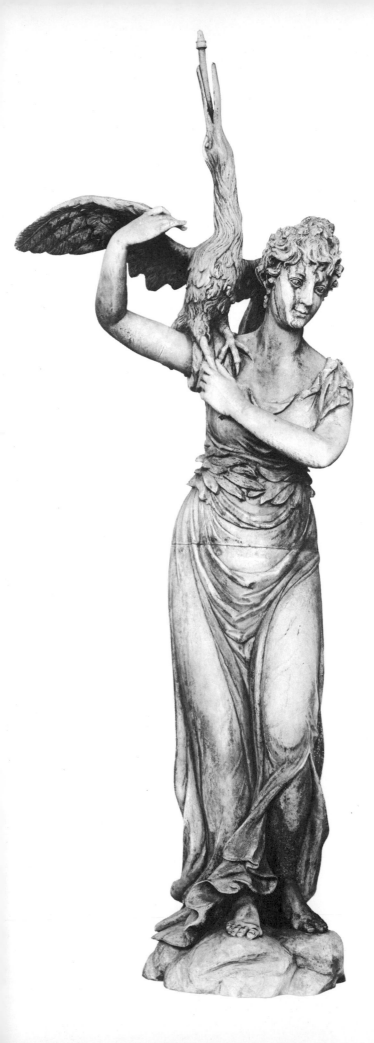

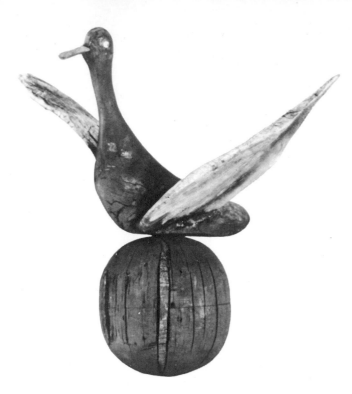

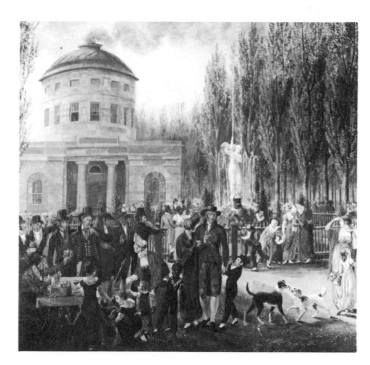

302 (left). Nymph and Bittern. Wooden original carved by William Rush in 1809. Philadelphia. Cast in bronze in 1854. H. 91″. The work of William Rush, the famous Philadelphia carver, was admired by Benjamin Latrobe: "Commerce has called for beauty in the forms and decorations of her ships, and where in Europe is there a Rush?" [21] (Fairmount Park Commission)

303 (above). Detail of the painting *Fourth of July in Center Square, Philadelphia*. John Lewis Krimmel. 1810–1812. Oil on canvas. H. 23″. William Rush's figure of a nymph holding a bittern is visible in the fountain at the Center Square pumphouse. (Pennsylvania Academy of Fine Arts)

BIRDS OF A FEATHER

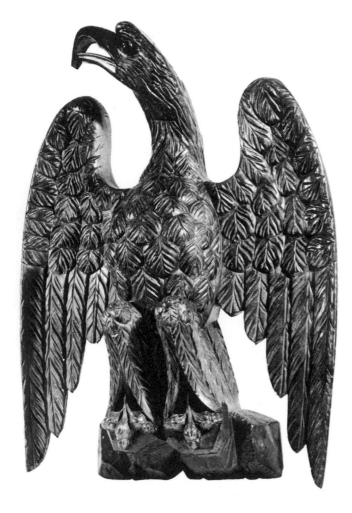

304 (above). Eagle. New Hampshire. 1790–1800. Maple, gilded. H. 32″. Because this carving possesses a strong vertical thrust, it is conceivable that it was used as an architectural embellishment. (Private collection; photograph courtesy Leah and John Gordon)

305 (opposite). Eagle. New Jersey. Nineteenth century. Wood. H. 21½″. Few representations of the national symbol have the quality of this carving. The backswept wings and the forward thrust of the head create a dramatic sense of power. (Mr. and Mrs. Edwin Braman)

Following the American Revolution, a distinct home-grown folk-art style began to emerge in the United States. The nationalistic themes that inspired the art of the new democracy were responsible for the creation of countless representations of the eagle, which became the symbol of the new republic in 1782.

Not everyone was pleased when the Continental Congress selected the bald eagle as the national emblem. Benjamin Franklin, a member of the original committee assigned to choose the seal of the United States, preferred the turkey: "A much more respectable Bird and a true Native of America . . . He is a bird of courage and would not hesitate to attack a grenadier of the British Guards." [22] Franklin considered the eagle, a bird of prey, to be ". . . of bad moral character." [23]

Eagles carved by John Hales Bellamy (1836–1914) are probably some of the most decorative and vital representations of this bird, figure 314. In the spring of 1857 Bellamy was apprenticed to the renowned woodcarver, Laban Beecher, at Charlestown, Massachusetts. For nearly a decade he remained at the Charlestown Navy Yard where he developed a highly personal style by simplifying details and formalizing his designs. By 1872 he had moved to Portsmouth, New Hampshire, where he maintained, at 17 Daniel Street, a prosperous studio that could "service a single order for 100 eagles." Also available were "emblematic frames and brackets." In addition, he offered "house, ship, furniture, sign and frame carving. Garden figures furnished at short notice." [24] John Bellamy, like many folk artists, spread himself over many fields and was proficient in several. An ingenious inventor, he held several patents; he wrote poetry and articles for newspapers; and the *Portsmouth Herald,* upon his death, proclaimed him ". . . a most entertaining companion; a wit and a philosopher combined, and with all, a man whose like is rarely to be met with." [25]

Though American folk artists expressed their enthusiasm for their country and its newly won independence through eagle carvings, they carved many other types of birds as well. The familiar barnyard turkey, hen, and rooster, and numerous water birds attest to the artists' great originality. Miniature birds, despite their small size, can often be as impressive as carvings many times larger.

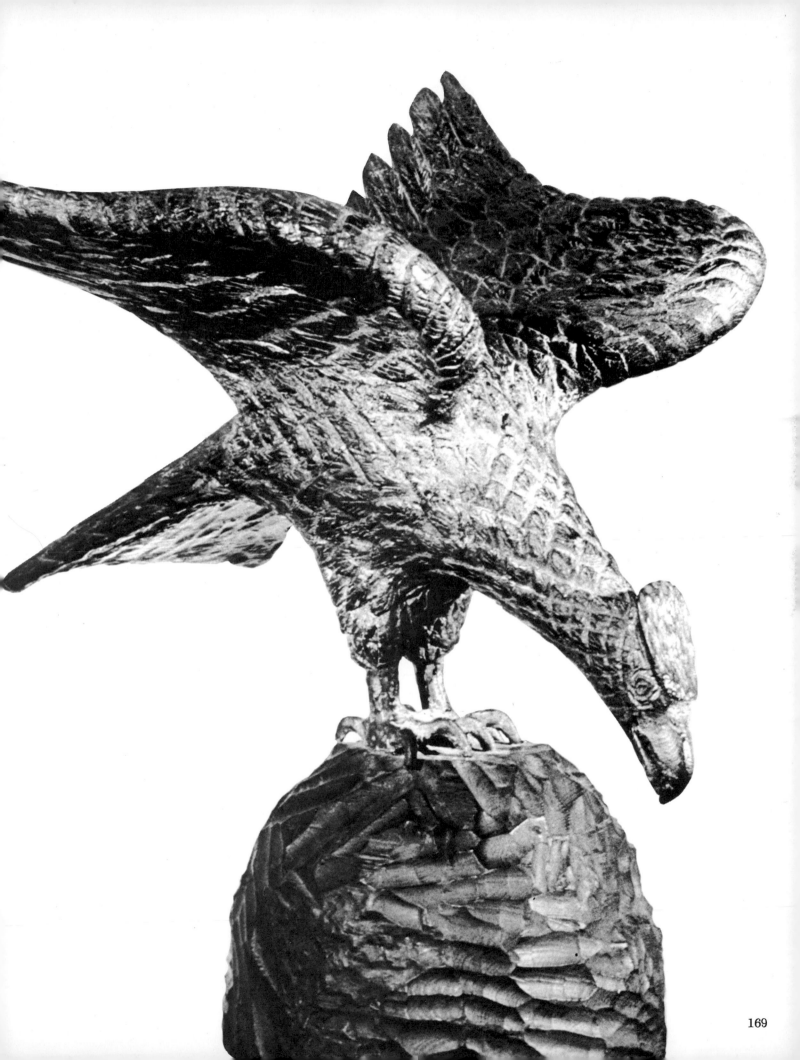

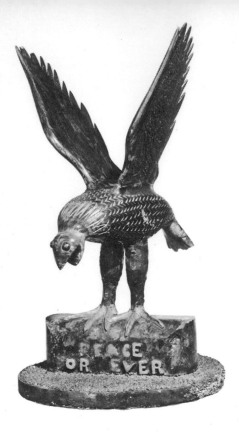

306 (left). Eagle. Maine. Second half of the nineteenth century. Pine, painted. H. 20″. Carved and applied letters form the inscription "U. S. PEACE FOREVER" on the base of this dynamic piece. (Private collection)

307 (below). Eagle. John Jelliff (1813–1893). Newark, New Jersey. C. 1830. Wood. H. 12½″. John Jelliff carved an overall diaper pattern on the wings and body of this eagle. The piece has descended in the LeMassena-Jelliff family and is currently owned by Jelliff's great-grandson. Jelliff was a famous nineteenth-century furniture maker who lived and worked in Newark. (William LeMassena)

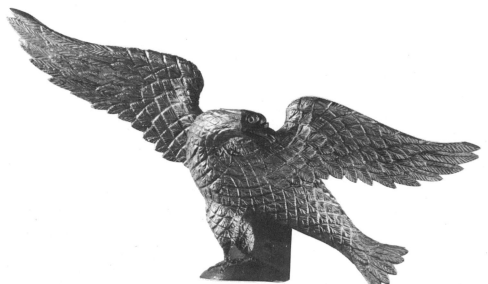

308 (below). Eagle. New England. 1790–1810. Pine, painted and gilded. H. 25¾″. This large, handsome eagle is painted black. Gold leaf has been applied to the wing tips, the head, and the snake, creating a striking contrast. (Greenfield Village and Henry Ford Museum)

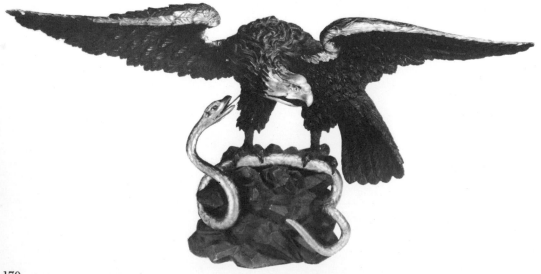

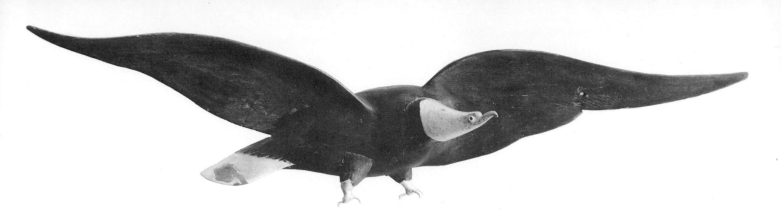

309 (above). Eagle. New Jersey. C. 1880. Wood, painted. L. 25″. Though eagles are known for their ferocity, most folk artists gave them amiable expressions. (George E. Schoellkopf Gallery)

310 (below, left). Eagle. Massachusetts. 1880–1900. Pine, gilded. H. 27″. This is an effectively stylized bird. (Private collection; photograph courtesy Leah and John Gordon)

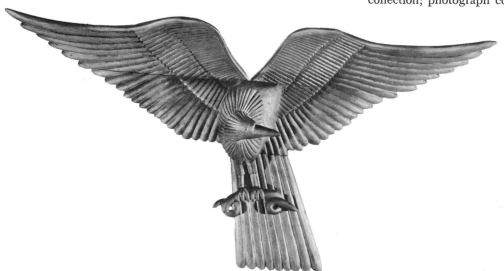

311 (below). Eagle with flags and the slogan "Happy New Year." John Bellamy. Late nineteenth century. Pine, painted red, white, and blue. L. 38″. Bellamy executed several eagles with special slogans that were intended as gifts for his friends. Among the other recorded greetings are "Merry Christmas" and "Happy Birthday." (Gary C. Cole)

312 (below). Eagle. C. 1850. Wood. H. 17″. This impressive piece retains much of its original blue paint. (Mr. and Mrs. Harvey Kahn)

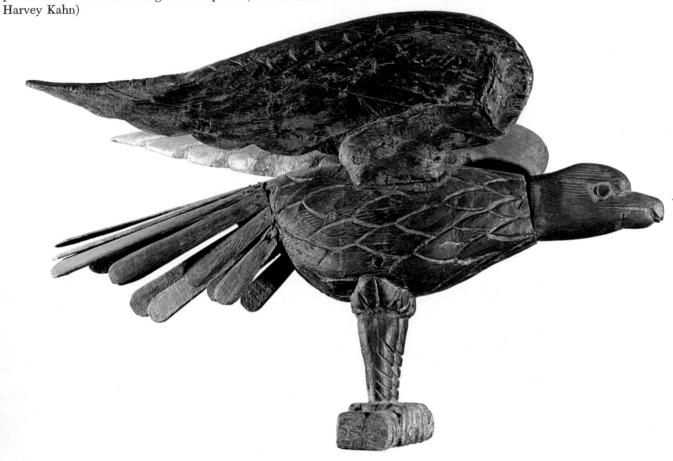

313 (below). Eagle and snake. Attributed to the Skillin workshop. Boston. C. 1790. Wood, gilded. W. 72″. This eighteenth-century carving is believed to have originally been part of the decoration on the Boston Custom House. (Dr. and Mrs. William Greenspon)

314 (opposite, above). Eagle and flag. Attributed to John Bellamy. 1860–1875. Pine. W. 36½″. Bellamy's earliest carvings are more representational than his later highly stylized creations. (Greenfield Village and Henry Ford Museum)

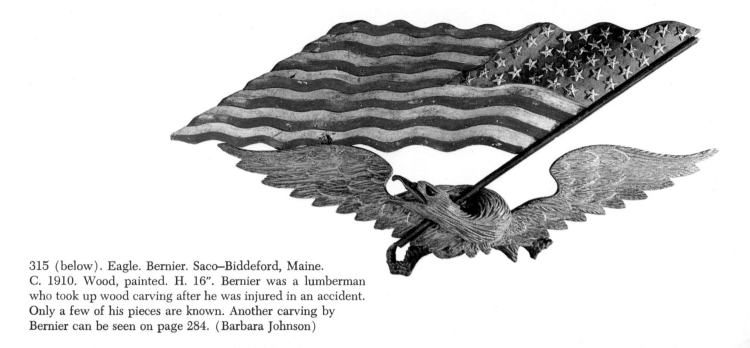

315 (below). Eagle. Bernier. Saco–Biddeford, Maine.
C. 1910. Wood, painted. H. 16″. Bernier was a lumberman
who took up wood carving after he was injured in an accident.
Only a few of his pieces are known. Another carving by
Bernier can be seen on page 284. (Barbara Johnson)

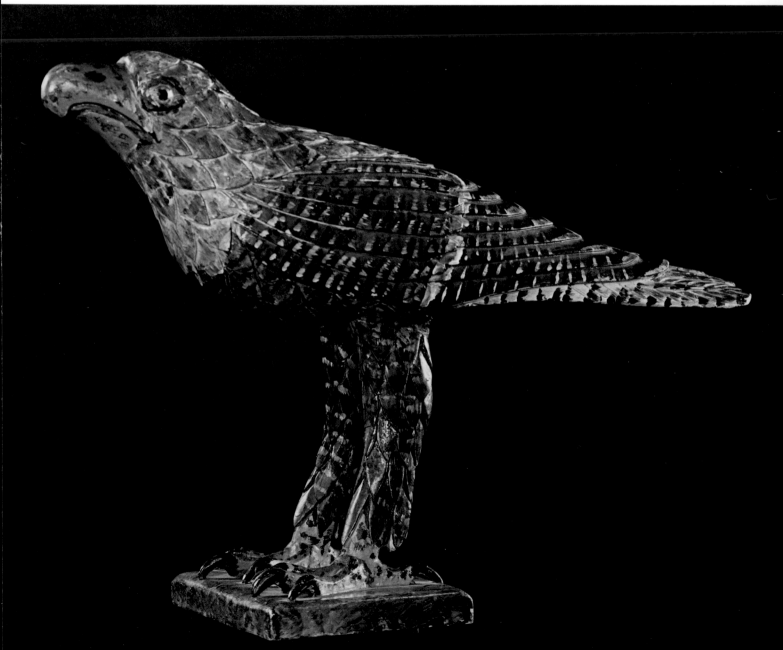

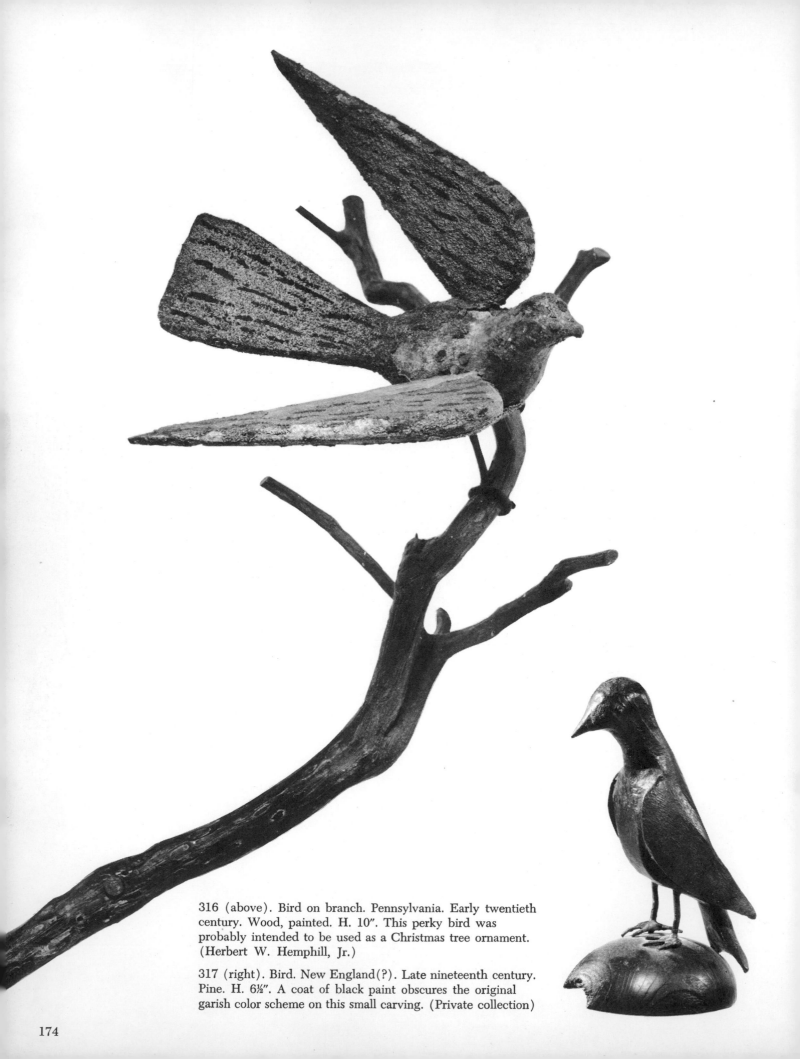

316 (above). Bird on branch. Pennsylvania. Early twentieth century. Wood, painted. H. 10″. This perky bird was probably intended to be used as a Christmas tree ornament. (Herbert W. Hemphill, Jr.)

317 (right). Bird. New England(?). Late nineteenth century. Pine. H. 6½″. A coat of black paint obscures the original garish color scheme on this small carving. (Private collection)

318 (right). Birdhouse. Pennsylvania. 1880–1900. Wood and tin. H. 25½". The artist apparently decided it was easier to carve birds for his birdhouse than to attract them with suet. (Greenfield Village and Henry Ford Museum)

319 (below). Group of ornamental bird carvings. Late nineteenth century. Wood. H. of tallest bird, 7½". The individuality of these carvings is heightened by bright paint. (Greenfield Village and Henry Ford Museum)

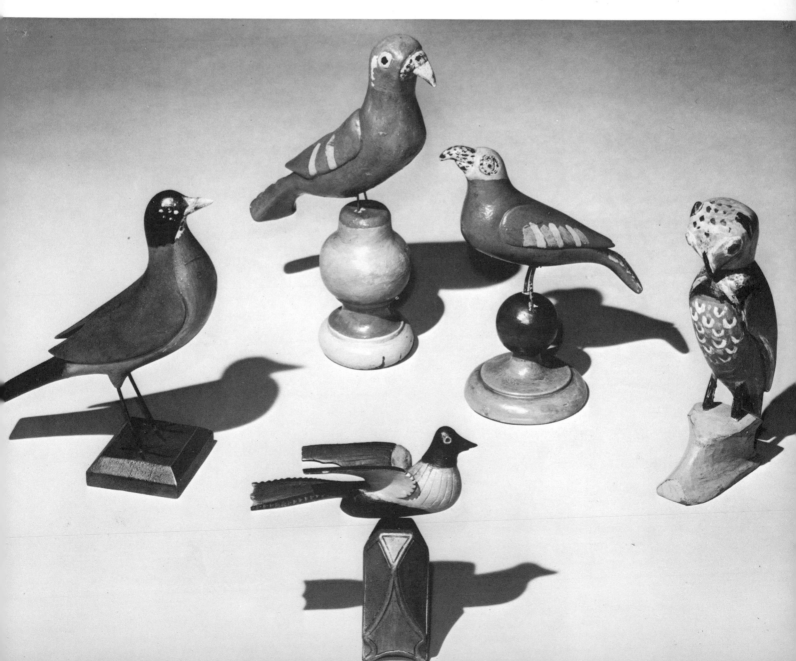

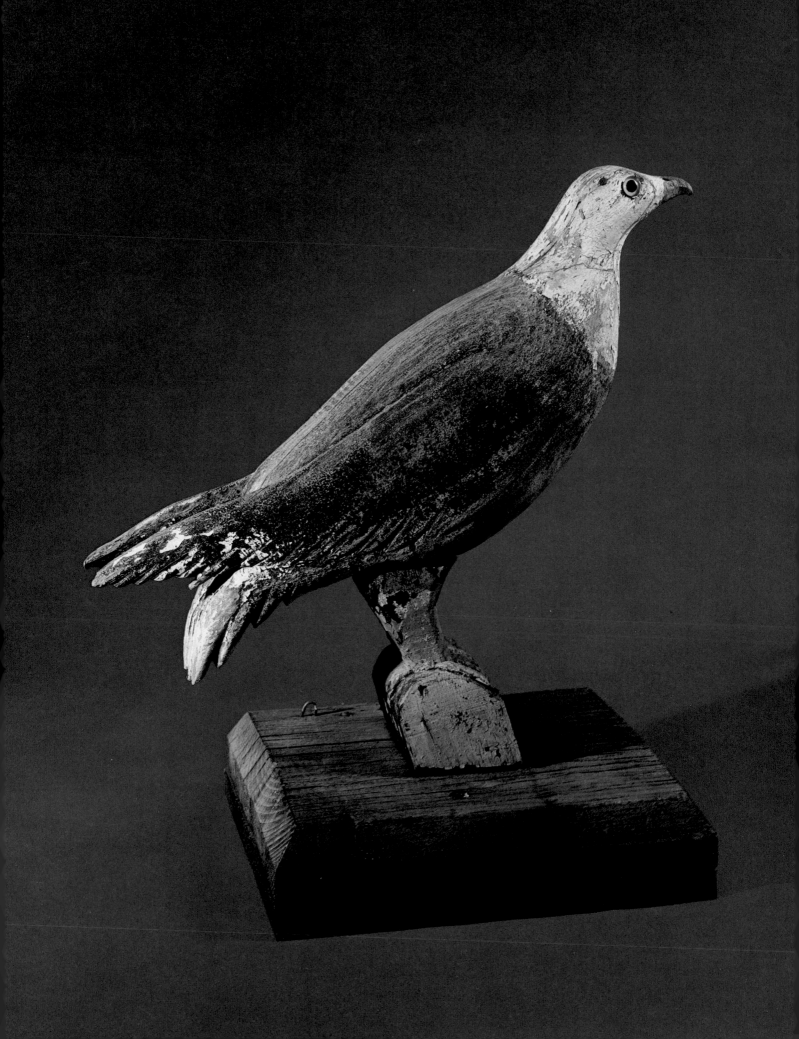

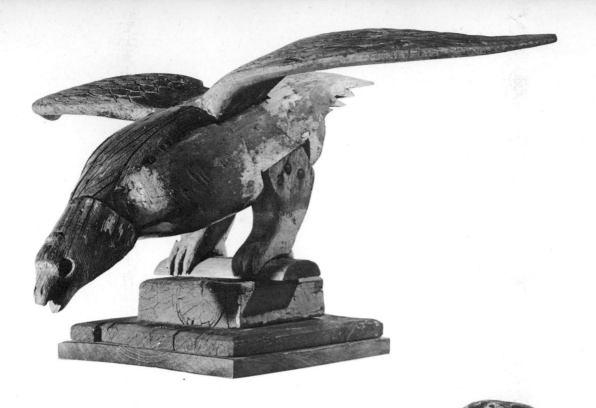

320 (opposite). Seabird. Dixfield, Maine. Second half of the nineteenth century. Wood. H. 18″. The unknown artist who fashioned this bird created a masterpiece of American folk sculpture. The bold and yet delicate details are further enhanced by the fine weathering of the paint. This seabird was used as a ridgepole ornament on a house. (Private collection)

321 (above). Seabird. Dixfield, Maine. Second half of the nineteenth century. Wood. Wingspread 35¼″. Although quite different in feeling from figure 320, this piece was probably carved by the same unidentified artist, for both sculptures were taken from the same ridgepole. This carving is notable for the sense of power and motion that seems to surge through it. (Kennedy Galleries, Inc.; photograph courtesy James Kronen Gallery)

322 (right). Penguin, one of a pair. Nantucket, Massachusetts. Early twentieth century. Wood, painted. H. 20″. These carvings were fencepost ornaments at the Nantucket Yacht Club. (Herbert W. Hemphill, Jr.)

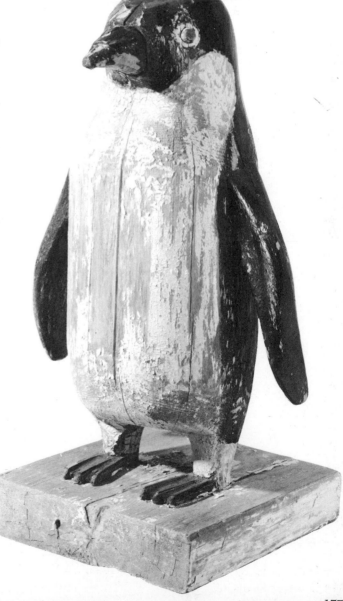

323 (right). Turkey. Miles B. Carpenter. Waverly, Virginia. 1972. Pine. H. 6″. The head, body, and base of the carving are formed from one piece of wood. The feathers are individual pieces pegged into position. (Private collection)

324 (below). Birds on stand, one of a pair. Pennsylvania. Third quarter of the nineteenth century. Wood and wire, polychromed. H. 14″. Whimsical bird trees were popular among the Pennsylvania Germans. This example retains its original paint. (Howard and Jean Lipman)

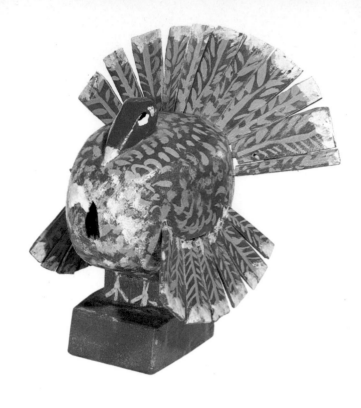

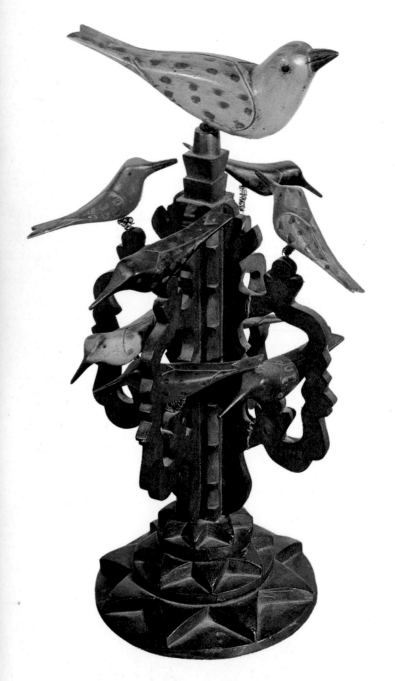

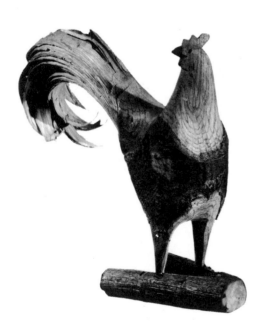

325 (above). Rooster. Virginia. C. 1950. Wood. H. 6¼″. Only a jackknife was used to make this delightful sculpture, which was carved out of a tree branch. Another branch forms the base. (George O. Bird)

327 (opposite, below left). Rooster. John Reber (1857–1938). Pennsylvania. C. 1830. Wood, polychromed. H. 8″. Reber lived at Slatington, Pennsylvania, and among collectors is known as the "Slatington carver." Another Reber carving is illustrated on page 338. (Private collection; photograph courtesy Leah and John Gordon)

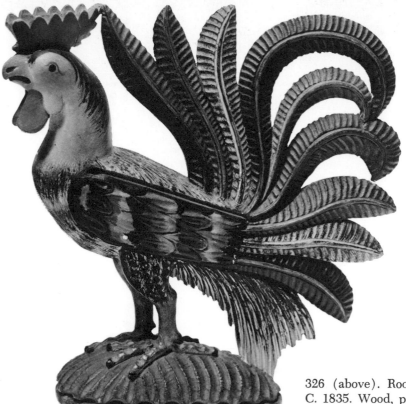

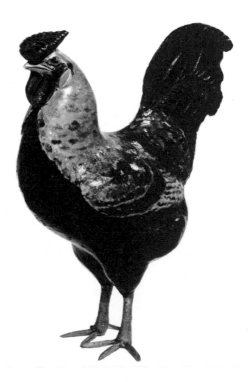

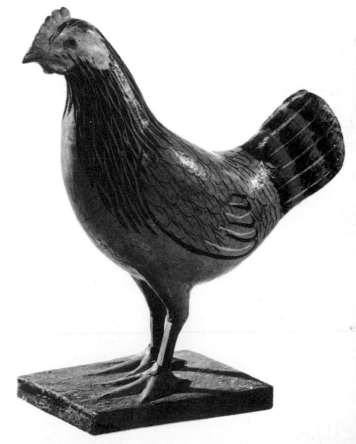

326 (above). Rooster. Lancaster County, Pennsylvania. C. 1835. Wood, polychromed. H. 8″. Countless European prototypes are known for this type of bird carving. After coming to America, emigrants from Europe continued to carve traditional subjects. (Private collection; photograph courtesy Leah and John Gordon)

328 (right). Hen. Pennsylvania. Late nineteenth century. Wood. H. 5¾″. The body of the hen has been meticulously painted. (Private collection)

Few decoy carvers have enjoyed the reputation that A. Elmer Crowell (1862–1951) developed through the years, both as a carver of decoys and as a witty man. Wallace H. Furman suggests that Bill Mackey, the distinguished decoy collector, and Crowell are "settin' up in Heaven, talkin' and a-jawin' . . . lollin' in the shade, baitin' hooks and anglin', settin' by the shallows forever and forever, swappin' yarns an' fishin' in a little river." [26] Crowell once told a friend that he made about eight full-bodied duck weathervanes like figure 331; these were never mounted outside, but were used as interior ornaments so that the fine carving and painting would be preserved.

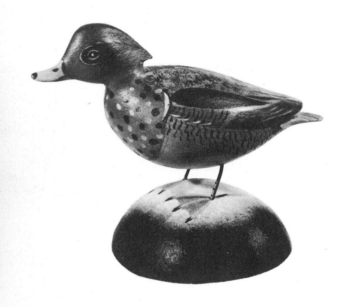

329 (above). Shop sign. Believed to have been made by A. Elmer Crowell for his own business. East Harwich, Massachusetts. 1875–1925. Wood. H. 19". (Shelburne Museum, Inc.)

330 (left). Green-winged teal. A. Elmer Crowell. East Harwich, Massachusetts. Early twentieth century. Wood. H. 2⅞". (Private collection)

331 (below). Red-breasted merganser weathervane. A. Elmer Crowell. East Harwich, Massachusetts. 1907–1915. Wood, painted. L. 30". (Private collection)

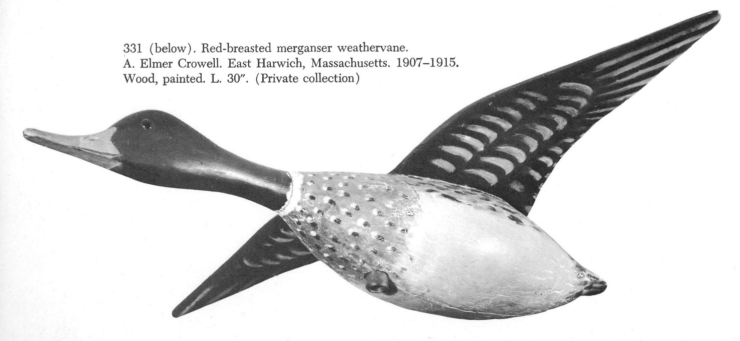

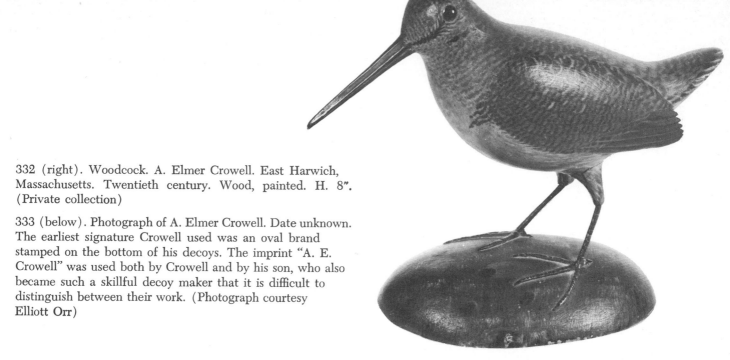

332 (right). Woodcock. A. Elmer Crowell. East Harwich, Massachusetts. Twentieth century. Wood, painted. H. 8". (Private collection)

333 (below). Photograph of A. Elmer Crowell. Date unknown. The earliest signature Crowell used was an oval brand stamped on the bottom of his decoys. The imprint "A. E. Crowell" was used both by Crowell and by his son, who also became such a skillful decoy maker that it is difficult to distinguish between their work. (Photograph courtesy Elliott Orr)

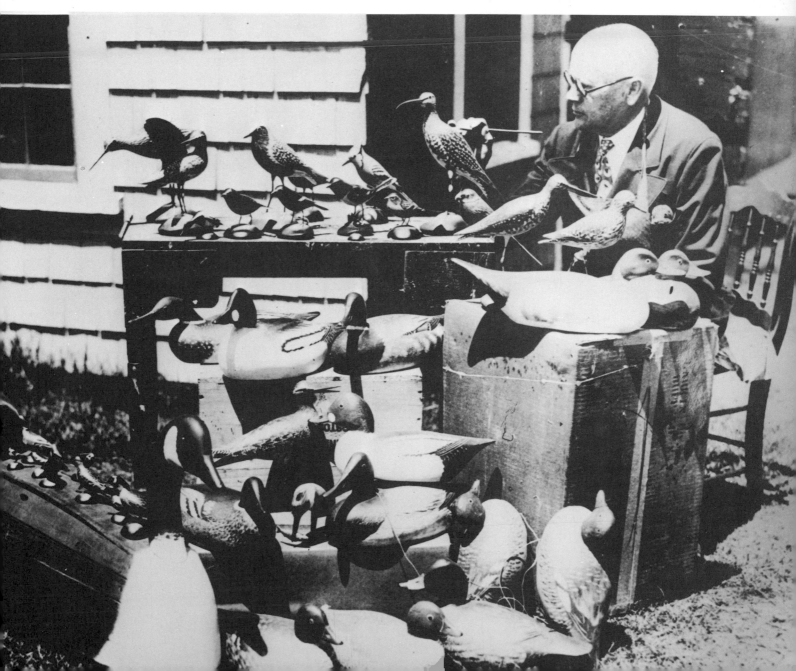

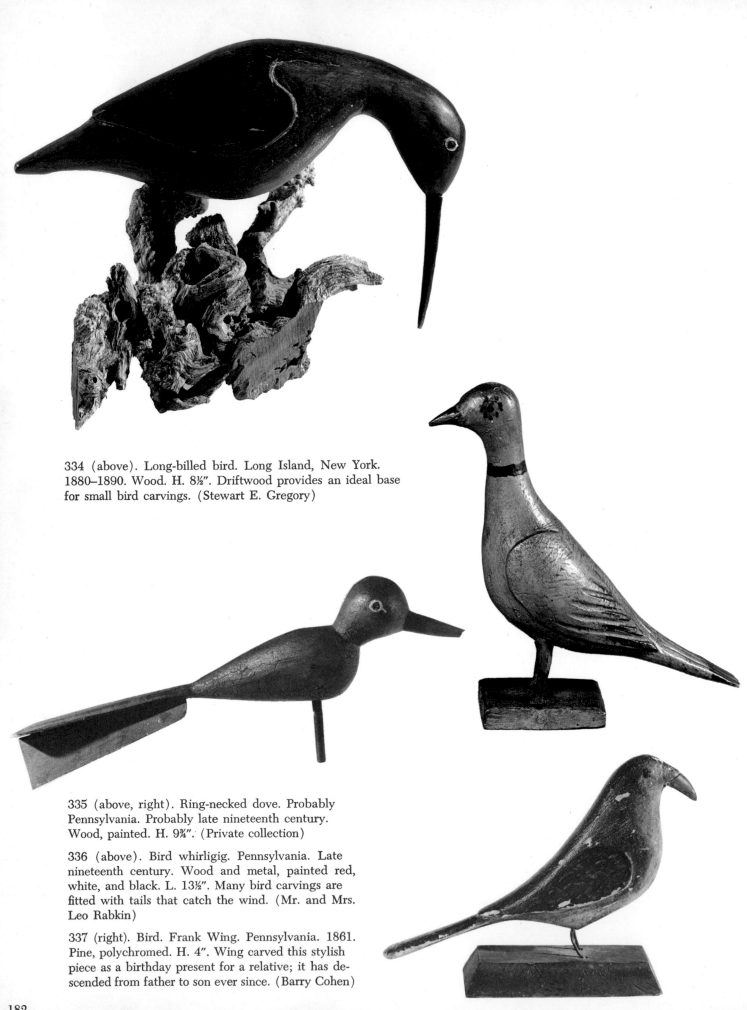

334 (above). Long-billed bird. Long Island, New York. 1880–1890. Wood. H. 8½″. Driftwood provides an ideal base for small bird carvings. (Stewart E. Gregory)

335 (above, right). Ring-necked dove. Probably Pennsylvania. Probably late nineteenth century. Wood, painted. H. 9¾″. (Private collection)

336 (above). Bird whirligig. Pennsylvania. Late nineteenth century. Wood and metal, painted red, white, and black. L. 13½″. Many bird carvings are fitted with tails that catch the wind. (Mr. and Mrs. Leo Rabkin)

337 (right). Bird. Frank Wing. Pennsylvania. 1861. Pine, polychromed. H. 4″. Wing carved this stylish piece as a birthday present for a relative; it has descended from father to son ever since. (Barry Cohen)

338 (right). Black-backed gull. Late nineteenth century(?). Wood, painted. H. 10″. The gull, an aquatic bird, has webbed feet and usually lives near large bodies of salt water. The folk artist who fashioned this piece either was unfamiliar with the bird or simply chose not to bother webbing the wooden feet. Small rocks have been stuck to the octagonal base to create a more lifelike setting. (Private collection)

339 (below). Hooded merganser. Late nineteenth century(?). Wood, painted. H. 11″. The feet and legs of this delightful carving appear to be covered with the actual skin of a duck. The edges of the base are grain-painted and tiny shells have been sprinkled over the surface. (Private collection)

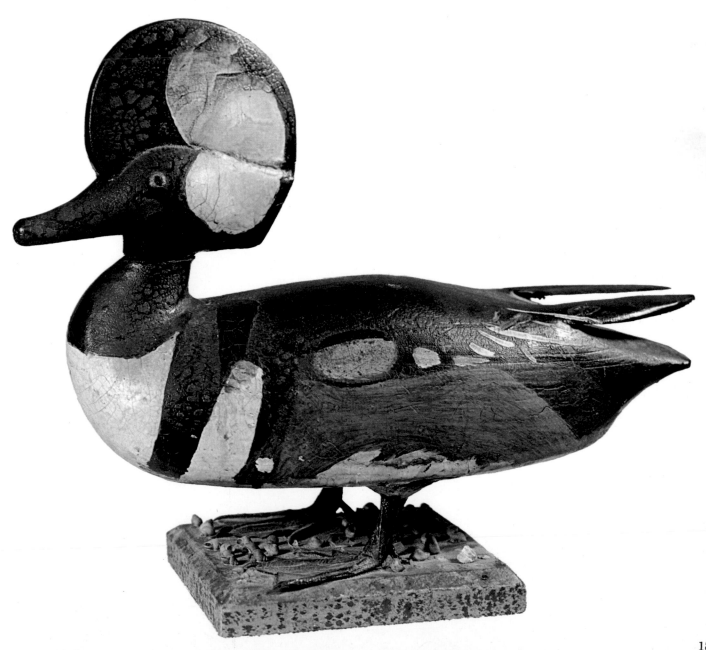

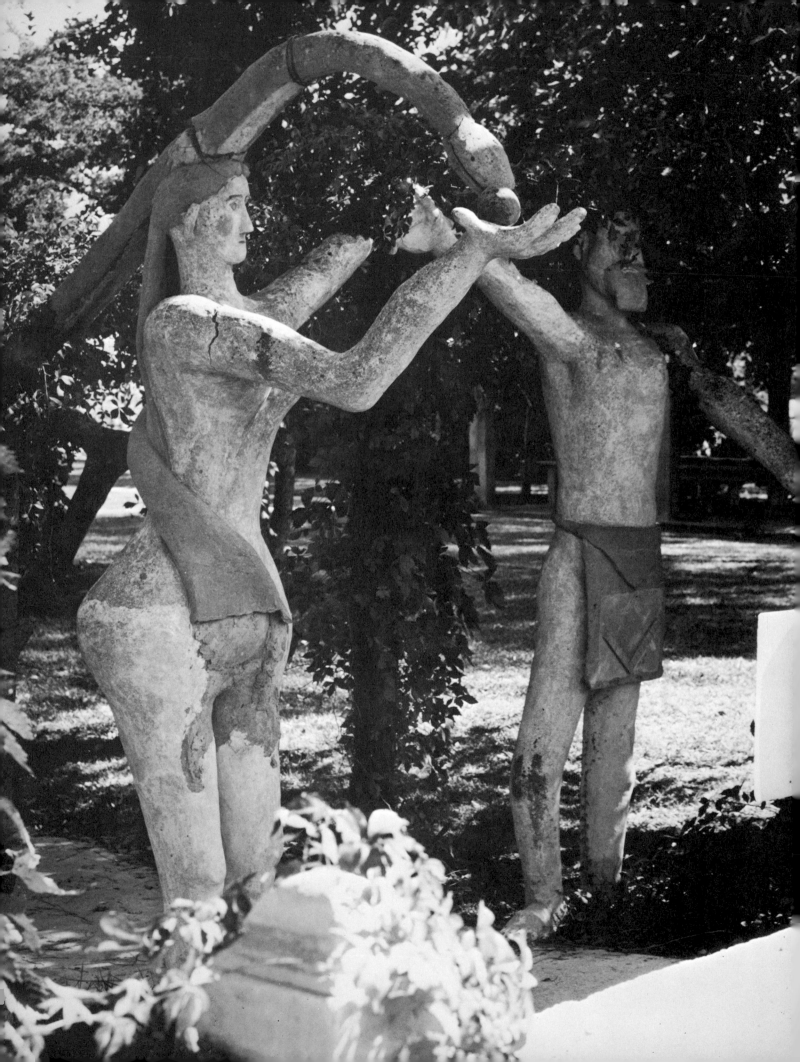

THE RELIGIOUS OBJECT

This chapter acknowledges the fact that from the earliest time man's need for religion in his life has been a constant inspiration for great art.

While America has not produced a Michelangelo, it can be said that the most powerful religious art created here is that of its folk artists. One needs only to study the stone sculptures by William Edmondson, the bas-reliefs by Elijah Pierce, the Perates icons, or James Hampton's incredible Throne of the Third Heaven to understand the depth of the belief in God that is manifested in these splendid pieces.

S. P. Dinsmoor (1843-1932) built in 1907 at Lucas, Kansas, "The most unique home, for living or dead, on earth." [27] His Rock Log Cabin was embellished through the years with a Garden of Eden, and countless other sculptures and buildings. By 1927 Dinsmoor had used over 113 tons or approximately 2,273 sacks of cement to form a unique expression of American artistic creativity. Dinsmoor, a deeply religious man, explained his elaborate sign just visible in figure 340, "I could hear so many as they go by, sing out, 'What is this?' so I put this sign up. Now they can read it, stop or go on, just as they please." [28] Of his Adam and Eve, figure 340a, he explained, "Two snakes form the grape arbor. One is giving Eve the apple. The Bible tells all about that. The other snake didn't have any apple, so Adam got hot about it, grabbed it, and is smashing its head with his heel. That shows the disposition of man. If he doesn't get the apple there is something doing. And the Bible says, the heel of the seed of the woman shall smash the serpent's head, or something to that effect." [29]

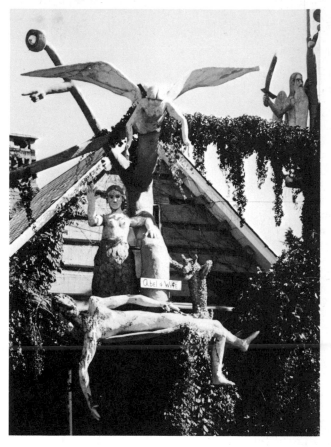

340 (below). Overall view of the cabin home of S. P. Dinsmoor. Lucas, Kansas. 340a (opposite). Adam and Eve. 340b (above). Abel Slain by Cain. Made from found objects and cement. (Photographs courtesy Mr. and Mrs. Wayne Naegele)

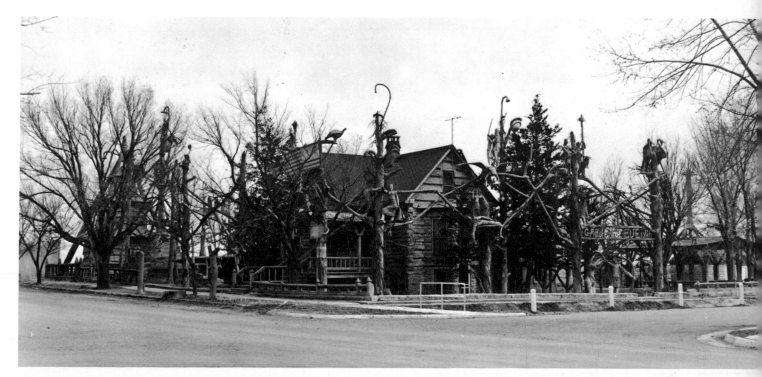

341, 341a (right). Crucifix. Dated 1796. Maple. H. 5¼″. Fort Pontchartrain du Detroit, now known as Detroit, Michigan, was founded on July 24, 1701, by Antoine de la Mothe Cadillac, a French colonial administrator. Throughout the eighteenth century, zealous missionaries attempted to convert the local Indians to the Christian religion. Several artifacts, created as a result of such conversions, demonstrate a combination of French and Indian designs. (Mr. and Mrs. James O. Keene)

342 (below). Nativity group. Michigan. C. 1850. Wood. H. of tallest figure, 13″. These carvings were found at the famous Indian settlement, Cross Village. (Mr. ond Mrs. James O. Keene)

343 (opposite). Crucifixion with angels. Joseph Koenig. Wisconsin. 1875. Wood, painted. H. 23″. Religious carvings were frequently inspired by illustrations in early Bibles and printed tracts. (Herbert W. Hemphill, Jr.)

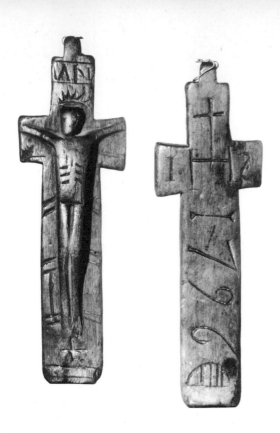

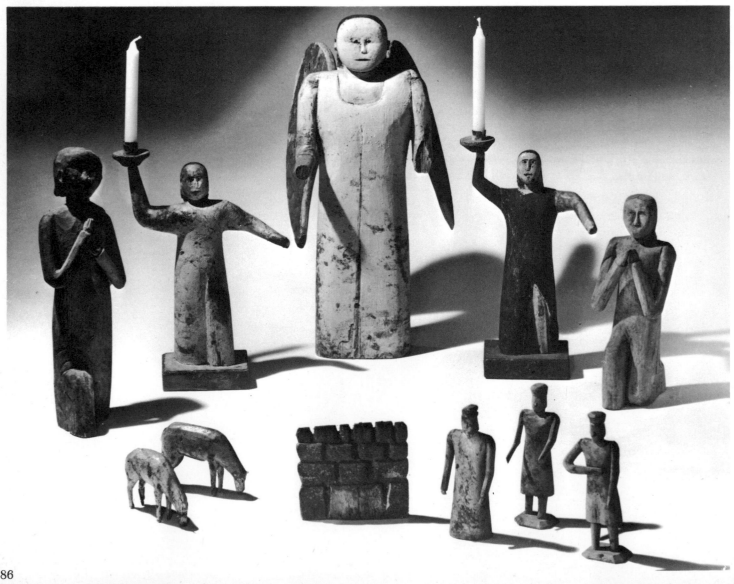

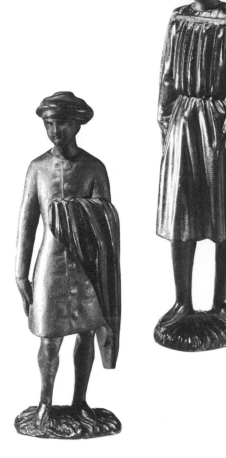

344, 345 (left). Wise Men. Roman Indercoffer. Norwalk, Ohio. 1844. Wood. H. 10¾″. These figures represent two of the three Magi and were originally part of a nativity group carved for St. Paul's Catholic Church in Norwalk. (Greenfield Village and Henry Ford Museum)

346 (below), 346a (opposite). Altarpiece. Lars Christenson. Benson, Minnesota. 1894–1904. Maple and black walnut applied to veneer on pine panels. H. 148″. Christenson, a Norwegian emigrant, came to America at the age of twenty-five and spent two years in Iowa before he moved north to Minnesota. Though he worked from 1897 to 1904 on his altarpiece, the lower section remains incomplete. The altarpiece was never used in the church for which it was intended. The detail on page 188 shows the Transfiguration and a decorative motif once identified by the carver as "The Angel Amongst Flowers." (Norwegian–American Museum)

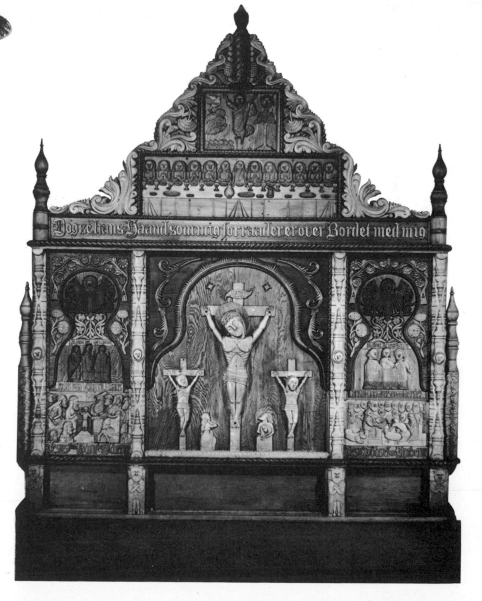

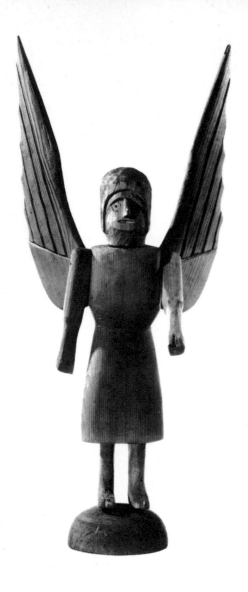

347 (left), 347a (opposite). Angel. Wisconsin. Mid-twentieth century. Pine. H. 16¾". Similar pieces attributed to the same unidentified craftsman have been found in Door County, Wisconsin. It is conceivable that the carver of this piece was familiar with the work of Albert Zahn. This representation of God's messenger exhibits an attention to detail that elevates it above similar carvings. An attempt has been made to refine the arms and legs; the face has been sensitively carved; and the wings, which flare out symmetrically, framing the head, have been shaped in a convincing manner. (Private collection)

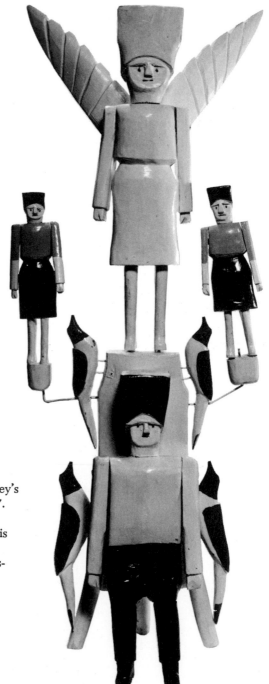

348 (right). Woodcarving. Albert Zahn (died 1950s). Bailey's Harbor, Door County, Wisconsin. C. 1950. Cedar. H. 31". Zahn was of German extraction. When he had completed his carvings, which he claimed were inspired by visions, his wife painted them. Much of Zahn's work is religious in nature, reflecting his Lutheran background. (Chicago Historical Society)

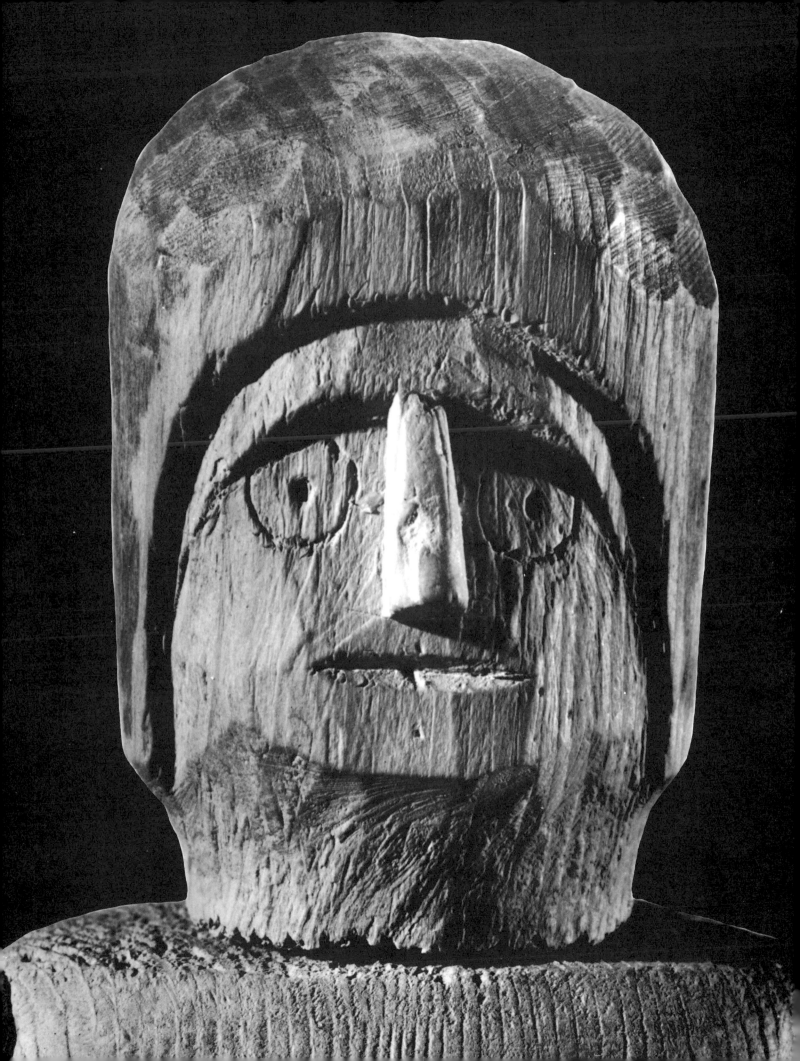

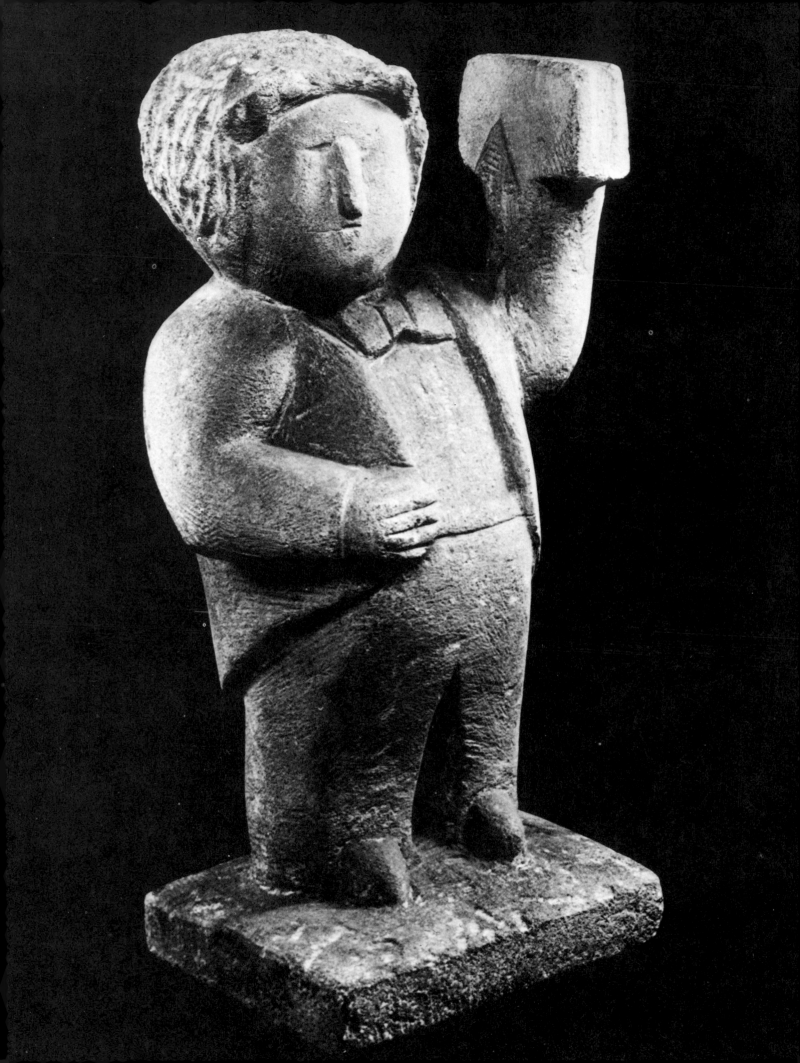

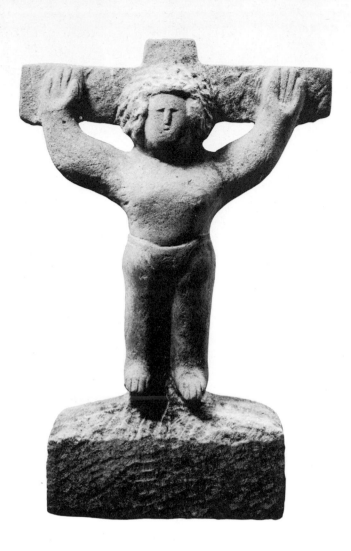

349 (opposite). Preacher. William Edmondson (c. 1883–1951). Nashville, Tennessee. C. 1937. Limestone. H. 17″. (Edmund L. Fuller)

350 (left). The Stone Cross. William Edmondson. Nashville, Tennessee. 1930–1940. Limestone. H. 47½″. (Abby Aldrich Rockefeller Folk Art Collection)

351 (below). Angel. William Edmondson. Nashville, Tennessee. C. 1939. Limestone. H. 25″. Edmondson supported himself with various jobs ranging from janitorial work to tombstone carving. Birds, beasts, "varmints," preachers, angels, and teachers were among his favorite subjects. He used limestone building blocks that he obtained from local rock quarries; his only tools were a simple mallet and a steel point fashioned from a railroad spike. (Edmund L. Fuller)

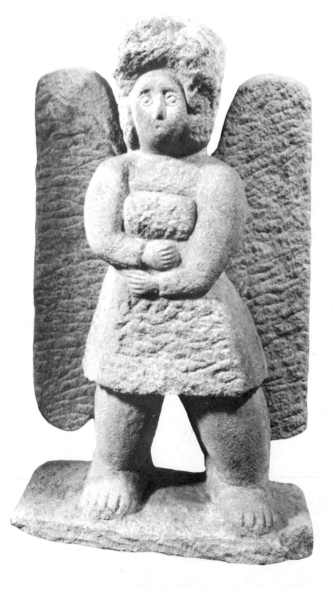

In 1934 William Edmondson, who was born in Davidson County, Tennessee, about 1883, had a vision. God appeared and commanded the stonecutter to take up a mallet and chisels. "I knowed it was God telling me . . . to cut figures . . . first to make tombstones . . . then figures. He gave me them two things." [30]

Though Edmondson carved numerous secular pieces, his preachers, angels, and religious figures are his most powerful sculptures. As he explained: "The Almighty talked to me like a natural man . . . He talked so loud he woke me up. It's wonderful. When God gives you something, you've got it for good, and yet you ain't got it. You got to do it and work for it . . . The Lord just say, 'Will, cut that stone . . . and it better be limestone, too . . .' " [31]

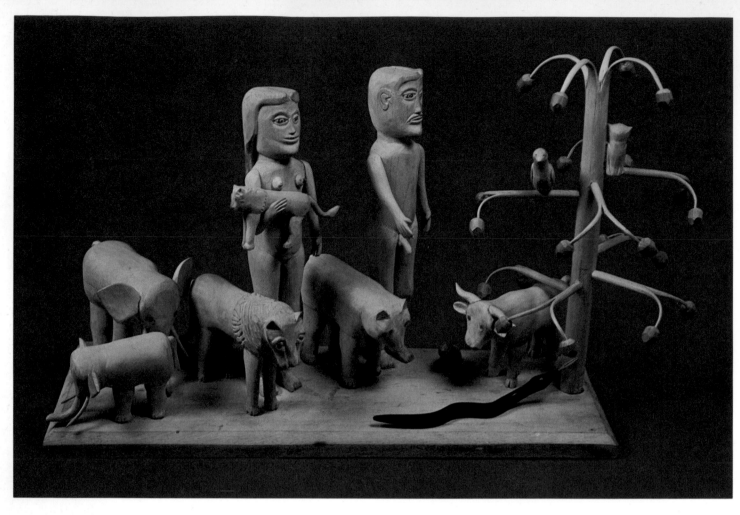

Edgar Tolson. Campton, Kentucky. 1969–1970. Carved and assembled wood. (Mr. and Mrs. Michael D. Hall)
352 (above). Paradise. H. 12¼".
353 (left). Temptation. H. 15½".

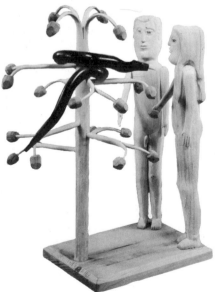

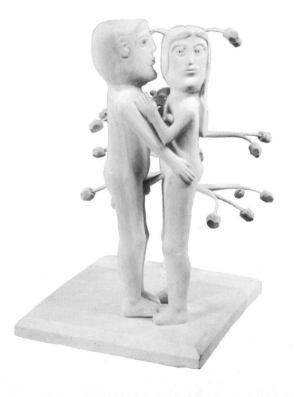

354 (right). Original Sin. H. 14½".
355 (opposite, top left). Expulsion. H. 12½".
356 (opposite, top right). Paradise Barred. H. 15½".
357 (opposite, center). Birth of Cain. H. 8".

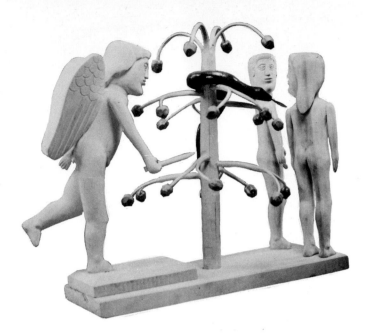

Edgar Tolson, the tobacco-chewing, hard-drinking philosopher of Campton, Kentucky, was born in 1904. This colorful wood-carver, the survivor of numerous mountain feuds, has enjoyed a varied career, which includes being a preacher (he ultimately blew up his own church during Sunday prayers), a cobbler, a chairmaker, a farmer, an itinerant worker, and finally a woodcarver. For the past thirty-five years, Tolson has sometimes worked in stone, but prefers the texture of wood. He is probably best known for his numerous versions of the Adam and Eve theme. Museums today eagerly seek his "whittlings." The eight-part representation of the "Fall of Man" shown on these two pages is one of Tolson's most significant works.

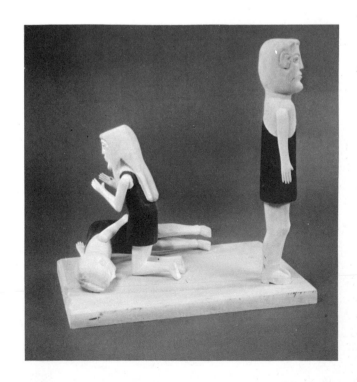

358 (above). Cain Slays Abel. H. 13".
359 (right). Cain Goes into the World. H. 14½".

360 (right). Preacher. Edgar Tolson. Campton, Kentucky. 1971. Poplar. H. 23″. Though many of Tolson's carvings are small in size, they possess monumental power. (Mr. and Mrs. Joshua Kind)

361 (below). Catholic funeral procession. Vermont. Early twentieth century. Wood and bone, painted. W. approximately 36″. Folk sculpture is generally a joyous expression of the people and only on rare occasions is it concerned with death. (Herbert W. Hemphill, Jr.)

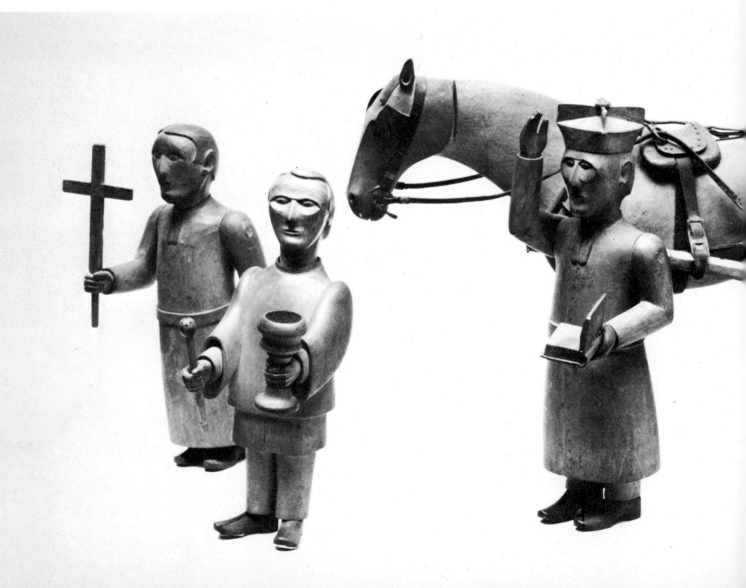

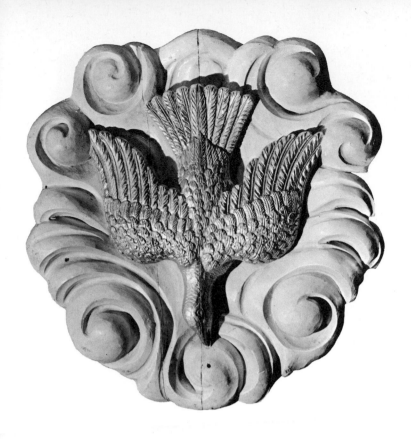

362 (left). The Dove of the Holy Spirit. New York. C. 1830. Wood. H. 22". This dove comes from an old church in Brooklyn, New York, where it probably hung on the wall behind the altar. (Mr. and Mrs. Harvey Kahn)

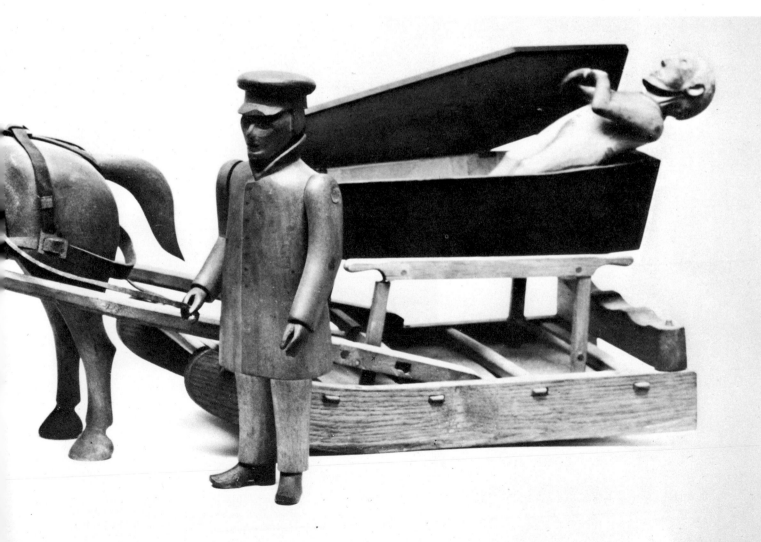

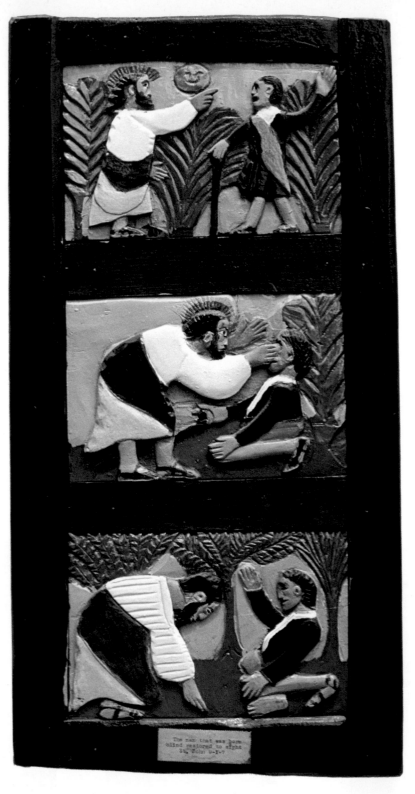

363 (left). Judas Hangs Self. Joseph Thomas Barta (1904–1972). Spooner, Wisconsin. Twentieth century. Sugar pine. H. 60″. (Museum of Woodcarving)

364 (above). The Man That Was Born Blind Restored to Sight. Elijah Pierce. Columbus, Ohio. 1938. Wood, painted. H. 23¼″. (Mr. and Mrs. Michael D. Hall)

366 (opposite, below). Story of Job. Elijah Pierce. Columbus, Ohio. 1938. Wood, painted. L. 27⅞″. Pierce's representations of biblical incidents are among the most beautiful folk carvings being executed today. (Mr. and Mrs. Michael D. Hall)

Elijah Pierce, a Mississippi farm boy born in 1892, grew up in an intensely religious family. After becoming a barber, he settled at Columbus, Ohio, during the mid-1930s. His carved, freestanding figures and bas-reliefs in wood represent a highly personal interpretation of biblical as well as contemporary themes. He frequently works on his pieces between haircuts.

The carver, Joseph Thomas Barta, was born in 1904 on a little farm at Algonquin, Illinois. As a child, when he saw a jackknife with an unusual blade, he bought it. He has used his collection of knives to shape his carvings. For over seventeen years, Barta worked on the "Carved by Prayer" group that has been installed in his own private museum. Religious conviction and frequent visitations by divine spirits directed this monumental work. Barta relates that when he started The Last Supper, a voice, speaking in English, but with a German accent, said: "This young man will do." [32] Throughout the creation of "Carved by Prayer," the artist insists he was shown pictures in his dreams and was directed by divine guidance.

An elderly lady, when viewing the carvings, exclaimed: "These carvings don't belong to you. They belong to God, no man could make them." [33] Another visitor to the museum said: "I am interested in art. I have seen everything in Rome, Athens and the east. This beats them all. It was given you by God." [34]

365 (above). Photograph of Elijah Pierce. Date unknown. (Collin Hall)

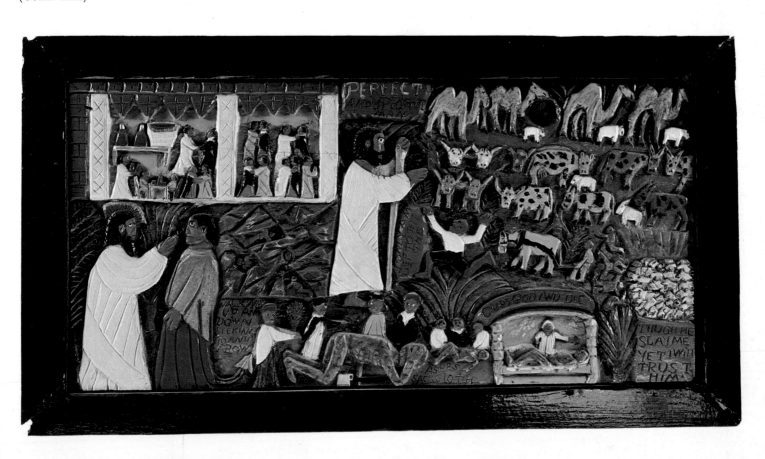

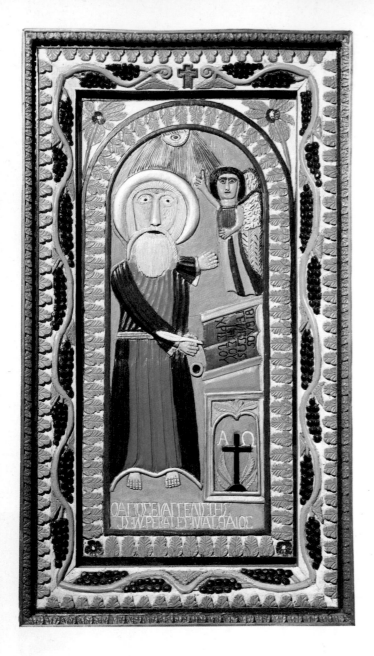

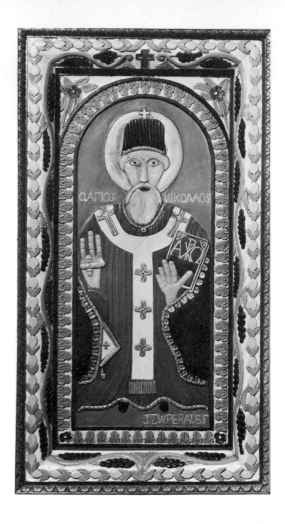

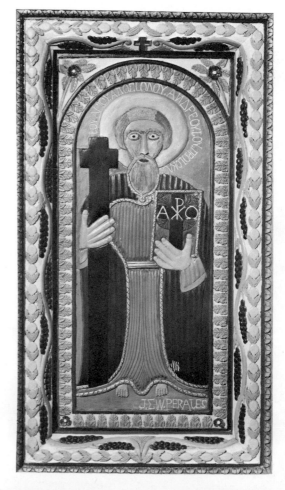

367 (above, left). Icon depicting Saint Matthew. J. W. Perates. Portland, Maine. Mid-twentieth century. Ironwood. H. 49″. An angel appears to Saint Matthew and points to heaven. (Private collection)

368 (above, right). Icon depicting Saint Nicholas. J. W. Perates. Portland, Maine. Mid-twentieth century. Ironwood. H. 49″. Perates, a furniture finisher, upholsterer, and cabinetmaker, turned to "building furniture for the house of the Lord" in idle periods during the late 1930s. (Private collection)

369 (right). Icon depicting Saint Andrew. J. W. Perates. Portland, Maine. Mid-twentieth century. Ironwood. H. 52½″. Perates estimated that he spent over four hundred hours on each of his large icons, which he began carving in 1938. He used ironwood, walnut, cherry, and pumpkin pine for his elaborate pieces, which also include a massive altar and ornate pulpit. (Private collection)

370 (opposite, above). Icon depicting the Madonna and Child. J. W. Perates. Portland, Maine. Mid-twentieth century. Ironwood, varnished and partially gilded. H. 29″. (Private collection)

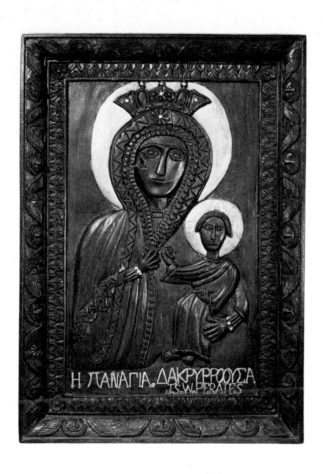

John W. Perates (1894–1970), a Portland, Maine, cabinetmaker, combined his knowledge of the Bible with his woodcarving skill to produce a Byzantine-style pulpit and related icons that were intended to be used in a Greek Orthodox church in Portland. Perates, an immigrant, came to America from his native town of Amphikleia in Greece. He began carving in 1938, and his monumental icons are a significant contribution to American folk sculpture.

James Hampton (1911–1964), like Elijah Pierce, was exposed to deep religious experiences. The son of a Baptist minister, Hampton worked as a laborer for the General Services Administration in Washington, D.C., during the day. About 1950 he began, at night, to build his amazing Throne of the Third Heaven of the Nation's Millennium General Assembly, figure 371 below, in a nearby unheated garage. This giant assemblage of secondhand furniture, light bulbs, glass jars, and cardboard, all covered with silver and gold foil, includes fifty thrones, altars, pulpits, plaques, and crowns. It is further embellished by touches of color, pen-and-ink geometric panels and symbols, English inscriptions, and secret hieroglyphics. Hampton's Throne of the Third Heaven was completed about 1964. It measures 32′ x 9′ and is owned by the National Collection of Fine Arts of the Smithsonian Institution.

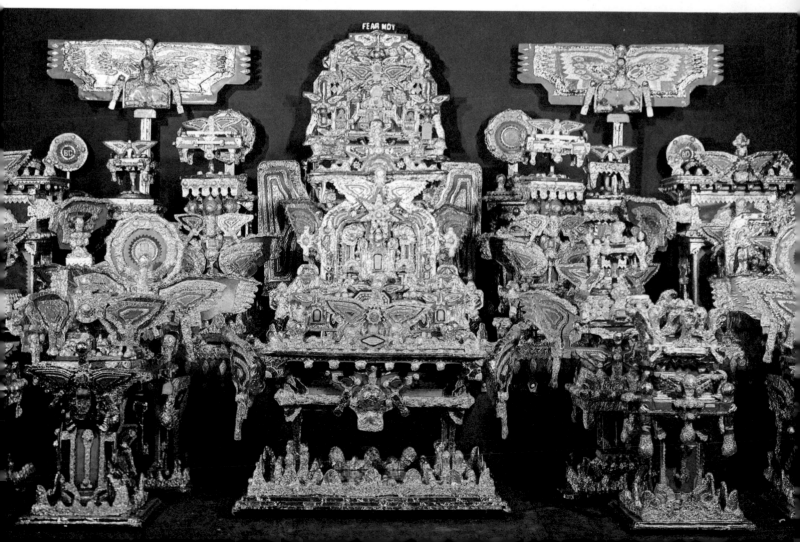

372 (below). The Wages of Sin. Miles B. Carpenter. Waverly, Virginia. 1971. Wood, plastic, and paper, painted. H. 19". Carpenter's carving might well have served as a symbol for nineteenth-century temperance workers who believed that alcohol and tobacco were the damnation of man. The skewered figure holds a cigar in one hand and a drink in the other. (Herbert W. Hemphill, Jr.)

373 (right). Voodoo carving. New Orleans. Probably nineteenth century. Wood, painted. H. 13¾". This Creole carving was used in the practice of black magic. The body is painted dark pink, the hair is black, the cheeks and lips are rouge-red, and the eyes are glass. The figure is pocked with holes over the entire torso and head. (Mr. and Mrs. Leo Rabkin)

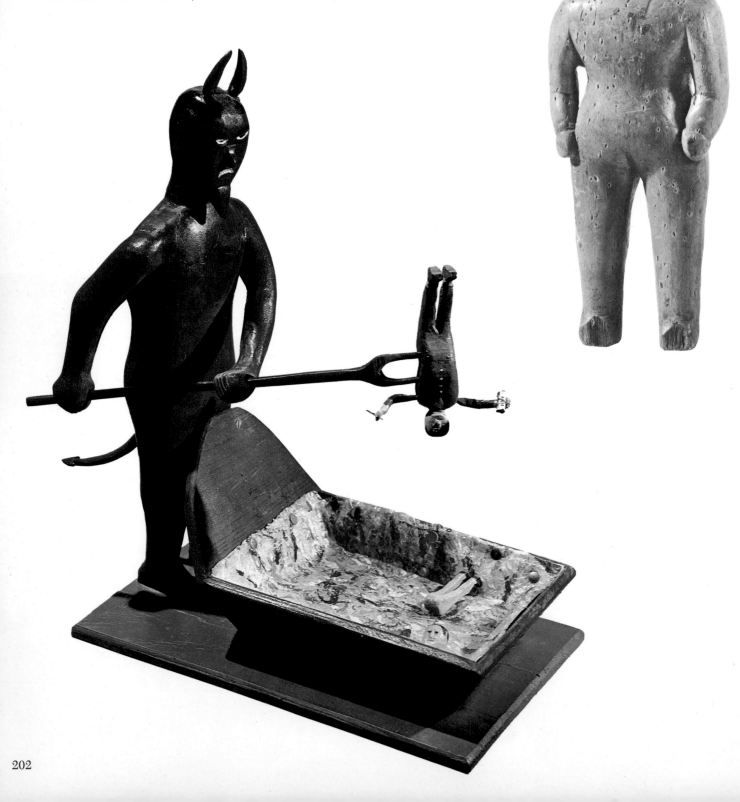

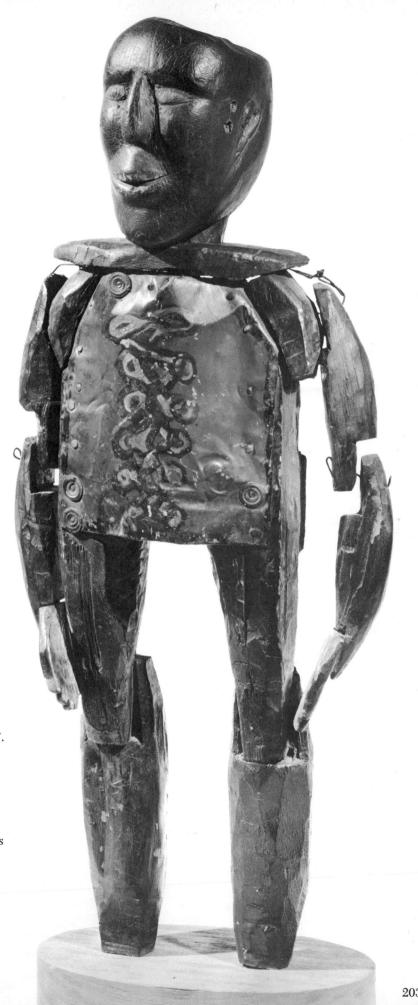

374 (right). Baron Samedi (voodoo figure). New Orleans. C. 1930. Wood and metal, painted. H. 36″. The practice of voodoo originated in Africa and was transported to America by slaves. The voodoo religion is characterized by a belief in sorcery, fetishes, and rituals in which participants communicate by trance with ancestors, saints, or animalistic deities. Carved figures are believed to increase the potency of the fetish, spell, or curse. This figure was found covered with blood and chicken feathers in a black barbershop in New Orleans. Special shops servicing practitioners of this black-magic religion continue to exist in cities like New York, Philadelphia, and New Orleans. (Herbert W. Hemphill, Jr.)

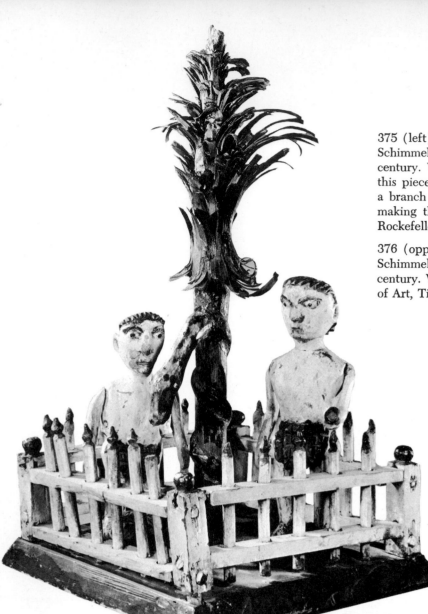

375 (left). Adam and Eve in the Garden of Eden. Wilhelm Schimmel. Pennsylvania. Last quarter of the nineteenth century. Wood, polychromed. H. 18½". The trees on both this piece and figure 376 were fashioned by simply shaving a branch with a knife. This same technique was used in making the rooster, figure 325, page 178. (Abby Aldrich Rockefeller Folk Art Collection)

376 (opposite). Adam and Eve. Attributed to Wilhelm Schimmel. Pennsylvania. Second half of the nineteenth century. Wood, polychromed. H. 20". (Philadelphia Museum of Art, Titus C. Geesey Collection)

The Carlisle, Pennsylvania, *Evening Sentinel* on August 7, 1890, carried the following obituary: "'Old Schimmel' the German who for many years tramped through this and adjoining counties making his headquarters in jails and almshouses, died at the almshouse on Sunday. His only occupation was carving heads of animals out of soft pine wood. These he would sell for a few pennies each. He was apparently a man of very surly disposition."

Wilhelm Schimmel was born in 1817 at Hesse-Darmstadt, Germany, and immigrated to the United States soon after the Civil War. Though he wandered the Pennsylvania countryside, he always returned to one of his favorite haunts—the carpentry shop of Samuel Bloser at Possum Hill in the Conodoguinet Creek area north of Carlisle, where he gathered bits of wood. At nearby Greider's Mill, a covered bridge spanned the creek. Here he carved endlessly, fashioning with a jackknife his now famous wooden figures, which he traded for food or an occasional jug of whiskey. His "fogels" are one of the first examples of true American folk sculpture to receive wide recognition.

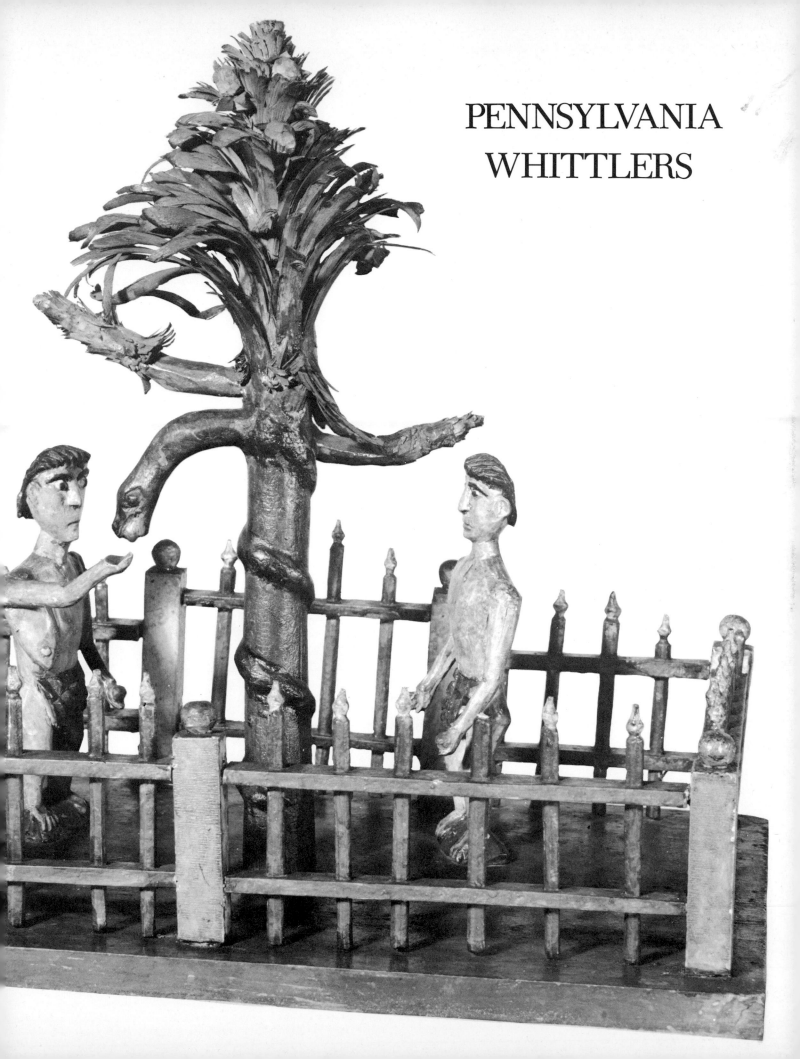

PENNSYLVANIA
WHITTLERS

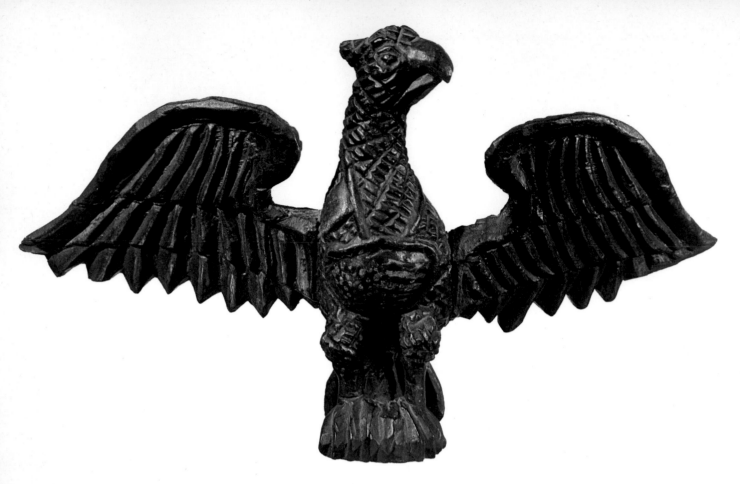

377 (above). Eagle with shield. Wilhelm Schimmel.
Pennsylvania. C. 1870. Pine. W. 17¼". This is the only known
instance where Schimmel incorporated an American shield
into his work. (Mr. and Mrs. James O. Keene)

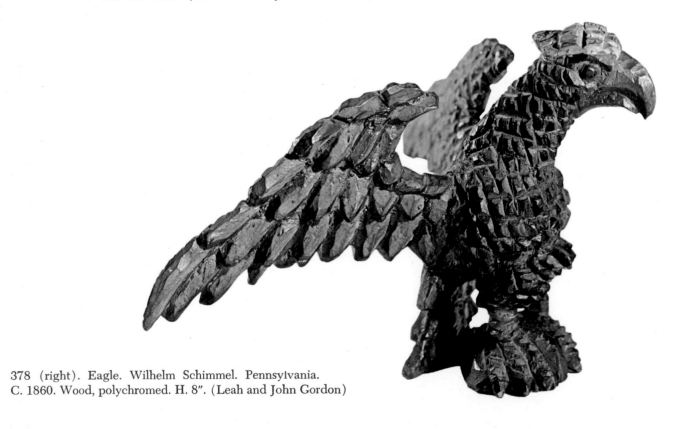

378 (right). Eagle. Wilhelm Schimmel. Pennsylvania.
C. 1860. Wood, polychromed. H. 8". (Leah and John Gordon)

379 (above). Photograph of Wilhelm Schimmel. Date unknown. Schimmel frequently used his carvings as payment for food and "spirits." It is said that the local barrooms and saloons had their shelves filled with his pieces. (Cumberland County Historical Society)

380 (below). Poodle with basket. Wilhelm Schimmel. Pennsylvania. C. 1880. Pine. H. 4¾". (Mr. and Mrs. James O. Keene)

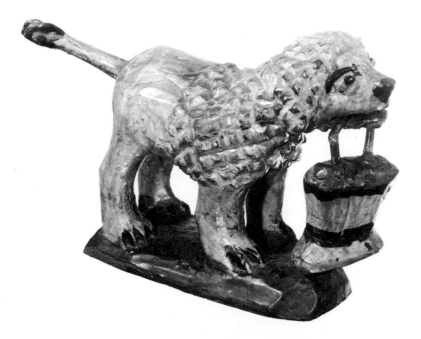

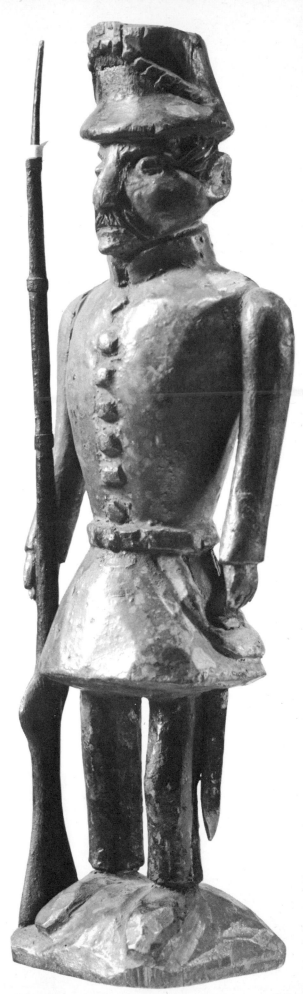

381 (right). Soldier. Wilhelm Schimmel. Pennsylvania. 1817–1890. Wood and plaster, painted. H. 12". Schimmel's bird and animal carvings are usually much more primitive than this representation of the human figure. (Museum of Fine Arts, Boston)

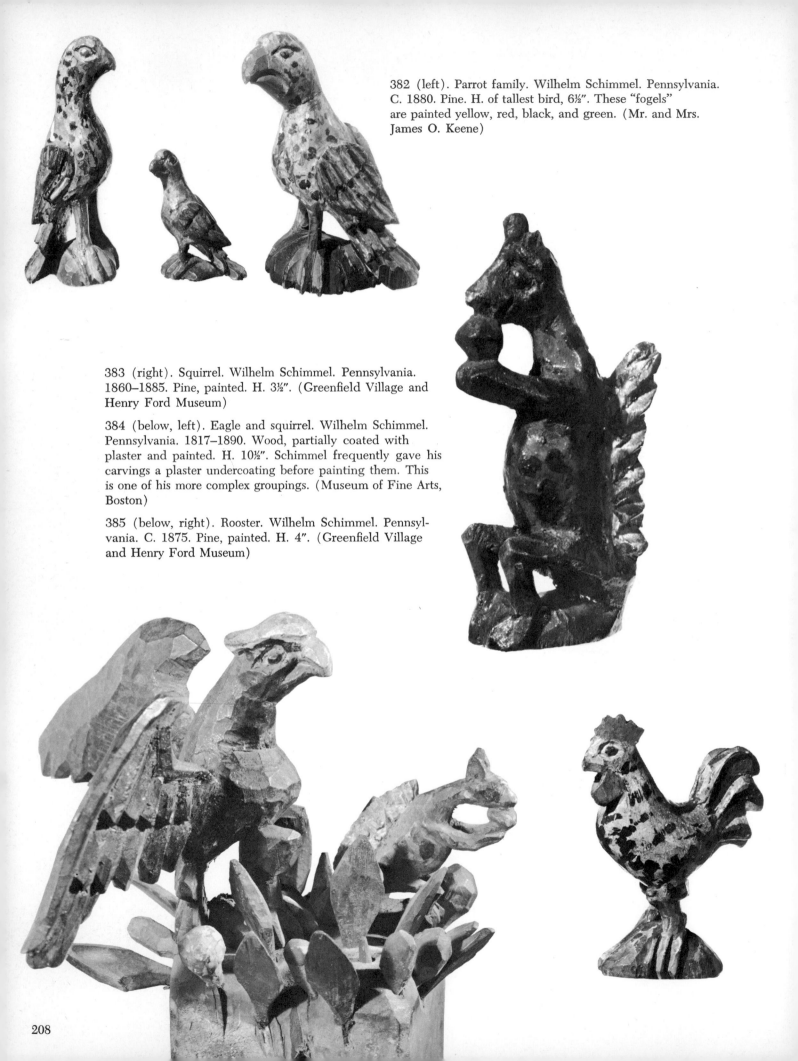

382 (left). Parrot family. Wilhelm Schimmel. Pennsylvania. C. 1880. Pine. H. of tallest bird, 6½″. These "fogels" are painted yellow, red, black, and green. (Mr. and Mrs. James O. Keene)

383 (right). Squirrel. Wilhelm Schimmel. Pennsylvania. 1860–1885. Pine, painted. H. 3½″. (Greenfield Village and Henry Ford Museum)

384 (below, left). Eagle and squirrel. Wilhelm Schimmel. Pennsylvania. 1817–1890. Wood, partially coated with plaster and painted. H. 10½″. Schimmel frequently gave his carvings a plaster undercoating before painting them. This is one of his more complex groupings. (Museum of Fine Arts, Boston)

385 (below, right). Rooster. Wilhelm Schimmel. Pennsylvania. C. 1875. Pine, painted. H. 4″. (Greenfield Village and Henry Ford Museum)

386 (right). Photograph of Aaron Mountz at about sixteen years of age. Mountz, a woodcarver from Carlisle, Pennsylvania, was an admirer of the irascible Schimmel and, when he began carving, his work was greatly influenced by the older man. (Private collection)

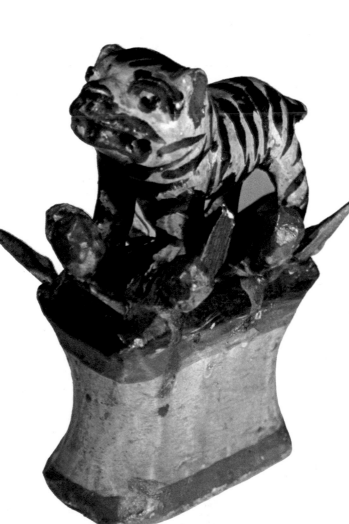

387 (left). Tiger among flowers. Wilhelm Schimmel. Pennsylvania. C. 1880. Pine, painted. H. 4½". Schimmel could have seen a tiger in a traveling circus. If so, he was impressed by the ferociousness of the beast, for his carving emphasizes a mouthful of jagged teeth. (Mr. and Mrs. James O. Keene)

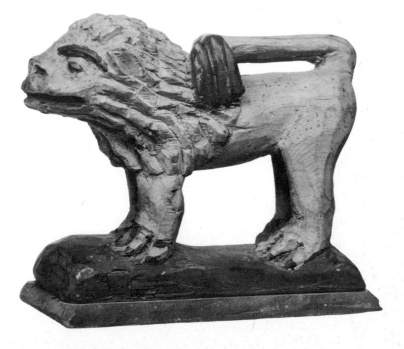

388 (right). Lion. Probably Wilhelm Schimmel. Pennsylvania. Late nineteenth century. Pine. H. 6⅜". (Museum of Fine Arts, Boston)

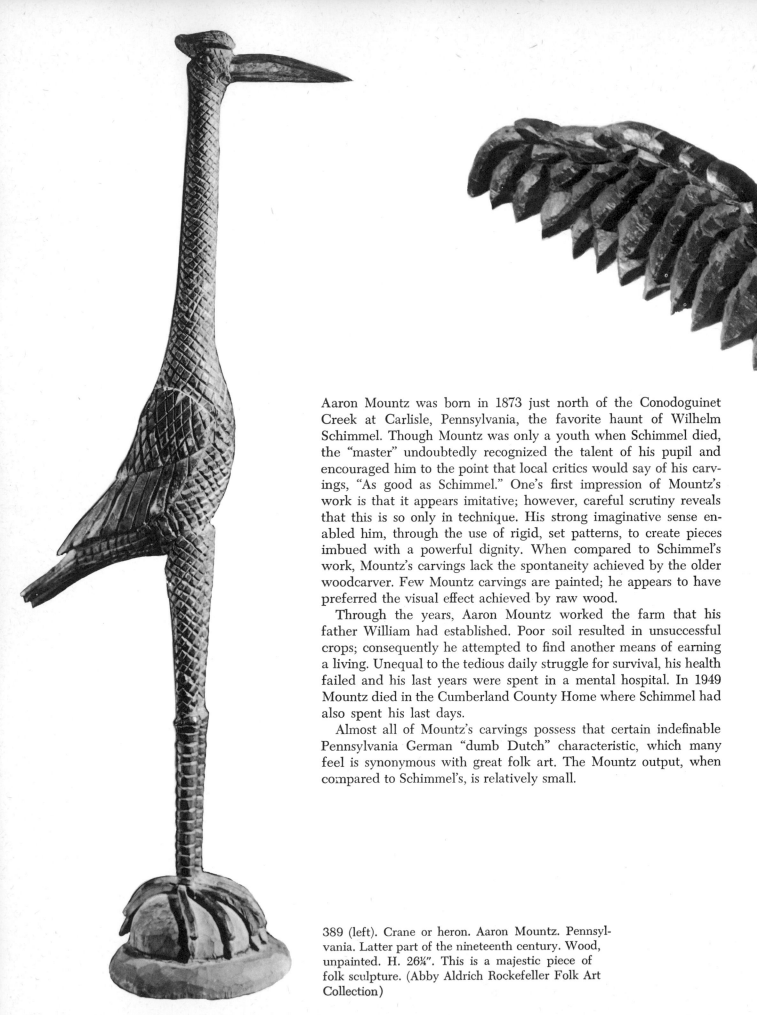

Aaron Mountz was born in 1873 just north of the Conodoguinet Creek at Carlisle, Pennsylvania, the favorite haunt of Wilhelm Schimmel. Though Mountz was only a youth when Schimmel died, the "master" undoubtedly recognized the talent of his pupil and encouraged him to the point that local critics would say of his carvings, "As good as Schimmel." One's first impression of Mountz's work is that it appears imitative; however, careful scrutiny reveals that this is so only in technique. His strong imaginative sense enabled him, through the use of rigid, set patterns, to create pieces imbued with a powerful dignity. When compared to Schimmel's work, Mountz's carvings lack the spontaneity achieved by the older woodcarver. Few Mountz carvings are painted; he appears to have preferred the visual effect achieved by raw wood.

Through the years, Aaron Mountz worked the farm that his father William had established. Poor soil resulted in unsuccessful crops; consequently he attempted to find another means of earning a living. Unequal to the tedious daily struggle for survival, his health failed and his last years were spent in a mental hospital. In 1949 Mountz died in the Cumberland County Home where Schimmel had also spent his last days.

Almost all of Mountz's carvings possess that certain indefinable Pennsylvania German "dumb Dutch" characteristic, which many feel is synonymous with great folk art. The Mountz output, when compared to Schimmel's, is relatively small.

389 (left). Crane or heron. Aaron Mountz. Pennsylvania. Latter part of the nineteenth century. Wood, unpainted. H. 26¼". This is a majestic piece of folk sculpture. (Abby Aldrich Rockefeller Folk Art Collection)

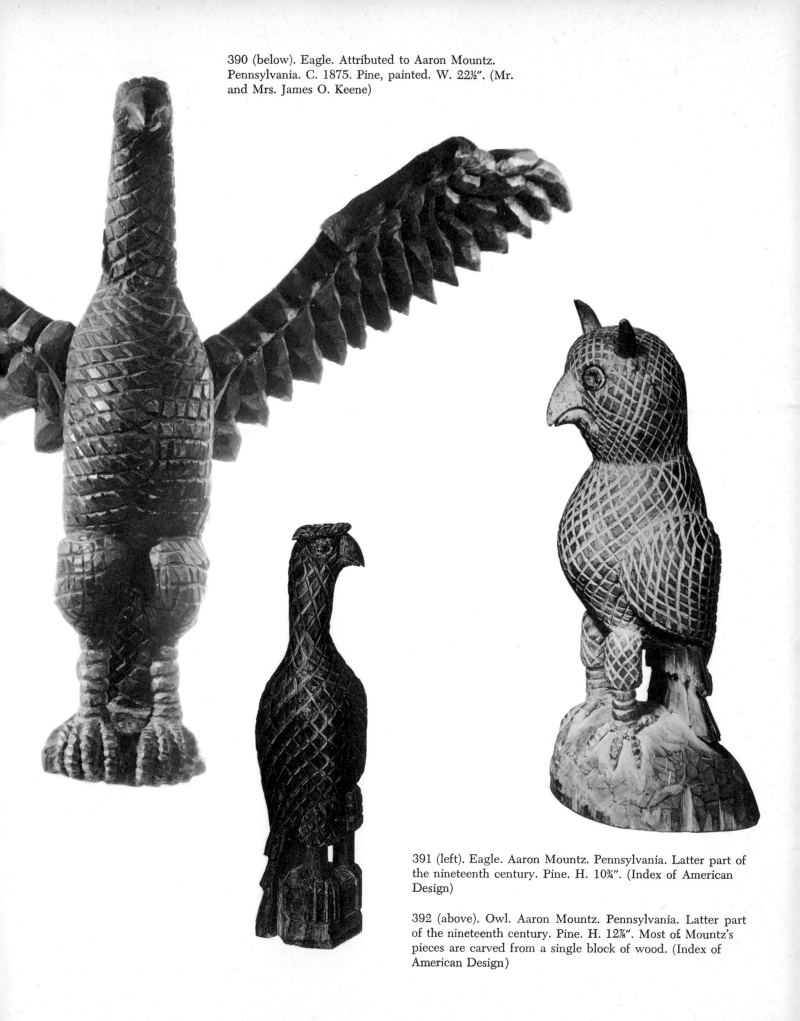

390 (below). Eagle. Attributed to Aaron Mountz. Pennsylvania. C. 1875. Pine, painted. W. 22½". (Mr. and Mrs. James O. Keene)

391 (left). Eagle. Aaron Mountz. Pennsylvania. Latter part of the nineteenth century. Pine. H. 10¾". (Index of American Design)

392 (above). Owl. Aaron Mountz. Pennsylvania. Latter part of the nineteenth century. Pine. H. 12⅞". Most of Mountz's pieces are carved from a single block of wood. (Index of American Design)

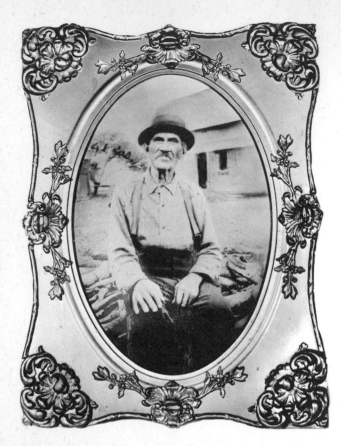

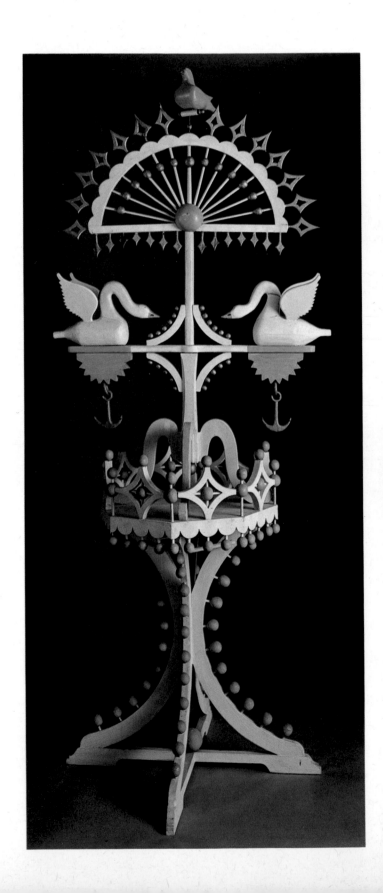

John Scholl (1827–1916) was born in Württemberg, Germany. At the age of twenty-six, he came to the United States and settled in Germania, Pennsylvania. A carpenter by trade, he cleared his own land, built his own house, built the village church, the local brewery, and the general store.

Between 1907 and 1916, he fashioned his ingenious, high-spirited carvings with a jackknife as his only tool. Traditional Pennsylvania German designs—the tulip, the peacock, the dove, and the circle enclosing a star—permeate the rich variety of his imagery. John Scholl was so attached to his carvings that he seldom sold or gave them away. Many can be seen in the 1910 photograph of the parlor in his Germania home, figure 397.

Scholl painted his wooden delights in gold and white, soft blues, greens, reds, and occasionally mustard yellow. He constructed special stands for his carvings and richly embellished them with beads, bobbins, and bangles. In addition to elaborate fantasies, Scholl fashioned toys with movable parts. Ferris wheels, carousels, tiny birds and people, activated by his ingenious wheel-pulley and crank devices, display a mechanical ingenuity that recalls the work of the Black Forest cuckoo-clock-makers of his native Germany.

394 (right). Swan carving. John Scholl. Pennsylvania. Late nineteenth century. Wood. H. 83½". (Memorial Art Gallery of the University of Rochester)

portraits of sweethearts and families on whale's teeth (p. 58). And others, such as a ship's mate named Coleman, aboard the *Joseph Grinnell*, drew with chalk on a board to record the dying whale off the coast of California (pp. 58-59).

A lucky few were exposed to a little training. Erastus Salisbury Field was one of them, having studied with the painter-inventor Samuel F. B. Morse for all of three months. When he did *The Garden of Eden* (below) in about 1860, he based his canvas on a Bible illustration and borrowed additional details from Jan Brueghel the Elder and Thomas Cole. Taking a bit from one and a bit from the other, Field came up with a lush Eden of his own, not unlike an Italian Renaissance landscape. Yet some of his mountains have about

them a touch of the Berkshires near where Field lived.

The nonacademic tradition is also not without its geniuses. One of them was Edward Hicks, a Quaker preacher and trained coach and sign painter, who turned out numerous canvases based on the Isaiah prophecy that one day the lion would lie down with the lamb. Into his animal menagerie, known as *The Peaceable Kingdom,* Hicks introduced William Penn and a group of Colonists and Indians signing their famous treaty. Between about 1820 and 1849 he painted this subject over and over again, each time infusing his canvases with a freshness that any accomplished artist would envy.

Sculptors, as such, were almost unknown in the early Republic and like the painters had their roots in

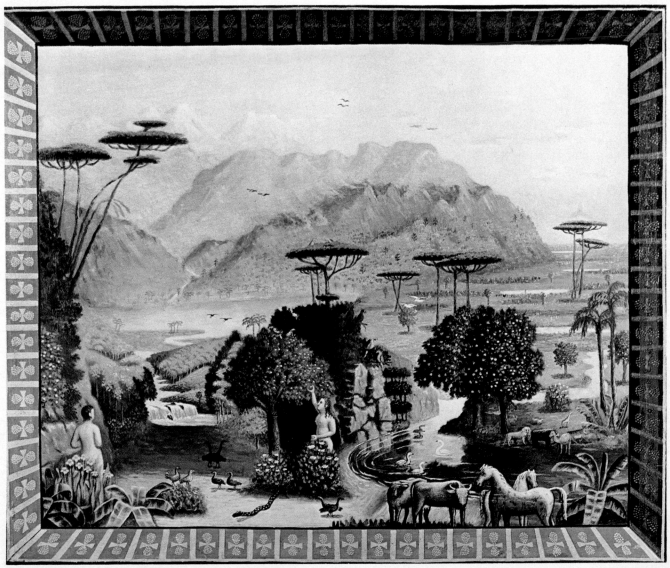

The Garden of Eden by Erastus Salisbury Field has a painted, trompe-l'oeil frame that is actually flat.

them," wrote John Canaday, the *New York Times* art critic. Although the Whitney show includes both groups and, for want of a better term, calls it all folk art, the completely naive paintings and sculptures should not properly be called folk art.

Perhaps more than any other nation, the United States during its first century was ripe to produce a varied and vigorous art tradition. At the time of the Revolution almost three million people lived in the Colonies. Eighty years later the population had swelled to 31 million. Except for short periods, the country was prosperous and, until the 1840s, there were no photographers. Out there were all those faces and landscapes waiting to be painted.

Somebody plastered to the wall

The Americans of the 19th-century had an insatiable passion for paintings, particularly of themselves. "You can hardly open the door of a best room anywhere, without surprising or being surprised by, the picture of somebody plastered to the wall and staring at you with both eyes and a bunch of flowers," observed the American writer John Neal in 1829.

In addition to a willing audience, America also had a band of willing artists—men and a few women without much schooling who would try their hand at anything. In many respects our artists were upstarts. Unlike Europeans, Americans made no sharp distinction between the fine and useful arts. From its very beginnings, the artistic tradition of the United States was linked with the crafts. Charles Willson Peale was an upholsterer and silversmith before he studied painting in England. Even John Singleton Copley complained that people generally regarded painting as a useful trade, "like that of a carpenter, tailor or shoemaker and not as one of the noblest arts in the world."

America had no effective guilds, few art schools and no salons to dictate taste, style or technique. It was every man for himself, and for some it was disastrous; for the talented, a boon. "The new nation had the added advantage of unashamed variety, fluidity and cultural anarchy," explains Daniel J. Boorstin, Senior Historian of the Smithsonian's Museum of History and Technology. "Americans were luckily free of the Royal Academies and National Academies that tended to cast cultures in respectable molds."

Consequently, house, sign and coach painters also doubled as portrait and landscape artists. Young women were trained in seminaries to paint on velvet, to draw with needle and thread and to compose, as Emma Cady did, still lifes combining a stencil technique with free-hand details (right): Even the restless sailors, who sometimes spent as much as two years at sea, whiled away the lonely hours engraving scrimshaw

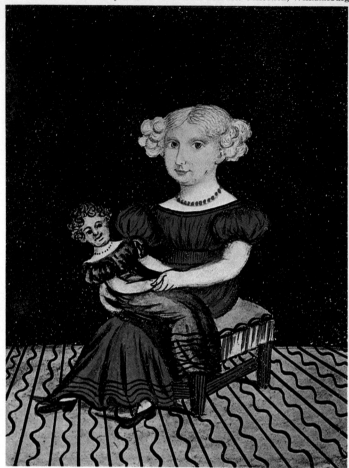

An anonymous artist painted this watercolor portrait of a demure little girl named Emma Clark in 1829.

The glass compote in this still life, painted about 1820 by Emma Cady, has tiny flecks of mica.

395 (above). Tools belonging to John Scholl. Germania, Pennsylvania. 1900. (Museum of American Folk Art)

396 (right). Carousel of feeding birds. John Scholl. Pennsylvania. Late nineteenth century. Wood. H. 25″. (Mr. and Mrs. Harvey Kahn)

397 (below). Photograph of the parlor in the home of John Scholl. Germania, Pennsylvania. C. 1910. Much of Scholl's entire output is illustrated in this photograph. At the left of the photograph is the swan carving, figure 394. (Stony Point Folk Art Gallery)

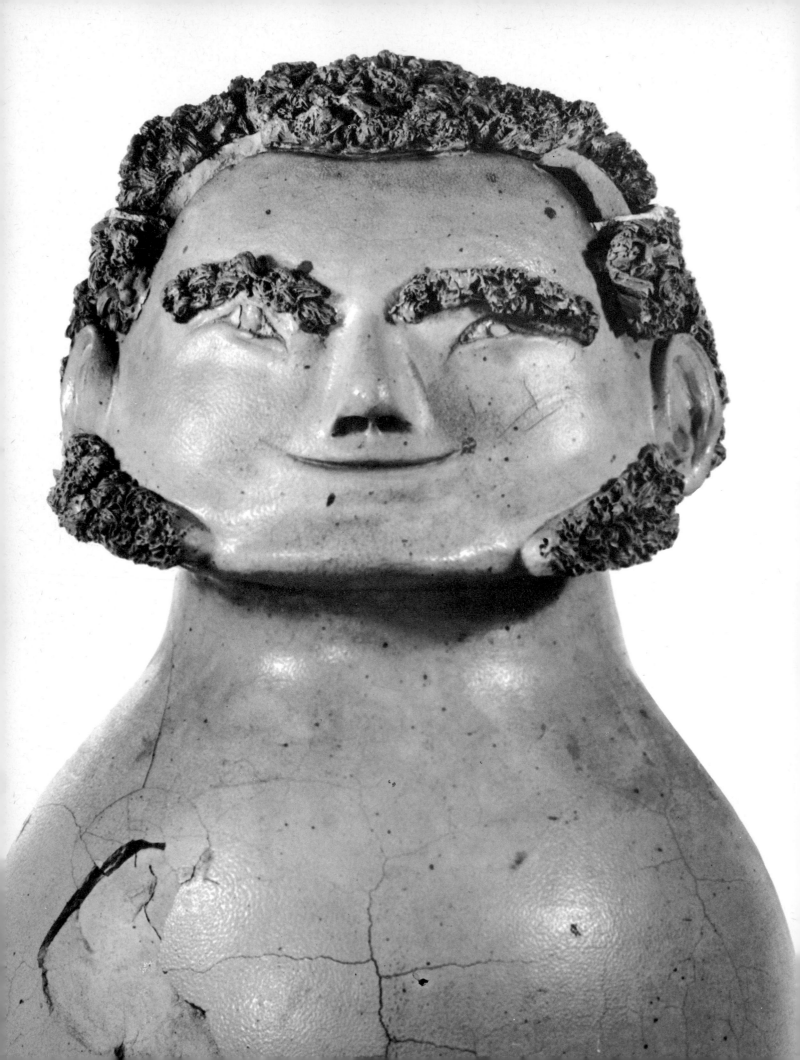

POTTERY

Until the time of the Industrial Revolution, no other type of folk art was probably created in such prodigious numbers as objects made of clay—the basic earth ingredient.

As long as household and utilitarian pieces were fashioned by hand, they continued to be original and beautiful. Once factory production made it economically impossible for handcrafted objects to be competitively marketed, they all but ceased to be made.

Potters were an important part of every community, and while they were not all gifted designers, their products usually met the undemanding aesthetic requirements of most clients. Many rural craftsmen fashioned delightful and sometimes frivolous clay pieces to satisfy the countrywoman's craving for the fashionable imported Staffordshire mantel ornaments she could not afford.

Potters first removed the topsoil from the earth and then dug their clay. After taking it to the shop, it was ground and diluted with water to achieve a uniform consistency and then stored where it would remain moist until ready for use. Most utilitarian objects such as pots and bowls were thrown on a wheel. After shaping, they were set out to dry and later fired in a kiln, which had been skillfully sealed so that each piece would be equally heated. Upon completion of the firing—some thirty to fifty hours—the flames were extinguished and the kiln left to cool. Those pieces that were perfect, and even those that were imperfect but still salable, were glazed and fired a final time.

Most potters adapted their products to the requirements of their local market. Thomas Symmes of Boston advertised in the *Boston Gazette* on April 16, 1745, that he "Made and Sold reasonably . . . at *Carlestown*, near the Swing Bridge, blue and white stone Ware of forty different sorts; also red and yellow Ware of divers Sorts, either by Wholesale or Retail." [35]

Obviously, potters' kilns represented a real hazard to community life. The *New York Daily Advertiser* on April 1, 1788, announced "Yesterday morning . . . a fire broke out in the building of Mr. Campbell, pot-baker in Broadway, near the Hospital; which in a little time nearly destroyed the same. The wells in the neighborhood being exhausted in a few minutes of their water . . ." [36]

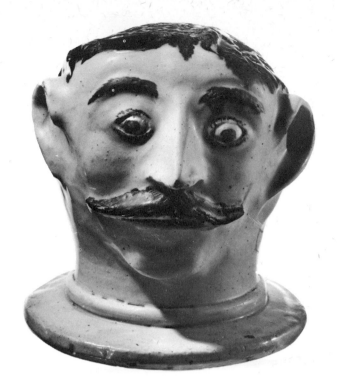

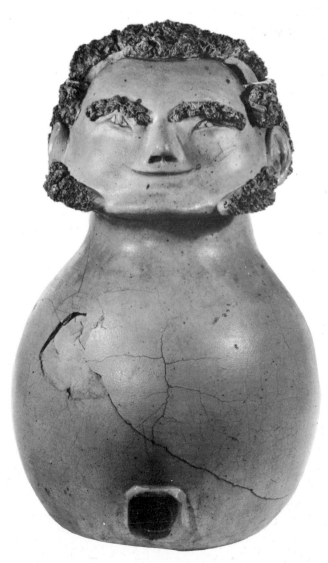

398 (right, above). Head. 1850–1900. Stoneware. H. 7½″. This figure was probably the lid for a crock, jar, or churn. (Mr. and Mrs. Charles V. Hagler)

399 (right, below), 399a (opposite). Water cooler. 1850–1875. Stoneware. H. 25″. Stoneware, the oldest type of vitreous ware and the immediate ancestor of porcelain, is made of coarse, sandy, heat-resistant clays. It becomes hard, dense, nonabsorbent, opaque, and light gray to brown in color when fired at extremely high temperatures. (Greenfield Village and Henry Ford Museum)

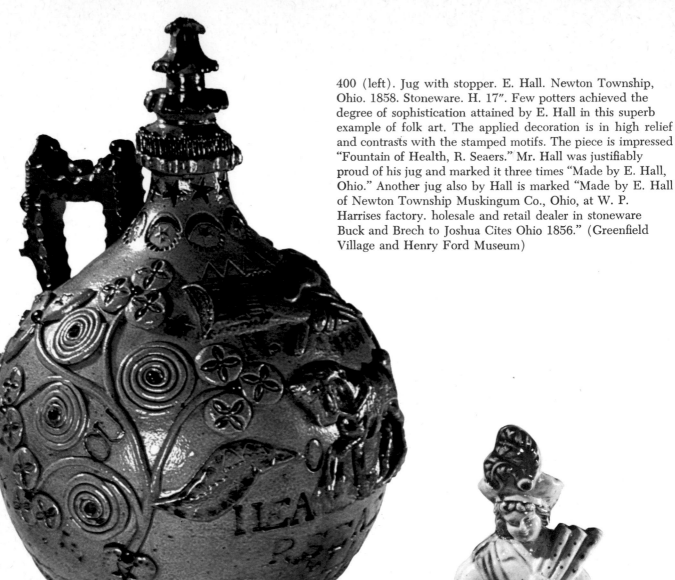

400 (left). Jug with stopper. E. Hall. Newton Township, Ohio. 1858. Stoneware. H. 17″. Few potters achieved the degree of sophistication attained by E. Hall in this superb example of folk art. The applied decoration is in high relief and contrasts with the stamped motifs. The piece is impressed "Fountain of Health, R. Seaers." Mr. Hall was justifiably proud of his jug and marked it three times "Made by E. Hall, Ohio." Another jug also by Hall is marked "Made by E. Hall of Newton Township Muskingum Co., Ohio, at W. P. Harrises factory. holesale and retail dealer in stoneware Buck and Brech to Joshua Cites Ohio 1856." (Greenfield Village and Henry Ford Museum)

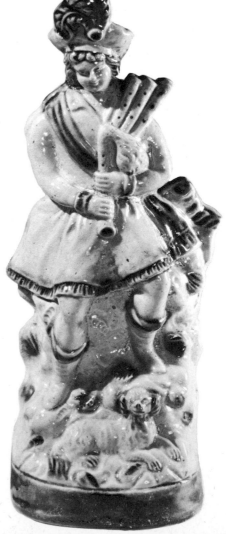

401 (right). Figure, one of a pair. New York State. C. 1850. Stoneware. H. 9¹³⁄₁₆″. American potters frequently attempted to approximate imported European mantel ornaments. This kilted Scotsman with bagpipe was made en suite with a maiden holding a sheet of music. (Greenfield Village and Henry Ford Museum)

402 (left). Turtle flask. Attributed to G. Gre(en?) Albany, New York area. C. 1800. Salt-glazed stoneware. L. 8". By applying bits of clay and utilizing multicolor glazes, the artist created the impression of a turtle with an economy of means. (Mr. and Mrs. John Remensnyder)

403 (below). Sculptured jug. Cornwall E. Kirkpatrick at the Anna Potteries. Anna, Illinois. 1871. Stoneware. H. 12¼". Thomas Nast, the American Hogarth, was given this jug in recognition of his powers as a caricaturist. It shows William "Boss" Tweed and his followers attempting to climb into the Tammany money pot. (The New-York Historical Society)

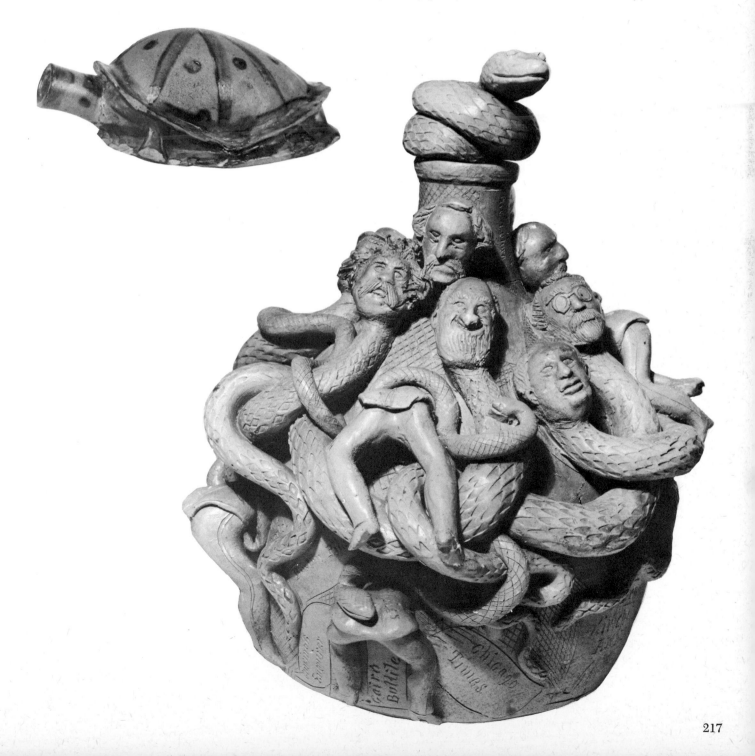

405 (below). Doorstop. C. 1900. Buffware. L. 7½″.
Buffware is generally unglazed. (Greenfield Village and
Henry Ford Museum)

404 (above). Wall ornament. United States Fire Clay Co.
New Lisbon, Ohio. 1875–1900. Sewer tile. Diameter
13⅜″. Craftsmen working in sewer tile plants, like their
counterparts in glassworks, frequently made end-of-day
pieces out of bits of leftover clay. This ornament, how-
ever, was probably one of a large group of mass-
produced pieces that served as advertisements.
(Greenfield Village and Henry Ford Museum)

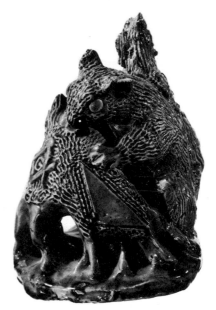

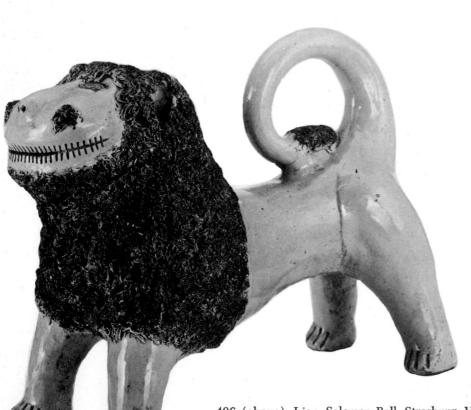

406 (above). Lion. Solomon Bell. Strasburg, Virginia. C. 1850.
Redware. H. 11″. This smiling lion sports a robust "coleslaw" mane.
(Museum of Early Southern Decorative Arts)

218

407 (opposite, right). Squirrel on stump. Late nineteenth century. Sewer tile. H. 8⅛″. During the nineteenth century the Masonic Order became especially popular in Midwestern towns. This end-of-day piece probably was made as a gift for a fellow Mason, since the emblem of the fraternal order is incorporated into its design. (Mr. and Mrs. Charles V. Hagler)

408 (right). Pair of bears. Attributed to Daniel, Nathaniel, and Lewis Dry. Dryville Pottery, Dryville, Pennsylvania. C. 1875. Redware. H. of tallest bear, 14⁷⁄₁₆″. These "coleslaw"-decorated figures have captured a man in a top hat and his hound and seem to be hugging them to death. (Greenfield Village and Henry Ford Museum)

409 (below). Whippet. Ohio. 1875–1900. Buffware. L. 10⅜″. The artist has successfully captured the graceful lines of the dog. (Greenfield Village and Henry Ford Museum)

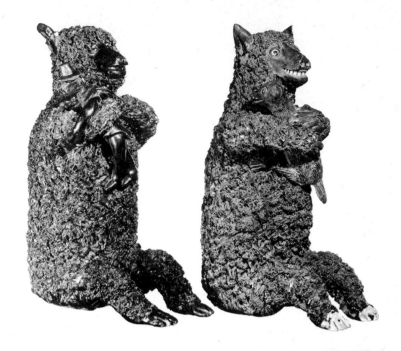

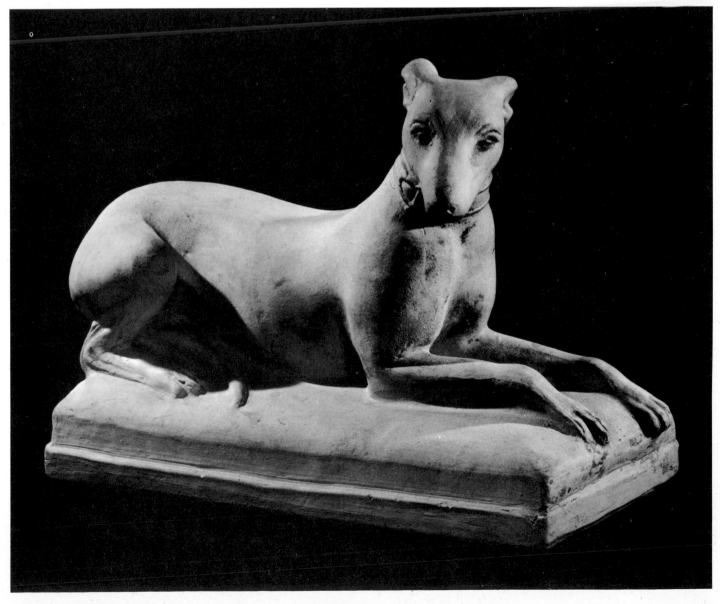

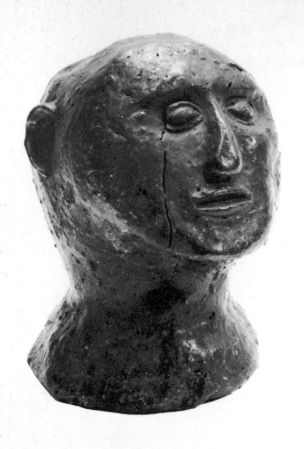

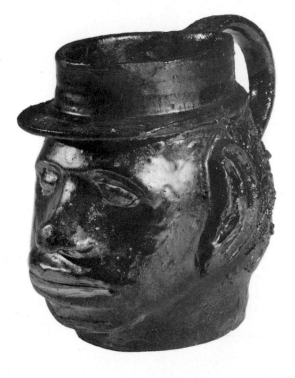

410 (left). Head. East Sparta, Ohio. C. 1910. Sewer tile. H. 8¼″. This whimsy is a powerful and original piece of sculpture. (Mr. and Mrs. Michael D. Hall)

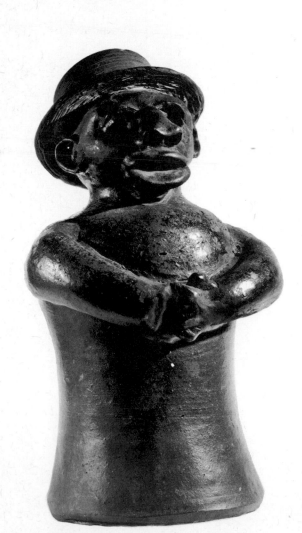

411 (above). Jug. Pennsylvania. C. 1870. Pottery. H. 8¼″. This jug represents a black soldier of the Civil War. (Gary C. Cole; photograph courtesy George E. Schoellkopf Gallery)

412 (left). Preacher man. Anonymous black artist. Georgia. C. 1860. Pottery, painted and glazed. H. 16½″. (Leah and John Gordon)

413 (opposite). Grotesque jug. 1850–1900. Pottery. H. 5¾″. Few pieces of pottery are comparable to this folk art masterpiece, which is believed to have been made at Zanesville, Ohio. (George O. Bird)

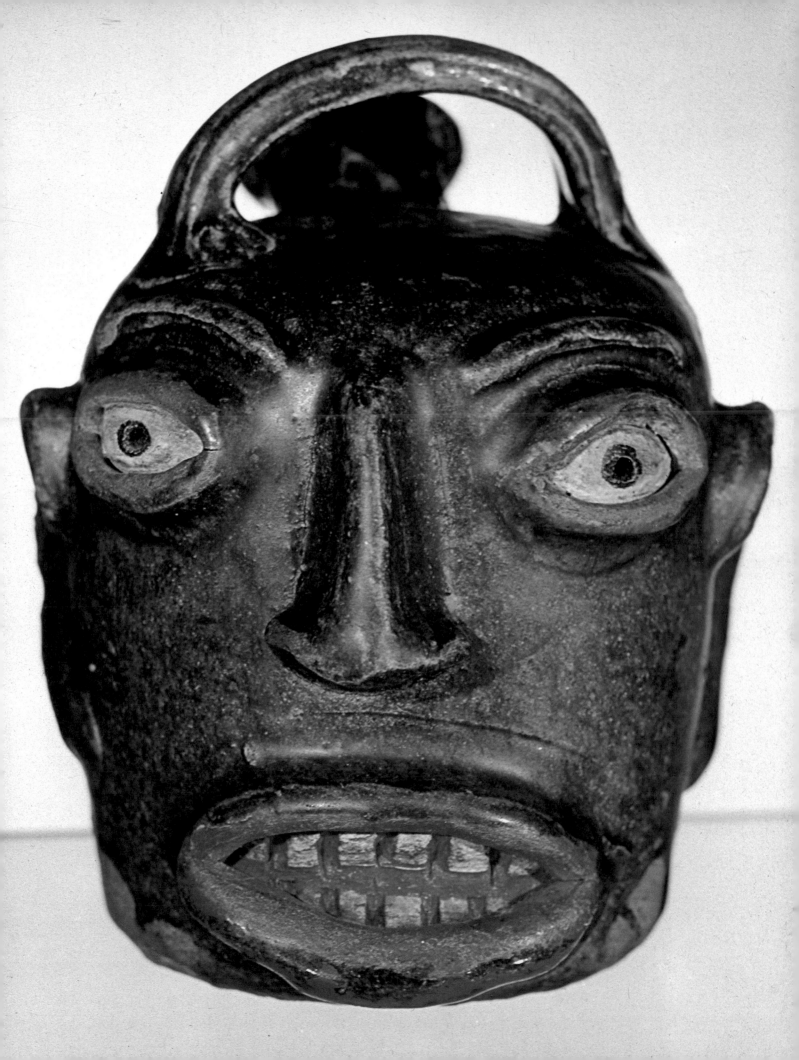

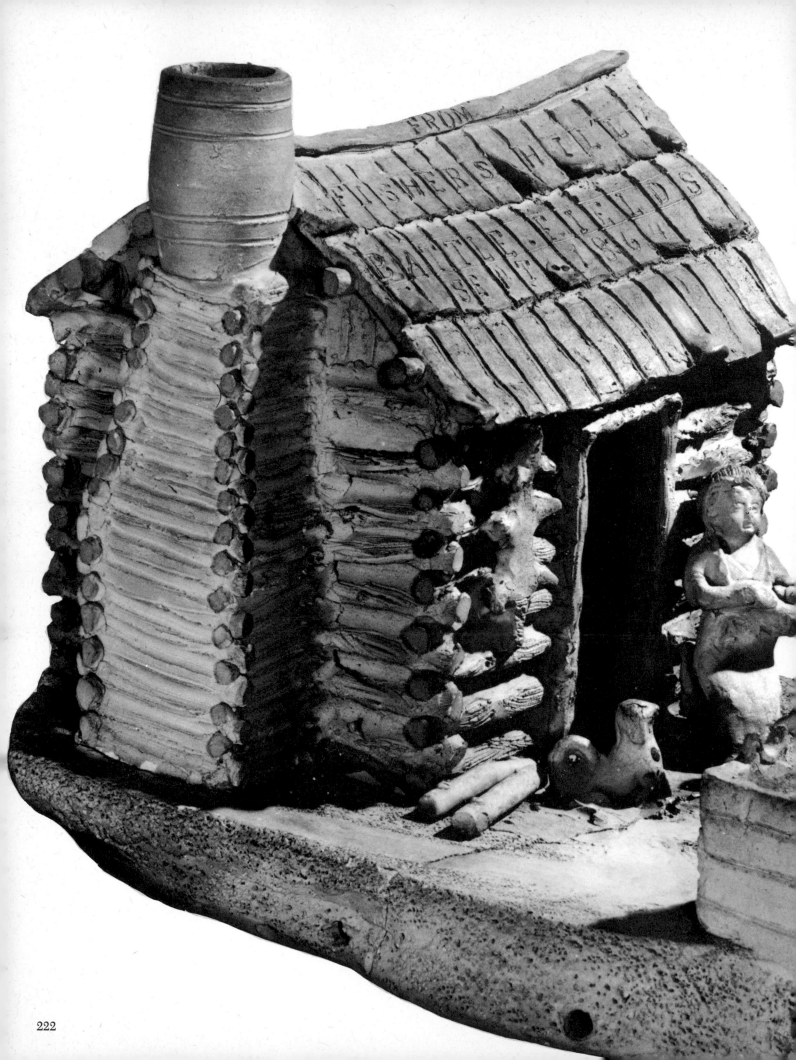

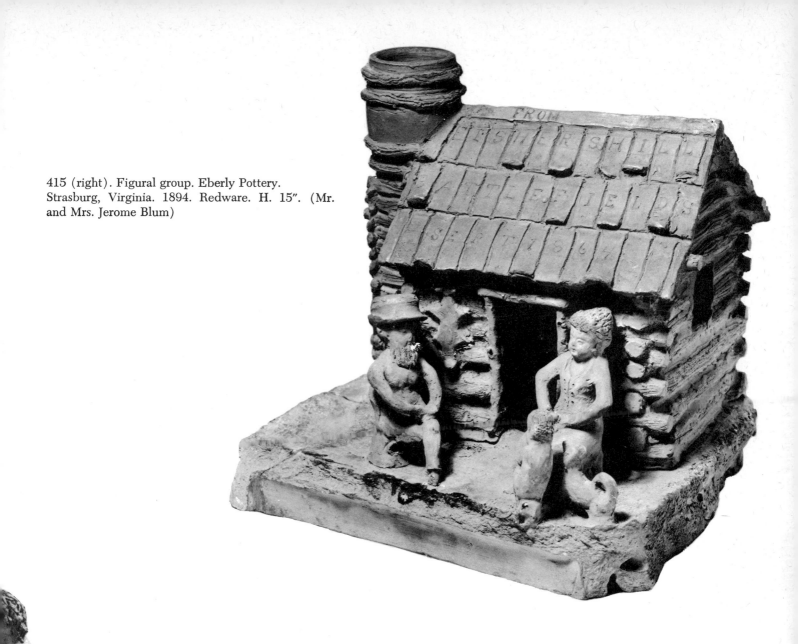

415 (right). Figural group. Eberly Pottery. Strasburg, Virginia. 1894. Redware. H. 15″. (Mr. and Mrs. Jerome Blum)

Folk art is especially interesting when it serves as a social document relating information about past life-styles. Though figures 414 and 415 attempt to convey the same rustic scene, the treatment of the figures differs. The cabins illustrate how frontier homes were constructed. The log chimneys would have been plastered with clay on the inside, and each is topped with a barrel. Obviously, such an arrangement was a fire hazard at best. Both groups commemorate the thirtieth anniversary of the Battle of Fisher's Hill and were made in the late nineteenth century by Levi Begerly and Theodore Fleet, two potters employed by the Eberly Pottery at Strasburg, Virginia. It is said that the clay used for these pieces was gathered from various sites on this famous Civil War battleground.

414 (opposite). Figural group. Eberly Pottery, Strasburg, Virginia. 1894. Redware, unglazed. H. 15½″. (Greenfield Village and Henry Ford Museum)

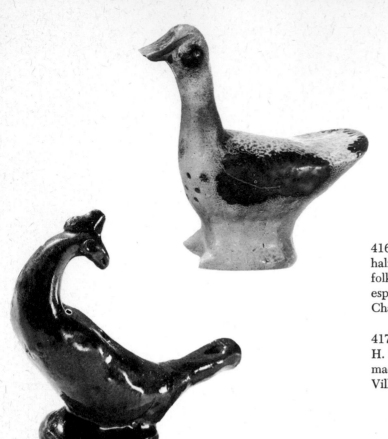

416 (left, above). Shaker in the form of a duck. Second half of the nineteenth century. Stoneware. H. 4½″. When folk pottery is utilitarian as well as decorative, it is especially interesting to the collector. (Mr. and Mrs. Charles V. Hagler)

417 (left, below). Whistle. Pennsylvania. 1849. Redware. H. 3¹¹⁄₁₆″. Flocks of pottery whistles shaped like birds were made to delight nineteenth-century children. (Greenfield Village and Henry Ford Museum)

418 (right). Inkwell. Second half of the nineteenth century. Stoneware. W. 8¼″. (Mr. and Mrs. Charles V. Hagler)

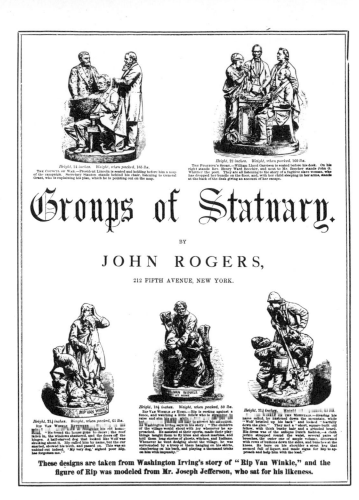

419 (left). Advertisement for the sentimental plaster groups created by the New York artist, John Rogers (1829–1904). Rogers was one of the first to realize that Americans, in their quest for culture, would accept mass-produced figural groups as substitutes for one-of-a-kind pieces of sculpture. Though Rogers' groups are not technically folk art, they are to academic sculpture what Currier & Ives prints are to academic painting. (Greenfield Village and Henry Ford Museum)

420 (below). The Council of War. John Rogers. New York. C. 1880. Plaster. H. 24″. Represented in this piece are President Lincoln, who is seated and holding the map of a Civil War campaign; Secretary of War Edwin M. Stanton, who stands behind Lincoln's chair (at right); and General Ulysses S. Grant, who is explaining his proposed plan of attack (at left). Rogers' larger plaster groups weighed about 165 pounds. The smaller pieces weighed 50–65 pounds. (Greenfield Village and Henry Ford Museum)

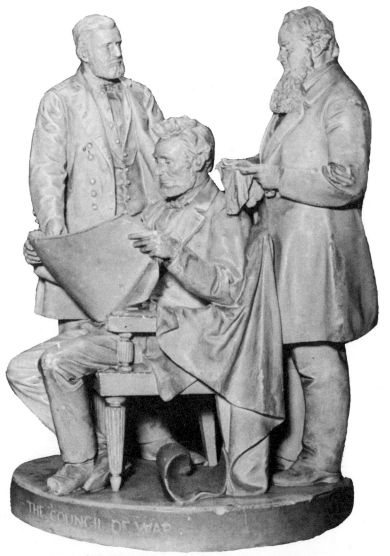

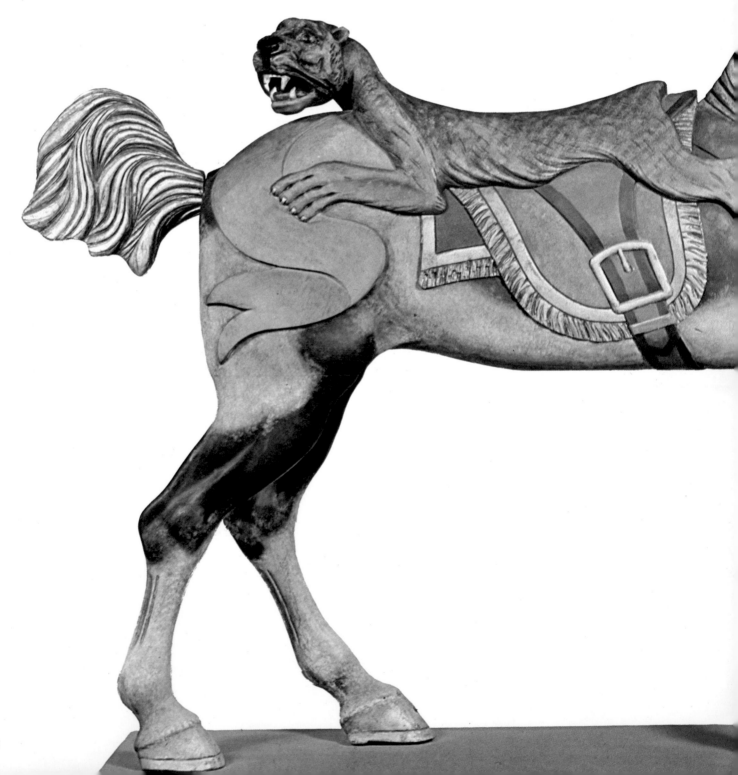

421 (below). Carousel horse. Late nineteenth century. Wood. L. 62".
Because carousel figures were constantly in use, few survive that retain
their original paint. This horse is superbly carved. (Smithsonian Institu-
tion, Van Alstyne Collection)

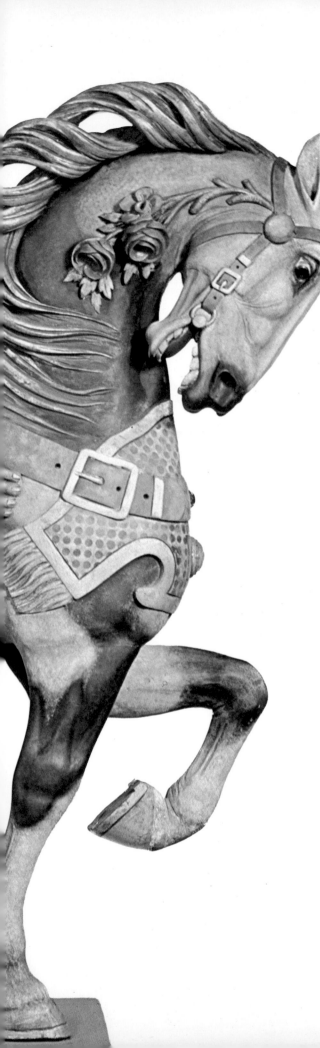

CAROUSEL SCULPTURE

The term "carrousel" was first used to describe a tournament in which mounted knights engaged in various exercises and races. It is not surprising, therefore, that it was later applied to the merry-go-round where the figures, although never overtaking one another, compete in a continual race.

In 1825 John Sears was granted by the Common Council of Manhattan Island, New York, a permit to "establish a covered circus for a Flying Horse Establishment," [37] but the first American carousel patent was registered in 1850 by Eliphalet S. Scupture of Greenpoint, New York. His development of an overhead suspension system, which created the galloping effect, was the first of many subsequent improvements.

Primitive "flying horses" were probably first made by wheelwrights and unemployed shipcarvers. However, by the close of the nineteenth century, they were manufactured, like cigar store Indians, in specialty shops utilizing assembly-line production techniques.

The earliest merry-go-rounds were turned by a horse. Occasionally a rustic band provided spirited musical accompaniment. The resort town of Long Branch, New Jersey, sported such a merry-go-round in 1857. Frank Leslie's *Weekly* of August 22 gave the following description: ". . . beneath a large circular tent on the beach below, people were amusing themselves quite as heartily, if not in such an aristocratic manner, as the waltzers and promenaders at the brilliant hotels above. Eight rotary cars were in operation and a large country wagon close by, filled with rustic Paganinis and unstudied artistes, whose tremendous zeal and energy supplied all the lacking style and polish, served as a musical department . . . In one of the cars was seated an ebon-faced daughter of Africa, gorgeous in a buff calico and pink bonnet, with a beau who officiated as a waiter during the day, turned Romeo at night . . . Another was full of children, another of gray-headed people who had not yet forgotten youth and all her embodiments of solid comfort." [38]

Hand-carved carousel figures continued to be made well into the twentieth century. Because wooden animals were expensive to produce and maintain, metal, plastic, and fiber glass counterparts, fashioned in molds, eventually replaced the wooden flying horses.

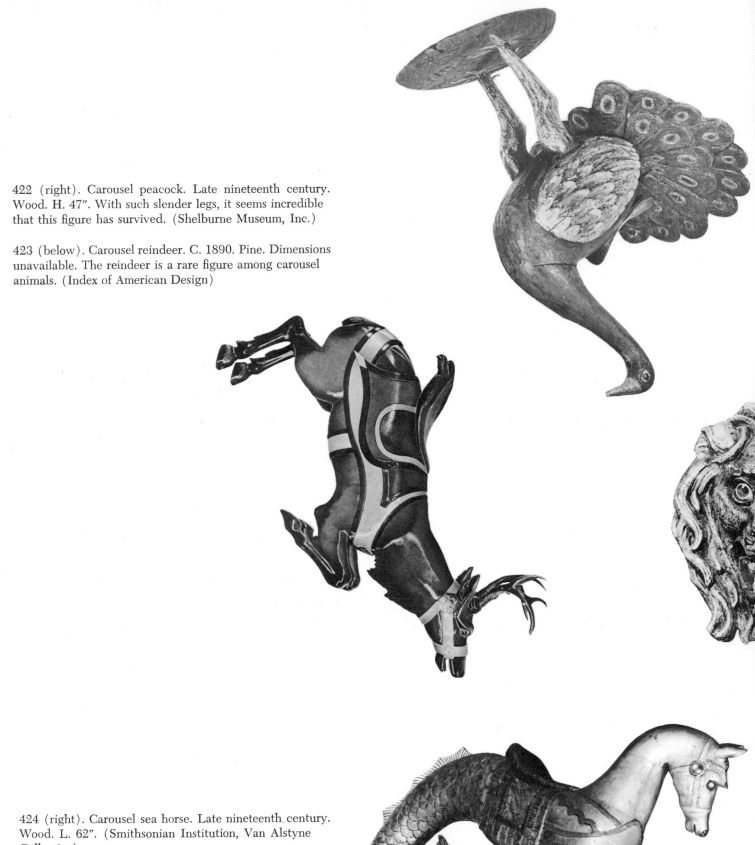

422 (right). Carousel peacock. Late nineteenth century. Wood. H. 47″. With such slender legs, it seems incredible that this figure has survived. (Shelburne Museum, Inc.)

423 (below). Carousel reindeer. C. 1890. Pine. Dimensions unavailable. The reindeer is a rare figure among carousel animals. (Index of American Design)

424 (right). Carousel sea horse. Late nineteenth century. Wood. L. 62″. (Smithsonian Institution, Van Alstyne Collection)

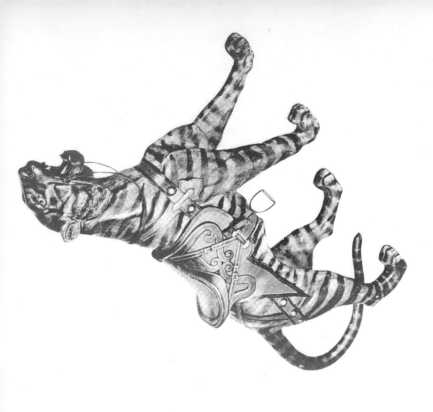

425 (left). Carousel tiger. Dintzel Factory. Philadelphia. 1894. Wood. L. 82″. Many carousel figures, like this one, are fitted with round, miniature mirrors that catch the light and reflect the movement and gaiety of the merry-go-round. (Shelburne Museum, Inc.)

426 (below). Carousel giraffe. 1875–1900. Wood. L. 45″. Children discovered that it was easiest to catch the brass ring from the back of a giraffe since his neck made a good, firm handhold. (Greenfield Village and Henry Ford Museum)

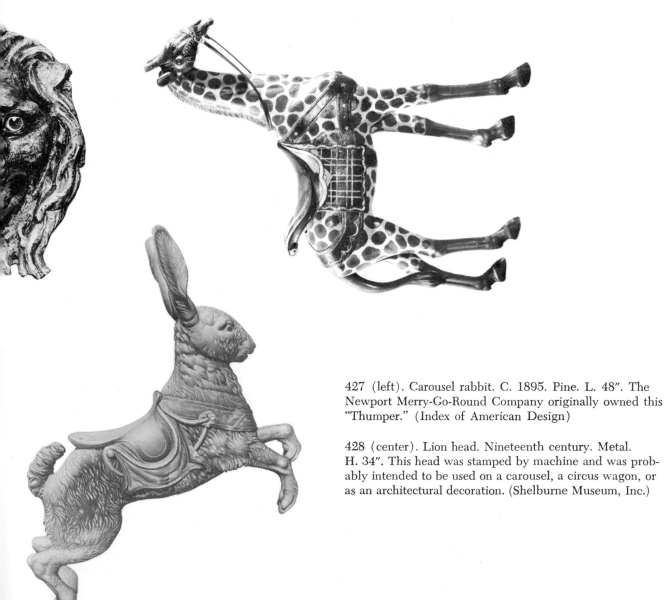

427 (left). Carousel rabbit. C. 1895. Pine. L. 48″. The Newport Merry-Go-Round Company originally owned this "Thumper." (Index of American Design)

428 (center). Lion head. Nineteenth century. Metal. H. 34″. This head was stamped by machine and was probably intended to be used on a carousel, a circus wagon, or as an architectural decoration. (Shelburne Museum, Inc.)

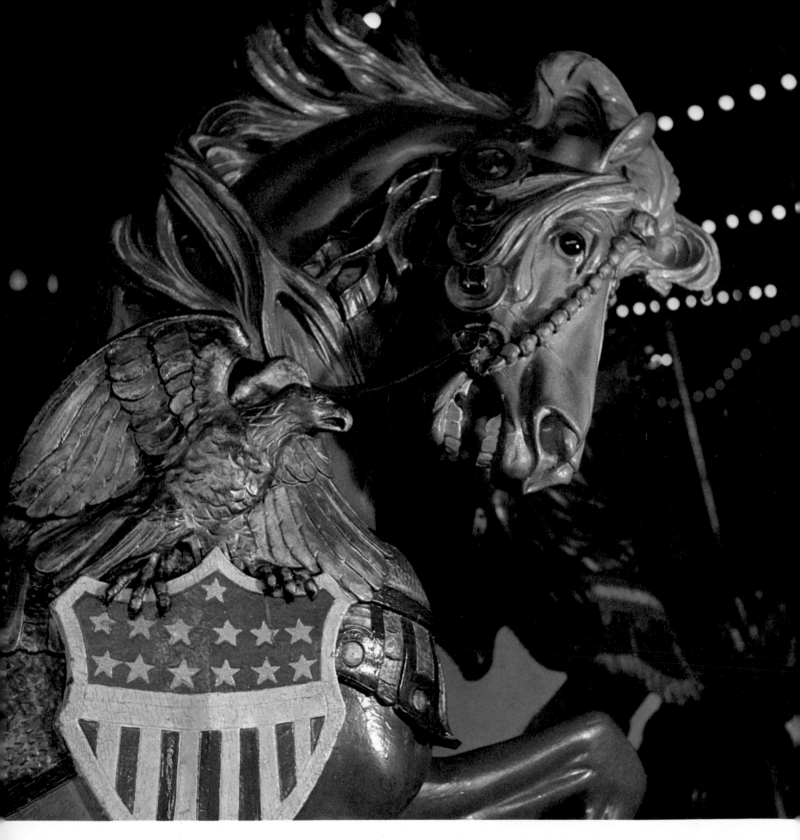

429 (above). Carousel horse. Philadelphia Toboggan Co., Germantown, Pennsylvania. Carved by Daniel Carl Muller. 1917–1918. Wood. H. 56″. This lead horse was from a five-row carousel originally made for the Palace Gardens at Detroit in 1918. The carousel was later removed to Olympic Park, Maplewood, New Jersey, and finally to Florida where it is part of a major amusement park. The eagles have been converted to falcons, the American shields have become heraldic shields, and the horse has been converted into a "jumper." Further mutilation of the carousel includes the conversion of the Columbia figures and American shields on the rims to "ladies of the round table" with heraldic shields. All the chariots have been removed and several of the horses have been replaced with fiber glass adaptations. It is discouraging that thoughtless destruction of folk art should result from such unsympathetic commercial interests. How much better it would be to follow the lead of Heritage Plantation of Sandwich and Greenfield Village and Henry Ford Museum, where nineteenth- and early twentieth-century carousels have been skillfully restored and preserved and continue, even today, to provide rides for the young at heart. (Photograph courtesy Frederick Fried)

430 (above). Appliqué in the form of a dragon used to decorate a carousel wagon. 1875–1900. Wood, cut by jigsaw. L. 94″. Paint was used to transform a simple jigsaw cutout pattern into a fantastic, gaudy creature from another world. (Greenfield Village and Henry Ford Museum)

431 (below). Side panel for a carousel wagon. Late nineteenth century. Wood. L. 90″. Uncle Sam and the American eagle appear even on merry-go-rounds. Carousel wagons were used by the more sedate riders who were intimidated by the "jumpers." (Greenfield Village and Henry Ford Museum)

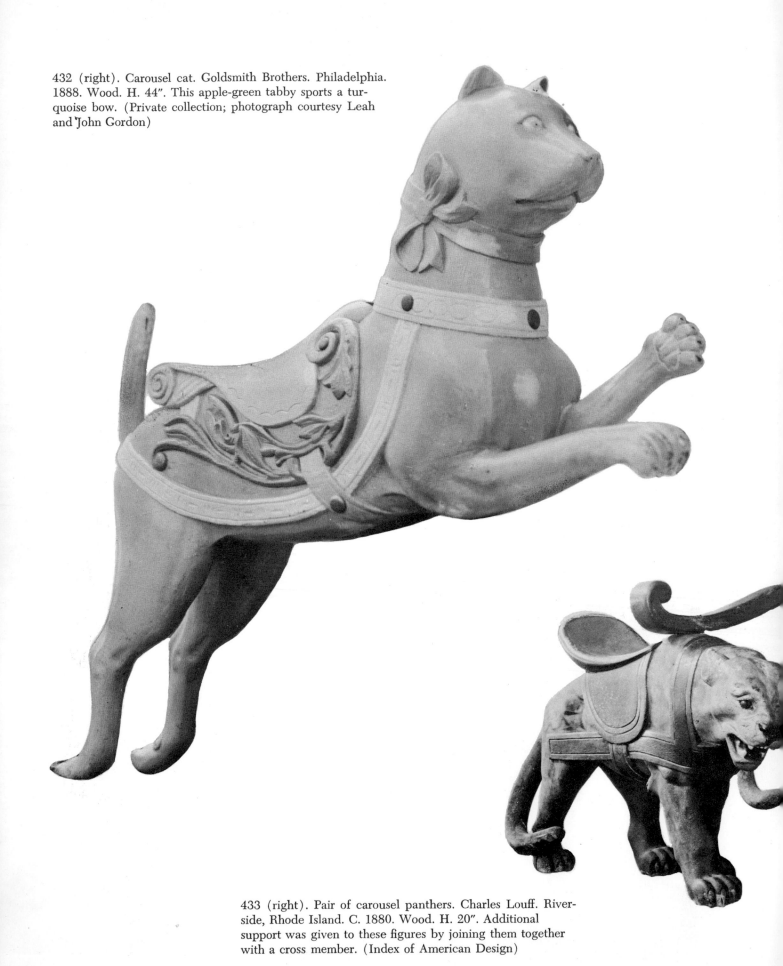

432 (right). Carousel cat. Goldsmith Brothers. Philadelphia. 1888. Wood. H. 44″. This apple-green tabby sports a turquoise bow. (Private collection; photograph courtesy Leah and John Gordon)

433 (right). Pair of carousel panthers. Charles Louff. Riverside, Rhode Island. C. 1880. Wood. H. 20″. Additional support was given to these figures by joining them together with a cross member. (Index of American Design)

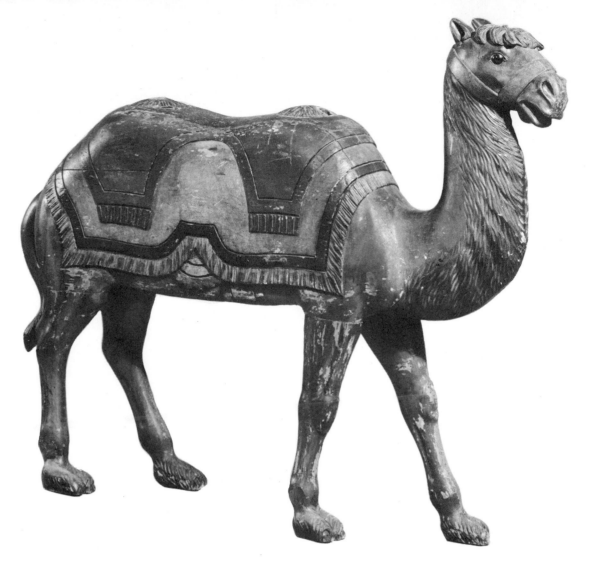

434 (above). Carousel Bactrian camel. Attributed to Charles W. F. Dare & Company. New York. 1890–1896. Wood. L. 60″. Dare was a maker of toys, carousel figures, and amusement devices of various types. (Abby Aldrich Rockefeller Folk Art Collection)

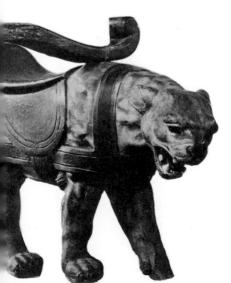

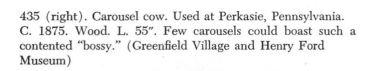

435 (right). Carousel cow. Used at Perkasie, Pennsylvania. C. 1875. Wood. L. 55″. Few carousels could boast such a contented "bossy." (Greenfield Village and Henry Ford Museum)

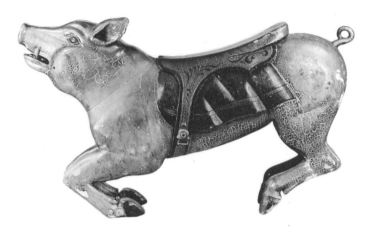

436 (above). Carousel pig. Late nineteenth century. Wood, painted. L. 46". (Smithsonian Institution, Van Alstyne Collection)

437 (right). The Bauern Haus and Carousel. C. 1880. Oil on canvas. 31" x 28½". The Bauern Haus [hotel] and carousel at Rockaway Beach, New York, was painted by an unknown guest at the hotel about 1880. The property was owned by Frederick Schildt, who was also an agent for imported organs, carousels, and so forth. The merry-go-round was brought to America by him from the Black Forest in Germany. It was first driven by manpower, then by a pony, and later by a steam boiler, until it was destroyed by fire in September, 1892. To the right of the carousel is an elevated open-air dining room with guests seated at the tables. Below the dining room is a refreshment bar. Just visible in the elevated structure to the left of the carousel is an elaborate organ, also imported by Mr. Schildt. There is also a drummer, who probably provided a resounding accent to the festive music. The animals on the carousel include reindeer, horses, lions, gryphons, and other exotic creatures. The carousel also includes wagons. Of special interest on the hotel roof are the ridgepole decorations in the form of horses' heads; the heron, which probably was made of metal; and the tiny weathervane. The Bauern Haus must have been a wonderful place to stay. (Museum of the City of New York)

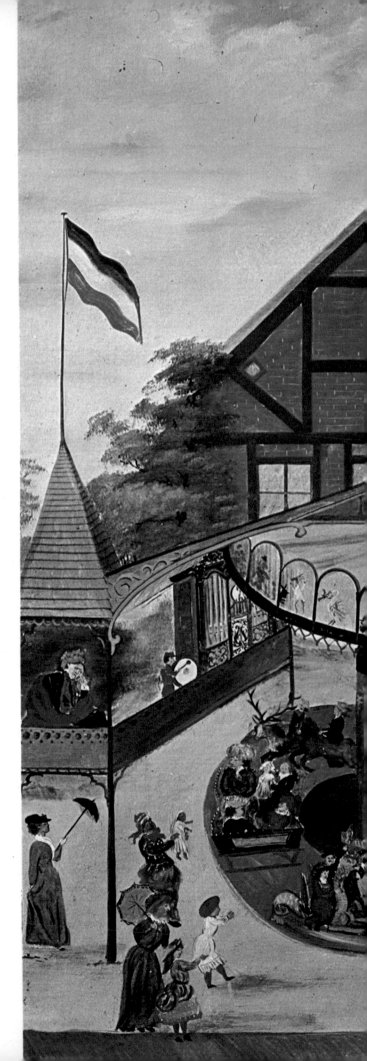

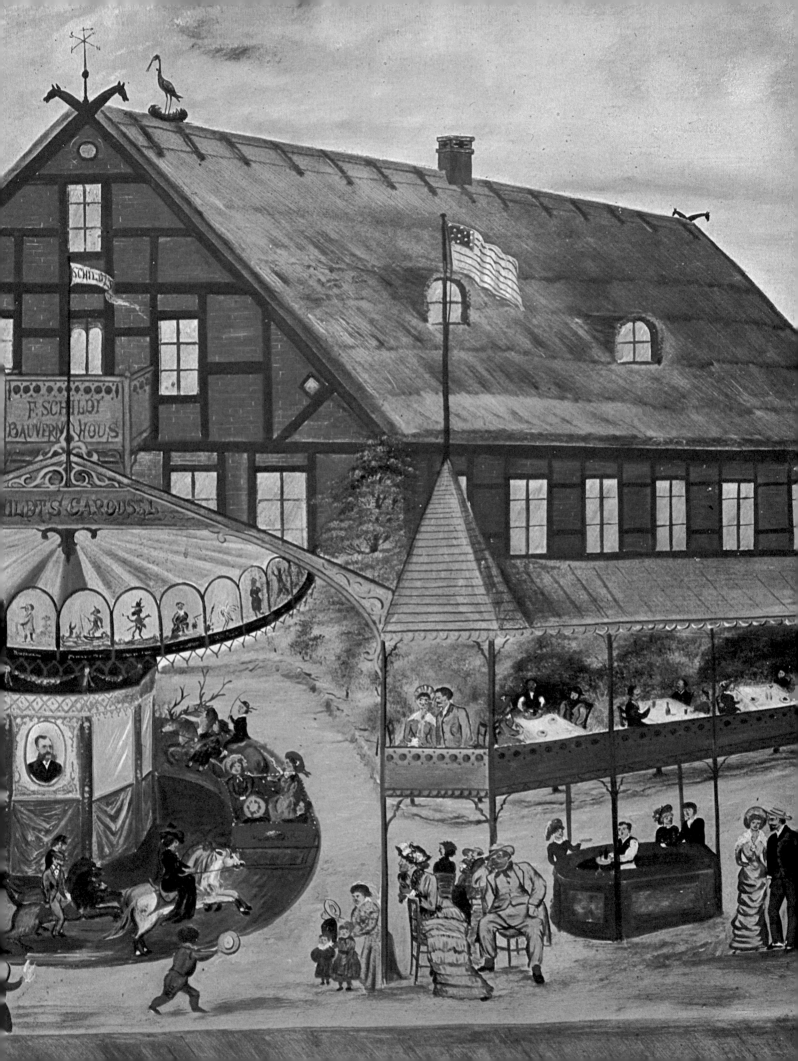

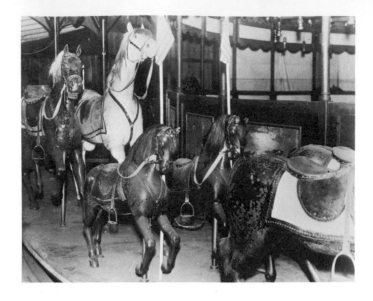

438 (left). Early photograph of Brown's flying horses formerly at Salem Willows, Salem, Massachusetts. Notice the great variety in the sizes of the figures. (Essex Institute)

439 (below, center). Photograph of Joseph Brown, owner and manufacturer of the flying horses. Date unknown. (Essex Institute)

440 (below, left). Few American carousels could boast of an elephant bearing a howdah. (Essex Institute)

Joseph Brown was born in Poland in 1840 and came to Salem, Massachusetts, in 1870 where he sold pipe organs. Like many European emigrants, he was a skilled carver and manufactured "flying horses." He established at Salem Willows one of the earliest New England carousels, which was operated by three generations of the Brown family until its removal in 1945 by the R. H. Macy Company of New York.

Brown's figures are comparatively static in design; in many ways they are a truer folk art expression than the products of the professional woodcarving studios where factorylike techniques were employed.

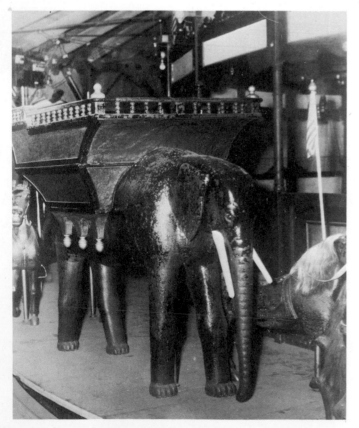

441 (opposite, above). Brown's flying horse carousel was especially decorated for Christmas. Tinsel, roping, and glass balls were complemented by the miniature figures visible in this photograph. Some of these miniatures still exist and are in a private collection. (Essex Institute)

442 (opposite, below). Overall view of Brown's flying horses. Advertising space was sold around the base of the carousel. (Essex Institute)

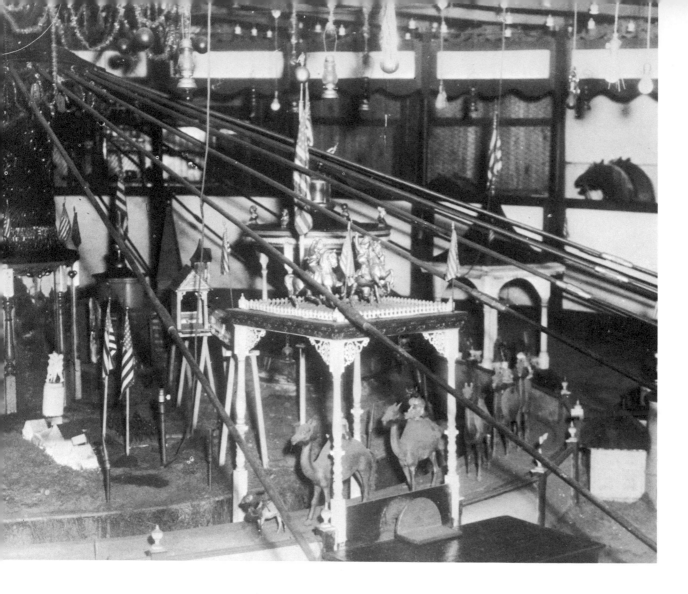

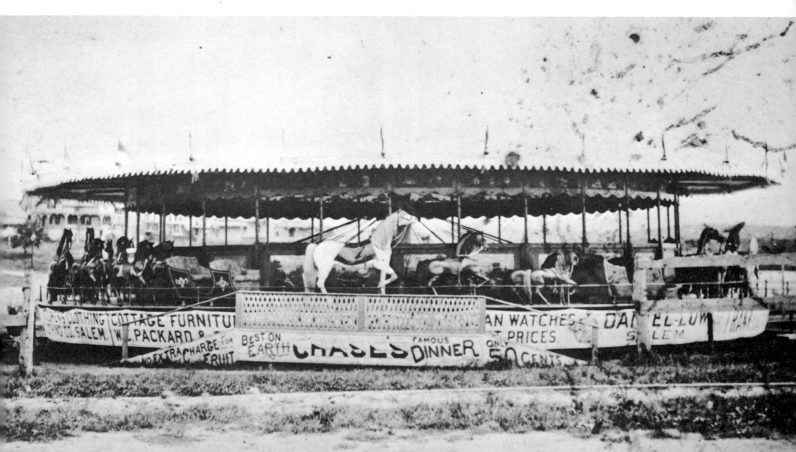

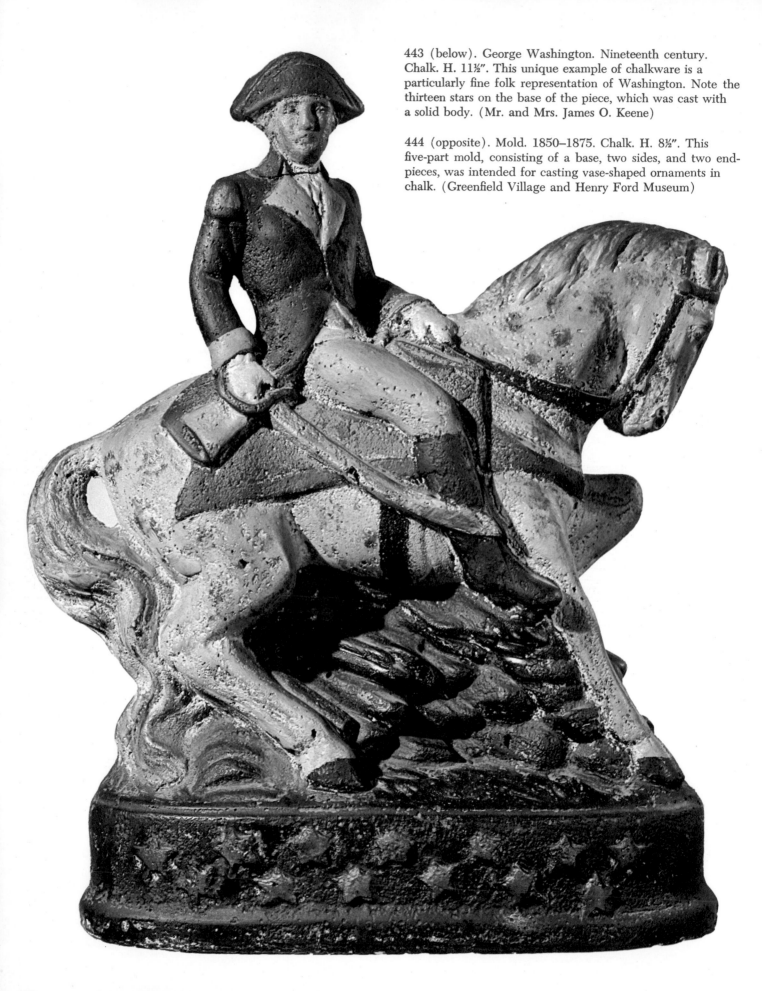

443 (below). George Washington. Nineteenth century. Chalk. H. 11½″. This unique example of chalkware is a particularly fine folk representation of Washington. Note the thirteen stars on the base of the piece, which was cast with a solid body. (Mr. and Mrs. James O. Keene)

444 (opposite). Mold. 1850–1875. Chalk. H. 8½″. This five-part mold, consisting of a base, two sides, and two end-pieces, was intended for casting vase-shaped ornaments in chalk. (Greenfield Village and Henry Ford Museum)

CHALK

As the expansion of the Industrial Revolution made it increasingly difficult for potters to compete in the production of utilitarian household objects, many were forced to discontinue the operation of their kilns. Consequently, the craftsman who had fashioned gifts for relatives and friends from unused clay at the end of his workday no longer created these whimsical pieces.

Plaster figures, often elaborately shaped, began to appear in Pennsylvania during the nineteenth century. They were made in molds and, after drying, were brightly painted in individual patterns. Frequently the molds for "chalk" were similar in design to those used by glassmakers. Early chalk is hollow and therefore much lighter than a solid-cast plaster piece. Generally, the inside remains unpainted and the degree of discoloration can often be helpful in establishing the approximate age of a piece.

Most American chalkware has been found in Pennsylvania and until recently, it had been assumed that all chalk had originated there. Research in France, however, has established that chalkware was also produced in that country and quite possibly could have been exported to America to provide a less expensive alternative to sophisticated European ceramics.

While chalkware was being cast for householders of modest means, John Rogers (1829–1904), the American sculptor, was mass-producing in New York another kind of cast-plaster sculpture for the parlors of the nouveau riche (see page 225). As one of his critics explained in 1869: "His art is for the people. All can understand it; all can appreciate its meaning; all can perceive its truth, and respond to its feeling." [39] Between 1860 and 1893, over 80,000 pieces of his putty-colored groups were purchased.

445 (right). Poodle. Late nineteenth century. Chalk. H. 12". Though this poodle has a winning personality, he would receive no blue ribbons, for the muzzle is broad and flattened. A delicate rose design decorates the base. (Mr. and Mrs. James O. Keene)

446 (left). Swan. Nineteenth century. Chalk. H. 4¾". Chalk figures are especially fragile; it is surprising that so many have survived. (Effie Thixton Arthur)

448 (opposite, above). Squirrel. Pennsylvania. 1850–1875. Chalk. H. 6½". Though several identical pieces could be pulled from a mold, the painted decoration was nearly always individual. The base of this piece is decorated with impressed interlaced swags and circles and is painted brilliant green. (Greenfield Village and Henry Ford Museum)

449 (opposite, below). Stag. Signed "T.C. '59." Nineteenth century. Chalk. H. 7½". Signed chalk pieces are a great rarity. Where casting was especially difficult, parts made from other materials were occasionally substituted. Several stags with metal horns are known. (Russell Carrell)

447 (above). Rooster. Nineteenth century. Chalk. H. 6". (Effie Thixton Arthur)

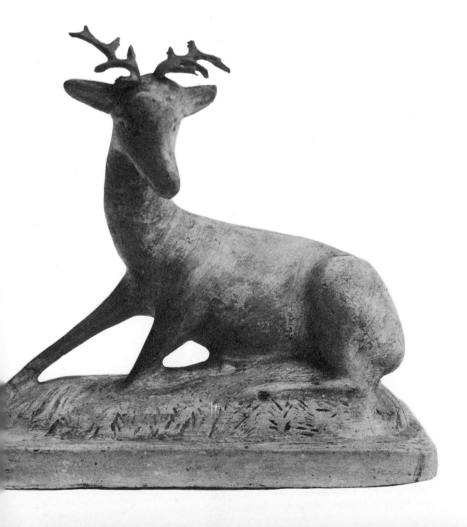

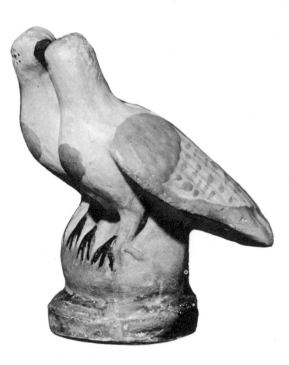

450 (above). Lovebirds. Nineteenth century. Chalk. H. 5". (Effie Thixton Arthur)

241

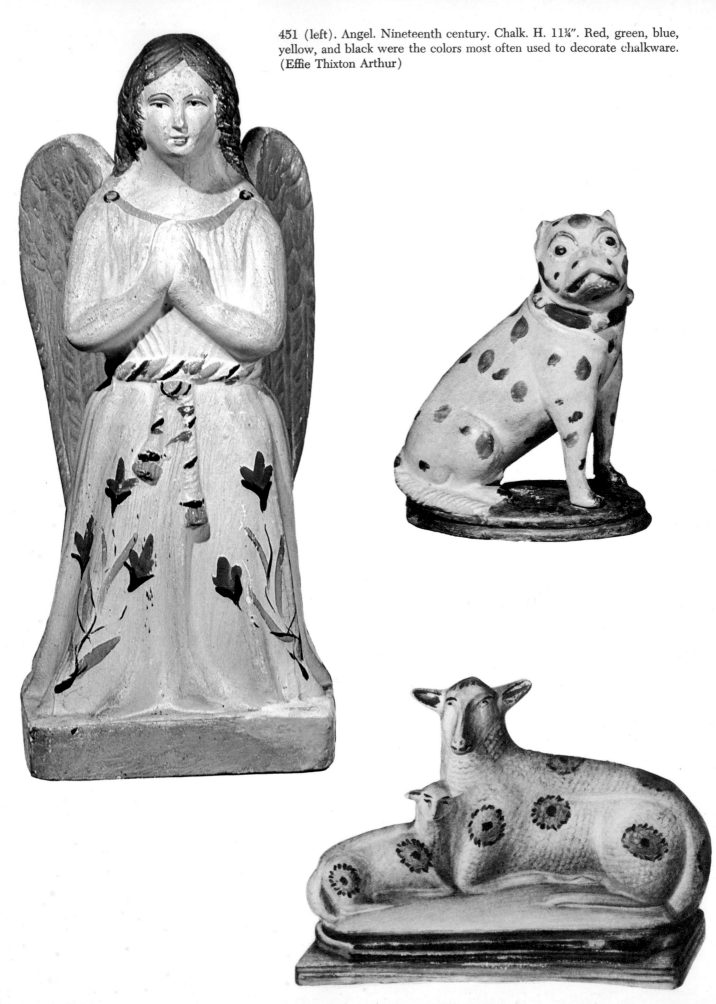

451 (left). Angel. Nineteenth century. Chalk. H. 11¼". Red, green, blue, yellow, and black were the colors most often used to decorate chalkware. (Effie Thixton Arthur)

Chalk appears to have been produced primarily in the East. Few indeed are the pieces that are found west of Ohio, although family history occasionally documents that a treasured piece of chalk survived the hazardous overland trek of the westward migration. The fruit and religious pieces appear to be of somewhat earlier date than representations of animals and famous people.

452 (opposite, above). Dog. Nineteenth century. Chalk. H. 6½″. (Effie Thixton Arthur)

453 (opposite, below). Ewe and lamb. Mid-nineteenth century. Chalk. L. 8½″. (Index of American Design)

454 (right). Kissing birds. Nineteenth century. Chalk. H. 4¾″. (Effie Thixton Arthur)

455 (below). Plaque. Nineteenth century. Plaster set in a wood shadow box under glass. H. 8″. This is a piece of unusual charm. (Effie Thixton Arthur)

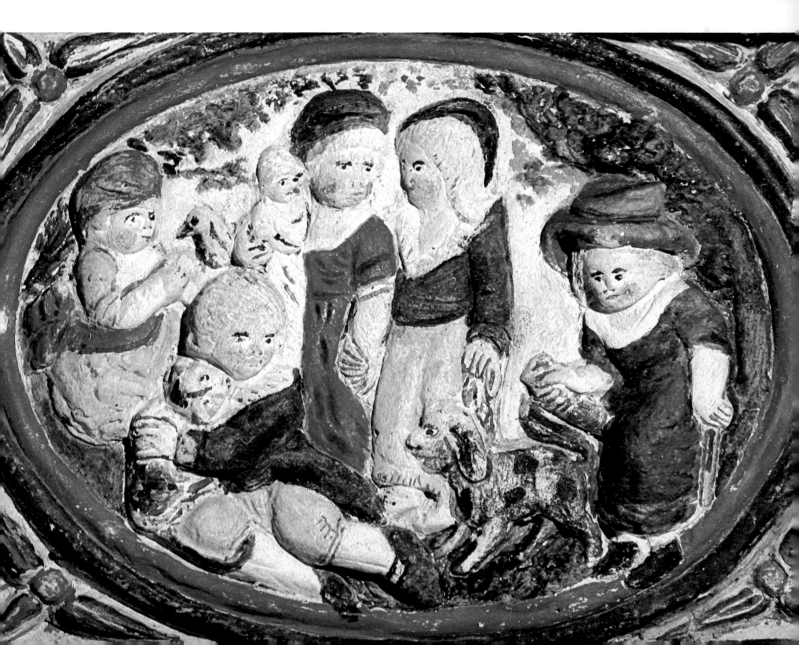

456 (below). Cat. Nineteenth century. Chalk. H. 16″. Several fine chalk cats have survived. (Effie Thixton Arthur)

457 (opposite, above). Watchstand. Nineteenth century. Chalk. H. 12″. Very little is known about the manufacture of chalk. One collector believes that peddlers brought their equipment to fairs and made and sold their pieces there. Several watchstands with wax figures are known, but they are generally considered to be of European origin (Effie Thixton Arthur)

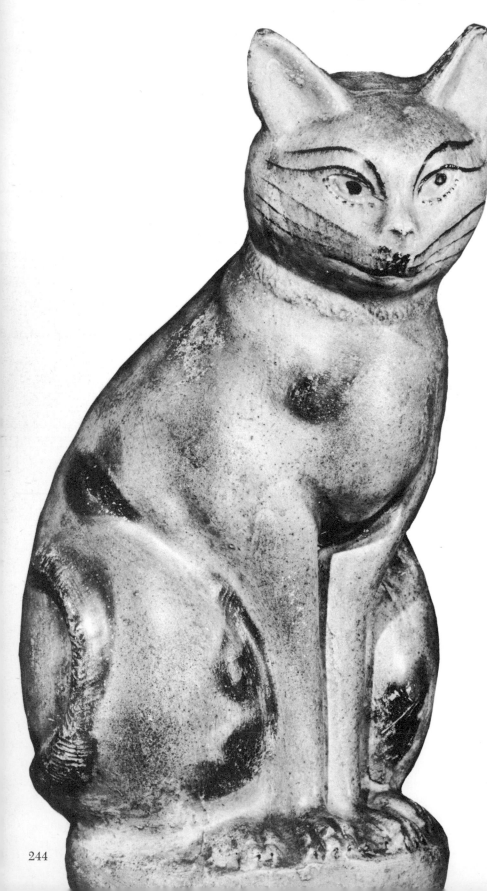

458 (below). Rabbit with nodding head. Pennsylvania. 1850–1875. Chalk. L. 6⅛″. Animals with nodding heads are probably the rarest of all chalk figures. Collectors especially treasure nodding-head goats and rabbits. (Private collection)

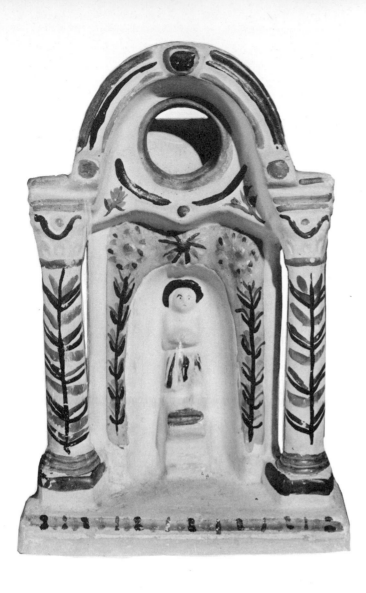

460 (overleaf). "Pineapple" garniture. Nineteenth century. Chalk. H. of tallest piece, 10½". (Effie Thixton Arthur)

459 (right). Child with dove. 1850–1875. Chalk. H. 6". (Greenfield Village and Henry Ford Museum)

461 (right). Garniture. Second half of the nineteenth century. Chalk. H. 14″. Fruits and vegetables are incorporated into the overall pattern of these pieces. Mantel decorations were not restricted to garnitures, however; as Mark Twain's Huck Finn observed on one of his eventful trips: "Well, there was a big outlandish parrot on each side of the clock made out of something like chalk and painted up gaudy. By one of the parrots was a cat made of crockery, and a crockery dog by the other; and when you pressed down on them they squeaked, but didn't open their mouths nor look different nor interested. They squeaked through underneath." [40] (Private collection)

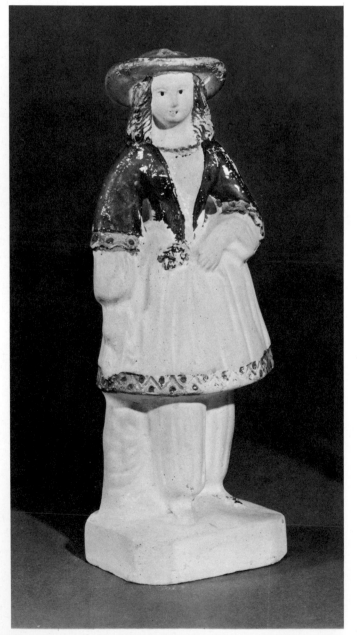

462 (left). Bloomer girl. Late nineteenth century. Chalk. H. 10″. The American social reformer, Amelia Jenks (1818–1894), agitated for women's suffrage. She affected a costume that was composed of loose trousers gathered about the ankles and worn under a short skirt. This fashion was adopted by young women participating in athletic activities. (Effie Thixton Arthur)

463 (right). Santa Claus. Nineteenth century. Chalk. H. 18½".
The patron saint of Christmas is seen here perched on top of
a church steeple. (Private collection; photograph courtesy
Mr. and Mrs. Jerome Blum)

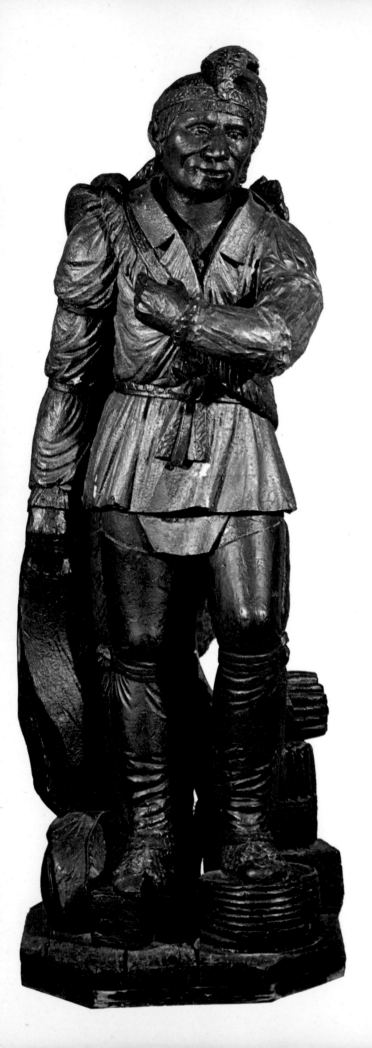

464 (left). Trapper Indian. Late nineteenth century. Pine, polychromed. H. 42½″. Few cigar store figures possess the strong humanity that the carver so skillfully portrayed in this beautiful figure. (Abby Aldrich Rockefeller Folk Art Collection)

466 (opposite, left). Detail of woodcut, "View of Broadway, New York City." Late nineteenth century. The unidentified smoke shop offered Bully Segars and Lorilards Long Cuts. Two cosmopolitan princesses are passing by one of America's native queens. (Private collection)

465 (above). Advertisement from the *Albany Gazette*, June 3, 1819. This woodcut accompanied an advertisement for the Caldwell & Solomons Tobacco and Snuff Store at 346 North Market Street, New York, offering sweet-scented tobacco of their own manufacture, "Fine Plug Tobacco, 6 and 8 hands to the lb. Plugtail Tobacco, in 12 lb. rools and kegs . . ." (The New-York Historical Society)

CIGAR STORE INDIANS

During the eighteenth century figures of black boys were a regular fixture in English smoke shops, and in America a similar piece was used in an isolated instance at Baltimore before 1780. During the mid-nineteenth century, when cigar smoking became popular, the Indian, the first American to cultivate tobacco, was the advertising symbol for smoke shops. By the last half of the nineteenth century, cigar store Indians reflected the taste and success of tobacconists. Tribes of figures of all sizes invaded every city until the 1890s, when ordinances required that the brightly painted obstructions be confined to the inside of the shops. The death knell for the cigar store Indian tolled when skillful marketing practices by chain stores caused the independent tobacconist to close his doors.

467 (right). Cigar store Indian. John Philip Yaeger. Baltimore. C. 1876. Wood. H. 55″. It is thought that the artist's daughter Eva Isabelle served as the model for this piece. Note the heart-shaped device that embellishes the bodice. (Maryland Historical Society)

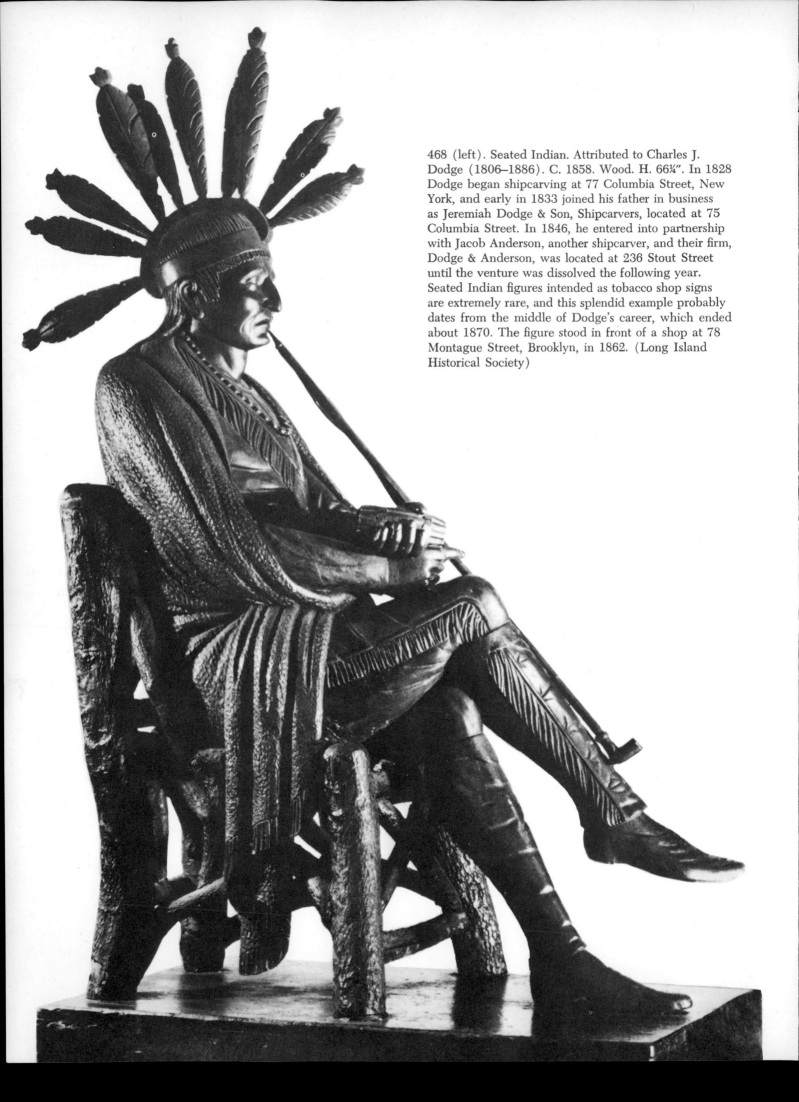

468 (left). Seated Indian. Attributed to Charles J. Dodge (1806–1886). C. 1858. Wood. H. 66¼″. In 1828 Dodge began shipcarving at 77 Columbia Street, New York, and early in 1833 joined his father in business as Jeremiah Dodge & Son, Shipcarvers, located at 75 Columbia Street. In 1846, he entered into partnership with Jacob Anderson, another shipcarver, and their firm, Dodge & Anderson, was located at 236 Stout Street until the venture was dissolved the following year. Seated Indian figures intended as tobacco shop signs are extremely rare, and this splendid example probably dates from the middle of Dodge's career, which ended about 1870. The figure stood in front of a shop at 78 Montague Street, Brooklyn, in 1862. (Long Island Historical Society)

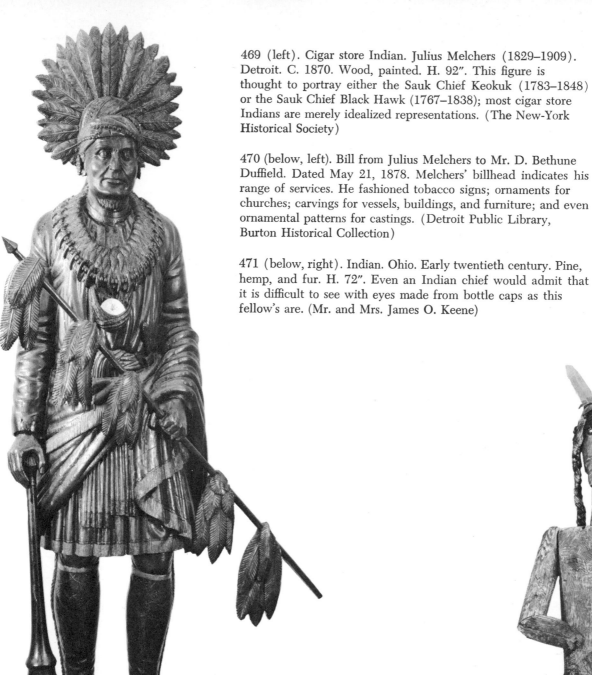

469 (left). Cigar store Indian. Julius Melchers (1829–1909). Detroit. C. 1870. Wood, painted. H. 92″. This figure is thought to portray either the Sauk Chief Keokuk (1783–1848) or the Sauk Chief Black Hawk (1767–1838); most cigar store Indians are merely idealized representations. (The New-York Historical Society)

470 (below, left). Bill from Julius Melchers to Mr. D. Bethune Duffield. Dated May 21, 1878. Melchers' billhead indicates his range of services. He fashioned tobacco signs; ornaments for churches; carvings for vessels, buildings, and furniture; and even ornamental patterns for castings. (Detroit Public Library, Burton Historical Collection)

471 (below, right). Indian. Ohio. Early twentieth century. Pine, hemp, and fur. H. 72″. Even an Indian chief would admit that it is difficult to see with eyes made from bottle caps as this fellow's are. (Mr. and Mrs. James O. Keene)

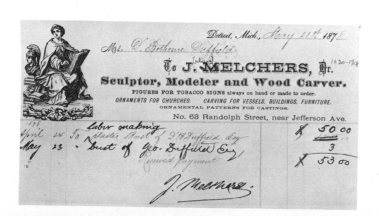

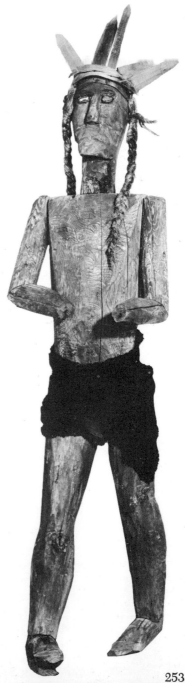

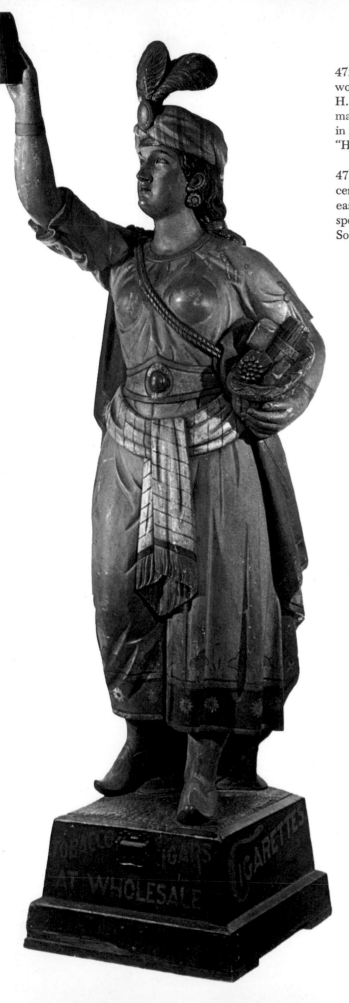

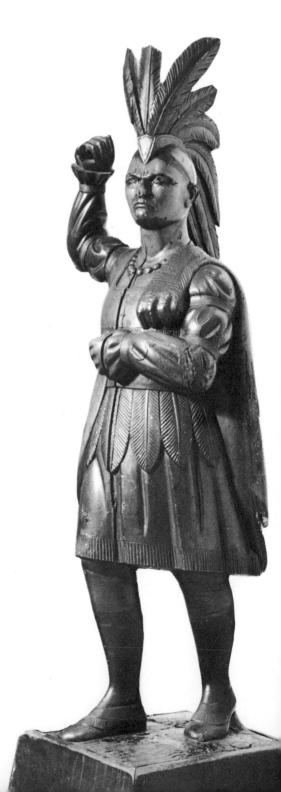

472 (left). Turkish princess or Sultana. Probably from the workshop of Samuel A. Robb. New York. C. 1875. Wood. H. 87″. This piece was found in New York State and was made for a wholesale tobacconist's shop. On top of the base in front of the Sultana's feet is the peremptory admonition, "HANDS OFF." (Gerald Kornblau Gallery)

473 (below). Indian. Ohio. Second half of the nineteenth century. Wood. H. 79″. The Gregor Albert Cigar Store at the east corner of Euclid Avenue and 9th Street, Cleveland, Ohio, sported this handsome brave. (Western Reserve Historical Society)

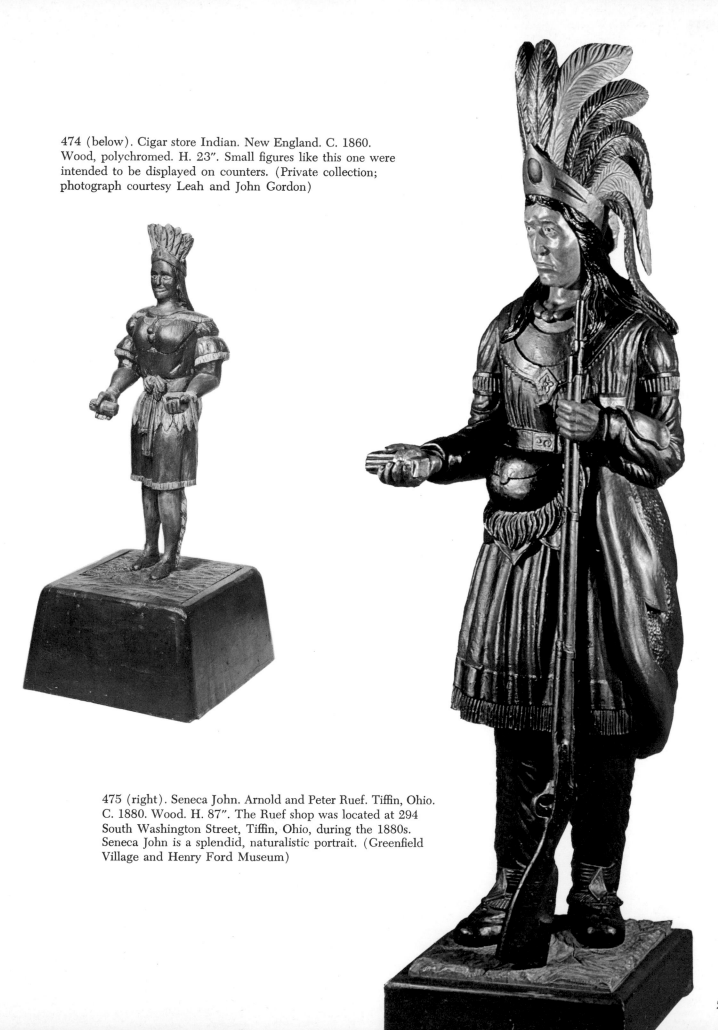

474 (below). Cigar store Indian. New England. C. 1860. Wood, polychromed. H. 23". Small figures like this one were intended to be displayed on counters. (Private collection; photograph courtesy Leah and John Gordon)

475 (right). Seneca John. Arnold and Peter Ruef. Tiffin, Ohio. C. 1880. Wood. H. 87". The Ruef shop was located at 294 South Washington Street, Tiffin, Ohio, during the 1880s. Seneca John is a splendid, naturalistic portrait. (Greenfield Village and Henry Ford Museum)

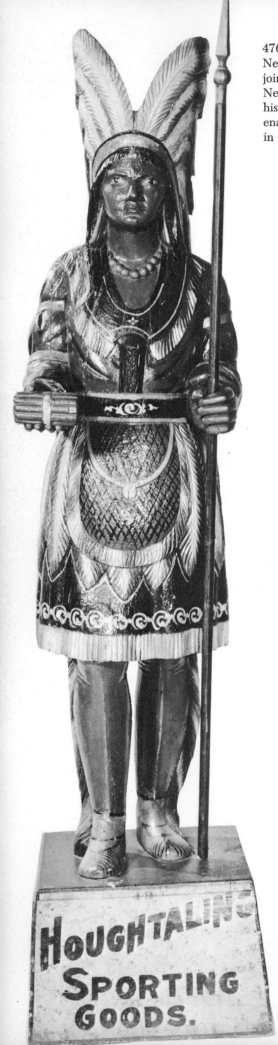

476 (left). Indian chief. Thomas V. Brooks (1828–1895).
New York. C. 1894. Wood, painted. H. 70″. In 1840 Brooks
joined the shop of John L. Cromwell at 419 Water Street,
New York, as an apprentice shipcarver, and in 1848 he opened
his own shop at 267 South Street. His success was phenom-
enal, and by 1868 his establishment was one of the largest
in the city. (Virginia Museum of Fine Arts)

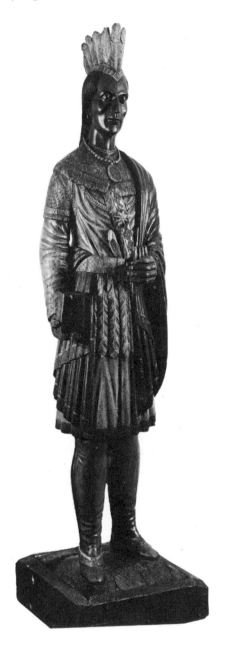

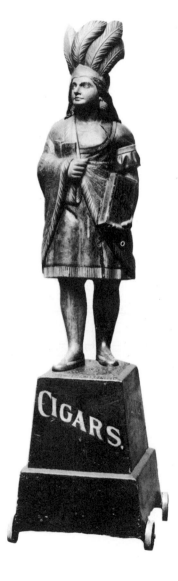

477 (above, left). Indian brave. C. 1865. Wood, polychromed. H. 82″. After a
peace treaty had been negotiated, government officials frequently presented
silver medals and other decorations to the Indian chiefs signing the treaty
papers. This figure is wearing a portrait medallion on a string of beads. (New
York State Historical Association)

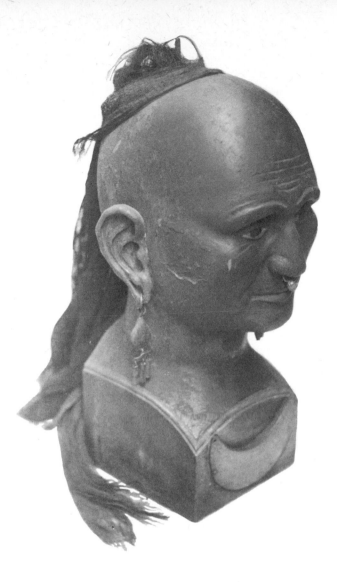

479 (left). Indian head. John Fisher (1740–1805). York, Pennsylvania. 1775–1805. Wood covered with gesso, painted; brass gorget; tin earrings; human hair. H. 12″. John Fisher was one of the most sophisticated clockmakers in the York area during the Revolutionary War period. The gorget around the neck of this piece is engraved with crossed tomahawks and bears the name of Captain John Carlton and the date 1789. (Historical Society of York County)

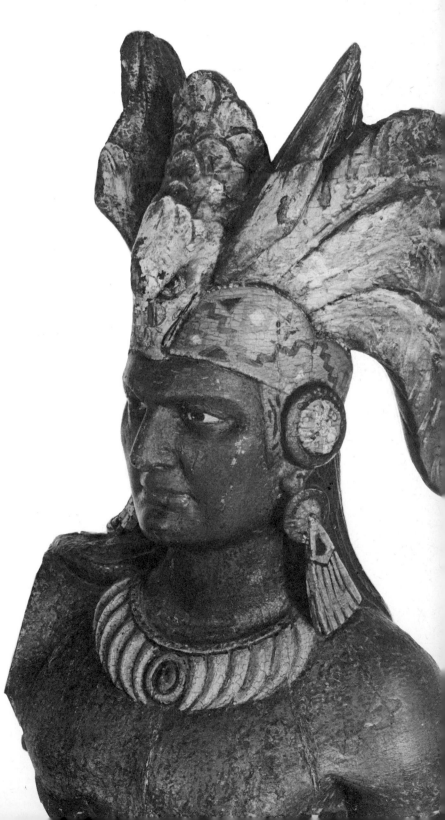

478 (opposite, right). Indian. Samuel A. Robb. New York. 1878–1888. Wood. H. 77″. Across the front edge of this piece is the inscription, "S. A. Robb, Carver, 195 Canal St. N.Y." Not all of the figures originating in the Robb shop were signed; only those that he made and completed himself bore his name. (The New-York Historical Society)

480 (right). Indian bust. Probably by Charles or Samuel A. Robb. New York. C. 1900. Wood, polychromed. H. 27½″. This portrait bust was probably used above the lintel of a cigar store door in place of the usual full figure in front of the shop. It is possible that this bust is only the upper section of a full-size Indian. The base might have been destroyed by a fire. (Shelburne Museum, Inc.)

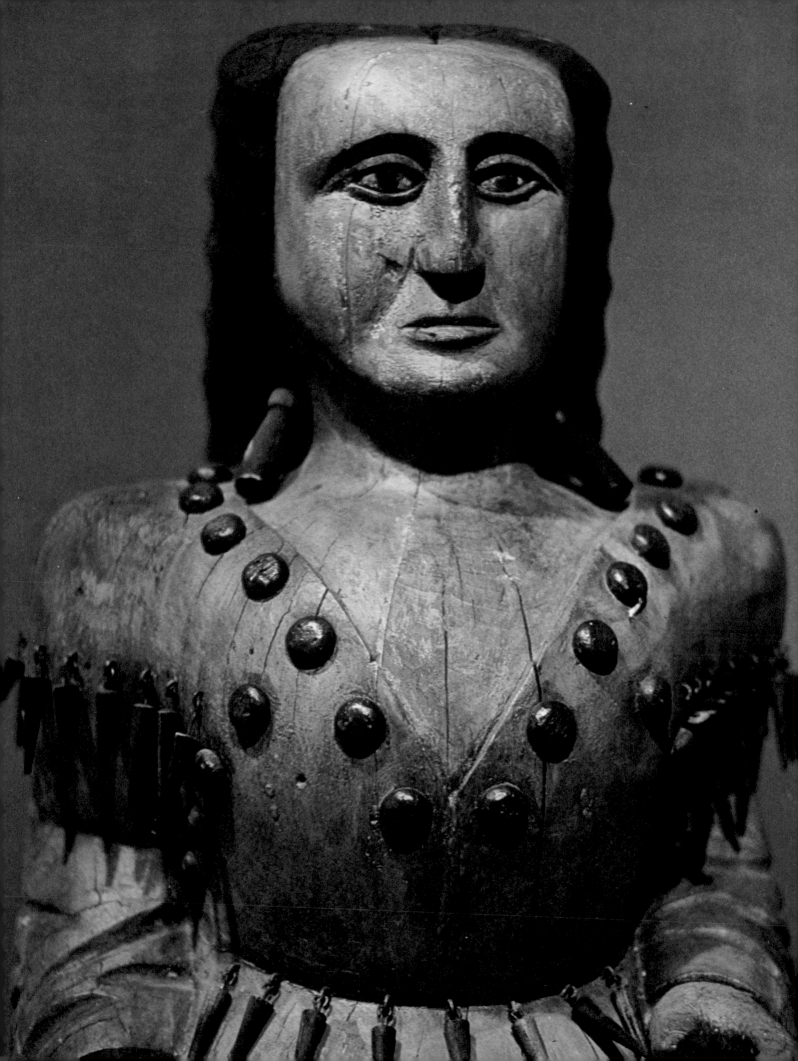

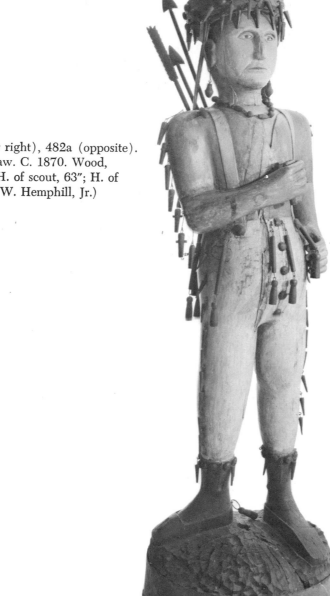

481 (right), 482 (far right), 482a (opposite). Indian scout and squaw. C. 1870. Wood, painted and stained. H. of scout, 63″; H. of squaw, 48″. (Herbert W. Hemphill, Jr.)

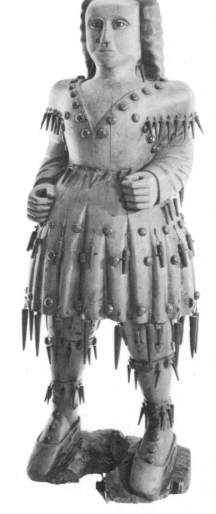

Indian scouts, often accompanied by their squaws, made it possible for adventurers to extend the midwestern and western frontiers, thus opening vast new areas of the American continent to ever-increasing numbers of settlers. The scout and his squaw, figures 481 and 482, are without question the most significant cigar store figures that exist. These masterpieces of American folk sculpture, unique both in the monumentality of their conception and in their fascinating details, make almost all other cigar store figures look slick in comparison.

483 (left). Indian princess. Samuel A. Robb. New York. 1875. Cast zinc, painted. H. 69½″. Few carvers actually had foundry facilities for casting their figures. Moritz J. Seelig (b. 1809), in his Art Establishment in Brooklyn, cast most of the single figures for both William Demuth and J. W. Fiske. Seelig, a German immigrant to America in 1851, developed new methods for casting zinc and bronze, which enabled him to produce show figures and cigar store Indians of superior quality. (Virginia Museum of Fine Arts)

485 (opposite). Advertisement of Wm. Demuth & Co. Printed by M. Thalmessinger & Co. New York. 1871. H. 19⅛″. Demuth claims in his advertisement that he was the first in the country to introduce metal show figures. (Smithsonian Institution)

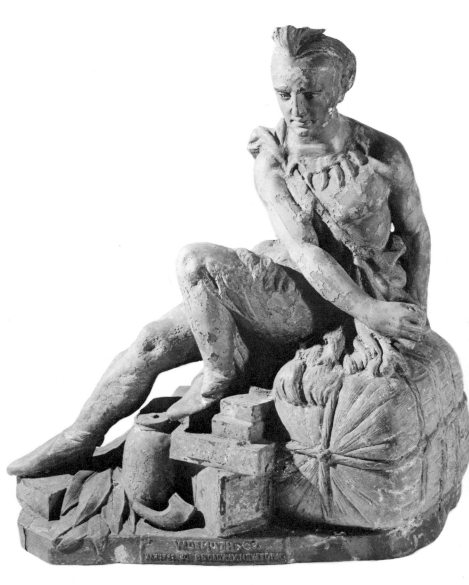

484 (above). Seated Indian. William Demuth (1835–1911). New York. Nineteenth century. Cast zinc, painted. H. 32″. This rare figure sits on a bale of tobacco, and his left foot rests on cigar boxes. (Stewart E. Gregory)

WM. DEMUTH & CO.,
No. 403 BROADWAY, N. Y.,
IMPORTERS AND MANUFACTURERS OF
EGARS AND SMOKERS' ARTICLES.

WOODEN FIGURES.

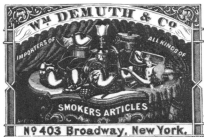

We would respectfully solicit from the Public generally an Inspection of our Large and Varied Assortment of

WOODEN SHOW FIGURES,

which we are constantly manufacturing for all classes of business, such as

SEGAR STORES, WINE & LIQUORS, DRUGGISTS, YANKEE NOTIONS, UMBRELLA, CLOTHING, TEA STORES, THEATRES, GARDENS, BANKS, INSURANCE COMPANIES, &c.

Before we commenced Manufacturing Show Figures, their use was almost entirely confined to Tobacconists, who displayed before their Stores a figure of what by a great stretch of imagination might have been recognised as an Indian—the workmanship of which, to say the least, was not very artistic.

Since then we claim not only to have Manufactured Figures which are both carved and painted in a manner which cannot be excelled, but also to have introduced a number of entirely new and original designs for same, to which we are constantly making additions to suit many other classes of trade (as stated above) besides the Tobacco.

But although our Figures invariably gave full satisfaction, still we wished to make a greater improvement in the line; and by the use of some more durable substance than Wood, thus prevent cracking, which will sometimes occur in Wooden Figures, especially when exposed to the climate of our Southern States.

For this purpose, after incurring a heavy outlay for Designs, Moulds, &c., we commenced the Manufacture of our New

METAL SHOW FIGURES,

(being the first parties in the country to introduce same), which have now been before the public for over two years, during which time we have sent large numbers to all sections of the country without ever having received the slightest word of complaint in regard to them.

We claim for these Figures the following qualities : that they are durable, and as light as wooden figures ; are designed and executed in a highly artistic manner ; and can be furnished at comparatively low prices.

We are constantly receiving orders for Statues and Emblematic Signs, and can furnish same, of any required design, to order, with promptness.

WILLIAM DEMUTH & CO.,
403 BROADWAY, New York.

M. Thalmessinger & Co., Stationers, 308 Broadway, N. Y.

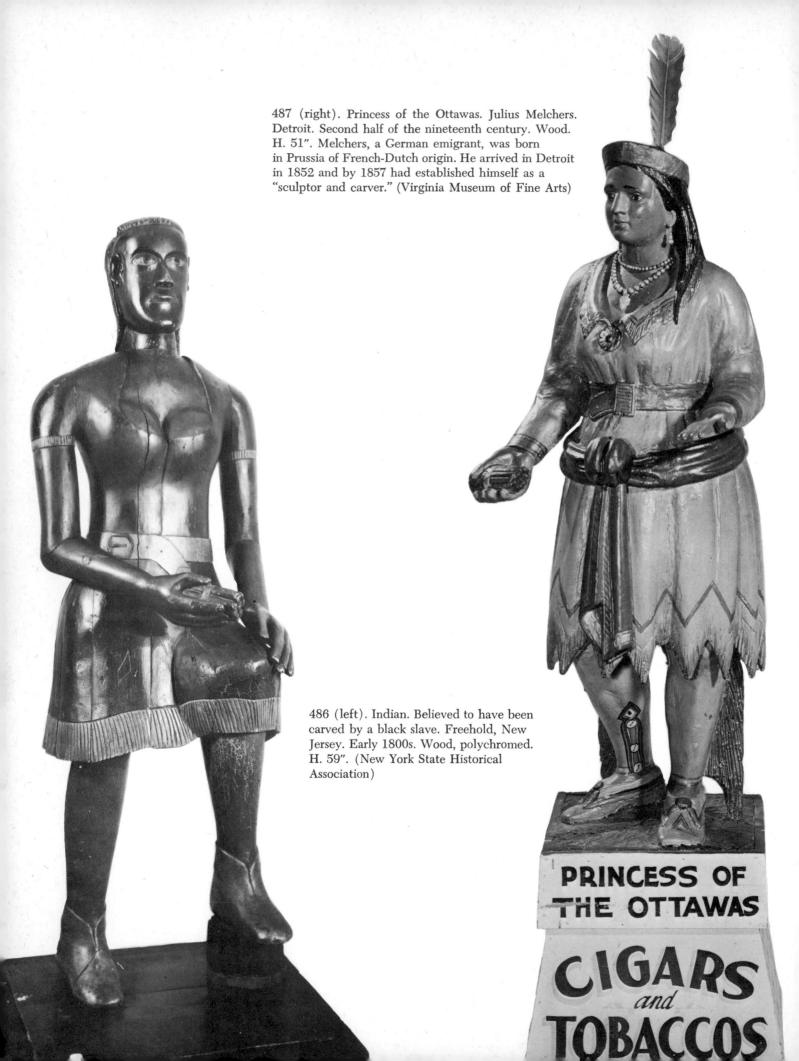

487 (right). Princess of the Ottawas. Julius Melchers.
Detroit. Second half of the nineteenth century. Wood.
H. 51″. Melchers, a German emigrant, was born
in Prussia of French-Dutch origin. He arrived in Detroit
in 1852 and by 1857 had established himself as a
"sculptor and carver." (Virginia Museum of Fine Arts)

486 (left). Indian. Believed to have been
carved by a black slave. Freehold, New
Jersey. Early 1800s. Wood, polychromed.
H. 59″. (New York State Historical
Association)

PRINCESS OF
THE OTTAWAS

CIGARS
and
TOBACCOS

488 (left). Indian. Mid-nineteenth century. Wood, polychromed. H. 50". Some cigar store figures held carved tobacco leaves in their hands; others displayed a bunch of cigars. (Index of American Design)

490 (right). Indian. Last half of the nineteenth century. Wood. H. 75¼". Since cigar store figures were expensive to buy, even secondhand, they were highly prized. If a store went out of business, a competitor would frequently acquire its figure and put his own advertising message on the base. Bases have been repainted as many as five or six times. (Smithsonian Institution, Van Alstyne Collection)

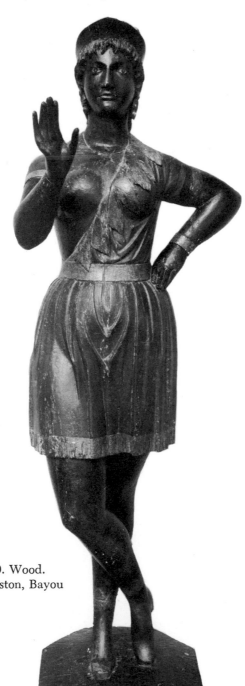

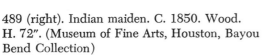

489 (right). Indian maiden. C. 1850. Wood. H. 72". (Museum of Fine Arts, Houston, Bayou Bend Collection)

491 (right). "Battle of Lexington." M. Betsch. Probably New York. 1849. Oil on composite wood panel. H. 30″. This panel is from Lexington Engine No. 7 of the Fire Engine Company, New York, which was organized on December 26, 1849. Many folk carvers also made frames. (Insurance Company of North America)

492 (below). Lithograph of a fire department float in a New York City parade. Published by Imbert & Co. New York. Mid-nineteenth century. Dimensions unavailable. Phenix Company Pumper No. 22 carried an elaborate bird holding a wreath in its mouth. (Private collection)

494 (opposite, below). Harry Howard. New York. C. 1850. Wood. H. 91″. Howard was chief engineer of the New York Volunteer Fire Department from 1857 to 1860. (The New-York Historical Society)

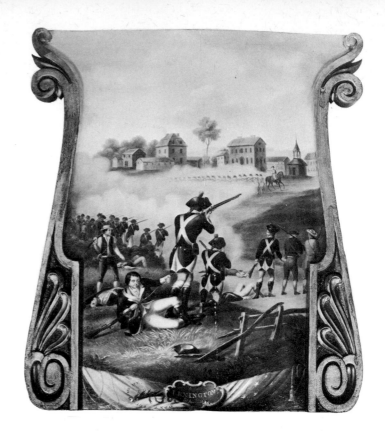

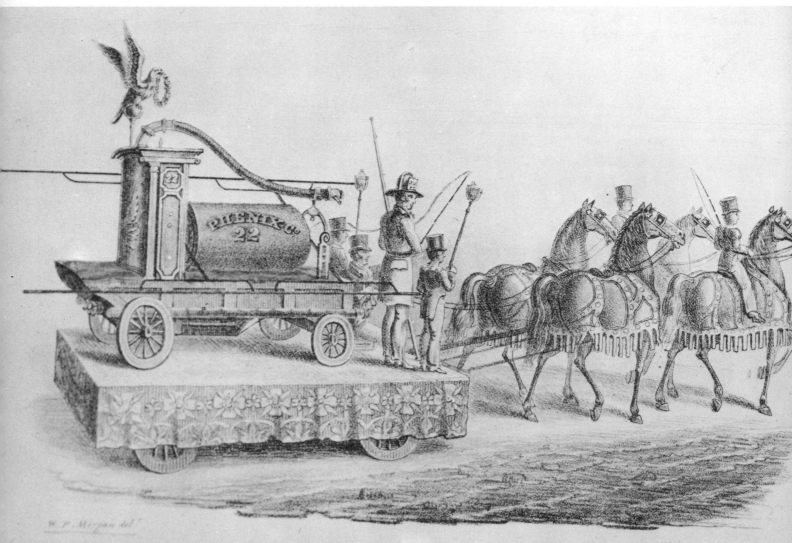

FIRE DEPARTMENT.

FIREMEN'S SCULPTURE

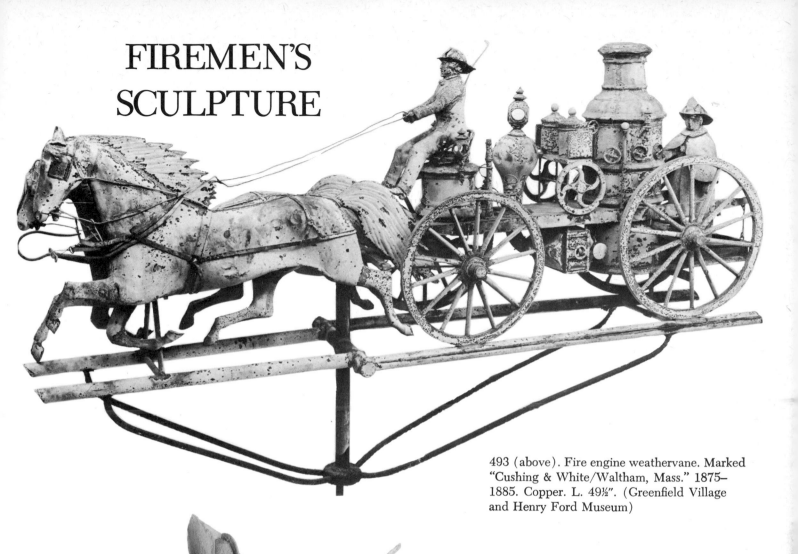

493 (above). Fire engine weathervane. Marked "Cushing & White/Waltham, Mass." 1875–1885. Copper. L. 49½". (Greenfield Village and Henry Ford Museum)

Though the pealing of church bells calling the congregation to Sunday worship was a pleasant and familiar signal, the insistent clanging of those same bells caused terror in the hearts of the townspeople, for they were used to sound the fire alarm in many seventeenth-, eighteenth-, and nineteenth-century American communities.

Most houses were equipped with buckets that stood near the front door and, at the call "Throw out the buckets," long bucket brigades were formed in a frantic effort to douse the flames.

Benjamin Franklin organized one of the first Philadelphia fire brigades, and in 1752 was a founder of the Philadelphia Contributionship for the Insurance of Houses from Loss by Fire.

As houses were built higher, hand pumps became necessary, and around 1819 suction pumps were introduced. The horse-drawn steam engine appeared around 1850 and continued in use until the day of motorized fire trucks.

Though firefighting equipment had to be utilitarian by necessity, it was often embellished with carved symbolic decorations and elaborately painted panels.

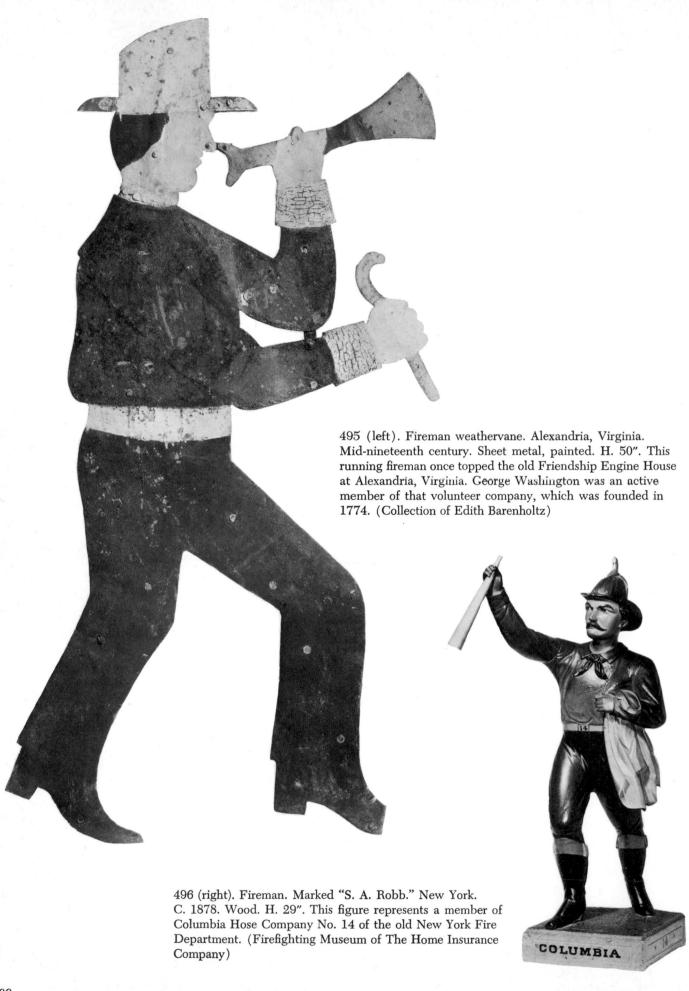

495 (left). Fireman weathervane. Alexandria, Virginia. Mid-nineteenth century. Sheet metal, painted. H. 50″. This running fireman once topped the old Friendship Engine House at Alexandria, Virginia. George Washington was an active member of that volunteer company, which was founded in 1774. (Collection of Edith Barenholtz)

496 (right). Fireman. Marked "S. A. Robb." New York. C. 1878. Wood. H. 29″. This figure represents a member of Columbia Hose Company No. 14 of the old New York Fire Department. (Firefighting Museum of The Home Insurance Company)

497 (above). Decoration from a volunteer firefighting wagon. Last half of the nineteenth century. Wood, polychromed. L. 28″. Volunteer departments frequently competed with one another in exhibitions of skill. Firemen were especially proud of their elaborate and colorful equipment, which they embellished with splendid carvings and painted decoration. (Effie Thixton Arthur)

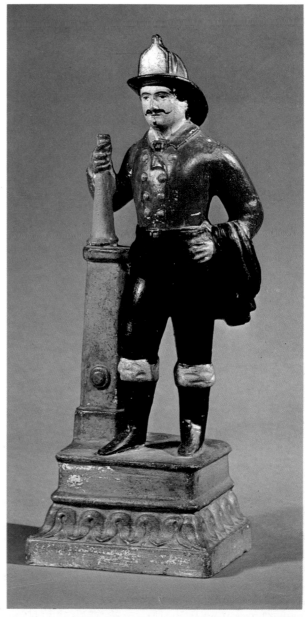

498 (above). Fire engine weathervane. C. 1850. Metal. W. 22″. (Mr. and Mrs. Harvey Kahn)

499 (right). Fireman. Late nineteenth century. Chalk. H. 14″. Before the development of the plastic hard-hat, fire helmets were usually made of leather or cast metal. (Allan L. Daniel)

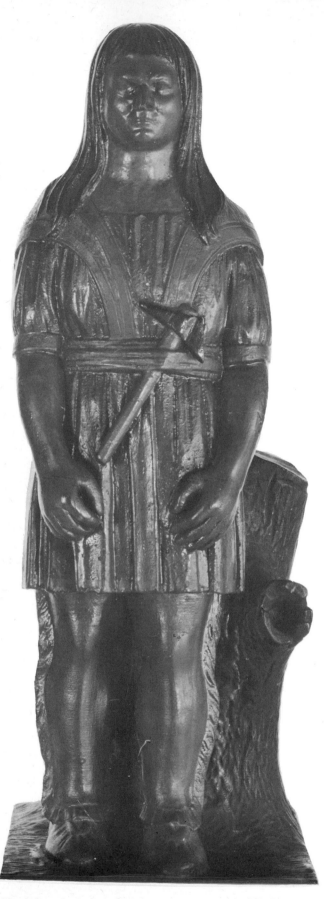

500 (above). Indian fire engine ornament. A. W. Jones.
C. 1830. Mahogany. H. 19″. This figure, one of a pair, is
from the Metamora fire engine that was purchased from the
City of New York by the Village of Goshen, New York, in
1843. The engine was used until 1855 by the Cataract Engine
and Hose Company at Goshen. (Museum of the City of
New York)

501 (left). Photograph of the headquarters of the Volunteer Firemen's Association at 143 West 8th Street, New York. 1884. The statue of a fireman, figure 502, stands between the two first-floor windows. (Museum of the City of New York)

502 (below). Statue of a fireman. 1884. Wood. H. 73½". Like his flesh-and-blood counterpart, this firefighter wears a leather helmet. (Museum of the City of New York)

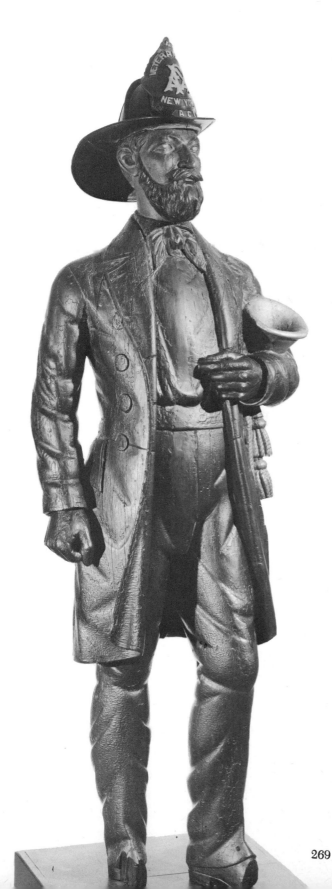

THE CIRCUS

The word "circus" recalls fond memories from childhood days for most Americans. Sadly, however, the circus is now all but a thing of the past.

The Latin word "circus" means "circle" and refers to a circular arena in which games, races, and gladiatorial combats were held. Probably the most famous early circus was the incredible Circus Maximus at Rome dating c. 61 B.C., in which the fierce slaughter of over five hundred Numidian lions provided a gory accent to chariot racing, equestrian riding, and acrobatic feats of daring and dexterity. At the opening of this five-day performance, a glittering state parade wound its gaudy way through the city. Spirited horses pulled blazing chariots and red and gold tableau wagons were drawn by mules and elephants.

The modern circus developed from four different types of amusement: the Roman races and athletic contests, itinerant players and jugglers of the Middle Ages, Italian Renaissance comedies, and European and English countryside festivals and fairs. Most scholars date the modern circus to the performances of the Englishman Philip Astley, who was born in 1768. This "Father of the Circus" was an ex-sergeant major and a trick rider. He discovered that by riding his horse in a circle, centrifugal force would help maintain his balance.

John Bell Ricketts, another Englishman, came to Philadelphia from Scotland in 1792 and brought his royal circus. On April 3, 1793, the Ricketts company gave the first complete circus performance in America. President George Washington attended the show on April 22 and was so intrigued that he returned many times. Washington and Ricketts became fast friends and often rode together. As America's first distinguished circus fan, President Washington lent "the benefit of his presence as a guarantee of respectability" [41] to Ricketts' endeavor.

503 (right). Circus parade float. Carved by Samuel A. Robb for the Sebastian Wagon Company. New York. 1903. Wood. L. 18'. The dazzling "Golden Age of Chivalry" must have thrilled parade spectators in almost every major American city, for it was part of the Barnum & Bailey Circus. (Circus World Museum)

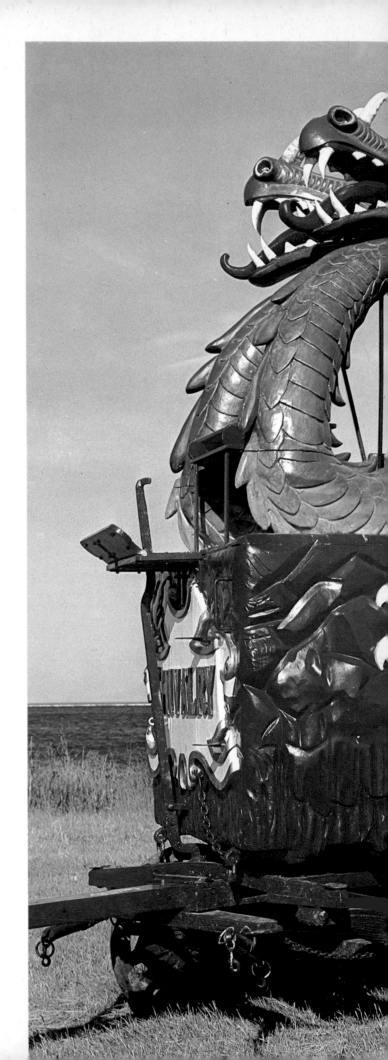

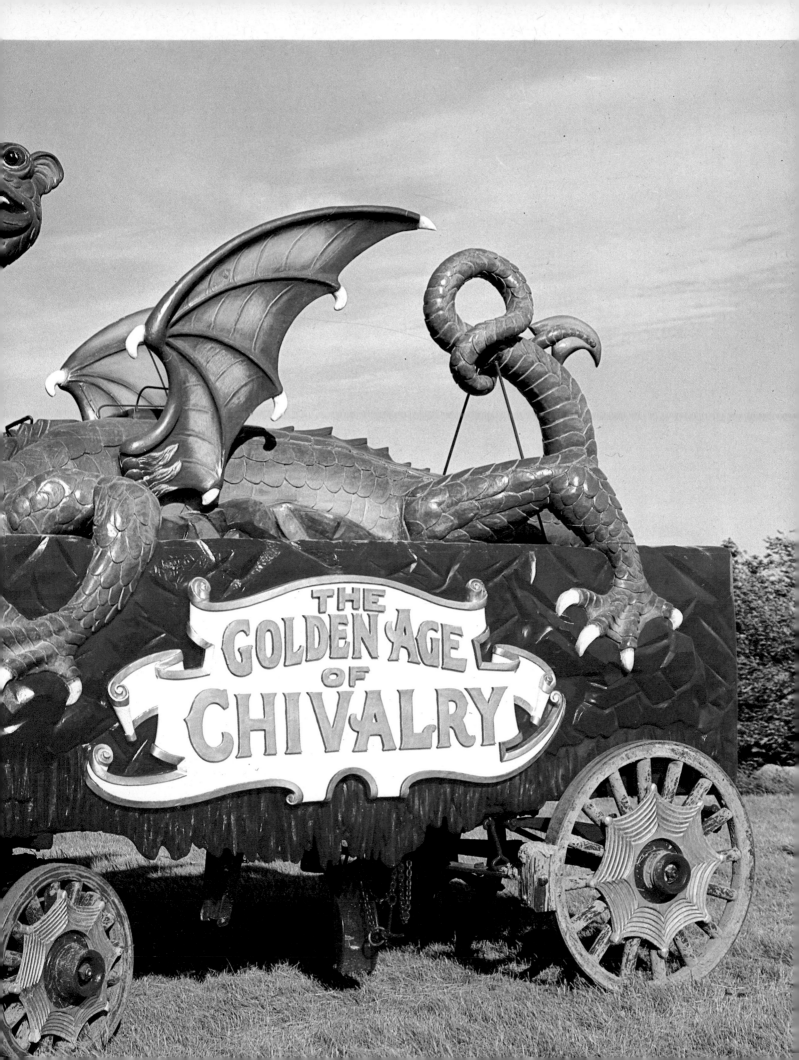

After the invention of the calliope in 1855 by Joshua C. Stoddard, a farmer of Powert, Vermont, no circus parade was complete without one. This "new musical instrument to be played by the agency of steam or highly compressed air" [42] derived its name from the Greek word meaning "beautiful voice." Nixon & Kemp's Circus first used the calliope in 1858, and in 1859 the Sands, Nathan and Company's American and English Circus was probably the first to use one in a parade.

504 (left), 505, 506 (opposite, right). Three Muses. Probably carved by Samuel A. Robb for the Sebastian Wagon Company. New York. C. 1880. Pine. Height of each figure, approximately 49". These classical Muses, which were originally finished with gold leaf, once decorated a Barnum & Bailey circus wagon. (William L. Warren; photograph courtesy Jean Lipman)

507 (above). Calliope. Bode Wagon Works. Cincinnati, Ohio. 1917. Redwood. L. 18'. The Mugivan & Bowers American Circus Corporation announced its arrival in town with a circus parade accompanied by this ornately decorated calliope. (Greenfield Village and Henry Ford Museum)

508 (opposite, below). Photograph of a circus wagon decorated with the Three Muses, figures 504, 505, and 506. C. 1900. Enthusiastic children appear to be exchanging quips with the clowns on this Barnum & Bailey wagon. (Photograph courtesy William L. Warren)

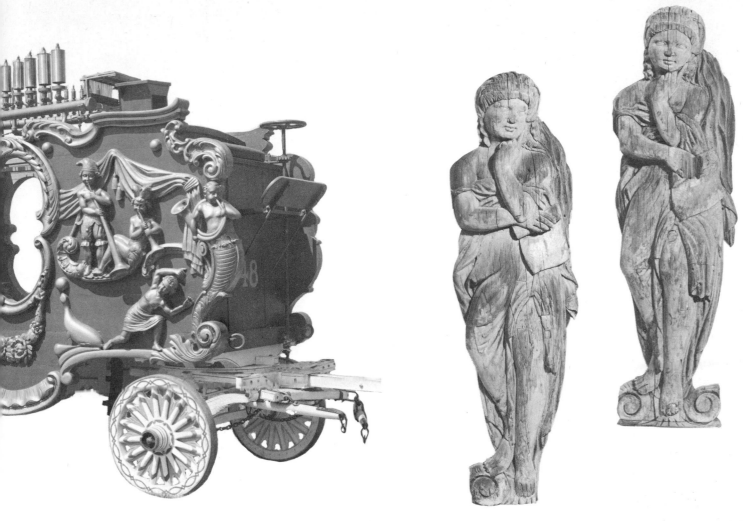

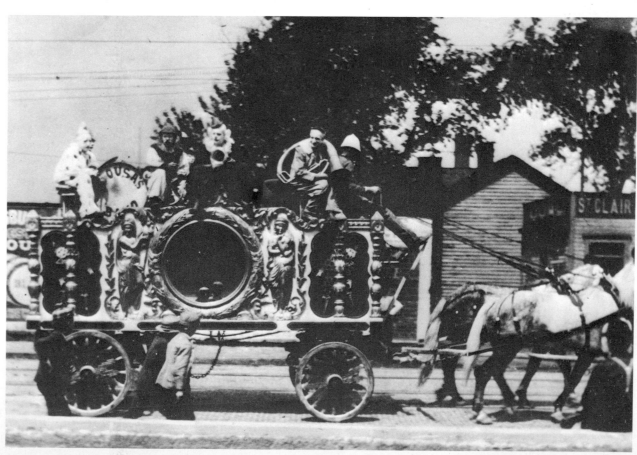

Both figuratively and literally the late nineteenth and first quarter of the twentieth centuries represent the golden age of flamboyant American circus carvings. During these years the traveling circus brought to all parts of rural America a magnificence that was unequaled.

The origin of the circus parade dates back to the triumphal processions of the Romans. During the Mardi Gras of 1883 festive parade floats were used. This was the first organized parade in New Orleans, and from it American circus magnates conceived the idea of a street parade as a means of attracting audiences to their shows. Parades became elaborate affairs and included lavish floats decorated with robust carvings that were gaily painted and that depicted tableaux of historical and religious events. The heyday of the circus parade was from 1900 to 1920, and they continued to exist in smaller towns through the 1930s.

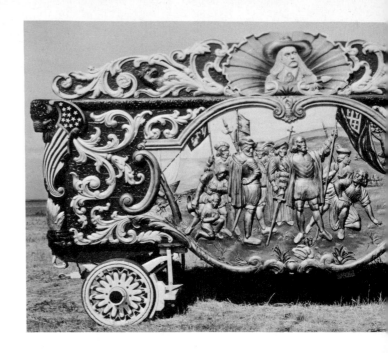

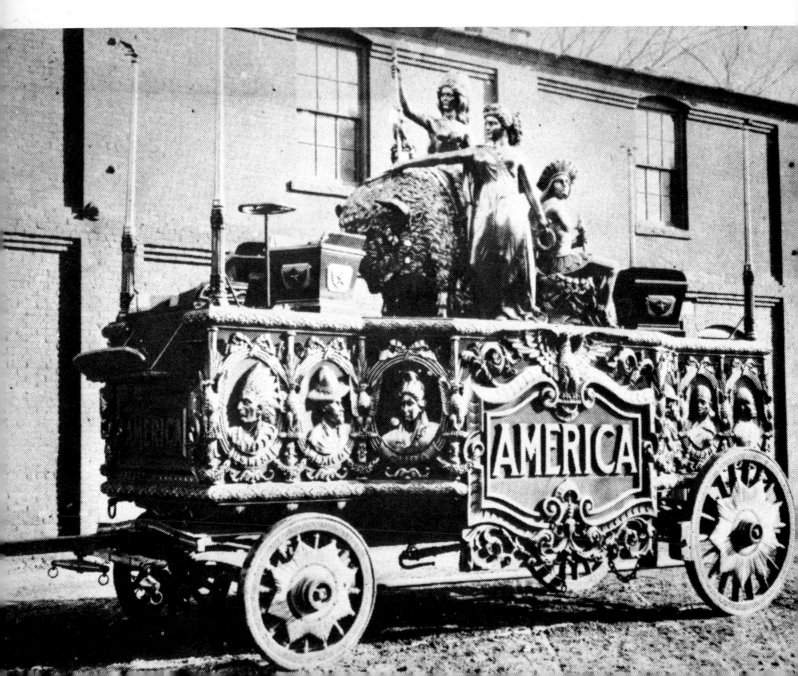

510 (opposite, bottom). Photograph of the American circus wagon that was carved by Samuel A. Robb for the Sebastian Wagon Company, New York. C. 1902. The designs are scaled-down copies of the corner figures of the Prince Albert Memorial in Hyde Park, South Kensington, London. Barnum & Bailey's parade included floats representing the four continents, Europe, Asia, Africa, and America. (Princeton University Library)

509 (opposite, top), 509a (above). Pawnee Bill's Wild West Show bandwagon. Sebastian Wagon Company. New York. 1903. Wood L. 21′ 8″. Because circus and show wagons represented a considerable investment, like cigar store Indians, they were salvaged when a company ceased operation. This wagon was later used by the Mighty Haag Circus and the Miller Bros.' 101 Ranch Wild West Show. The carved tableau on one side represents Columbus' discovery of America (figure 509), based on the painting, *The Landing of Columbus,* by John Vanderlyn (1775–1852), and the other side illustrates Pocahontas saving the life of Captain John Smith (figure 509a). (Circus World Museum)

511 (left). Europa and the Bull. Carved by Samuel A. Robb for the Sebastian Wagon Company. New York. C. 1903. Wood. L. 91″. This carving topped the tableau float, "Europe." (Smithsonian Institution)

512 (above). Advertising banner for "The Busy World." New York. C. 1840. Cloth, painted. Dimensions unavailable. (Greenfield Village and Henry Ford Museum)

513 (below), 513a (opposite). "The Busy World" show wagon. David Hoy. Walton, New York. C. 1840. Wood, polychromed. L. 11′ 4″. This horse-drawn wagon was pulled throughout upper New York State during the nineteenth and early twentieth centuries. Biblical scenes, household and social activities, contemporary industry, and military life are depicted by more than 350 polychromed figures. Movement is supplied to each of the carved figures by an intricate series of wooden gears and pulleys powered by a hand crank. (Greenfield Village and Henry Ford Museum)

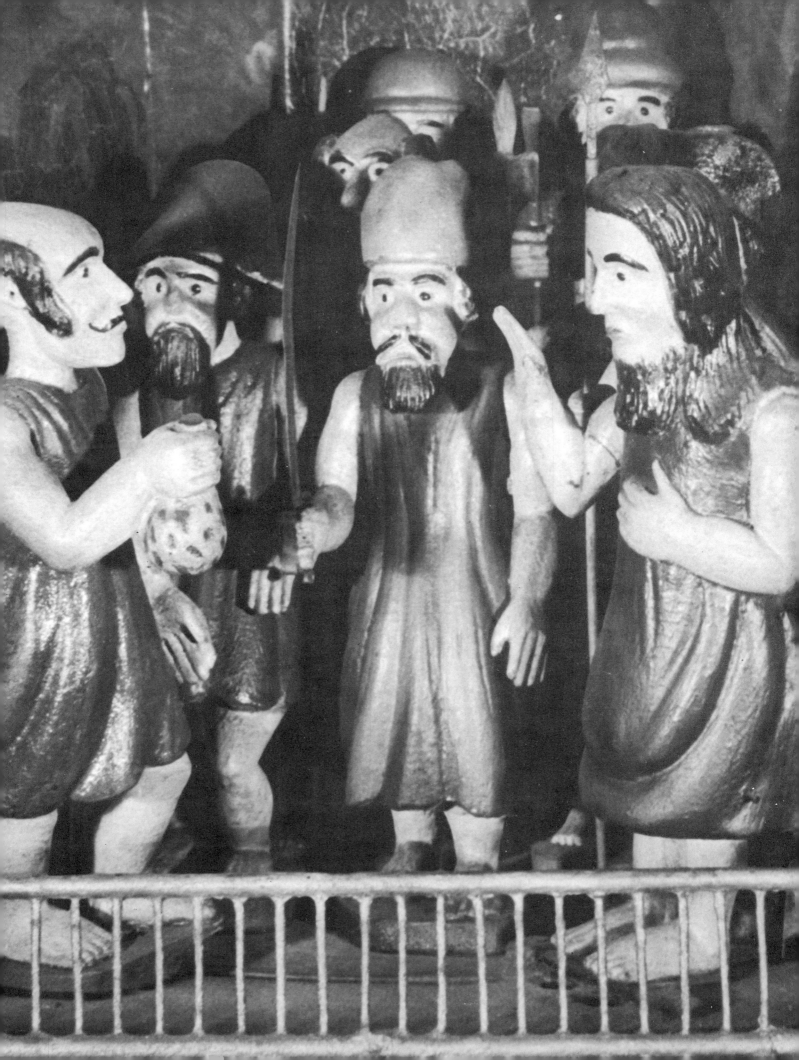

FROM WOODS
AND JUNGLES

514 (below). Stag. Attributed to Wilhelm Schimmel. Pennsylvania. Late nineteenth century. Pine. H. 11½". Folk artists occasionally used glass eyes, which were manufactured for taxidermists. (Mr. and Mrs. James O. Keene)

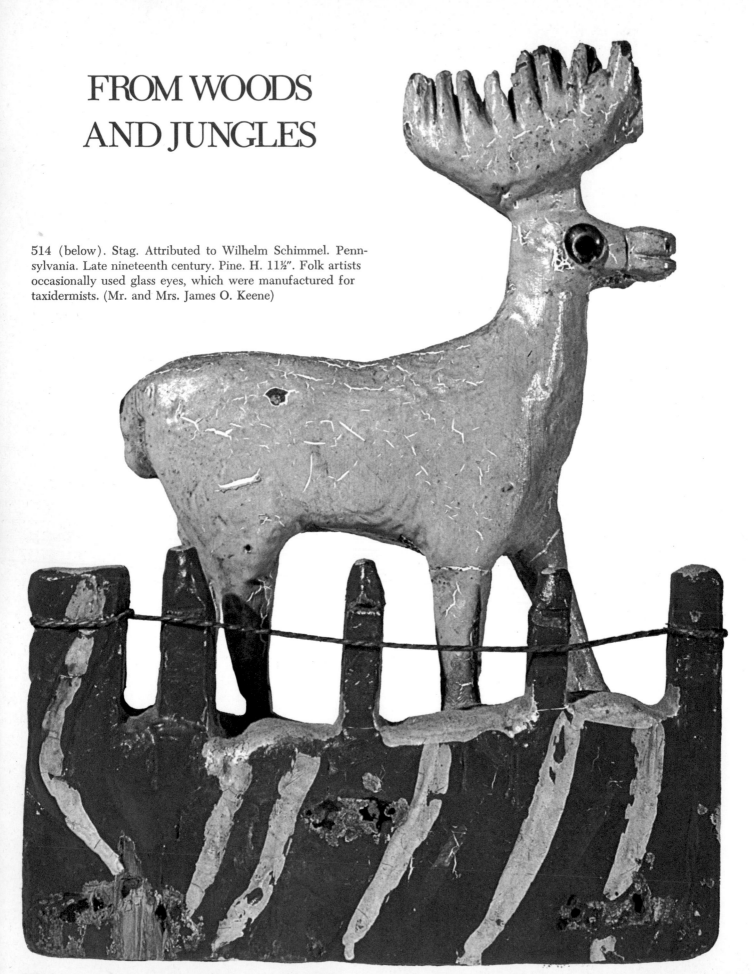

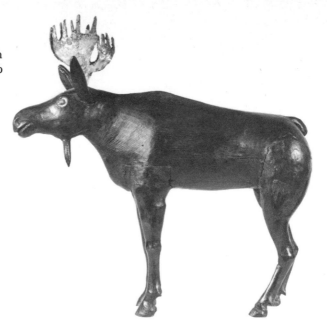

515 (right). Moose. Maine. C. 1880. Pine. H. 16″. This carving was originally on a child's pull toy. It is fitted with lead antlers that have been covered with a mixture of gesso and varnish. (Private collection)

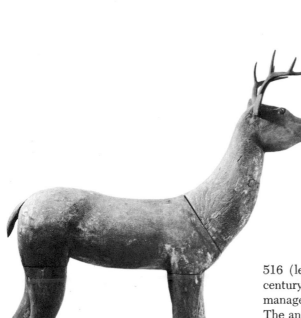

516 (left). Stag. From a hunting lodge in Maine. Late nineteenth century. Pine. H. 36½″. Through sensitive handling, the artist has managed to achieve a delicate representation of this forest animal. The antlers are also carved from wood. (Mr. and Mrs. Michael D. Hall)

517 (below). Squirrel. Michigan. Early twentieth century. Walnut. H. 7¾″. This carving was the finishing decorative touch to a mammoth electric lamp made from a gnarled root. (Private collection)

Though there have been many basic changes in lifestyles since earliest man, perhaps none has been more significant than the fact that we no longer must hunt in order to survive.

The Pilgrims were forced to hunt for food, and the first Thanksgiving, observed in the fall of 1621 by decree of Governor William Bradford at the Plymouth Colony after the infant settlement had come through its first year, was an acknowledgment of nature's bounty. Today, hunters shoot for sport instead of for food.

During the eighteenth and nineteenth centuries many folk artists lived away from the population centers and must have enjoyed a closeness to nature. Their carvings of the wild animals that surrounded them can often be highly realistic like figures 515, 520, and 532; or they can be rendered in an abstract, unconventional, and even almost personal style, as seen in figures 514, 523, and 535. Occasionally, the folk sculptor was also able to give human attitudes to his carvings, a quality that collectors today find especially engaging.

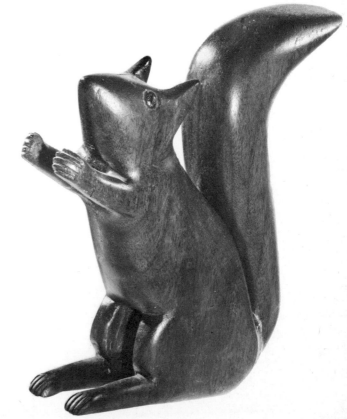

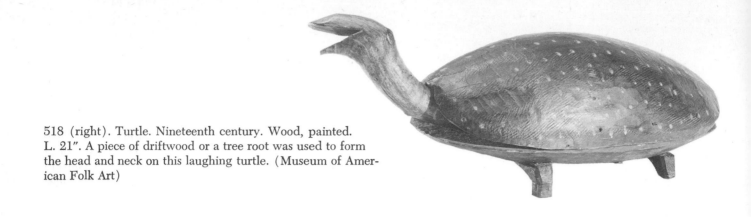

518 (right). Turtle. Nineteenth century. Wood, painted. L. 21″. A piece of driftwood or a tree root was used to form the head and neck on this laughing turtle. (Museum of American Folk Art)

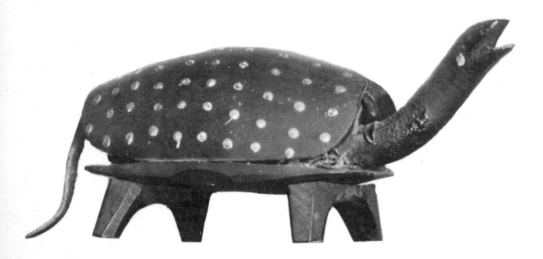

519 (above). Turtle. New England. C. 1840. Wood, cloth, and leather, painted. L. 7½″. (Leah and John Gordon)

520 (right). Snake swallowing a mouse. Late nineteenth century. Wood, painted. L. 17½″. In this beautiful carving one can sense the power in the snake's coils. (Abby Aldrich Rockefeller Folk Art Collection)

521 (opposite, top left). Root snake. Probably Appalachia. C. 1930. Wood, painted. L. 36″. (Herbert W. Hemphill, Jr.)

522 (opposite, center). Snake. Maine. Last quarter of the nineteenth century. Wood, polychromed. L. 81″. The sections of this articulated snake are joined by hinges. (Leah and John Gordon)

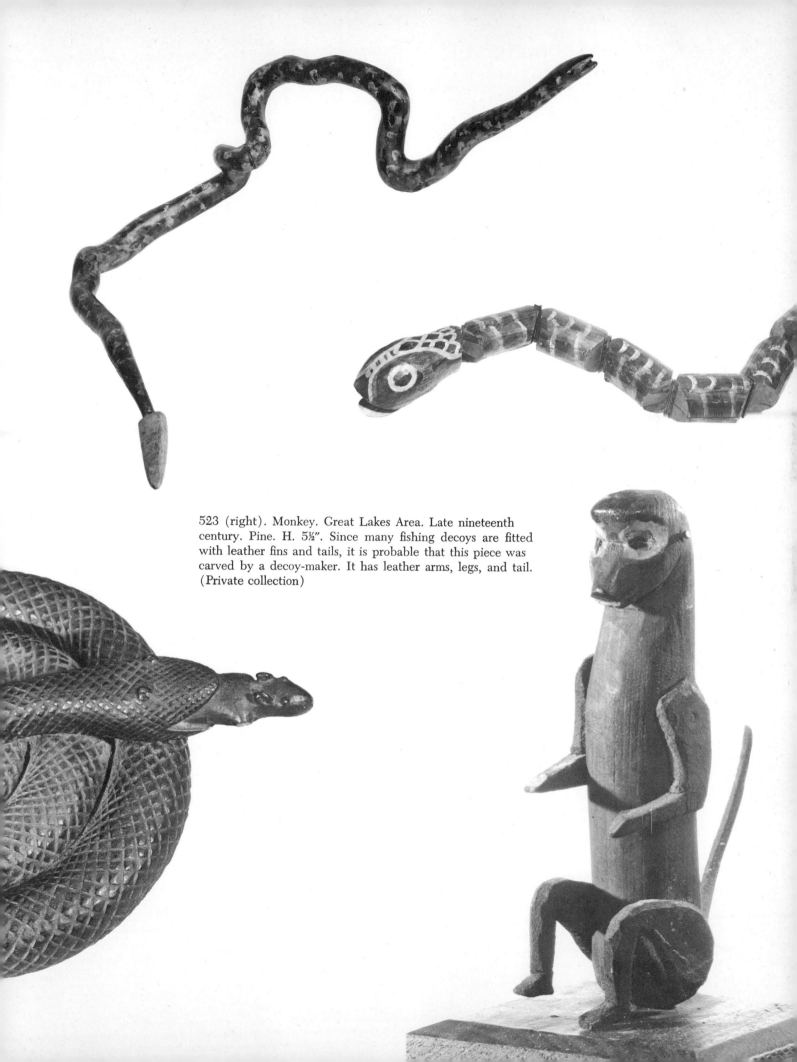

523 (right). Monkey. Great Lakes Area. Late nineteenth century. Pine. H. 5½″. Since many fishing decoys are fitted with leather fins and tails, it is probable that this piece was carved by a decoy-maker. It has leather arms, legs, and tail. (Private collection)

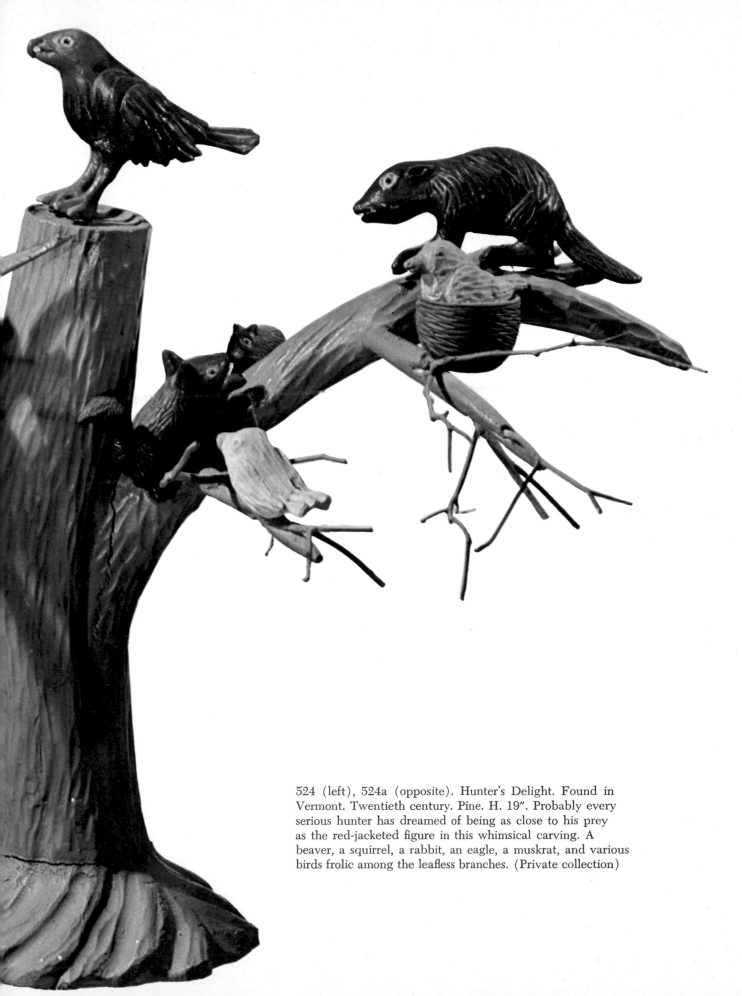

524 (left), 524a (opposite). Hunter's Delight. Found in Vermont. Twentieth century. Pine. H. 19″. Probably every serious hunter has dreamed of being as close to his prey as the red-jacketed figure in this whimsical carving. A beaver, a squirrel, a rabbit, an eagle, a muskrat, and various birds frolic among the leafless branches. (Private collection)

525 (below). Deer. Pennsylvania. Nineteenth century. Wood. H. 9″. (Mr. and Mrs. Jack Sharp)

527 (opposite, above). Rabbit. Louisiana. Late nineteenth century. Pine. L. 17½″. Not every long-eared cottontail has teeth made from cutoff nails. Another carving by the same unidentified artist, in the form of a setting hen, was intended to be used as the cover for an egg box. (Private collection)

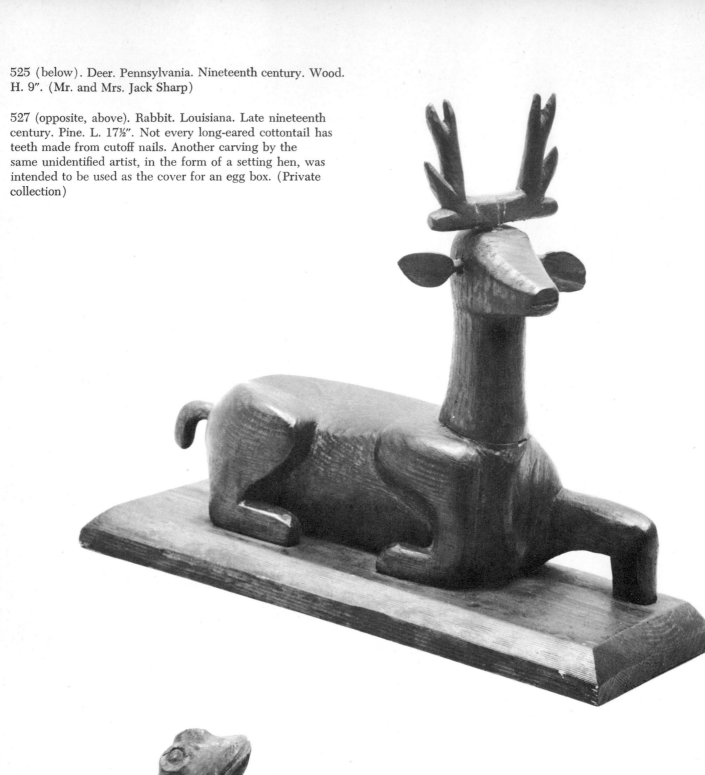

526 (left). Bullfrog. Bernier. Saco, Maine. C. 1900. Pine. H. 6″. (Private collection)

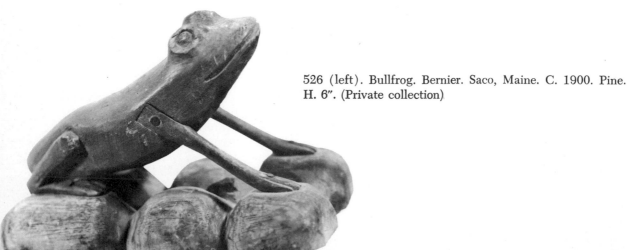

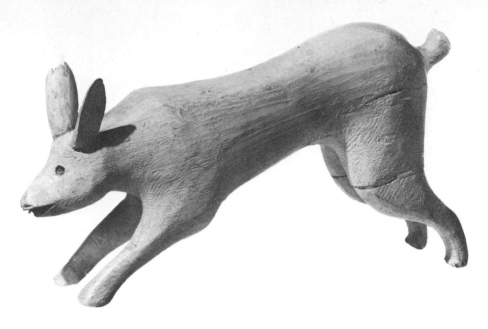

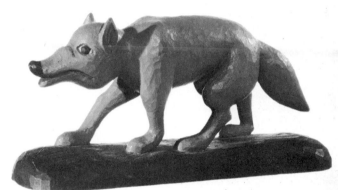

528 (right). Wolf. Mid-twentieth century. Pine. L. 6½″. (Private collection)

529 (below). Forest scene. Halvor Landsverk. Minnesota. 1939. Black walnut. W. 64″. In the center rear two distraught sportsmen appear to be the surprised hosts for the bears' picnic. (Courtesy of the artist)

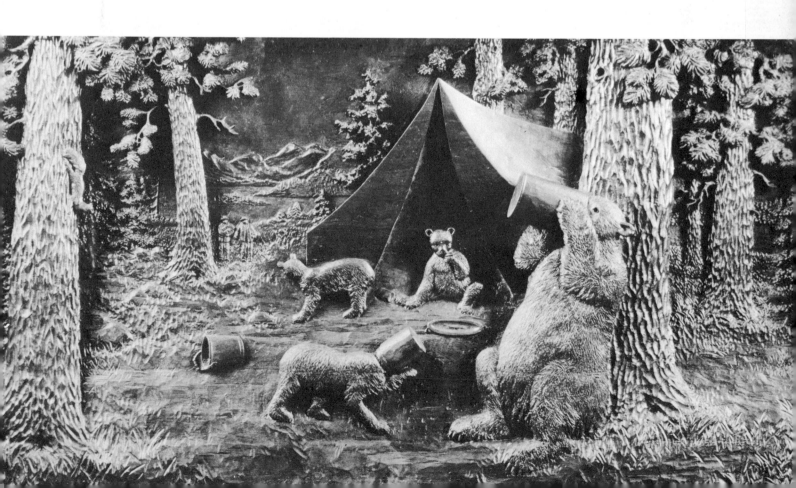

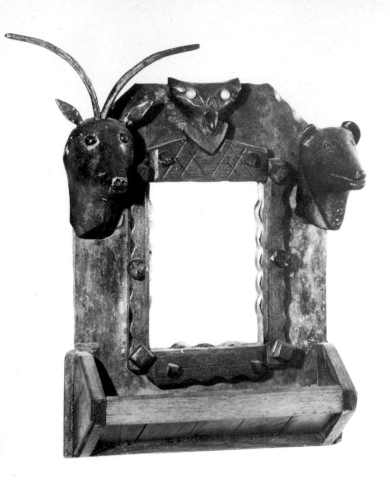

530 (left). Shaving mirror. Found near Zoar, Ohio. Late nineteenth century. Pine. H. 11¾″. The German Separatists who settled the communal society at Zoar, Ohio, in 1817 brought with them the European love for wood carvings. This piece might well have been fashioned by a descendant of one of the original settlers. Though the head of the bear is naturalistic, the deer and the eagle are stylized abstractions. (Private collection)

531 (below, left). Box. Zoar, Ohio. Late nineteenth century. Pine. H. 5¾″. The deer family on top of this box was carved from a single piece of wood. This piece and figure 530 were found in the same house and appear to be the work of one artist. (Private collection)

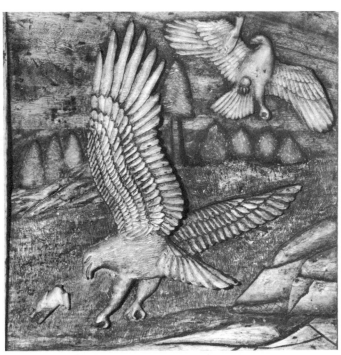

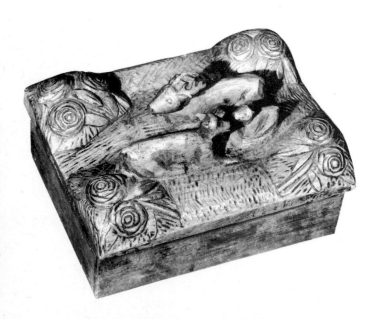

532 (above). Top of a magician's box. Ohio. Twentieth century. Pine. W. 10½″. A similar carving by the same artist is signed, "Lytle, Medina Co., Ohio." This magician's box was originally fitted with many compartments. The decoration on the front includes a nude woman and a hawk. (Private collection)

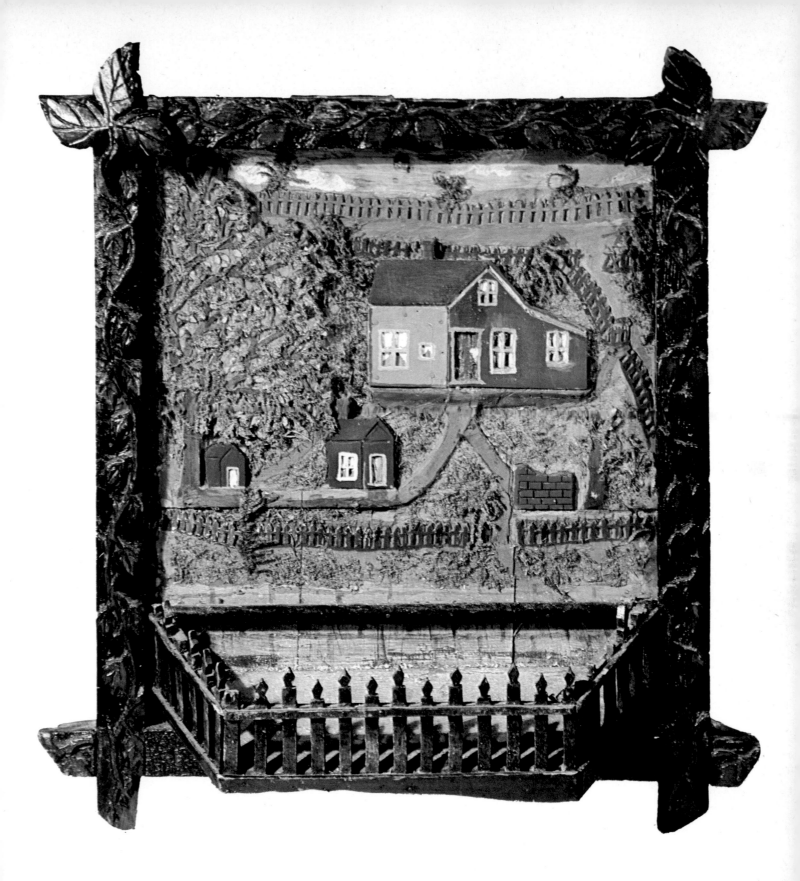

533 (above). Comb holder. J. F. Wells. Wisconsin. 1889. Wood. H. 18″. Bits of moss have been glued to the surface of this rustic collage to create the illusion of grass and trees. The picket fence surrounds the comb shelf. (Private collection)

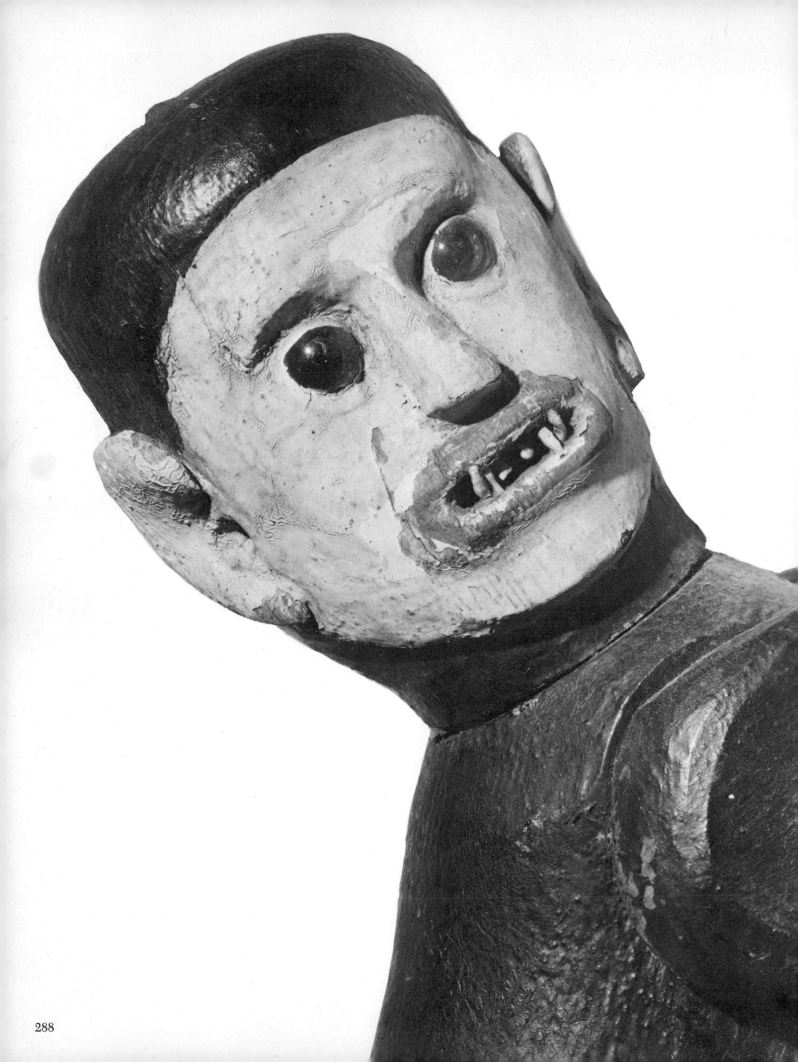

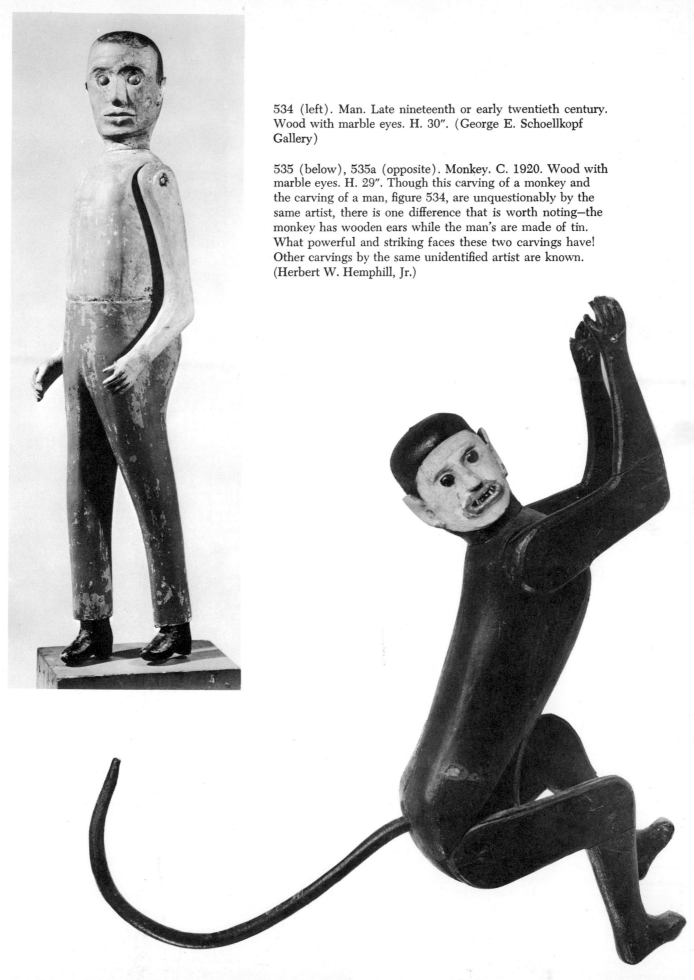

534 (left). Man. Late nineteenth or early twentieth century. Wood with marble eyes. H. 30″. (George E. Schoellkopf Gallery)

535 (below), 535a (opposite). Monkey. C. 1920. Wood with marble eyes. H. 29″. Though this carving of a monkey and the carving of a man, figure 534, are unquestionably by the same artist, there is one difference that is worth noting—the monkey has wooden ears while the man's are made of tin. What powerful and striking faces these two carvings have! Other carvings by the same unidentified artist are known. (Herbert W. Hemphill, Jr.)

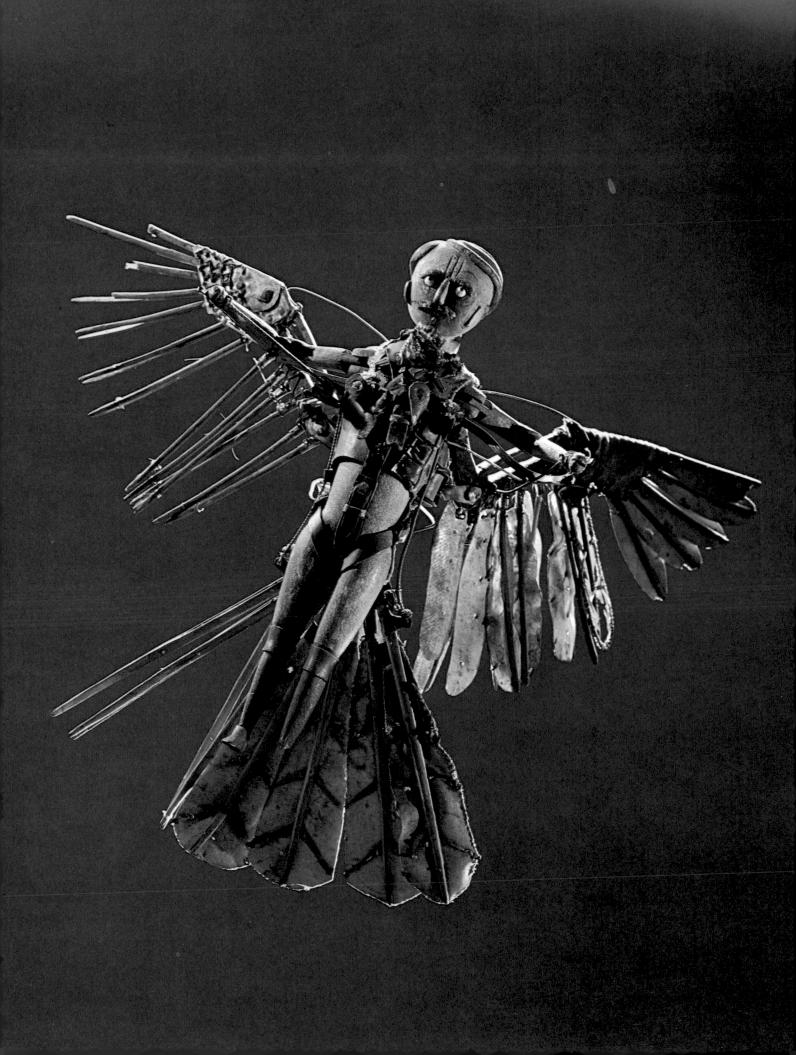

After Congress enacted the first patent laws in 1790, any inventor who applied for a patent was required to submit a drawing and a three-dimensional model to show how it worked. Models poured into Washington in a staggering quantity and, by 1810, Congress was forced to appropriate funds to purchase Blodgett's Hotel for storage and display. In 1836 a fire leveled Blodgett's and over seven thousand models were lost. An elegant new Patent Office was built to house the ever-increasing number of models.

By 1870 the submission of models was required only at the discretion of the Commissioner of Patents, and in 1880 this stipulation was completely dropped, with the exception of patents for flying machines. This last requirement was finally removed in 1903 after the Wright brothers managed to remain aloft in their legendary airplane, the *Kitty Hawk*.

Many applications for patents were filed by do-it-yourself types who believed they had created something unique. Reuben Spalding's sculptural model for a flying machine, figure 536 (opposite), is one of many hundred models for flying devices.

536 (opposite). Patent model for flying device. Reuben Spalding. Rosita, Colorado. 1889. Wood, metal, leather, and feathers. H. 14″. Spalding was an unsuccessful prospector for gold who turned to invention. (Museum of Air and Space, Smithsonian Institution; photograph courtesy William R. Ray)

537 (bottom), 537a (below). Two deer. C. 1940. Archie Gilbert. Landaff, New Hampshire. Real antlers are attached to these deer, which are made from flat pieces of wood. The heads and necks are three-dimensional. Gilbert was a farmer who also worked part-time in a local sawmill. After being disabled in an accident, he turned to wood carving. (Private collection)

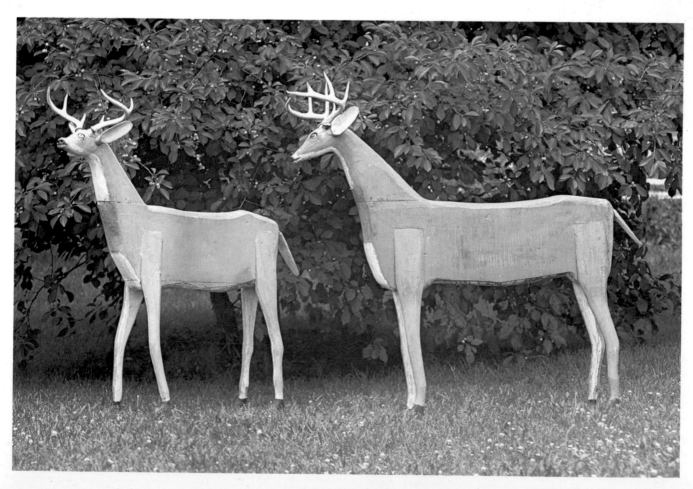

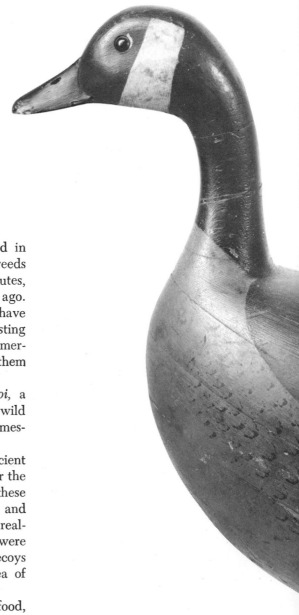

538 (above). Preening duck. H. H. Ackerman. Allen Park, Michigan. C. 1965. Wood, painted. H. 9″. Though many of Ackerman's birds are crudely formed, they possess a sculptural vitality and strength that are found in few other decoys. (Private collection)

Archaeologists have determined that decoys were probably first used in America by Indians in the Southwest. By combining tightly bound reeds with feathers, a tribesman of the Tule Eaters, predecessors of the Paiutes, created a remarkable image of a canvasback duck some thousand years ago. Indians in eastern North America of the same period are known to have stacked small stones on top of larger ones to form visual images of resting ducks that would lure wildfowl within bow-and-arrow range. Early American colonists soon recognized the value of decoys and began to use them also.

The name "decoy" is a contraction of the Dutch word *ende-kooi*, a duck cage or trap that antedated the general use of firearms. At first, wild ducks were merely driven into the traps by men in boats; later, semidomesticated birds were used to entice their wild cousins.

At the opening of the nineteenth century decoys were not in sufficient demand to enable a woodcarver to earn his living by making them. After the 1840s or 1850s, however, carvers who specialized in the production of these wooden lures could make a career of fashioning decoys for sportsmen and market hunters. By the mid-nineteenth century decoys became more realistic. Until this time, hunters felt that only vague representations were necessary to pique the interest of the wild birds. Regional types of decoys developed because of local conditions, and in the Barnegat Bay area of New Jersey the hollow duck, made in two pieces, became popular.

During the last half of the nineteenth century, when the demand for food, improved firearms, and a seemingly inexhaustible supply of wild birds gave rise to the sport of duck hunting, it became financially profitable to manufacture in specialized factories wooden birds that were marketed at a price of $9 to $12 per dozen. Both the Dodge and Mason factories at Detroit, Michigan, competed favorably in a nationwide marketplace. Factory production permitted the introduction of innovations that a single carver could not achieve. Rubber decoys, which appeared in 1867, and honking decoys, operated by the water currents, were factory products. By 1873, numerous patents had been granted for metal duck bodies that floated on wooden bases and tin shorebird decoys that could be folded and transported easily.

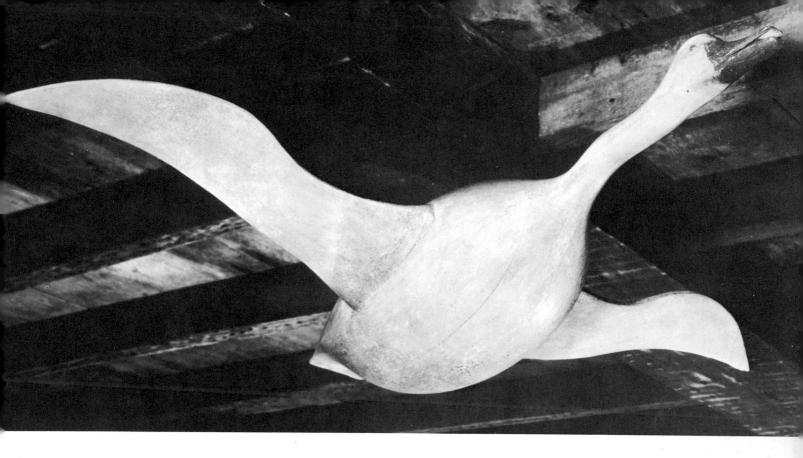

540 (above). Snow goose. Chesapeake Bay area, Maryland. Last quarter of the nineteenth century. Wood, painted. L. 39″. The snow goose breeds in northern regions of the United States and Canada. (Private collection)

539 (center). Goose. Charles Schoenheider. Peoria, Illinois. 1900. Wood, painted. H. 26″. Schoenheider originally made twelve identical goose decoys for a client, who refused them because he thought they were too expensive. This decoy has glass eyes and a single iron leg with a webbed foot. (Herbert W. Hemphill, Jr.)

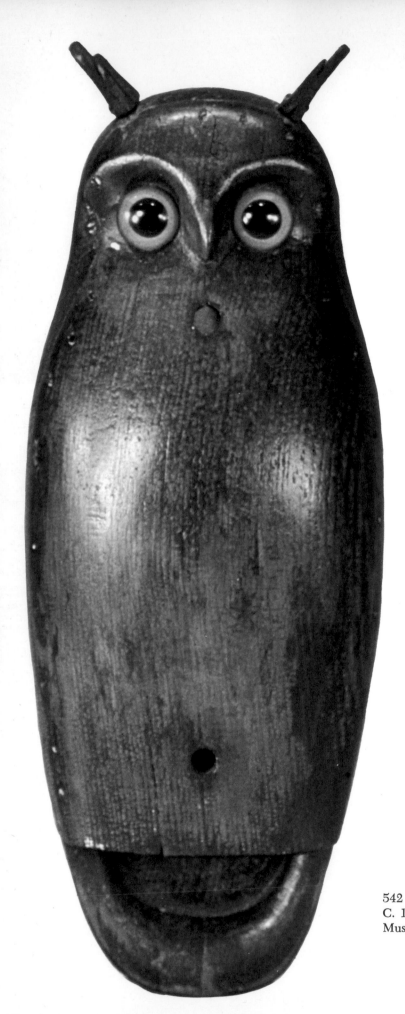

In the twentieth century, decoy carvers were not always concerned with producing working lures. Charles E. (Shang) Wheeler of Stratford, Connecticut, and numerous other artists carved ornamental birds. Wheeler won the Grand Championship Award for the now-famous gray mallard decoy that he exhibited in 1923 at Bellport, Long Island, at the first decoy exhibition ever held. Since the 1930s, annual contests, sponsored by the National Sportsman's Association, have increased interest in ornamental birds, and most carvers today have turned from the utilitarian lure to showpieces that are intended for display only.

Decoys are available to the collector probably in greater number than any other form of folk sculpture. Like the beasts from the woods and jungles illustrated in the preceding chapter, they vary greatly in design and competence of execution.

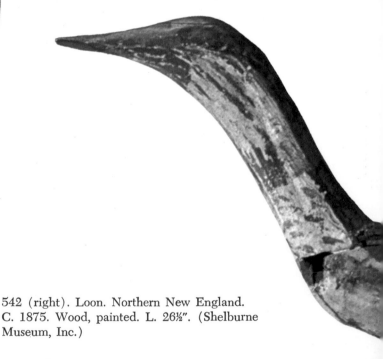

542 (right). Loon. Northern New England. C. 1875. Wood, painted. L. 26½". (Shelburne Museum, Inc.)

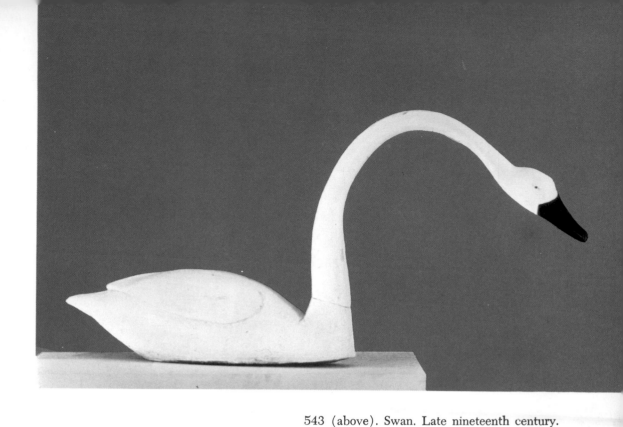

543 (above). Swan. Late nineteenth century. Wood, painted. H. 23½″. The extraordinary curve of the long, extended neck gives special grace to this great sculpture. (Abby Aldrich Rockefeller Folk Art Collection)

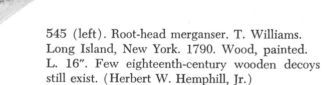

544 (right). Loon. Nineteenth century. Wood, painted. L. 27″. This decoy is fitted with a wooden rudder. Others are fitted with lead weights so that they sit upright when floated in water. (Herbert W. Hemphill, Jr.)

545 (left). Root-head merganser. T. Williams. Long Island, New York. 1790. Wood, painted. L. 16″. Few eighteenth-century wooden decoys still exist. (Herbert W. Hemphill, Jr.)

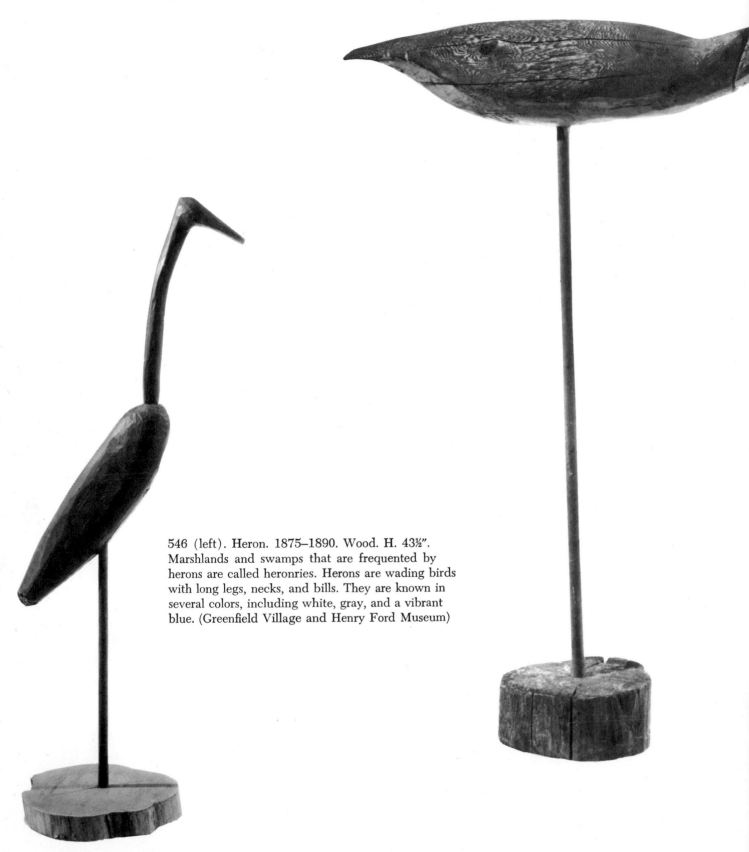

547 (below). Heron. Eastern United States. Late nineteenth century. Wood. L. 51½". With an economy of means, the decoy-maker has skillfully shaped a splendid, impressionistic representation. (Greenfield Village and Henry Ford Museum)

546 (left). Heron. 1875–1890. Wood. H. 43½". Marshlands and swamps that are frequented by herons are called heronries. Herons are wading birds with long legs, necks, and bills. They are known in several colors, including white, gray, and a vibrant blue. (Greenfield Village and Henry Ford Museum)

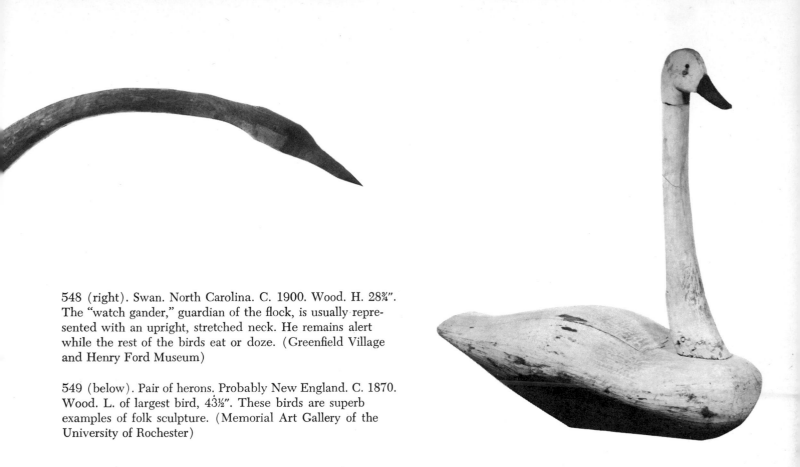

548 (right). Swan. North Carolina. C. 1900. Wood. H. 28¾".
The "watch gander," guardian of the flock, is usually repre-
sented with an upright, stretched neck. He remains alert
while the rest of the birds eat or doze. (Greenfield Village
and Henry Ford Museum)

549 (below). Pair of herons. Probably New England. C. 1870.
Wood. L. of largest bird, 43½". These birds are superb
examples of folk sculpture. (Memorial Art Gallery of the
University of Rochester)

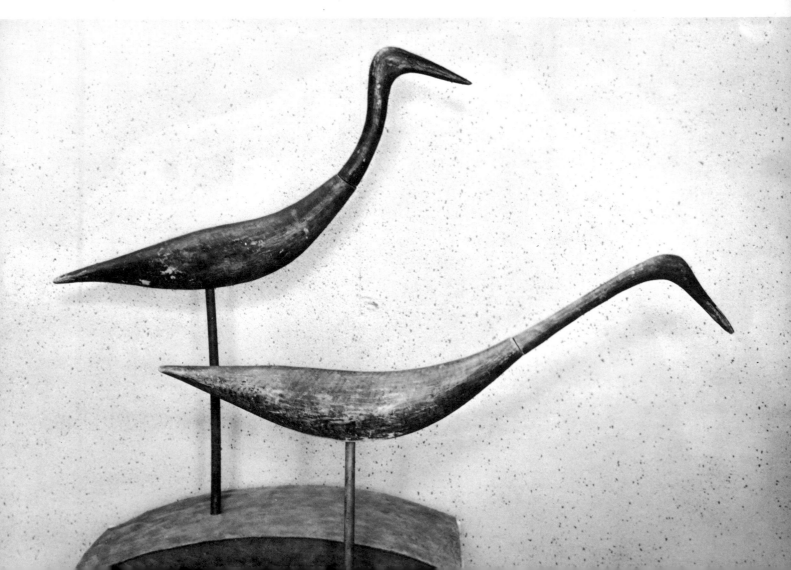

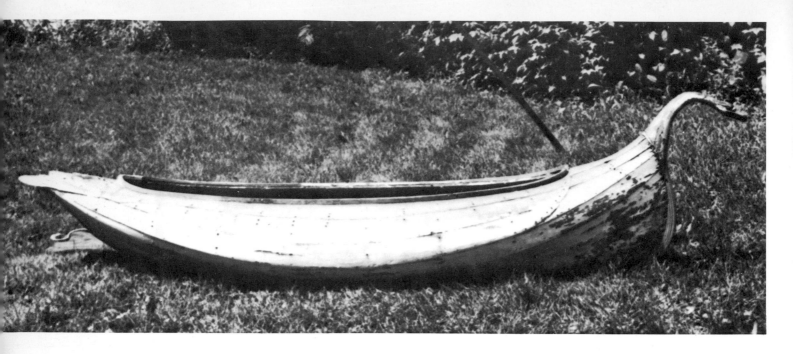

550 (above), 550a (below). Duck boat. Lake Sunapee, New Hampshire. Nineteenth century. Wood. L. 10′ 6″. Duck hunters often built camouflaged structures onshore. This ingenious boat was an attempt to provide a floating camouflage as well. The stern is shaped like the tail of a duck, and the prow is fitted with a lifelike three-dimensional carving that might be compared to a figurehead. (Clark Voorhees; photograph courtesy George Finckel)

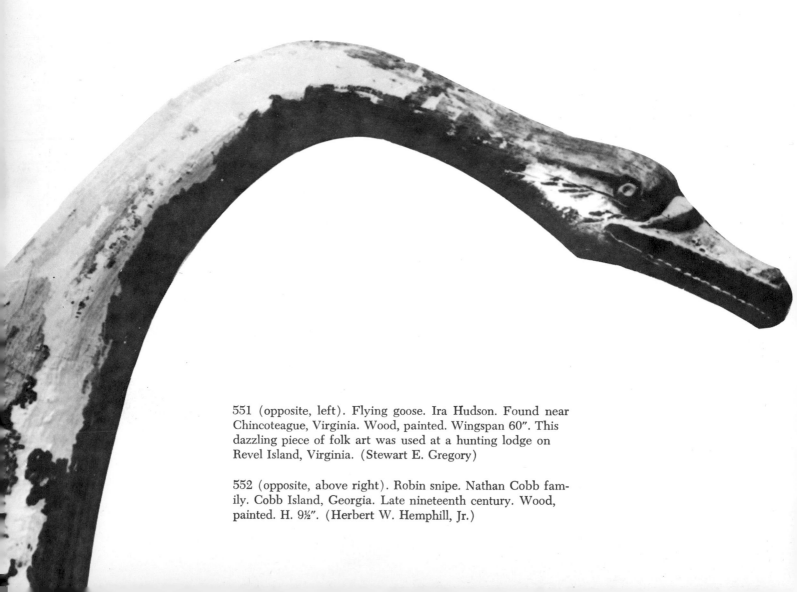

551 (opposite, left). Flying goose. Ira Hudson. Found near Chincoteague, Virginia. Wood, painted. Wingspan 60″. This dazzling piece of folk art was used at a hunting lodge on Revel Island, Virginia. (Stewart E. Gregory)

552 (opposite, above right). Robin snipe. Nathan Cobb family. Cobb Island, Georgia. Late nineteenth century. Wood, painted. H. 9½″. (Herbert W. Hemphill, Jr.)

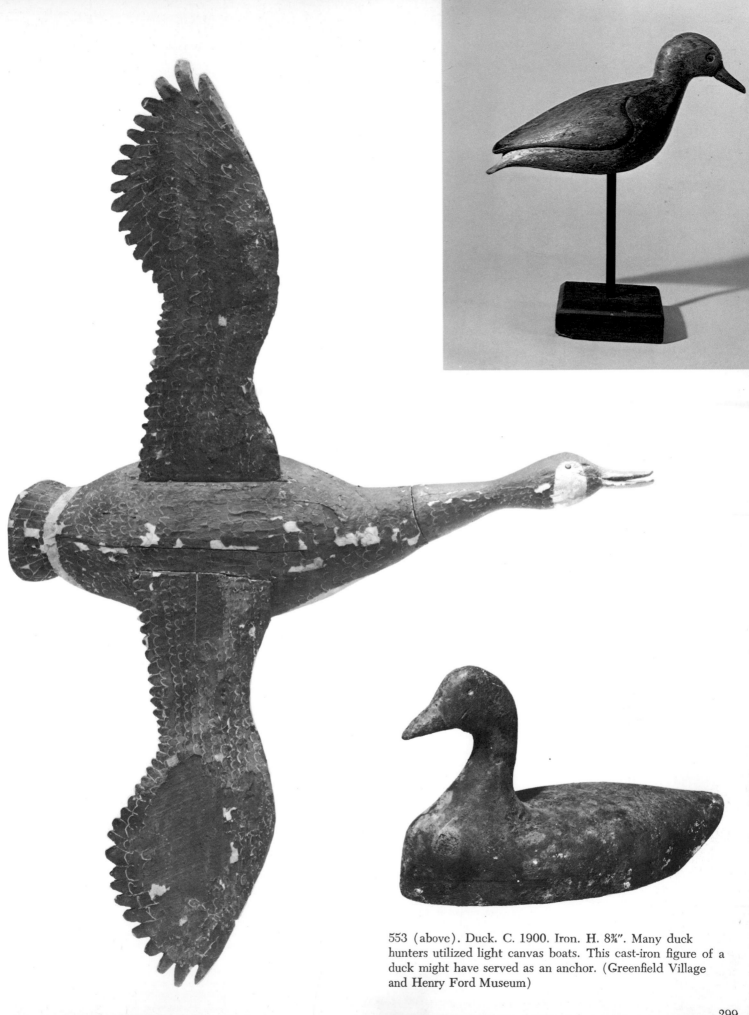

553 (above). Duck. C. 1900. Iron. H. 8¾". Many duck
hunters utilized light canvas boats. This cast-iron figure of a
duck might have served as an anchor. (Greenfield Village
and Henry Ford Museum)

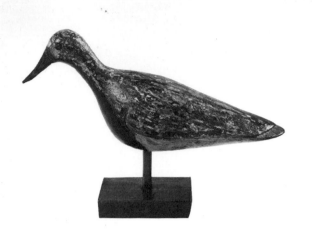

554 (left). Yellowlegs. Late nineteenth century. Wood, painted. L. 10¼". The initials "D.H." are incised on the bottom of the decoy. Such initials sometimes stand for the maker; more frequently they indicate the owner. This working decoy has grooves on its back showing where it was hit by shot. (Private collection)

555 (below). Snowy egret. Found on eastern Long Island, New York. 1850–1880. Wood. L. 32". During the breeding season the egret, a wading bird, has long, showy feathers that were extensively used in women's fashions in the 1920s. The creator of this fine piece has used hemp to simulate these plumes. (Private collection; photograph courtesy The 1807 House)

556 (below). Sandpiper. Long Island, New York. C. 1900. Wood and nails. H. 4". Sandpipers scurry along sandy beaches near the water's edge in quest of food. (Herbert W. Hemphill, Jr.)

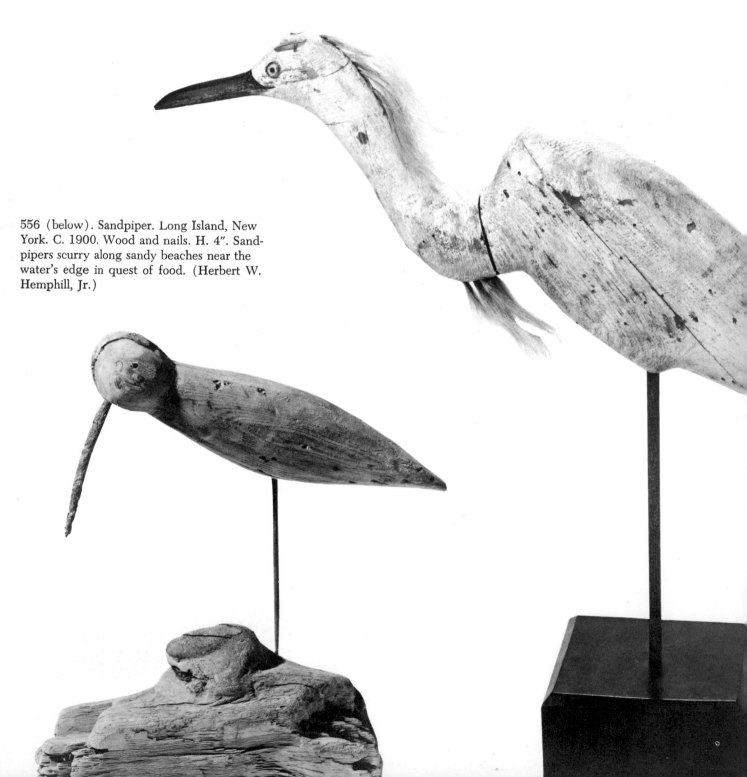

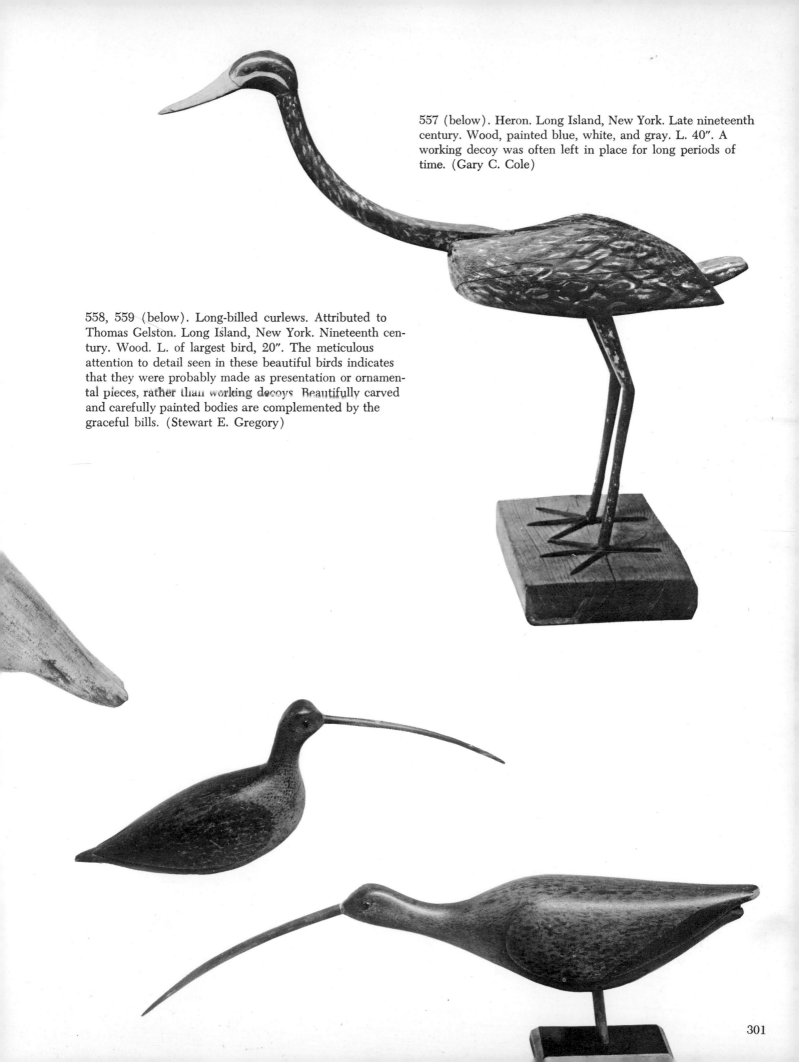

557 (below). Heron. Long Island, New York. Late nineteenth century. Wood, painted blue, white, and gray. L. 40″. A working decoy was often left in place for long periods of time. (Gary C. Cole)

558, 559 (below). Long-billed curlews. Attributed to Thomas Gelston. Long Island, New York. Nineteenth century. Wood. L. of largest bird, 20″. The meticulous attention to detail seen in these beautiful birds indicates that they were probably made as presentation or ornamental pieces, rather than working decoys. Beautifully carved and carefully painted bodies are complemented by the graceful bills. (Stewart E. Gregory)

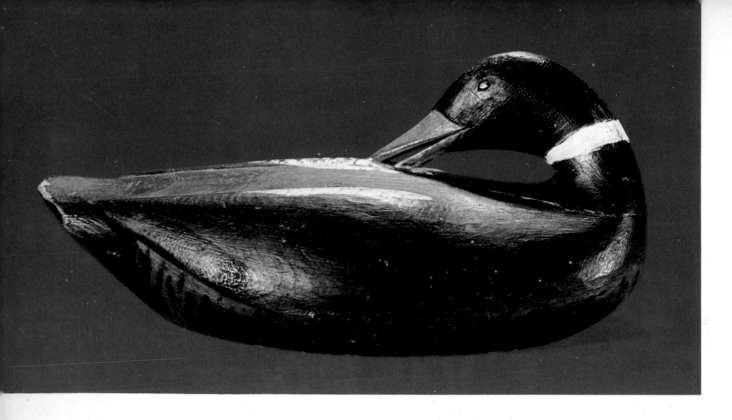

560 (above). Preening mallard. Monhegan Island, Maine.
C. 1865. Wood, painted. L. 14″. The mallard is the ancestor
of most domestic ducks. (Barbara Johnson)

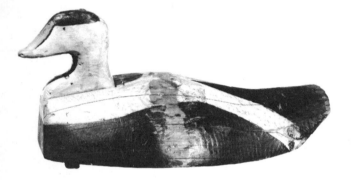

561 (above). American eider duck. Early twentieth century.
Pine. L. 19″. This crude decoy, one of a pair, was found in
Maine. Eider ducks were prized for their especially soft
feathers that were used to stuff pillows and mattresses.
(Greenfield Village and Henry Ford Museum)

562 (right). Pair of Canadian geese in flight. C. 1900. Wood.
L. of each, 9¼″. Tin wings have been fitted to the pine
bodies. (Greenfield Village and Henry Ford Museum)

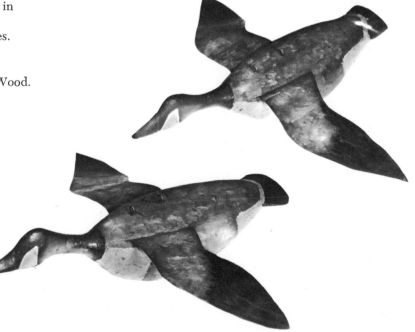

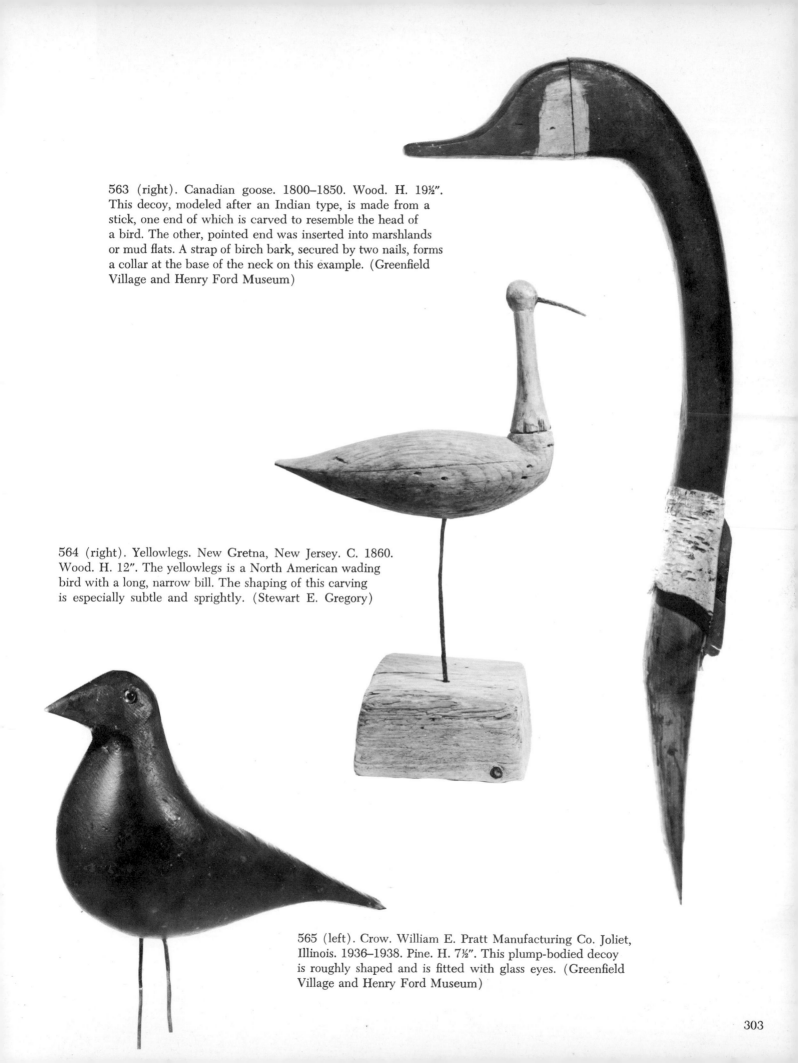

563 (right). Canadian goose. 1800–1850. Wood. H. 19½".
This decoy, modeled after an Indian type, is made from a
stick, one end of which is carved to resemble the head of
a bird. The other, pointed end was inserted into marshlands
or mud flats. A strap of birch bark, secured by two nails, forms
a collar at the base of the neck on this example. (Greenfield
Village and Henry Ford Museum)

564 (right). Yellowlegs. New Gretna, New Jersey. C. 1860.
Wood. H. 12". The yellowlegs is a North American wading
bird with a long, narrow bill. The shaping of this carving
is especially subtle and sprightly. (Stewart E. Gregory)

565 (left). Crow. William E. Pratt Manufacturing Co. Joliet,
Illinois. 1936–1938. Pine. H. 7½". This plump-bodied decoy
is roughly shaped and is fitted with glass eyes. (Greenfield
Village and Henry Ford Museum)

566 (right). Duck. Late nineteenth century. Maple. H. 5¼″. The breast and head of this duck have been well shaped, while the back and tail are merely suggested. (Mr. and Mrs. James O. Keene)

567 (below). Hooded merganser. Doug Jester. Chincoteague, Virginia. 1900–1925. Cedar. H. 4½″. Compare the appealing blockiness of this merganser to the elegant shape of figure 545. (Greenfield Village and Henry Ford Museum)

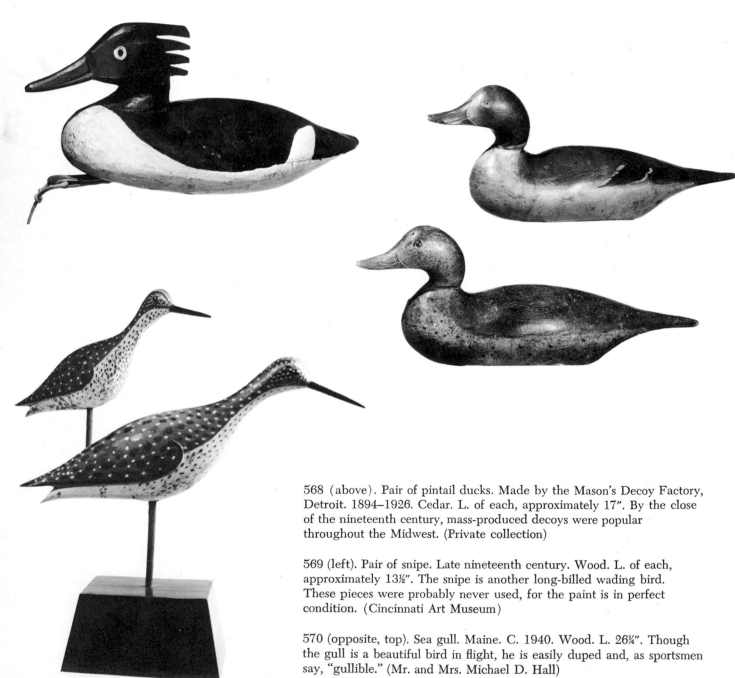

568 (above). Pair of pintail ducks. Made by the Mason's Decoy Factory, Detroit. 1894–1926. Cedar. L. of each, approximately 17″. By the close of the nineteenth century, mass-produced decoys were popular throughout the Midwest. (Private collection)

569 (left). Pair of snipe. Late nineteenth century. Wood. L. of each, approximately 13½″. The snipe is another long-billed wading bird. These pieces were probably never used, for the paint is in perfect condition. (Cincinnati Art Museum)

570 (opposite, top). Sea gull. Maine. C. 1940. Wood. L. 26¼″. Though the gull is a beautiful bird in flight, he is easily duped and, as sportsmen say, "gullible." (Mr. and Mrs. Michael D. Hall)

571 (below, left). Sandpiper. Long Island, New York. C. 1900. Wood. H. 5″. (Stewart E. Gregory)

572 (below, center). Shore bird. Al Harris. 1920. Wood. H. 7″. Birds with turned heads were difficult to carve in a convincing manner. This specimen has a fluid beauty. (Allan L. Daniel)

573 (below, right). Yellowlegs. Harry V. Shourds. Tuckertown, New Jersey. 1905–1910. Cedar, painted. L. 10″. (Greenfield Village and Henry Ford Museum)

574 (below). Duck. Twentieth century. Wood and canvas, painted. L. 15″. This piece was constructed with a wooden head and a canvas body so that it would fold for convenient storage and transportation. (Allan L. Daniel)

SOUTHWESTERN RELIGIOUS SCULPTURE

When the Spanish Conquistadores, in their search for gold and the legendary cities of incredible wealth, established permanent mission outposts in North America, they brought with them the Catholic religion and they attempted to convert the native Indians. Their efforts to glorify God and make beautiful new places of worship produced a folk art that has continued for more than three hundred years.

Southwestern religious folk carving can easily be divided into three periods: Spanish Colonial, 1692–1820; Mission Republic, 1820–1850; and the American period from 1850 to the present.

Most of the greatest pieces date from the Spanish Colonial period, when community life revolved around the mission or parish church. At that time, those with artistic talent carved santos, or representations of Christ and other holy persons. The santos usually are of two classes, the *bulto* and the *retablo*. The bulto is a figure in the round and the retablo is a flat picture, either carved or pierced. The *santero,* or santos-carver, not unlike the itinerant New England portrait painter, traveled from one community to another executing figures for devout patrons. Since settlements in the Southwest were a great distance from one another, isolated artísans reduced sophisticated Spanish artistic concepts to a primitive, highly personalized folk art style.

Almost from the first, the Franciscan fathers attempted to involve their native converts in the construction and decoration of local churches. Remnants of the florid Spanish Baroque style permeated the earliest carvings. Through the years, native Indians grafted onto the Spanish concept their own geometric patterns and designs, and in time the two cultures blended together to form a unique style. Spanish-American churches, like the religious carvings they contain, are folk sculptures in themselves.

575 (right). Modern photograph of Santo Tomás Church. Las Trampas, New Mexico. The little church of Santo Tomás is a lay church and was constructed by the local villagers in 1761. The original bell tower was destroyed and the bell now hangs from a beam. As in many Southwestern adobe churches, broad, flat surfaces prevail. Geometric patterns are created by the balcony and the door. Time-weathered fences surround the *camposantos,* or burying grounds. This and similar adobe churches resemble monumental pieces of sculpture. (New Mexico Department of Development)

576 (right). Photograph of a *retablo*. New Mexico. Eighteenth century. This painted *retablo,* found in an old chapel located on the original plaza of Chimayo, a tiny mountain village in northern New Mexico, serves as the focal point for a group of religious carvings. (Private collection)

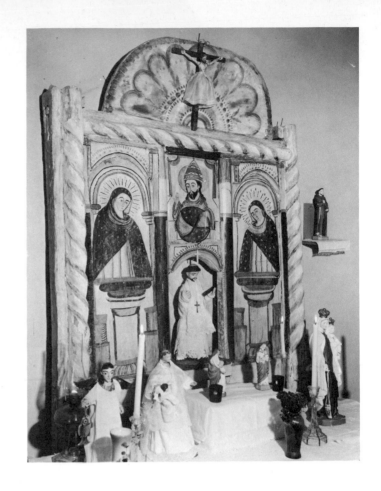

577 (left). Nuestra Señora la Reina de los Cielos. New Mexico. Late eighteenth century. Cottonwood and painted canvas. H. 33". This representation of "Our Lady Queen of Heaven" wears a silver crown. The skirt is made of fabric stretched over wooden staves. (Mr. and Mrs. James O. Keene)

578 (opposite). Nuestra Señora de la Luz. New Mexico. C. 1784. Wood. H. 32¼". The artist who created this piece combined several techniques. The three-dimensional forms have been modeled in gesso on a hand-adzed wooden panel and then painted. The inspiration for the composition probably was the center panel of a *retablo* of c. 1760, which formerly stood in the Castrense Chapel at Santa Fe. "Our Lady of Light" was first associated with the Portuguese Franciscans who, in 1516, founded a mission in India in her honor. (Taylor Museum, Colorado Springs Fine Arts Center)

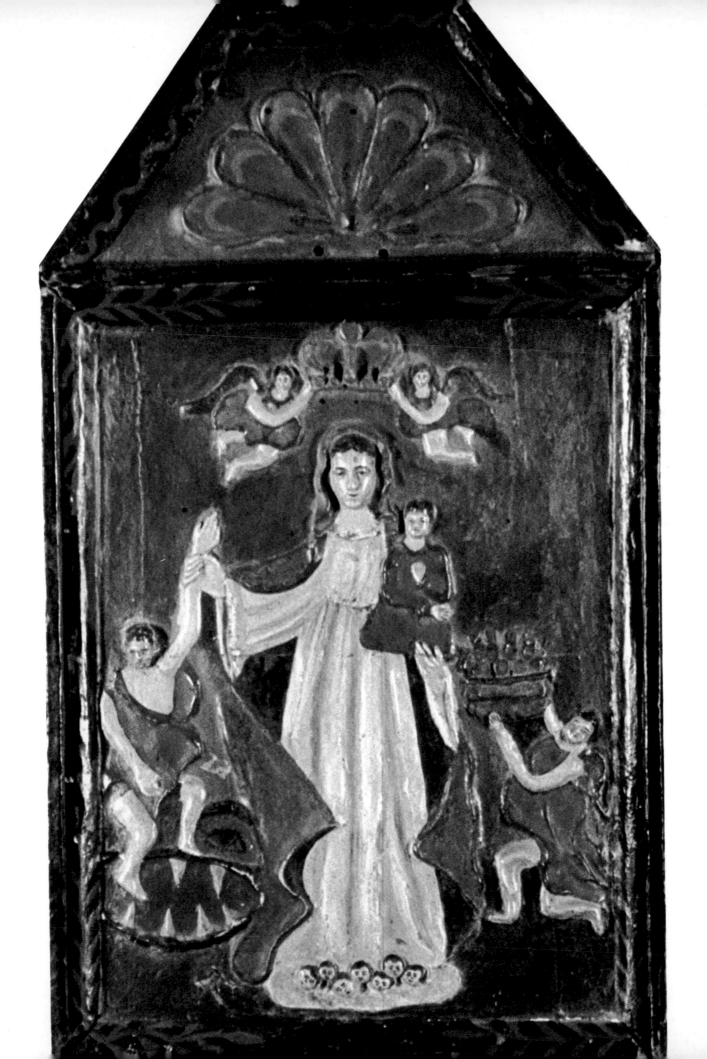

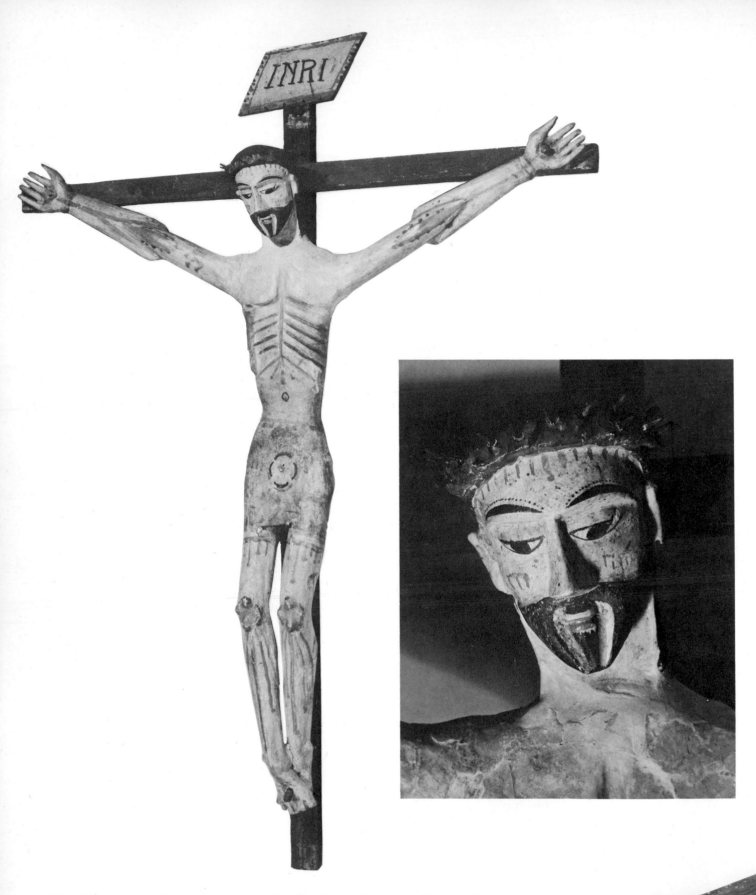

579, 579a (above). Penitente carving of the Crucifixion. Southwest. Nineteenth century. Probably pine. Dimensions unavailable. The sculpture has been carved and painted in a barbaric style emphasizing the gore. This is typical of the way Spanish artists depicted Christ's Passion. (Private collection)

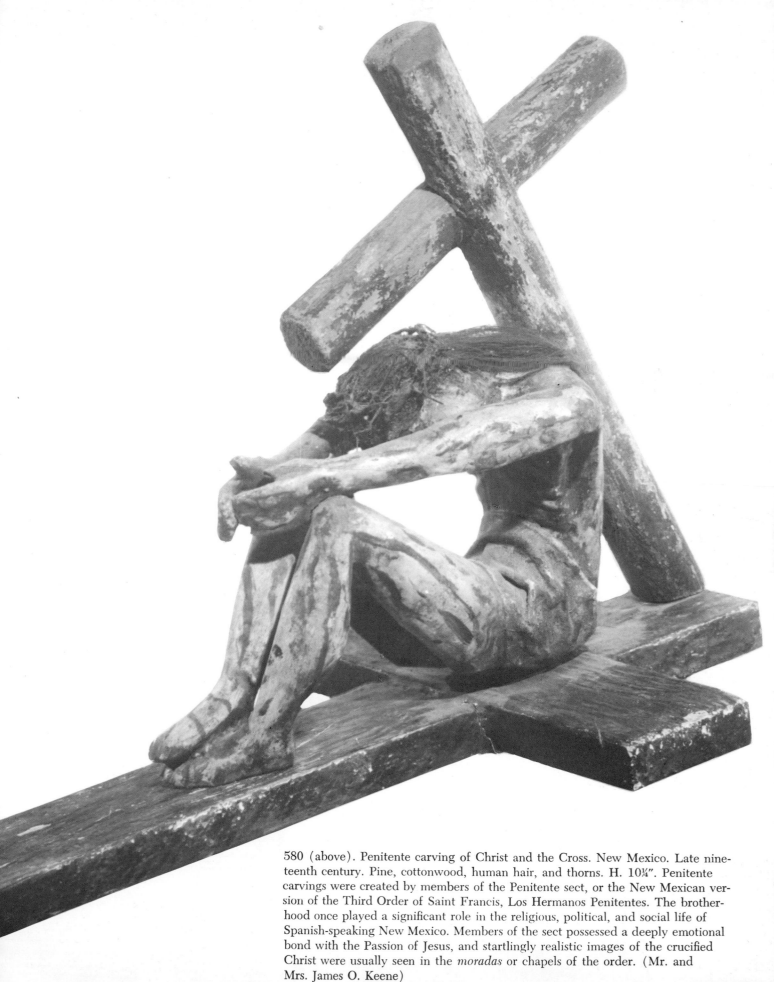

580 (above). Penitente carving of Christ and the Cross. New Mexico. Late nineteenth century. Pine, cottonwood, human hair, and thorns. H. 10¼". Penitente carvings were created by members of the Penitente sect, or the New Mexican version of the Third Order of Saint Francis, Los Hermanos Penitentes. The brotherhood once played a significant role in the religious, political, and social life of Spanish-speaking New Mexico. Members of the sect possessed a deeply emotional bond with the Passion of Jesus, and startlingly realistic images of the crucified Christ were usually seen in the *moradas* or chapels of the order. (Mr. and Mrs. James O. Keene)

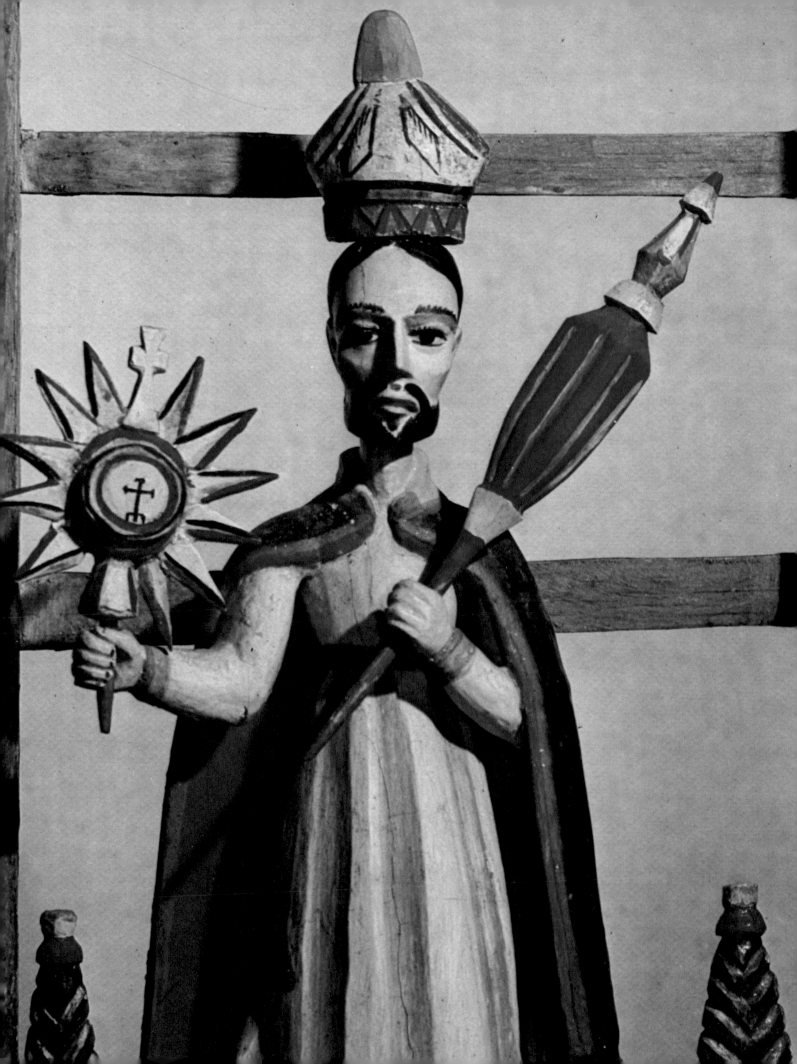

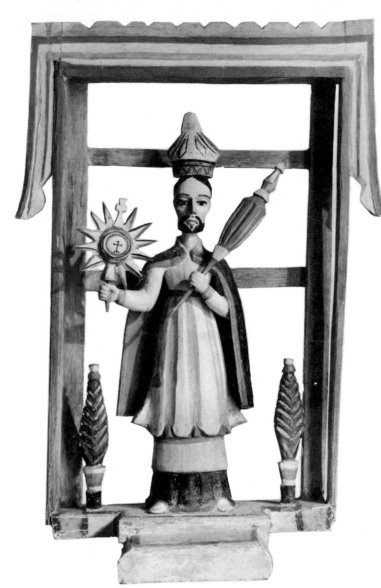

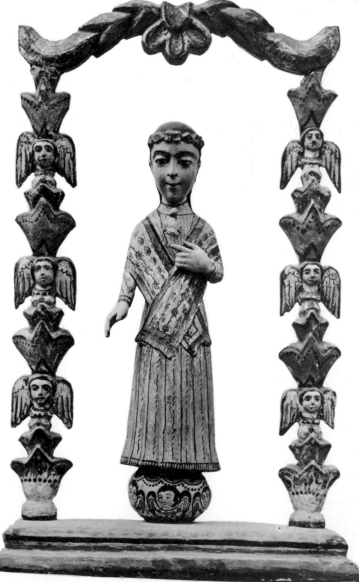

581 (left), 581a (opposite). San Ramon Nonato. José Rafael Aragón. Talpa, New Mexico. 1830–1840. Wood, gesso, paint. H. 26″. Saint Raymond, the Unborn, patron saint of midwives, is revered by expectant mothers. Saint Raymond was persistent in the conversion of Mohammedans to Christianity, and an outraged group of them pierced his lips with a red-hot iron and locked them shut with a padlock. He is also venerated as the keeper of secrets. (Taylor Museum, Colorado Springs Fine Arts Center)

582 (right). Nuestra Señora de la Immaculada Concepción. José Rafael Aragón. New Mexico. 1882–1835. Cottonwood. H. 21½″. In-depth, statistical reassessment of the entire body of the remaining religious folk carvings from the Southwest indicates that they were made by a surprisingly small group of artists. (Taylor Museum, Colorado Springs Fine Arts Center)

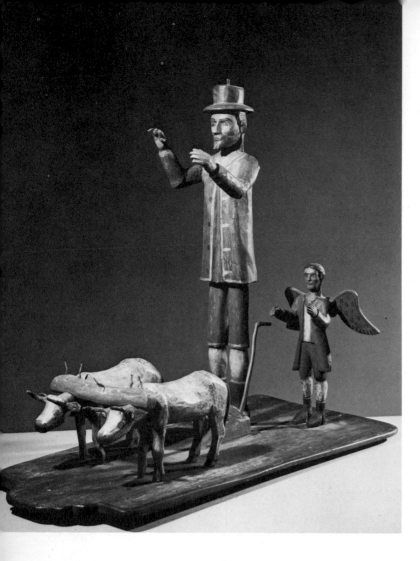

583 (left). San Ysidro Blessing the Crops. Southwest. Nineteenth century. Wood, polychromed. H. 28". Three-dimensional carvings appear to have been more popular with pious villagers than painted panels depicting the same subjects. (Memorial Art Gallery of the University of Rochester)

584 (right). San Acacio. Southwest. Nineteenth century. Probably pine. Dimensions unavailable. Saint Acacius of Mount Ararat was a Roman legionary. Acacius was an immensely popular subject in New Mexico and was usually depicted in a soldier's costume with his tormenters at the foot of the cross. (Private collection)

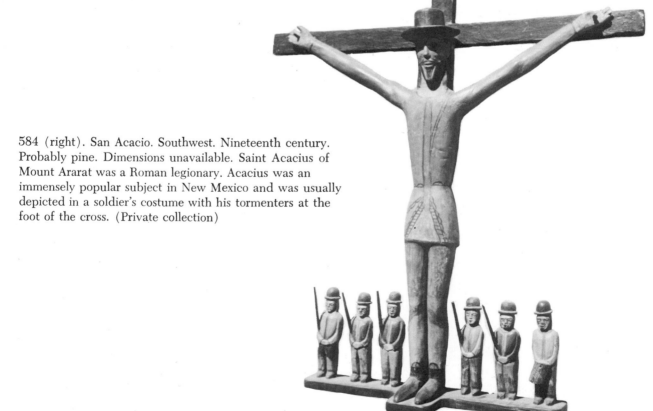

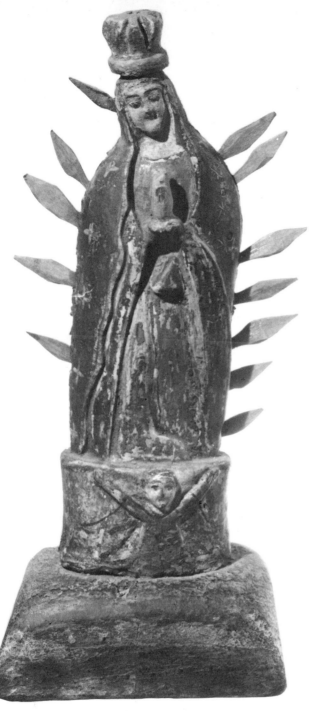

585 (left). Nuestra Señora de Guadalupe. Southwest. 1820–1840. Wood. H. 14″. "Our Lady of Guadalupe," patron saint of Mexico, was a frequent subject for woodcarvers in New Mexico. (Mr. and Mrs. James O. Keene)

586 (right). San Miguel, Arcangel. From the main altar of the church at San Miguel del Vado, New Mexico. 1800–1870. Wood, gesso, paint. H. 29″. Saint Michael weighed souls on a scale and, at the hour of death, rescued the deserving from the devil. It was Saint Michael who drove Lucifer from heaven. He is occasionally depicted holding scales; here he holds the devil by a chain instead. (Taylor Museum, Colorado Springs Fine Arts Center)

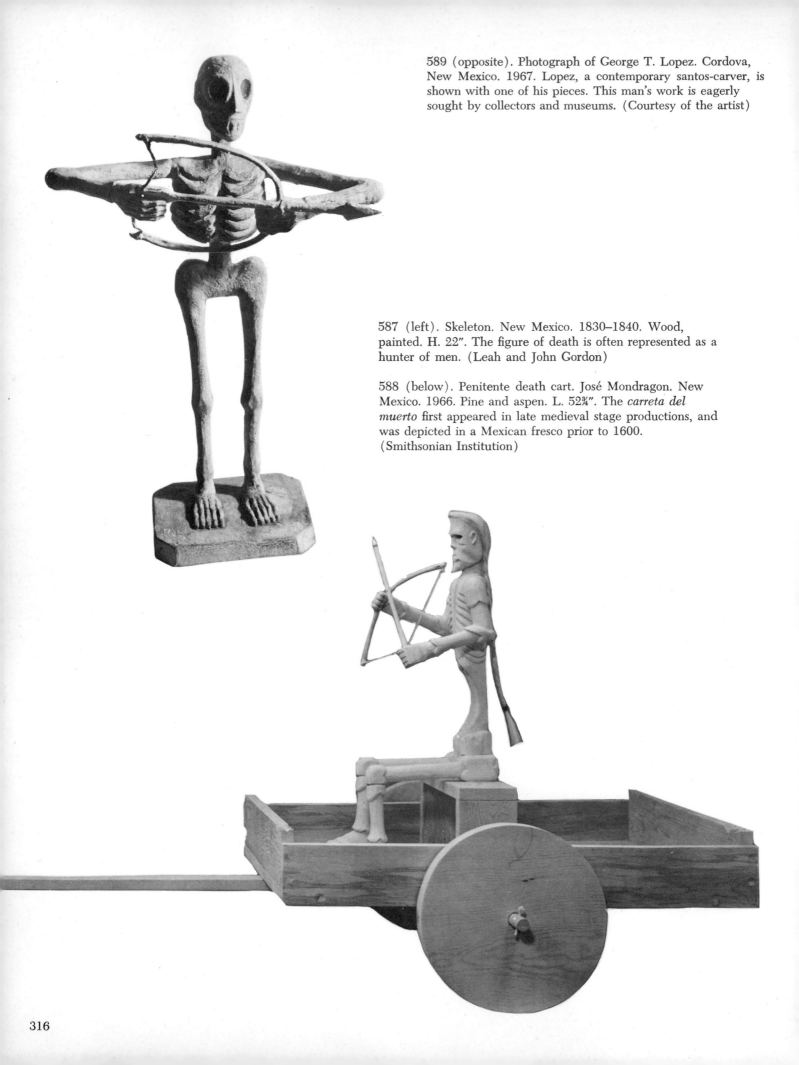

589 (opposite). Photograph of George T. Lopez. Cordova, New Mexico. 1967. Lopez, a contemporary santos-carver, is shown with one of his pieces. This man's work is eagerly sought by collectors and museums. (Courtesy of the artist)

587 (left). Skeleton. New Mexico. 1830–1840. Wood, painted. H. 22". The figure of death is often represented as a hunter of men. (Leah and John Gordon)

588 (below). Penitente death cart. José Mondragon. New Mexico. 1966. Pine and aspen. L. 52¾". The *carreta del muerto* first appeared in late medieval stage productions, and was depicted in a Mexican fresco prior to 1600. (Smithsonian Institution)

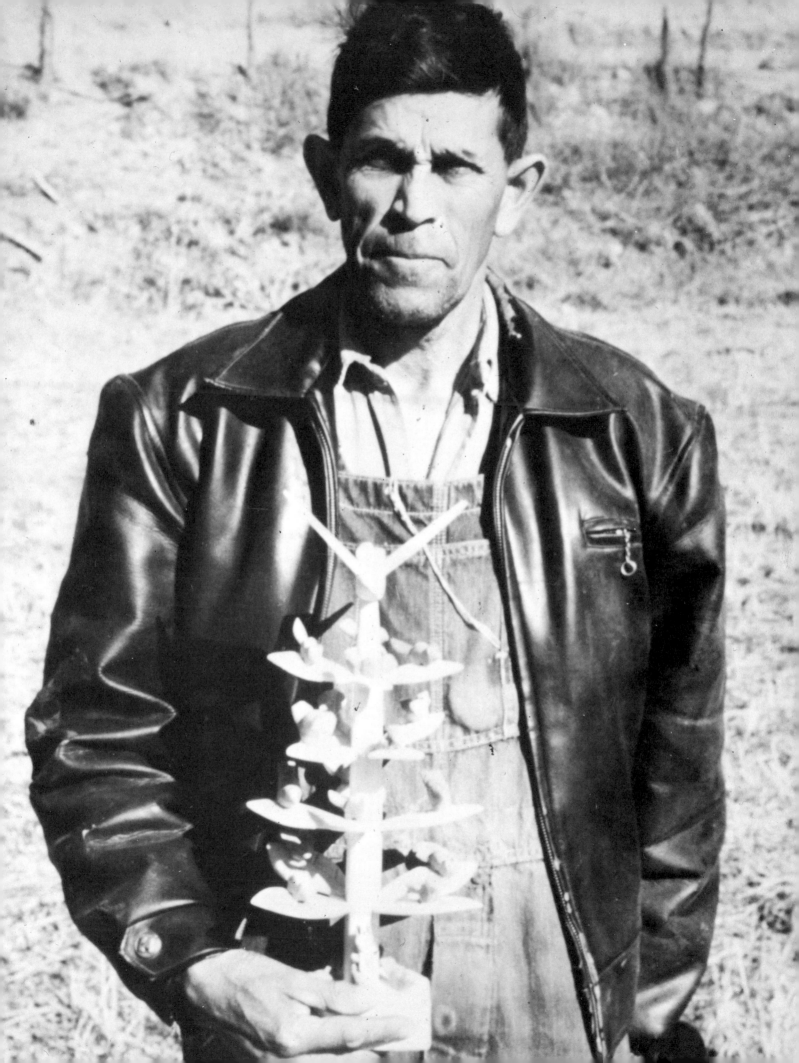

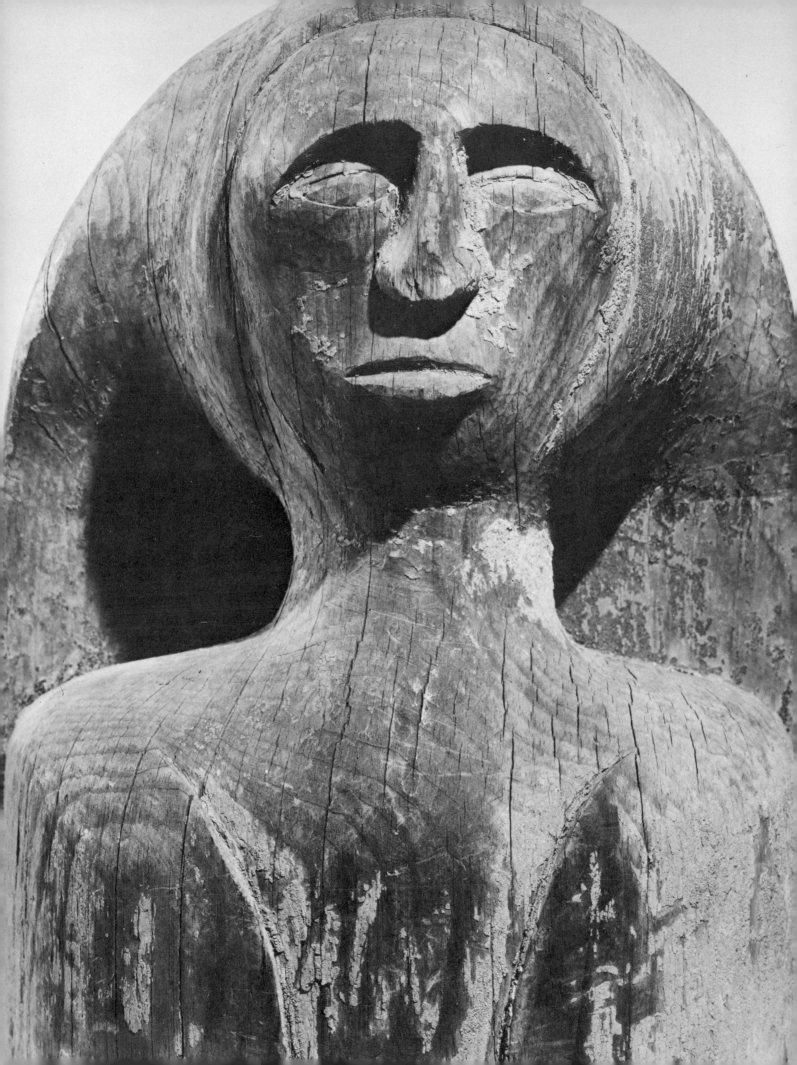

FAMILY OF MAN

Though most American settlements of the seventeenth century were established by those seeking religious self-determination, in the eighteenth century other motives, such as the opportunity for greater financial rewards, caused people to endure the hazardous voyage to the New World.

After the Revolutionary War and the founding of the republic, to live in America became the dream of men and women throughout the world. With the emancipation of slaves in 1865 and then the granting of suffrage to women in 1920, America was perceived a land where all could hope to belong in equality to the family of man.

One stanza of the song of America might be sung by sophisticated artists such as Benjamin West and Gilbert Stuart, but the song of the multitude was a folk art song. In a land where life, liberty, and the pursuit of happiness were the ideals of daily life, diverse interests were depicted by the folk artist, who usually responded in a grass-roots way to American themes. Men and women from all walks of life—black and white; rich and poor—are seen here pursuing their livelihoods or enjoying their more frivolous pastimes. All are part of the American story as told by the folk sculptor.

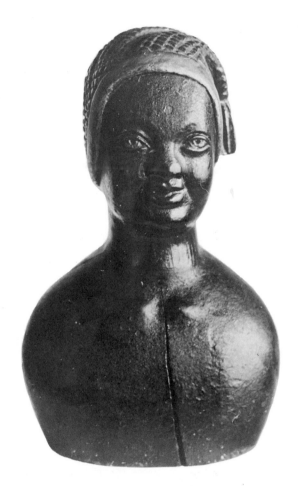

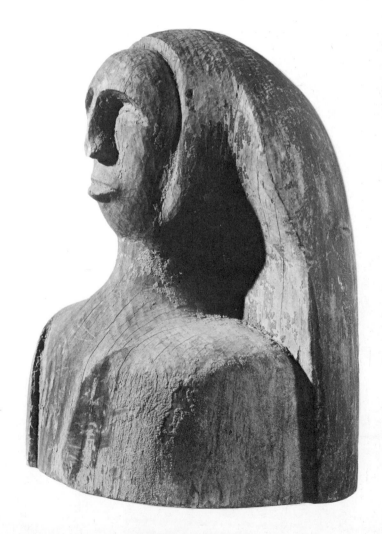

590 (above). Bust of a woman. New England(?). 1850–1860. Wood, painted. H. 19″. The black woman portrayed in this beautiful carving wears a Liberty Cap. The sculpture possibly reflects the fact that prior to the Civil War New England was a hotbed of passionate Abolitionist sentiment, which was fanned by such literary efforts as Harriet Beecher Stowe's sensational novel, *Uncle Tom's Cabin.* (Mrs. Jacob M. Kaplan; photograph courtesy Gerald Kornblau Gallery)

591 (right), 591a (opposite). Bust of a woman. Eighteenth century. Wood. H. 15″. This extraordinary head was found in Essex, Massachusetts. It retains traces of the original white and black paint. (Dr. and Mrs. William Greenspon)

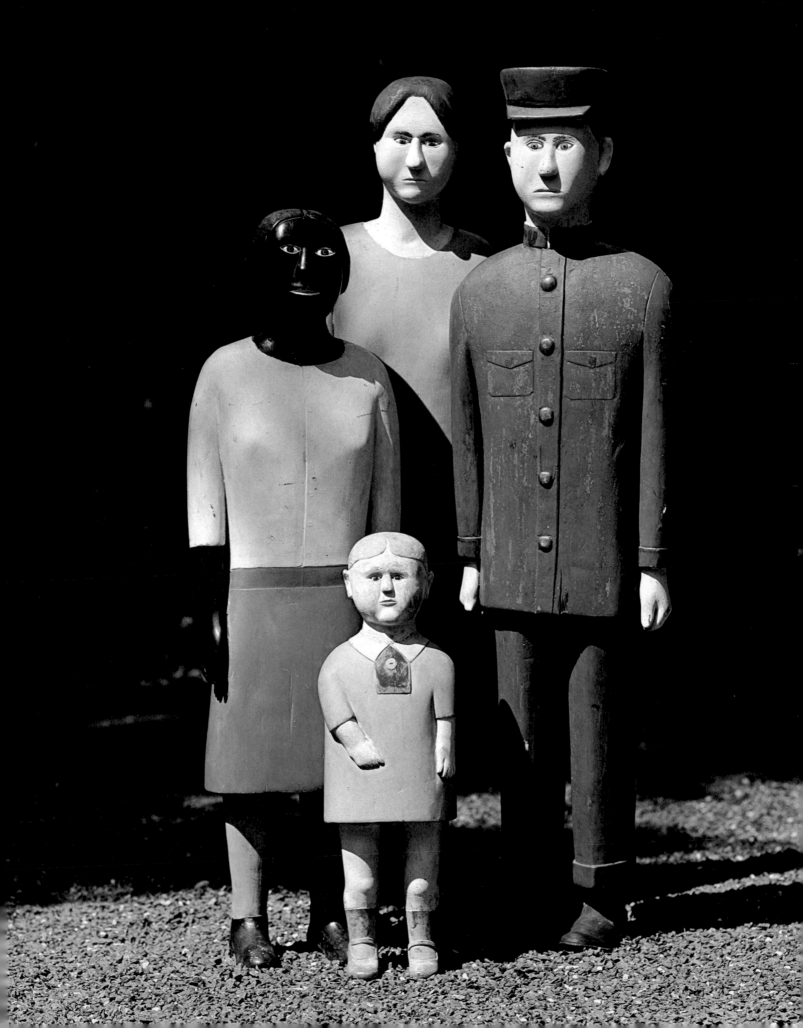

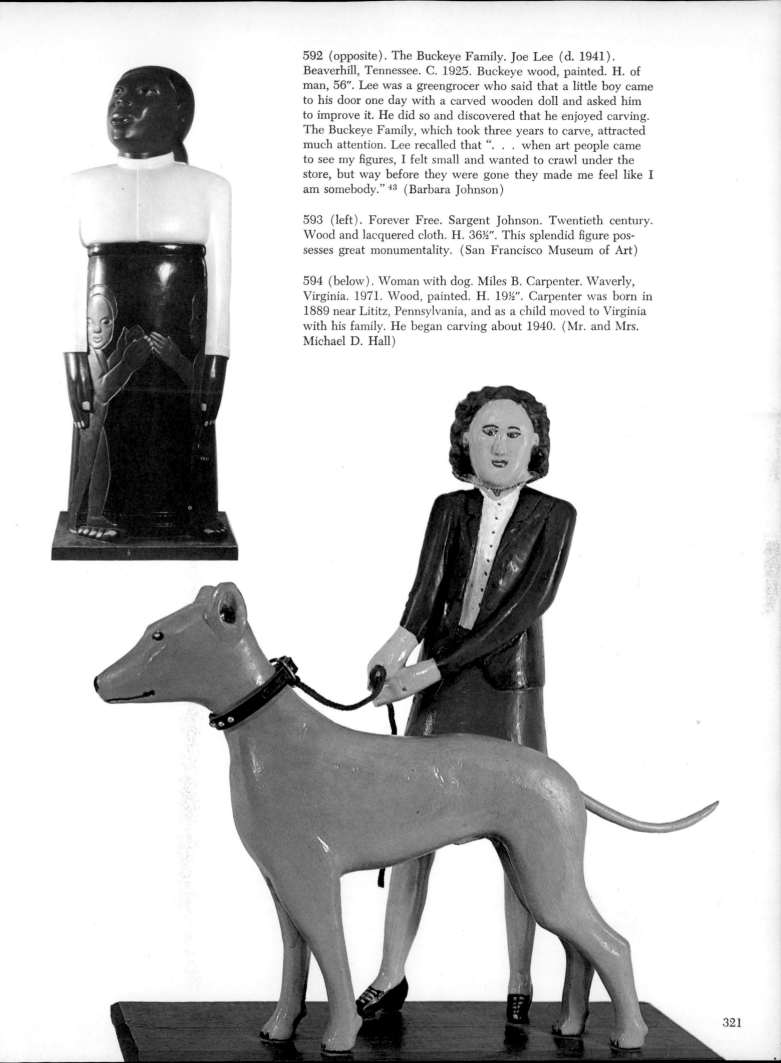

592 (opposite). The Buckeye Family. Joe Lee (d. 1941). Beaverhill, Tennessee. C. 1925. Buckeye wood, painted. H. of man, 56″. Lee was a greengrocer who said that a little boy came to his door one day with a carved wooden doll and asked him to improve it. He did so and discovered that he enjoyed carving. The Buckeye Family, which took three years to carve, attracted much attention. Lee recalled that ". . . when art people came to see my figures, I felt small and wanted to crawl under the store, but way before they were gone they made me feel like I am somebody." [43] (Barbara Johnson)

593 (left). Forever Free. Sargent Johnson. Twentieth century. Wood and lacquered cloth. H. 36½″. This splendid figure possesses great monumentality. (San Francisco Museum of Art)

594 (below). Woman with dog. Miles B. Carpenter. Waverly, Virginia. 1971. Wood, painted. H. 19½″. Carpenter was born in 1889 near Lititz, Pennsylvania, and as a child moved to Virginia with his family. He began carving about 1940. (Mr. and Mrs. Michael D. Hall)

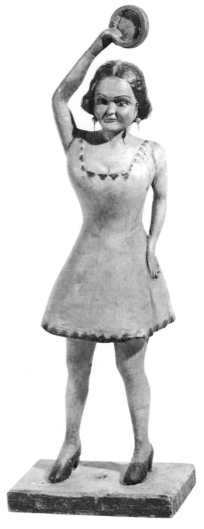

595 (below). Girl with tambourine. Ed Davis. New York State. 1935. Wood, painted. H. 16½". This refugee from an all-girl band is giving that tambourine a real shaking! (Herbert W. Hemphill, Jr.)

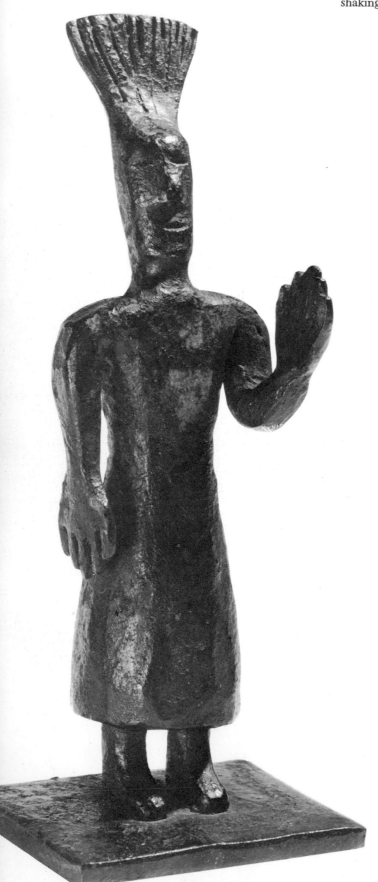

596 (left). Pocahontas. Harrison Humphrey. Monhegan Island, Maine. 1907–1912. Forged iron. H. 6½". Harrison Humphrey was the village blacksmith on Monhegan Island. He made this and a companion figure of Captain John Smith to commemorate the fact that Monhegan had been "officially" discovered by Smith in 1614. Pocahontas, of course, had nothing to do with Monhegan, but in history she is eternally linked with the captain. Humphrey forged several sets of these little figures, but most of them have disappeared over the years. (Private collection)

598 (opposite, left). Seated woman. Found near Ephrata, Pennsylvania. Mid-nineteenth century. Wood, polychromed. H. 12". Believed to be of Pennsylvania German origin, this charming, decorative sculpture sports white-stockinged legs with red garters, which can be seen beneath the lady's skirt from the back. (Abby Aldrich Rockefeller Folk Art Collection)

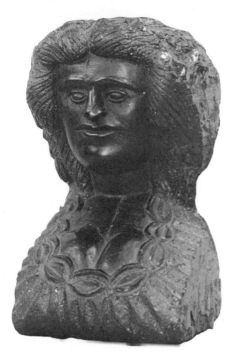

597 (above). Bust of a woman. Pennsylvania. C. 1900. Anthracite coal. H. 12″. This carving is believed to have been executed by a miner. (Everhart Museum)

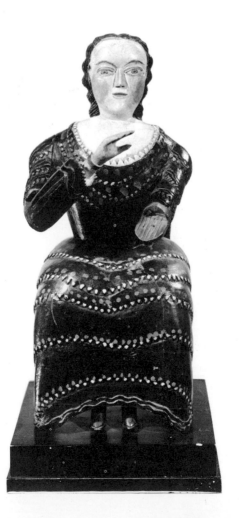

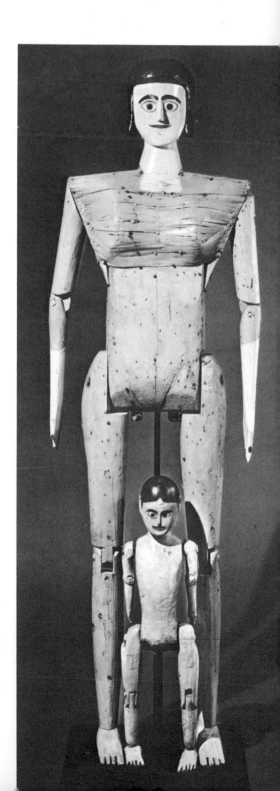

599 (right). Woman and child. New York State. 1920. Pine. H. of woman, 58″. These impressive figures were found in a dress shop and were probably meant to be used as a mannequins. The diversity of modern art has caused twentieth-century folk art, much of which is utilitarian, to be appreciated and valued. (James Kronen Gallery)

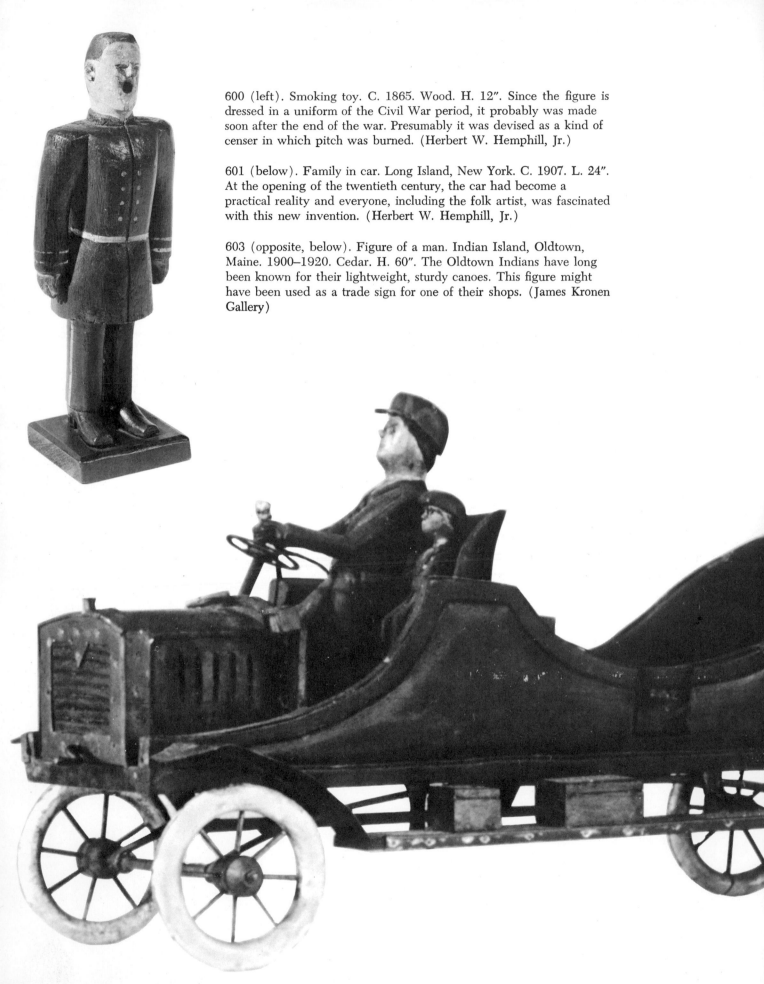

600 (left). Smoking toy. C. 1865. Wood. H. 12″. Since the figure is dressed in a uniform of the Civil War period, it probably was made soon after the end of the war. Presumably it was devised as a kind of censer in which pitch was burned. (Herbert W. Hemphill, Jr.)

601 (below). Family in car. Long Island, New York. C. 1907. L. 24″. At the opening of the twentieth century, the car had become a practical reality and everyone, including the folk artist, was fascinated with this new invention. (Herbert W. Hemphill, Jr.)

603 (opposite, below). Figure of a man. Indian Island, Oldtown, Maine. 1900–1920. Cedar. H. 60″. The Oldtown Indians have long been known for their lightweight, sturdy canoes. This figure might have been used as a trade sign for one of their shops. (James Kronen Gallery)

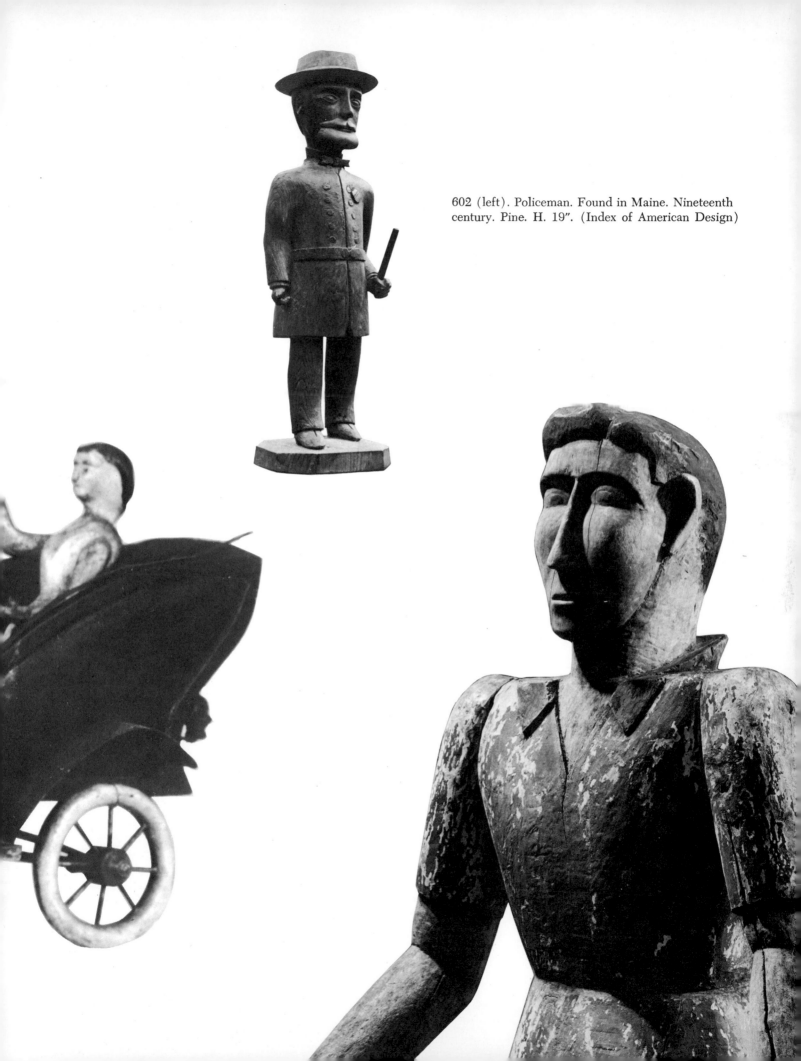

602 (left). Policeman. Found in Maine. Nineteenth century. Pine. H. 19″. (Index of American Design)

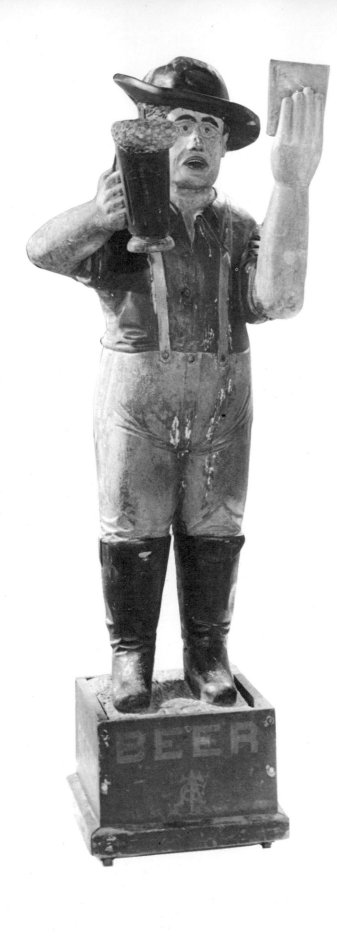

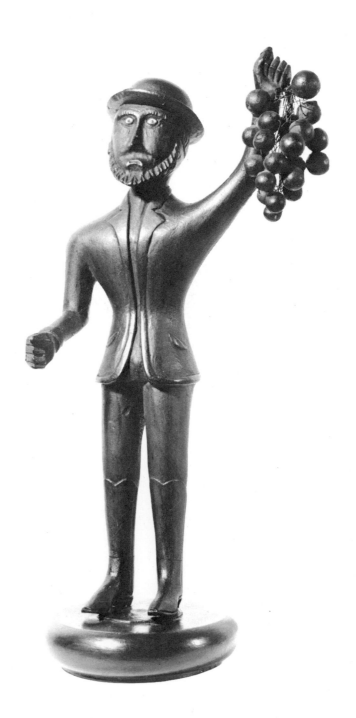

604 (left). Bar figure. Signed: "T. A. Chapman/Sculptor/& Painter/Richwood, Ohio." Nineteenth century. Pine, painted. H. 66¼". Like all seasoned brew drinkers, this Midwestern farmer complements his mug of beer with a slice of cheese. This figure stood outside a tavern at Bucyrus, Ohio. (Ohio Historical Society)

605 (below). Man with grapes. Wells, Maine. C. 1850. Wood, painted. H. 15". This masterfully stylish figure might have been used either at a winery or as a bar decoration. (Private collection)

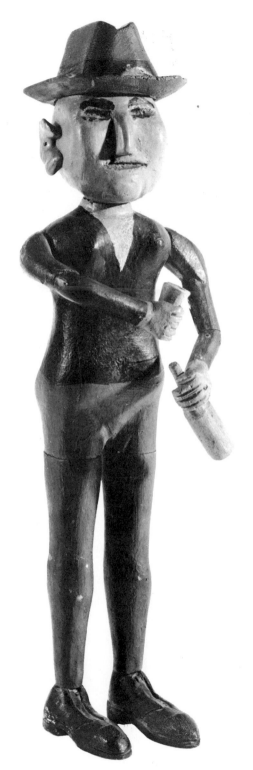

606 (left). "Prohibition" man. 1910–1930. Wood, painted. H. 13″. The Prohibition Party; an American political organization formed in 1869, advocated banning the manufacture, transportation, sale, and possession of alcoholic beverages. The Eighteenth Amendment to the Constitution outlawed alcohol in 1920 and was not repealed until 1933. This figure probably represents a regular at the speakeasies. (Mr. and Mrs. Leo Rabkin)

607 (below). Seated man. Pennsylvania. Second half of the nineteenth century. Wood, polychromed. H. 6½″. The painted eyes and moustache give an intense quality to this wonderful little figure. (Dr. and Mrs. William Greenspon)

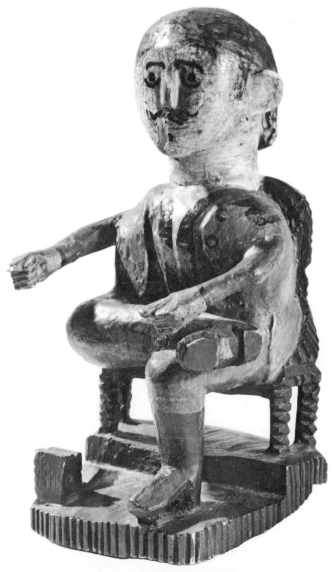

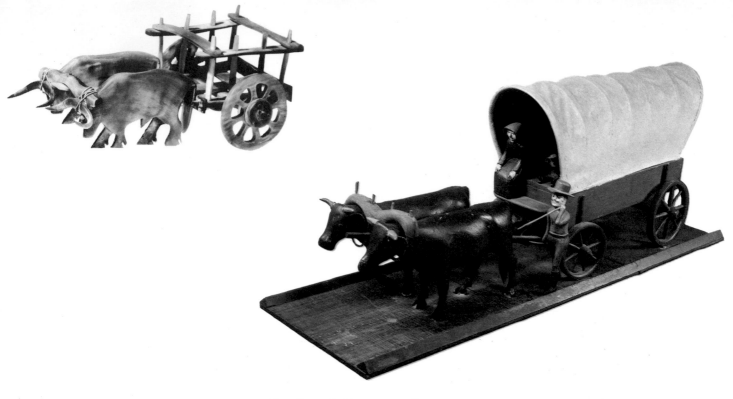

608 (above, left). Oxen pulling a cart. Western United States. Early twentieth century. Steer horn. L. 15″. It is most unusual to find a sculpture made of this material. (Private collection)

609 (above, right). Prairie wagon. Ohio. C. 1920. Wood and canvas, polychromed. L. 34″. This piece is believed to have been made by a prisoner in an Ohio correctional institution. (Mr. and Mrs. Jeremy Samson)

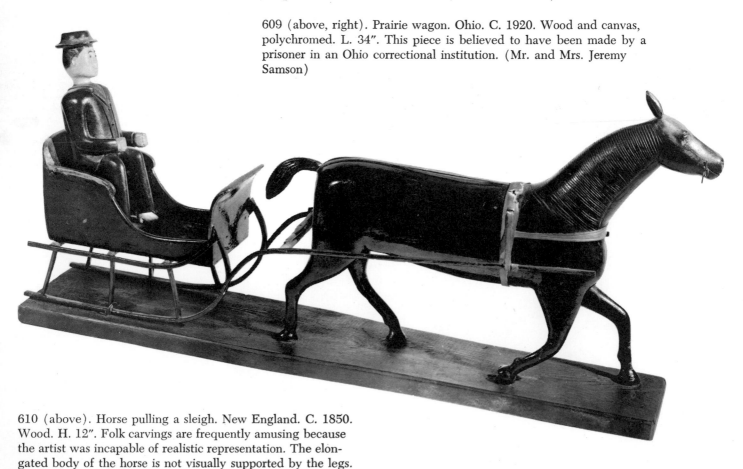

610 (above). Horse pulling a sleigh. New England. C. 1850. Wood. H. 12″. Folk carvings are frequently amusing because the artist was incapable of realistic representation. The elongated body of the horse is not visually supported by the legs. (Mr. and Mrs. Harvey Kahn)

611 (right). Man with horse. Edgar Tolson. Campton, Kentucky. C. 1950. Wood, painted. H. 23¼". Though Tolson has concentrated on religious themes in his sculpture, his secular carvings also possess great vitality. (Mr. and Mrs. Michael D. Hall)

612 (below). Photograph of the punishment horse at Fort Bridger, Utah. 1866. Fort Bridger, a military outpost some thirty miles east of Evanston, Utah, used a wooden horse for much the same purpose as the stocks in seventeenth-century New England. A man sentenced to mount the horse and hold the giant sword was forced to endure the malicious taunts of his comrades. (The Church of Jesus Christ of Latter-Day Saints)

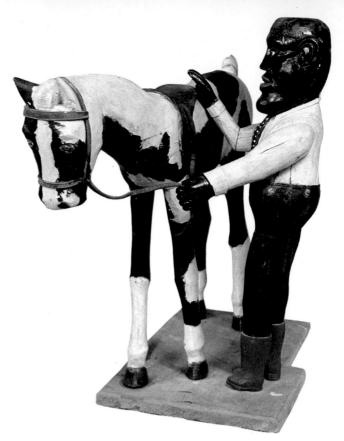

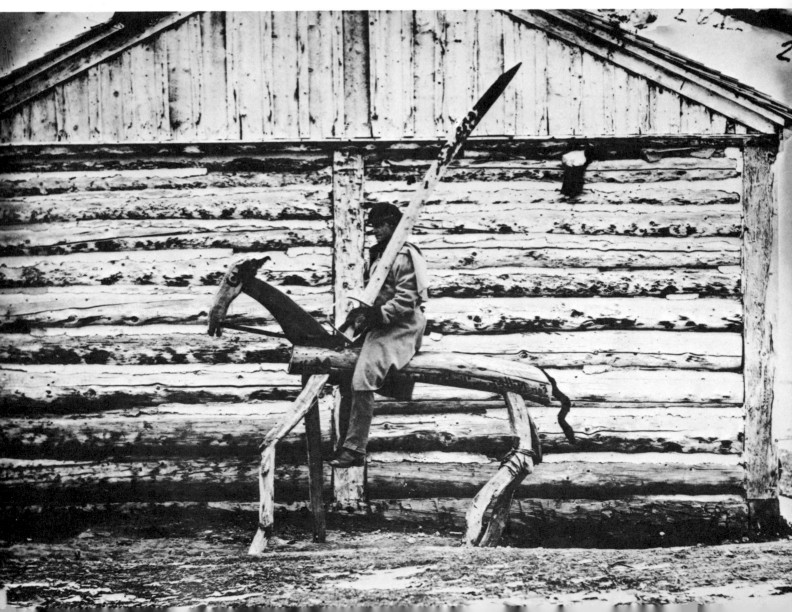

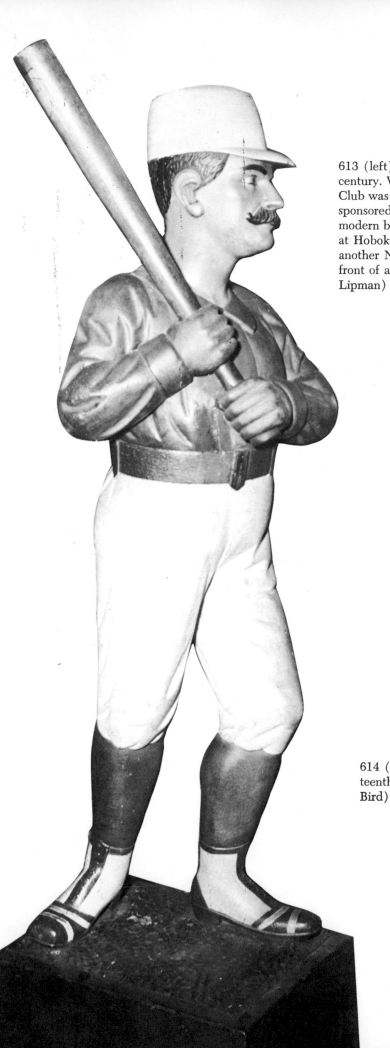

613 (left). Baseball player trade store figure. Late nineteenth century. Wood. H. 60". In 1845 the Knickerbocker Baseball Club was organized in New York City, and the amateur team sponsored by this organization established a foundation for modern baseball. The "Knicks" played their first game in 1846 at Hoboken, New Jersey, and lost to the New York Nine, another New York City club. This figure probably stood in front of a sporting goods store. (Photograph courtesy Jean Lipman)

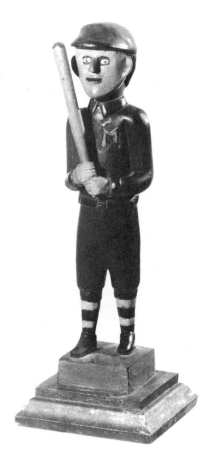

614 (above). Baseball player. New York State. Late nineteenth or early twentieth century. Wood. H. 8¾". (George O. Bird)

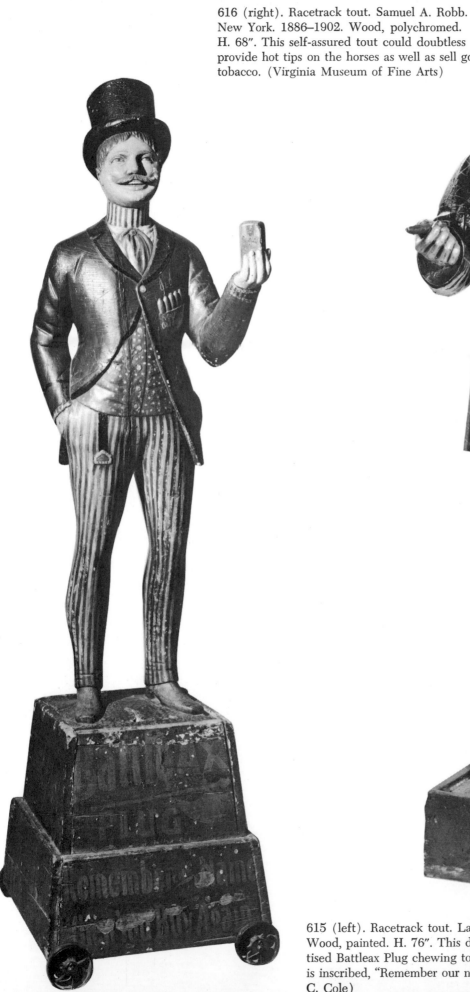

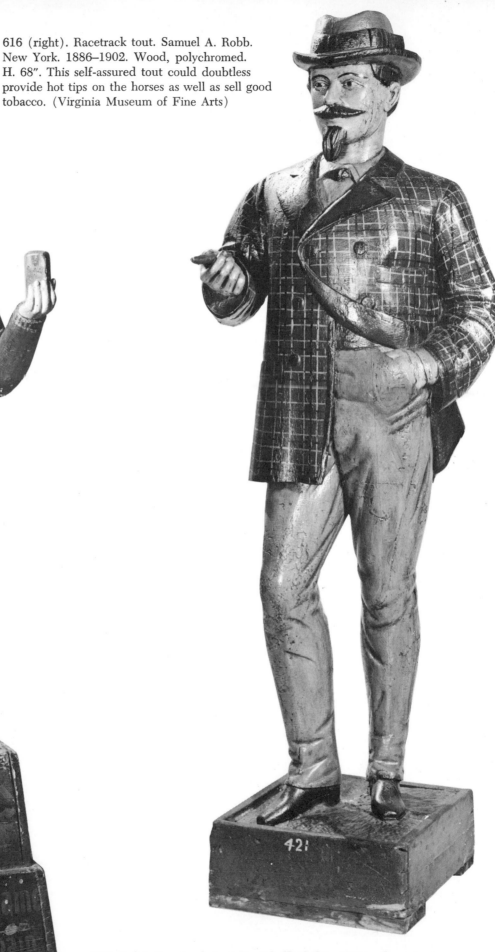

616 (right). Racetrack tout. Samuel A. Robb.
New York. 1886–1902. Wood, polychromed.
H. 68". This self-assured tout could doubtless
provide hot tips on the horses as well as sell good
tobacco. (Virginia Museum of Fine Arts)

615 (left). Racetrack tout. Last half of the nineteenth century.
Wood, painted. H. 76". This dandy from Emporia, Kansas, adver-
tised Battleax Plug chewing tobacco. The lower section of the base
is inscribed, "Remember our name when you buy again." (Gary
C. Cole)

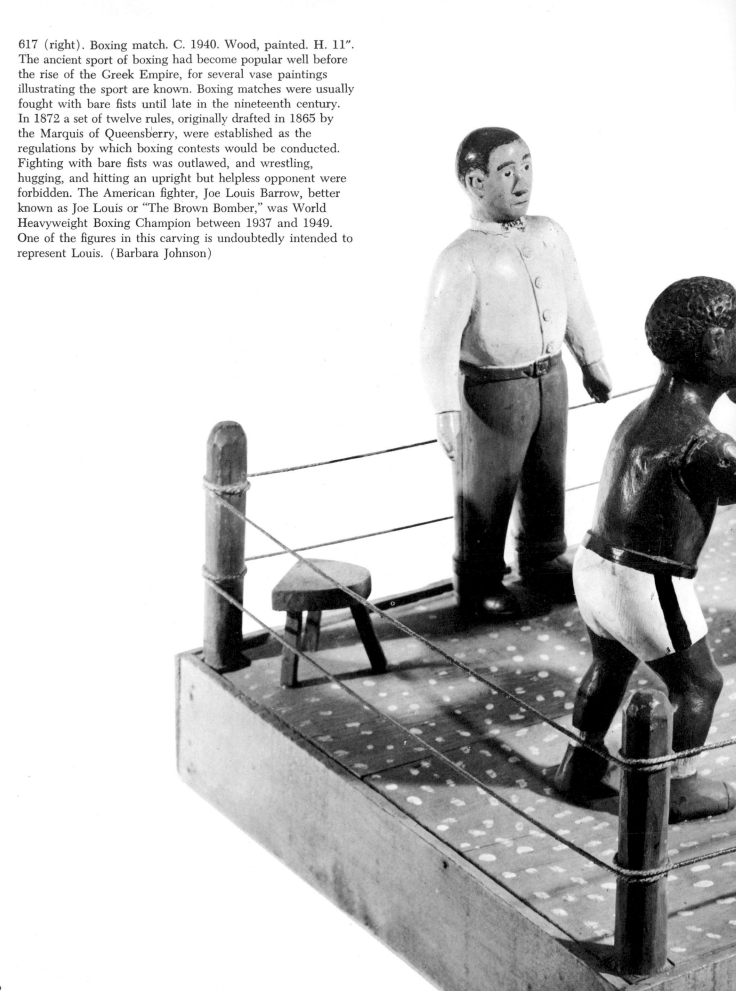

617 (right). Boxing match. C. 1940. Wood, painted. H. 11″. The ancient sport of boxing had become popular well before the rise of the Greek Empire, for several vase paintings illustrating the sport are known. Boxing matches were usually fought with bare fists until late in the nineteenth century. In 1872 a set of twelve rules, originally drafted in 1865 by the Marquis of Queensberry, were established as the regulations by which boxing contests would be conducted. Fighting with bare fists was outlawed, and wrestling, hugging, and hitting an upright but helpless opponent were forbidden. The American fighter, Joe Louis Barrow, better known as Joe Louis or "The Brown Bomber," was World Heavyweight Boxing Champion between 1937 and 1949. One of the figures in this carving is undoubtedly intended to represent Louis. (Barbara Johnson)

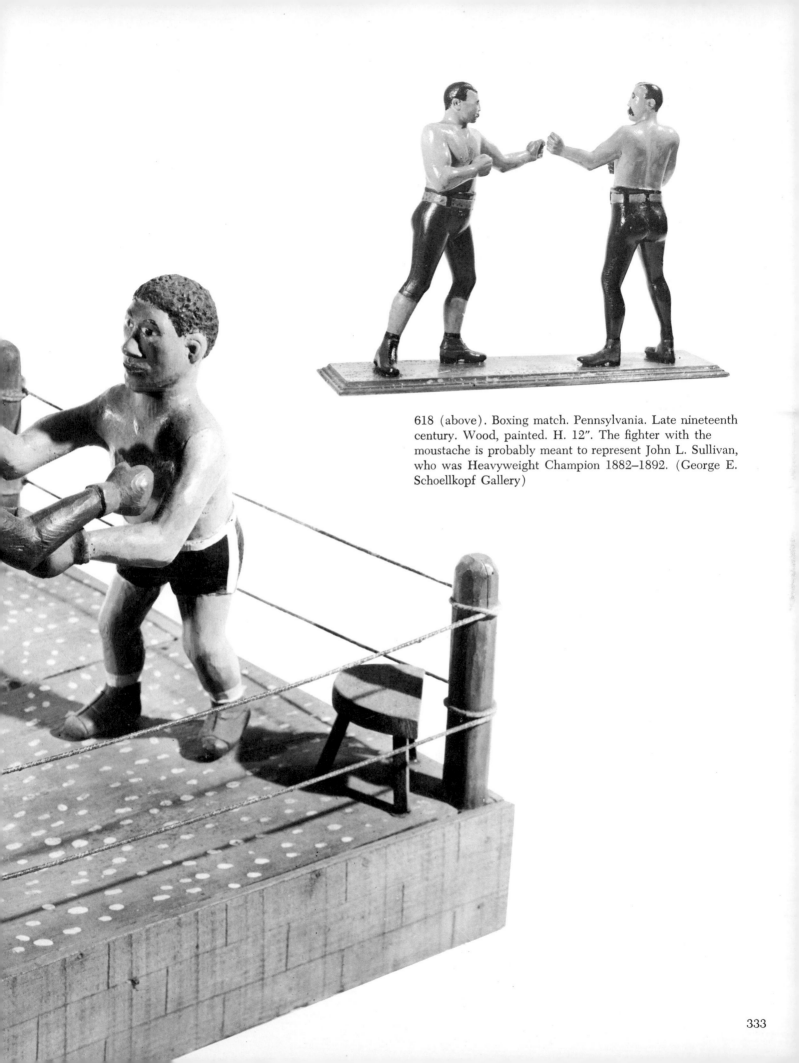

618 (above). Boxing match. Pennsylvania. Late nineteenth century. Wood, painted. H. 12″. The fighter with the moustache is probably meant to represent John L. Sullivan, who was Heavyweight Champion 1882–1892. (George E. Schoellkopf Gallery)

619 (right). Figural group. Edgar Alexander McKillop (1878–1950). Balfour, North Carolina. Second quarter of the twentieth century. Wood. H. 51½". McKillop, a self-taught artist, wished his work to be included at Henry Ford's Greenfield Village; consequently, he presented to Mr. Ford in 1929 this extraordinary carving of a man, an eagle, and two frogs. McKillop was obviously proud of his work, for he twice signed it, "Made · by E A · McKillop, Balfour · N.C." (Greenfield Village and Henry Ford Museum)

620 (below). Hippoceros. Edgar Alexander McKillop. Balfour, North Carolina. C. 1928. Walnut. L. 58¼". McKillop's daughter, in a letter, once described her father: "Edgar Alexander McKillop was a talented man. He could cook and sew and make rustic and fancy furniture. He could make anything from wood or any kind of metal. He was an inventor. We don't know of any kind of work that he could not do some of." [44] A blacksmith by profession, he lived all his life in the area around Balfour. This extraordinary, massive creature, with a Victrola in its back, wags its tongue as the turntable revolves. (Abby Aldrich Rockefeller Folk Art Collection)

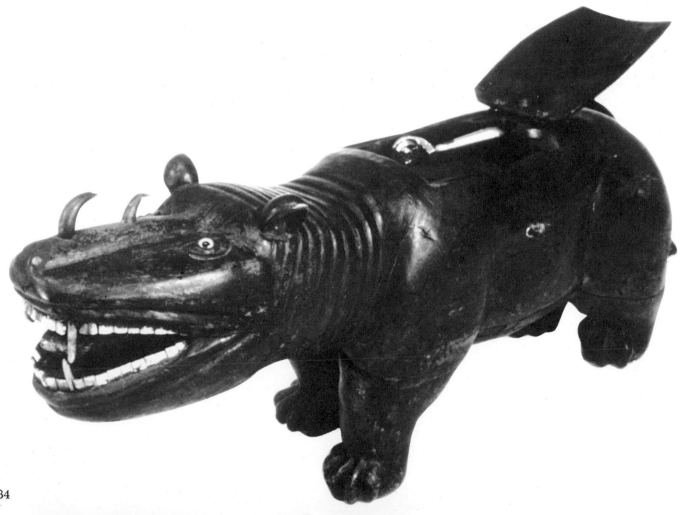

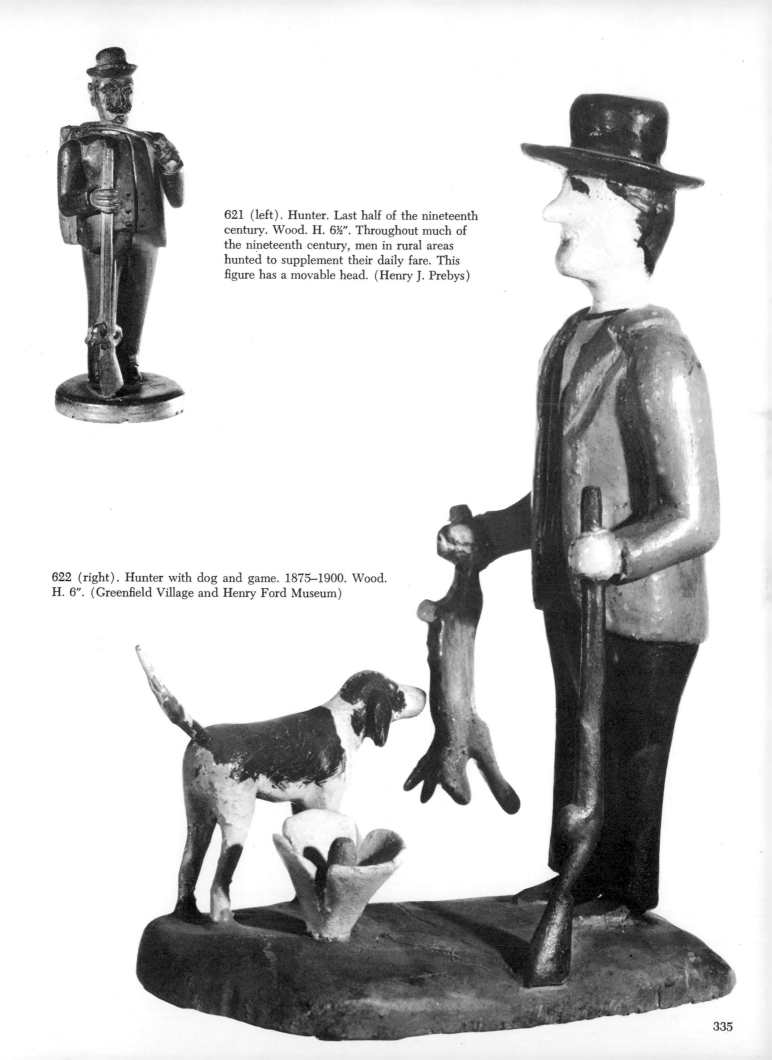

621 (left). Hunter. Last half of the nineteenth century. Wood. H. 6½″. Throughout much of the nineteenth century, men in rural areas hunted to supplement their daily fare. This figure has a movable head. (Henry J. Prebys)

622 (right). Hunter with dog and game. 1875–1900. Wood. H. 6″. (Greenfield Village and Henry Ford Museum)

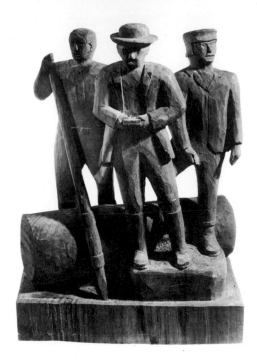

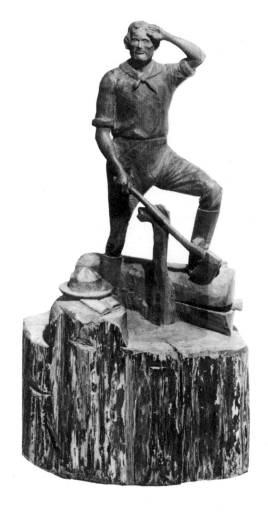

623 (above). Lumberjacks and timber boss. Henry Dyker. Grandville, Ohio. C. 1900. Pine. H. 14¾″. Though logrolling was a popular sport during the nineteenth century, the term, in the twentieth century, has come to be used in conjunction with the exchanging of political favors among legislators. (Mr. and Mrs. James O. Keene)

624 (right). The rail-splitter. Marked "TR." Early twentieth century. Cedar. H. 18″. This is the occupation for which Abraham Lincoln was so famous in his early manhood. (Mr. and Mrs. James O. Keene)

626 (opposite, above). Two pair of oxen pulling a man seated on a sledge. Midwest. 1850–1875. Wood. L. 32″. The ox, an adult, castrated bull, is ideally suited as a dray animal, for he possesses a tractable temperament. (Greenfield Village and Henry Ford Museum)

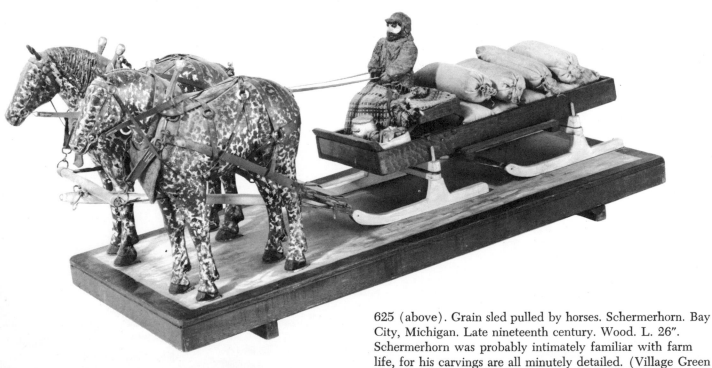

625 (above). Grain sled pulled by horses. Schermerhorn. Bay City, Michigan. Late nineteenth century. Wood. L. 26″. Schermerhorn was probably intimately familiar with farm life, for his carvings are all minutely detailed. (Village Green Antiques)

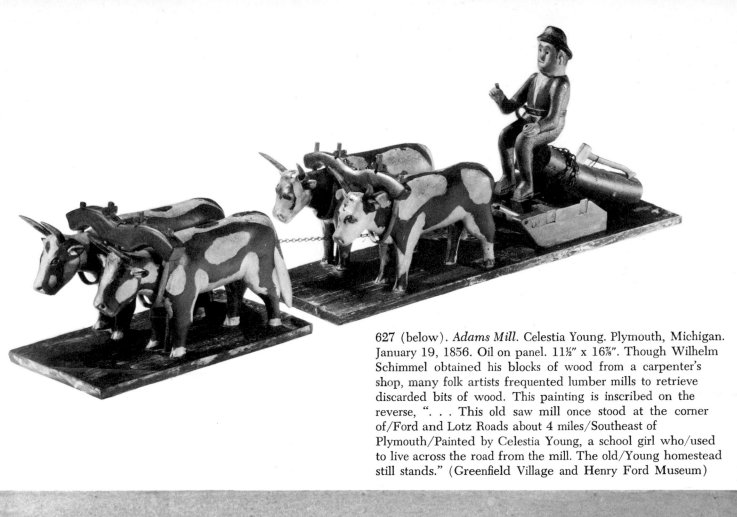

627 (below). *Adams Mill.* Celestia Young. Plymouth, Michigan. January 19, 1856. Oil on panel. 11½" x 16⅞". Though Wilhelm Schimmel obtained his blocks of wood from a carpenter's shop, many folk artists frequented lumber mills to retrieve discarded bits of wood. This painting is inscribed on the reverse, ". . . This old saw mill once stood at the corner of/Ford and Lotz Roads about 4 miles/Southeast of Plymouth/Painted by Celestia Young, a school girl who/used to live across the road from the mill. The old/Young homestead still stands." (Greenfield Village and Henry Ford Museum)

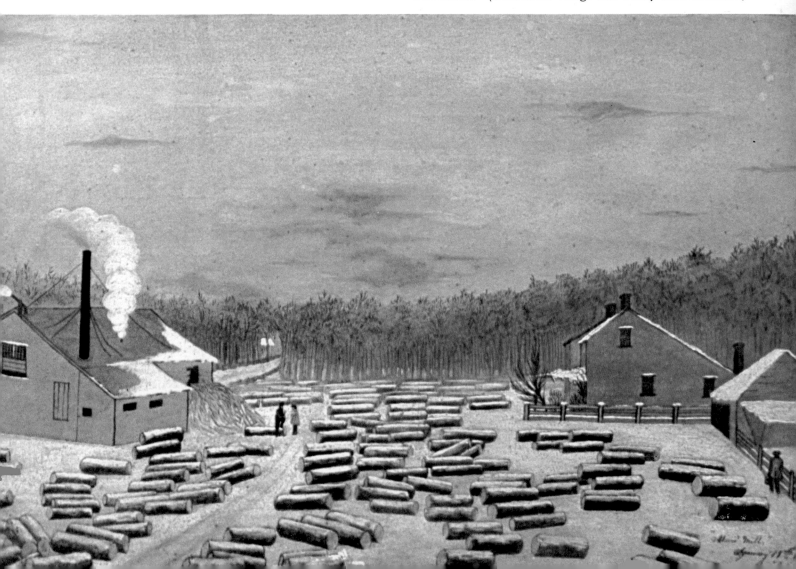

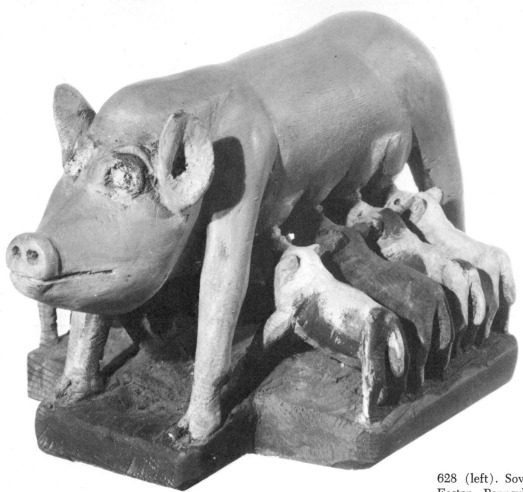

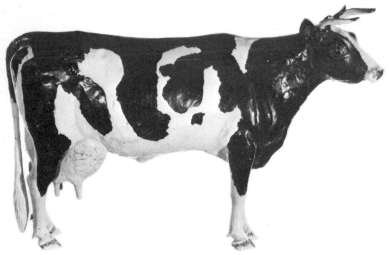

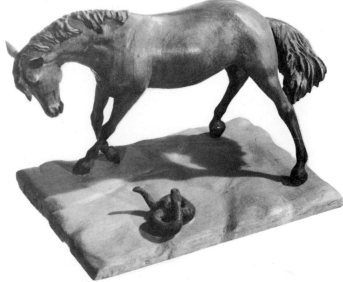

628 (left). Sow and piglets. Joe Weidinger. Easton, Pennsylvania. Twentieth century. Pine. H. 4". Life on the farm can be busy. (Mr. and Mrs. James O. Keene)

629 (above). Cow. John Reber. Pennsylvania. 1880–1920. Wood and gesso, painted. H. 7¼". Reber lived most of his life in Lehigh County. (Greenfield Village and Henry Ford Museum)

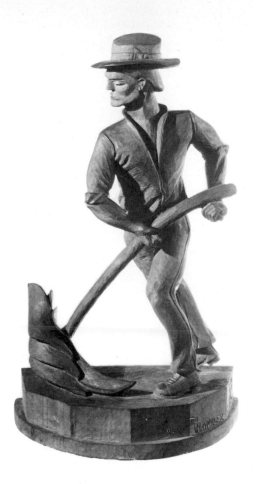

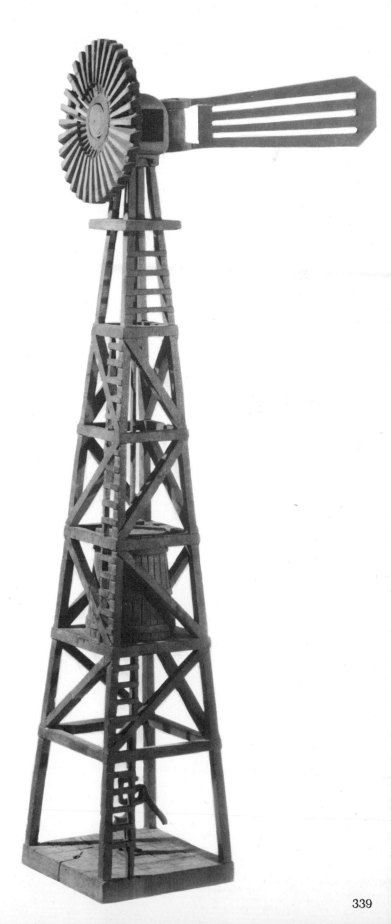

630 (opposite, below). Horse shying away from a rattle-snake. Arlean Wood. Ithaca, Michigan. Mid-twentieth century. Gumwood. H. 6¼″. (Mr. and Mrs. James O. Keene)

631 (above). The haymaker. Marked "TR." 1932. Maple. H. 14¾″. "TR.," the carver of this piece and of figure 624, the rail-splitter, remains unidentified. (Mr. and Mrs. James O. Keene)

632 (right). Windmill. R. D. Ackley. Ann Arbor, Michigan. Early twentieth century. Pine. H. 18¼″. Nearly every Midwestern farm established during the second half of the nineteenth century included a windmill to draw water for the use of family and livestock. This carving was fashioned from one piece of wood. (Mr. and Mrs. James O. Keene)

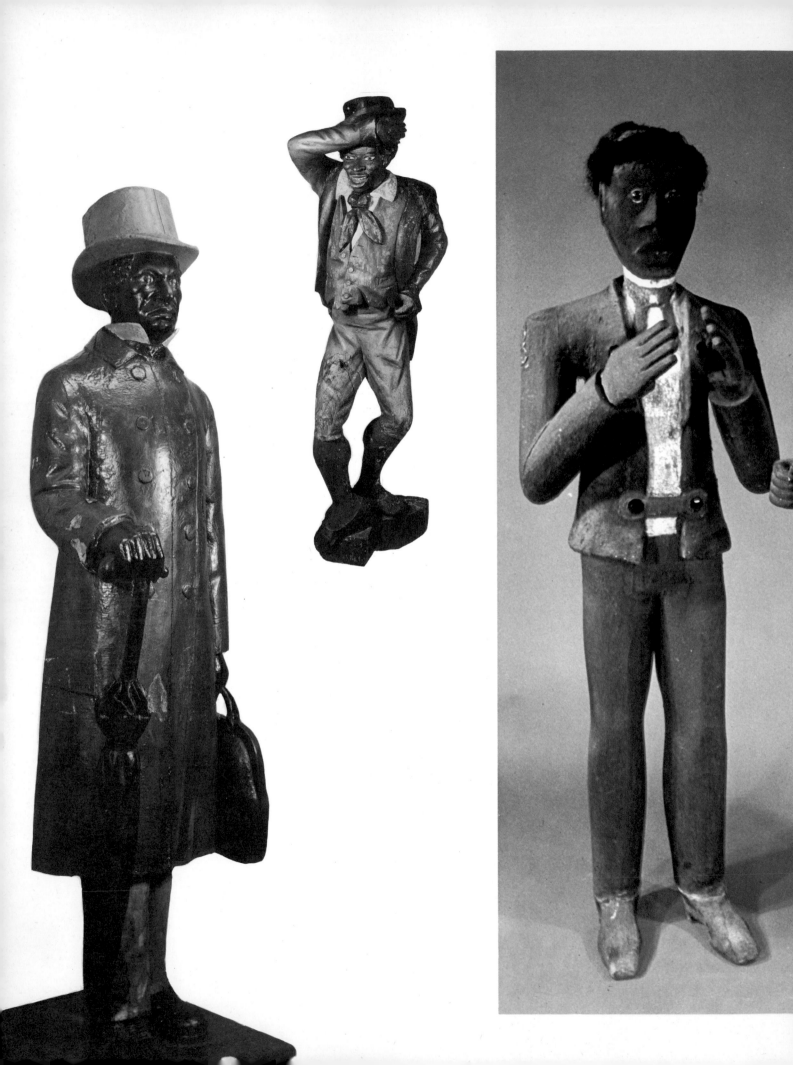

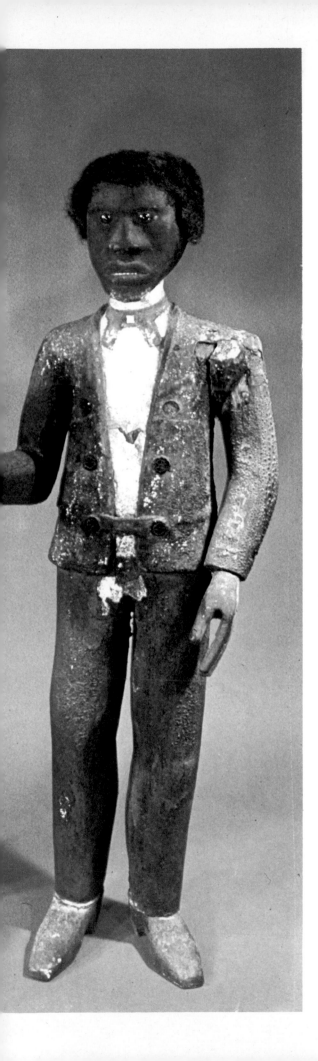

633 (opposite, left). Reverend Campbell. Thomas V. Brooks. Chicago. C. 1880. Wood, polychromed. H. 84″. Reverend Campbell was a preacher and physician on Detective Alan Pinkerton's estate at Onarga, Illinois. (New York State Historical Association)

634 (opposite, right). "Dancing darky" cigar store figure. Third quarter of the nineteenth century. Wood, polychromed. H. 54″. (The New-York Historical Society)

635 (center), 635a (below). Two black men. Hamilton, Ohio. C. 1880. Wood, metal, glass, plaster, leather, and hemp. H. of taller figure, 56½″. These powerful figures are believed to have been used in conjunction with funeral rites in either a church or a lodge hall. A loop in the lapel of one of the figures probably held fresh-cut flowers, and one figure undoubtedly grasped a Bible while the other held a staff. It is thought that these carvings were fashioned by a black man. (Mr. and Mrs. Michael D. Hall)

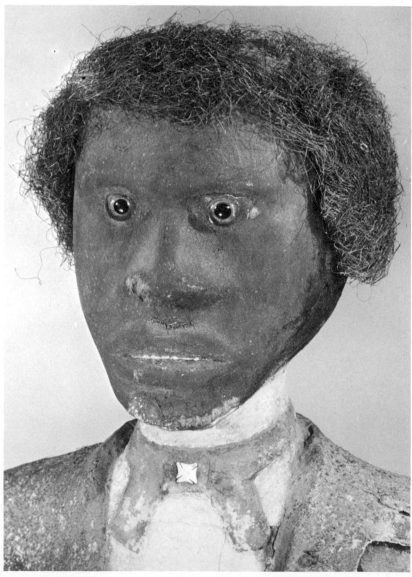

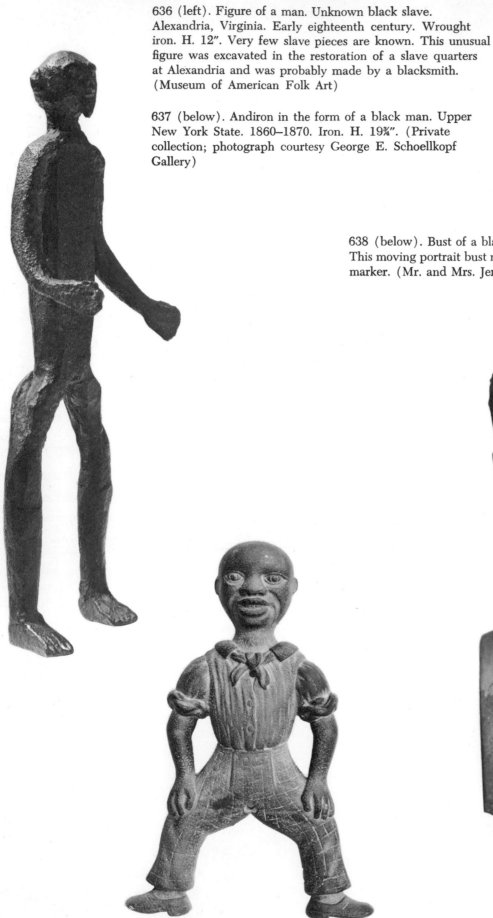

636 (left). Figure of a man. Unknown black slave. Alexandria, Virginia. Early eighteenth century. Wrought iron. H. 12″. Very few slave pieces are known. This unusual figure was excavated in the restoration of a slave quarters at Alexandria and was probably made by a blacksmith. (Museum of American Folk Art)

637 (below). Andiron in the form of a black man. Upper New York State. 1860–1870. Iron. H. 19¾″. (Private collection; photograph courtesy George E. Schoellkopf Gallery)

638 (below). Bust of a black man. C. 1840. Stone. H. 26″. This moving portrait bust might have been intended as a grave marker. (Mr. and Mrs. Jerome Blum)

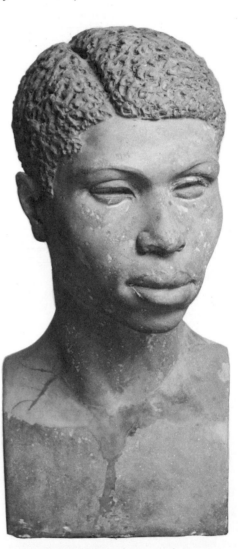

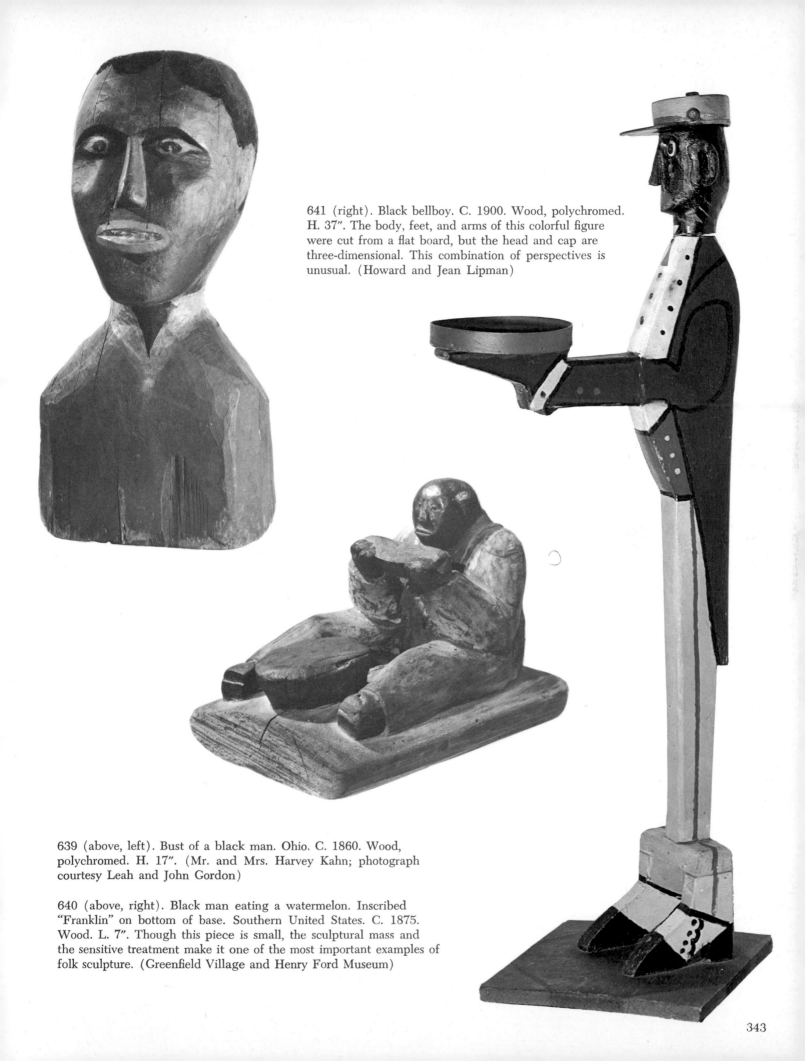

641 (right). Black bellboy. C. 1900. Wood, polychromed. H. 37". The body, feet, and arms of this colorful figure were cut from a flat board, but the head and cap are three-dimensional. This combination of perspectives is unusual. (Howard and Jean Lipman)

639 (above, left). Bust of a black man. Ohio. C. 1860. Wood, polychromed. H. 17". (Mr. and Mrs. Harvey Kahn; photograph courtesy Leah and John Gordon)

640 (above, right). Black man eating a watermelon. Inscribed "Franklin" on bottom of base. Southern United States. C. 1875. Wood. L. 7". Though this piece is small, the sculptural mass and the sensitive treatment make it one of the most important examples of folk sculpture. (Greenfield Village and Henry Ford Museum)

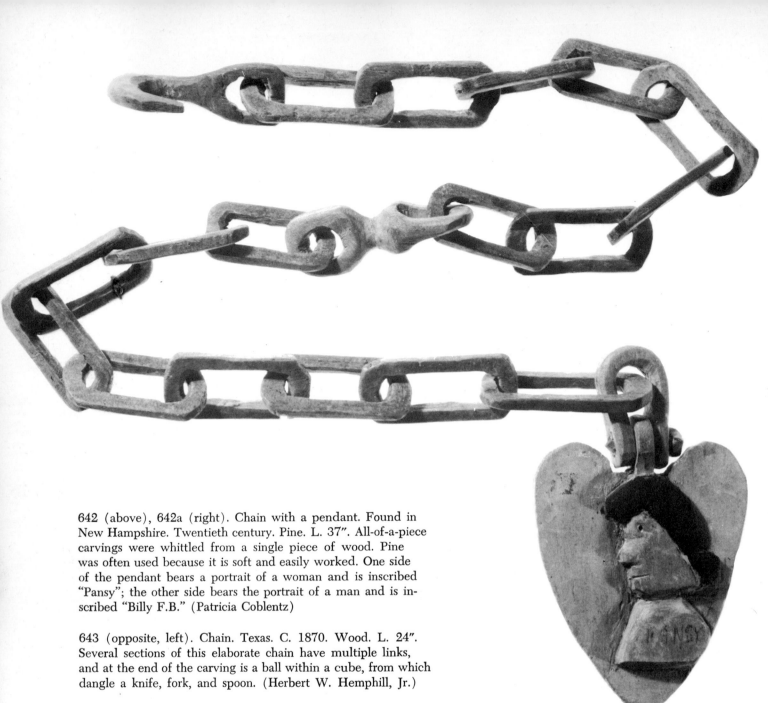

642 (above), 642a (right). Chain with a pendant. Found in New Hampshire. Twentieth century. Pine. L. 37″. All-of-a-piece carvings were whittled from a single piece of wood. Pine was often used because it is soft and easily worked. One side of the pendant bears a portrait of a woman and is inscribed "Pansy"; the other side bears the portrait of a man and is inscribed "Billy F.B." (Patricia Coblentz)

643 (opposite, left). Chain. Texas. C. 1870. Wood. L. 24″. Several sections of this elaborate chain have multiple links, and at the end of the carving is a ball within a cube, from which dangle a knife, fork, and spoon. (Herbert W. Hemphill, Jr.)

644 (opposite, middle). Lantern. New England. Twentieth century. Walnut. H. 4½″. (Patricia Coblentz)

645 (opposite, above right). Yoked oxen. 1875–1900. Wood. L. 7″. This entire carving is made from one piece of wood. (Greenfield Village and Henry Ford Museum)

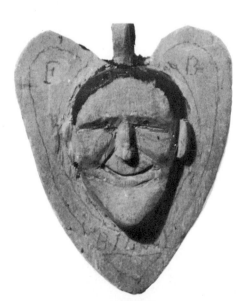

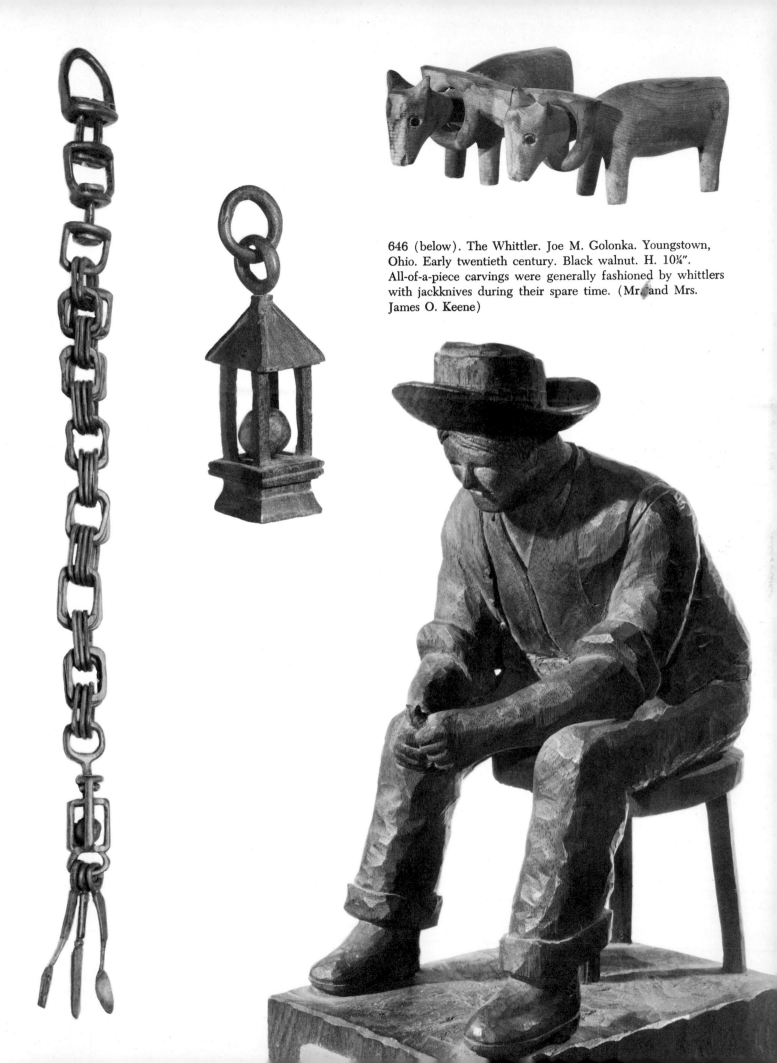

646 (below). The Whittler. Joe M. Golonka. Youngstown, Ohio. Early twentieth century. Black walnut. H. 10¼". All-of-a-piece carvings were generally fashioned by whittlers with jackknives during their spare time. (Mr. and Mrs. James O. Keene)

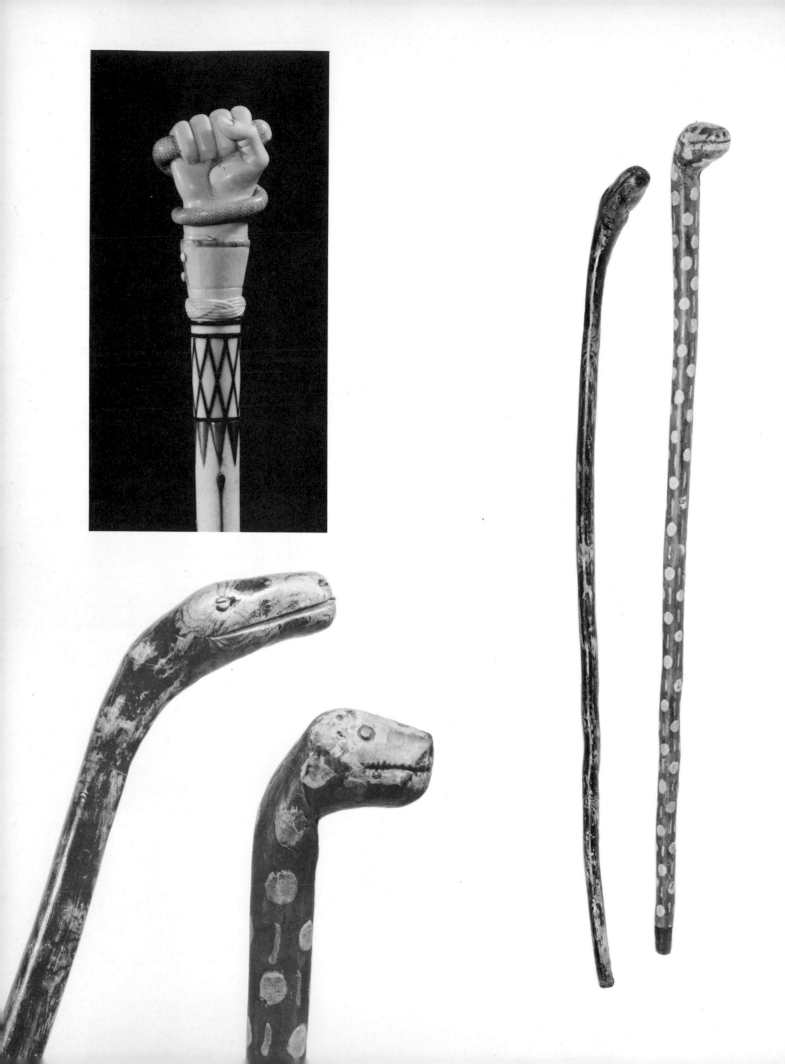

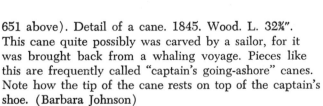

647 (opposite, above left). Detail of a scrimshaw cane. Nantucket, Massachusetts. 1840. Whale ivory, whalebone, inlaid with baleen, silver, abalone shell, tortoise shell, and mother of pearl. L. 35¾". Probably the greater number of canes were showpieces or intended as exhibits of a carver's skill. This exceptional piece is inlaid with a silver whaling harpoon and lance on the shaft. The snake in hand was a popular cane-top motif. (Barbara Johnson)

648 (opposite, right), 648a (opposite, below left). Cane. West Virginia. C. 1875. Wood, painted. L. 38". (Herbert W. Hemphill, Jr.)

649 (opposite, right), 649a (opposite, below left). Cane. West Virginia. C. 1875. Wood, painted. L. 36½". Walking sticks were fashioned from an endless variety of tree roots and driftwood. Imaginative carvers could deftly turn one of these into an amusing, utilitarian piece. (Herbert W. Hemphill, Jr.)

650 (far left). Detail of a cane. Michigan (?). Mid-nineteenth century. Twisted grapevine. L. 34¾". According to family tradition, this cane was given by an Indian chief to John Phillippe, a Detroit citizen, in 1850. Phillippe maintained a residence and trading store at the foot of Orleans Street. It is interesting that an Indian would include the American shield in his carving. (Mr. and Mrs. James O. Keene)

651 above). Detail of a cane. 1845. Wood. L. 32¾". This cane quite possibly was carved by a sailor, for it was brought back from a whaling voyage. Pieces like this are frequently called "captain's going-ashore" canes. Note how the tip of the cane rests on top of the captain's shoe. (Barbara Johnson)

652 (right). Detail of a cane. Maine or Connecticut. 1886. Pearwood, polychromed. L. 37". The carving on canes is often in the form of a caricature. The black-painted head on this walking stick is humanized by traces of red paint around the nostrils and lips. This piece shows that its creator had a fine grasp of the art of caricature. (Barry Cohen)

653 (right). Hobbyhorse. Woodbury Gerrish. Portsmouth, New Hampshire. C. 1844. Wood with leather ears. L. 47″. This toy was ordered by Charles J. Colcord for his son, J. Edward. (Photograph courtesy Jean Lipman)

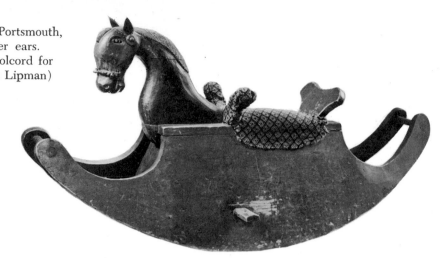

654 (below). Toys displayed in the window of Hadley's Toy Shop. European as well as American toys are shown. During the nineteenth century, the importation of European toys by American retailers was extensive and, in many instances, it is impossible to be certain of the origin of a piece. (Greenfield Village and Henry Ford Museum)

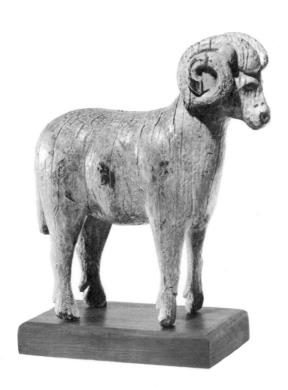

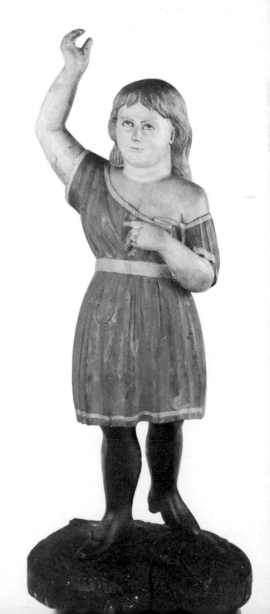

655 (top). Hadley's Toy Shop on the Street of Shops houses a vast collection of toys intended for both girls and boys. (Greenfield Village and Henry Ford Museum)

656 (above). Ram. 1850–1875. Wood, painted. H. 9″. (Howard A. Feldman)

657 (right). Trade figure. Early nineteenth century. Pine. H. 57″. This figure of a child probably stood outside of a toy shop much like that illustrated above. (Greenfield Village and Henry Ford Museum)

658 (below). Civil War toy. 1865–1885. Wood and tin. L. 31″. The positions of the soldiers are changed when the wires underneath are moved forward and backward. (Stewart E. Gregory)

659 (opposite). Pecking chickens. Pennsylvania. Mid-nineteenth century. Wood. L. 36″. Articulated toys, animated by pulleys and strings, never fail to please young children. This large-size construction is covered with several groups of painted chickens. (Gary C. Cole)

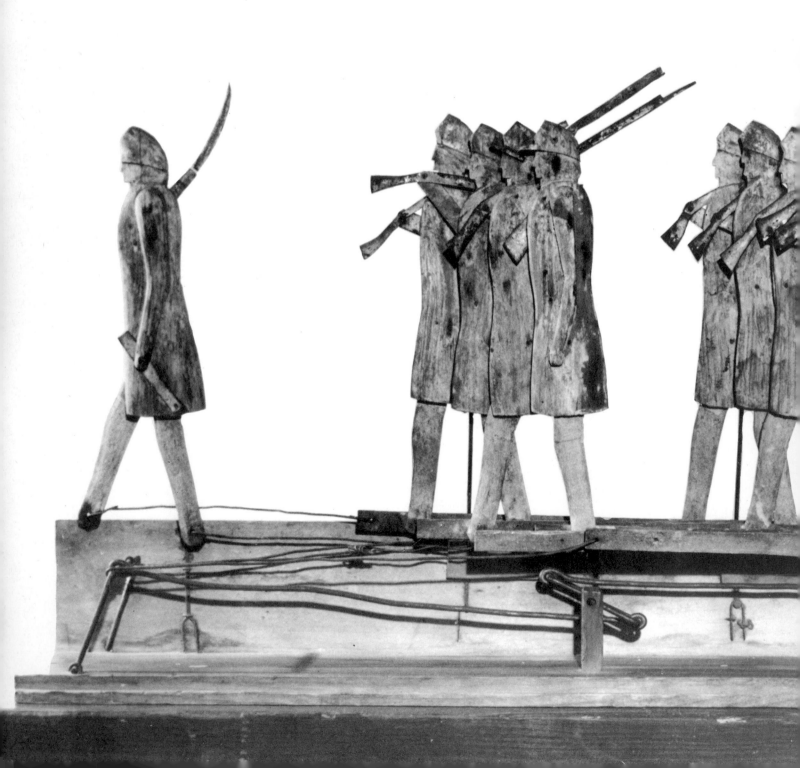

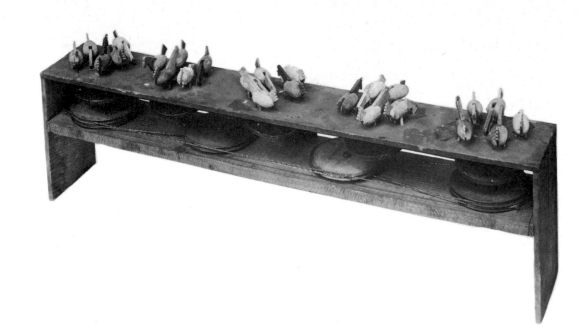

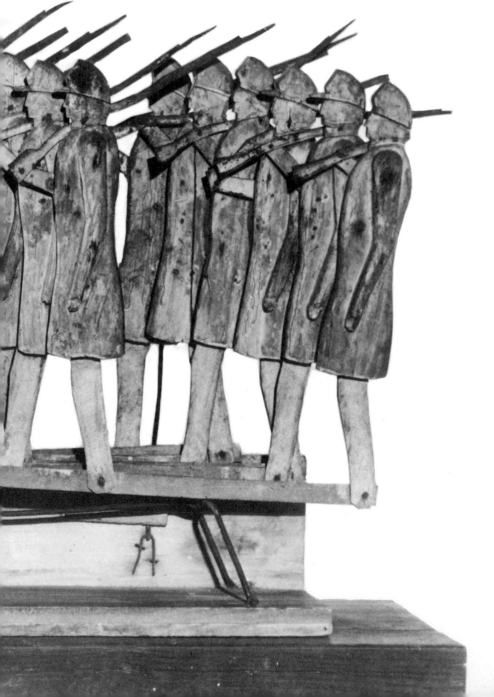

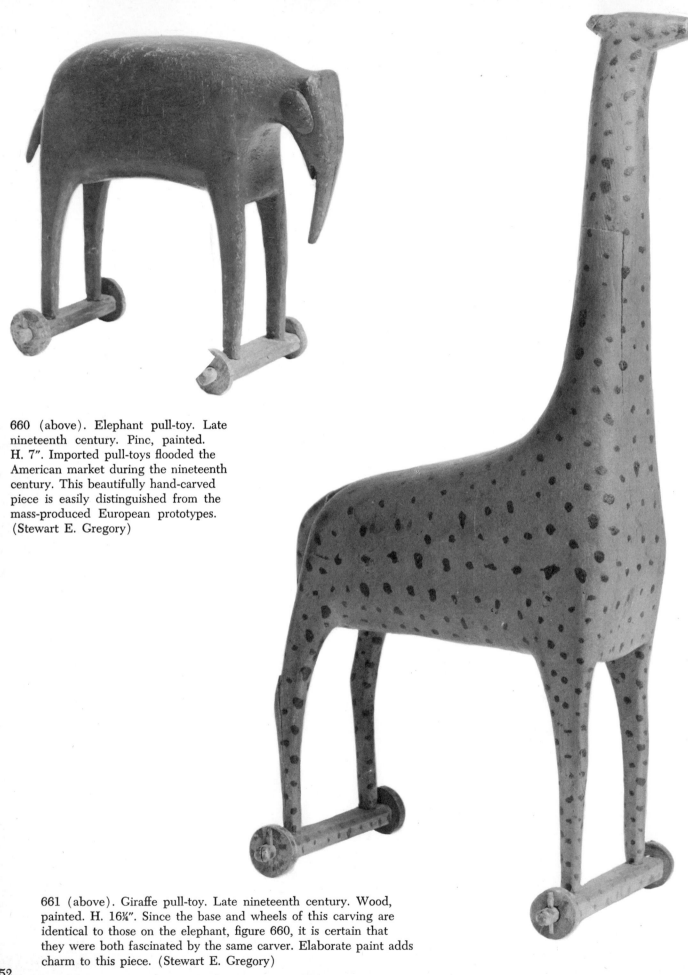

660 (above). Elephant pull-toy. Late nineteenth century. Pine, painted. H. 7". Imported pull-toys flooded the American market during the nineteenth century. This beautifully hand-carved piece is easily distinguished from the mass-produced European prototypes. (Stewart E. Gregory)

661 (above). Giraffe pull-toy. Late nineteenth century. Wood, painted. H. 16¼". Since the base and wheels of this carving are identical to those on the elephant, figure 660, it is certain that they were both fascinated by the same carver. Elaborate paint adds charm to this piece. (Stewart E. Gregory)

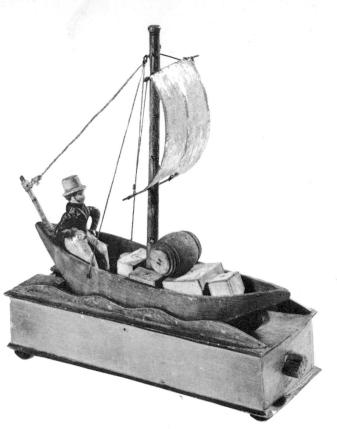

662 (left). Ship. New York State. C. 1880. Wood, tin, and string, polychromed. L. 8½″. (Private collection; photograph courtesy Leah and John Gordon)

663 (below). Galley. Post Civil War. Wood, cloth, string, and metal, painted. H. 11″. A small metal plate affixed to the back of the carving is inscribed, "Trojan War—1200 B.C." The three figures in the boat wear uniforms of the Civil War period. (Mr. and Mrs. Leo Rabkin)

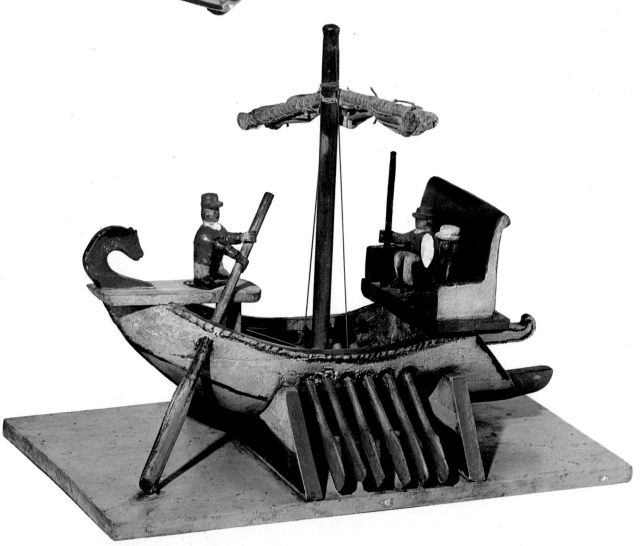

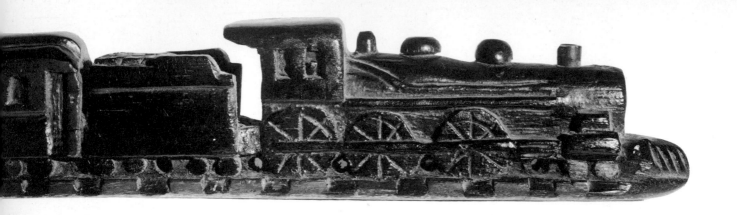

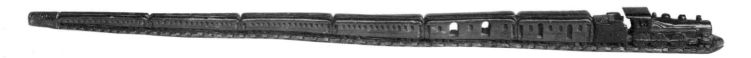

664, 664a (above). Walking stick. New Jersey. C. 1900. Wood, painted. L. 38". The artist showed real ingenuity when he made this cane in the shape of a toylike train. (Barbara Johnson)

665 (right). Articulated toy. Edgar Tolson. Campton, Kentucky. 1968. Poplar. H. 11¼". This toy is intended to be suspended by a loop on the head. When the string is pulled, the figure dances. (Mr. and Mrs. Michael D. Hall)

666 (below). Train. C. 1840. Wood and cardboard. H. 4½". (The Society for the Preservation of New England Antiquities)

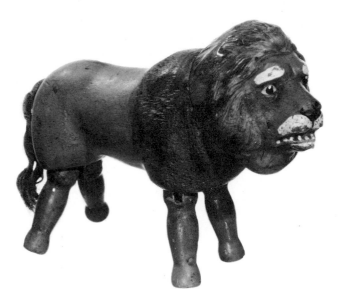

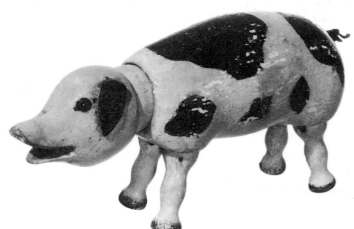

667 (above). Lion. Schoenhut. Philadelphia. C. 1910. Wood. L. 7⅛″. Schoenhut manufactured many kinds of toys, including articulated dolls, circus figures and animals, and even miniature pianos that played. The head and legs of this lion, as in many of his pieces, are attached to an interior network of strings. By twisting the limbs or the head and tightening the string, the toys can be made to assume various positions. (Private collection)

668 (right). Pig. Schoenhut. Philadelphia. C. 1910. Wood. L. 7⅛″. (Private collection)

669 (right). Shooting gallery target. New York State. Last quarter of the nineteenth century. Iron, polychromed. H. 15½″. The chick, which is attached to a spring mechanism, can be pulled down and hooked behind the rooster. When a projectile goes through the hole and hits the chick, it will spring free and snap back over the rooster. (Mr. and Mrs. Gary J. Stass)

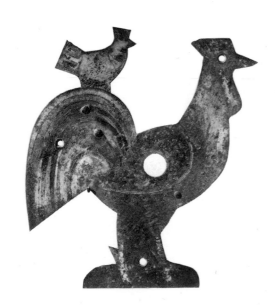

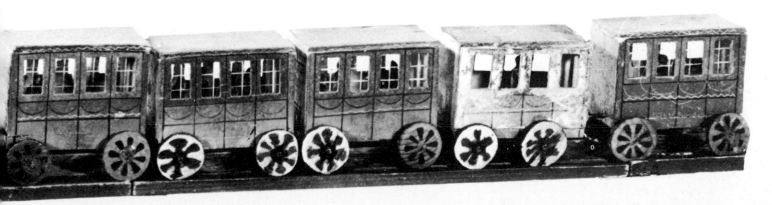

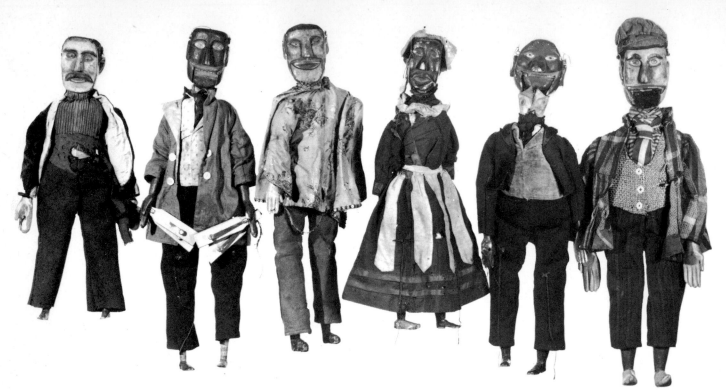

670 (above). Marionettes. 1850–1885. Wood and cloth.
H. of tallest figure, 30″. These marionettes were intended to
be activated by strings. A skillful operator could make them
perform a delightful dance, while the second figure from the
left provided a rhythmic, clanging accompaniment. (Green-
field Village and Henry Ford Museum)

671 (left). Articulated walking man. New England. 1850–1870.
Tin figure on an iron staff. H. 13½″. Farmers often fashioned whimsical
toys to divert their children during the long winter months. (Mr. and
Mrs. Leonard Balish)

672 (above). Doll. 1750–1825. Wood. H. 17″. Articulated dolls are
recorded in American inventories as early as the second half of the
eighteenth century. These were often imported pieces that were
dressed in the latest European styles and were called fashion dolls.
(Greenfield Village and Henry Ford Museum)

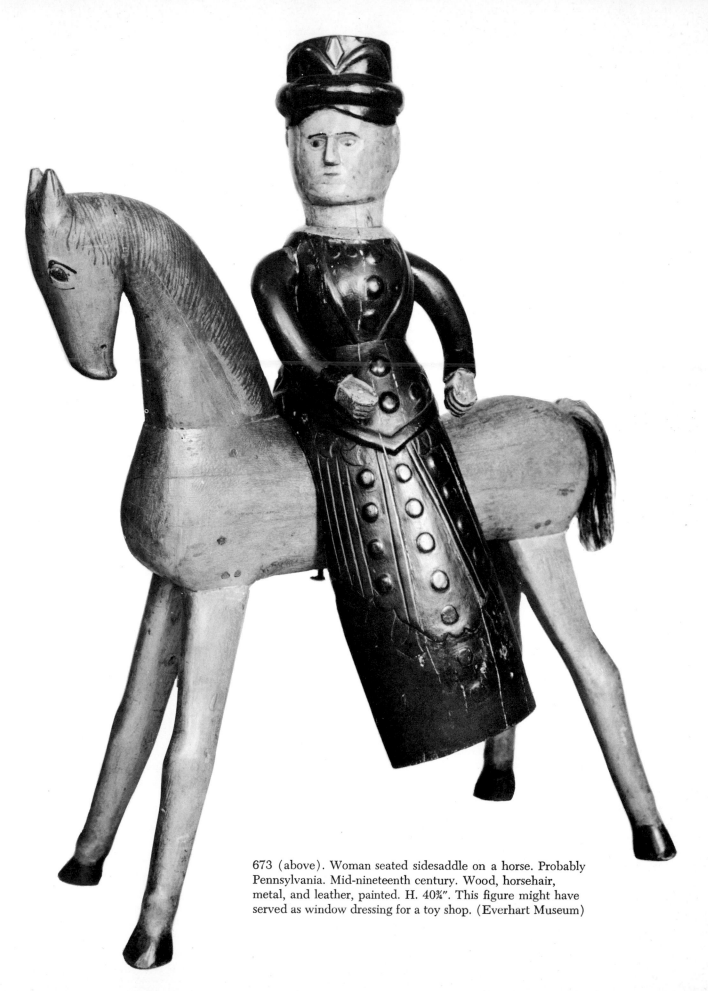

673 (above). Woman seated sidesaddle on a horse. Probably
Pennsylvania. Mid-nineteenth century. Wood, horsehair,
metal, and leather, painted. H. 40¾". This figure might have
served as window dressing for a toy shop. (Everhart Museum)

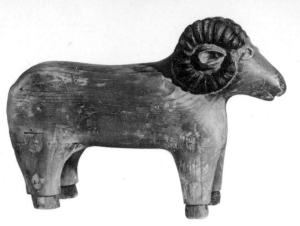

674 (left). Ram. Pennsylvania. C. 1890. Wood. L. 17″. Sturdy construction indicates that this carving was intended as a sitting toy, or child's stool. (Stewart E. Gregory)

675 (below). Dalmatian. Late nineteenth or early twentieth century. Wood. L. 20½″. Though this Dalmatian could win no blue ribbons at a dog show, he has won the hearts of nearly every collector of folk sculpture. (Museum of American Folk Art)

676 (below). Dog. Pennsylvania. 1840. Wood. H. 21″. This pooch was found at a farmhouse in Chester County. (Gary C. Cole)

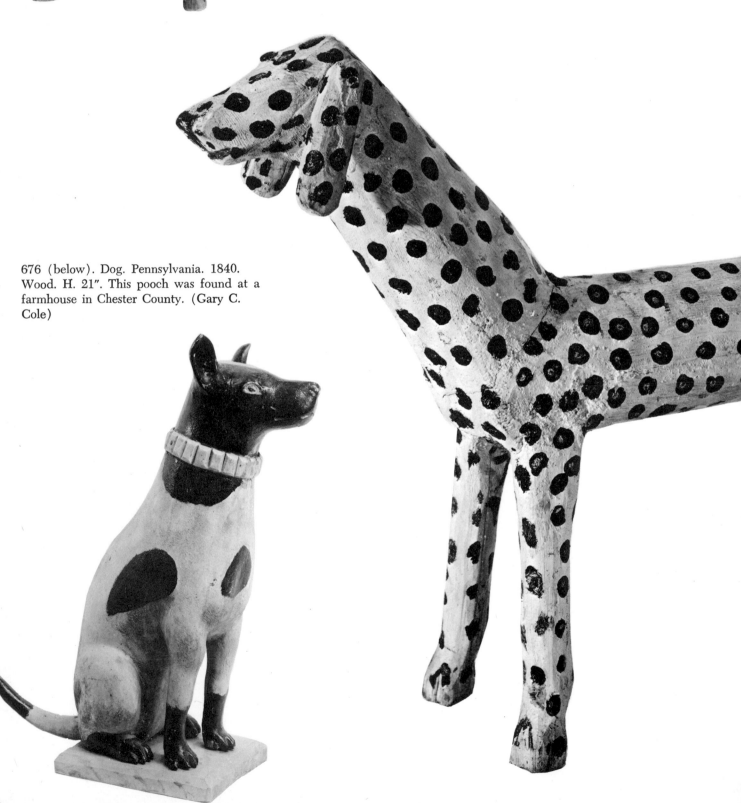

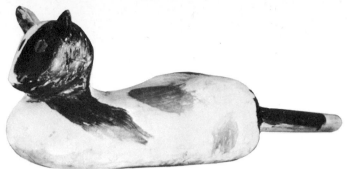

677 (above). Calico cat. Nineteenth century. Wood
and metal, polychromed. L. 21″. The nursery rhyme
tells us: "The gingham dog and the calico cat, side
by side by the chimney sat . . ." (Abby Aldrich
Rockefeller Folk Art Collection)

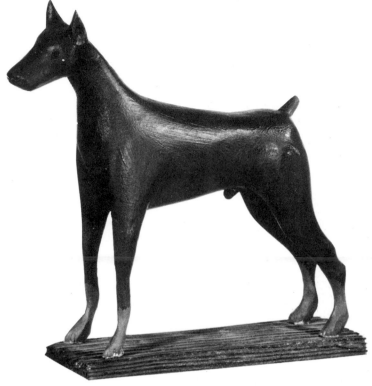

678 (above). Champion Andelane's Indigo Rock. Carl Wesen-
berg. Ann Arbor, Michigan. 1972. Pine. L. 6¼″. During the
early 1970s, this Doberman pinscher was one of the superla-
tive champion dogs in the United States. (Private collection)

679 (right). Foxhound. New England. C. 1850.
Wood, painted black and white. H. 32″. (Private col-
lection; photograph courtesy Leah and John Gordon)

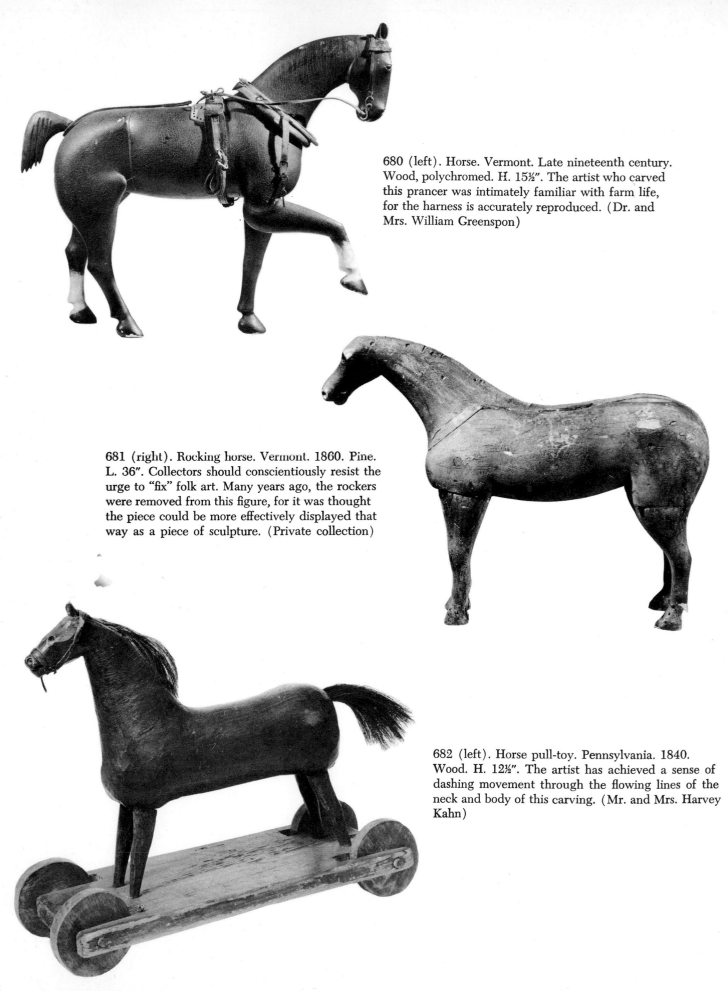

680 (left). Horse. Vermont. Late nineteenth century. Wood, polychromed. H. 15½″. The artist who carved this prancer was intimately familiar with farm life, for the harness is accurately reproduced. (Dr. and Mrs. William Greenspon)

681 (right). Rocking horse. Vermont. 1860. Pine. L. 36″. Collectors should conscientiously resist the urge to "fix" folk art. Many years ago, the rockers were removed from this figure, for it was thought the piece could be more effectively displayed that way as a piece of sculpture. (Private collection)

682 (left). Horse pull-toy. Pennsylvania. 1840. Wood. H. 12½″. The artist has achieved a sense of dashing movement through the flowing lines of the neck and body of this carving. (Mr. and Mrs. Harvey Kahn)

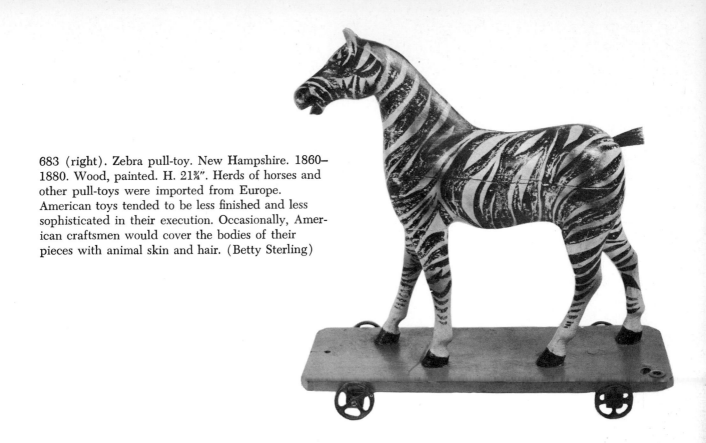

683 (right). Zebra pull-toy. New Hampshire. 1860–1880. Wood, painted. H. 21¾″. Herds of horses and other pull-toys were imported from Europe. American toys tended to be less finished and less sophisticated in their execution. Occasionally, American craftsmen would cover the bodies of their pieces with animal skin and hair. (Betty Sterling)

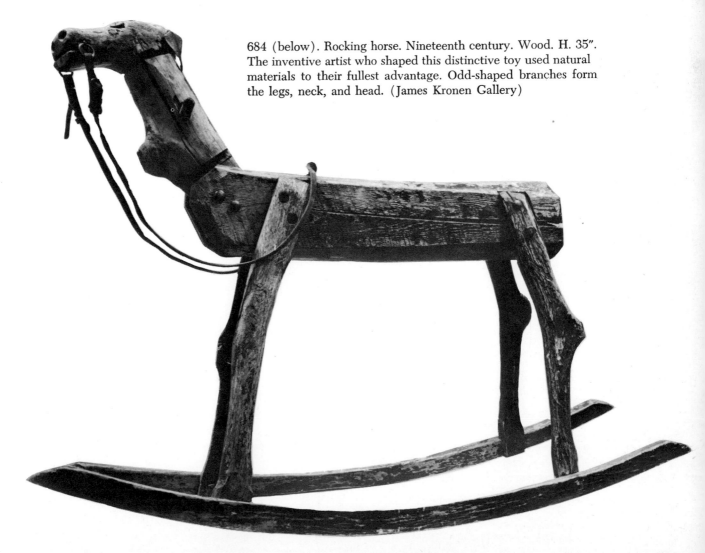

684 (below). Rocking horse. Nineteenth century. Wood. H. 35″. The inventive artist who shaped this distinctive toy used natural materials to their fullest advantage. Odd-shaped branches form the legs, neck, and head. (James Kronen Gallery)

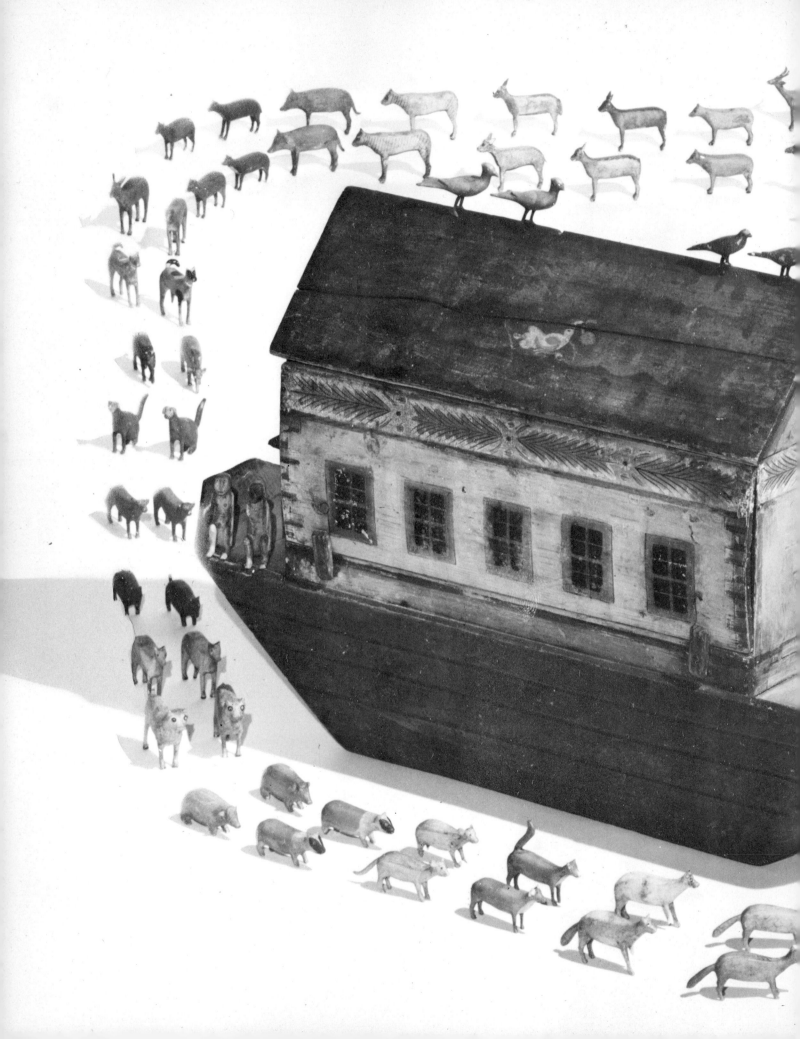

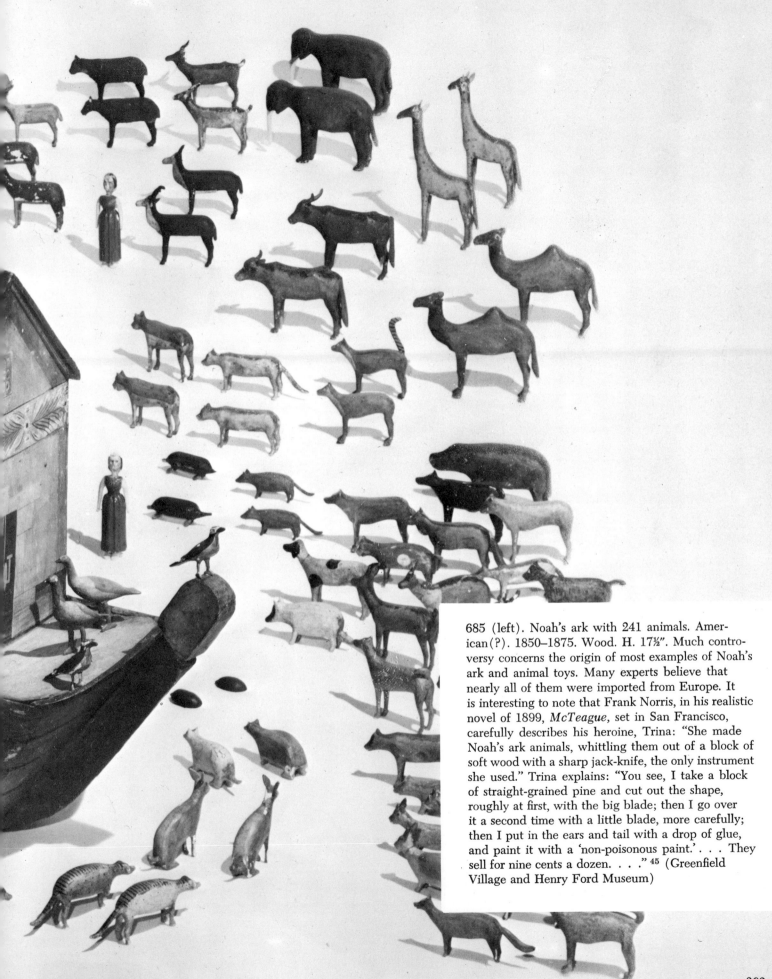

685 (left). Noah's ark with 241 animals. American(?). 1850–1875. Wood. H. 17½". Much controversy concerns the origin of most examples of Noah's ark and animal toys. Many experts believe that nearly all of them were imported from Europe. It is interesting to note that Frank Norris, in his realistic novel of 1899, *McTeague*, set in San Francisco, carefully describes his heroine, Trina: "She made Noah's ark animals, whittling them out of a block of soft wood with a sharp jack-knife, the only instrument she used." Trina explains: "You see, I take a block of straight-grained pine and cut out the shape, roughly at first, with the big blade; then I go over it a second time with a little blade, more carefully; then I put in the ears and tail with a drop of glue, and paint it with a 'non-poisonous paint.' . . . They sell for nine cents a dozen. . . ." [45] (Greenfield Village and Henry Ford Museum)

686 (right). Doll. Clark Coe. Killingworth, Connecticut. Early twentieth century. Wood and metal. H. 11¾". (Mr. and Mrs. Leo Rabkin)

687 (below). Girl on a pig. Clark Coe. Killingworth, Connecticut. Early twentieth century. Wood and metal, painted. H. 37". This powerful figure has been exhibited extensively and was included in the exhibition of American art at the Brussels World's Fair of 1958. (Herbert W. Hemphill, Jr.)

688 (opposite, above). Early photograph of Clark Coe's images installed at Killingworth, Connecticut. (Photograph courtesy Adele Earnest)

689 (opposite, below). Musician with lute. Clark Coe. Killingworth, Connecticut. Early twentieth century. Wood, painted. H. 30". (Mr. and Mrs. Gordon Bunshaft; photograph courtesy Stony Point Folk Art Gallery)

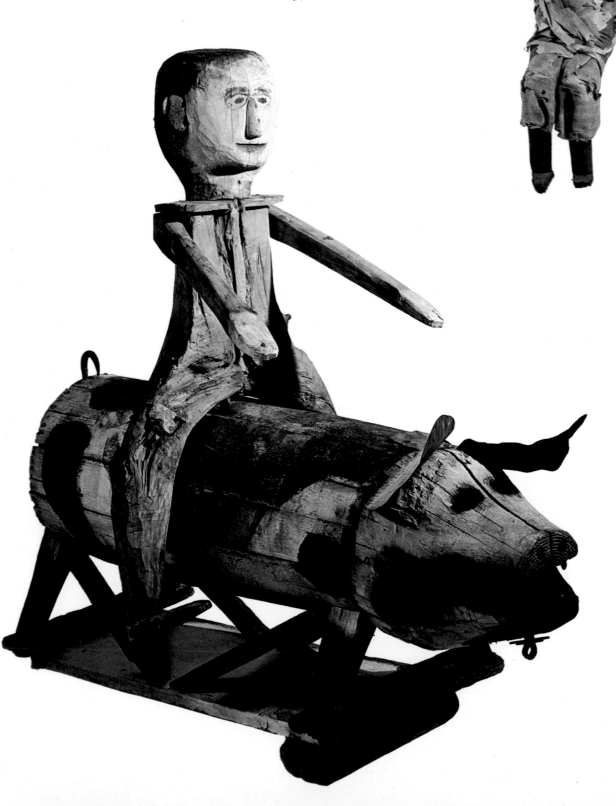

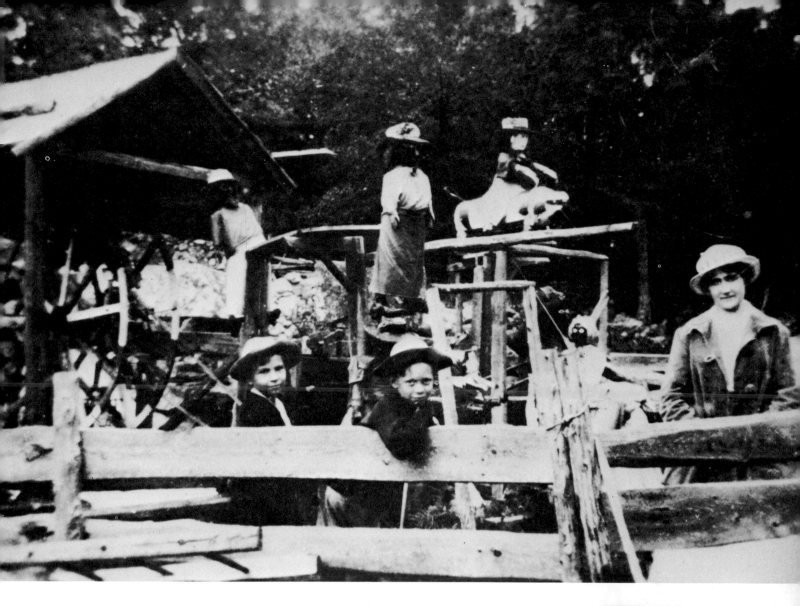

Clark Coe, a farmer and basketmaker by trade, supplemented his income by making ax handles that were sold in New Haven, Connecticut. His claim to fame—the Killingworth "images"—is perhaps one of the most celebrated figural groups of American folk sculpture. Utilizing barrel staves, slats, driftwood, and tree stumps, this unique talent constructed life-size images that he mounted in a waterway near his home in Killingworth, Connecticut. The figures, animated by the flow of the water, were originally intended to amuse a physically disabled child in his family.

Coe's images became a local tourist attraction, and visitors from miles around flocked to see these curious figures at their numerous tasks. One visitor recorded: "And suddenly we come upon them: a planked floor, partially roofed but with open sides, inhabited by a random group of life-size figures built of wood, with painted faces and makeshift hair, but garbed authentically (if somewhat out of date) in real cast-off clothes. The few that have no motion of their own are in a pair or tableau in which something is astir: an arm, a head, or some accessory." [46]

WHIRLIGIGS

690 (right). Collection of whirligigs. Nineteenth century. Wood, tin, iron, and so forth. Crackled and glazed paint is often evident on the surface of these wind toys. (Museum of American Folk Art)

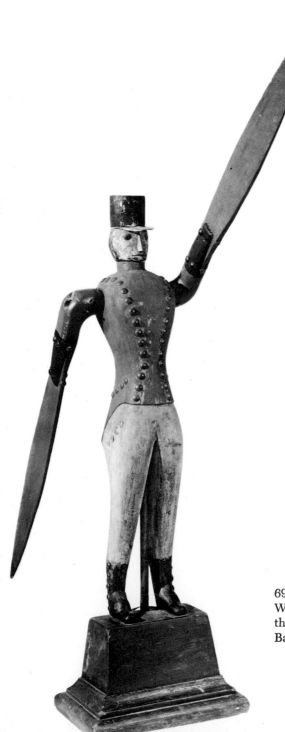

691 (left). Soldier. Probably New England. 1870–1880. Wood. H. 38″. Large-headed tacks were used for trimming the jacket and boots and for the eyes. (Collection of Edith Barenholtz)

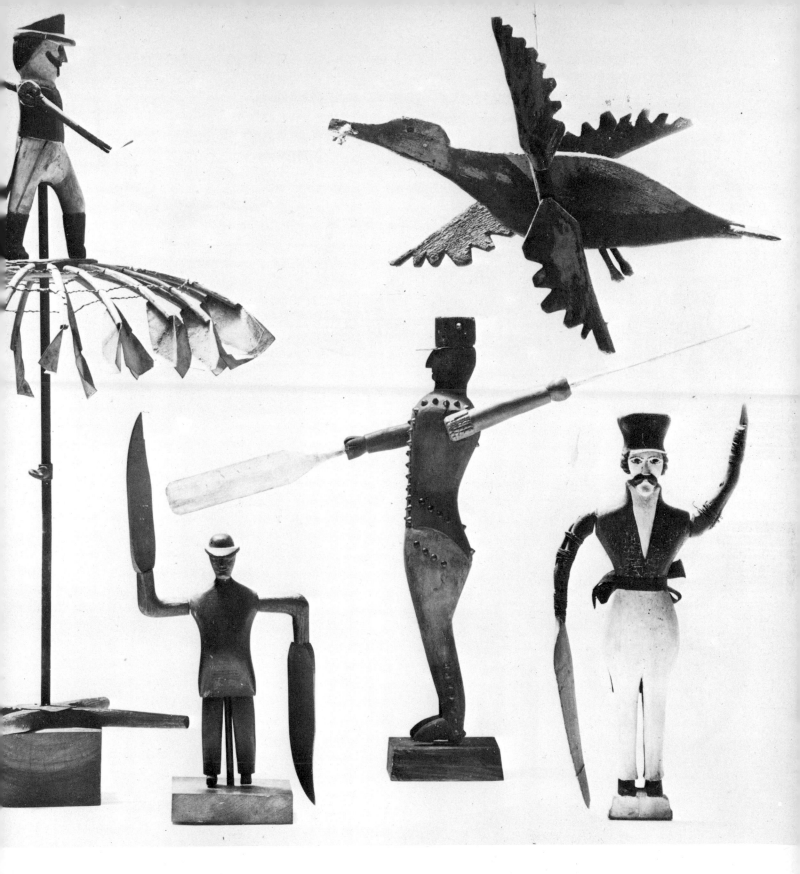

Certainly no one can be sure when the first American whirligig, or wind toy, was made. One of the earliest references to such a device was made by Washington Irving in his story, "The Legend of Sleepy Hollow," which was written in 1819: "Thus, while the busy dame bustled about the house, or plied her spinning-wheel at one end of the piazza, honest Balt did sit smoking his evening pipe at the other, watching the achievements of a little wooden warrior, who, armed with a sword in each hand, was most valiantly fighting the wind on the pinnacle of the barn."

Because of their fragility, few whirligigs that date before the second half of the nineteenth century have survived. Since most were created by untrained carvers, many are quite crudely executed. Despite this crudeness, which often actually adds to their appeal, the whirligig conveys a whimsical point of view that is characteristic of American folk sculpture.

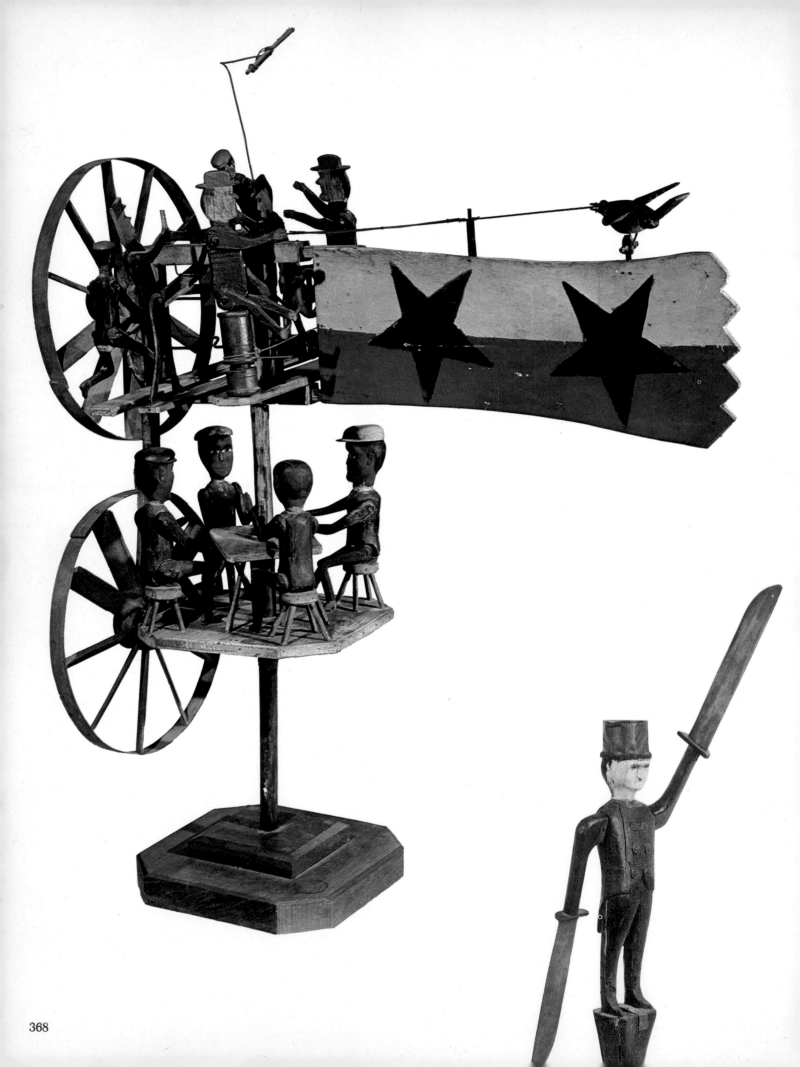

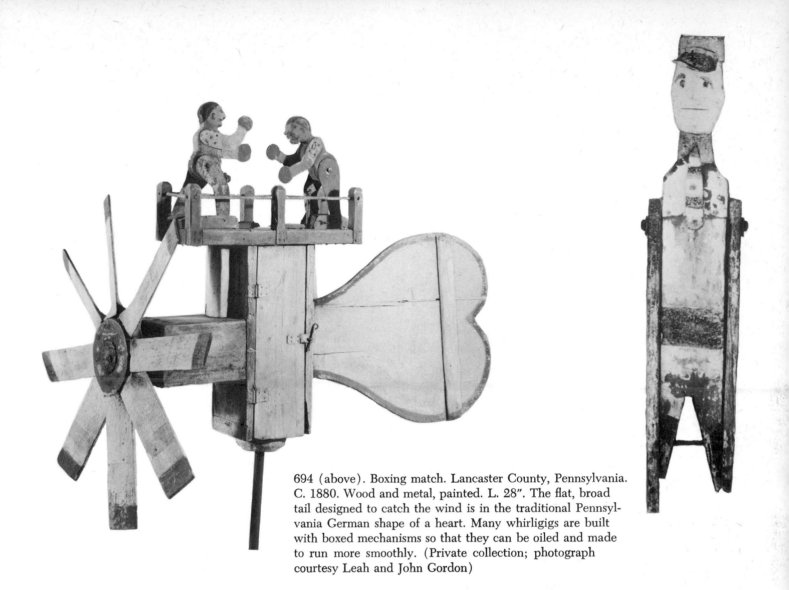

694 (above). Boxing match. Lancaster County, Pennsylvania. C. 1880. Wood and metal, painted. L. 28″. The flat, broad tail designed to catch the wind is in the traditional Pennsylvania German shape of a heart. Many whirligigs are built with boxed mechanisms so that they can be oiled and made to run more smoothly. (Private collection; photograph courtesy Leah and John Gordon)

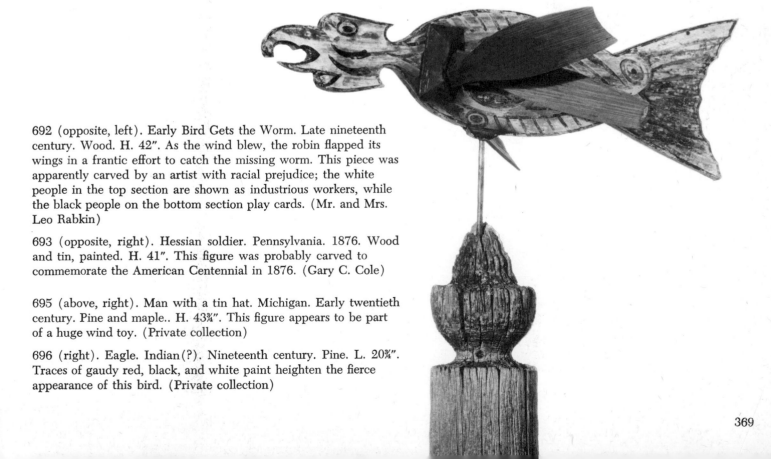

692 (opposite, left). Early Bird Gets the Worm. Late nineteenth century. Wood. H. 42″. As the wind blew, the robin flapped its wings in a frantic effort to catch the missing worm. This piece was apparently carved by an artist with racial prejudice; the white people in the top section are shown as industrious workers, while the black people on the bottom section play cards. (Mr. and Mrs. Leo Rabkin)

693 (opposite, right). Hessian soldier. Pennsylvania. 1876. Wood and tin, painted. H. 41″. This figure was probably carved to commemorate the American Centennial in 1876. (Gary C. Cole)

695 (above, right). Man with a tin hat. Michigan. Early twentieth century. Pine and maple.. H. 43¾″. This figure appears to be part of a huge wind toy. (Private collection)

696 (right). Eagle. Indian(?). Nineteenth century. Pine. L. 20¾″. Traces of gaudy red, black, and white paint heighten the fierce appearance of this bird. (Private collection)

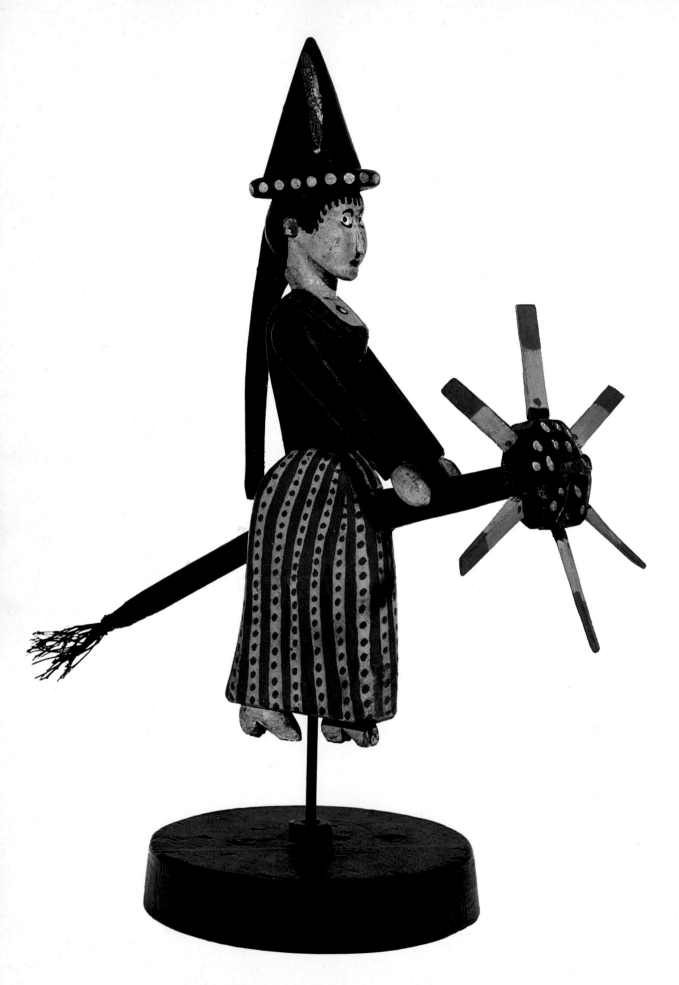

697 (opposite). Witch. New Hampshire or Massachusetts. Mid-nineteenth century. Wood. H. 11½″. This colorful hag rides a broomstick equipped with a propeller! (Mr. and Mrs. Leo Rabkin)

698 (right). "Darky." C. 1900. Wood, painted. H. 33½″. Even today whirligigs continue to be made by rural craftsmen who enjoy the sight of moving figures in their yards. (James Kronen Gallery)

699 (below). Bicycle rider. 1875. Wood and metal. H. 21″. When the high-wheel bicycle was first introduced, it was fondly referred to as the "ordinary." The speed of these treacherous "bone shakers" was determined by the length of the rider's legs. (Mr. and Mrs. Harvey Kahn)

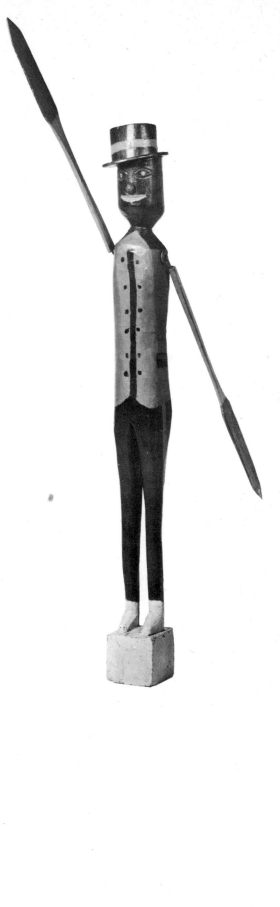

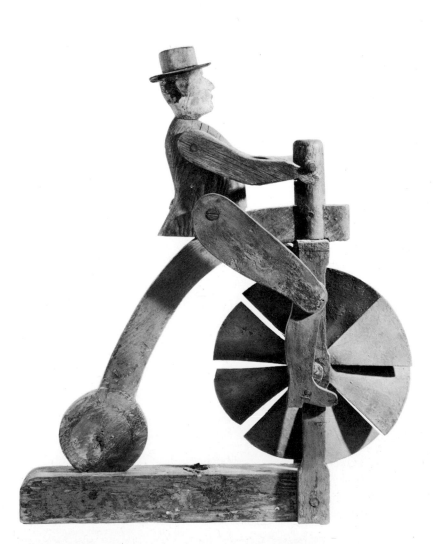

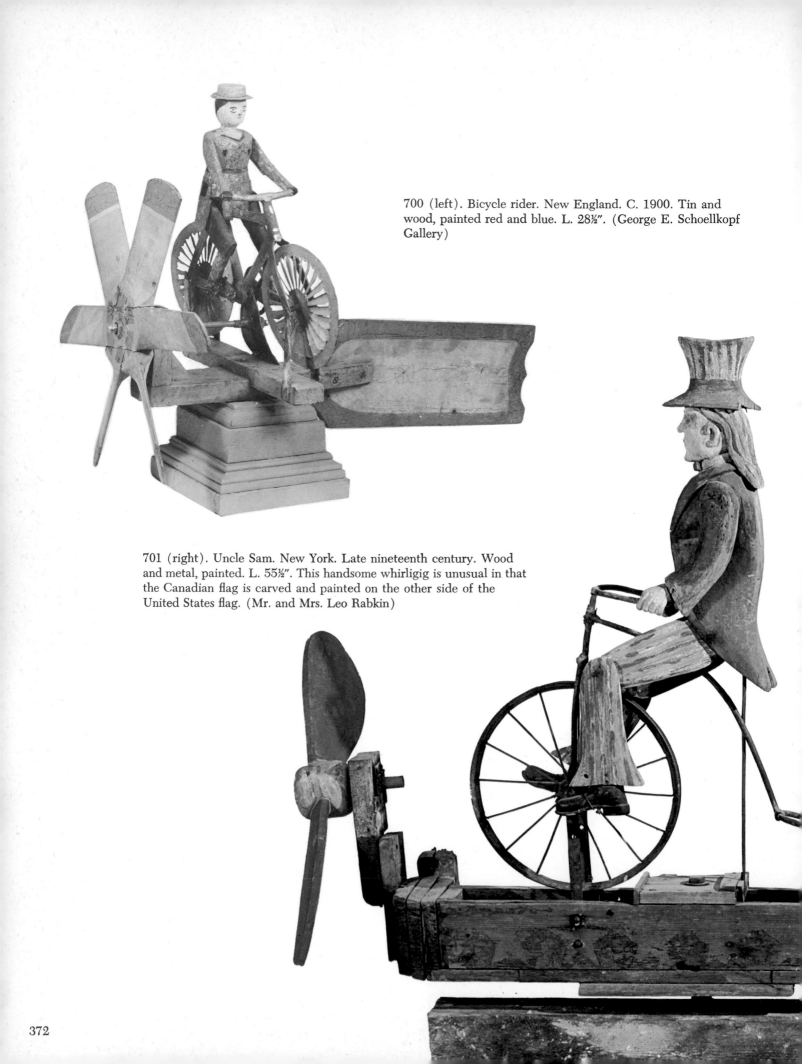

700 (left). Bicycle rider. New England. C. 1900. Tin and wood, painted red and blue. L. 28½". (George E. Schoellkopf Gallery)

701 (right). Uncle Sam. New York. Late nineteenth century. Wood and metal, painted. L. 55½". This handsome whirligig is unusual in that the Canadian flag is carved and painted on the other side of the United States flag. (Mr. and Mrs. Leo Rabkin)

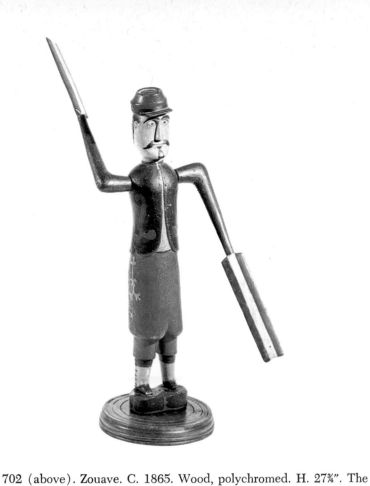

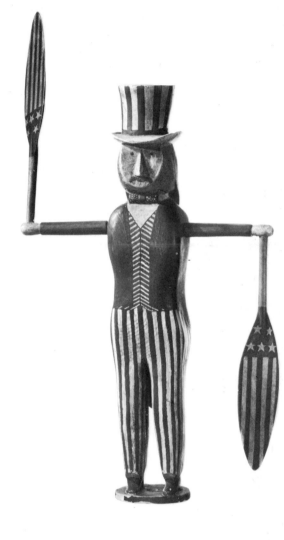

703 (below). Uncle Sam. Carl Wesenberg. Ann Arbor, Michigan. 1972. Pine. H. 20″. Wesenberg, a cabinetmaker by trade, generally carves in a nineteenth-century style. (Private collection)

702 (above). Zouave. C. 1865. Wood, polychromed. H. 27¾″. The Zouave was originally a member of a French infantry unit composed of Algerian recruits who were dressed in colorful Oriental uniforms and were known for their precision drills. During the Civil War units of Union soldiers adopted a flamboyant costume patterned after the French prototype. (Howard A. Feldman)

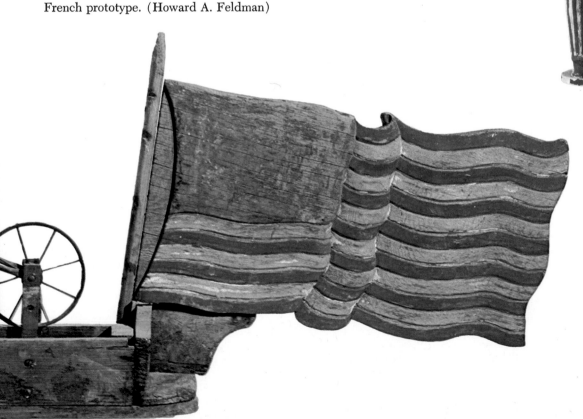

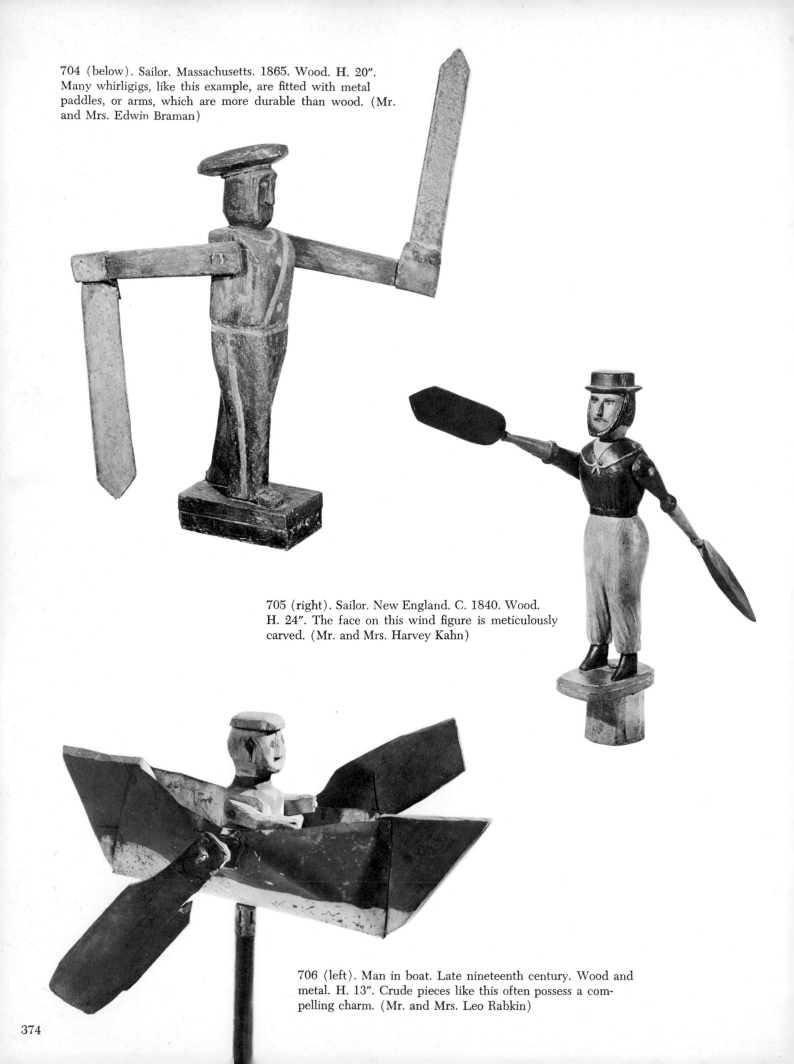

704 (below). Sailor. Massachusetts. 1865. Wood. H. 20″.
Many whirligigs, like this example, are fitted with metal
paddles, or arms, which are more durable than wood. (Mr.
and Mrs. Edwin Braman)

705 (right). Sailor. New England. C. 1840. Wood.
H. 24″. The face on this wind figure is meticulously
carved. (Mr. and Mrs. Harvey Kahn)

706 (left). Man in boat. Late nineteenth century. Wood and
metal. H. 13″. Crude pieces like this often possess a com-
pelling charm. (Mr. and Mrs. Leo Rabkin)

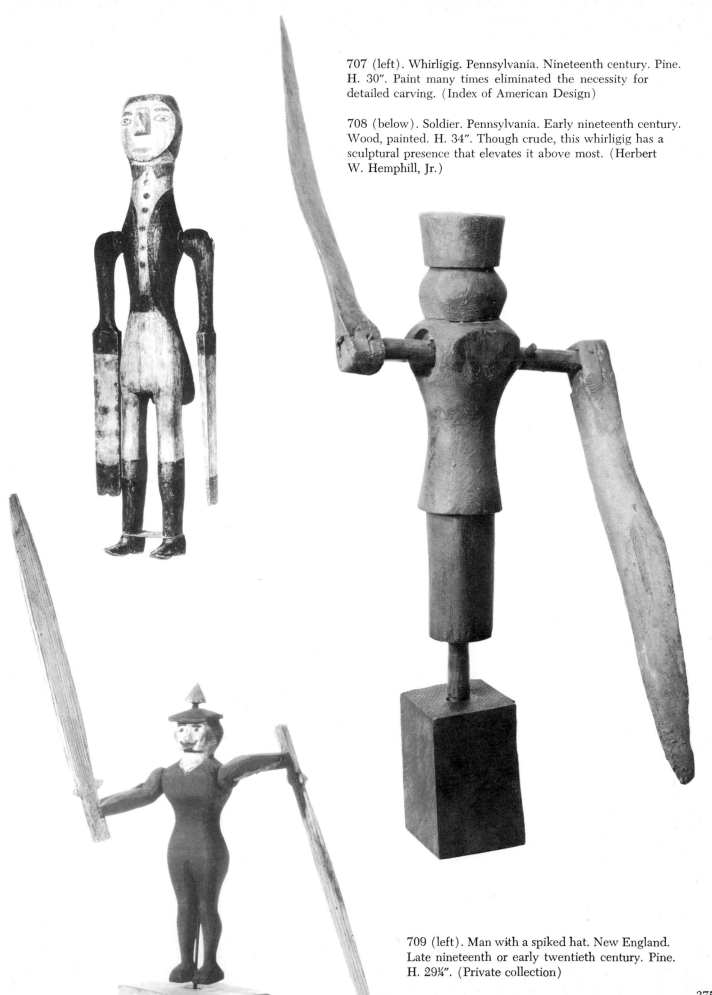

707 (left). Whirligig. Pennsylvania. Nineteenth century. Pine. H. 30″. Paint many times eliminated the necessity for detailed carving. (Index of American Design)

708 (below). Soldier. Pennsylvania. Early nineteenth century. Wood, painted. H. 34″. Though crude, this whirligig has a sculptural presence that elevates it above most. (Herbert W. Hemphill, Jr.)

709 (left). Man with a spiked hat. New England. Late nineteenth or early twentieth century. Pine. H. 29¼″. (Private collection)

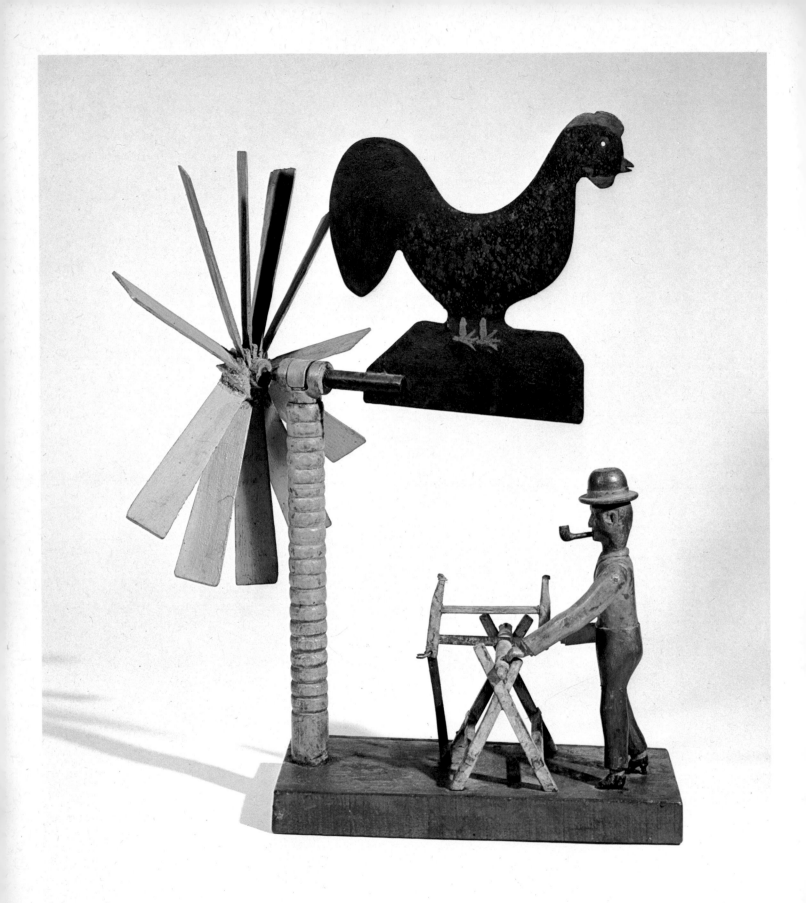

710 (above). Farm scene. Pennsylvania. Nineteenth century. Wood and metal. H. 21".
A man sawing wood is one of the most popular subjects with whirligig makers.
The rooster "weathervane" is a fine touch of whimsy. (Mr. and Mrs. Harvey Kahn)

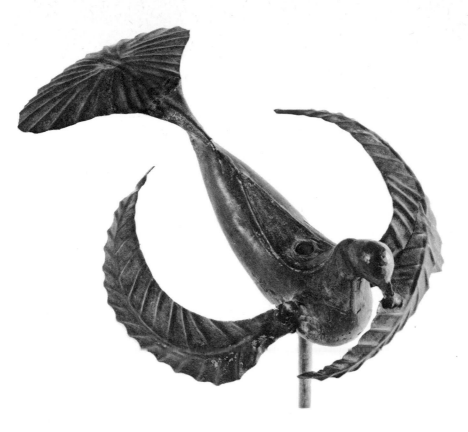

711 (above). Dove. New England. C. 1820. Metal. L. 11½″. The design of this dove is beautiful; the craftsmanship is exceptional. (Mr. and Mrs. Harvey Kahn)

712 (right). Rooster. Late nineteenth century. Wood. H. 11½″. Flat cutout boards have been assembled to form the body and tail of this colorful and sturdy piece. (Raymond Saroff; photograph courtesy Kennedy Galleries, Inc.)

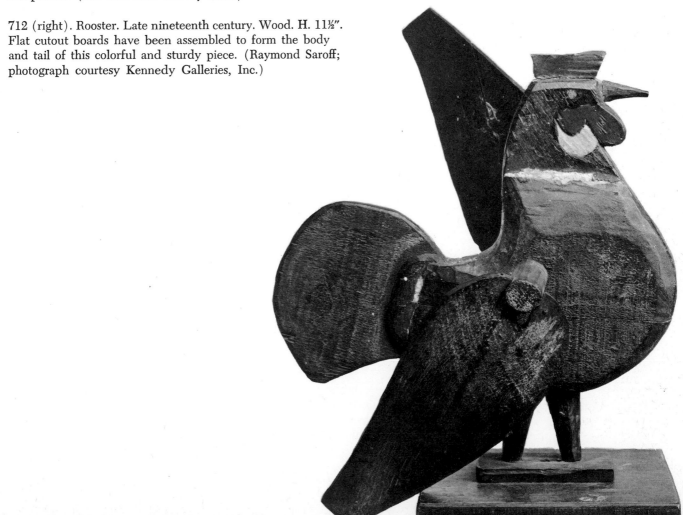

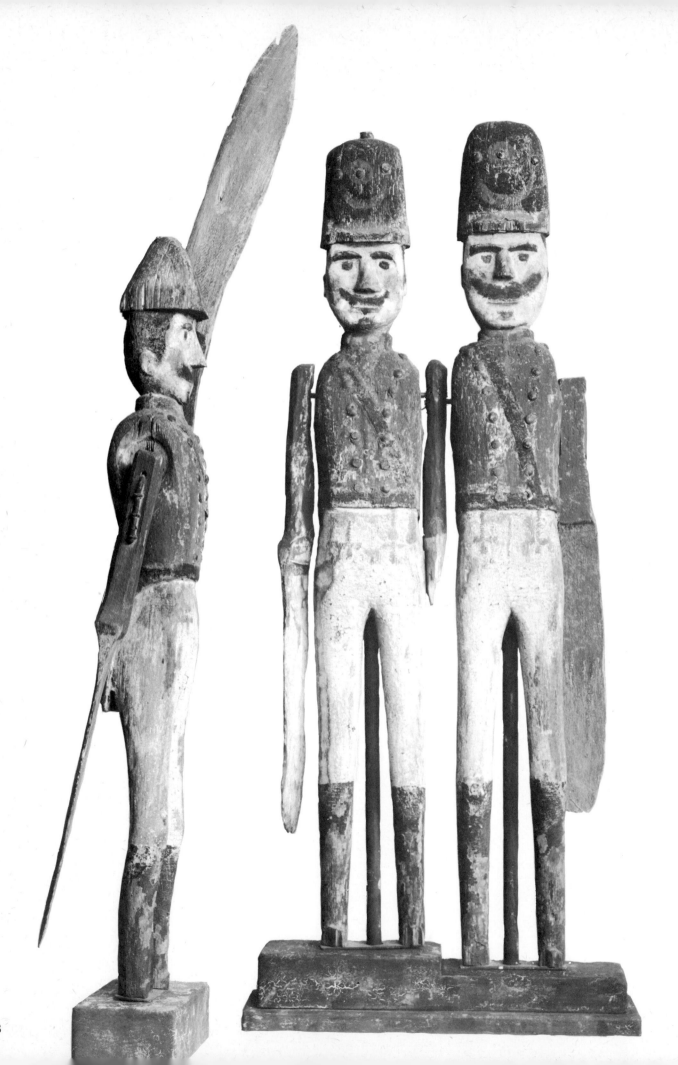

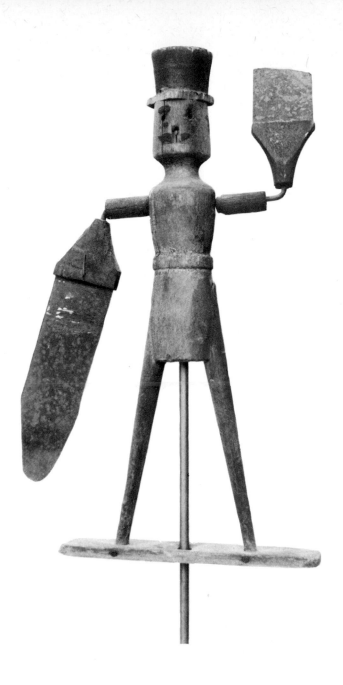

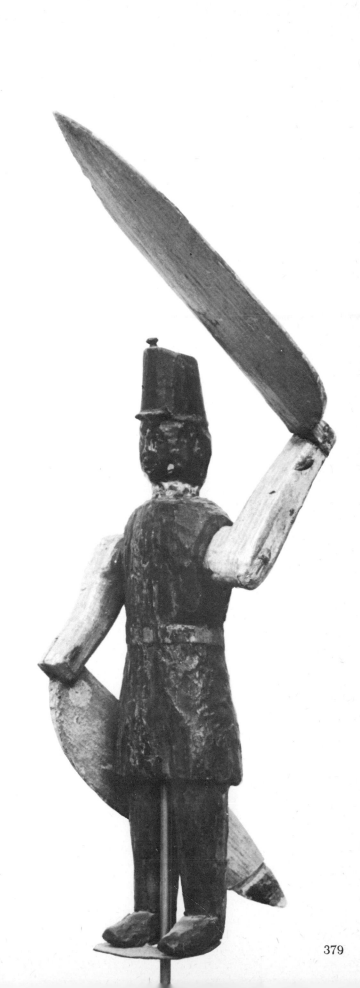

713 (opposite). Hessian soldiers. Early nineteenth century. Wood. H. of tallest figure, 27″. Any yard that sported these dazzling figures would have been fun to visit. (Mr. and Mrs. Robert Peak and Mr. and Mrs. Harvey Kahn; photograph courtesy Kennedy Galleries, Inc.)

714 (above). Whirligig. Pennsylvania. Nineteenth century. Wood and tin. H. 10″. A turned piece of wood forms the body of this piece. The legs are nailed on. (Mr. and Mrs. Michael D. Hall)

715 (right). Soldier. Pennsylvania. C. 1860. Wood. H. 15″. A soldier with such formidable bladelike chopping swords would prove a difficult adversary. This piece is sensitively balanced. (Mr. and Mrs. Michael D. Hall)

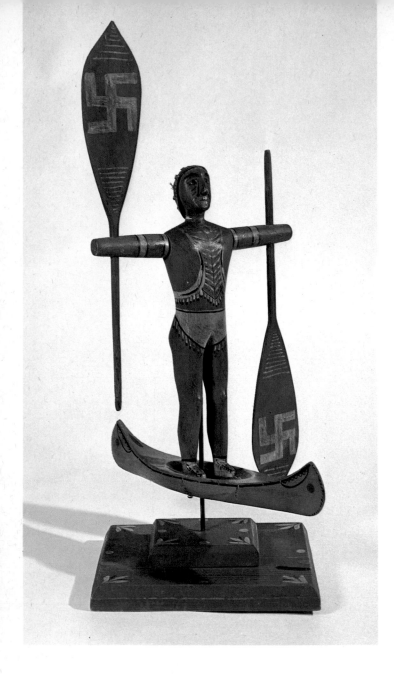

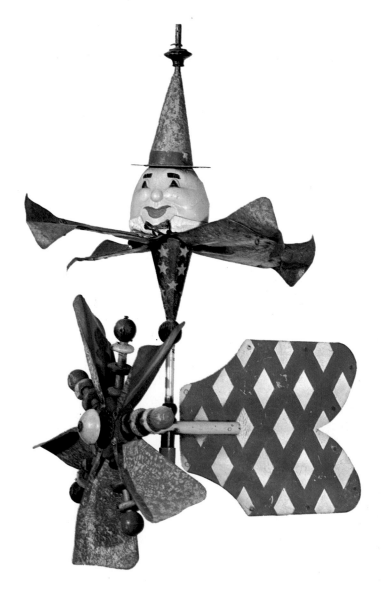

716 (above). Indian with paddles. Late nineteenth century. Wood. H. 20½". It is possible that this whirligig was intended as a toy or ornamental carving, for the paint on the original base matches that on the figure. (Mr. and Mrs. Harvey Kahn)

717 (right). Humpty Dumpty. Late nineteenth or early twentieth century. Metal, rubber, and wood. H. 26". "Humpty Dumpty sat on a wall, Humpty Dumpty had a great fall, All the King's horses and all the King's men couldn't put Humpty together again"—but some folk artist could! (Mr. and Mrs. Leo Rabkin)

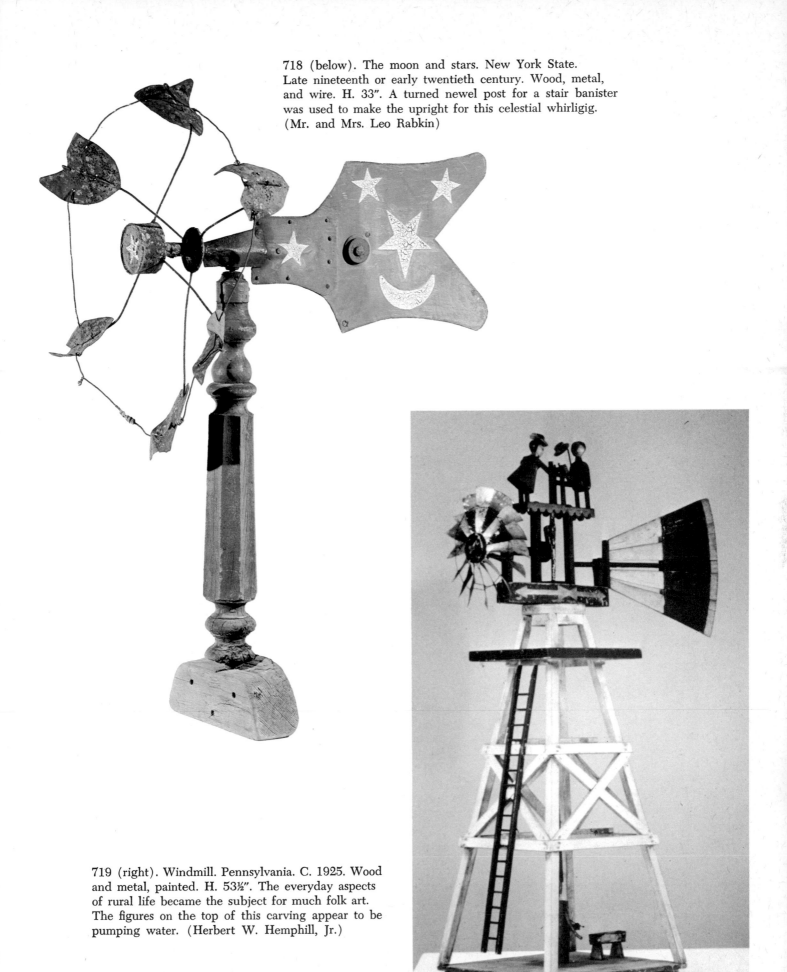

718 (below). The moon and stars. New York State.
Late nineteenth or early twentieth century. Wood, metal,
and wire. H. 33″. A turned newel post for a stair banister
was used to make the upright for this celestial whirligig.
(Mr. and Mrs. Leo Rabkin)

719 (right). Windmill. Pennsylvania. C. 1925. Wood
and metal, painted. H. 53½″. The everyday aspects
of rural life became the subject for much folk art.
The figures on the top of this carving appear to be
pumping water. (Herbert W. Hemphill, Jr.)

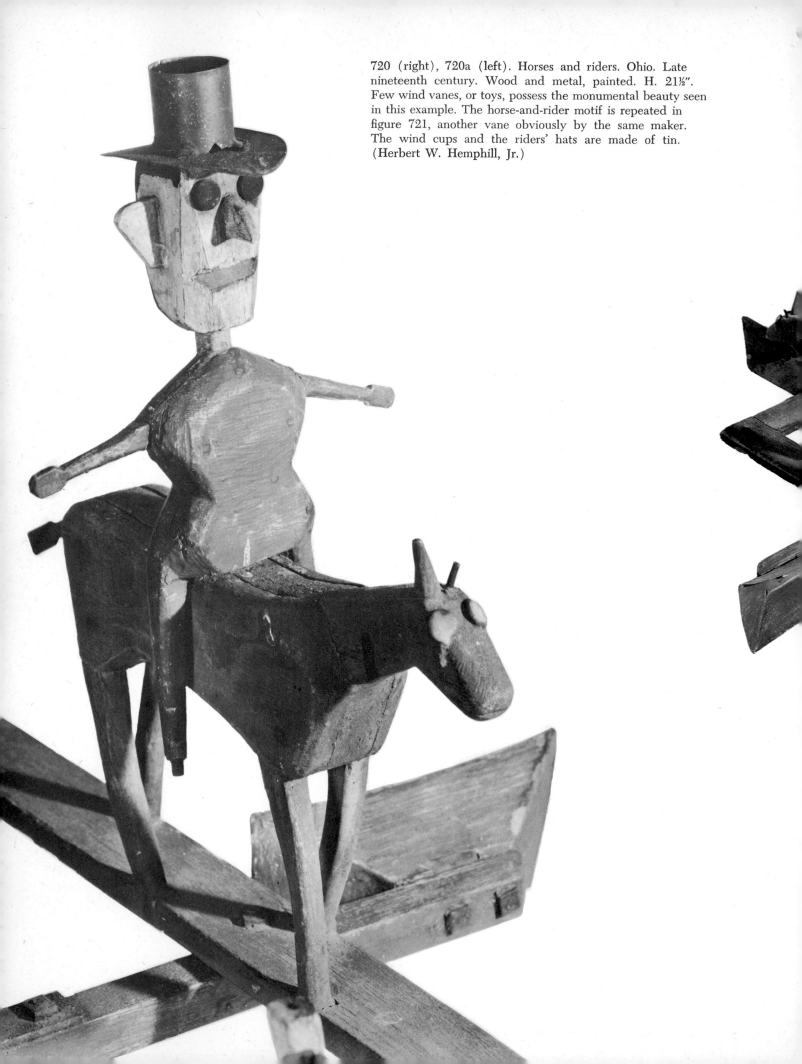

720 (right), 720a (left). Horses and riders. Ohio. Late nineteenth century. Wood and metal, painted. H. 21½″. Few wind vanes, or toys, possess the monumental beauty seen in this example. The horse-and-rider motif is repeated in figure 721, another vane obviously by the same maker. The wind cups and the riders' hats are made of tin. (Herbert W. Hemphill, Jr.)

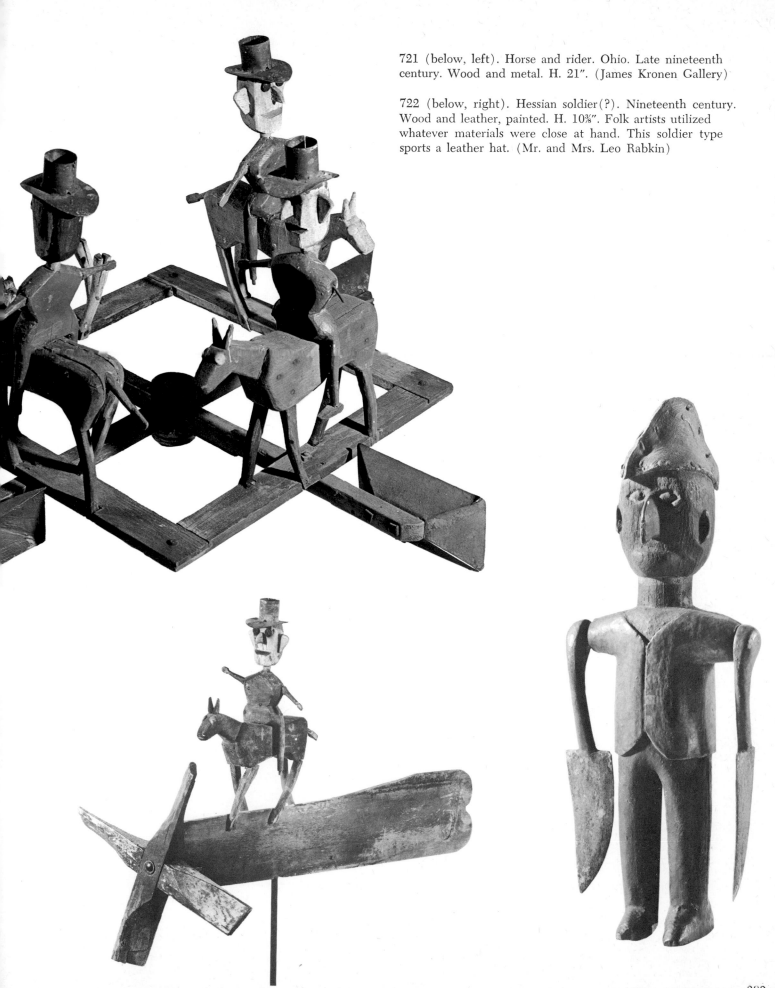

721 (below, left). Horse and rider. Ohio. Late nineteenth century. Wood and metal. H. 21". (James Kronen Gallery)

722 (below, right). Hessian soldier(?). Nineteenth century. Wood and leather, painted. H. 10⅝". Folk artists utilized whatever materials were close at hand. This soldier type sports a leather hat. (Mr. and Mrs. Leo Rabkin)

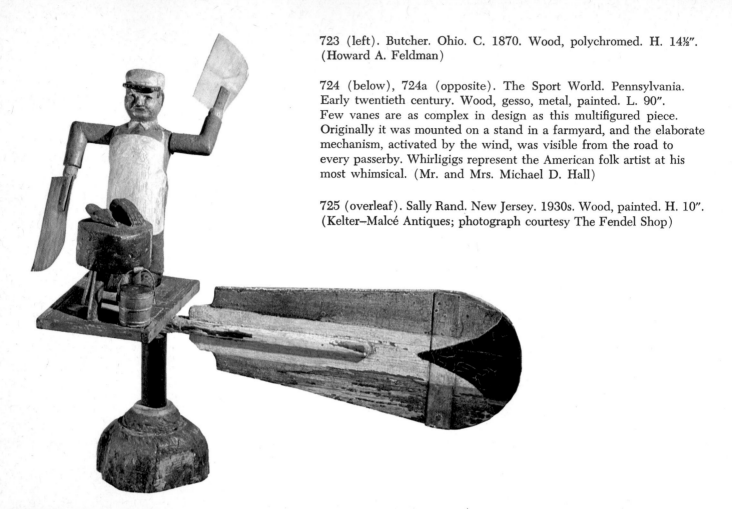

723 (left). Butcher. Ohio. C. 1870. Wood, polychromed. H. 14½″. (Howard A. Feldman)

724 (below), 724a (opposite). The Sport World. Pennsylvania. Early twentieth century. Wood, gesso, metal, painted. L. 90″. Few vanes are as complex in design as this multifigured piece. Originally it was mounted on a stand in a farmyard, and the elaborate mechanism, activated by the wind, was visible from the road to every passerby. Whirligigs represent the American folk artist at his most whimsical. (Mr. and Mrs. Michael D. Hall)

725 (overleaf). Sally Rand. New Jersey. 1930s. Wood, painted. H. 10″. (Kelter–Malcé Antiques; photograph courtesy The Fendel Shop)

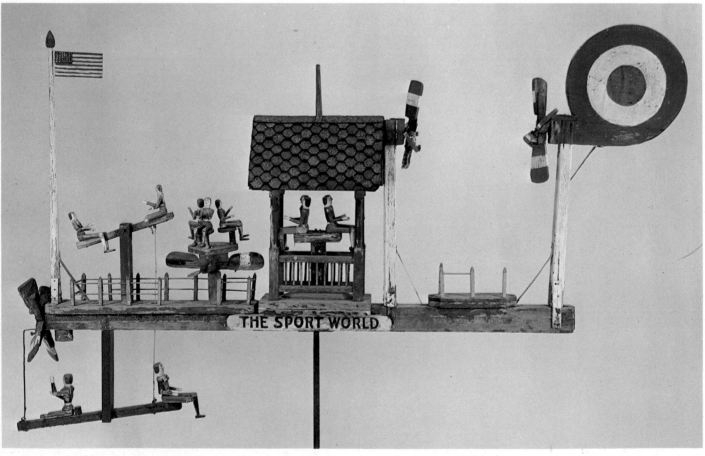

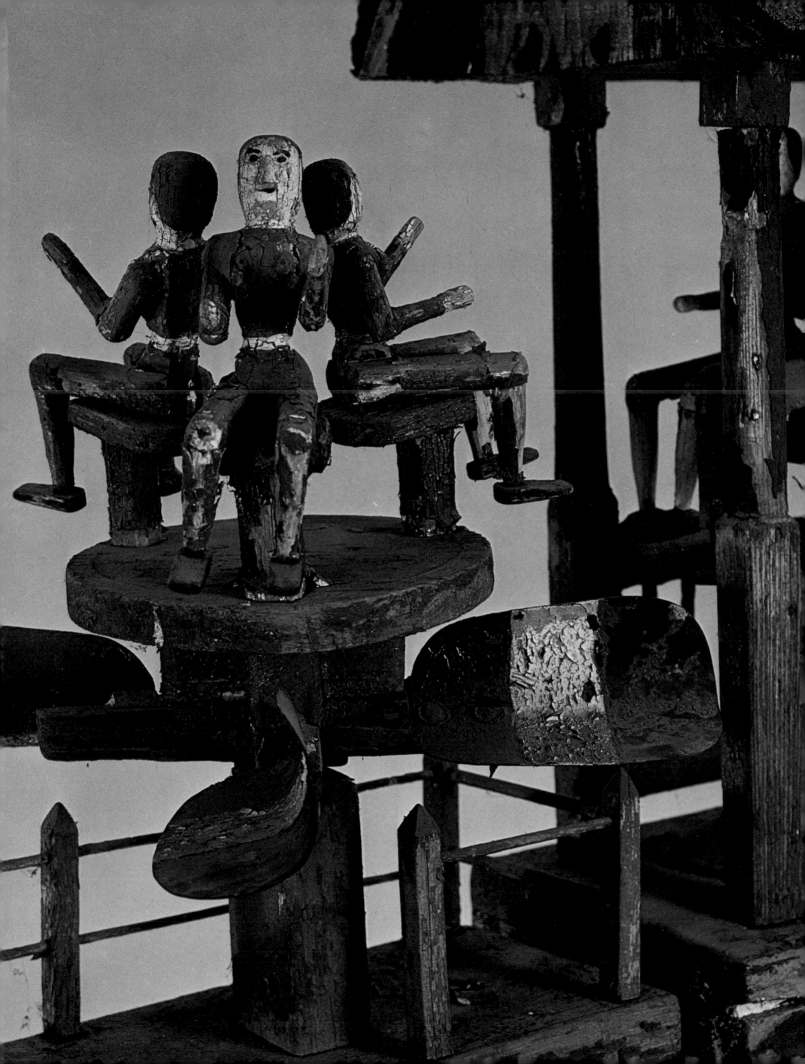

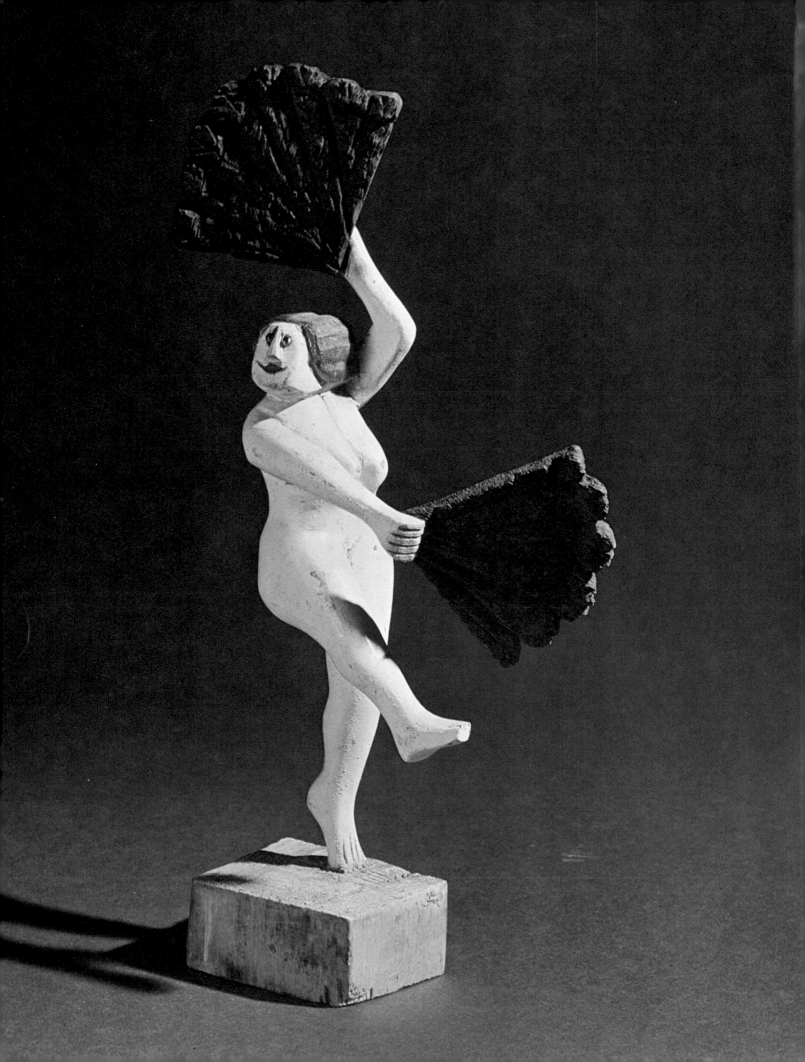

NOTES

1. Marshall Davidson, *The American Heritage History of Colonial Antiques* (New York: American Heritage Publishing Co., Inc., 1967), p. 12.

2. Neil Harris, ed. *The Land of Contrasts 1880–1901* (New York: George Braziller, Inc., 1970), p. 105.

3. Morgan B. Brainard, *Tavern Signs* (Hartford: The Connecticut Historical Society, 1958), p. 13.

4 Frederick Fried, *A Pictorial History of the Carousel* (New York: A. S. Barnes & Co., Inc., 1964), p. 119.

5. Luke 22:34.

6. George Washington to Joseph Rakestraw, *Writings*, vol. 29, p. 250, The Mount Vernon Ladies' Association of the Union.

7. George Washington to George A. Washington, Supplementary Letters, The Mount Vernon Ladies' Association of the Union.

8. M. V. Brewington, *Ship Carvers of North America* (Barre, Mass.: Barre Publishing Co., 1962), p. 8.

9. Ibid., p. 33.

10. Ibid.

11. Ibid., p. 26.

12. Private journal in the collection of the Old Dartmouth Historical Society Whaling Museum, New Bedford, Massachusetts.

13. Ibid.

14. Ralph K. Andrist, ed., *George Washington: A Biography in His Own Words,* The Founding Fathers Series, vol. 1 (New York: Harper & Row, Publishers, 1973), p. 69.

15. Marshall Davidson, *The American Heritage History of American Antiques from the Revolution to the Civil War* (New York: American Heritage Publishing Co., Inc., 1968), p. 72.

16. *Encyclopædia Britannica*, vol. 9 (Chicago: William Benton, Pub., 1973), p. 402.

17. Marshall Davidson, *The American Heritage History of Antiques from the Civil War to World War I* (New York: American Heritage Publishing Co., Inc., 1969), p. 74.

18. John P. Marquand, *Timothy Dexter Revisited* (Boston: Little, Brown and Company, 1960), p. 26.

19. Ibid., p. 10.

20. Ibid., p. 235.

21. Davidson, *American Antiques from the Revolution to the Civil War,* p. 156.

22. Ibid., p. 75.

23. Ibid.

24. Yvonne Brault Smith, "Bellamy—Carver of Eagles," *National Antiques Review* (October 1972), p. 16.

25. Ibid.

26. Quintina Colio, *American Decoys* (Ephrata, Pa.: Science Press, 1972), p. 49.

27. S. T. Dinsmoor, *The Cabin Home* (n.p., n.d.).

28. Ibid.

29. Ibid.

30. Quoted by John Thompson in *The Nashville Tennessean,* February 9, 1941.

31. Ibid.

32. *Carved by Prayer* (Spooner, Wis.: Museum of Woodcarving, n.d.).

33. Ibid.

34. Ibid.

35. George Francis Dow, *The Arts and Crafts in New England 1704–1775* (Topsfield, Mass.: The Wayside Press, 1927), p. 81.

36. Rita Susswein Gottesman, *The Arts and Crafts in New York 1777–1799* (New York: The New-York Historical Society, 1954), p. 95.

37. Fried, *Carousel*, p. 51.

38. Ibid.

39. Davidson, *Antiques from the Civil War to World War I*, p. 88.

40. Samuel Clemens, "Adventures of Huckleberry Finn," *The American Tradition in Literature*, 3rd ed., vol. 2, ed. Sculley Bradley, Richmond Croom Beatty, and E. Hudson Long (New York: W. W. Norton & Company, Inc., 1967), p. 343.

41. Esse Forrester O'Brien, *Circus Cinders to Sawdust* (San Antonio, Texas: Naylor Company, 1959), p. 5.

42. George L. Chindahl, *A History of the Circus in America* (Caldwell, Idaho: The Caxton Printers, Ltd., 1959), p. 73.

43. Manuscript material provided by Barbara Johnson.

44. Letter in the collection of the Abby Aldrich Rockefeller Folk Art Collection.

45. Frank Norris, *McTeague, A Story of San Francisco* (Greenwich, Conn.: Fawcett Publications, Inc., 1960), p. 97.

46. Alfred Stevens, "The Images," *Yankee Magazine* (July 1969), p. 108.

SELECTED BIBLIOGRAPHY

This selected bibliography lists the books and catalogues that were used in the preparation of this work. Listing the scholarly articles that have appeared over the years in *The Magazine* ANTIQUES would in itself comprise a book and, therefore, they have not been included.

"American Eagle." *The American Way* (July–August 1969).

American Folk Art from the Abby Aldrich Rockefeller Folk Art Collection. Williamsburg, Va.: Colonial Williamsburg, 1959.

American Folk Sculpture, the Personal and the Eccentric. Bloomfield Hills, Mich.: Cranbrook Academy of Art Galleries, 1971.

American Folk Sculpture, the Work of Eighteenth and Nineteenth Century Craftsmen. Newark, N.J.: The Newark Museum, 1931.

American Paintings and Sculpture. Newark, N.J.: The Newark Museum, 1944.

Andrist, Ralph K., ed. *George Washington: A Biography in His Own Words,* The Founding Fathers Series, vol. 1. New York: Harper & Row, Publishers, 1973.

Arts in Virginia, Vol. 12, No. 1 (Fall 1971). Richmond, Va.: Virginia Museum, 1971.

Babcock, Mary Kent Davey. *Christ Church, Salem Street, Boston.* Boston: Thomas Todd Company Printers, n.d.

Barber, Joel. *Wild Fowl Decoys.* New York: Dover Publications, Inc., 1954.

Boyd, E. *New Mexico Tin Work.* Santa Fe, N.M.: School of American Research Leaflet No. 2, 1953.

Bradshaw, Elinor Robinson. "American Folk Art in the Collection of The Newark Museum." *The Museum News Series,* Vol. 19 (Summer–Fall 1967).

Brainard, Morgan B. *Tavern Signs.* Hartford, Conn.: The Connecticut Historical Society, 1958.

Brewington, M. V. *Ship Carvers of North America.* Barre, Mass.: Barre Publishing Co., 1962.

Burgess, Robert H. *Scrimshaw, The Whaleman's Art.* Newport News, Va.: The Mariners Museum, n.d.

Cain, Thomas. "Santos: Record of a Way of Life Now Gone." *Arizona Highways* (September 1955).

Carlisle, Lilian Baker. *18th and 19th Century American Art at Shelburne Museum.* Shelburne, Vt.: Shelburne Museum, 1961.

Carved by Prayer. Spooner, Wis.: Museum of Woodcarving, n.d.

Catalogue of an Exhibition of Early American Art. New York: Whitney Studio Club, 1924.

Catalogue of the Initial Loan Exhibition. New York: Museum of Early American Folk Art, 1962.

Chase, Judith Wragge. *Afro-American Art and Craft.* New York: Van Nostrand Reinhold, 1971.

Chindahl, George L. *A History of the Circus in America.* Caldwell, Idaho: The Caxton Printers, Ltd., 1959.

Christensen, Erwin O. *Index of American Design.* New York: The Macmillan Company, 1959.

———. *Early American Wood Carving.* New York: Dover Publications, Inc., 1972.

Clemens, Samuel. *Adventures of Huckleberry Finn.* In *The American Tradition in Literature.* Edited by Sculley Bradley, Richmond Croom Beatty, and E. Hudson Long. New York: W. W. Norton and Company, Inc., 1967.

Colio, Quintina. *American Decoys.* Ephrata, Pa.: Science Press, 1972.

Craven, Wayne. *Sculpture in America.* New York: Thomas Y. Crowell Company, 1968.

Cummings, Abbott Lowell. *Rural Household ·Inventories 1675–1775.* Boston: The Society for the Preservation of New England Antiquities, 1964.

Davidson, Marshall. *The American Heritage History of Colonial Antiques.* New York: American Heritage Publishing Co., Inc., 1967.

———. *The American Heritage History of American Antiques from the Revolution to the Civil War.* New York: American Heritage Publishing Co., Inc., 1968.

———. *The American Heritage History of Antiques from the Civil War to World War I.* New York: American Heritage Publishing Co., Inc., 1969.

Dinsmoor, S. P. *The Cabin Home.* N.p., n.d.

Discoveries in American Folk Art. New York: John Gordon Gallery, 1973.

Dover, Cedric. *American Negro Art.* Greenwich, Conn.: New York Graphic Society, Ltd., 1960.

Dow, George Francis. *The Arts and Crafts in New England 1704–1775.* Topsfield, Mass.: The Wayside Press, 1927.

Earnest, Adele. *The Art of the Decoy.* New York: Clarkson N. Potter, Inc., 1965.

J. W. Fiske 1893. Princeton, N.J.: The Pyne Press, 1971.

Fitzgerald, Ken. *Weathervanes and Whirligigs.* New York: Clarkson N. Potter, Inc., 1967.

Flower, Milton E. *Wilhelm Schimmel and Aaron Mountz, Wood Carvers.* Willamsburg, Va.: Abby Aldrich Rockefeller Folk Art Collection, 1965.

Folk Art and The Street of Shops. Dearborn, Mich.: The Edison Institute, 1971.

Fried, Frederick. *A Pictorial History of the Carousel.* New York: A. S. Barnes & Co., Inc., 1964.

———. *Artists in Wood.* New York: Clarkson N. Potter, Inc., 1970.

Gillon, Edmund V., Jr. *Victorian Cemetery Art.* New York: Dover Publications, Inc., 1972.

"Gone are the Days of Figureheads." *The Iron Worker.* Lynchburg, Va.: Lynchburg Foundry Company, 1969.

Gordon, Leah. "Vanes of the Wind." *Natural History* (January 1972).

Gottesman, Rita Susswein. *The Arts and Crafts in New York 1726–1776.* New York: The New-York Historical Society, 1938.

————. *The Arts and Crafts of New York 1777–1799.* New York: The New-York Historical Society, 1954.

Harris, Neil, ed. *The Land of Contrasts 1880–1901.* New York: George Braziller, Inc., 1970.

Hemphill, Herbert W., Jr. *Twentieth-Century American Folk Art and Artists.* New York: E. P. Dutton & Co., Inc., 1974.

Hill, Ralph Nading, and Carlisle, Lilian Baker. *The Story of the Shelburne Museum.* Shelburne, Vt.; Shelburne Museum, Inc., 1960.

Hornung, Clarence P. *Treasury of American Design.* 2 vols. New York: Harry N. Abrams, Inc., n.d.

Illustrated Catalogue and Price List of Copper Weather Vanes and Finials Manufactured by J. W. Fiske. New York: Gerald Kornblau Antiques, 1964.

Jackson, Lowell, ed. *Benj. J. Schmidt, A Michigan Decoy Carver 1884–1968.* Birmingham, Mich.: Lowell Jackson, 1970.

The John and Mable Ringling Museum of Art. Orlando, Fla.: Hannau Robinson, Inc., 1971.

Kauffman, Henry J. *Pennsylvania Dutch American Folk Art.* New York: Dover Publications, Inc., 1964.

Lichten, Francis. *Folk Art of Rural Pennsylvania.* New York: Charles Scribner's Sons, 1946.

————. *Pennsylvania Dutch Folk Art from the Geesey Collection and Others.* New York: The Metropolitan Museum of Art, 1958.

Lipman, Jean. *American Folk Art.* New York: Pantheon Books Inc., 1948.

————, and Winchester, Alice. *The Flowering of American Folk Art 1776–1876.* New York: The Viking Press, 1974.

Little, Nina F. *Abby Aldrich Rockefeller Folk Art Collection.* Williamsburg, Va.: Colonial Williamsburg, 1958.

The Living Museum. Springfield, Ill.: Illinois State Museum (November–December 1971).

Lord, Priscilla S., and Foley, Daniel J. *The Folk Arts and Crafts of New England.* Philadelphia: Chilton Book Company, 1965.

Lowe, David G. "Wooden Delights." *American Heritage,* Vol. XX, No. 1 (December 1968).

Ludwig, Allen I. *Graven Images.* Middletown, Conn.: Wesleyan University Press, 1966.

Mackey, William J., Jr. *American Bird Decoys.* New York: E. P. Dutton & Co., Inc., 1965.

"Made for the Season." *Art in America,* Vol. 55 (1967).

Marquand, John P. *Timothy Dexter Revisited.* Boston: Little, Brown and Company, 1960.

The Metal of the State. New York: Museum of American Folk Art, 1973.

"The Newark Museum Collection and Exhibition, 1959–69." *The Museum News Series,* Vol. 21 (Summer–Fall 1969).

Norris, Frank. *McTeague, A Story of San Francisco.* Greenwich, Conn.: Fawcett Publications, Inc., 1960.

O'Brien, Esse Forrester. *Circus Cinders to Sawdust.* San Antonio, Tex.: Naylor Company, 1959.

Peabody Museum of Salem. Salem, Mass.: Peabody Museum of Salem, 1969.

Pendergast, A. W., and Ware, W. Porter. *Cigar Store Figures in American Folk Art.* Chicago: The Lightner Publishing Corp., 1953.

Pennsylvania Dutch Folk Arts. Philadelphia: Philadelphia Museum of Art, n.d.

Polley, Robert L., general ed. *America's Folk Art.* New York: G. P. Putnam's Sons, n.d.

Report of the Director. Salem, Mass.: Peabody Museum of Salem, 1971.

Ross, Marjorie Drake. *The Book of Boston.* New York: Hastings House Publishers, Inc., 1960.

Sams, Henry W., ed. *Autobiography of Brook Farm.* Englewood Cliffs, N.J.: Prentice-Hall, Inc., 1958.

Santos. Fort Worth, Tex.: Amon Carter Museum of Western Art, 1964.

Smith, Yvonne Brault. "Bellamy—Carver of Eagles." *National Antiques Review* (October 1972).

Speare, Elizabeth George. *Child Life in New England, 1790–1840.* Sturbridge, Mass.: Old Sturbridge Village, 1961.

Stevens, Alfred. "The Images." *Yankee Magazine* (July 1969).

Stitt, Susan. *Museum of Early Southern Decorative Arts in Old Salem.* Winston-Salem, N.C.: Museum of Early Southern Decorative Arts, 1970.

The Story of the Circus World Museum. Madison, Wisc.: State Historical Society of Wisconsin, 1971.

Stoudt, John J. *Early Pennsylvania Arts and Crafts.* New York: A. S. Barnes & Co., Inc., 1964.

Tavares, M. A. "Scrimshaw, The Art of The Whaleman." *National Antiques Review* (February 1972).

Todd, A. L., and Weisbord, Dorothy B. *Favorite Subjects in Western Art.* New York: Dutton Paperbacks, 1968.

Watson, John F. *Annals of Philadelphia.* Philadelphia, 1930.

Webster, David S., and Kehoe, William. *Decoys at Shelburne Museum.* Shelburne, Vt.: Shelburne Museum, Inc., 1961.

Welsh, Peter C. *American Folk Art, the Art and Spirit of a People.* Washington, D.C.: Smithsonian Institution, 1965.

Wilder, M. A. "Santos." *The American West* (Fall 1965).

INDEX

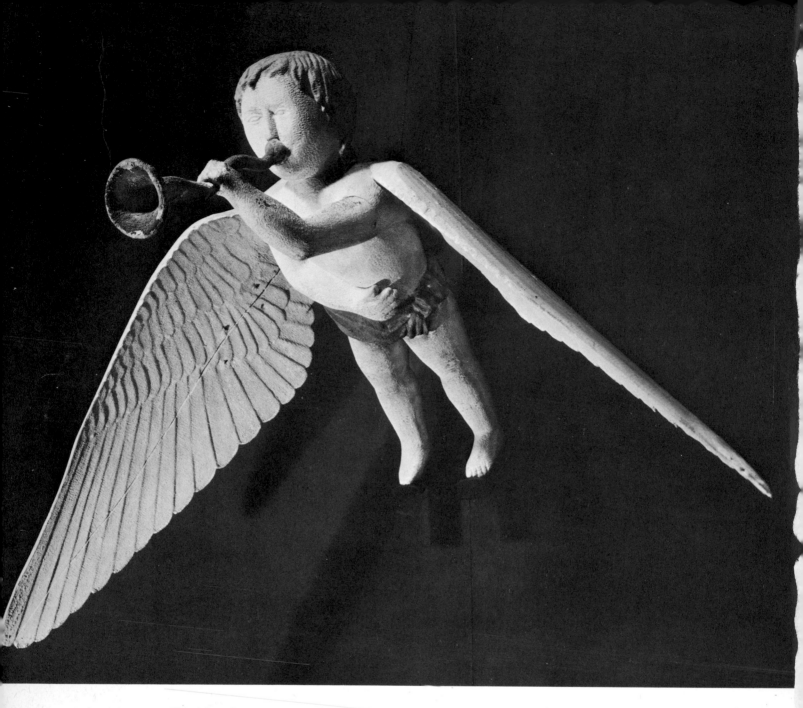

726 (above). Tavern sign. Guilford, New York. C. 1827. Wood, painted. W. 46½".
This splendid angel Gabriel, one of the masterpieces of American folk sculpture, was
used under the portico of the Angel Tavern at Guilford. The tavern was built by
Captain Elihu Murray for his son, Dauphin. See the frontispiece, page 2, for a color
illustration of this piece. (Mrs. Jacob M. Kaplan; photograph courtesy Gerald
Kornblau Gallery)